THE SALON ALBUM OF
VERA SUDEIKIN-STRAVINSKY

THE SALON ALBUM OF

Vera Sudeikin-Stravinsky

EDITED AND TRANSLATED BY

JOHN E. BOWLT

PRINCETON UNIVERSITY PRESS, PRINCETON, NEW JERSEY

Copyright © 1995 by Princeton University Press
Published by Princeton University Press, 41 William Street,
Princeton, New Jersey 08540
In the United Kingdom: Princeton University Press,
Chichester, West Sussex

Library of Congress Cataloging-in-Publication Data

The salon album of Vera Sudeikin-Stravinsky / edited and translated
by John E. Bowlt

p. cm.

Includes a facsimile of the album with translation and
commentary in English.
Includes bibliographical references and index.
ISBN 0-691-04424-4
1. Albums. 2. Stravinsky, Vera—Diaries.
I. Bowlt, John E.
ML63.S14 1995 759.13—dc20 95-10264

The publication of this book has been made possible by
a gift from Robert Craft

This book has been composed in Berkeley Medium

Princeton University Press books are printed on
acid-free paper and meet the guidelines for permanence
and durability of the Committee on Production
Guidelines for Book Longevity of the
Council on Library Resources

Printed in the United States of America

2 4 6 8 10 9 7 5 3 1

CONTENTS

PREFACE VII

INTRODUCTION X

NOTES TO THE INTRODUCTION XXVII

THE SALON ALBUM OF VERA SUDEIKIN-STRAVINSKY

FOLLOWING P. XXX

THE SALON ALBUM OF VERA SUDEIKIN-STRAVINSKY:
TRANSLATION AND ANNOTATION 1

BIBLIOGRAPHY 101

INDEXES 103

GENERAL INDEX 103

INDEX TO WRITTEN ENTRIES 112

INDEX TO ILLUSTRATIVE ENTRIES 112

INDEX TO MUSICAL ENTRIES 113

INDEX TO PORTRAITS 113

INDEX TO DATES 113

PREFACE

This book is divided into two sections. The first section is a facsimile of the album or scrapbook (hereafter referred to as the Album) that Vera Sudeikina (1888–1982)—more familiar to us as Vera Stravinsky, wife of the great composer—kept during her journey from Petrograd, Moscow, the Crimea, Tiflis, and Baku to Paris in 1917–20. It has been assumed that the primary, if not sole, initiator and keeper of the Album was Vera Sudeikina, even though several of the entries are dedicated to both her and Sergei Sudeikin. (The poet Yurii Degen even refers to the "owners of the Album" in entry 107b.)

Vera Sudeikina—or, according to her marital status at that time, Vera Shilling—left Petrograd for Moscow in April 1917 and then, joined by her companion, the artist Sergei Sudeikin, arrived in Simferopol in the Crimea in the summer. The couple took up residence in Alushta on the Black Sea coast, moved to Yalta in September or thereabouts, and then went to Miskhor (Meskhor) in December. Sailing from Yalta to Batum via Novorossiisk in mid-April 1919, they arrived in Tiflis toward the end of that month and in December went on to Baku. In March 1920 they returned to Tiflis and two months later made their way to France, arriving in Paris via Batum and Marseilles on 20 May. The Album carries entries from all these locations, except for Moscow, Simferopol, Batum, Novorossiisk, and Marseilles. Among the contributors are Konstantin Balmont, Ivan Bilibin, Yurii Degen, Nikolai Evreinov, Sergei Gorodetsky, Boris Grigoriev, Lado Gudiashvili, Boris Kochno, Mikhail Kuzmin, Osip Mandelstam, Grigorii Robakidze, Igor Stravinsky, Mikhail Struve, the Sudeikins themselves, Maximilian Voloshin, and many other representatives of the Silver Age in Russia and Transcaucasia.

The second section contains the English translation (from Russian, unless stated otherwise) of all the written items in the Album. Each entry contains commentary on the context of the item; biographical information about its author, artist, or composer; and a short bibliography. A peripheral source of information has been a corpus of casual, unsystematized notes written for the most part by Vera Sudeikina-Stravinskaia but usually undated and not sequential. This group of documents has been referred to as the Varia. For the sake of textual clarity as well as the reader's patience, and with all respect to the keeper of these precious documents, I have abbreviated the name of Vera Arturovna Bosset-Luryi-Shilling-Sudeikina-Stravinskaia throughout the second section of the book to simply Vera. Mme Stravinsky was by all accounts supremely unaffected, spontaneous, and direct, so perhaps she would not have objected too violently to this extreme informality.

VERA'S ALBUM

Most of the epigrams, poems, designs, and musical passages in the Album are on pages of white, pink, red, blue, or ocher paper with a standard size of 36 × 34 cm. Where entries are on smaller pieces of paper that have been glued onto larger pages (e.g., entry 1b), or where the page is of colored paper, this, along with dimensions (in centimeters, the height preceding the width), is noted in the curatorial data. A few entries are on separate pieces of paper that have been sewn in or loosely inserted, and this has also been indicated where relevant. Occasionally drawings that have been glued onto the pages of the Album also carry other drawings or fragments on their reverse. But until a conservational decision is reached regarding the ultimate status of the Album and the feasibility of removing the attachments, these reverse images cannot be examined in detail. However, when a text or an image is known to exist on the reverse of a given entry, this information is included in the description.

The Album covers the period from April 1916 (entry 17a) through the summer of 1923 (entry 111b), although the focus of attention is on the years 1918–20, when Vera was in the Crimea, Tiflis, and Baku. The Petrograd and Paris contributions (e.g., the two 1916 poems by Mikhail Kuzmin in entries 15 and 17a and the 1922 poem by Boris Kochno in entry 49b) are, of course, extremely important, but they are outnumbered by the dedications made in Alushta, Yalta, Miskhor, Tiflis, and Baku. In any case, it can be presumed that the two Kuzmin manuscripts, "The same dream, alive yet bygone . . ." and "Another's Poem," while written for the Sudeikins in 1916, were inserted in the Album at a later date; the same may be true of other items loosely inserted, such as Osip Mandelstam's "The stream of golden honey . . ." of 1917 (entry 51a). Three additional works from one of Sergei Sudeikin's exercise books dated January–February 1917 were kept at the back of the Album and have been treated here as a supplement. In view of the direct relevance to the unexpected denouement of Vera and Sergei Sudeikin's romance after the couple arrived in Paris in 1920, two documents that Boris Kochno and Igor Stravinsky contributed to another album in 1921 have also been included here and denoted as S4 and S5. Many of the entries are untitled, and this lacuna has been preserved except when a drawing or watercolor is obviously of a particular person, such as Vera: the information has then been provided.

Entry numbers refer to the imposed folio numbers of the Album. Where more than one separate entry appears on a given page in the

Album, a letter follows the entry number to indicate which entry is being discussed (e.g., entries 1a and b). The fact that a poem and a figure may appear on the same page does not always indicate that one describes or illustrates the other. However, if a poem and a picture that share a single page are related and are by the same contributor, then they have been treated as a contiguous item (e.g., entries 112–13). Some pages in the Album are blank, and consequently from time to time the sequence misses numbers (for a complete list of the entries, showing their numerical sequence, see the beginning of the index section at the back of this volume). Nor is the distribution of the entries in the Album chronological—for example, the first item, by Konstantin Balmont (entry 1a), was written in August 1920, after the Sudeikins' arrival in Paris; whereas the last item, by one D.W. (entry 173b), was composed in Yalta in 1917. Within the 206 entries there are many strange combinations and non sequiturs, for example, 111a (Mandelstam in Alushta in 1917), followed by 111b (Mitsishvii in Paris in 1923), followed by 112–13 (Gorodetsky in Baku in 1920). At times this illogical progression of the entries and the several loose insertions previously mentioned prompt us to wonder whether Vera did not at some point make a casual rearrangement of the original sequence or haphazardly add poems and art from other sources, especially in the last years of her life, when she was considering publishing the Album and her Diaries. Moreover, the Diaries for 1917–19 do not carry any direct reference to this particular album—which is puzzling, given how assiduously Vera recorded her daily rounds. But be that as it may, for the purposes of this volume, the Album in its present state has been accepted as the original and authentic text.

Biographical and bibliographical information is given each time a new author or artist appears in the sequence of entries; and, where relevant, activities in the Crimea, Tiflis, and Baku have received particular attention. In those cases where collected works or scholarly appreciations have already been published—for example, for Konstantin Balmont (entry 1a)—the major bibliographical sources are indicated in "Further Reading" sections, and readily accessible data have not been repeated. To avoid confusion in dating sequences, the dates that often accompany the entries have been rendered, where possible, by day, month, and year, in that order. Even though the Russian calendar was updated on 14 February 1918 (the Old Style calendar was thirteen days behind the Western calendar), most of the contributors seem to have continued to use the pre-Revolutionary version, although in some cases (e.g., entries 87, 89) the authors indicate both. For the sake of consistency, the date and place (if inscribed) are included at the bottom left of each text entry in the translation section, whereas the signature (if inscribed) appears at the bottom right. At the outbreak of the World War I the name of the city of St. Petersburg was changed to Petrograd and then, after Lenin's death in 1924, to Leningrad; it was changed back to St. Petersburg in 1992. Tiflis was renamed Tbilisi in 1936.

All texts in the Album, including artists' signatures and monograms, are in Russian unless stated otherwise. My translations are in prose, and although many of the entries are poems, I have made no attempt to render them into metrical English verse. The transliteration system used is a modified version of the Library of Congress system, although the soft and hard signs have been rendered by i or have been omitted, and *Aleksandr* and *Aleksei* have been rendered as *Alexander* and *Alexei* throughout. When a Russian name has already received a conventional transliteration that varies from the preceding system (e.g., Benois, not Benua), this has been preserved.

The Album is currently in a private collection in New York.

❋ ❋

Many people have rendered invaluable assistance in this undertaking. In particular, I would like to acknowledge my debt to the following: Damian Alaniia, Edwin Allen, Victor Borovsky, Maria Carlson, George Cheron, Allison and Walt Comins-Richmond, Robert Craft, Antonina Dolgushina, Valerian Dudakov, Irina Dzutsova, Lazar Fleishman, Anna Galichenko, Musya Glants, Cyrille Grigorieff, Allan Ho, Dmitri Ivanov, Gerald Janecek, Boris Kerdimun, the late Boris Kochno, the late Dora Kogan, Mark Konecny, Vladimir Kupchenko, Nikita D. and Nina Lobanov-Rostovsky, Luigi Magarotto, John Malmstad, Jean-Claude Marcadé, Vladimir Markov, the late Marzio Marzaduri, Olga Matich, Nicoletta Misler, Tatiana Nikolskaia, Anna Opochinskaia, Mikhail Parkhomovsky, Alexander Parnis, Helen and Franklin Reeve, Natalie Roklina, Bernice Rosenthal, Andrei de Saint-Rat, Dmitrii Sarabianov, Rusudama Shervashidze, the late Beryl M. Smith, Bella Solovieva, Roman Timenchik, James West, Ekaterina Yudina, the late Hélène Zdanevitch, and Alexander Zholkovsky.

My special appreciation goes to Mark Roberts for his photographic work, to Andrea Rusnock for her help with the general index, and to my editor, Lauren Oppenheim, for her unfailing patience and cooperation.

I would also like to thank the staff of the following institutions for their help in facilitating access to bibliographical and archival sources: the All-Union Theater Society, Moscow; the Bakhrushin Museum, Moscow; the Chekhov Museum, Yalta; the Getty Center for the History of Art and the Humanities, Santa Monica; the Institute of Modern Russian Culture, Los Angeles; the International Research and Exchanges Board, Washington, D.C.; the Russian National Library, Moscow; the Russian State Archive of Literature and Art, Moscow; the St. Petersburg Theater Museum; the New York Public Library; the State Museum of the Arts of Georgia, Tbilisi; the State Russian Museum, St. Petersburg; the State Tretiakov Gallery, Moscow; the University of California, Los Angeles; and the University of Southern California, Los Angeles.

INTRODUCTION

The Album presented here belonged to Vera Arturovna Bosset-Shilling-Sudeikina-Stravinskaia (1888–1982)—Anglicized in the title of this volume as Vera Sudeikin-Stravinsky—a lady more familiar to us now as the vibrant and dedicated wife of one of the greatest composers of our time, Igor Fedorovich Stravinsky.[1] While this "Muse of the Muses," as Boris Kochno once called her,[2] has, of course, the right to be remembered as the companion and protectress of Stravinsky, she also merits a fuller and more personal appreciation. After all, not only did Vera happen to be the wife of three other cultured gentlemen before Stravinsky but she herself was also an accomplished artist and writer, a Corinne du Nord whose creative talents, physical beauty, and lively wit inspired many other poets, artists, and musicians of her time, from Konstantin Balmont to Boris Grigoriev, from Sergei Gorodetsky to Lado Gudiashvili, from Mikhail Kuzmin to Sigizmund Valishevsky. All these—and many other—celebrities left their *ricordi* in Vera's Album, and they are offered here as the milestones on a grand and sentimental tour from Petrograd to Yalta and from Tiflis to Baku as well as a vital testimony to the cultural regeneration that Russia and Transcaucasia continued to enjoy in 1917–20. The Album also documents the itinerary of a diaspora that journeyed from the Bolshevik north to the Menshevik south; and it tells us that in spite of military intervention, constant travel, and physical deprivation, Russia's Silver Age, hosted so brilliantly by the salons of St. Petersburg and Moscow, did not fade with the cataclysm of war and revolution but continued to flourish in Yalta, Tiflis, and Baku.

Vera Sudeikina was an avid keeper of albums, notebooks, and diaries in which she recorded her daily experiences, impressions of people and events, and general philosophy of life.[3] The exact sequence of all these documents, especially the diaries, cannot be established with total accuracy, because some components have been lost or destroyed; but it is supposed that her first records began in 1897—a tiny notebook with red cloth covers bearing the embossed word "Notes" and encompassing the years 1897–1901. On the front cover of this notebook Vera had written in Russian, "1897. When I was five years old."

Obviously this statement was added much later in life, because although Vera's American passport gives the year 1892 as the year of her birth, she was in fact born in 1888. Later on, Vera explained this discrepancy by the fact that Sudeikin had induced her to become four years younger when she applied for a Georgian passport in Tiflis in 1919. It is in the section for 1901 in this first notebook, incidentally, that Vera mentions keeping a diary and "many other notebooks" and also being a "lady of society and not just a fourteen-year-old girl." One of the entries is written in the "blood of V. Bosse"

(= Bosset), and many entries are dedicated to the births and deaths of dogs, cats, and calves.

More relevant to the Album are the diaries that Vera kept for the period 1 (14) January 1917–27 August 1919 (with gaps), and frequent parenthetical references to these, designated here as Diaries, will be found in the commentary to the Album. Like the Album, the Diaries cover the Sudeikins' journey from Petrograd to Moscow, from Moscow to the Crimea, and from the Crimea to Tiflis; but unfortunately the Tiflis-Baku-Tiflis-Batum-Marseilles itinerary is omitted. It is not clear whether Vera failed to keep a diary during this time (September 1919–May 1920) or whether the documents have been lost, although, in view of her passion for recording events and meetings, it seems likely that she did indeed keep accounts during that exciting and complex time in Tiflis and Baku. The loss is to be much regretted, because, as the Diaries for May–August 1919 and the Album demonstrate, this period was one of the most fascinating chapters not only of the history of the Sudeikins' lives together but also of the history of Russian Modernism. The rich cultural environments of Tiflis and Baku in 1917–21 have still to be appreciated and described in detail, but relative documents, especially firsthand reports, are rare, and there can be no question that, were they to be found, Vera's full memoirs of 1919–20 would shed light upon many perplexing issues.

As they traveled south, such leading representatives of Russian Symbolism and Cubo-Futurism as Sergei Gorodetsky, Viacheslav Ivanov, Vasilii Kamensky, Alexei Kruchenykh, Sergei Makovsky, Osip Mandelstam, Sergei Sudeikin, and Maximilian Voloshin continued to publish, lecture, act, paint, and polemicize; and of no lesser importance to the appreciation of this Album is the fact that these artists and poets also maintained the intensity of their amatory adventures, often conducting the same promiscuous and heterosexual lifestyle that characterized the bohemia of fin-de-siècle St. Petersburg. After all, the explicit and implicit eroticism in the poetry and confessions of Yurii Degen, Grigoriev, Kuzmin, and Pallada Deriuzhinskaia constitute one of the most forceful and human dimensions of the Album. Vera was certainly part of and party to this inclination herself, and she too did not deride the common sensual pleasures of life and refused to equate immorality with physical urge, whether for food or for sex. One of the recollections of her childhood that Vera wrote much later in New York emphasizes this uncompromising attitude toward healthy mind and healthy body: "Everybody went to the hunting party, and I was left at home. But I took my vengeance—and ate all the caviar that had been prepared for lunch. 'Next time we'll lock you in your room,' was the reaction. 'You couldn't have been that hungry; you were just being gluttonous, and that's a sin.'

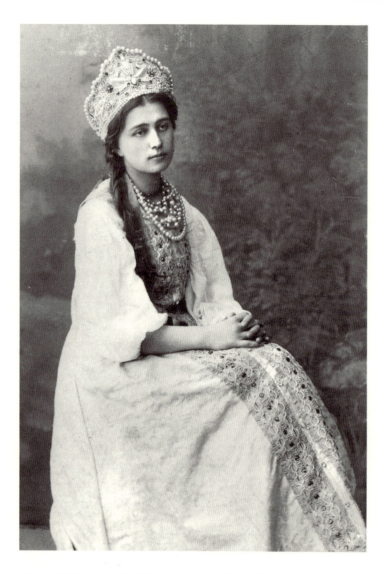

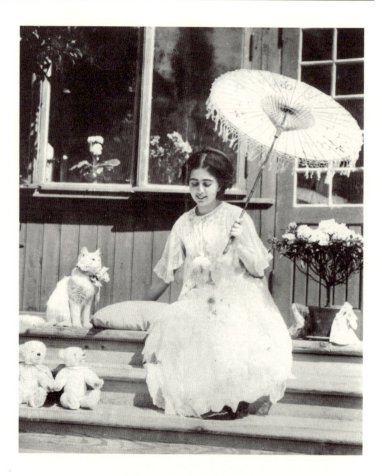

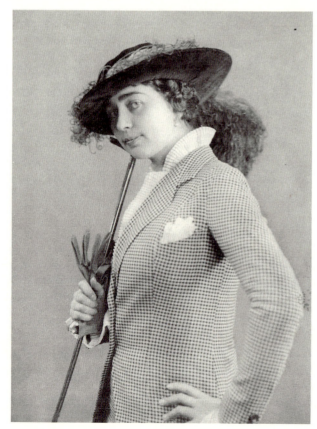

Above, left: Photograph of Vera Arturovna Bosset in graduation costume, St. Petersburg, 1904. The reverse of the photograph bears a dedication to an unidentified individual: "Basically, life is good. How pleasant and cheering it is to see life bubbling around you, to realize that you're needed, and that you know how to work." Courtesy of Robert Craft.

Above, right: Vera and her cat, Mashka, at Kudinovo, 1902. Kudinovo is the town between Moscow and Nizhnii-Novgorod where Vera's father, Artur de Bosset, owned a factory called Electric Coals, which produced "electric coals for arc lighting, soldering, and welding." The Bossets also owned a house at Kudinovo. Courtesy of Robert Craft.

Below, right: Vera in costume for an unidentified film, Moscow, 1915. Courtesy of Robert Craft.

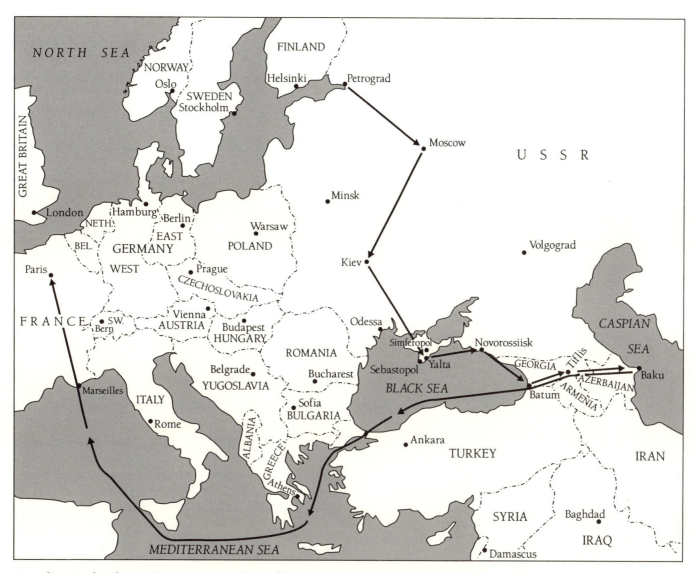

Map of Russia, the Ukraine, Transcaucasia, and part of Europe showing the itinerary of Vera and Sergei Sudeikin between 1917 and 1920.
In April 1917 Vera moved from Petrograd to Moscow. In May or June, she and Sudeikin traveled to Simferopol and then to the
Black Sea coast, living near and in Yalta until April 1919. They then went on to Tiflis via Novorossiisk and Batum and stayed there
until December, before moving on to Baku. In March 1920 they returned to Tiflis, and in May 1920 they left Batum for Marseilles,
arriving in Paris on 20 May 1920.

'It was a joy,' I replied, 'and joy can't be a sin.' But I was very sick"
(Varia).

It is important to remember that the contributors to the Album
are representatives of Russia's Silver Age, that is, of Symbolism and
Acmeism rather than of the avant-garde. Only Vasilii Kamensky,
Igor Terentiev, and the Zdanevich brothers, Ilia and Kirill, can be
relegated to the same radical camp as Kazimir Malevich and Vladimir
Tatlin, who were distant from the Sudeikins and from their aesthetic
taste. "The merry dream is ending," wrote Degen in 1919 (entry
25b), and indeed the Album reflects the final iridescence rather than
the dawn of an epoch; it is the homage to an Alexandrine culture
perhaps more suited to the pages of the elegant St. Petersburg jour-
nals *Apollon* (Apollo) and *Starye gody* (Bygone years), and Kuzmin's

nocturnal reveries, Grigorii Robakidze's Decadent sensibility, and
Sudeikin's stylized scenes of the commedia dell'arte express a nostal-
gia for an era fast receding. Symptomatic of this mood is the center-
fold of the Album—Gorodetsky's rendering of the main figures from
the Symbolist and Acmeist Pantheon (entries 112–13).

Vera's Album belongs to a literary or artistic category, if not genre,
that was common to nineteenth- and twentieth-century Russian cul-
ture.[4] Its composition and maintenance presupposed a salon and pa-
tron (more often, patroness) if not as noble as Princess Zinaida Vol-
konskaia in Russian Rome in the 1830s then at least intelligent and
charming like Vera. In fact, Vera belonged to an entire generation of
privileged protectors of the arts in St. Petersburg that also included
Nadezhda Dobychina, Genrietta Girshman, and Olga Della-Vos-

Kardovskaia.[5] These women helped the cause of Russian art by collecting, commissioning, subsidizing, and publishing, by organizing museums, schools, *jours fixes*, and art colonies, and by simply knowing how to bring together the most disparate intellects and talents. They often moved in particular cultural orbits: Girshman, for example, one of Valentin Serov's favorite sitters, was a guiding force behind the establishment of the Society of Free Aesthetics in Moscow; while Dobychina brought the work of Natan Altman, Grigoriev, and Marc Chagall to public attention through her private gallery. These women often commissioned particular paintings and poems, encouraged historic confrontations (such as Vera's own fateful meeting with Stravinsky in Paris in 1921), and maintained and preserved records of their numerous meetings, which today are precious records of a lost cultural topography. Still, unlike the scrapbooks of her contemporaries, Vera's Album is "active" rather than "passive" in the sense that Vera conducted her salon wherever she happened to be, and in the most modest settings—including a single room in a damp cellar in Tiflis. The Album, therefore, is a record of geographical peregrinations, a movable feast of cultural encounters, which provides us with a unique glimpse not only into Vera's autobiography, but also into the cultural integration—rather than disintegration—of the early Russian emigration.

Furthermore, Vera herself was a gifted writer who could record events clearly and engagingly, sometimes with ironic amusement, sometimes with brutal sobriety; and by the time she began to compile her Petrograd, Crimean, and Transcaucasian observations, she had been writing fact and fiction for well over twenty years. Vera's tiny notebook for 1897–1901, the earliest diary that has come down to us, is full of poems, aphorisms, character descriptions, and stories (in Russian, German, and French) that are remarkably mature and poised for a tender child of ten or twelve.

Vera's Album is both miraculous and nonsensical. It is miraculous in the sense that it contains masterpieces of poetry and painting and nonsensical in that many of the contributions are casual, informal, and even ingenuous. The Album is also miraculous in its persistence of memory, for it has survived war, revolution, and exile, and is nonsensical in its wanton disregard of chronological or thematic sequence. Even so, there is an overriding unity to the Album, and it is much more than resort literature. It is also the recollection of cultural and emotional climaxes that constitute a "literature of loss"—not only of city and country (e.g., Alexander Fainberg's nostalgia for St. Petersburg in "Chanson Triste," entry 33) and childhood (e.g., Georgii Evangulov's poem "Childhood," entries 90a–91a) but also of a fantastic Golden Age with tapestries, porcelains, and jesters, cavaliers and ladies dancing to the music of Mozart and Schumann at some imaginary St. Petersburg *fête galante*. Loss of homeland and identity evokes a "momentary delirium, a charming ephemerality," as Yurii Degen writes in "Carnival" (entry 25b), which, in turn relates to the theme of sleep and languor that persists throughout the Album, from Ivan Bilibin's "languorous somnolence" (entry 37c) to Kochno's "light smoke of dreams" (entries 48–49c).

THE SYMBOLIST HERITAGE

In its very content and composition, the Album is a monument to the Russian fin de siècle. It is a synthetic artifact, integrating word, image, and sound, which in this creative interaction must have appealed to its Symbolist contributors nurtured on the traditions of the *Gesamtkunstwerk*.

Poets and musicians painting pictures; actors, dancers, and painters writing poetry—these role reversals, encouraged by the leaders of Russia's cultural renaissance, are a major and exciting aspect of the Album. Moreover, the Album communicates many things about the creative spirit of the Russian Silver Age—and not only the thematic and philosophical aspirations of its poets and painters: to a considerable extent, the Album bears witness to the artistic process of that era and suggests that the literature of Balmont, Sergei Gorodetsky, Kamensky, Kuzmin, Mandelstam, Nikolai Minsky, Voloshin, and so on was not always written as the result of severe intellectual regime or arduous deliberation but was often born spontaneously, *en famille*. The Sudeikins' homes in Petrograd, Tiflis, and Baku provided an artistic inspiration as much by virtue of their unceremonious hospitality and "simple nonsense" as through abstract discourse. In any case,

in the 1910s Vera felt herself to be a principal witness to the prosperity of the cultural renaissance that signified Russia's Silver Age, as she wrote in January 1917 from her Petrograd apartment:

Today I'm working away cheerfully and feeling that all around me, along the canals, are studios where Russian artists are working. They are united by history, they are asserting their genealogical tree and striving to revive their national art. Only our mighty country is destined to drink the bitter cup of life to the end, but no events can stop our family tree from becoming a garden in bloom. (Varia)

The fact that the Sudeikins decorated the interior walls of their various apartments and that they painted, wrote, ate, slept, and entertained their guests within the same narrow enclosure prompts analogy with the St. Petersburg cabaret culture that they supported so diligently in the 1910s and that, to an appreciable extent, molded their artistic personalities. Like the ballet, the opera, and the Album itself, the cabaret is also an extension of artistic synthesis and pertains to a theatrical context that is especially rewarding for any dis-

cussion of the Album. After all, the cabaret and the carnival are among the principal motifs here, and many of the contributors (Balmont, Gorodetsky, Grigoriev, Vladimir Pol, the Sudeikins, et al.) took a direct part in the activities of the St. Petersburg cabarets. Recalling the long St. Petersburg winter as they tolerated the sultry heat of Tiflis or the oil-pervaded air of Baku, the Sudeikins and their friends thought involuntarily of two theatrical establishments that in many ways summarized the finest aspirations of the St. Petersburg intelligentsia in the 1910s: the two cabarets known as the Stray Dog and the Comedians' Halt. Many of the contributors to the Album had been members of these cultural clubs, and their poems and pictures here contain direct and indirect allusions to the literary, pictorial, and musical achievements of the two cabarets. Furthermore, the fact that in Tiflis and Baku both Vera and Sergei perpetuated this medium through their creative contributions to the welfare of such similar institutions as the Fantastic Tavern (Tiflis) and the Merry Harlequin (Baku) indicates how closely they adhered to the tradition of the miniature theater.

The format of the Russian cabaret—a confined stage housed in a small restaurant or café providing amusement through variety sequences—owed much to Western models (Nikita Baliev's Bat, for example, founded in Moscow in 1908, carried an obvious reference to the Fledermaus).[6] However, the Russian cabaret was also indebted to local traditions; and perhaps one reason why this theatrical form flourished so well in St. Petersburg and Moscow is that it had such strong links with the conventions of the indigenous folk theater—the *balagan*, the *skomorokhi* (traveling buffoons), and the *narodnoe gulianie* (popular promenading), an "allegorical sentimentalism"[7] that Sudeikin interpreted in numerous pictures. The Russian cabaret incorporated various elements from the folk theater—quick repartee, rapid sequence of numbers, clowning, the *pliaska* (Russian dance), and so on—but it also relied heavily on the talents of the master of ceremonies, or impresario. At the Bat, the Stray Dog, and the Comedians' Halt—and the Sudeikins attended all these—the audience was baited and abated by the interpolations of the impresario, who continued the tradition of the *zazyvala*, or touter of the *balagan*. The writer Teffi (pseudonym of Nadezhda Buchinskaia), who composed many of the numbers for the Bat and who was a close friend of the Sudeikins, recalled that "everything . . . was the invention of one man—N. F. Baliev. He asserted his individuality so directly and totally that his assistants, in the true sense of the word, would only hinder him. . . . He is a real sorcerer."[8] Within the specific context of the cabaret, the communication between the impresario and the audience was of vital significance, although successful contact also presupposed a particular kind of public—a public that had the time, means, and inclination to attend the cabaret evenings; that possessed a degree of sophistication; and that was willing to listen to and interact with the impresario. By 1908, as its capitalist economy advanced, Russia had such an audience, a fact demonstrated by the mushrooming of intimate societies, clubs, and cabarets in the metropolitan

areas; and their names collectively constitute a kaleidoscope of the most exotic epithets—Bi-Ba-Bo, the Comedians' Halt, the Green Lampshade, Petrouchka, the Pink Lantern, the Stable of Pegasus, the Stray Dog, and so on. In general, the Russian (and Western European) cabarets confronted artists with a set of circumstances that forced them to rethink the question of design. The close proximity of the audience to the actors, the miniature stage, the ever-changing repertoire, and the need to change sets and costumes rapidly, the extension of the decorative scheme to the walls and even to the roof—such conditions caused the critic André Boll to observe in 1926 that this kind of theater was the "ultimate refuge, where the decorator could exercise his fantasy and imagination."[9]

Rather like Sergei Diaghilev with his productions of *Petrouchka*, *The Firebird*, and *Le Sacre du printemps* in Paris, Baliev, one of Sudeikin's primary sponsors both in Russia and in the U.S. propagated a mythology of Russia. He reinforced the public's desired interpretation of Russia as a colorful, barbaric nation consisting of samovars, bears, merchants, and peasants in high leather boots, lovely country maidens, sleighs hastening across the snow, and carousing hussars—themes that recur in Sudeikin's paintings and designs. Baliev commissioned talented artists to render these images, including Gudiashvili, Nikolai Remizov (Re-mi), Vasilii Shukhaev, and Sergei Chekhonin as well as Sudeikin. Even before the Revolution, the Bat identified itself with this sentimental evocation, and its numbers—such as *The Coachman's Yard*, *Village Women*, *The Hawker*, and *The Wooden Soldiers*—made frequent reference to a bygone Russia.

Baliev—and his favorite designer, Sudeikin—stressed the appeal of Old Russia during his American years, playing to the taste of his émigré audience and of his clientele from Newport and the Hamptons, who refused to regard Russia as anything but imperial pomp and circumstance or a mercantile bacchanalia. They wanted to see the expansive Russian soul, and Baliev gave it to them: "If Russia laughs, the sky resounds with her laugh; if she weeps, her tears pass through countries like a tempest."[10] Sudeikin produced numerous visual interpretations of this "counterfeit Russian provincialism,"[11] some of which are manifest in the Album; and the result was a noticeable influence on many aspects of American life in the 1920s. The critic Oliver Sayler wrote in 1927:

> Arriving unheralded, [the Bat] became at once the "thing to see." . . . Its music permeated our orchestras. *The Wooden Soldiers* traveled across the continent as fast as trains could carry people whistling it. Jazz received a staggering blow, and never since has it been so raucous. The unabashed colors and designs of the costumes of the Chauve-Souris started a vogue that revolutionized our raiment.[12]

The Bat maintained a high professional standard, but it was not a radical theater either dramatically or visually, and it tended to attract a bourgeoisie without high intellectual aspirations, in spite of its personnel. The St. Petersburg cabarets, however, especially the Stray

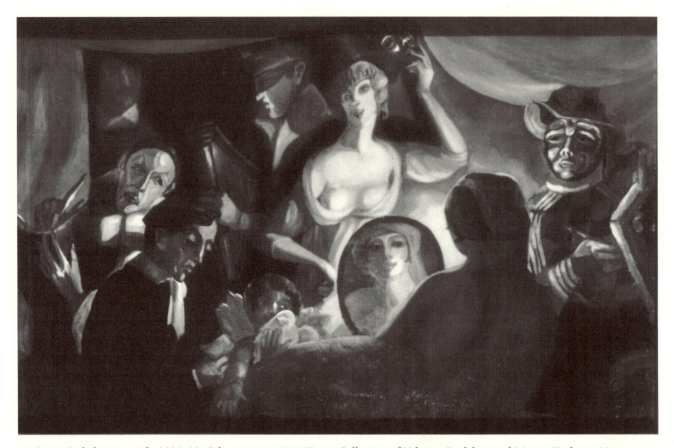

Sergei Sudeikin, *My Life*, 1916–19. Oil on canvas. 45 × 70 cm. Collection of Valerian Dudakov and Marina Kashuro, Moscow.
On the far right Sudeikin is painting a portrait of Vera, who looks into the mirror, while Olga Sudeikina, opposite, holds a mask,
and Mikhail Kuzmin, on the left, reads his poetry.

Dog and the Comedians' Halt, attracted prominent intellectuals from all disciplines, commissioned lectures and recitations, and led debates and polemics on "hot issues." They were at once more international and more provocative, even though they too were indebted to the new middle classes for financial support.

The Stray Dog, for example, compered by Nikolai Petrov and Boris Pronin, hosted many important cultural events during its brief active life (1911–15), and it encouraged discussions on a wide if esoteric range of issues, including the Tarot, theosophy, Alexandrian Christianity, the French magic revival, Russian Orthodoxy, Neo-Platonism, Jacob Boehme, and the monks of Athos.[13] The Stray Dog did not espouse the cause of the avant-garde as represented by Malevich and Tatlin, but it was at the head of Russian intellectual life and counted Anna Akhmatova, Balmont, Diaghilev, Nikolai Evreinov, Grigoriev, Tamara Karsavina, Kuzmin, Evgenii Lancéray, Olga Glebova, Pallada, Alexei Radakov, Savelii Sorin, and Sudeikin among its habitués.

The Stray Dog organized a wide variety of artistic and literary engagements, inviting, for example, Gorodetsky to speak on "Symbolism and Acmeism," Sergei Auslender to speak on "Theatrical Dilettantism," Marinetti to recite his poetry, and young musicians such as Arthur Lourié and Pol to perform their works.[14] Sudeikin, as artist

in residence, often marked these events by designing programs, panneaux, and even fancy dress costumes, a tradition that he continued in the Crimea and Tiflis. Above all, assisted by Veniamin Belkin and Nikolai Kulbin, the "audacious Mr. Sudeikin," as Kuzmin called him,[15] was responsible for the decoration of the walls and ceiling of the cabaret based on motifs from Baudelaire's *Fleurs du mal*. The poet Benedikt Livshits has left the following description of the ambience and programs of the Stray Dog:

On so-called "extraordinary" Saturdays and Wednesdays, guests were required to put paper hats on their heads. They were handed these at the entrance to the cellar. Illustrious lawyers or members of the State Duma, famous the length and breadth of Russia, were taken unawares and, uncomplainingly, submitted to this stipulation.

At masquerades, Twelfth Night and Shrovetide actors, sometimes whole companies, would turn up in theatrical costume. . . .

The programs were the most diverse—from Kulbin's lecture "On the New Worldview" or Piast's "On the Theater of the Word and the Theater of Movement" to the "Musical Mondays," Karsavina's dancing, or a banquet in honor of the Moscow Arts Theater.

In some cases the program dragged on for several days. It swelled into a *Caucasian Week* with lectures on travels in the Fergana Mountains and the Zaravshanskii Chain, or into an exhibition of Persian miniatures, majolica, and fabrics, evenings of oriental music and dances, or a *Marinetti Week* or a *Week of Paul Fort, King of French Poets*, etc.

However, the main point of the program was not the scheduled part but the unscheduled one—the appearance of which had not been foreseen and which would usually enthrall us the whole night through.[16]

As Livshits implies, until its closure in 1915, the Stray Dog entertained a wide and varied clientele, although its activities presupposed a literary and artistic awareness, and many key representatives of Russian (and European) Modernism were to be seen there. But the rapid interchange of numbers, rehearsed or impromptu, the close alliance between spectacle and spectator, the marriage of "life" (the guests eating and drinking) and "art" (the performance) accommodated the Stray Dog easily within the genre of cabaret and connected it directly to other intellectual cabarets of the time, especially to its direct heir, the Comedians' Halt.

When Vera met Sergei Sudeikin around the beginning of 1913,[17] she had just returned from Berlin University, was already married to a "compulsive gambler," Robert Shilling,[18] and evinced a keen interest in the ballet, the movies, and the theater. In other words, in spite of (or perhaps because of) her twenty-five years and bourgeois upbringing, Vera was already an experienced woman of the world. Surely she was not at all crestfallen by the ill rumors that dogged Sudeikin, even though by 1913 he had already managed to marry Olga Glebova, reject her in favor of Kuzmin, surround himself with a harem of girl students, and throw his rival, Nikolai Sapunov, down the stairs.[19] On the other hand, by the time Vera met him, Sergei had secured a national and international reputation for the brilliant stage and costume designs that he had realized for productions at the Stray Dog and for Diaghilev's Ballets Russes in Paris, especially *La Tragédie de Salomé*. Vera fell deeply in love with Sergei Sudeikin, and from the beginning of their relationship through its denouement in Paris, she catered to his physical and spiritual needs and did all she could to propagate his artistic talent. She even reminded herself of her self-imposed obligations by writing them down in one of her notebooks, under the heading "Duties of an Artist's Wife":

1. Force the artist to work, even with a stick.
2. Love his work no less than him.
3. Welcome every burst of creative energy. Kindle him with new ideas.
4. Keep the main works and the drawings, sketches, and caricatures in order. Know each work, its scheme and meaning.
5. Relate to new works as if they were surprise gifts.
6. Know how to look at a painting for hours on end.
7. Be physically perfect and, therefore, his model forever.

(Varia).

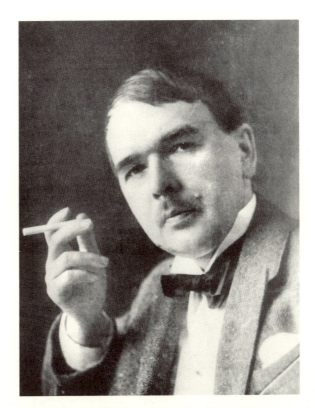

Photograph of Sergei Sudeikin, Paris, 1922.
In the collection of the Institute of Modern Russian Culture, Los Angeles.

Vera's devotion was returned by Sergei, as he made clear in a passionate letter that he once wrote to her when he had lost his voice:

How can I thank you for all that you are doing for me? At least I want to tell you that I do notice your attentiveness, your anxiety, your sadness and joy and that I can't tell you this at the time simply because I can't talk. For me it is a great happiness to be able to write that I do understand you and that I am eternally appreciative of your genuine human soul. . . . You are a limitless source of life.[20]

If fragmentary information can be believed, Vera even eloped with Sergei to Paris and traveled with him to Belgium in the late spring of 1913. Regardless of whether Vera's and Sergei's romance began in 1913, there can be no question that they were already living together in 1915 when both were employed at Alexander Tairov's Chamber Theater in Moscow. Sergei was so infatuated by Vera that he persuaded Tairov to include a special Spanish dance for her as a pendant to Beaumarchais's *Le Mariage de Figaro*, which he designed and which premiered there on 10 October 1915.[21]

Sudeikin's sets and costumes for *Le Mariage de Figaro* did not suit Tairov, who felt that this stylized opulence killed the dramatic action. One suspects that these disagreements between producer and designer prompted Sudeikin's decision to return to Petrograd—the more so since a new cabaret, intended to replace the defunct Stray Dog, was being planned by Pronin. In this way, Sudeikin became a leading light in the Comedians' Halt, which opened on the corner of

the Field of Mars and the Moika, in Petrograd in April 1916; according to one source, the cabaret was even named after one of his paintings.[22] Here he also designed part of the interior, a so-called Venetian hall in black and gold, while his colleagues Grigoriev and Alexander Yakovlev (Jacovleff) evoked the image of a Montmartre bistro and painted frescoes in the style of Piero della Francesca, respectively.[23] Sudeikin also designed the gala production of Arthur Schnitzler's *Columbine's Scarf*, with which Vsevolod Meierkhold initiated the cabaret's theatrical activities. It is interesting to recall that after their transference from Moscow to Petrograd in March 1916, the Sudeikins even rented an apartment above the Comedians' Halt before moving to more spacious quarters by the Ekaterinskii Canal. Once again, Boris Pronin and his wife, Vera Alexandrovna, supervised the many poetry declamations, lectures, and musical soirées that took place at the cabaret during the three years of its existence. In September 1915 Pronin wrote to the actor Vladimir Podgornyi that Vera Sudeikina was a member of the permanent company and that they were preparing a pantomime about a "man who has lost his image," involving "Kreisler himself, a black cat, and a fireplace"[24]—recurrent motifs in the Album. But although the Comedians' Halt survived as a cultural center until after the October Revolution, the Sudeikins severed their links less than one year after its opening—Sergei was drafted into the Izmailovskii Regiment and sent to the front, while Vera, alarmed by the civic disorders in Petrograd, fled to Moscow, and her mother, as she described so vividly in her Diaries. There she was joined by Sudeikin, who one day turned up unexpectedly—a deserter "worn out by shell shock and a nervous illness."[25] As the political and social structures of Old Russia trembled, as the troops began to return from the front en masse, as the rich yielded to the poor, and as revolution became inevitable, the Sudeikins decided to retire to what they hoped would be a more tranquil environment, and in May or June of 1917 they left Moscow for the Ukraine.

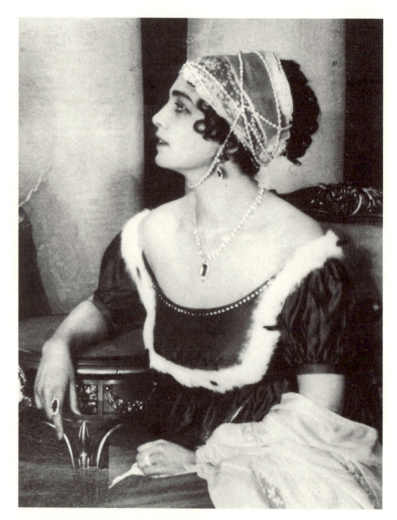

Vera dressed for the role of Helen in the first filmed version of *War and Peace*, April 1915. Courtesy of Robert Craft.

THE CRIMEA

In an interview conducted by Yakov Lvov in Tiflis in 1919, Sudeikin recalled many details of his Crimean residence, some of which are also mentioned in the Diaries and the Album entries. From this interview, we learn that Vera brought Sudeikin, "a sick soldier from the front," to the Crimea and that only after six months was he able to return to a normal working life: "We lived in Miskhor. I used to wander around the home, painted my wife either in the kitchen garden or in the greenhouse. I chopped wood, carried the water, and ate my dinner . . . in the kitchen that I had decorated myself. In the evening, the lamp turned on, I used to draw at my desk in the same kitchen."[26]

From the summer of 1917 through April 1919, the Sudeikins lived in the Crimea, on the southern coastline of the Ukraine. They changed residences several times, shuttling between Simeiz, Alushta,

Gaspra, Yalta, Miskhor (Meskhor), Novyi Miskhor, Alupka, and other resorts in the vicinity of Yalta. Sometimes their geographical movements were dictated by the military advances of the Whites and the Reds, sometimes by invitations to stay with friends, sometimes by their fondness for a certain location. What is striking throughout this itinerary is the Sudeikins' ability to conduct a rich cultural life in spite of the many inclemencies—and even to get married in Yalta on 24 February 1918. Actually, neither Vera nor Sergei was legally divorced, and rumor has it that Sudeikin replaced the photograph of Olga Glebova (at that time still his legal wife) in his passport with a photograph of Vera in order to procure the new marriage certificate.

As the following chronology indicates, during 1917–19 it was almost impossible to know which military faction would be occupying the Crimea from one day to the next: after the October Revolution

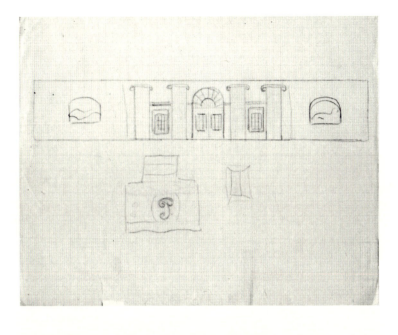

Three pages from Vera's Diaries: entries of 7–17 April 1918, and of 13 and 14 March 1919. Courtesy of Robert Craft.

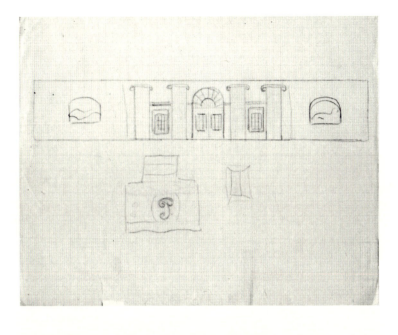

the Ukraine declared itself a national republic with the Rada (Parliament) as its supreme authority. The Red Army took possession of Yalta in January 1918, but the Germans began to occupy the Ukraine the following month, responding to the plea of the counter-revolutionary Rada, and they proceeded to take Kiev (16 March), Kharkov (5 April), Odessa (13 April), and the Crimea (20 April). The Turks occupied Batum on 15 April; however, in the wake of the general German retreat, the forces of the National Union led by Petliura entered Kiev on 14 December, and the French also occupied Odessa from December 1918 through April 1919. Petliura was ousted from Kiev by the Reds on 4 February 1919, and the Reds, in turn, were replaced by National Ukrainian forces on 30 August. The Bolsheviks retook Kiev on 11 June 1920.[27]

Many of the Sudeikins' friends were also in the Crimea in 1917–

19, not least the artists Bilibin, Leonid and Rimma Brailovsky, and Savelii Sorin (who lived in the same house as the Sudeikins in Yalta); and the writers Sergei Makovsky and Voloshin, as well as Vera, recorded many of their meetings, during which, encouraged by the balmy evenings and the heady wine, they would pronounce on the destiny of Russia and the Ukraine. For example, Vera noted down the responses to the question, "What will the Crimean situation be in the near future?" discussed on Monday, 8 April 1918, in Brailovsky's studio:

Sorin: "The Germans won't enter the Crimea, and the Crimea will be Soviet."

Rimma Brailovskaia: "The Germans and the Ukrainians will arrive during April."

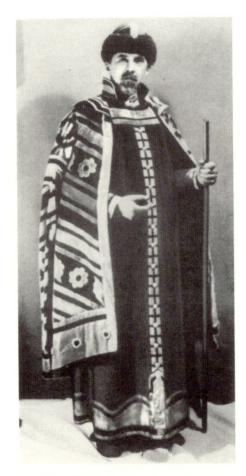

Photograph of Ivan Bilibin in a Russian costume that he designed
for the production of Igor Stravinsky's *The Firebird*, at the Teatro Colón,
Buenos Aires, 1931. Courtesy of Sergei Golynets, Sverdlovsk

Leonid Brailovsky: "The Crimea will soon be occupied either by
the Germans or by the Allies, and the Germans will soon be
here."
Vera: "The Germans will be here within a week."
Sergei Sudeikin: "The Crimea cannot remain an independent
republic. It will fuse with the Ukraine. The Ukrainians will
soon come with the Germans."
Sorin asks permission to add that what he said will happen as
long as the peace with the Bolsheviks is not broken.

(Varia)

In a note entitled "Predictions" dated 17 November 1917 Vera also
reported other prognoses (perhaps her own), some far from histori-
cal truth, others disturbingly close to it:

The British and French will come.
In two or three months the French will leave because of revo-
lution in France. In six months there will be revolution in
England.
The volunteer front [i.e., White Army] will weaken.
The Bolsheviks will be in direct contact with the Germans,
and within the year Germany also will have Bolshevism.

France, too.
In a year's time there will be revolution in America. In less
than a year Russia will be united into a single country by the
Bolsheviks (Soviet Russian Republic).
There'll be a total massacre of the intelligentsia, except for
those who join the Bolshevik camp.

(Varia)

Because of the presence of many St. Petersburg and Moscow art-
ists and writers in the Crimea in 1917–20, it is not surprising that
Yalta, the "All-Russian sanatorium,"[28] witnessed a number of impor-
tant artistic events in which the Sudeikins were involved. One of
these was the "First Exhibition of Paintings and Sculpture by the
Association of United Artists," which opened in December 1917 on
the premises of the Yalta Women's Gymnasium. Among the forty-
one participants, Bilibin contributed ten works, Brailovsky six, Sorin
three, and Sudeikin four. The catalog also lists Lev Bakst as a con-
tributor (mistakenly—his name was confused with Lev Zack), as
well as Anna Belokopytova, represented by a portrait of Pallada, both
of whom, incidentally, had been habitués of the Stray Dog. Also in-
cluded are fourteen landscapes by Vladimir Yanovsky, one of the
artists in the Album. However, of a much higher caliber and of more
grandiose proportions was the exhibition that Sergei Makovsky or-
ganized at the end of October 1918 under the title "Art in the Cri-
mea," also in Yalta. Makovsky, whom Vera described disparagingly
as "sickly and lanky, a moth in gloves" (Varia, undated), and who

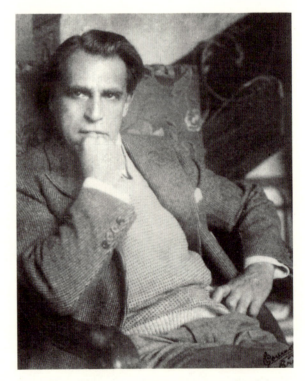

Photograph of Savelii Sorin, ca. 1932. Sorin painted and drew several
portraits of Vera. In the collection of the Institute of
Modern Russian Culture, Los Angeles.

was then living in Yalta with his mother, had had considerable experience in arranging major art exhibitions in St. Petersburg, such as his "Salon" of 1909 and "One Hundred Years of French Painting" in 1912, and, of course, had been editor-in-chief of the influential journal *Apollon* (1909–17/18), in which Gorodetsky, Grigoriev, Kuzmin, Sudeikin, Voloshin, and many other Album contributors had been represented. Like Diaghilev, Makovsky recognized the great inner strength and potential of Russian art and, as he indicated in one of his lead articles of 1910, believed that Russia was on the threshold of a cultural renaissance: "Over the last ten years Russian art has done the work of a whole generation. As for Russian culture in particular, I am deeply convinced that Russia has never before experienced such a fruitful era. What many people call by the derisive sobriquet of 'Modernism' is a symptom of the true advance of our aesthetic self-awareness."[29]

Consequently, Makovsky did much to propagate the values of the new Russian art both at home and abroad. For example, when the Belgian Ministry of Arts and Sciences asked him to organize a Russian section for the "Exposition Internationale Universelle" in Brussels in 1910, he made sure to include a number of provocative works, including Bakst's *Terror Antiquus* and Nicholas Roerich's hieratic landscapes. In the same year, Makovsky arranged an exhibition of modern Russian art for Bernheim Jeune in Paris, and back in St. Petersburg offered the editorial offices of *Apollon* as an exhibition space for shows of works by Mstislav Dobujinsky, Kuzma Petrov-Vodkin, Nikolai Tarkhov, and caricaturists from the *Satirikon* journal. But in spite of these meritorious services, Makovsky was not an apologist of the extreme avant-garde and preferred the neoclassical culture that pervaded St. Petersburg in the 1910s. His "Art in the Crimea" exhibition reflected his moderate taste and sense of measure, as did his project to establish an academy of arts in the Crimea and his efforts to save such noble houses on the Black Sea coast as the Vorontsov Palace.[30] "Art in the Crimea" was a complex venture, in part commercial, that combined the old and the new, inasmuch as the 284 contemporary works (by fifty-three artists) were complemented by a historical and antique section of 156 items by both Russian and Western masters (Ivan Aivazovsky, Levkii Borovikov-

sky, Karl Briullov, Greuze, Snyders, Teniers, Van der Neer, et al.). According to Sudeikin, the Brailovskys, Sorin, and Sudeikin were exclusive shareholders in the exhibition, they gave themselves the right to "exhibit ex jury and occupy whatever space they want," and they divided profits from the entrance fees and sale of works.[31] Among Sudeikin's contributions was his "beautiful portrait of Vera,"[32] *Carnaval*, and also a picture called *Fortune Telling*, described as the property of Vera Sudeikina, which may or may not be the same as the untitled picture in entry 134. Vera herself was also represented at "Art in the Crimea" by "twenty silhouettes based on designs by Sudeikin," some of which may relate to the many silhouettes in the Album (e.g., entry 162). It is of interest to note that the Stravinsky family was also linked to the exhibition: Elena Stravinskaia (wife of Yurii Stravinsky, Igor's brother) showed eight pieces (including views of Petrograd and a silk embroidery), while her husband contributed several works from his own collection, including caricatures by Nikolai Vasiliev, a bust of himself by Dmitrii Stelletsky, and a miniature portrait by Mikhail Terebenev. But in spite of Yalta's lively art scene and the social and financial success of Makovsky's exhibition, the Crimea was an uncertain place of refuge, as is clear from Vera's recollections of 1918–19: "The morning was calm, but toward evening came a lot of alarming reports: in Massandra fighting, in Simeiz fighting, many casualties, Bakhchisarai had been taken—by whom? Sevastopol had decided to defend itself. Somebody started the rumor that the area between Yalta and Alupka was crawling with counter-revolutionaries."[33] The result was that the Sudeikins decided to flee the Crimea for France via Constantinople; and in mid-April 1919, they embarked from Yalta harbor on what they thought was a ship bound for Constantinople. The inscription in entry 54a tells us that they were not alone in their effort to leave the Crimea for more serene territory, although, as Vera often recounted later, their voyage took them not to Constantinople but to Novorossiisk and then Batum, much farther south on the Black Sea coast: "A heavy storm came up, and, after many queasy hours, the couple was put ashore at Batum, at the wrong end of the Black Sea. From there they journeyed to Tiflis, where camels were still the main means of transportation in the bazaar."[34]

TIFLIS

Tiflis (renamed Tbilisi in 1936) was the capital of what in May 1918 had become the new Menshevik Republic of Georgia. The Sudeikins spent six months there before moving on to Baku, and many important dedications in Vera's Album—by Nikolai Evreinov, Gorodetsky, Sergei Rafalovich, Igor Terentiev, Ilia Zdanevich, and others—were made there. For many Russians, in both the nineteenth and early twentieth centuries, Georgia had long been a "kind of Switzerland," as Mandelstam called it,[35] "a land of exile . . . but of a welcoming, hospitable, and desired exile";[36] and the history of Russian literature

contains many direct references to Tiflis and the Caucasus. The case of Mikhail Lermontov is perhaps the most notable, and the sobriquet that Sudeikin earned while he was living there—a "prisoner of the Caucasus"[37]—reinforces the double image of paradise and expulsion that Tiflis presented to so many Russians of the diaspora.

What kind of place was Tiflis in April 1919? It was both very sophisticated and very primitive, a city separated rigidly between a chic European section and teeming "Asiatic" suburbs that sprawled back from the Maidan (the main square of the old town). A guide-

book published just before the Revolution makes no attempt to conceal these contrasts:

> Apart from a few fashionable streets, the city—in the way it looks and functions—leaves a lot to be desired. Most of the streets are paved with cobblestones, but in the most primitive manner, and moreover, they are dirty, so that thick clouds of dust envelop the city, particularly when the wind blows. Only the main streets are cleaned.
>
> The water supply in Tiflis hardly satisfies the needs of the population, which often goes without water for days on end. . . . The sewage system is not much better. . . . Illumination is by kerosene. . . .
>
> In the "new town," the visitor can almost imagine himself to be in St. Petersburg or Moscow, whereas in the old Georgian and Persian districts he comes face-to-face with Asia. . . .
>
> Tiflis has the following consulates: Belgian, German, Persian, Turkish, French, and Swiss.[38]

The Russian writers, artists, and musicians who came to Tiflis in 1917–21 lived, of course, in the European section on or near Golovinskii Prospect (now Rustaveli Prospect), the main thoroughfare. The Sudeikins rented a room on Griboedov Street, parallel to Golovinskii Prospect. If they could afford it, the Russians would take their coffee and cocktails in such elegant hotels as the Russia and the Oriant (Orient), eat ice cream at Frascati's Restaurant, visit the usual tourist attractions (the Sion Cathedral, the open market in the Maidan)—and lead an intellectual life that did not differ too much from that of old St. Petersburg and Moscow. At the same time, many Russian artists felt an attraction to Georgia and the Orient, not just because it was "exotic" but rather because they subscribed to the fashionable sentiment expressed by Modernists as diverse as Natalia Goncharova, Mikhail Le-Dantiu, Arthur Lourié, and Georgii Yakulov that Russia was actually an organic component of Asia and that her art owed much more to the East than to the West.[39] Even Vera seems to have had this in mind when she wrote, "Via India, Persia, Georgia, Russia, we eastern peoples raise the curtain of the truth of art concealed from the West" (Varia, undated).

There are many reasons why the Sudeikins and their colleagues felt at ease in Tiflis in 1919. In contrast to Russia, ravaged by war and revolution, Georgia seemed outwardly calm. Georgia had proclaimed herself a free country on 26 May 1918, not without German support, issuing an Act of Independence that, inter alia, asserted:

1. From now on, the Georgian people are the source of sovereign rights, and Georgia is a competent, independent nation.
2. The political structure of independent Georgia is that of a Democratic Republic.
3. In cases of international conflicts, Georgia remains perpetually neutral.[40]

But Georgia's initiative also prompted Armenia and Azerbaijan to proclaim themselves sovereign states—which destroyed any semblance of Transcaucasian unity that had accompanied the establishment of the ephemeral Democratic Federative Republic of Transcaucasia in April 1918. From May through November 1918 Georgia played a dominant role in the politics of the entire region—the more so since she signed a peace treaty with her traditional enemy, Turkey, leased part of her oil industry to Germany, and even welcomed German occupation in the summer of that year. With the collapse and surrender of Germany, the British occupied Batum and Tiflis in the fall of 1918 and remained in Georgia until July 1920. Even though in 1917–21 the Georgian government was Menshevik and tried to put its social ideas into practice (over four thousand estates had been nationalized by January 1920), there seems to have been little attempt to raise the Georgians' consciousness above their inbred hatred of the Turks, to cool their xenophobia, or to integrate the many ethnic groups. In other words, Georgia was in a state of flux, divided but unruled, where White Russian officers were granted safe passage while Sergei Kirov struggled to maintain his Soviet Embasssy, and where the sunshine and laden markets were a welcome change after the deprivation and uncertainty of the North. Moreover, by the time the Sudeikins arrived in Tiflis, there was already a sizable and varied Russian colony:

> It was a bit crammed, but it had one advantage—everything was near at hand: the market, the Orthodox church, the synagogue, the sulfur baths, the Armenian convent, Golovinsky Street, and the bridge leading to the mosque over the rapid Kira river.
>
> The Mensheviks, beset by complex political problems and a mismanaged, corrupt economy, did not interfere with literary and artistic events. Thus a number of literary groups, circles, salons, magazines, and publishing houses sprang up in Tiflis.[41]

In this intimate and exciting environment the Sudeikins encountered many of their former friends, for, in spite of its predominantly "Asiatic" population, Tiflis already boasted an active and vociferous intellectual community au courant with the latest trends in European and Russian Modernism. As a matter of fact, David Burliuk, Kamensky, Kulbin, and Vladimir Maiakovsky had all lectured in Tiflis before World War I, Ilia Zdanevich, a native of Tiflis, had already published his booklet *Chto takoe futurizm* (What is futurism) there in 1914, and he and his brother, Kirill, had even turned their home into an avant-garde center, entertaining Kruchenykh there for much of 1919, organizing Kirill's one-man exhibition in October 1917, propagating Neo-Primitivism, Cubo-Futurism, and Everythingism and advocating the art of the Georgian naive painter Niko Pirosmanashvili. Indicative of this orientation of the Russian Modernists toward Georgia is the fact that in April 1914 alone the Stray Dog had organized two lectures by I. Zdanevich and a Caucasian celebration.[42]

By the beginning of 1917, and in spite of war and civil discontent, Tiflis had become an important laboratory for avant-garde activity: Kruchenykh arrived there in 1916; Kirill Zdanevich returned from

the front in January 1917 to publish, with Kamensky and Kruche-nykh, the collection *1918*, in which Kamensky reproduced his "ferroconcrete" map of Tiflis;[43] and November of that year saw the opening of the Fantastic Tavern, a cabaret that maintained and en-riched the traditions of the Stray Dog and the Comedians' Halt. At the same time, Kruchenykh—assisted by Nikolai Cherniavsky, Gu-diashvili, Kara-Darvish (Akop Gendzhian), and Sigizmund Valishev-sky—established the Syndicate of Futurists, which served as the real stimulus to Kruchenykh's and I. Zdanevich's so-called Futurvseuch-bishche, or Futurist University (which Terentiev joined in the spring of 1918).[44] The ensuing months were no less rich in cultural events—from the scandalous (Kruchenykh and Terentiev lectured on anal eroticism at the Fantastic Tavern in January 1918) to the sentimental (the "Exhibition of Portrait Sketches of Tiflis Beauties" at the Fraternal Consolation café, also in January 1918). Poetry and painting flourished, thanks to the organizational efforts of Kruche-nykh on the one hand, and Gorodetsky on the other: while the for-mer arranged the First Evening of Transrational Poetry in January 1918, the latter announced the formation of a new journal, *Ars*, and, remembering his recent St. Petersburg past, went on to establish a new Guild of Poets in April. The same month Gorodetsky organized an exhibition of children's drawings in the editorial offices of *Ars*, which he followed by the "Exhibition of Paintings and Drawings by Moscow Futurists."[45] However, Gorodetsky's authority was shaken when in August his Guild split into two groups—one moderate, led by Gorodetsky, the other radical, led by Degen, who renamed his faction Hauberk.[46]

By the time the Sudeikins arrived in Tiflis, toward the end of April 1919, Tiflis was a dynamic center of creative experiment, an artificial hothouse that forced the most diverse and curious cultural phenom-ena: one could listen to the poets of the Blue Horns recite their late Symbolist verse at the Khimerioni Café (opened in April 1919)[47] or Kruchenykh recite his transrational verse at the Imredi Restaurant;[48] one could take a class at Georgii Giurdzhiev's Institute for the Har-monious Development of Man[49] or watch the fabulous Sofia Melni-kova dance at the Theater of Miniatures;[50] one might join the "weak students" in Genrikh Neigauz's class at the Conservatory[51] or attend a concert staged by Nikolai Cherepnin, his son, Alexander, and Foma Gartman (Thomas von Hartmann) at the Theater of Opera and Ballet;[52] one might go to see the new works by Gudiashvili, David Kakabadze, and Yakov Nikoladze at the "First Exhibition of Geor-gian Artists"[53] and then try to decipher the single issue of *41°* (July 1919) and its claim to "use all the great discoveries of its col-laborators and place the world on a new axis";[54] alternatively, one could always drop by one of the many cafés and nightclubs, such as the Boat of the Argonauts and the Peacock's Tail, and partake in less exacting pastimes. The painter Gregorio Sciltian, who later made his career in Italy, was then staying in Tiflis:

> Every day other representatives of philosophy and art arrived
> from Russia, and they were welcomed with open arms. Poetry
> and poets were at their apogee. In that city alone one could have

counted several hundred of them. Among the Georgian poets was the famous Titsian Tabidze, who always used to walk around with a muzzled bear, and there was also Paolo Yashvili, each leading a different trend and always fighting with each other.

All these people used to hang about the cafés, restaurants, and taverns, conducting interminable philosophical and artistic discussions and sometimes getting so worked up that hand-to-hand fighting was the result.[55]

A brilliant symbol of what the late Marzio Marzaduri called the "Tiflis Parnassus"[56] was the cabaret called the Fantastic Tavern (at first called the Studio of Poets), which opened on 12 November 1917 at no. 12, Golovinskii Prospect, opposite the Theater of Opera and Ballet. Tempered by Yurii Degen and the poet-composer Sandro (Al-exander) Korona, the Fantastic Tavern was a meeting place for poets, painters, composers, actors, and critics who aspired to refurbish the traditions of the Stray Dog and the Comedians' Halt. Indeed, Degen had frequented both establishments, the Tavern's secretary, Nina Vasilieva, was a friend of Kuzmin, and its cultural format—lectures and poetry readings accompanied by food and drink—reminded St. Petersburg visitors of these precedents, even though this time there was no entrance fee or theater. The Fantastic Tavern consisted of one room accommodating ten, twelve, fifteen, forty, or fifty people (depending on the source of information),[57] decorated by Degen, Gudiashvili (after a design by Nikoladze), Valishevsky, and I. Zda-nevich, assisted by the journalist Alexander Petrakóvsky and the caricaturist Sergei Skripitsyn. Just as Vera Pronina had been the "mistress of the Dog,"[58] so the Fantastic Tavern had its Muse: I. Zda-nevich's friend, the actress and poetess Sofia Melnikova, to whom its second "almanac" was dedicated.[59] Like the St. Petersburg prece-dents, too, the Fantastic Tavern inspired descriptive "hymns," for example, by Alexander Kancheli, Alexander Poroshin, and Paolo Yashvili.[60] Not surprisingly, this combination of literature and visual art, private and public space, and informality and intellectual regi-men has led some critics to compare the Fantastic Tavern to the Café Voltaire in Zurich in 1916.[61]

At first the Fantastic Tavern, open nearly every evening, was a center for the "Neo-Acmeists"; but at the beginning of 1918, with the consolidation of the Futurists led by the "three idiots" (Kruche-nykh, I. Zdanevich, and then Terentiev), this sympathy changed.[62] Their Futurist University also attracted the support of Cherniavsky, Degen, and Korona and even some of the Blue Horns poets who reaffirmed the poet's right to use both experimental and eclectic poetry. By August 1918, therefore, the Fantastic Tavern represented three principal camps of literary investigation—Gorodetsky and his Guild of Poets; Degen and his Hauberk group, supported by the Blue Horns; and the Futurist 41° group, which aspired to "incarnate a new poetical school by renewing the current poetical language, so as to lead it toward the total abstraction of *zaum*. The [Futurist] Uni-versity holds fiery meetings at the Fantastic Tavern and organizes numerous conferences on Futurism and *zaum* poetry in the Tavern,

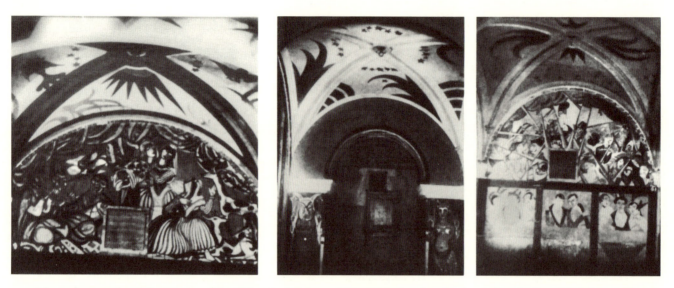

Three photographs of the interior of the Khimerioni Cabaret, Tiflis, 1919, showing the decorations by Sergei Sudeikin et al.
Courtesy of Irina Dzutsova.

the Conservatory, and the Imedi Restaurant during 1918 and 1919."[63] The Fantastic Tavern also supported two magazines of art and literature—*Feniks* (Phoenix), edited by Degen, and *Kuranty* (Chimes), edited by Boris Korneev—which, incidentally, contained Kruchenykh's article on the cabaret.[64]

The Fantastic Tavern closed in July 1919, but its impetus was maintained, perhaps less brilliantly, by the Khimerioni cabaret, with which the Sudeikins were intimately involved and to which a number of the Album entries have a direct relation. The idea of organizing this successor belonged to the "three Georgian brothers,"[65] the poets Valeriian Gaprindashvili, Titsian Tabidze, and Paolo Yashvili, founding members of the Blue Horns fraternity. This group of latter-day Georgian Symbolists, founded in Kutaisi in 1915 and much influenced by Baudelaire, Mallarmé, Rimbaud, and Verlaine, relates directly to the Album for several reasons. First, by aesthetic inclination the Sudeikins were closer to Symbolism than to Futurism, since their artistic sensibilities had matured within the crepuscular decadence of fin-de-siècle Russia; second, the Blue Horns poets were among the Sudeikins' closest friends in Tiflis—Nikollo Mitsitshvili, Nikoladze, Robakidze, Tabidze all left dedications; and third, Gudiashvili, whose several contributions include the elegant if haunting pencil portrait of Vera (entry 29) was also associated with the group, illustrating their first almanac in 1916 and their main periodical, *Dreaming Gazelles*, in 1919–22.[66]

Named after one of Gaprindashvili's chimeric poems, the Khimerioni opened its doors in April 1919 on Golovinskii Prospect in the foyer of the Tiflis Artistic Society and in the same building as the Anona Restaurant (now the Rustaveli Theater). As in the case of the Stray Dog, the Comedians' Halt, and the Fantastic Tavern, the interior of the Khimerioni was also decorated, and Sudeikin was chosen as chief designer—much to the relief of Gudiashvili and Kakabadze: "When Gudiashvili and Kakabadze first entered the premises and

realized what had to be done, their faces fell. Neither of them had ever worked as designers, and both were scared by the dimensions of the space. But Sergei Sudeikin had only to appear—a real master designer for the Imperial Theater and the Diaghilev seasons—and everything changed."[67] That he received this major commission is not surprising, given his reputation as a stage designer, the prestige of his one-man show shortly after he arrived in Tiflis,[68] and his decoration of three walls of Tumanishvili's private theater with scenes from the commedia dell'arte.[69] Invited by Gaprindashvili, Tabidze, and Yashvili, and helped by scene painters that Alexander Zaltsman sent over from the Theater of Opera and Ballet, Sudeikin supervised the designs, developing an ambitious cycle of panneaux that he implemented with the help of Gudiashvili, Kakabadze, Valishevsky, and the Zdanevich brothers.[70] Although the murals have not survived, the memoirs of contemporaries express the vividness of impression:

> According to Titsian Tabidze's descriptions, Sudeikin placed the figure of the Poet in a Roman toga at the entrance to the café; he also included a portrait of P. Yashvili in a Spanish cape and hat, carrying a blue horn in his hands.
>
> Tabidze also mentions a mural in which Sudeikin had included his self-portrait with a mirror together with Cupid peering into it, while next to him, wearing the white raiments of a Madonna, stood his wife, the beautiful Vera Arturovna Sudeikina. The Georgian poet also names several themes, including Titsian Tabidze wearing the costume of Pierrot, his wife Nina Makashvili in the guise of Columbine, portraits of A. Rimbaud and A. Bely, a tragic Punch and Judy booth, etc.[71]

The pictorial contributions by Sudeikin's assistants were also notable. Gudiashvili painted a fresco called *Stepko*, Kakabadze painted one fresco on the theme of *The Creator and the Muse* and another that

included a self-portrait and portraits of the writer Vasilii Barnov and Gudiashvili, and also painted the ceiling. As Tabidze described it, "Gudiashvili's wall was a masterpiece of modern Georgian art. Even Sudeikin acknowledged this. In the whole world you would hardly find a café painted with such enthusiasm."[72] Still, it seems that Sudeikin's contribution was the most impressive—Gorodetsky even referred to it as "narcotic,"[73] although reports concerning the details are conflicting. For example, Nina Tabidze, widow of Titsian, recalled that in the Sudeikin mural "to the left of the entrance," Vera was wearing a "dress borrowed from ancient Georgian frescoes" and that Tabidze was leaning against a pomegranate tree, while Sudeikin was wearing an "ancient Russian costume."[74] Gudiashvili also referred to Sudeikin painting the "left wall along the staircase leading into the café on the subject of Georgian poets and episodes from old Tiflis."[75] Furthermore, Gudiashvili wrote that Sudeikin contributed designs for one of his Khimerioni frescoes together with a portrait of his wife to the "Exhibition of Russian Painting and Sculpture" at the Brooklyn Museum, New York, in 1923 and that they were reproduced in the catalog.[76] Neither work, however, is mentioned or illustrated in that catalog, and probably Gudiashvili was confusing this with the "Exposition des oeuvres des artistes russes" in Paris in 1921, to which Sudeikin did contribute his portrait of Vera, which was reproduced in the catalog.[77]

The activities at the Khimerioni seem to have been nutritional rather than cerebral, and the Georgian penchant for merrymaking was certainly not impeded. The café quickly became known for its impromptu balls and Queens of Beauty, serious drinking, and opulent cuisine—the ambience was evidently so exotic and carefree that "deer used to walk freely around the fountain and amid the tables . . . sometimes nabbing the fruits and vegetables."[78] Still, like the Fantastic Tavern, it also brought together poets, artists, and musicians, arranged exhibitions and auctions, the proceeds of which were transferred to the account of the Society of Georgian Artists, and even organized a gala evening for Kamensky (for which Sudeikin designed the poster; see entry 26 in the Album). On the other hand, the Khimerioni did not witness the intellectual debates of its predecessors or inspire the publication of important literary anthologies and magazines in the way the Fantastic Tavern did.

Obviously the Khimerioni was a focus of the Sudeikins' cultural

life in Tiflis in the second half of 1919, and at least two of the pictures in the Album, by Gudiashvili and Sudeikin (entries 65 and 169), seem to be preliminary designs for the frescoes. But, of course, it was not the only center of their artistic activity. Sudeikin, assisted by Sorin, also decorated the interior of the Boat of the Argonauts, another cabaret favored by Alexander Cherepnin, Nikolai Evreinov, Gorodetsky, and Sergei Rafalovich, visited the Peacock's Tail (decorated by Tabidze, Valishevsky, and K. Zdanevich), and attended the Theater of Opera and Ballet and the Theater of Miniatures. Sudeikin also made an impressive contribution to the second exhibition of the Little Circle in May 1919—in the company of Raisa Florenskaia (sister of Father Pavel Florensky), Sorin, Valishevsky, Zaltsman, and others. In his review of the exhibition, Gorodetsky was especially impressed by Sudeikin, this "capricious master and unrestrained visionary" who was now seeking a "different beauty, eternal and pensive."[79] But for all its cultural effervescence, Tiflis could not satisfy the cosmopolitan Sudeikins for long, and it seemed very distant from the international and elegant milieu in which they had once circulated. Perhaps they could have survived artistically in Tiflis, since intellectual life continued to thrive there even after the Soviet occupation in 1921, and avant-garde experiment went on throughout the 1920s, witness to which was the establishment of the H_2SO_4 group there in March 1924 and the publication of its journal.[80] Gudiashvili returned from Paris in 1926, and Kakabadze the following year; Semeon Chikovani, Tabidze, and Yashvili continued to write and publish their poetry until the Stalin purges of the 1930s. But no doubt the Sudeikins felt alien in that oriental setting. Perhaps Sudeikin longed for grand theatrical commissions, and because her mother was in Moscow and her father was in Berlin, Vera must have felt especially remote. But with St. Petersburg and Moscow off limits, Paris still seemed the obvious response to their geographical dilemma. Diaghilev, the Ballets Russes, and many Russian acquaintances were—or soon would be—in Paris (Balmont, Gudiashvili, Minsky, Mikhail Struve, I. Zdanevich), and allegedly Paris had been witness to their passionate elopement seven years before. Even so, their westward yearning was thwarted once again; for instead of heading back to the Black Sea, they pressed on from Tiflis to Azerbaijan, reaching Baku in December 1919.

BAKU

The exact circumstances surrounding the Sudeikins' journey from Tiflis to Baku are obscure; it is not known even whether they traveled by railroad or by river, although the former seems more likely. Vera's Diaries from that period do not exist, and the Album does not provide solid clues. Certainly by the end of 1919 it was becoming increasingly evident that the valiant, if fragmented, offensive by the White Army was losing momentum and that the Bolsheviks were

gaining ground rapidly, even though Transcaucasia still had time to spare—Armenia fell in December 1920, Azerbaijan in April 1920, and Georgia as late as February 1921. Furthermore, with the British forces still in Batum, the Sudeikins could have returned to the Black Sea so as to renew their efforts to reach Constantinople by ship. On the other hand, perhaps they hoped that after arriving in Baku, where the British also had representation, they would have been able

to emigrate via Persia. It is possible that mere wanderlust and the spirit of romantic adventure bore them to the shores of the Caspian Sea, although, when all is said and done, traction rather than volition seems to have been the real motive for their journey.

Whatever the objective reasons for their move to Baku, if the Sudeikins were seeking tranquility after the unease of Tiflis, they could hardly have chosen a less appropriate place. In April 1918 the Soviets had occupied Baku after terrible massacres between Armenians and Azerbaijanis. The oil industry was then nationalized, and the Congress of Soviet Deputies issued a resolution condemning the "Mensheviks, Nationalists, and Dashnaks."[81] But this initial presence of the Soviets was brief, because the local army was divided by racial strife, the troops being mainly Christian Armenians who hated the Muslim Azerbaijanis. A direct consequence of this military and political instability was the fall of the Soviet commissariat in Baku in July 1918 and its replacement by the Centro-Caspian dictatorship composed of non-Bolshevik Russians and Armenians, which then urged the British forces in Persia to come to their defense. But the British stayed for only two months, and as soon as their main forces had left for Persia on 14 September 1918 (a farewell gesture was their notorious execution of the twenty-six Baku commissars on 20 September), Azerbaijani troops stormed into the city, massacring nine thousand Armenians and establishing their own government. Paradoxically, this led to the restoration of the British representation, although Parliament continued to be made up of Azerbaijan oilmen and feudal landowners. Although this Parliament lasted less than two years (December 1918–April 1920) and was conservative and nationalistic, it established the Azerbaijan State University in Baku (appointing Viacheslav Ivanov professor of classical philology in 1920) and, surprisingly, introduced suffrage for women. In August 1919 the British troops left Azerbaijan again, its Parliament fell victim to internal dissension and political disorientation, and, after constantly rejecting the possibility of a Baku occupied by the White Army (in the spring of 1918, Denikin's troops were just across the border in Daghestan), it dissolved when the Red Army entered Baku on 23 April 1920.

Of course, Baku had always been a frontier town, and its strategic position as a major commercial port and the center of the southern oil industry had long rendered it prey to external military and financial interests. Perhaps for this reason, Kruchenykh referred to Baku as "that most American of cities."[82] Its local population of Russians, Armenians, Georgians, Azerbaijanis, and Persians was a model of interracial disharmony that, to such tolerant and well-bred observers as Vera, must have seemed as bizarre as the gigantic oil slicks on the dazzling waters of the Caspian. At the beginning of the twentieth century, Baku, like Tiflis, was divided sharply between the old and the new, as we learn from a guidebook of the time: "Hardly anything grows in the town. Baku has two pitiful squares and a rather nice City Park. . . . In summer the squares turn into doss-houses and the City Park . . . into a kind of bazaar because in the evening almost the entire population gathers there to take the air."[83] Like Tiflis,

Baku also had elegant hotels and restaurants, spectacular ruins such as the Maiden's Tower and the Monastery of Fire-Worshipers, a mosque, a palace, and a fortress. There were also Mme Krol's fashion studio for designer apparel, several lycées, a branch of the Institute of St. Nina (mentioned in entry 13b), bookstores, two theaters, two libraries, and two local Russian newspapers.

Baku boasted at least a semblance of artistic life, if not radical and experimental, then at least competent and academic. The real problem was that the entire Western tradition of the fine arts was, of course, lacking in Azerbaijan, a Muslim state, and the structure of academies, exhibitions, auctions, art magazines, and the like was hardly developed. Still, the Society of Baku Artists held regular exhibitions in 1910–14, to which Mikhail Gerasimov, a Baku acquaintance of the Sudeikins, contributed (see entries 90b, 91b, 138a), and there were private art schools for painting, such as Evgenii Samoradov's, and for sculpture, such as Yakov Keilikhis'. True, as early as 1914 Kamensky had announced a "ferroconcrete" affiliation in Baku,[84] and three years later Arthur Lourié explained to a local audience of "young artists of the Caucasus" why Russian art was organically linked to the East and not to the West.[85] In 1919 the 41° group also announced the establishment of a Baku affiliation,[86] while Kruchenykh continued to publish his vociferous commentaries in the Baku journal *Parus* (Sail).[87] But in spite of these isolated gestures and the intermittent presence of Degen, Kruchenykh, Riurik Ivnev, Sofia Melnikova, Robakidze, Nikolai Semeiko, and Tatiana Vechorka, the avant-garde did not flourish in Baku; even an agit-train that Nikolai Kochergin, Evgenii Lancéray, and Iosif Sharleman painted with slightly leftist designs at the end of 1921 was censured and painted over.[88] In other words, in 1919–20 Baku had little of the sophistication associated with the Modernist groups of Petrograd, Moscow, and Tiflis; and the first graduates from the Baku Art Studio in the early 1920s had little appreciation of Cubism, Futurism, and Suprematism.

When the Sudeikins arrived in Baku in December 1919, they joined, or were joined by, many friends whom they had known from Tiflis and before. Kruchenykh also came to Tiflis at the end of 1919 to embark upon the frenetic productivity of publishing works that he just had written in Tiflis;[89] Gorodetsky also came, immediately establishing his review *Iskusstvo* (Art) and employing Velimir Khlebnikov who arrived in Baku in October 1920 as a poster artist in the Baku OknaROSTA (Baku Windows of the Russian Telegraph Agency).[90] The Album entries for December 1919–March 1920 testify to the diverse and active Russian colony in Baku, although they represent only a small contingent of the many Russian artists and writers living in Baku at that time. To the names in the Baku entries we should add those of Degen, Mechislav Dobrokovsky, Ivnev, Kochergin, Lancéray, Poroshin, Robakidze, Semeiko, Sharleman, Vechorka, and K. Zdanevich. They all proceeded to indulge in the same kind of artistic pursuits as before—art exhibitions, writing and publishing poetry, attending the cabaret called the Merry Harlequin (entry 125b), discussing the destiny of Russia, editing journals, and

polemicizing. But just before and after the Soviets took over Baku, most of these individuals left, fleeing north or west: Gorodetsky and Kruchenykh departed for Moscow in 1921, followed by Ivnev and Vechorka, whereas Robakidze, Sorin, and the Sudeikins left for Western Europe in March 1920; Degen and Poroshin were shot by the Bolsheviks in 1924.

FINAL EMIGRATION

The Sudeikins started back from Baku to Tiflis on 12 March 1920, just a few weeks before the final Soviet invasion. They spent almost two months in Tiflis reentering the cultural orbit that had so attracted them the year before, and it was there and then, for example, that they made the acquaintance of the English journalist Carl Bechhofer. Unfortunately, the exact occasions for their decision to leave Tiflis are not known, although Titsian Tabidze recalled that Sudeikin "left behind all his paintings in Tiflis, including a self-portrait that decorated the Blue Horns editorial office" and that the Sudeikins and Sorin left Tiflis by train for Paris.[91] Alarmed by the increased threat of Soviet occupation, Vera sold her diamond-and-pearl earrings for three thousand Kerensky rubles to buy passage for herself and her husband on a French steamer bound for Marseilles,[92] and, accompanied by Princess Alexandra Melikova, Prince Alexander Melikov, and Sorin, they set sail on the steamship *Souirah* from Batum to Marseilles on 8 May 1920, finally arriving in Paris on 20 May.[93] One of the first persons that they saw was their old friend Gudiashvili, who later recounted Sudeikin's own story of their final voyage, which, in this version, carries no reference to Vera:

> After procuring a visa, I immediately went off to Batum and arrived there late at night. . . . At last we cast off, everything grew quieter, calmed down. I moved into my cabin, lay down, and fell asleep at once. Shots, noise, a great racket suddenly woke me up . . . I listened. The noise grew louder and louder, and the shouts turned into wails of despair. I went up on deck, and what did I see? An entire band of big pirates had taken charge of the ship. They were robbing the unfortunate passengers, and as soon as they saw me they rushed up and began to search me. . . . They were somehow merry and relaxed as they robbed, accompanying their actions with song and dance. I would even say that their robbery carried no violence. They simply asked the passengers whether they had any money, went into the cabins, took the powder and perfume from the women, and sprayed perfume all over their own heads as they roared with laughter. . . . Eventually they were all arrested (fourteen of them!).[94]

On 19 February 1921, Sergei Diaghilev invited Vera to dine with Igor Stravinsky at a Paris restaurant, and the consequences of that encounter were felicitous for her but disastrous for Sudeikin, as the ensuing months witnessed the flowering of a passionate and clandestine love affair between the composer and the Muse. Using Boris Kochno as a mediator, Vera and Stravinsky exchanged letters that revealed both misgivings about their illicit behavior and alarm that Sudeikin might kill Vera for her unfaithfulness.[95] But perhaps Sudeikin's jealousy was aroused not only by his wife's change of affection but also by her career advancement, for in November 1921, Diaghilev invited her to dance the Queen in *Sleeping Beauty* for the Ballets Russes at the Alhambra Theater in London—while Sudeikin languished in Paris, waiting for a major theatrical commission that never came. In May 1922 Vera broke with Sudeikin, and on 19 August he left Le Havre on the SS *France* bound for the U.S. with 30 paintings and about 150 sketches[96] to make his fortune in the New World. But perhaps Vera felt sorry for her jilted escort, for she sent him a consoling postcard immediately: "You are now approaching

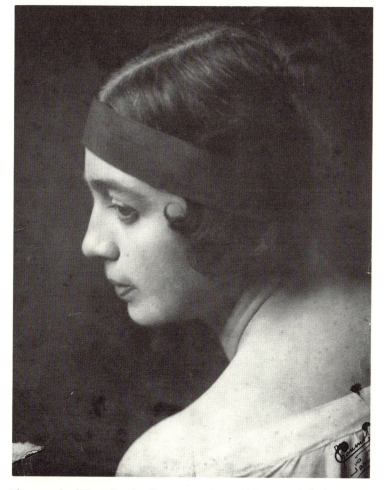

Photograph of Vera taken by Choumov in Paris, 1921, around the beginning of her affair with Igor Stravinsky. Courtesy of Robert Craft.

Vera as the Queen in Diaghilev's *Sleeping Beauty*, 1921. Courtesy of Robert Craft.

New York and can see the Statue of Liberty. May she bring you victory."[97] Indeed, Sudeikin did secure certain victories in the 1920s and 1930s, designing productions at the Metropolitan Opera and Radio City Music Hall, working for the Chauve-Souris, and fulfilling numerous private commissions for portraits and panneaux. But as he indicated in a melodramatic interview entitled "Artist, Through with Love, Finds Solace in Work," which he gave to a New York newspaper in 1925, the separation from Vera seems to have saddened and embittered him:

Once I thought I had found real love. I married a woman who is called the most beautiful actress on the Russian stage. At first we were divinely happy.

But at last I realized that no love can last forever. So I am through with love. My wife and my children are in Paris now. I am here to stay. My art is the only thing that counts.

I came to America to forget and to find solace in my art. That is all I care for now. It is all I live with.

What is love? What is money? Of course, one must have

enough to live. But to be a millionaire—no; that I would not want to be.

I am content with just enough—when I find happiness and contentment in my work.[98]

In spite of this tone of sentimental resignation, Sudeikin continued to indulge in amatory escapades and even married an American pupil of his, Jeanne Palmer, after he and Vera divorced officially in 1940, allowing Vera and Stravinsky to marry on 9 March in Bedford, Massachusetts. In any case, Vera still wrote to Sudeikin occasionally, and when he was working on the Metropolitan productions of *Petrouchka* and *Le Rossignol* in 1925 and 1926 he maintained contact with Stravinsky, trying to extend the composer's "synthetic realism"[99] to his own sets and costumes. In August 1924 Stravinsky even wrote how glad he was that Sudeikin was the artist for the New York *Petrouchka*.[100] However, Sudeikin's American success was brief and never matched the international recognition that Stravinsky enjoyed, perhaps in part because like so many Russian émigré artists he was unable to transcend his indigenous traditions and adapt to a

foreign culture; for, as Sorin stated in 1929, he "has remained Russian! Sudeikin advances and learns but does not change his physiognomy."[101]

During her emigrations in France and America, Vera continued to pursue her own career as a painter and decorator and to mix with Russian poets and painters: for example, in 1922 we find her modeling a dress designed by Sonia Delaunay, with *zaum* poetry written on the sleeves by Ilia Zdanevich.[102] But Vera's principal and constant inspiration was now, of course, Igor Stravinsky, and it is perhaps because of this permanent attachment to such a gifted individual that Vera continued to value the importance of the present tense and to record it for posterity in the form of scrapbooks, photograph albums, and diaries. Vera continued to attend salons of the highest order and the most luxurious splendor. But her memory never forsook the Russian setting that she, Stravinsky, Sudeikin, Olga Glebova, and Kuzmin had inhabited many years before. Her unflinching love of Russian culture was expressed in her visit, with Stravinsky, to the Soviet Union in September–October 1962 and in her active help in rediscovering neglected heroes of the Silver Age. To this end, she also started to prepare her Russian and Transcaucasian Album and Diaries for press, rewriting and summarizing parts of them, jotting down thoughts and chance recollections on visiting cards, hotel stationery, and menus, and endeavoring to identify Album entries. But, as is clear from Vera's emendations and written questions, by the 1970s she had forgotten many names and places, and certain pieces of the puzzle were missing. Even so, in this Album Vera Sudeikina-Stravinskaia preserved an entire literary and artistic heritage; and in enabling us to "conduct a discourse with the past," as Sergei Rafalovich writes in entry 13b, it now serves as a tribute and monument to an individual, a generation, and an entire epoch.

NOTES TO THE INTRODUCTION

1. Some information on Vera's childhood, education, and early acting career is provided in R. Craft, ed., *Dearest Babushkin: The Correspondence of Vera and Igor Stravinsky, 1921–1954, with Excerpts from Vera Stravinsky's Diaries, 1922–1971* (London: Thames and Hudson, 1985), pp. 5–10; and V. Stravinsky and R. McCaffrey, eds., *Igor and Vera Stravinsky: A Photograph Album, 1921 to 1971* (London: Thames and Hudson, 1982), pp. 32–46. For biographical information on Vera and Sergei Sudeikin relevant to the Crimean and Transcaucasian journey, see especially entries 1b and 16.

2. Boris Kochno used this expression in his dedication in one of Vera's Paris albums (for 30 September 1920 onward).

3. The Diaries for the Crimean and Transcaucasian periods deserve to be published in full, even though they are incomplete. They consist of seventeen exercise books written in ink or pencil, plus many loose leaves and scraps of paper that have been designated herein as Varia. Extracts from Vera's later Diaries of 1922–31, 1938, and 1940–71 have already been published (see Craft, *Dearest Babushkin: The Correspondence of Vera and Igor Stravinsky, 1921–1954, with Excerpts from Vera Stravinsky's Diaries, 1922–1971*; Stravinsky and McCaffrey, *Igor and Vera Stravinsky: A Photograph Album, 1921 to 1971*; and V. Stravinsky and R. Craft, *Stravinsky in Pictures and Documents* [New York: Simon and Schuster, 1978]). The Diaries are in a private collection.

4. For an informative discussion of the nineteenth-century literary album, see A. Kornilova, *Mir albomnogo risunka* (Leningrad: Iskusstvo, 1990).

5. Nadezhda Evseevna Dobychina (1884–1949) was the owner of St. Petersburg's first private gallery of modern Russian art, the so-called Art Bureau. Genrietta Leontievna Girshman (1885–1970) and her husband, Vasilii Osipovich Girshman (died 1936), were important collectors of Symbolist art in Moscow and just before and after the Revolution also kept an album with entries by Konstantin Balmont, Konstantin Somov, Sergei Sudeikin, and similar writers and artists. Olga Liudvigovna Della-Vos-Kardovskaia (1877–1952), artist and wife of the artist Dmitrii Nikolaevich Kardovsky (1866–1943), kept a similar album; for information, see Yu. Kozlova, "Albom O. L. Della-Vos-Kardovskoi," in *Pamiatniki kultury. Novye otkrytiia. Ezhegodnik 1986* (Leningrad: Nauka, 1987), pp. 122–30. It should be noted that Sergei Sudeikin also kept an album or scrapbook, although in a more desultory and egocentric fashion than Vera did. It is preserved in the Russian State Archive of Literature and Art, Moscow (RGALI) in the corpus of materials registered as *Albom dokumentalnykh materialov o tvorcheskoi deiatelnosti S. Yu. Sudeikina, podgotovlennykh k monografii* (call no. f. 947, op. 1).

6. For information on the Russian cabaret, see A. Konechnyi, V. Morderer, A. Parnis, and R. Timenchik, "Artisticheskoe kabare 'Prival komediantov,'" in *Pamiatniki kultury. Novye otkrytiia. Ezhegodnik 1988* (Moscow: Nauka, 1989), pp. 96–154; and A. Parnis and R. Timenchik, "Programmy 'Brodiachei sobaki,'" in *Pamiatniki kultury. Novye otkrytiia. Ezhegodnik 1983* (Leningrad: Nauka, 1985), pp. 160–257. Also see H. Segal, *Turn-of-the-Century Cabaret* (New York: Columbia University Press, 1987), especially pp. 255–320; and J. Bowlt, "Cabaret in Russia," in *Canadian-American Slavic Studies* 19, no. 4 (Irvine, Calif., 1985): 443–63.

7. Quoted in D. Kogan, *Sergei Sudeikin* (Moscow: Iskusstvo, 1974), p. 91, where the original source is not given.

8. Statement by Teffi (Nadezhda Buchinskaia) in RGALI, f. 1174, op. 1, ed. khr. 10, l. 79.

9. A. Boll, *Du Décor de théâtre. Ses tendances modernes* (Paris: Chiron, 1926), p. 69.

10. *Chauve-Souris* (program of the 1924–25 Paris season), p. 1.

11. V. Shklovsky, *Zoo or Letters Not about Love*, trans. R. Sheldon (Ithaca: Cornell University Press, 1971), p. 89.

12. *The Bat* (program of the 1927–28 New York season). Sudeikin was the designer of *The Wooden Soldiers*, one of Baliev's most popular revues in the U.S.

13. J. Moore, *Gurdjieff and Mansfield* (London: Routledge and Kegan Paul, 1980), pp. 54–55.

14. For information on these presentations, see Parnis and Timenchik, "Programmy 'Brodiachei sobaki.'"

15. M. Kuzmin, "Hymn for the Stray Dog," in J. Bowlt, trans., *Benedikt Livshits: The One and a Half–Eyed Archer* (Newtonville, Mass.: Oriental Research Partners, 1977), p. 216.

16. Livshits, *The One and a Half–Eyed Archer*, p. 215.

17. It is not clear exactly when Vera and Sergei first met or when their love affair began, although both Vera Shilling and Sergei Sudeikin were among the guests at a formal dinner in Belgium, according to the invitation, dated May 1913. Letter from Robert Craft to John E. Bowlt, dated 14 September 1990. See, however, entry 16.

18. Stravinsky and Craft, *Stravinsky in Pictures and Documents*, p. 237.

19. On Olga Glebova, see entry 103a. On Kuzmin, see entries 15 and 17a. Nikolai Nikolaevich Sapunov (1880–1912) was a fellow student of Sudeikin at the Moscow Institute of Painting, Sculpture, and Architecture, and they collaborated on a number of projects. Sudeikin mentions throwing Sapunov down the stairs in his autobiography in Varia.

20. Undated letter from Sudeikin to Vera in the Varia. Sudeikin often complained about physical and emotional disorders. As early as February 1900 his "nervous exhaustion" prompted his doctor to send him to the south—his first visit to the Caucasus (see Kogan, *Sergei Sudeikin*, p. 171), and he returned from the front to Moscow in 1917 again because of "nervous illness" (ibid., p. 135).

21. On the production of *Le Mariage de Figaro*, see entry 17a and Stravinsky and Craft, *Stravinsky in Pictures and Documents*, pp. 237–39.

22. According to Kogan, *Sergei Sudeikin*, p. 116. Sudeikin's oil painting called *The Comedians' Halt*, dated 1914, is in the collection of the Kustodiev Art Gallery, Astrakhan.

23. For details on the murals at the Comedians' Halt, see Konechnyi, Morderer, Parnis, and Timenchik, "Artisticheskoe kabare 'Prival komediantov'"; and V. Kuleshova, ed., *Khudozhnik i zrelishche* (Moscow: Sovetskii khudozhnik, 1990), pp. 321–27. Four of Sudeikin's designs for the interior of the Comedians' Halt are reproduced in *Apollon*, nos. 8–10 (Petrograd, 1911): 23, 26, 27.

24. Letter from Boris Pronin to Vladimir Podgornyi dated 21 September 1915. Quoted in Kogan, *Sergei Sudeikin*, p. 190. For information on the reference to Kreisler, a character in E.T.A. Hoffmann's stories, see entry 19, n. 4.

25. Kogan, *Sergei Sudeikin*, p. 137.

26. Ya. Lvov, "U khudozhnika Sudeikina (beseda)," *Kavkazskoe slovo*, Tiflis, 11 May 1919.

27. For further details on the rapid political changes in Russia, the Ukraine, and Transcaucasia at this time, see H. Shukman, ed., *The Blackwell Encyclopedia of the Russian Revolution* (Oxford; Blackwell, 1988), pp. 217ff. Useful maps and statistics are also supplied in R. Milner-Gulland and N. Dejevsky, *Cultural History of Russia and the Soviet Union* (Oxford: Equinox, 1989), pp. 142ff.

28. L. Vrangel, *Vospomoninaniia i starodavnie vremena* (Washington, D.C.: Kamkin, 1964), p. 63.

29. S. Makovsky, untitled text in the miscellany *Kuda my idem* (Moscow: Zaria, 1910), p. 101.

30. Makovsky invited Sudeikin to help make an inventory of the treasures of the Vorontsov Palace, now the Alupka-Palace Museum (Diaries, 24 February 1918); also see Kogan, *Sergei Sudeikin*, p. 137.

31. Handwritten note by Sudeikin that Vera kept inside her copy of the catalog of the "Art in the Crimea" exhibition.

32. Bilibin described Sudeikin's portrait of Vera in this way. See S. Golynets, ed., *Ivan Yakovelvich Bilibin. Stati. Pisma. Vospominaniia o khudozhnike* (Leningrad: Khudozhnik RSFSR, 1970), p. 113.

33. From an untitled translation of sections of Vera's Diaries by Franklin and Helen Reeve. This quotation is from p. 35 of the typescript.

34. Stravinsky and Craft, *Stravinsky in Pictures and Documents*, p. 240. However, according to another source, Sudeikin came ashore at Poti, a port north of Batum, after a shipwreck and from there went to Tiflis. See the unsigned, undated article "Russkoe iskusstvo v Amerike," in the Sudeikin archive in RGALI, Moscow, call no. f. 977, op. 1, no. 300, l. 126.

35. O. Mandelshtam, "Mensheviki v Gruzii," in *Sobranie sochinenii v dvukh tomakh* (New York: Inter-Language Literary Associates, 1966), vol. 2, p. 236.

36. N. Mandelshtam, "Posledniaia zametka," in L. Magarotto, M. Marzaduri, and G. Pagani Cesa, *L'avanguardia a Tiflis* (Venice: Seminario di Iranistica, Uralo-Altaistica e Caucasologia dell'Università degli Studi di Venezia, 1982), p. 229.

37. Sudeikin was also called "the prisoner of the Caucasus" (the reference being to Alexander Pushkin's poem "Kavkazskii plennik" [Prisoner of the Caucasus] and also to Mikhail Lermontov's peregrinations in the Caucasus). See letter from Vera to Olga Sallard dated 13 August 1923, mentioned in Craft, *Dearest Babushkin: The Correspondence of Vera and Igor Stravinsky, 1921–1954, with Excerpts from Vera Stravinsky's Diaries, 1922–1971*, p. 5. For information on Tiflis and nineteenth-century Russian literature, see N. Eidelman, *Byt mozhet za Khrebtom Kavkaza . . .* (Moscow: Nauka, 1990). Also see L. Kelly, *Lermontov: Tragedy in the Caucasus* (London: Constable, 1977).

38. G. Moskvin, *Prakticheskii putevoditel po Kavkazu* (Odessa: Levinson, 1899), pp. 303–5, 333. For a more contemporary "guided tour" of Tbilisi, see G. Khutsishvili, *Tbilisi cherez veka i gody* (Tbilisi: Sabchota sakartvelo, 1983).

39. Goncharova rejected the art of the West, while greeting that of the East in the preface to the catalog of her one-woman show in Moscow in 1913. For translation and commentary, see J. Bowlt, ed., *Russian Art of the Avant-Garde: Theory and Criticism, 1902–1934* (London: Thames and Hudson, 1988), pp. 54–60. For Le-Dantiu's ideas on Russia and the East, see his declaration "Zhivopis vsekov," in *Minuvshee*, no. 5 (Paris, 1988): 183–202. Lourié, Georgii Yakulov, and Benedikt Livshits co-signed the declaration *My i zapad* (We and the West) in 1914, which the latter published in his memoirs. See Livshits, *The One and a Half–Eyed Archer*, pp. 174, 250–51.

40. Quoted in F. Kazemzadeh, *The Struggle for Transcaucasia (1917–1921)* (New York: Philosophical Library, 1951), p. 121. For further information on Georgian politics at this time, see R. Suny, *The Making of the Georgian Nation* (Bloomington: Indiana University Press, 1988), pp. 165–209.

41. B. Kerdimun, untitled essay in *Kirill Zdanevich and Cubo-Futurism: Tiflis, 1918–1920* (exhibition catalog, Rachel Adler Gallery, New York, 1987).

42. On Ilia Zdanevich's lectures and the Caucasian celebration at the Stray Dog, see Parnis and Timenchik, "Programmy 'Brodiachei sobaki,'" pp. 233–36.

43. The map, entitled "Ferroconcrete Poem Tiflis," was compiled by Kamensky and designed by K. Zdanevich. Although it shows concrete places such as Golovinskii Prospect, Mount St. David, the house "where Kirill and Ilia Zdanevich live," and the "circus where I am" (see entry 107a), the map is "flipped," placing the River Kura below Golovinskii, Mount St. David to the north, Baku to the West, and Batum to the East. The map has been reproduced several times, including in *41°. Ilia i Kirill Zdanevich* (exhibition catalog, Modernism Gallery, San Francisco, 1991), p. 22. For information on the miscellany *1918*, see G. Janecek, *The Look of Russian Literature* (Princeton: Princeton University Press, 1984), pp. 139–43.

44. For information on the Futurist University, see Magarotto, Marzaduri, and Pagani Cesa, *L'avanguardia a Tiflis*, p. 313; and M. Marzaduri, ed., *Igor Terentiev. Sobranie sochinenii* (Bologna: S. Francesco, 1988).

45. For information on the "Exhibition of Paintings and Drawings by Moscow Futurists" held in the editorial offices of *Ars* in April 1918, see Magarotto, Marzaduri, and Pagani Cesa, *L'avanguardia a Tiflis*, p. 114.

46. For information on Gorodetsky's Guild of Poets and Degen's Hauberk, see ibid., pp. 103–6.

47. For information on the Blue Horns, see ibid., pp. 112–13. Also see entries 29 and 55, here. It is of interest to note that a "first-class Russo-Georgian restaurant" called Khimerion was also open in Constantinople in 1921. See *Ves Russkii Konstantinopol*, Constantinople, May–July 1921, p. 35.

48. For information on Kruchenykh and transrationalism, see Janecek, *The Look of Russian Literature*, pp. 69–121.

49. Igor Terentiev published an article on one of the dance presentations at Giurdzhiev's Institute. See Marzaduri, *Igor Terentiev. Sobranie sochinenii*, p. 235–26, 481. Vera first met the occultist and philosopher Georgii Ivanovich Giurdzhiev (Georges Gurdjieff; 1877–1949) in Tiflis.

50. Sofia Georgievna Melnikova (1890–1980) was an actress at the Theater of Miniatures in Tiflis, a declaimer of poetry at the Fantastic Tavern, and a close

friend of Ilia Zdanevich. The second miscellany of the Fantastic Tavern, *Mel-nikovoi. Fantasticheskii kabachok* (Tiflis, 1919), was dedicated to her. On Mel-nikova, see Janecek, *The Look of Russian Literature*, pp. 183–88; Magarotto, Marzaduri, and Pagani Cesa, *L'avanguardia a Tiflis*, pp. 119, 316; *Novo-Bas-mannaia 10*, with an intro. by G. Andzhaparidze (Moscow: Khudozhestven-naia literatura, 1990), pp. 590–98; and V. Nechaev, "Muza 41°," in *Minuvshee*, no. 10 (Paris, 1990): 158–74. Also see entries 83a and 84.

51. G. Neigauz, *Razmyshleniia, vospominaniia, dnevniki* (Moscow: Sovetskii kompozitor, 1975), p. 33.

52. On the Cherepnins and Hartmann, see entries 37d and 65a. Hartmann's memoirs are of direct relevance to the Tiflis activities. See T. and O. de Hart-mann, *Our Life with Mr. Gurdjieff* (San Francisco: Harper and Row, 1983). It is of interest to note that before the Revolution Gartman had been a member of the Jack of Diamonds exhibition society in Moscow—at the instigation of his friend Vasilii Kandinsky, no doubt.

53. Vera described the "Exhibition of Georgian Painting" (also called the "First Exhibition of Georgian Artists") in her Diaries (1 May 1919).

54. From *41°* (July 1919). Quoted in *Iliazd: Maître d'oeuvre du livre moderne* (exhibition catalog, Galerie d'art de l'Université de Québec, Montreal, 1984), p. 13. For more information on the group and journal, see Magarotto, Mar-zaduri, and Pagani Cesa, *L'avanguardia a Tiflis*, pp. 120–21, 233–34.

55. G. Sciltian, *Mia avventura* (Milan: Rizzoli, 1963), pp. 131–32.

56. Magarotto, Marzaduri, and Pagani Cesa, *L'avanguardia a Tiflis*, p. 206, n. 30. Marzaduri was quoting Kruchenykh's article, A. Elin (Kruchenykh's pseudo-nym), "Na tiflisskom Parnase," *Parus*, no. 4 (Baku, 1919), pp. 22, 23. How-ever, Kruchnykh's enthusiasm for Tiflis was not shared by all his colleagues. Even Ilia Zdanevich, for example, referred to Tiflis as a "lazy town . . . a haven of dead cultures, a hospital of decrepit nations" (I. Zdanevich, manuscript on Niko Pirosmanashvili [1914], in the I. Zdanevich archive in the State Russian Museum, St. Petersburg, call no. f. 177, ed. khr. 23, l. 1).

57. Robakidze gave the numbers "10, 15, 50" (see *Iliazd: Maître d'oeuvre du livre moderne*, p. 13); Gudiashvili gave "10–12" (T. Kobaladze, *Lado Gudiashvili. Tainstvo krasoty* [Tbilisi: Merani, 1988], p. 13).

58. Georgii Ivanov referred to the "maîtresse du Chien" in G. Ivanov, *Peter-burgskie zimy* (New York: Chekhov, 1952), p. 68.

59. The first miscellany of the Tavern, *Fantasticheskii kabachok*, no. 1, with con-tributions by D. Burliuk, Cherniavsky, Degen, Kamensky, Velimir Khlebni-kov, Kruchenykh, Terentiev, I. Zdanevich, et al., was published (but not put on sale) at the end of 1918 (see Magarotto, Marzaduri, and Pagani Cesa, *L'avanguardia a Tiflis*, p. 119). The second miscellany (*Melnikovoi. Fantasti-cheskii kabachok*) was published in September 1919.

60. The "hymns" by Kancheli, Poroshin, and Yashvili are published in Maga-rotto, Marzaduri, and Pagani Cesa, *L'avanguardia a Tiflis*, pp. 317–21.

61. *Iliazd: Maître d'oeuvre du livre moderne*, p. 31.

62. The "three idiots" was the name of a picture by Igor Terentiev mentioned in *Melnikovoi. Fantasticheskii kabachok*, p. 178.

63. From the credo of the 41° group on the first page of their journal. Quoted in *Iliazd: Maître d'oeuvre du livre moderne*, p. 13.

64. Kruchenykh's article, "Fantasticheskii kabachek," is published in *Kuranty*, no. 2 (Tiflis, 1919): 19–21.

65. I. Dzutsova and N. Elizbarashvili, "S. Yu. Sudeikin v Gruzii," *Muzei*, no. 1 (Moscow: Sovetskii khudozhnik, 1980): 26. On his painting called *Still Life with Self-Portrait* (1920), which he gave to Tabidze (presumably in March or April 1920 after returning from Baku to Tiflis), Sudeikin wrote the dedication, "To one of the three Georgian brothers." This painting is now in the collec-tion of Tabidze's daughter in Tbilisi.

66. "Dreaming Gazelles" is the translation of the Georgian title, *Meocnebe niamorebi*.

67. Quoted in Dzutsova and Elizbarashvili, "S. Yu. Sudeikin v Gruzii," p. 25.

68. That Sudeikin had a one-man exhibition shortly after he arrived in Tiflis in 1919 is reported in Kobaladze, *Lado Gudiashvili. Tainstvo krasoty*, p. 14.

69. For information on these frescoes, see I. Dzutsova and N. Elizbarashvili, "Zabytye freski," in *Dekorativnoe iskusstvo*, no. 12 (Moscow, 1975), p. 40.

70. Most sources list Kirill Zdanevich among the group (e.g., L. Gagua, ed., *Lado Gudiashvili. Kniga vospominanii. Stati. Iz perepiski. Sovremenniki o khudozhi nike* [Moscow: Sovetskii khudozhnik, 1987], p. 6), but T. Kobaladze, *Lado Gudiashvili. Tainstvo krasoty*, p. 14, includes Ilia Zdanevich. For further infor-mation on the Khimerioni decorations, see I. Dzutsova, "The Wall Paintings in the 'Khimerioni'" (in Georgian), *Sabchota khelovneba* (Soviet art), no. 3 (Tbilisi, 1974).

71. Quoted in Dzutsova and Elizbarashvili, "S. Yu. Sudeikin v Gruzii," p. 25.

72. Quoted in Gagua, *Lado Gudiashvili. Kniga vospominanii. Stati. Iz perepiski. Sovremenniki o khudozhnike*, p. 38.

73. Quoted in Magarotto, Marzaduri, and Pagani Cesa, *L'avanguardia a Tiflis*, p. 114.

74. Quoted in Gagua, *Lado Gudiashvili. Kniga vospominanii. Stati. Iz perepiski. Sovremenniki o khudozhnike*, pp. 38–40.

75. Ibid., p. 37.

76. Ibid., pp. 74–76.

77. For the correct details on Sudeikin's portrait of Vera and its exhibitions, see Dzutsova and Elizbarashvili, "S. Yu. Sudeikin v Gruzii," p. 26.

78. Gagua, *Lado Gudiashvili. Kniga vospominanii. Stati. Iz perepiski. Sovremen-niki o khudozhnike*, p. 36.

79. S. Gorodetsky, "Malyi krug," *Kavkazskoe slovo*, Tiflis, 22 May 1919.

80. On H_2SO_4, see J. Bowlt, "H_2SO_4: Dada in Russia," in S. Foster, ed., *Dada Dimensions* (Ann Arbor: UMI, 1985), especially pp. 221, 234–36.

81. Quoted in Kazemzadeh, *The Struggle for Transcaucasia (1917–1921)*, p. 129.

82. A. Kruchenykh, *Kozel-Amerikanets* (Baku, 1921). Quoted in M. Marzaduri, *Dada Russo* (Bologna: Caviliere azzurro, 1984), p. 137.

83. G. Moskvin, *Prakticheskii putevoditel po Kavkazu* (Odessa: Levinson, 1899), p. 355.

84. On Kamensky's idea of establishing an affiliation in Baku, see *Iliazd: Maître d'oeuvre du livre moderne*, p. 35.

85. Lourié was in Baku in 1917. See A. Parnis et al., eds., *Benedikt Livshits. Polutoraglzyi strelets* (Leningrad: Sovetskii pisatel, 1989), p. 679.

86. According to *41°* (July 1919).

87. See Kruchenykh's review of his own collection, *Ozhirenie roz*, and Teren-tiev's *A. Kruchenykh. Grandiozar*, in *Parus*, no. 4 (Baku, 1919), p. 23. Also see Marzaduri, *Dada Russo*, pp. 195–97.

88. According to Marzaduri, *Dada Russo*, p. 127.

89. For example, *O zhenskoi krasote* (Baku: Literaturno-izdatelskii otdel po-litotdela Kasflota, 1920); and *Kozel-amerikanets* (cover by Alexander Rod-chenko) and *Zaum* (cover by Alexander Rodchenko) (n.p., 1921).

90. *Iskusstvo*, no. 12 (Baku, 1920–21; no longer published). This issue provides much information of cultural life in Baku; of particular interest is Goro-detsky's article "Nashi zadachi," on p. 6. See entry 60.

91. T. Tabidze, "Eto—moia doroga," *Literaturnaia Gruziia*, nos. 10–11 (Tbilisi, 1967): 50.

92. Stravinsky and Craft, *Stravinsky in Pictures and Documents*, p. 240.

93. See C. Bechhofer, *In Denikin's Russia and in the Caucasus, 1919–1920* (Lon-don: Collins, 1921), p. 322. According to one source, on arriving in Paris, Sudeikin (again, Vera is not mentioned) moved in with his old friend Lario-nov, together with Kirill Zdanevich (see Régis Gayraud, "Iz arkhiva Ilii Zdanevicha," in *Minuvshee*, no. 5 [Paris, 1988]: 130).

94. Quoted in Kobaladze, *Lado Gudiashvili. Tainstvo krasoty*, p. 30.

95. See letter from Igor Stravinsky to Vera Sudeikina dated 17 November 1921, formerly in the possession of the late Boris Kochno and auctioned as lot 401 at *Collection Boris Kochno* (Sotheby's, Monaco, 11–12 October 1991).

96. According to an article (neither author nor date indicated) entitled "Russkoe iskusstvo v Amerike," in the Sudeikin archive in RGALI, Moscow, call no. f. 977, op. 1, no. 300, l. 128. The same article gives October, not August, as the date of Sudeikin's arrival in the U.S.

97. Undated postcard sent from Paris by Vera to Sergei Sudeikin, in the Sudeikin archive in RGALI, Moscow, call no. f. 947, op. 1, ed. khr. 236, d. 251.

98. Undated, unsigned article entitled "Artist, Through with Love, Finds Solace in Work," in the Sudeikin archive in RGALI, Moscow, call no. f. 977, op. 1, ed. khr. 301, ll. 74–76. Sudeikin's reference to his children in Paris seems to be wishful thinking.

99. Robert van Rozen, "Khudozhnik S. Sudeikin," an undated article in the Sudeikin archive in RGALI, Moscow, call no. f. 977, op. 1, no. 300, l. 98.

100. Letter from Stravinsky to Sudeikin dated 15 August 1924, in the Sudeikin archive in RGALI, Moscow, call no. f. 947, op. 1, d. 146, ed. khr. 2489.

101. A. Liubimov, "Beseda s S.A. Sorinym," an undated article in the Sudeikin archive in RGALI, Moscow, call no. f. 977, op. 1, no. 300, l. 90.

102. According to Gayraud, "Iz arkhiva Ili Zdanevicha," pp. 130–31.

THE SALON ALBUM OF

Vera Sudeikin-Stravinsky

Вѣрѣ Артуровнѣ Судейкиной.

Jag älskar dig.

Любовь любовью остается,—
Но есть влюбленная любовь.
Она лишь прихотью дается,
И вдругъ такъ близко расцвѣтетъ,
Рыданьемъ тайнымъ оборвется,
И звучнымъ свѣтомъ долго льется.
Лишь ей все сердце приготовь.

Она одна — всегда живая,
Въ ней возрожденіе твое.
Она опять — какъ утро мая,
Какъ ключъ, гдѣ влага огневая,
Сама себя перебивая,
Горитъ, журчитъ, напѣвъ свивая.
Люблю тебя. Люблю ее.

1920.VIII.10.
Парижъ.

К. Бальмонтъ

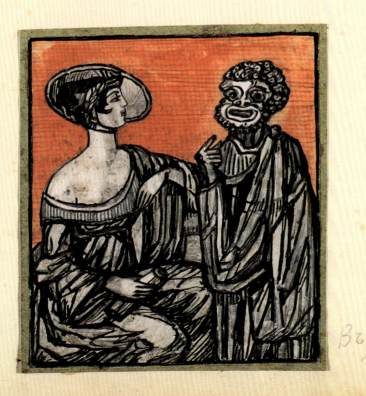

Въ 1921 году Урокъ
философіи примѣнилъ
къ женщинѣ

1a 1b

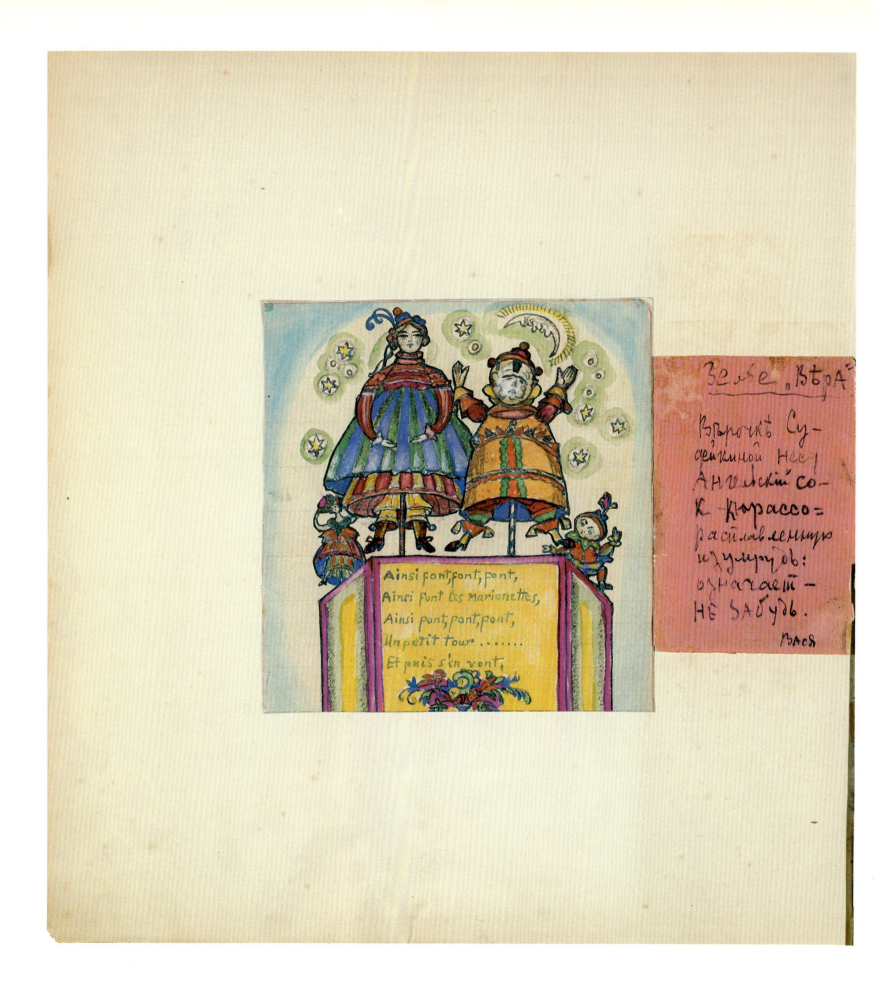

Ainsi font, font, font,
Ainsi font les marionettes,
Ainsi font, font, font,
Un petit tour
Et puis s'en vont.

Зелье „ВѢрА"

ВѢрочкѣ Су-
дейкиной несу
Ангельскiй со-
к -Кюрассо-
расплавленную
изумрудъ:
означаетъ-
НЕ ЗАБУДЬ.

Вася

2a 2b

Судейкинъ.

Сергѣй Судейкинъ

7a 7b

Къ моимъ стихамъ.

Ступайте въ міръ, повѣдайте, герольды,
Что кончена страданья и обмана.
Но не должна о нёмъ мечтать Изольда
И не должна печалиться Тристана.

Тебя, о многогрудая, тебя, о
Влюбленная и усталое развитье,
Тебя, Астарта, ~~страстная~~ Ромео
Служить открыто будутъ и Джульетта.

Ревнующей души презрѣвъ законы,
Своимъ ~~~~ будетъ подчиняться тѣло,
И будетъ, притаившись, радъ Отелло,
Внимая крикамъ страсти Дездемона...

Н. Минскій.

15 Іюля 1920
Парижъ.

Молитва

Прости насъ, Матерь Божія,
Не тѣхъ кто в бездорожьѣ,
Запичканный, загаженный,
Горделиво обряженный,
Подъемлетъ ношу башетей
Душой своей мозолистой.

Прости насъ чистыхъ, маленькихъ,
Отзывчивыхъ и сладенькихъ,
Изысканно-скучающихъ,
Движенья водъ не чающихъ,
Не будущихъ съ неба знаменій
В дому и яромъ пламени.

Отпилинъ — не уколемся,
Пришла бѣда — помолимся,
Во все печаль поплачемся,
Отъ всѣхъ грѣховъ упрячемся.
В насъ души неоропоксрѣй.
Прости насъ, Матерь Божія.

Помилуй насъ, не тѣхъ
Чей грубъ и явенъ грѣхъ,
Кто разврать и продрогъ,
И быть иныхъ не могъ.
Ты знаешь, Боже мой,
Ихъ не за что простить.

Сергѣй Рафаловичъ
Тифлисъ 24 июня 1919.

Не слушатъ в церковъ обѣдни,
Не зазвучатъ колокола,
Зима прошла, весна прошла,
Цвѣтетъ земля и зной послѣдній.

Давно умолкъ дивичій хоръ
И въ залахъ бродитъ день вчерашній.
Куранты четкіе на башнѣ
Ведутъ с минувшимъ разговоръ.

В души превобженой намежной
Мы вспашемъ ату пашенъ
Продолжимъ бороздиие трудомъ
Чужой — безпечный и побѣднѣй.

Когда же окрестные поля
Снова обхаритъ осенній вихръ
И избѣга сбирная дому
И молча разойдемся мы,

Огнями церково озарится
Подъ мѣдный звонъ колоколовъ
И намъ было из всѣхъ угловъ
Замелькаютъ какъ побылица

Изгнанамъ ваш путъ во наш,
Ибо милостива кнамъ гробница
Благослову своихъ Нона,
Окровшихся въ твоей дому.

Сергѣй Рафаловичъ
Завѣщаніе съ Нона
Тифлисъ 24 июня
1919.

13a 13b

Все тотъ же сонъ, живой и давный,
Стоитъ и не отходитъ прочь.
Окно закрыто плотной ставней,
За ставней стелющаяся ночь.
Трещатъ угли, тепла жаровня,
Вдали ... сонный песъ....
Я всталъ сегодня спозаранка
И мирно мирный день пронесъ.
Беззлобный день такъ свято длился,
Все — кроткій блескъ, и снѣгъ, и шумъ.
Читать тутъ можно только прелесть
Или Давыдову псалтырь...
И звонъ печной въ каморкѣ бѣдной,
И звонъ ночной издалека,
И при лампадкѣ нагорѣлой
Такая бѣлая рука!
Размориваетъ и покоитъ,
Лѣнь цвѣтетъ проста, пышна,
А вьюга въ полѣ мято воетъ.

Взломос ссгрол у окна.
Занесена пургой пуш...
Живи, любовь, не умирай!
Настанъ для насъ огненно-льд...
 дни
Морозно-ярный, русскiй рай!
сх... только въ снагъ, да къ зеръ
 любимый
Да краски нежной иконъ!
Желанной, неискоренимый,
Души моей давнишнiй сонъ. —

 М. Кузминъ

переписано для Серебрянной
 Судейкиной.
 1916.

Чужая поэма.

М. Кузмин,

1916

Апрель

Пасха.

17a 17b

Дорогимъ С. Ю. С. и
В. А. Б.

М. Кузминъ
на Пасху,
1916.

Въ осеннемъ снѣ то слово прозвучало:
«Лука взошла, а донынъ донынъ нѣтъ!»
Смѣшишь ли меня конецъ, или начало
Разсвѣта и таинственный привѣтъ?
Я долго дремалъ, я дремалъ даже лѣнаго ...
Чтобъ предо мной мелькнула огнемъ
даль
Какъ по водѣ, морѣ ватокъ, бездной свѣтѣ
Какъ отзвукъ заблудившагося пѣнья
И пришелъ вновь гладки и странному
волненью

Заплаканна, прекрасна и желанна,
Я думаю, сквозь дремлющие думы,
Что встречусь со мною донна Анна,
Которой ужъ не снится даже Жуанъ.
Разрушенъ небылъ дерзостный обманъ,
Развенчанъ дикій пронзительный и скорбный
И командору миръ на веки данъ.
Лишь вы поводите глазами серны,
А я у вашихъ ногъ, измѣнчивый и
 вѣрный.

Какъ призрачно здѣсь всё осуществилась,
И осень русская и почти зима,
И небо близко. Вы появились
Верхомъ (стоятъ по прежнему дома)
О, донна Анна! Вы блѣдна сама,
Не только я отъ этой встрѣчи блѣденъ,
На длинномъ письмѣ странно задрожа
Запомнилась... Какъ нашъ разсудокъ бѣденъ
А въ сердцѣ голосъ поетъ, докъ яренъ и
 подлѣнъ.

О, сердце, марфетъ, лучше не мечтай же?
Испанія и Моцартъ — Фигаро!
Безумный день, великолѣпная свадьба,
Огни горятъ, зажжены пестро!
Мнѣ арлекина острое перо
Судьба, смѣясь, сама въ тотъ день вручила,
И нанова раскинула Таро.
Какая то таинственная сила
Меня тогда вела, любила и учила.

Какъ если я создалъ неправо и пѣвчна
Для васъ разлилъ волшебную звѣздную
Для вашихъ огненныхъ и быстрыхъ серебра
Сіяетъ роскошь гроздвѣчнаго шкалеръ
Моихъ, моихъ... напрасно кавалеръ
Вамъ руку жметъ... но вы глядите страннѣ,
Я узнаю по должности манеръ;
Я — Фигаро, а вы всё — донна Анна.
Нѣтъ, дочь Жуана нѣтъ, и не придетъ
 Сусанна

17а

6.

Скорый, скорый!.. какой румяный холодъ
Какъ звонко лупила крылья городъ!
Кто такъ любитъ, какъ я, и кто былъ молодъ
Тотъ можетъ вспомнить и охарной роде
Какой то русскій, тепло-сонный чадъ
Роднитъ меня съ душою самоваръ
Вотъ корадоръ... лампада... въ голосъ
Цѣлуютъ... вѣдаръ... ураганщикъ скоро
За заневскою далъ она, моя Вечера!

7.

Всѣ-бѣгомъ, на утро всѣ дружали
(Господь, Господь, Тебѣ ся не жаль?)
Только жалобно лицо свое прижала
Къ рамщецамъ и долговѣчной, гдѣ вѣданъ
Одна слеза, какъ зарькая печаль,
Тяжелая, свинцово съ вѣкъ скользила,
Была лъ зарь вся ночь, не была лъ
Не знаю гдѣ и не обратилась?
Думалъ и взорамъ ты въ Череневъ прямъ
 стремилась

8.

Я черный платъ долго плотно скрывъ
 вашъ плечи
Твоя неподвижно вѣдаръ свои возвела
На благовѣщенье свѣтла двѣти,
Какъ будто двинутся да не могла.
И золотая, кованная мечта
Тебя вѣнча, благая, въ обрамленье,
Твоихъ рѣсницъ тяжелая мгла
Легла туда въ умилительномъ удавленье,
И проч скованъ въ мерцаньемъ
 голосовъ

9.

Еще обрызгана зеленой нивью
(О солнце зимнее, играй, играй!)
Пришла ко мнѣ, и сказка стала быль
И растворила врата мнѣ русскій рай,
Благословенъ родимый, снѣжный край,
И разлилъ на тайникахъ пустыни,
Дыши во снѣ! и скоро умирай!
Пусть меньше въ тихъ миломъ озарить
 атомъ!
И ты въ дачъ русскій рай была меньше
 васъ разумъ

10.

А помнишь ли?.. мы оба замолчали,
Твой взоръ смирился, грустенъ и широкъ,
Не надо ни... ни вспоминай печали!
"Рукой меня толкнула близко въ бокъ.
Надъ нами рядъ наряженыхъ голубокъ.
Два сердца нѣсь, сердца тѣ—двѣ лампадки,
И свѣтъ изъ нихъ такъ тепелъ и голубъ,
А дни подъ ними медленны и
 сладки,
Я кончилъ я на мѣстѣ пианидинной загадки

О дивна дивна, о, моя Венера!
Запечатлѣю ли твой странный ликъ?
Какой законъ, сму ниже, какая мѣра?
Очь пламененъ, таинственъ и великъ!
Жизнедаюшь ли лебединой кликъ?
Стою передъ тобой, сжаревши руки,
Какъ руки нищихъ, набаженыхъ нами,
Я не пѣвецъ, твои я слышу звуки,
Въ нихъ весь и адъ, и рай, и смерть, и страхъ,
 и мука!

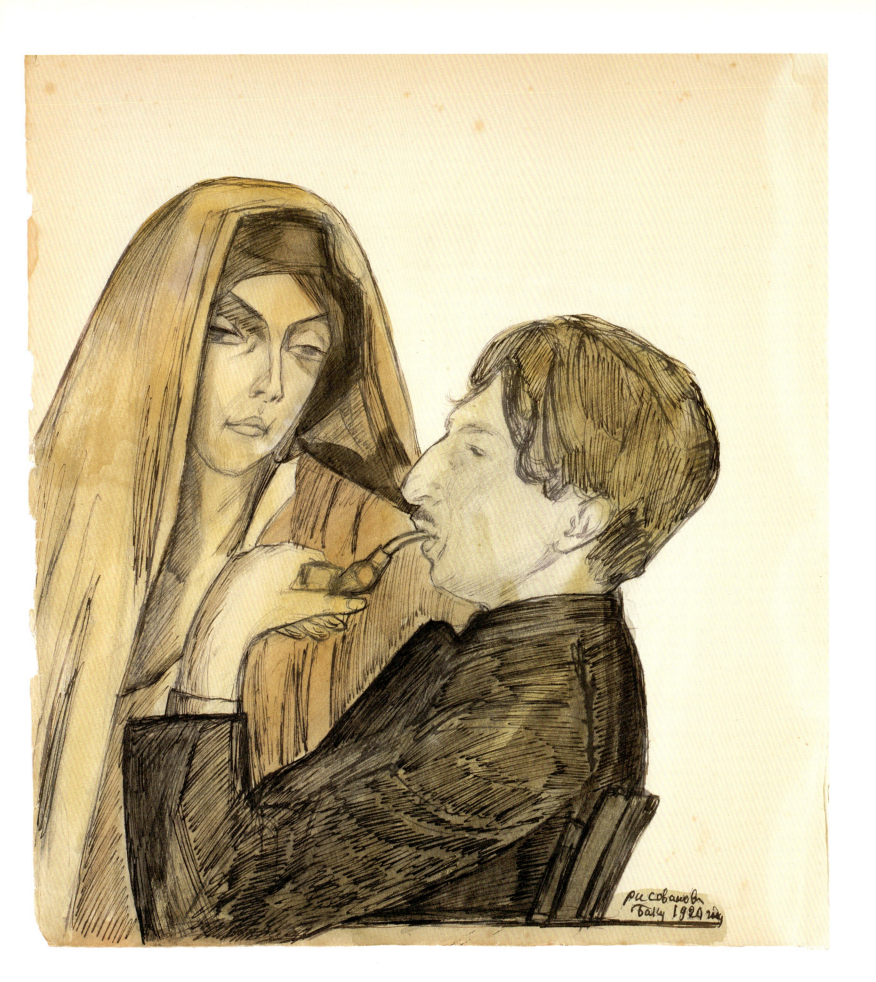

рисовалъ
Баку 1920 г.

18

В. А. и С. Ю. Судейкинымъ.

23—X—1919

Кузминъ пѣвучiй, камень-Мандельштамъ
Благословили вашъ уютъ укромный.
И я, войдя въ подвалъ, какъ въ тихiй храмъ,
Подъемлю колокола голосъ громный:
Звените сердцемъ, взорами звучите,
Венера-Вѣра*), два три полотенъ
И ты, Сергiй, кто, дорогъ и дремотенъ,
У радуги самой въ волшебной свитѣ,
Вы ангелами были въ оломъ мiрѣ,
Да! Шуманъ видѣлъ въ блескъ карнавала,
Москва надъ вами красный звонъ качала,
У четырехъ поэтовъ вы прiютились въ мiрѣ.
И вотъ: святый не знаю intérieur'а!
Старинныхъ чашекъ блещетъ позолота
Огнемечетъ кистъ, и рдѣетъ земляника,
Со стѣнъ глядятъ три прекрасныхъ лика,
И радуется имъ Мезонинъ кто-то
Иль непостижимаго небеснаго простора.

Сергѣй Городецкiй

Тифлисъ.

*) Варiантъ: Анна.

Corbeille des Arts.

Дитя Судейкину.

Разнузданную жизнь, всю роскошь луга,
Разстенныя образы и чувства
Стекутъ сливающся художникъ туго
Ремнями сыромятными искусства.

И жаждой торжества томимый властной, —
Чтобъ уберечь чертогъ своихъ сокровищъ
Въ пустыняхъ дня и въ ночи сладострастной
Онъ создалъ двухъ таинственныхъ чудовищъ.

И надъ звѣздою розою пурпурной
Возделилась лира и возникла Маска —
Corbeille des Arts — искусство смѣлыхъ сказа —
Та желтыхъ свиткахъ старины лазурной.

Обвита лаврами, предстала мiру
Театръ и музыка. Раскрыты храмы,
И дивные увѣтомъ летятъ мiру,
Рождал въ струнахъ звонъ эпиталамы

[handwritten poem in Russian cursive, four lines]

Воспламененное искусство мы вдохнувъ,
Твое, мне, раскрылось сердце наше.
Сверкаетъ розой и безбрежно плещетъ
Какъ Діонисъ своей безгранной чашей.

[signature]

11-VI-1919

Тифлисъ.

Рафаиловичу
Судейкинъ.

22a 22b

Осень

Безветренные солнечные дни
На рубеже меж осенью и летом
Но стало чуть прохладнее в тени
И медлит ночь [встуспъ] пред рассветом

В тяжелых гроздьях сочный виноград
Янтарный блеск струит по горным [скатам]
И золотом отягощенный сад
Костром недвижным рдеет [пред закатом]

Все [?]
новая тишина
И [?] [щет] [?]
Природа как [?]
Влюбленною [?]

Как [?] оня[?]но в это[?] цветет[?]
Покорного и робкаго [?] [возв?]ащее нас
Безмысленно [?]
Безудержно р[?]

[ой и такой [?]арекной]
[кой-крас]ной на[?]

23a 23b

Двойникъ Христовъ, мертвецы и распильные ...

За лихъ самихъ, Господи, прости.
Огонь систить и окутають грани.
Но какъ земли и в буряхъ не цвѣсти,
Къ тебѣ смиренной и такой знакомой.

Сергѣй Рафаловичъ

Іюнь 1919
Тифлисъ

Сентябрь 1918
Авіаши

Черенъ, грузенъ, неподвиженъ
Мракъ припалъ къ сырой земли,
Только облако во мгли
Фонари горятъ уныло,
Каждый на своемъ посту,
И въ ночную пустоту
Свѣтъ бросаютъ словно въ яму.
Звѣздъ не видно, нѣтъ луны;
Въ черной безднѣ двѣ стѣны
Съ двухъ сторонъ сходясь все ближе
Въ даль уходятъ подъ угломъ
И сырые камни лижетъ
Туруа ѳ ...еств ... языкомъ.

Сергѣй Рафаловичъ

Тифлисъ. Іюнь.
1919

24a 24b

Изъ „Оттепели" (посв. М. Кузмину)

V строфа I-ой главы.

V

Еще я помню начатый романъ,
По юношески нервный и нестройный,
И на столъ огъ лампы кругъ спокойный,
Каминъ и кресло — праздникъ сверянъ
И вечеровъ пленительный обманъ —
Душистый чай съ беседою любовной
Прелестно перемешанный. Твой санъ
Тогда уже не гибкiй и неровный
Былъ мне любезнъй стройности условной
Полетъ часовъ, который счастьемъ данъ,
Неправда ли былъ слишкомъ быстрымъ, словно
Мы только начинали свой романъ
И вдругъ въ нашъ мiръ межзально-спокойный
Ворвался глухо уличныя войны.

Юрiй Дегенъ.

— Карнавалъ

С. Юр. Судейкину

Довольно! Сброшены приличья! —
Одной любовью жизнь свята.
Не все равно ль чья нагота
Плѣнитъ: мужская, иль дѣвичья?
Что наша жизнь? — минутный бредъ,
Прелестное непостоянство...
Намъ такъ смѣшно пустое чванство,
Иль аскетическiй обѣтъ!
Пусть всякiй день нашъ будетъ веселъ,
Переживаемый остро!...
Зачѣмъ-же ты, слѣпой Пьеро,
Свой носъ напудренный повѣсилъ?
Ахъ! не забудьте: греза
И стихъ лукавый изъ подъ маски...
Пускай пѣшкомъ, пускай въ коляскѣ
Коварную ли отличишь изъ себя!

Такъ глупо варенъ Арлекинъ
Тобой, своей любовью гордый.
Не замѣчаетъ страшной морды
Грядущихъ, мерзвенныхъ годинъ.
Но маски мы, а не позы,
Чтобъ тратить время на пустяки.
Зоринъ скажемъ: тотъ дуракъ
Кто вѣритъ въ глупыя примѣты.
Да! мы утонченная знать
Берёмъ сегодняшнее честно.
Когда привезся такъ прелестно
Зачѣмъ про завтра будемъ знать?

Очнувъ маски! Поздно будетъ ...
Кончается весёлый сонъ.
Порвется сердце, какъ письмо́
И къ жизни смерть васъ всѣхъ разбудитъ.

Юрiй Дегенъ.

25a 25b

Чужая Муза

Вѣрѣ Артуровнѣ Судейкиной

Я рисовалъ любовь на чашечкахъ старинныхъ,
Но грустно думалъ: все-же далеки
Мнѣ женщины въ ~~расшитыхъ~~ кринолинахъ
И съ мушкою на бархатъ щеки —

Но я не говорилъ: любовь моя обуза.
Покорно проходилъ свой путь земной.
И удивилась постоянству Муза,
Пришла въ мой домъ и стала мнѣ женой.

Юрій Дегенъ

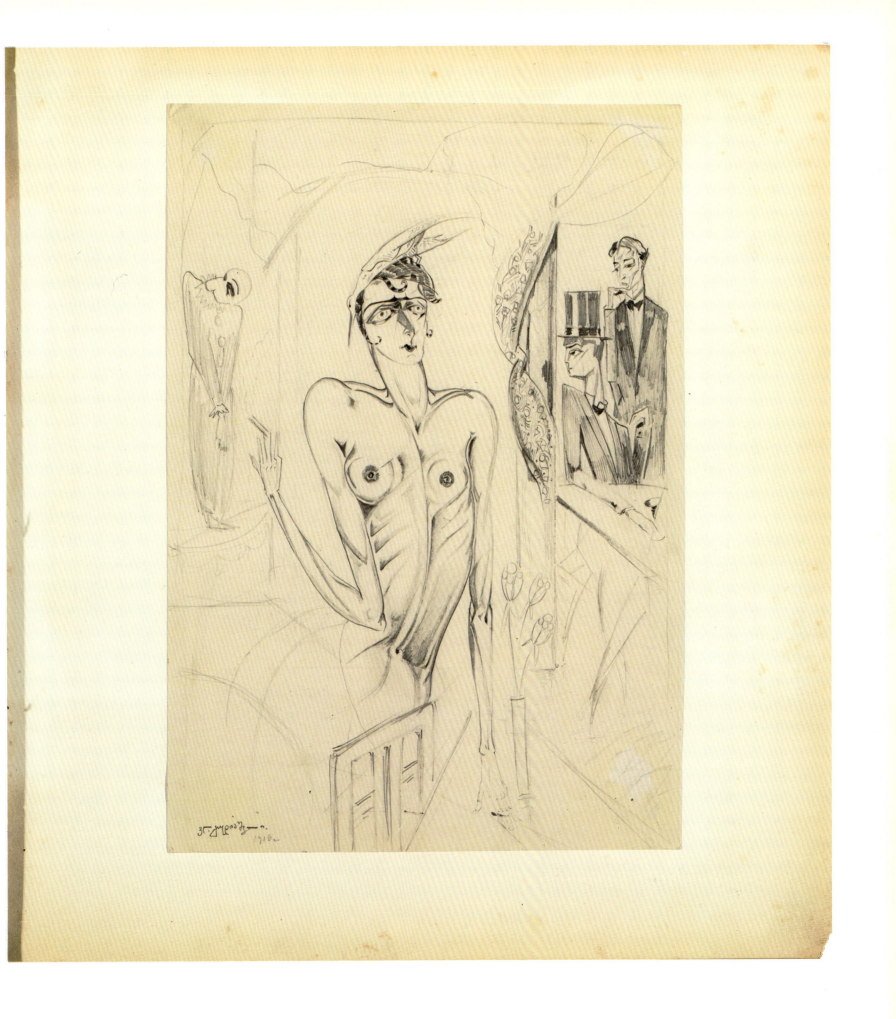

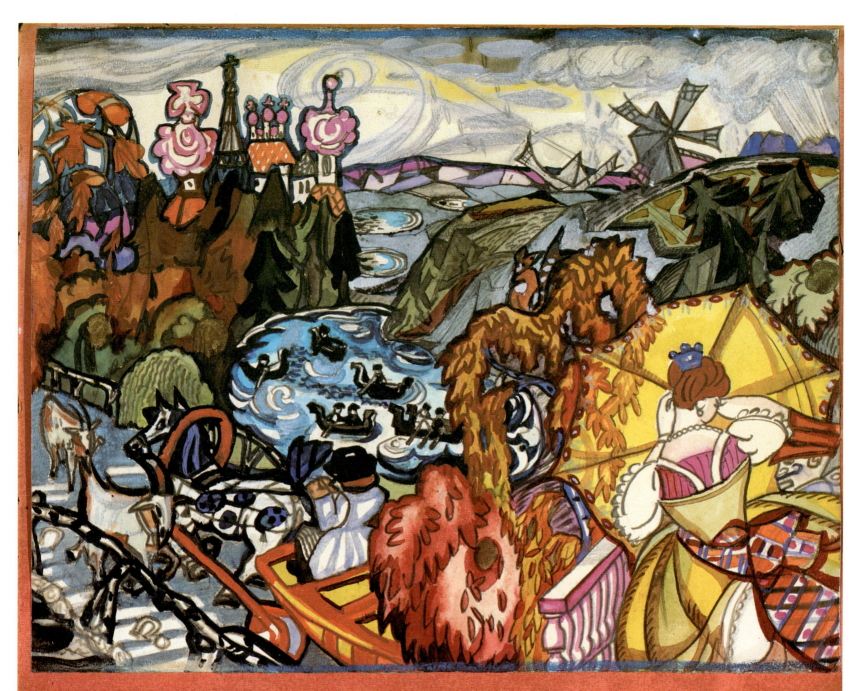

Августъ Псковскій

Веселушки и плакушки
Мостъ копытятъ козами,
А задорныя лавушки
Леденцуютъ розами.
По пестро-рябымъ огерцамъ
Гребенцы наверчены,
Бѣлыми, сырыми, черными перцами
Лодками наперчено.

Мельницъ мелево у кручи
Сухорукю машется

И свинцово капнетъ отъ тучи
Янтарева кашица.
Прозвучитъ вечернимъ шмелемъ
Съ колокольни узенько,
Бѣлка-спадка мелко мелетъ
Тпрусси-тпрусси тпрусенька
Заведетъ въ тирлю шпонтиче
Что-нибудь получится,
Всколыхнула желтый зонтикъ
На балконъ поручица.

31a 31b

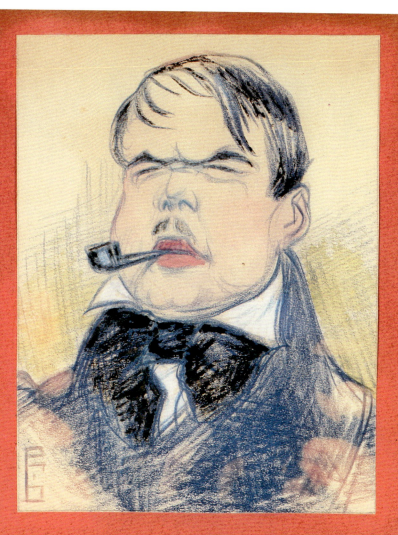

Карикатура Вл. Бѣлкина

Приписка

Вглядясь въ сію карикатуру
Поймемъ Судейкина натуру.
Да! ни одна изъ эпиграммъ
Сатиры злобствующе-клейкой
Во мнѣньи не уронитъ дамъ
Тебя, божественный Судейкинъ.
Красивъ ты всюду, словно горъ, —
Мужчина самый первый сортъ!

Юрій Дегенъ

Александръ Тиняковъ

А. Ахматовой.

Люблю узоръ твоихъ сандалій
И апельсинныхъ губъ разрѣзъ, —
Готовъ на тысячу скрижаляхъ
Слагать слова тоскливыхъ мессъ....

Сегодня вышелъ на Морскую,
Печальный, блѣдный, какъ всегда, —
А надъ Исакіемъ, ликуя, —
Горитъ ненужная звѣзда....

И вспомнилъ я Ирана водяной,
Своихъ наливокъ дерзкій рядъ....
Я буду вѣчнымъ пилигриммомъ
Творить молельный обрядъ....

Кто раскрылъ насъ разлучилъ,
И грусти между нами бросилъ?!.
Свѣтилъ шафранные лучи, —
Пришла морщинистая осень....

Я не пойду гулять одинъ: —
Неумолимо дуетъ вѣтеръ....
Но почему въ отеляхъ мертвыхъ
Гляжу, какъ короли пустынь?!..

На моемъ свѣтѣ-тихъ спитъ: —
Тамъ духъ Кавелина витаетъ....
Трупомъ угрюмый, скупо-гадъ, —
Засѣдалъ торжественный гробъ....
И я, какъ всѣ — я Петербургъ жгу!...
На что мнѣ государствъ лица?!..
Привыкъ къ твоей больной, стужѣ, —
И жить готовъ вѣкъ безъ конца! —

19/VII 1914

Петроградъ. —

Туки, туки, тучки
На горѣ стручки
Въ саду яблочки,
Карапаточки,
На лапаточкѣ
Бѣгутъ курочки
Чернохвосточки.
Дѣвки татарки
Взяли по палкѣ
Убрали въ доску
Поѣхали въ Москву
Купили коровку.
Коровка-то съ кошку
Надоили съ ложку.
Ай кукалка, кукалка
Што жъ ты дома не была,
Побоялась дергуна:
Дергуновы дѣти
Сидятъ на полѣти
хотятъ полетѣти
Къ Ивану на мостку,
У Ивана, у Романа,
Жеребёнокъ голенястъ
На всѣ грамоты гораздъ:
Енъ читатъ, енъ играть
Енъ и пѣсенки поетъ.
Живетъ мужикъ на краю
Енъ не скуденъ, не богатъ,
У него много ребятъ:
Одинъ Ванька другой Панька
Третій Вася Козырекъ,
щ простымъ онъ мужиковъ
Енъ помѣщика братъ
Енъ шубёнокъ радъ.
Пѣтушокъ, пѣтушокъ
Золотой гребёшокъ
На наместкѣ сидялъ
Лапоточки онъ плёлъ
И сабъ, и жанъ,
Малымъ дѣточкамъ,
Яслиги по лапаточкамъ
И дергунокъ лапатей
И Машутъ лапотей
И Микешинъ лапотей
Лапотки на ножки
Пошли по дорожкѣ.

Прости мой другъ, когда ты встанешь,
Свѣтило будетъ высоко
Меня ты больше не застанешь,
Я, странникъ, буду далеко.
Пускай сулятъ мнѣ тучи грозы,
Пусть солнце знойное палитъ.
Спасибо другъ! Вино и розы
Мнѣ долго память сохранитъ.

Мисхоръ. 3 іюня 1918.
И. Б.

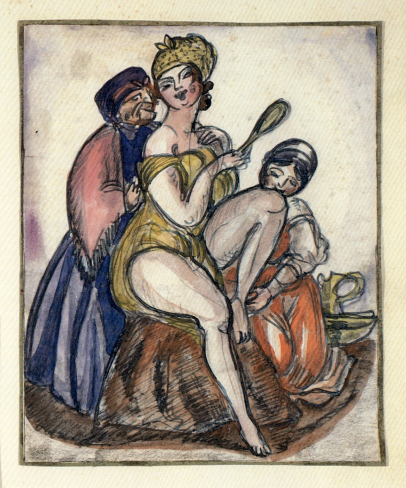

Роза

Капля, блестя какъ алмазъ, на розѣ
прекрасной дрожала;
Томно въ дремотѣ полдневной склони-
лась пышная роза.
Роза! не вѣдаешь ты, — на твоемъ
лепесткѣ отразился
Въ маленькой капелькѣ міръ; от-
разились высокія скалы,
Синяя моря лазурь, глубина безконеч-
наго неба,
Пышная зелень деревъ и безжалост-
ный блескъ Аполлона.

Мисхоръ
15 мая 1918.
И. Билибинъ

Восточный романсъ. Слова Билибина. Музыка Поль. Альбомъ Судейкиныхъ

37a 37b 37c 37d

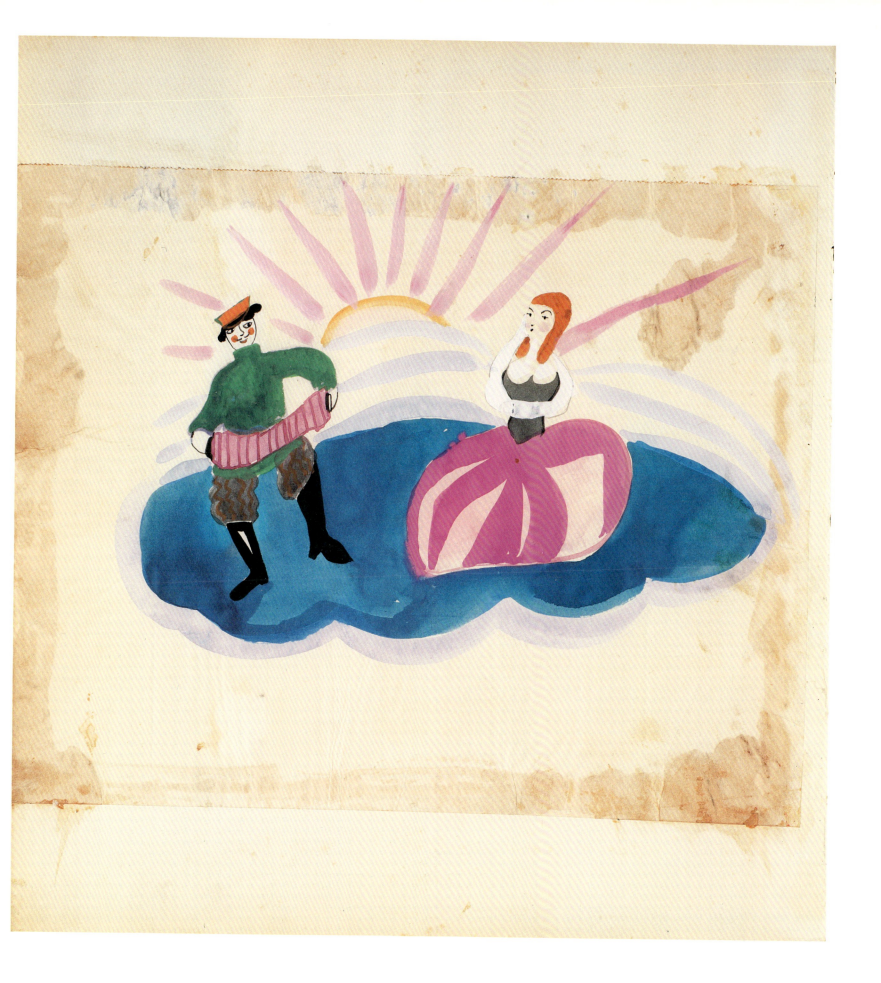

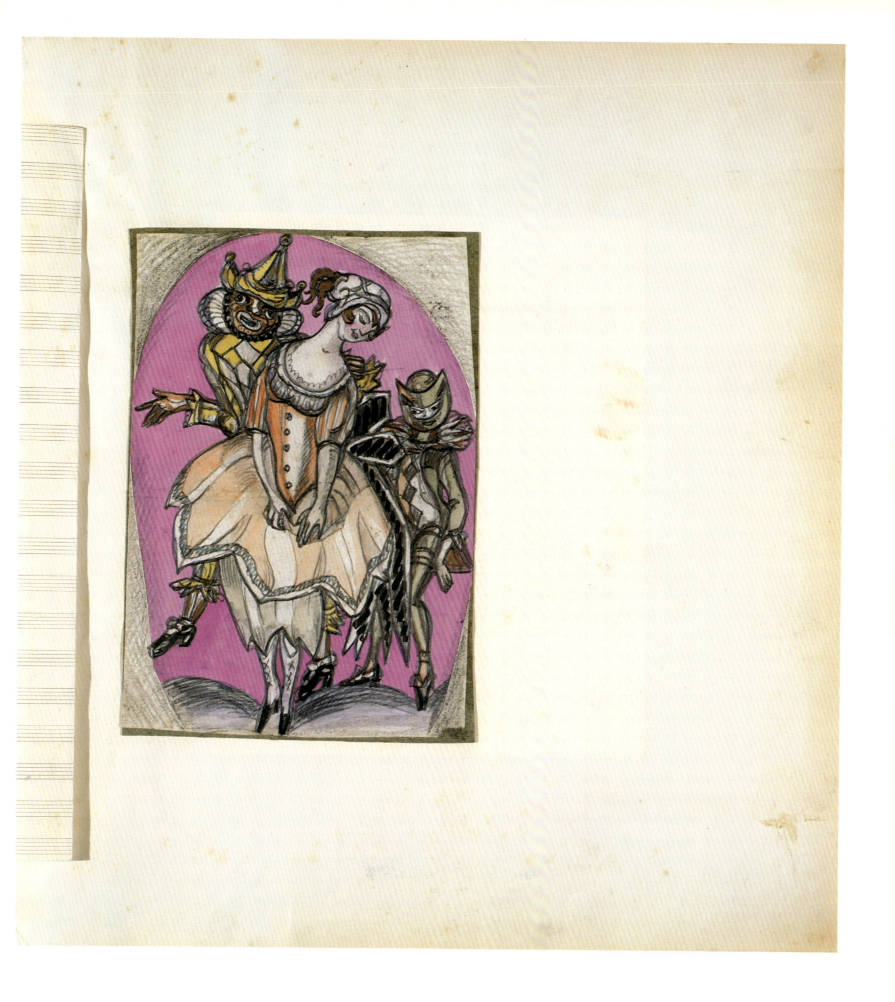

À Madame Daudet (...)

Daudijacque — Bruxelles 16 Juin 1918

En vain je t'attendais au bord de l'étang
Que tu vins t'asseoir sur le banc de pierre
Et je regardais les grands cygnes blancs
............ à l'ombre du hêtre
............ tout remplis de ...
D'un mâle amoureux ; d'autre ...
 différent
De t'attendre ainsi sur le banc de pierre
............ au bord de l'étang.

... et printemps jouaient dans la brise
Et dansaient gaiement parmi les gazons,
Je te maudissais
Qui me laissaient là, loin à l'horizon.
Peu à peu le soir qui d'immobilise
Descendit très lent et ta trahison
Maudit mon cœur plus que de raison.
Au bord de l'étang, j'attendais
 Marguerite

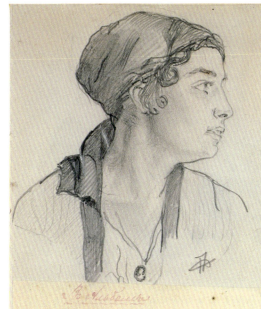

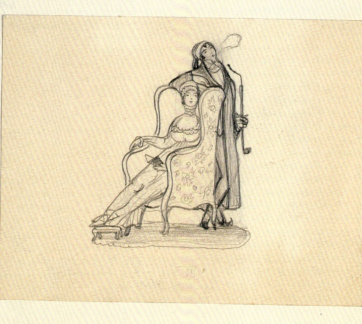

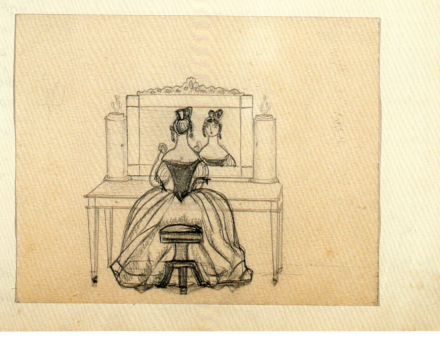

Я въ новый міръ попалъ,—
Міръ чуда, красоты.
Я новое узналъ,
Я мудрость увидалъ
Ясны стали дни!
 Жилъ въ замкнутомъ кругу
 Казармъ, рабовъ неволи,
 И зрѣлъ лишь мракъ и тьму,
 Томясь незнаньемъ боли,
 Привѣдшій къ красотѣ!
Завѣса мрака спала,
Случайно предо мной,
Душа возликовала,
Предъ нею мудрость встала
Блистая красотой!
 Инымъ узримъ я міръ.
 Вдохнувъ частицу знанья
 Стозвучными звонами лиръ
 Во мнѣ бушуетъ пиръ,
 Развитъ самосознанья.
Я въ новый міръ попалъ —
Міръ жизни красоты,
Я новое узналъ,
Я бога увидалъ.
Свѣтлѣе стали дни!

 Адамъ Ильберъ

Баку 8/ІІ 920 г.

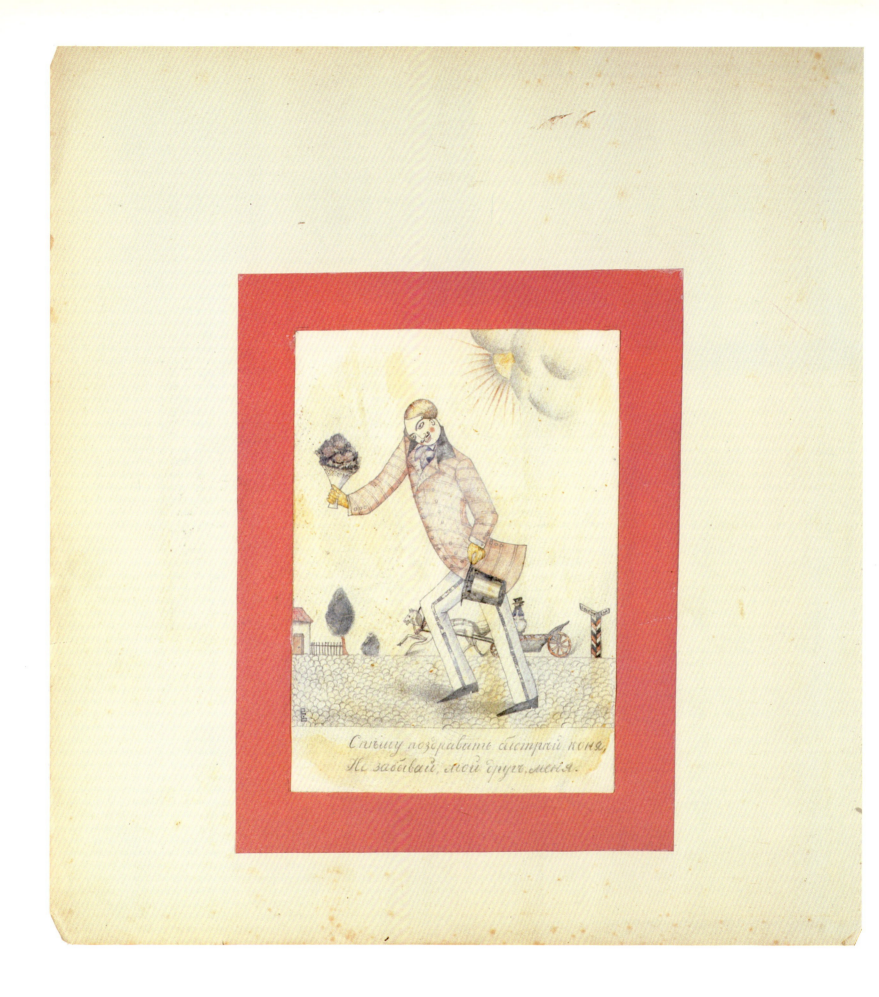

Спѣшу поздравить быстрый коня,
Не забывай, мой другъ, меня.

44

45a 45b 45c 45d

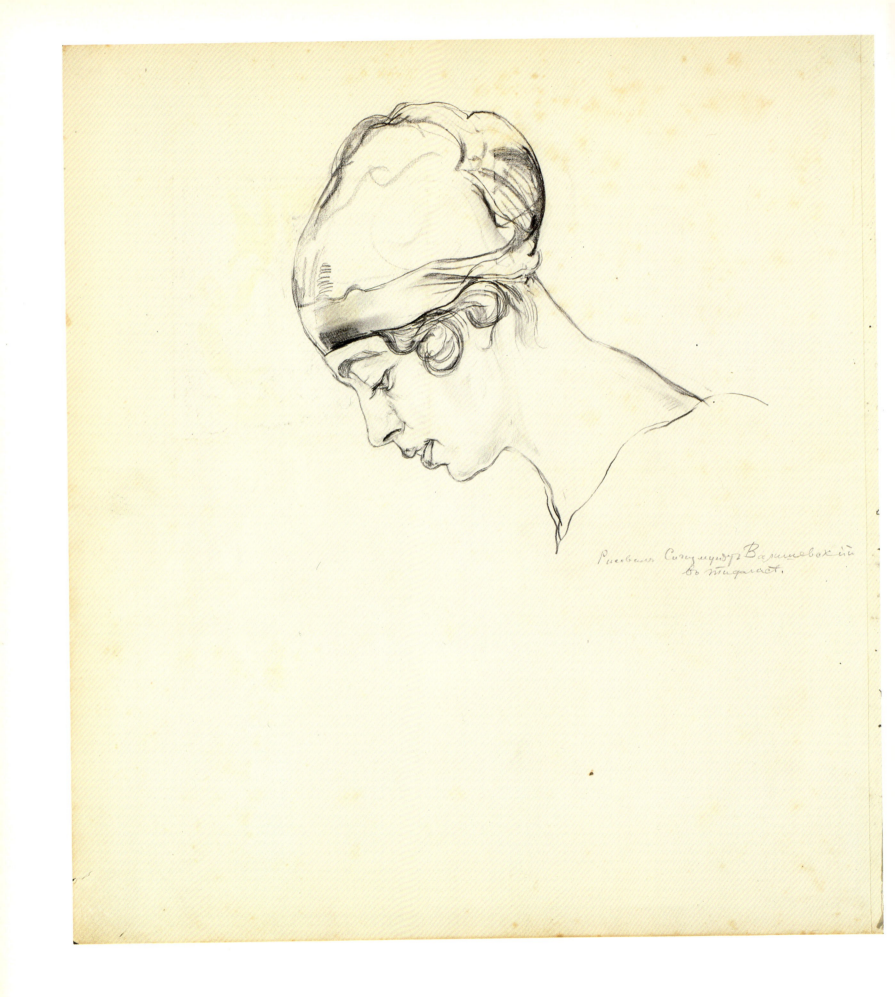

Рисовалъ Сигизмундъ Валишевскiй
въ Тифлисѣ.

46

Фуга.

Франклинъ похитилъ съ неба первый громъ.
Расплавилась во Франціи корона.
Сэръ Питтъ грозилъ сердито костылемъ
Повстанческимъ орламъ Наполеона.

Кичливо буйтъ возглавилъ сонархомъ.
Но славные безумцы внѣ закона:
Да будетъ зло обуздано добромъ,
Вильгельмовъ мечъ — оливою Вильсона.

Запутанный семижды правъ расчетъ:
Румянымъ сокомъ выжатыхъ столѣтій
Великій Духъ мужаетъ и растетъ.

Гдѣ двое спорятъ, радуется Третій:
Зелениха мудрой горечи цвѣтетъ
Подъ вихрики базарныхъ междоусобій.

Чудо Русскихъ Мастеровъ

Въ степи убогой русскіе избушки.
Плетутся чрезъ сани; это что за —
Звѣзда изъ фольги? Сѣверныя игрушки
Насмѣшника злая рѣзвая заноза?

Не въ пору апалашъ запѣть частушки…
Какъ можетъ изъ гнилаго навоза
Въ дыханьи лѣтва, на полу тетушки
Процвѣсти божественная роза?

Немтные воспреки просты Господь…
Склонись поближе къ лону изъ соломы
Вѣрочевать души тяжелый бредъ.

Кто наяву скучалъ въ чудесной драмѣ,
Въ Герсонахъ сихъ узнаетъ и повѣритъ,
Что „Вѣра двигаетъ горами“.

19/VII 1919 г.

*жертвенно.

Сергѣю Юрьевичу,
Дорогому.

"Майра." Лондонъ
1921.

Я памятью не измѣню
Вовѣкъ сегодняшнему дню
Счастливому. и тѣхъ послѣднихъ
Часовъ, когда передъ канвой
Садился я. въ окнѣ сосѣднемъ
Слѣдилъ запретный образъ Твой.

А какъ не помнить тѣхъ ночей,
Когда являлся въ легкомъ дымѣ
Мерцая. — блескъ Твоихъ очей
И повѣрялось дало имя
Твое. въ тревожномъ полуснѣ,
Но Ты не откликался мнѣ.

Теперь томительный запретъ
Нарушенъ!
— Душенька!
— И мнѣ,

Родной, конца блаженствамъ нѣтъ!
Господь васъ на новый союзъ.
Когда въ двойномъ союзѣ, — Третий
Бываетъ лишний Купидонъ!

Борисъ Кустодiевъ
18 февраля 22 г.

Золотистого меду струя из бутылки текла
Так тягуче и долго, что молвить хозяйка успела:
— Здесь, в печальной Тавриде, куда нас судьба занесла,
Мы совсем не скучаем, — и через плечо поглядела.

Всюду Бахуса службы! Как будто на свете одни
Сторожа и собаки! Идешь — никого не заметишь;
Как тяжелые бочки спокойные катятся дни;
Далеко в шалаше голоса: не поймешь, не ответишь.

После чаю мы вышли в огромный коричневый сад,
Как ресницы на окнах опущены темные шторы.
Мимо белых колонн мы пошли посмотреть виноград,
Где воздушным стеклом обливаются сонные горы.

Я сказал: виноград, как старинная битва, живет,
Где курчавые всадники бьются в кудрявом порядке;
В каменистой Тавриде наука Эллады — и вот
Золотых десятин благородные, ржавые грядки!

Ну, а в комнате белой, как прялка, стоит тишина,
Пахнет уксусом, краской и свежим вином из подвала...
Помнишь, в греческом доме, любимая всеми жена,
Не Елена — другая — как долго она вышивала?

— Золотое руно, где же ты, золотое руно?
Всю дорогу шумели морские тяжелые волны.
И, покинув корабль, натрудивший в морях полотно,
Одиссей возвратился, пространством и временем полный!

 Осип Мандельштам

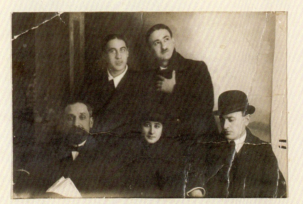

Офортъ „Негри въ бѣлыхъ парикахъ".

<div align="right">Изъ декорацiй Сергѣя Судейкина.</div>

Дремотный сонъ въ золѣ томленiй.
Струи червонныхъ тяжкихъ косъ.
И рдѣютъ бѣлыя колѣни
На лонѣ блѣдныхъ смятыхъ розъ.
Блудница луннаго азарта —
Сапфирно ярая въ лучахъ:
На солнцѣ княжится Астарта
Средь негровъ въ бѣлыхъ парикахъ.
Кровавый хмель гранатовъ зноя
Зоветъ всѣхъ женщинъ на разгулъ.
И слышень слышень темный гулъ
Любовныхъ помысловъ ночной.
Горитъ тигрина Саломея:
Въ садахъ у дикаго куста.
Зова любовь: янтарно млѣя:
Иллуетъ мертвыя уста.
Желанный ядъ въ изгибахъ торса:
Земля вся въ блудѣ въ тайный часъ.
И ростъ бредъ изжившихъ расъ
Въ плащѣ изъ крыльевъ альбатроса.
И вдругъ мертвѣетъ страстный шопотъ:
И слышитъ лётъ шумя звеня:
Все ближе ближе смертный топотъ
Апокалипсиса Коня.
И будетъ встрѣча двухъ страстей:
Огня копытъ и жала тѣла.
Конь-блѣдъ заржетъ еще блѣднѣй.
Жена возжаждетъ до предѣла.
И сладострастна будетъ пытка
Обезумѣвшей блудницы.
Но тамъ въ вѣкахъ крутымъ копытамъ
Нагое тѣло будетъ сниться.

<div align="right">Григорiй Робакидзе.</div>

<div align="right">Тифлисъ. 1919. Лѣто.</div>

51b

Тифлисъ.

Трамвай меня къ садамъ, повизгивая, мчитъ.
И кажется Тифлисъ бѣгущей каруселью.
Сторожевая съ, незыблемый Давидъ,
Слагаетъ проповѣдь нагорную - ущелью.

Шелками яркими коверъ вѣковъ расшитъ.
Шумливъ прибой племенъ, вселившихъ къ новоселью;
Вернулся бранный ротъ усидчивой свирелью.
Священный стволъ плющомъ и маніей повитъ.

На рынкѣ - дружескій гулъ враждующихъ нарѣчій;
Средь узкой улицы - автомобилей встрѣчи,
Гдѣ въ кружевѣ перилъ тоскуетъ минаретъ.

Поэтовъ кузница въ сосѣдствѣ съ гауптвахтой...
Босого старика пророческій портретъ -
Сіянье сквера - надъ красочною тахтой.

Пастырь добрый.

Народы льнутъ къ утѣхамъ и безволью.
Дикарь раба скрутилъ и воспиталъ.
Взирала жадность творческой болью -
Твоей улыбкой, хитрый Капиталъ.

Ты прѣсный міръ посыпалъ ѣдкой солью.
Въ горячкѣ роста скряга трепеталъ.
Отъ тайну золота у звѣздъ пыталъ -
И строилъ путь стальной къ первопрестолью.

Въ пустотѣ стеклъ грозовый бьется токъ.
Урчитъ, за тучу пущенный, волчокъ.
Есть упованье въ вынужденныхъ жертвахъ.

Но фарисей кричитъ: распни Его!
На третій день воскреснешь Ты изъ мертвыхъ,
Упорнаго разсчета торжество.

Что ты, мама, безпрестанно...

Да, Евангелье - Книга, водевиль есть вещь..
Пусть горитъ Александрійская библіотека.
Ты жъ учителю впѣйся, какъ умильный клещъ,
Въ плоскій урокъ необсохшаго ротика.

Гутенбергъ, вѣдалъ ли Ты,
Первую книгу печатая,
Что кликушество - манія?
Шути!
Юбилейное, двадцать пятое
С. Я. Надсона изданіе!

На подачки сберегательнаго банка
Въ старыхъ мѣхахъ щеголяетъ педантъ Сальери.
Сколько лѣтъ еще проскрипишь,
Неугомонная шарманка?
Стихи въ заведенномъ размѣрѣ
Тащитъ чиновникъ ученый чижъ.

Странно!

ГАХаразовъ
7/VII 1917 г.

53a 53b 53c

Villa Maïdель

Н. Голяшевская (?)

Княгиня Марія Владимірьевна Барятинская

14 Апреля 1919 Берегите воспоминанія
будущее всесильно, несите за собою
воспоминанія, и послѣднее прости и Боже!

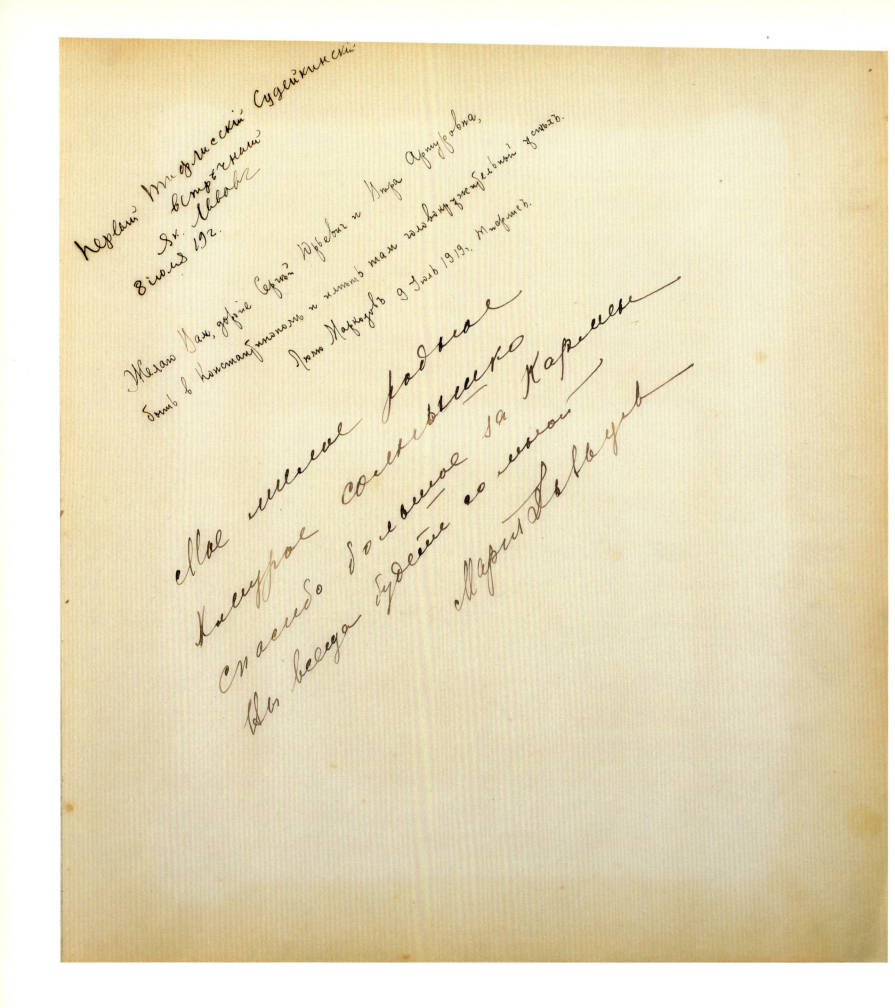

Первый тифлисскій Судейкинскій вечеринъ
Як. Львовъ
8 іюля 192.

Желаю Вамъ, дорогіе Сергѣй Юрьевичъ и Вѣра Артуровна,
быть въ Константинополѣ и имѣть тамъ головокружительный успѣхъ.
Яковъ Марковъ 9 Іюль 1919. Тифлисъ.

Мое милое дорогое
Кисуля соллейченко
спасибо большое за Кариш
Вы всегда будете со мной
Маріэтта Львовъ

55a 55b 55c

Въ этомъ 4-мъ классѣ я наконецъ
нашелъ то, что мнѣ дотолѣ
облегчитъ и научитъ моихъ
прекрасныхъ ученикъ. это любовь и
чувствованіе всего прекраснаго.
состоитъ изъ двухъ моихъ
живыхъ и любовь искусства
каждый видѣлъ свѣтомъ.
что стоитъ.

[подпись]

59a 59b

Вспоминаю всегда о Вас,
Я маленький человѣкъ
Любящій искусство! —
Карлъ Карловичъ
Лейтнеръ.
17/III 1920
Баку—

60

Нужно верить к русскій
народъ — не оставлять еду
— любить ея

17/VII 1919г Николай Соколовъ
Тифлисъ.

Подлинный талантъ — личится не толь-
ко въ творчествѣ человѣка, но да-
же въ случайной интимной бесѣдѣ.
У такой бесѣдѣ я почувствовалъ
Сергѣя Судейкина
 А. Пушкинъ

Тифлисъ. 16/VII 1919г.

мы вернемся в Россію
в 1920 году А. Пушкинъ

61a 61b

честное слово я не женюсь никогда

Александръ Черепнинъ
16 іюля 1919 Тифлисъ
Гротескъ (примитивъ № 1)

У Судейкиныхъ.

Сижу, гляжу, не зная что сказать.
Мила хозяйка. Судейкинъ чуть суровѣй.
Что пишете? —
— Какъ знать...
 Хочу я терпкостью Кавказа
 Свои цвѣтистыя проказы,
 Какъ даръ Колхиды, украшать...
 Я. Каменскій

14 Сентября
 19г.
Тифлисъ.

Пускай въ грядущей тьмѣ годинъ
Взойдетъ въ искусствѣ мною зерно, —
Судейкинъ будетъ милъ одинъ
И Софьи будетъ неповторенъ.

7 марта Ив. Радинъ
 1920 г.

Мечтой покорною безудержно играемъ
Но идетъ-ли вспомнить прошлую весну
Когда зарницы бѣлыя блеснутъ
Города опять у городскихъ окраинъ
Судьба бросаетъ ровно четъ и нечетъ
Но не понять намъ костировой
Что насъ заставитъ въ день сороковой
Нести въ алтарь заплаканныя свѣчи
Воспоминанія уйдутъ опять
Весной найдетъ что больше берегли мы
Какъ счастливы что можетъ забывать
Завѣтныхъ слов святые пилигримы.

Юрій Долгушинъ.

Тифлисъ, 21го іюля 1919го года.

Классъ седьмой.

71a 71b

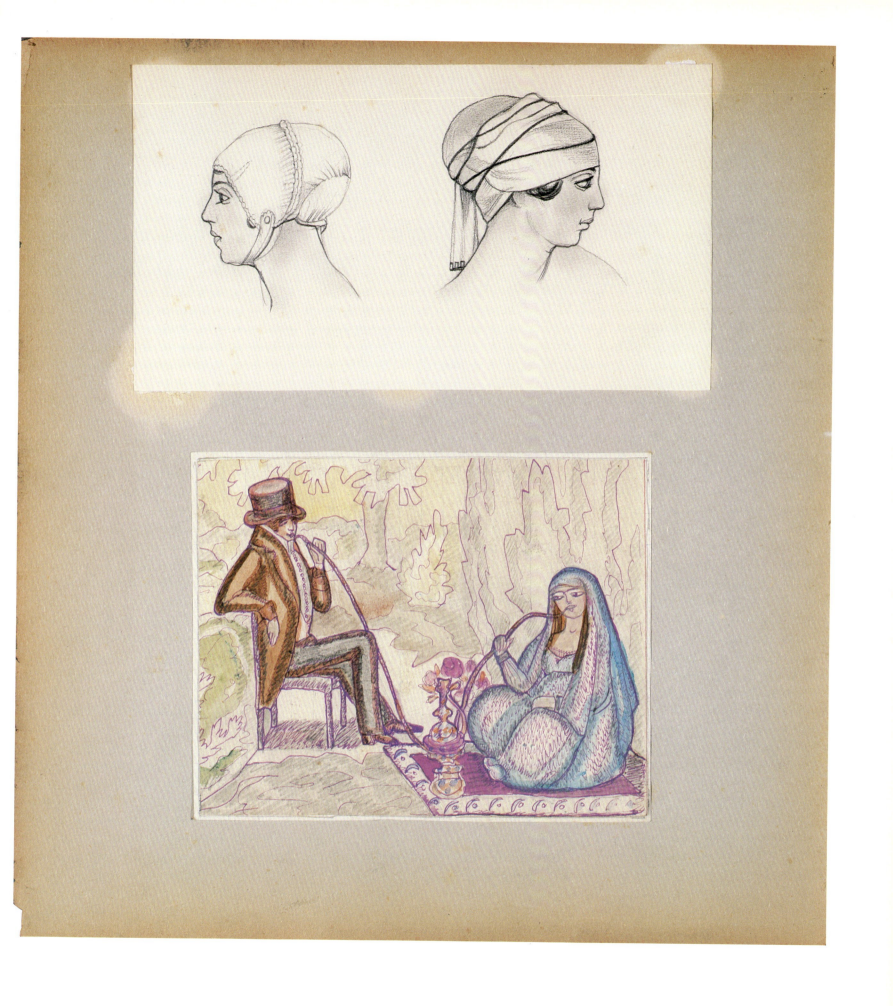

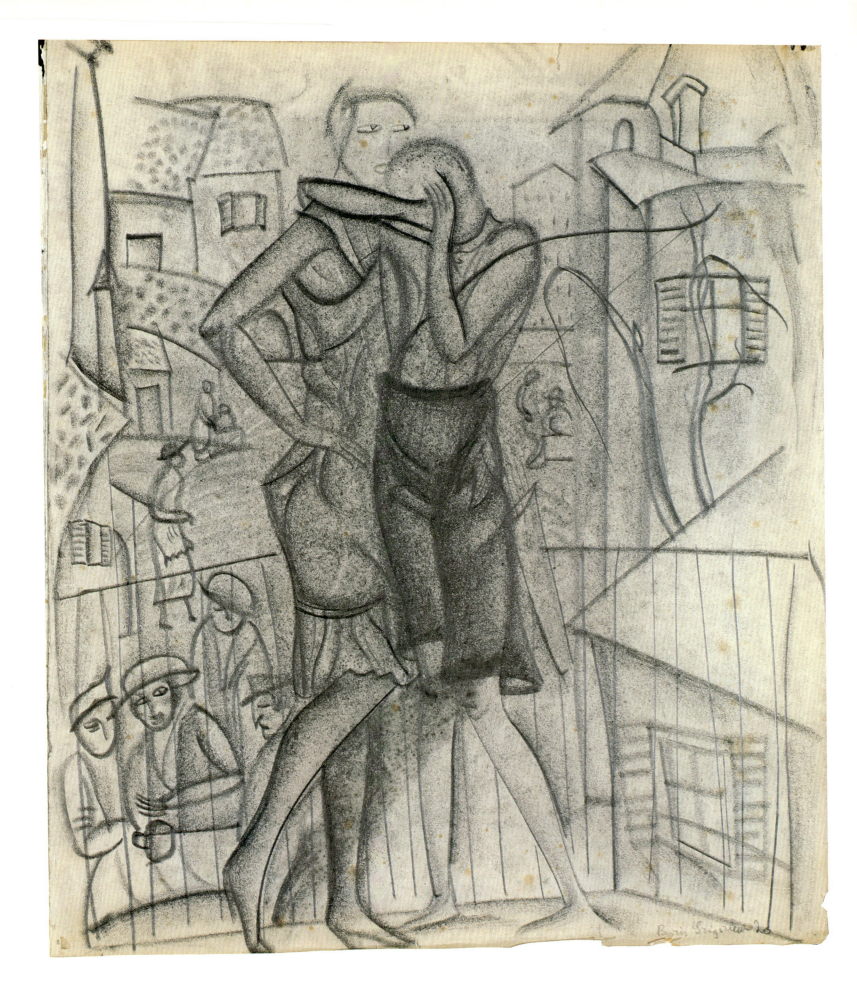

75

...

Гармонія душъ

Ему такъ больно: разлука снова;
Постылый поѣздъ, чужая даль...
Поцѣловались... Прощанья слова...
Кругомъ все чуждо, въ душѣ печаль

 Одно спасенье - скорѣй въ работу!
 Пройдутъ недѣли - и снова онъ,
 Вернувшись, броситъ свою заботу
 Опять безпеченъ, опять влюбленъ.

Ей такъ отрадно; кусочекъ воли,
Свободы призракъ... Ей такъ легко,
Какъ майскимъ утромъ ребенку въ полѣ,
Какъ рыбкѣ въ рѣчкѣ - онъ далеко.

 Пройдутъ недѣли - онъ возвратится;
 Опять безпеченъ, опять влюбленъ,
 Но тайнымъ страхомъ, въ душѣ струится
 Недавнихъ дней о счастьи сонъ...

 Сергѣй Яблоновскій

20/III 92

78

Солнце ясно свегрыло
На сугробъ городскомъ;
Съ королевой молодою
Итальянецъ повстрычалъ

—Я люблю тебя, красотка,—
Итальянецъ говоритъ
Королева закраснѣвшись
Итальянцу говоритъ:

„Я бъ желала быть Варварой
Итальянскою женой;
Я бъ играла на гитарѣ
Утромъ, вечеромъ, зарей.“

—Ахъ, Вы, люди городскіе
До чего жъ вы хороши!
Ваши очи голубыя
Людямъ скуки предносши...

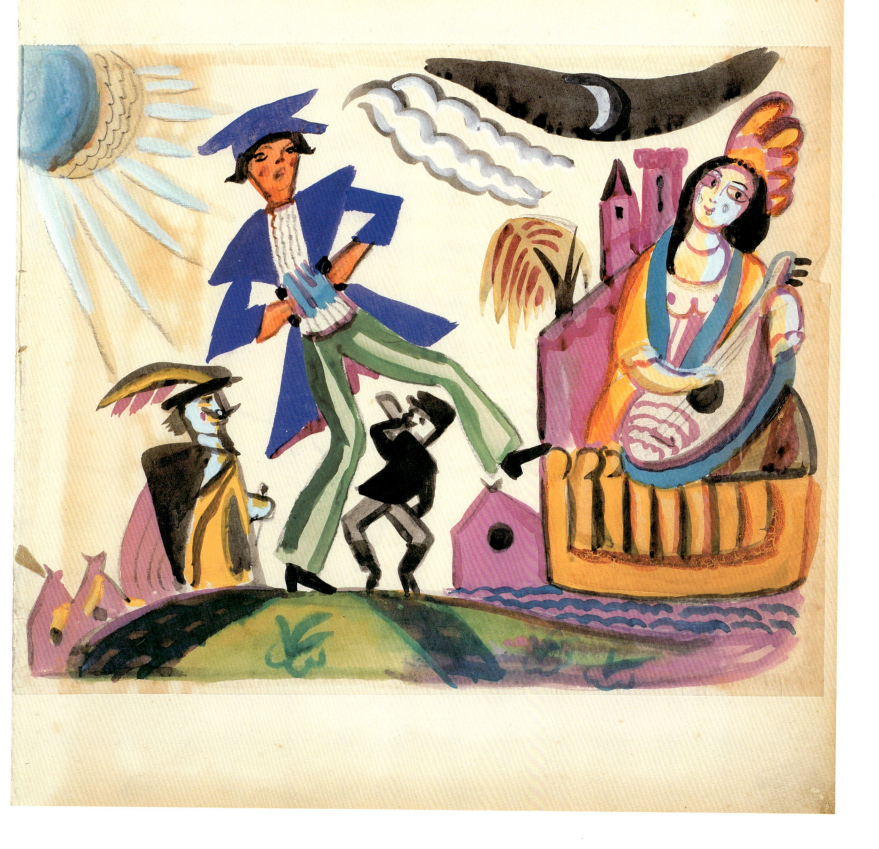

79a 79b

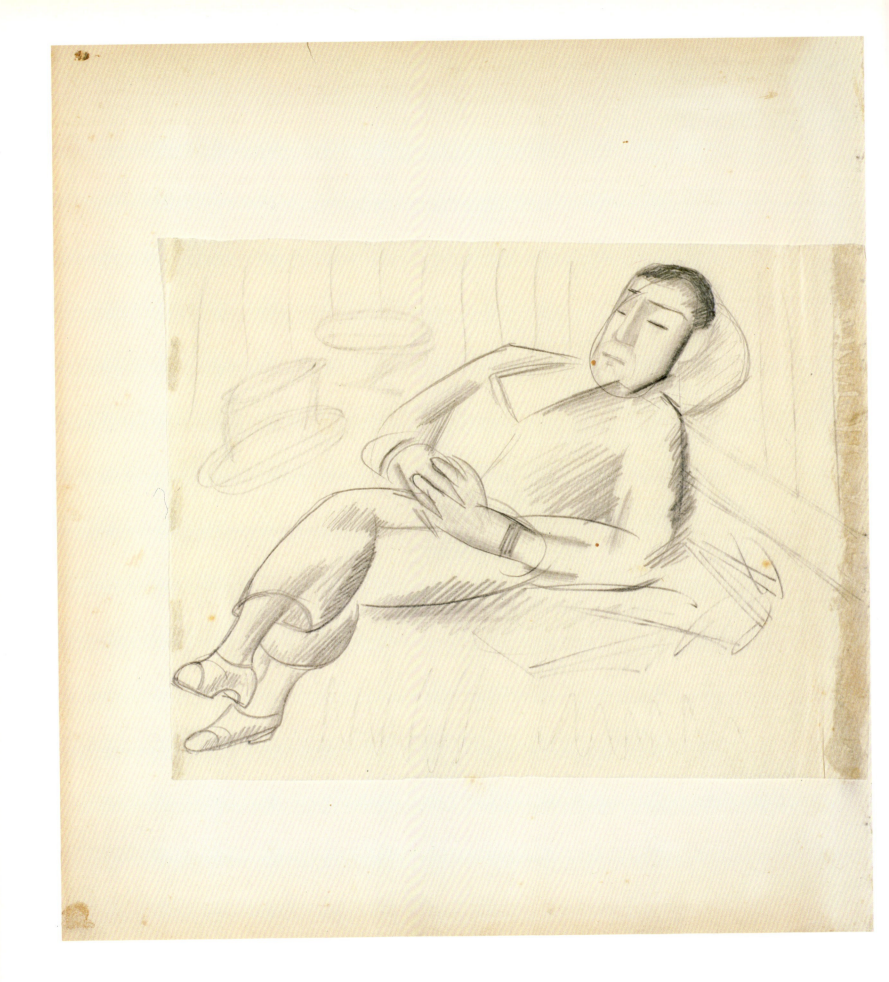

80

галота —

задержавшаяся адвоката кончилась
птичьей инстанцией в горе за зави-
танием мертвая ежада женщина...
и мертвая ежада женщина оживием
нал знаками занятыми у водораз-
долов рисунком обернулась ничанено
в воскресанье
 стала
 зданичем
 ежада мужчиной
 этой ежада

6/VII — 19

 Илья Зданевич
Виндавская 22

С. А. Сорину.

В снегу из парижских экранов
Мамонт мех и жемчуг
Сангина тусклых губ - легка
Хрусталь махровых глаз -
 Заману.

Спокойно, скальпель кисти
 светской
Безмерной силой вороожил,
Когда художник, нерв души
Открыл почтительно и дерзко.

 Татьяна. В. Июль

С. Судейкину

Идет к мечтающей соседке
Поэт в цилиндре и в плаще,
Но мадригал поет вотще
В тени подстриженной беседки.

Эрот боится бросить рану
В незашнурованный корсаж,
Где над брахманом Гарлатана
Кружочком вскинуты румяна
И в бровках ясен карандаш.

Бродя с каталогом в руках,
Мы ловим жизнь в музейных
 гнездах
И сладко плавают в глазах
Цветы в стеклянных парниках
И перепутанные звезды.
 Тат. Вем

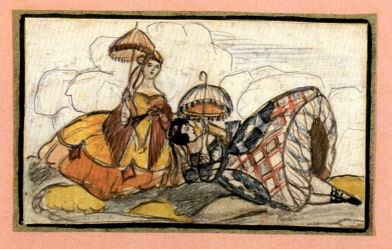

83a 83b 83c

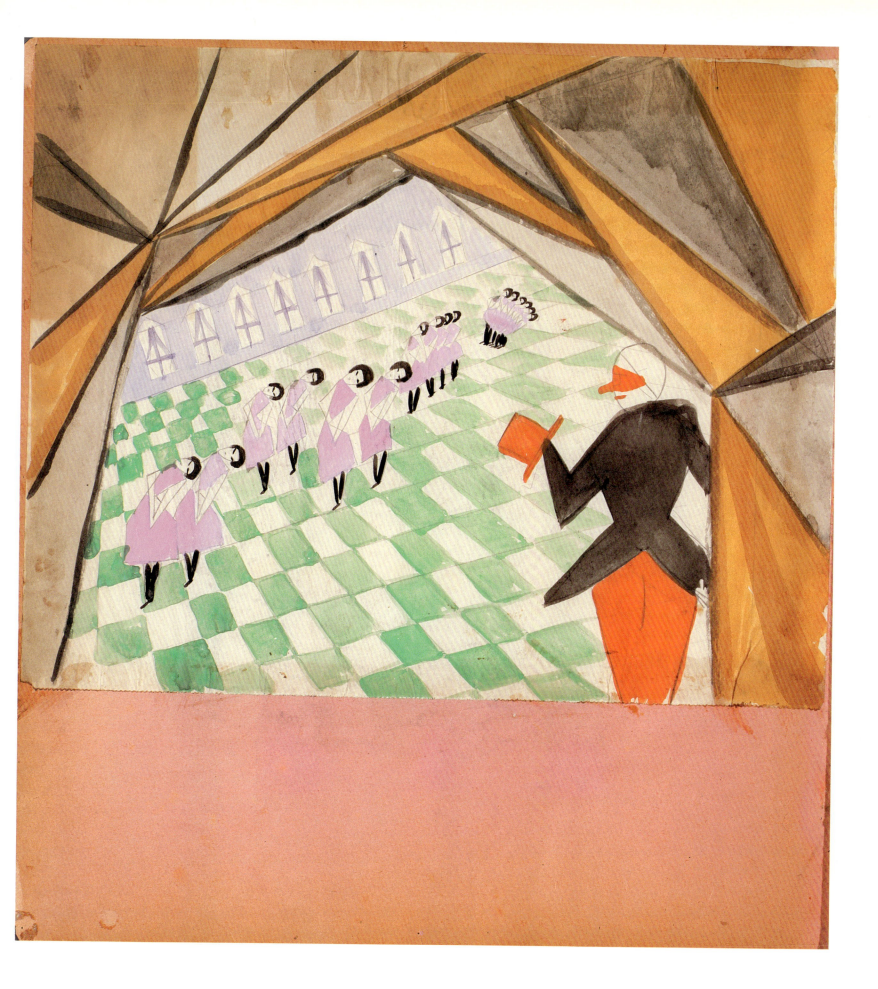

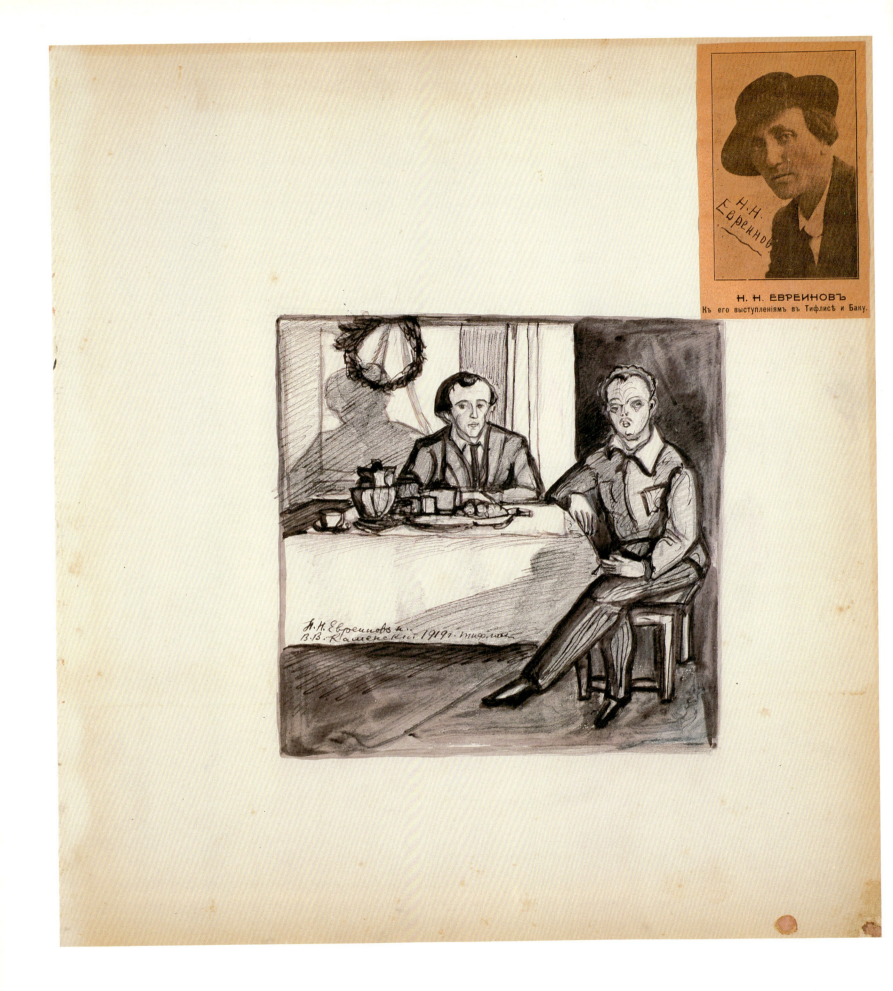

Н. Н.
Евреинов

Н. Н. ЕВРЕИНОВЪ
Къ его выступленiямъ въ Тифлисѣ и Баку.

85a 85b

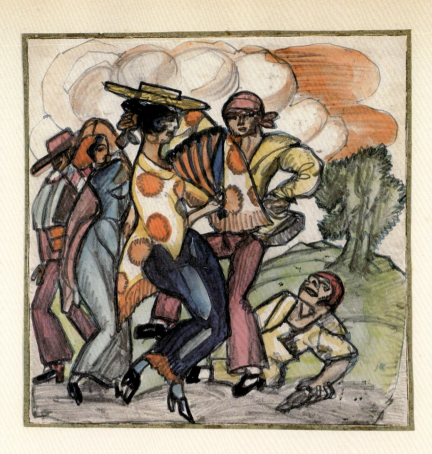

Блестящій кавалеръ танцуетъ с дамой вскользь —
Слюнявый фракъ и страшно бѣлы лица
Сквозь тонкій дымъ англійскихъ папиросъ
Вы тянетесь ко мнѣ чуть-чуть не бормоча.
Вашъ длинный взглядъ отъ сладости ласкается
Живетъ душа, страдаетъ каждый нервъ
Лѣтъ в сторону любовь, и сердце, и Бодлеръ,
И вы, развратная и юная дѣвица!

Василій Каменскій

15 сентября
1919
Тифлис.

Вѣрѣ Артуровнѣ
Судейкиной.

И крѣпкій чай, и красное вино,
И вишній садъ, и черный обликъ смерти
Я знаю испытать мнѣ суждено
И счастье вскрыть в сиреньевомъ конвертѣ.

Мнѣ всё равно, откуда вѣтеръ дуетъ
Съ армянскаго холма иль съ сѣверной Невы,
Но почему сейчасъ мнѣ сердце такъ волнуетъ
Дѣвичье поле дѣвичьей Москвы.

17/30 сентября
1919
Тифлисъ

Василій Каменскій

89

Дѣтство

отрывки

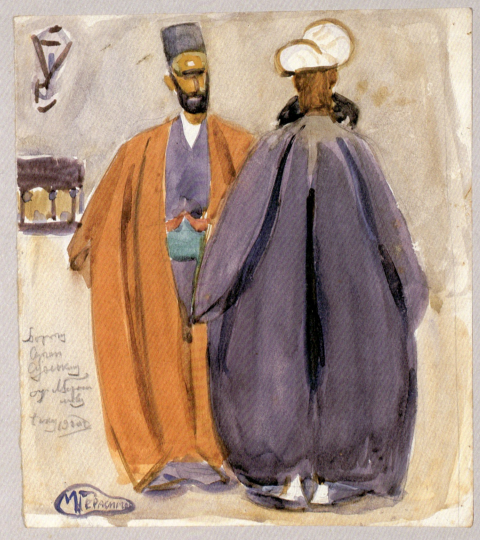

90a 90b

рода дьявольскими бури,
накинув бурку и башлык;
Следилъ какъ шумно галопируя,
Шитый барашковый башлык.

А за дуганомъ нашимъ, в ночи
Въ сверхъ неверной выстрела щелкали,
Какъ паруса надувши щеки
В дуду дудли зурначи...

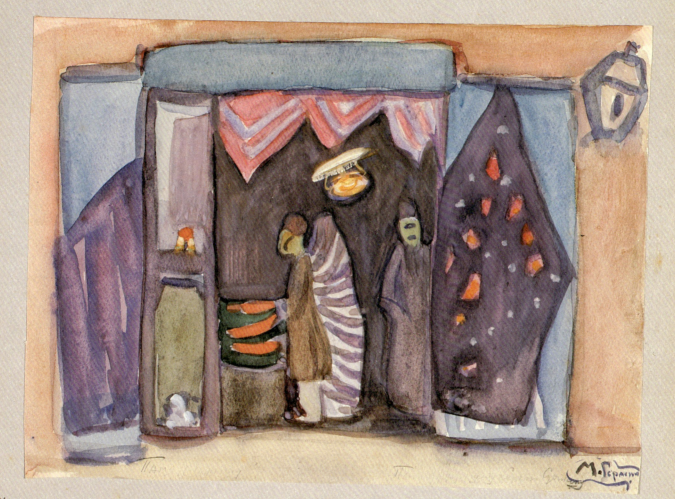

Я уходилъ, а вихрь хлопалъ,
И рвалъ дукапъ, и землю кренилъ,
На карабахскаго коня
Я вскакивалъ и галопомъ
Не зналъ самъ куда скакалъ.

И звонкій звенела скалы,
И в темной ночи лошадь вотъ
Прелестный брала и ржала,
И подо подковами дрожало
И гнулась гулкая шоссе...

Парижъ
1921
6 Разу Георгій Вакуличъ

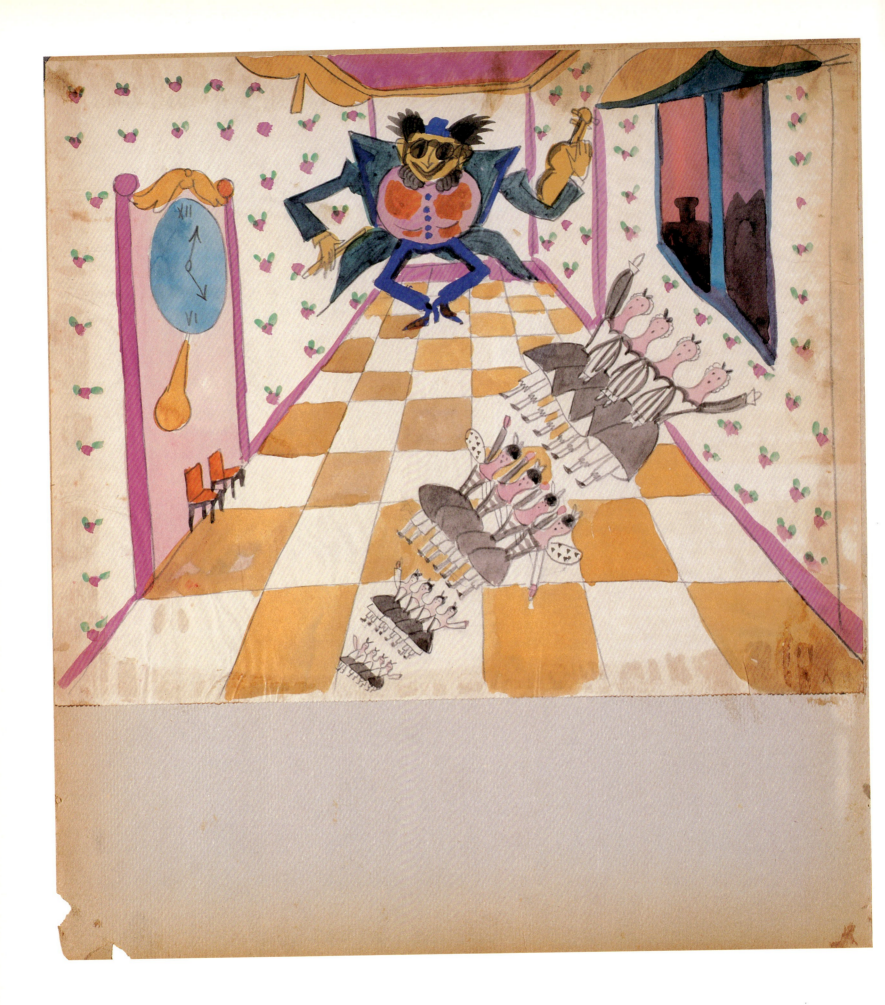

92

Смущенною душой взираю на полотна
И звуки мощные вздымаются волной
И чую: притаясь за темною листвой
Духъ Шумана присутствуетъ безплотно.

А тамъ — гляди! — широко и вольготно
Москва на Масляной разгулъ справляетъ свой
Разбрызгалъ воздухъ иглы острыхъ хвой
И мнѣ отъ нихъ морозно и щекотно.

Живыхъ полотенъ пышный карнавалъ,
Живая радость стилемъ и столпотьѣ
Взрываютъ будни праздникомъ соцвѣтой.

Несется красокъ солнечный обвалъ
И мечутся, кружась въ безумной пляскѣ,
Какъ взрывъ ракетъ волнующихъ краски!...

С. Сафаровъ

Баку, 7-III-20.

Дорогимъ сосѣдямъ
В. А и С. Ю. Судейкинымъ.

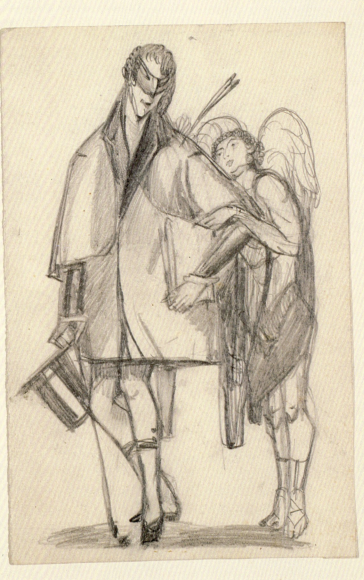

Въ кафе.

95a 95b 95c

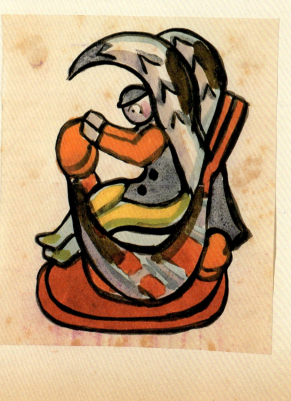

Петербург.

О, как мне горестно, мой город некрасивой
Мой Петр, мой Петр — я будто на чужбине
Сквозь здешний Кремль я вижу и над Невой
Плывет дымок чуть розовый, чуть синий

Я слышу сосен скрип. Сосна к сосне
Склоняется. О, время, о Движенье
Гранитный шум я слышу как во сне
И мудрых волн спокойное теченье

Мой Петр, мой Петр, верни, верни
Верни мой дом, верни мне наслажденье
Люби мои мучительные дни
Люби мои мучительное движенье
 1918, Москва

14 сент, 19. Тифлис.

В. Я. С.
Смотри на нас, Россия вспоминает
И волна Двины с волнами Невы
Под куполом ~~Кремля~~ Москвы
В аду любовь соединяет
И по глазам любви читая:
Степь. Шелест волны и травы
Наших судеб голова.
И Тверь Рим — как праздник Мая
 28 сент Тифлис

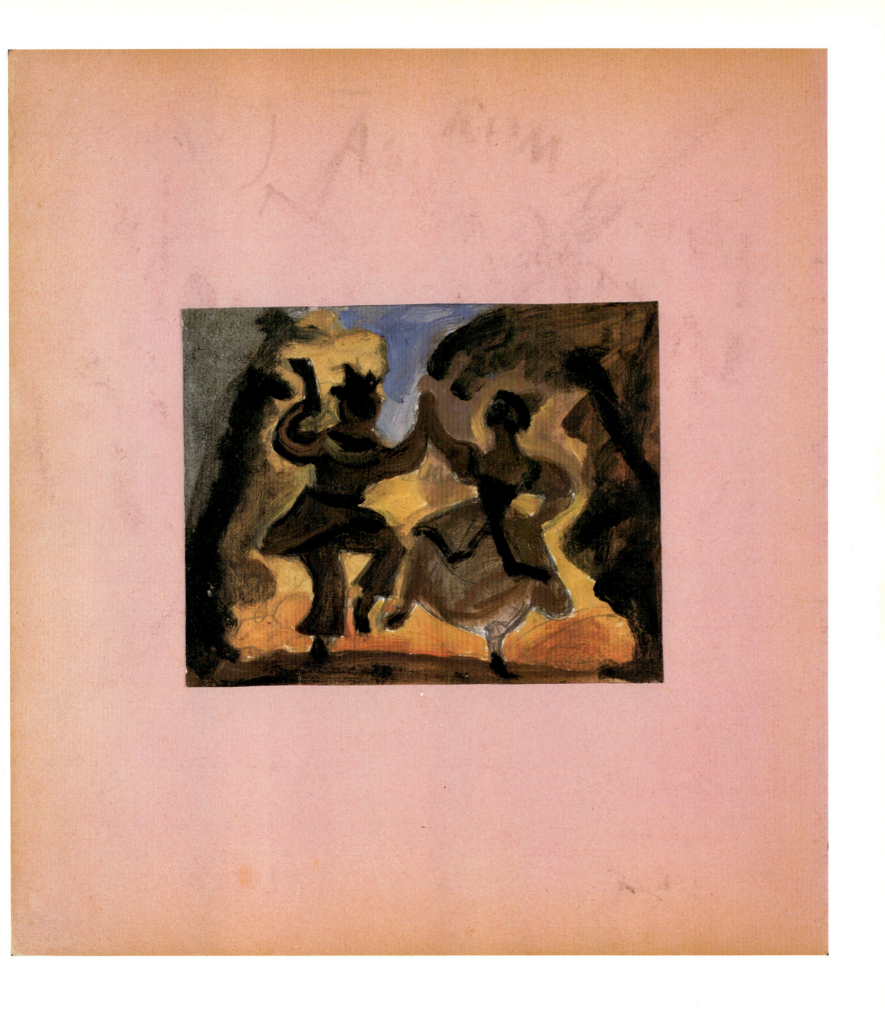

Поэзія моя

изъ ти скина оть

блянки

Ромул и рем
сосали

у форменной

Созда крутер дигон
Слово из в срж ж ж ва
не бида
не таба
я ногах
нагахааха → готово!

теренбевъ

Сссссс Суб
ССу ей
Суд кин
Судей
Судейки
Судейкин

(!)
(Сіу)ико (дьяк)
 (грамотей)
 (фарфоровая посуда)

99

100a 100b 100c

17 сентября 1919 г.

Въ исканьяхъ твари къ подбородку
Тянусь, прищуривъ лѣвый глазъ,
И разноцвѣтную бородку
Кажну и думаю о Васъ:

Въ узоръ сдвинутыхъ запястій,
Опершись на руку щекой,
Отъ утомительныхъ ненастій
Найти незлобивый покой.

Г. А. Харазъ

17/30. IX. 191?
Тифлис.

Вере Судейкиной

Приходят к нам из дали синих
Невиданные существа,
Чтоб с нами на земных равнинах
Земные говорить слова,

Чтоб воплотиться в наших буднях
И каждый день, и каждый час,
В заботах мелочных и трудных,
Любить и мыслить подле нас.

Но ты прошла, землерожденна,
Привычной, медленной стопой,
По тверди, грузно-отягченной,
На встречу бездны голубой;

И ярким пламенем объята,
Нежданно в сказку ты вошла
Видением мечты крылатой,
С венцом бессмертья вкруг чела.

Сергей Рафалович

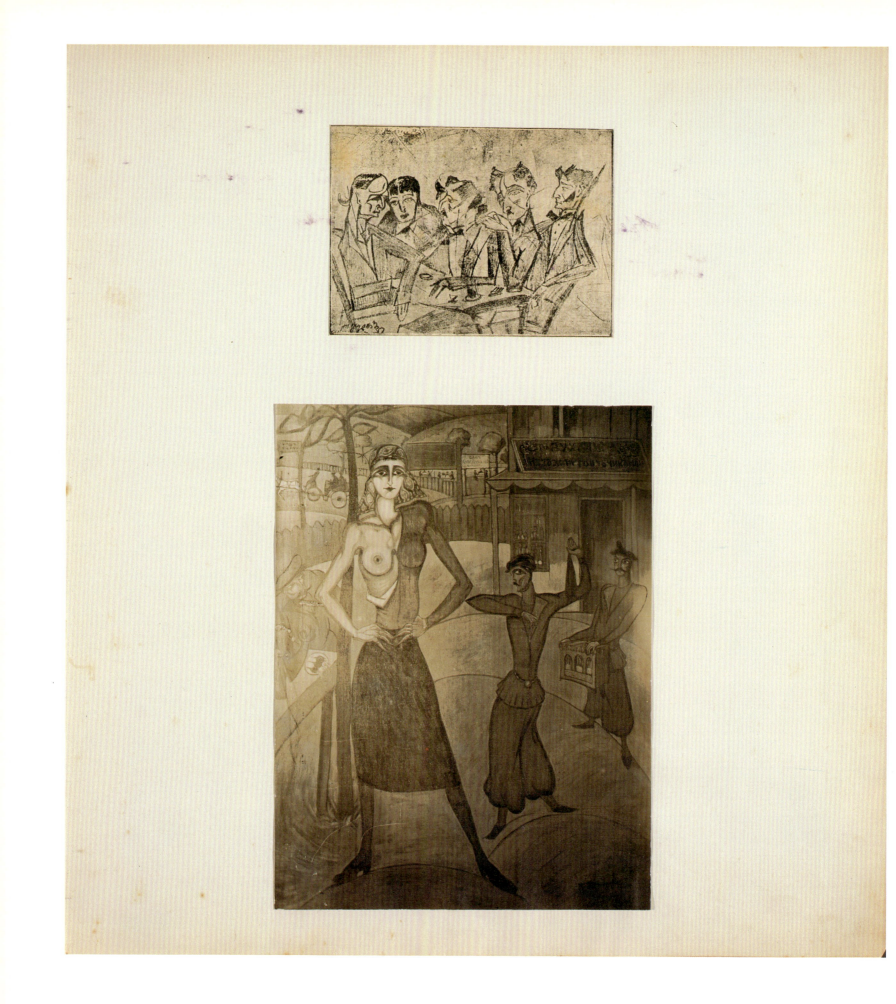

103a 103b

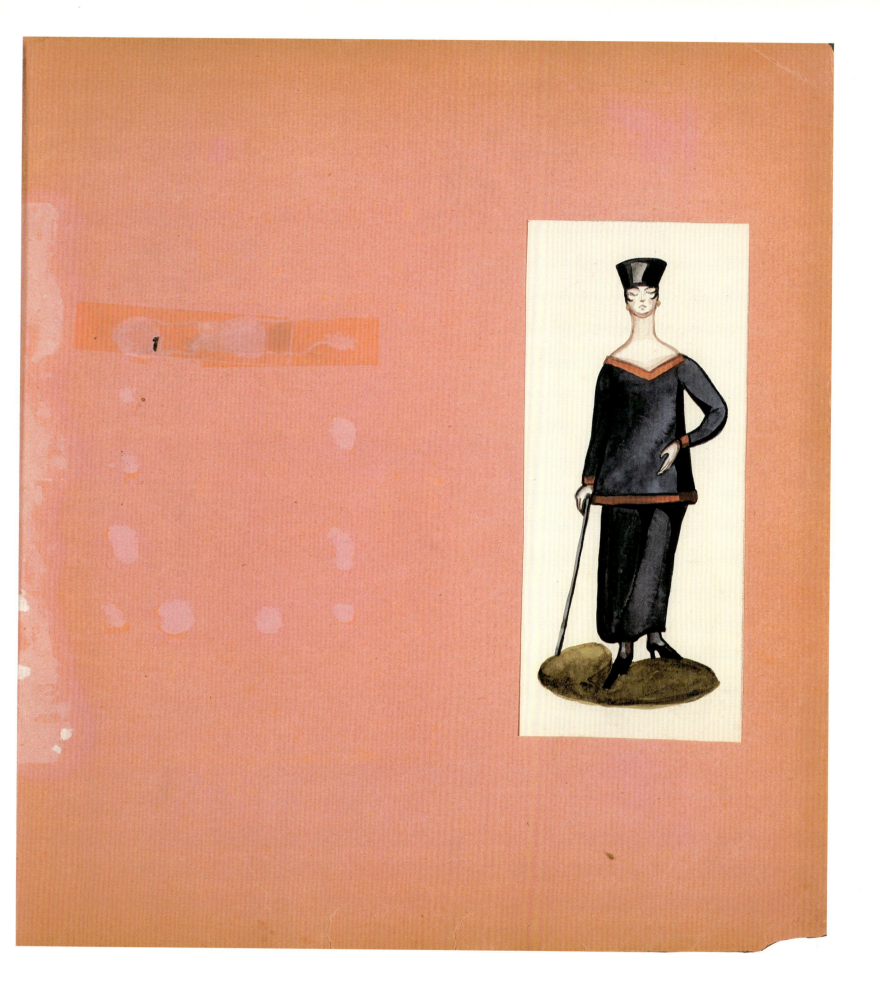

Кофе.

Тебя сбирала девушка нагой
По зарослям благоуханной Явы.
Как ящерицу, дико обжигал,
Ей кожу сделал рыжей луч кудрявый.

Замучена полуденной работой,
К любовнику, такому же нагому,
Она бежала в лунное болото
К сплетенному из веющих прутьев дому.

И там кричали, радуясь, как дети,
Что труд прошел, а ночь еще продлится,
Показывая на жемчужном свете
Блестящие от дымной ласки лица.

С утра голландец с ременною плеткой,
У пристани следил за упаковкой,
Клейменых ящиков и кровью кроткой
Окрашивал тугую плеть ловко.

Потом с валов могучих океана
Корабль срезал гниющую пену,
Пока в каюте мягкой капитана
Купцы высчитывали вес и цену

До пристани, закутанной в туманы,
Томились, гордо засыхая, зерна.
А там, на Яве, радости и раны
У девушки слетались, рыже-черной.

Вот отчего, когда кипит в фарфоре
С отливом золотистым черный кофе,
В мозгу встает желаний дробных море,
Душа тоскует вдруг по катастрофе.

Взорвать Европу! Спеть о дикарской воле
Бесстыдство злое купли и продажи.
Плетей не надо для увитых магнолий,
Не надо солнцу океана стражи.

Отмстить за блаженство битв решенных!
Пусть гавани в туманах ждут кровавый,
Чтоб можно было для наших влюбленных
Свободу ликовать в болотах Явы!

Сергей Городецкий.

Баку. 13.XII.1919

106

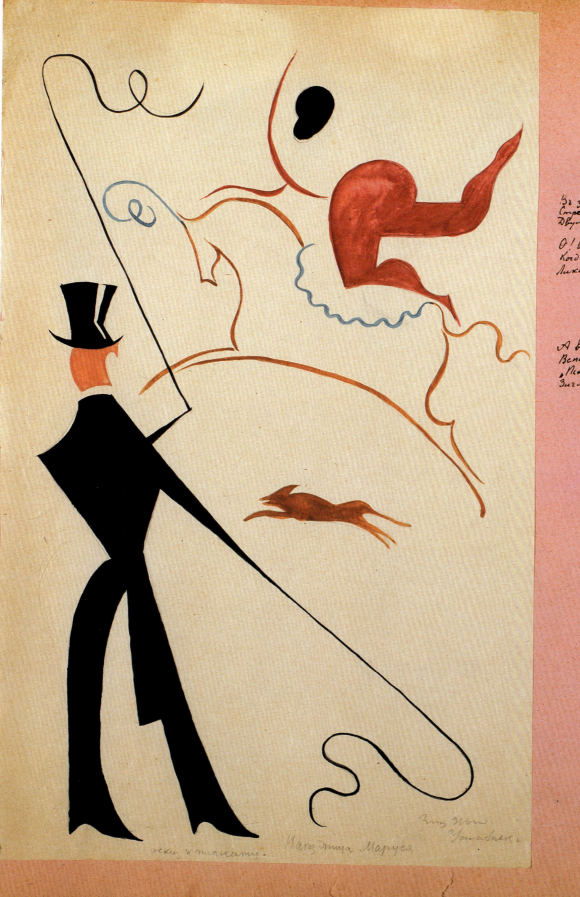

Рисунокъ.

Въ зигзагахъ линій цирковой огонь
Стремился впередъ турнирный шаришковъ,
Двумя ногами сей барейтеръ ръзкій.

О! всякій зритель цирку будетъ радъ,
Когда взлетишь ты къ куполу повыше
Лихой наъздницы клубничный задъ.

Собственникамъ
альбома.
Приписка.

А вы, причина сколькихъ вдохновеній
Вспомянуешь о юрій Дегенъ?
Психометрическую кипидель
Зигмунда пылкаго запомнише ль?

Тифл. 1919 г.
Тиль

рис. Л. М. Браиловскаго.

Поэтъ Косьма Петровичъ Прутковъ на прогулкѣ.

Косьма Петровичъ на прогулкѣ
Въ цилиндрѣ, въ клѣтчатыхъ штанахъ
Увидѣлъ даму, словно булку,
Забылъ жену, промолвилъ: ахъ!

Но стихъ мужа суровымъ словомъ
Любовный пылъ пресѣкъ усилья
И понялъ духъ поэзіи въ новомъ,
Но въ старомъ нашъ земной удѣлъ.

Мораль отсюда вытекаетъ одна:
Поэту доступна лишь жена.

По заказу С. Ю. исполнилъ Куз. Делемъ

Судейкину
Забвен бенши—
белница брез.

Под шопот ночи щуриный Карнавал.
В рампах рдяном пар весенний...
Перо, согнувшись тихо прорыдал.
Считала Смерть поблёкло тени.

Раздался хохот хриплый мертвецов...
Проплыли тени мёртвой вереницей.
Дерзали путь в Край Отцов
Из Царства Снов хмельных птицей.

Развеют вихри скорбь времён...
Так жизни пир окончен будет.
Воздвигнув всем смешливый трон
Одна лишь Смерть во мгле пребудет.

Я осёдлал коня стремянного
И закрыли стихийной тьк,
Взлетев на силговей Казбек
Восславил волю безымянного
Рождённый яростью тирановой
Из недр дышущей Земли...
Мы путь означивый пыли
Весельем Вакха щедро-пьяного.
Одни живёт жизнью маленей
Мастерт огненных мечтой...
Безумец, варвар и свётб
Под шум Диониса воскреснут.

А. Файнбр

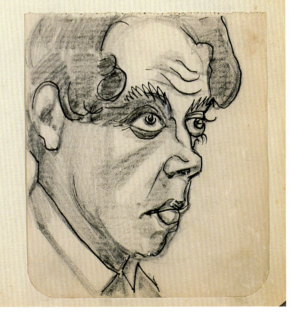

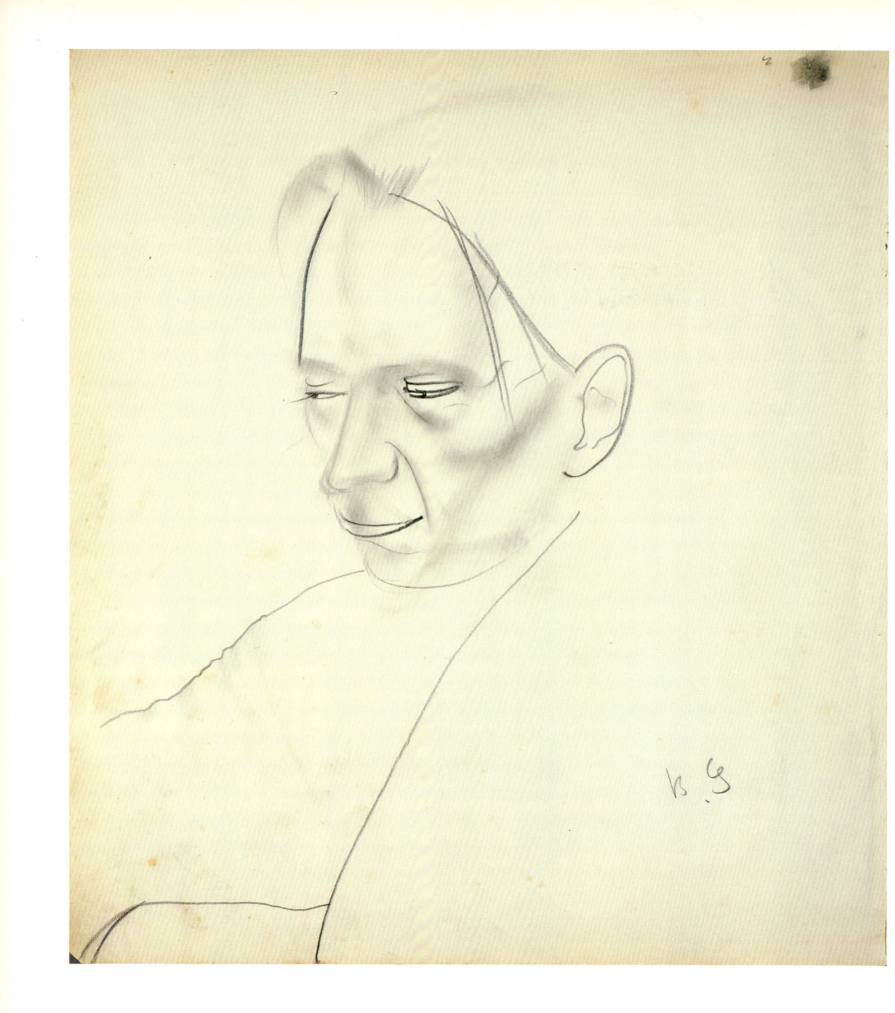

110

В разноголосице девическаго хора
Всѣ церкви нѣжныя поютъ на
 голосъ свой,
И въ дугахъ каменныхъ Успенскаго собора
Мнѣ брови чудятся высокiя, дугой!

И съ укрѣпленнаго архангелами вала
Я городъ озиралъ на чудной высотѣ.
Въ стѣнахъ акрополя печаль меня
 снѣдала
По русскомъ имени и русской красотѣ.

Не диво ль дивное, что вертоградъ
 намъ снился
Гдѣ рѣютъ голуба въ горячей синевѣ,
Что православные крюки поетъ
 черница:
Успенье нѣжное, Флоренцiя въ Москвѣ!

И пятиглавые московскiе соборы
Съ ихъ итальянскою и русскою душой
Напоминаютъ мнѣ явленiе Авроры
Но съ ея русскимъ именемъ и въ
 шубкѣ мѣховой!

 О. Мандельштамъ.
 9 августа 1916 г.
 Профессорскiй Уголокъ —
 Алушта.

Прощанiе.

 пер. О. Мандельштамъ.

Когда я свалюсь умирать под забором в какой-нибудь яме
И некуда будет душе уйти от чугунного хлада —
Я вежливо, тихо уйду. Незаметно смешаюсь с тенями
И собаки меня пожалеют, целуя под ветхой оградой.

Не будет процессии. Меня не украсят фиалки
И девы цветов не рассыплют над черной могилой.
Порядочных кляч не найдут для моего катафалка.
Кой как повезут меня одра, шагая уныло.

И кто допустит мои рубцы, нарывы и парши,
Туда, где сословны мечты ограниченного строя.
Кто честно спасающих душ откроет мой рай патриарший.
Друзья, даруйте прощенье, согрешившему много.

Поражена каждая клетка моя. Грехами гоним я.
И кровь моя пошатнулась от примеси гноя.
И доброе имя отцов. Заклеймаешь квадратное имя
В потоках погрязло — не ведая больше покоя.

Мне ли плечистым крестьянам нести ярмо родовое.
Добрую кровь отцов превратил я в уксус и землю.
Сам догорел, как лучина в медлительном зное.
В сновиденьях земли — я черний кошмар — не веселье.

Недопитые мысли мои сгорают в смятенье заката.
Чудовищных мыслей голос хочу я докончить напрасно.
Нет у меня никого — ни друга, ни кровного брата.
Хотя бы оружник какой ударил меня вероломно.

И ныне я — мертвый, босой, высохшим телом немея
Должен висеть — дождями бестолковым ветром стряхаем.
На перепутье миров в высокой сушилне чернея
И богов проклинать хриплым, иссохшим ласом.

 ✕ Николло Мицишвили

Париж. Лето.
923

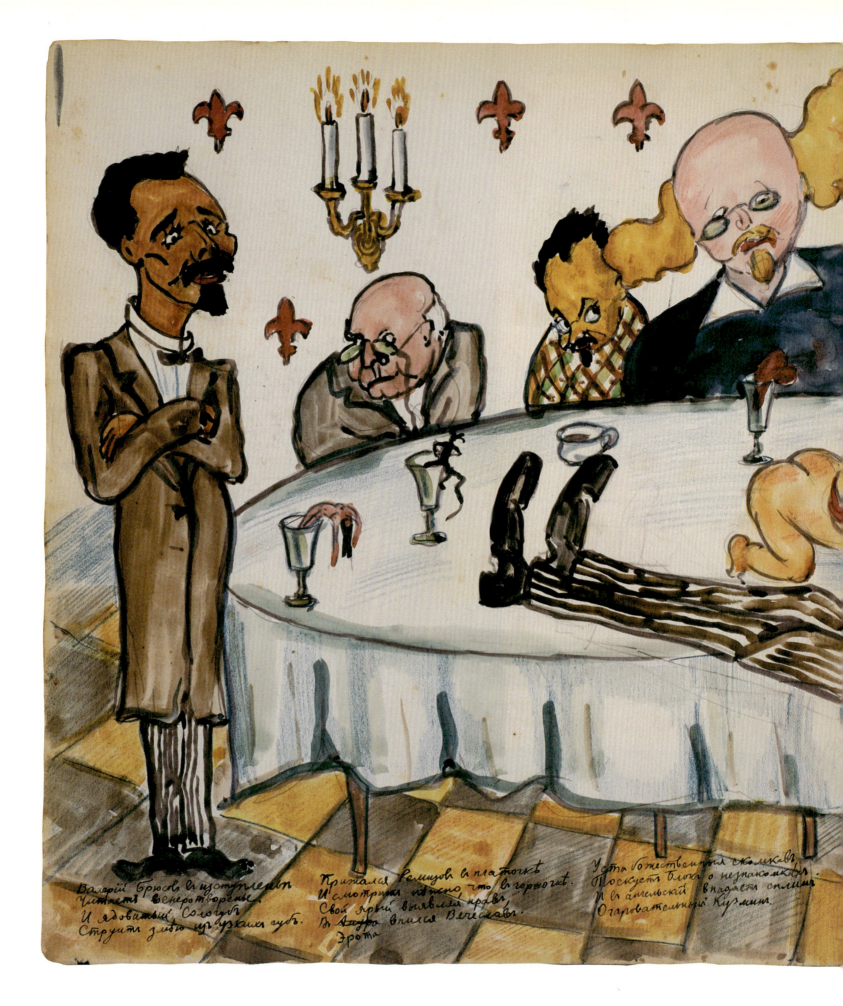

Валерій Брюсовъ в'ыступленіи
Читаетъ венеротворены.
И ядовитый Сологубъ
Струитъ злобу из'узкихъ губъ.

Прижалъ Ремизовъ и платочекъ
И смотритъ пристально, что в'горшокъ.
Свой ярый выявляя нравъ,
В'Амуро впился Вечеславъ.
Эрота

Уста божественныя смыкая,
Проскусить блохи о незнакомках.
И в'апельскiй впадаетъ сплинъ
Очаровательный Кузминъ.

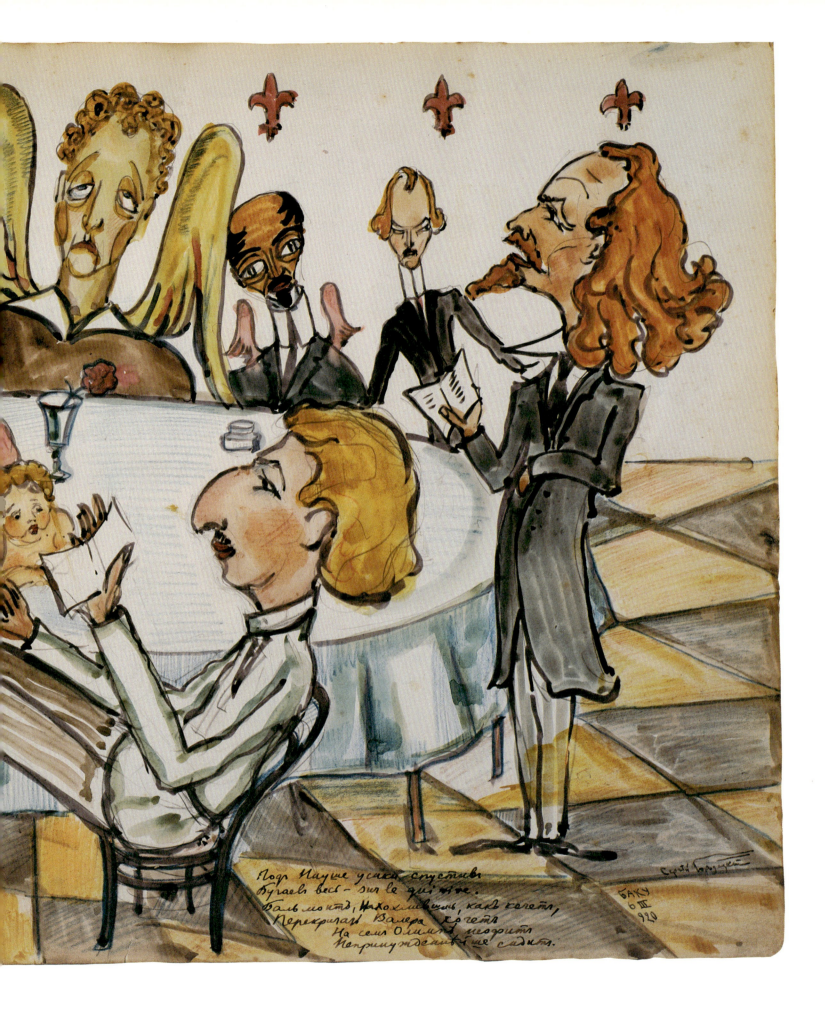

Под Музе усики спустивъ
Бугаевъ весь – sur le qui vive.
Бальмонтъ, Нахохлившись, какъ кочетъ,
Перекричать Валера хочетъ
На семь Олимпѣ неофитъ
Непринужденнѣе сидитъ.

БАКУ
6 III
920

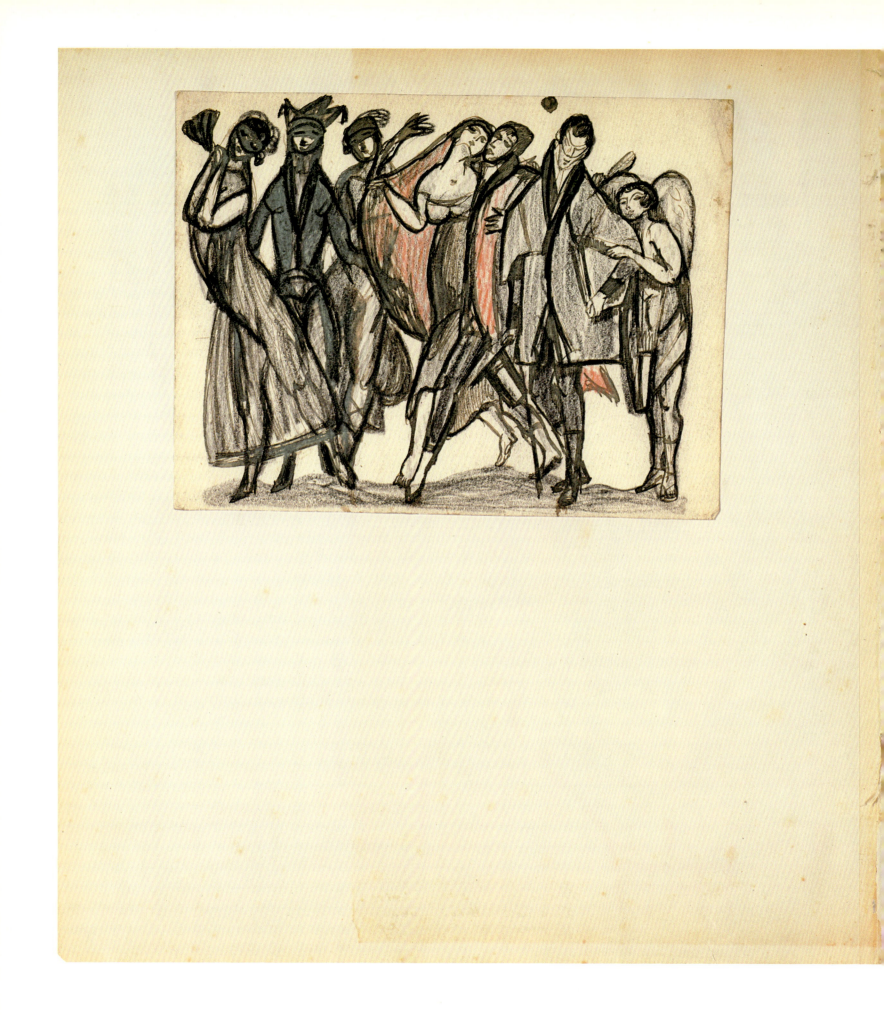

114

С. Ю. Судейкину.

Несутся маски въ бурной пляскѣ.
Смѣшались всѣ: Пьеро, берётъ,
А рядомъ высохшій скелетъ
Глядитъ гладкой точно въ сказкѣ.

 Лучами утра пробужденный
 Встаетъ лѣниво Аполлонъ.
 Опять раздался лиры звонъ,
 Онъ снова музами плѣненный.

И подъ могучею рукою
Ожила сразу Тѣнь Психеи
Красивѣй, тоньше и нѣжнѣй,
Чѣмъ подъ рукою вѣковою.

 Но все пересказать нѣтъ силы...
 Тутъ — сладострастія порывъ,
 Тамъ — торжествующій призывъ,
 А рядомъ — пѣсенка могилы.

Да, ты воистину художникъ!
И не затушитъ буря твой огонь
И не смѣтетъ, какъ дикій конь
Въ дорогѣ топчетъ подорожникъ!..

 Александръ Лебуа.

 7 Марта 1920 г.

 Баку.

Гекзаметръ унылый

Трижды убирался поэтъ, уныло считая ступени.
Сладкой надеждой томимъ, трижды у входа стоялъ.
Трижды къ художнику въ дверь стучался, руки не жалѣя.
Трижды отвѣтомъ ему злая была пустота.
 М. Струве 29/Ⅰ 20
 Парижъ, какое то кафе около Вокз.

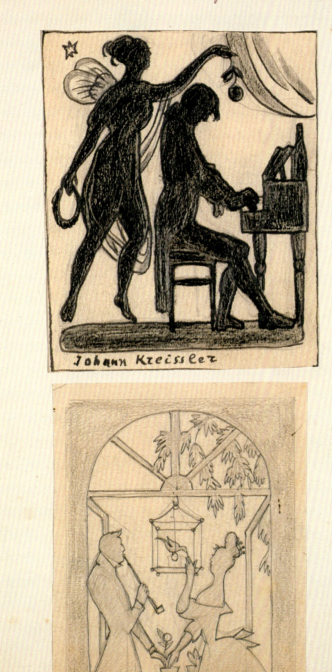

Johann Kreissler

116a 116b

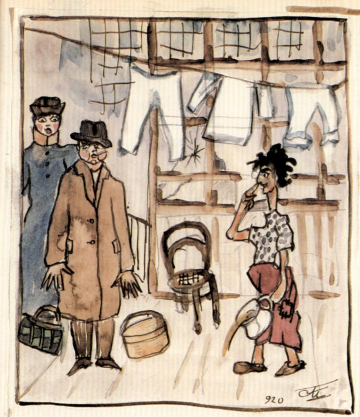

Ночь отъезда.

Полки свернуты. Осталось
Ихъ еще пересчитать.
Сколько будетъ — ахъ, усталость! —
Двадцать пять да двадцать пять?

Боны липнутъ, словно медомъ
Ихъ намазалъ Нассибъ-бекъ.
Не бейка, а всѣмъ народомъ
Не сочтешь ихъ въ цѣлый вѣкъ.

Только сложишь — снова спуталъ!
И считай сначала ихъ!
Оху пришлось бресть круто
Двѣсти тысячъ трудовыхъ!

С.

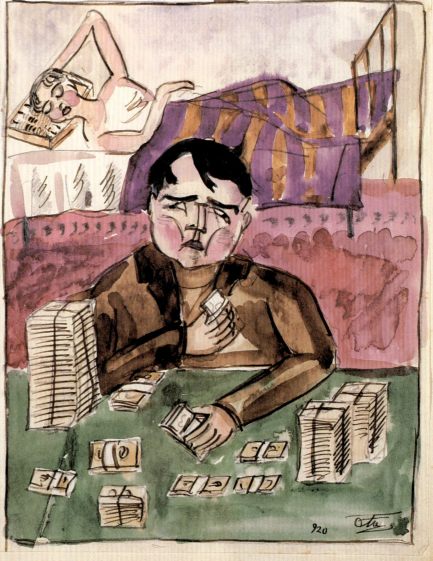

День прiъзда.

Какъ прiъхали супруги
Изъ Тифлиса въ Баку.
Отъ хоромъ своихъ въ испугъ,
Взд̇ли брови къ потолку.

Съ подобающимъ почетомъ
Ихъ встрѣчаетъ Шумашикъ.
Весь облитъ холоднымъ потомъ,
Зурейскихъ въ носовъ поникъ.

Сѣдломъ, брякаеть, стуля тревогой
Въ честь туристовъ реверансъ.
Игра думаетъ въ тревогѣ!
Гдѣ мы раскладывать пасьянсъ?

С.

Баку. 1920. 12-III.

117a 117b 117c 117d

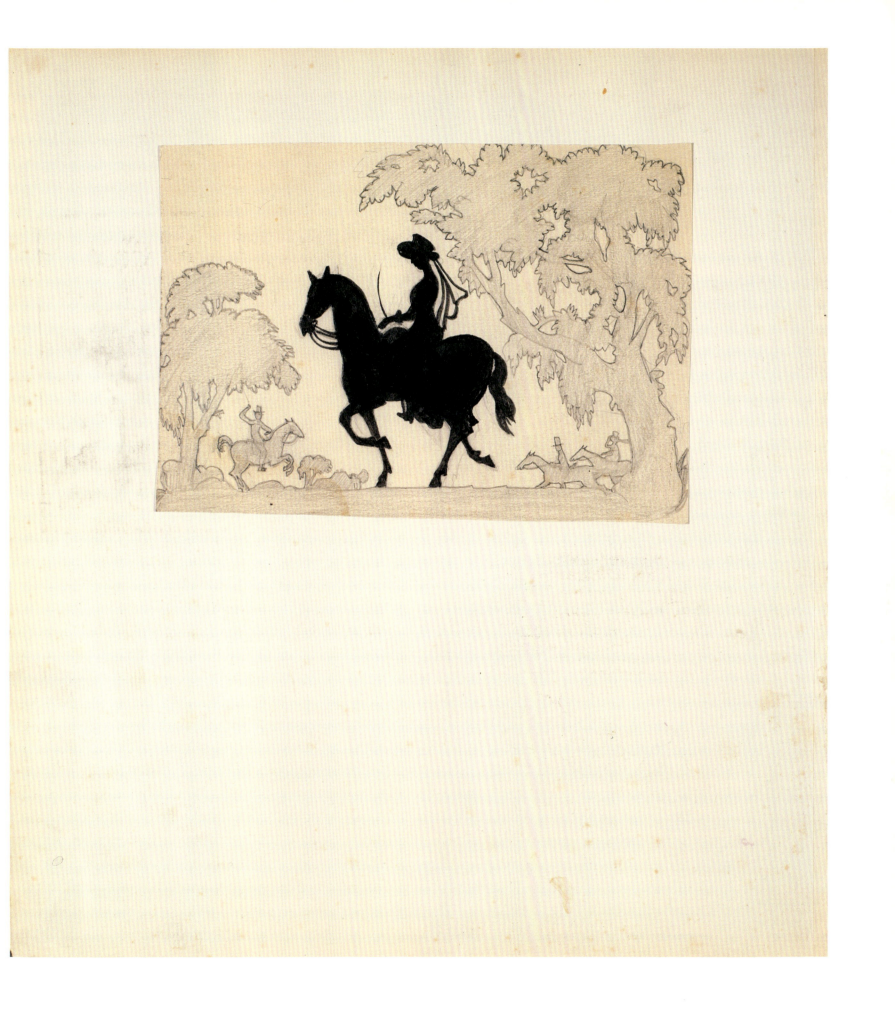

Наполеон Бонапарт

119

Собину

Портрет княжны грузинской Дадиани
Неробкий лик часовенных Мадонн.
Минейных дум прозрачный сон.
Тропа небесная божественных скитаний...

Чуть движимый шелест бархатных ресниц,
Скользящий луч молитвенных очей,
Земной поэт упал бессловный ниц,
Полнейший тайной глаз невинных Дадиани.

А. Рейтберг

Судейкину

Мгновенье душу раскололо,
Когда искал я жадных уст...
Провалы мысли стерегут
Безумца дикого раскола

В бреду веков за мира грани,
Поставив жертвенник Христа,
Рыдал безумец у креста,
Все беря земные раны.

Настал конец пути земному,
Кровавых лун забылся мак.
Испил до дна земли клоак.
Конец вселенскому Содому.

А. Рейтберг

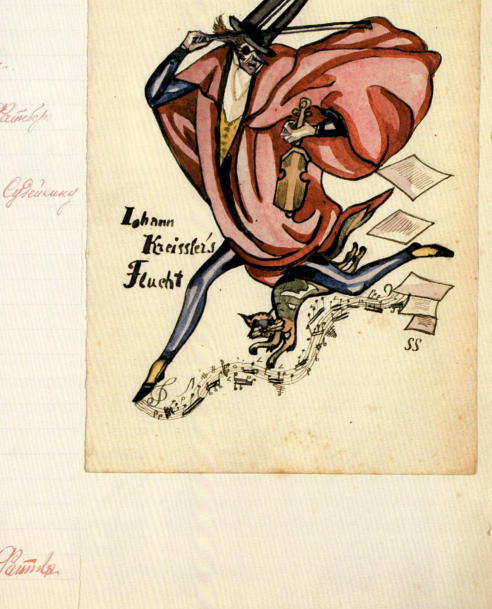

Johann Kreissler's Flucht

SS

Советская провинция
(1919)

Акация у дома
Не дом, а синев алкий
В нем гляди как скалы
Мои четыре тома.

Окошечко раскрыто
Белей азурной юбки,
Так раскрытых губки
Девушки непсихиот.

Девушке наспь что-то
Ввит на ленты косы —
Синтлив, курнос —
По тиши как котт.

мширкой по канаве,
С горки как сороки
Дишь знаной сроки
Сладко-усурей Яви.

Портфель у просто фили
Дымов впрои
Барвину с пол-мили
Сиктуют по усорой ивли
Все в наги крудщиной.

Брамить машер цико:
"Сто увликов окун —
Ю узкой передуал
в меиду глодок коил.

Забить обрд снегол
Лавок и трактира —
Ловки красной сотол,
Увашен под сартори!

Порота на засоль
Труден бубен деле
О трого таги
Пронала в рабосел.
Телеграфной и пот
Своц ттс не нукаша
И быль едиой стаи
преасного стаи красне
маша оттдут проб.—

Б. П.

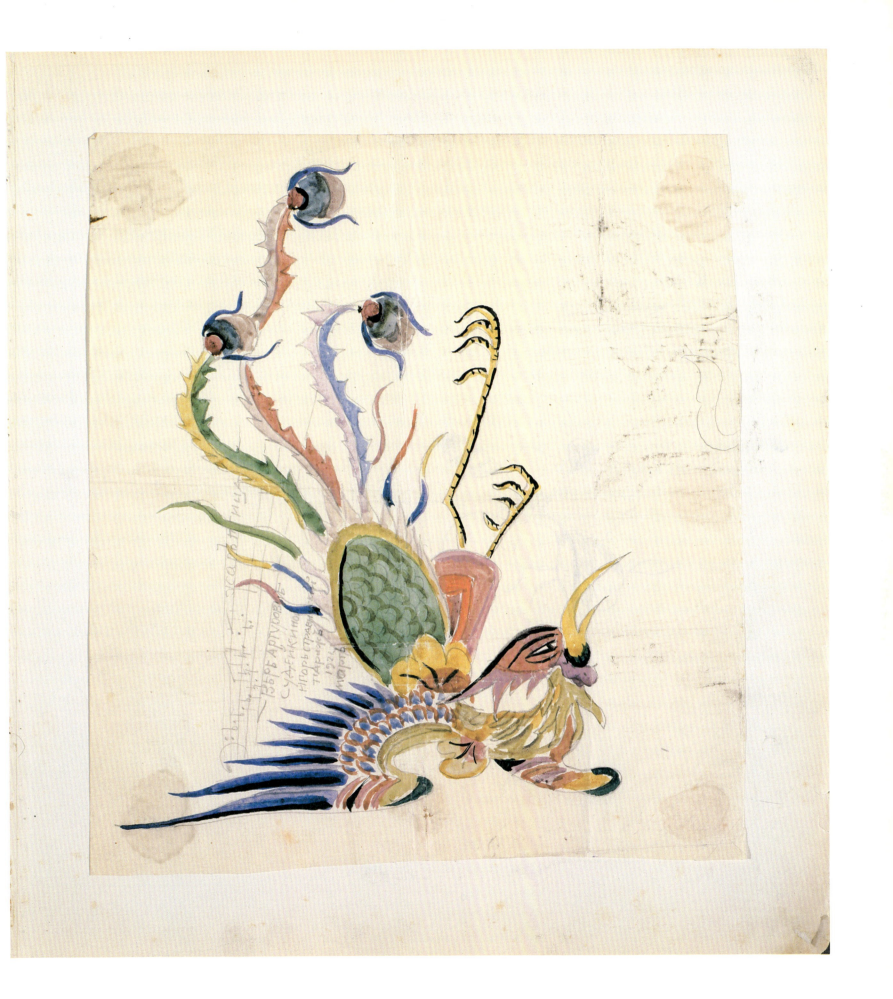

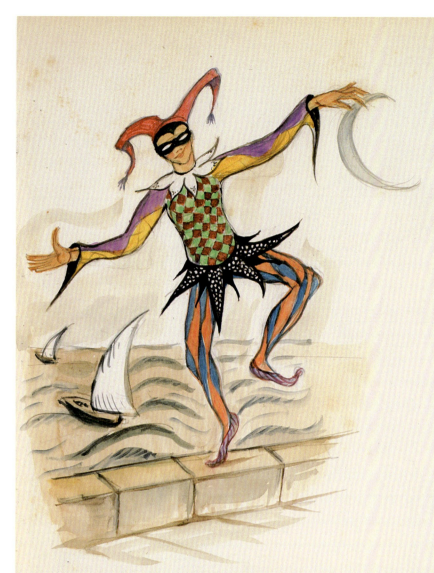

Гимнъ ночного театра в Баку
«Весёлый Арлекинъ».

Я в Италіи родился,
Тамъ, гдѣ спѣетъ виноградъ.
Я под солнцемъ появился
Лѣтъ пятьсотъ тому назадъ.

Люди не были угрюмы,
Юной вѣрили весны.
И рядились всѣ в костюмы
Вотъ такіе ж, какъ на мнѣ.

Лѣтъ пятьсотъ я душу грѣю,
Съ глупой скукою борюсь.
Оттого и не старѣю,
Что не хмурюсь и не злюсь.

И даю совѣтъ вамъ, люди,
Будьте веселы, какъ я:
Ѣшьте то, что есть на блюдѣ,
Отучитесь отъ нытья.

Пусть пустые пароходы
Взяты в Лондонъ хмурый сплинъ.
Будьте веселы, народы,
Какъ Весёлый Арлекинъ.

Много я бродилъ по свѣту,
То богатъ, то безъ гроша.
И, повѣрьте мнѣ, поэту,
Жизнь, ей богу, хороша.

Тамъ укуситъ, тутъ погладитъ,
Поцѣлуй, — человѣкъ по лбу.
Гдѣ поможетъ, иль подгадитъ, —
Всё же лучше, чѣмъ въ гробу.

Плылъ я къ Ленину Володѣ
Разогнать его тоску.
Да по внутренней погодѣ
Занесло меня в Баку.

Да здѣсь пахнетъ керосиномъ,
Люди, звѣри и дома.
Даже в морѣ осетрина
И за городомъ тюрьма.

Въ нефти хмурятся народы
И смѣюсь лишь я одинъ,
Потому что отъ природы
Я весёлый Арлекинъ.

Размыкелъ я сидѣлъ на боги
И участочекъ купилъ
Посреди нейтральной зоны,
Чтобъ никто не подстрѣлилъ.

И живу себѣ, буравлю
Средь такихъ, какъ я, повѣсъ.
Нефтяную землю славлю,
Жду фонтана до небесъ.

Каждой ночью непремѣнно
Опускаюсь я в подвалъ,
Гдѣ в печали неустанной
Полстыи томуа мирно спалъ.

Ужь мы, если пригласятся,
Мудрый ловъ тоски простить.
Научить васъ улыбаться,
И смѣяться, можетъ быть.

Вѣ мнѣ дороги народы,
Кромѣ тѣхъ, что любитъ сплинъ,
Потому что отъ природы
Я Весёлый Арлекинъ.

Сергѣй Городецкій
Написано в «Вес. Арл.» 6 декабря 1919 и исп. 1920.

125a 125b

Spring
(after Chavchavadze)

The swallow's song is heard again;
The forest dons its leafy dress;
The rose-bush in the garden pours
Tears for very happiness.

The hills are blossoming all round,
And flowers bloom upon the fen.
Home of my fathers & my own,
Wilt thou too blossom soon again?

To S. Y. Sudieikin Esq.

C. E. Bechhofer
Tiflis, 7 April, 1920.

Юрѣ и Серию Судейкинымъ

Знакома съ Вами была мы
давно,
Но ближе познакомились теперь —
Близорукимъ все кажется темно
— И мы никакъ не скрѣбъ своихъ по-
теръ.
Сначало на родѣянно ко мнѣ
счастливый шагъ свой повернулъ разъ.

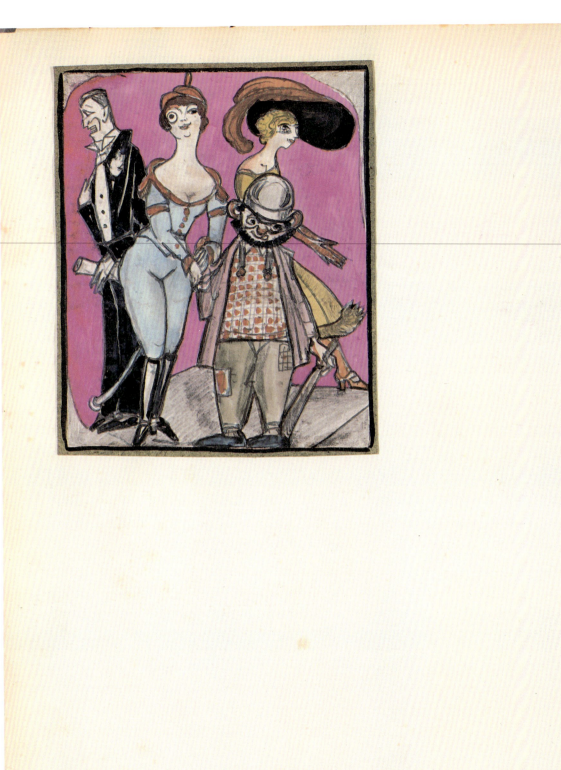

С. Ю. Судейкину

От приторной луны не знаю где укрыться,
Под маскою Пьеро скитаюсь, как больной,
И песни мне поет невиданная птица,
Невиданной страны, волшебной и иной.

Мятущийся поэт в огромном карнавале,
Я в жизни полюбил изгибы и цвета,
Но маска сорвана, и в пагубном провале
Безцветная во всем и злая пустота.

Кружись безумный мир, не уставайте маски,
Не может жить любовь без вычурных личин,
И только я один — неистощимой сказки
Последних страшных снов певец и властелин.

М. Струве.
Февраль 1920.
Баку.

131a 131b

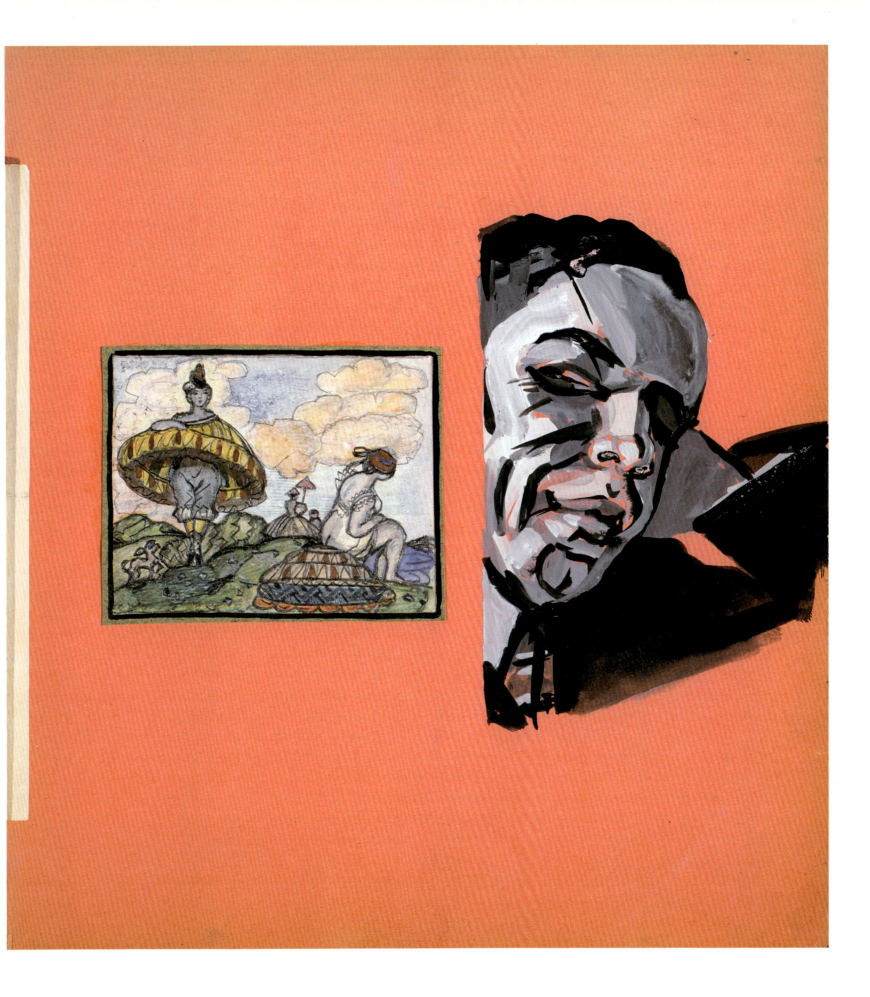

131c

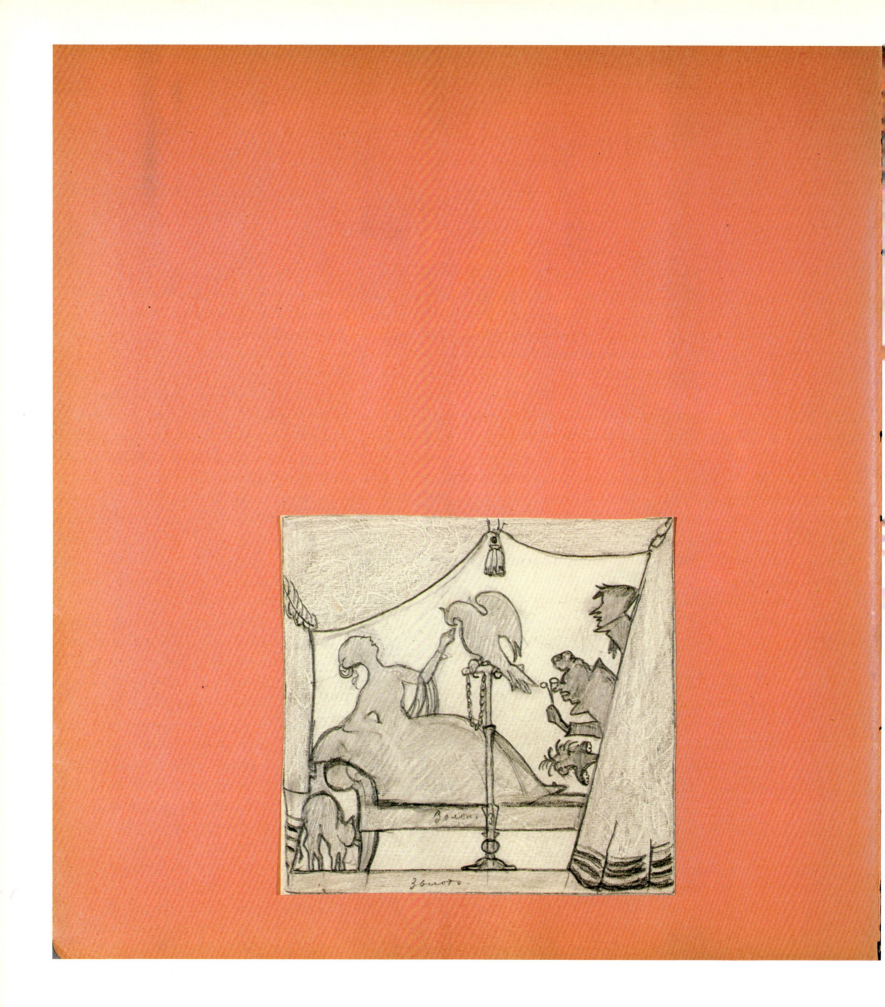

132

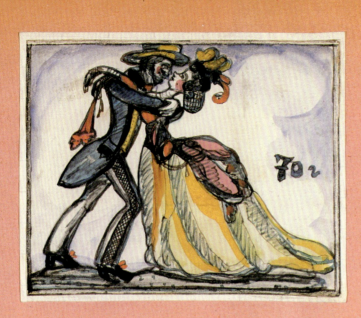

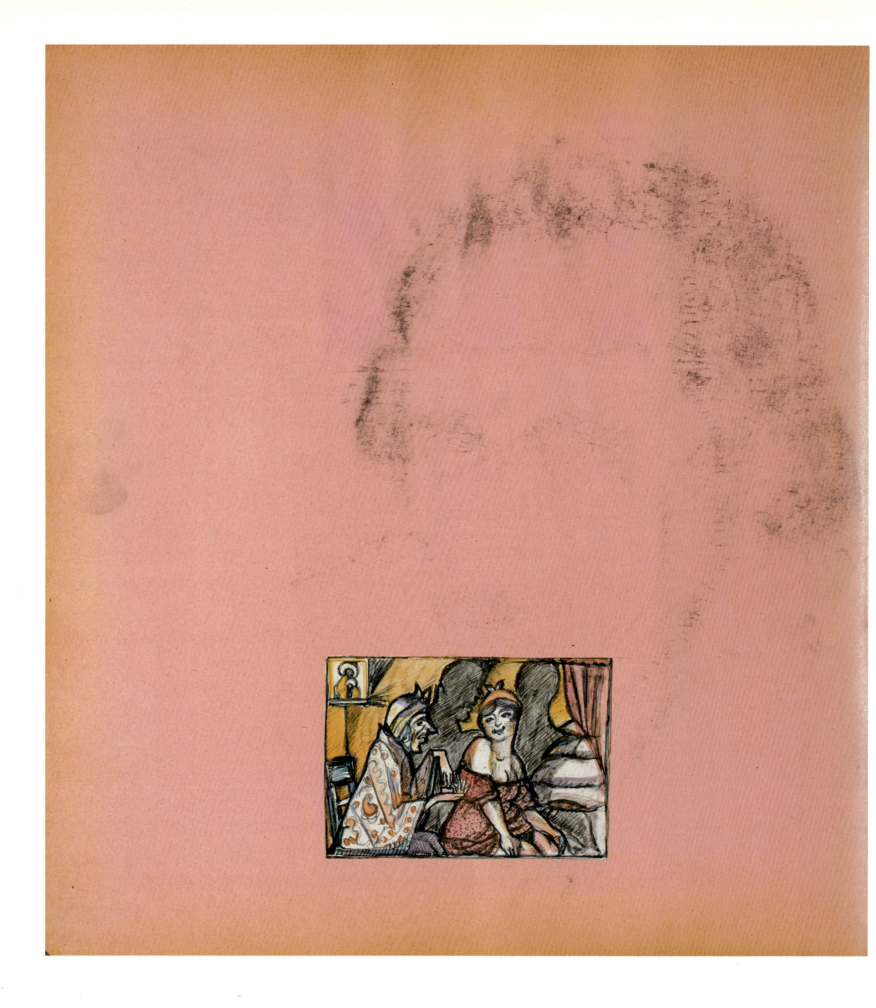

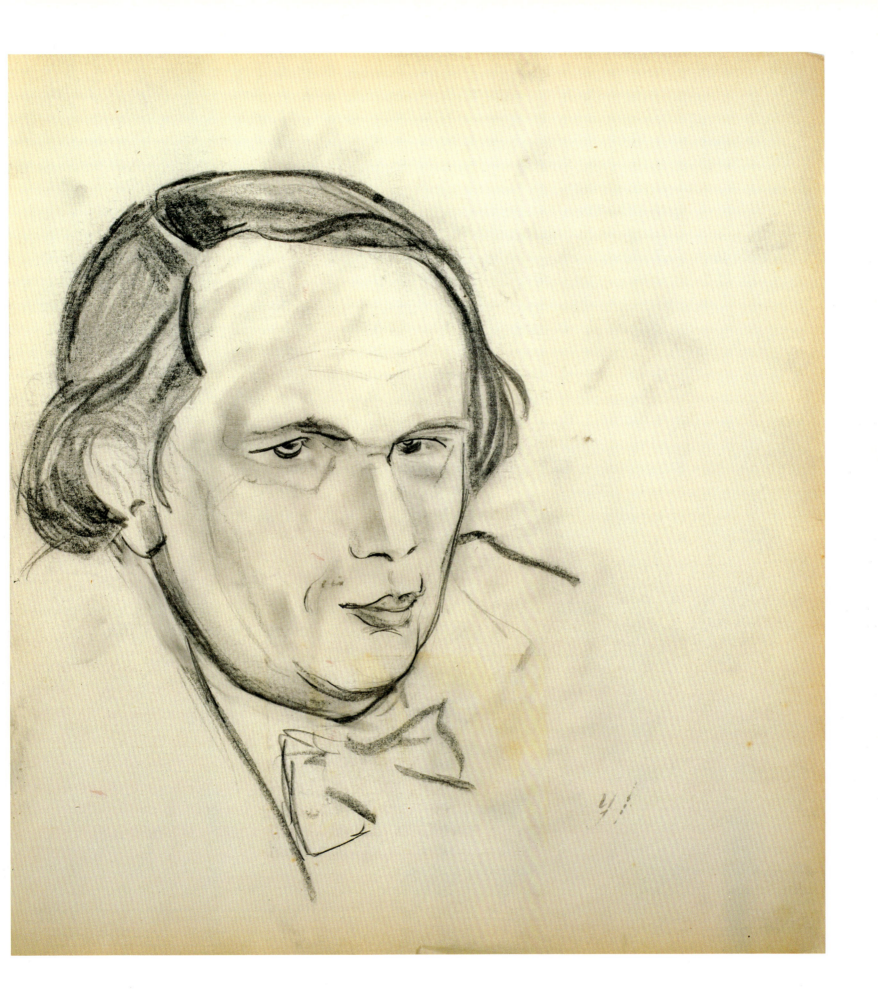

Славнымъ сосѣдямъ — Сергѣю Судейкину
Съ супругой слагаю сіи —

— Свистящія строки.

Скоро семь. смотри спустился
Сѣрый сумракъ, словно сѣнь.
Смутенъ свѣтъ. садится солнце
Садъ спокоенъ. спитъ сирень

Со степей сгоняетъ стадо
Свора сельскихъ сорванцовъ
Станутъ слышны серенады
Сребр、звучныхъ соловьевъ

Стихъ стрекозъ строптивый стрекотъ,
Стрекотаніе сверчковъ.
Словно сковано смѣнье
Страшной, страстной силой сновъ.

Сводъ сіяетъ, серебрится ...
Собирая свой салонъ,
Свѣтляки сверкаютъ, свадбу:
Свадбу — сказку, свадбу — сонъ!..

Суренъ

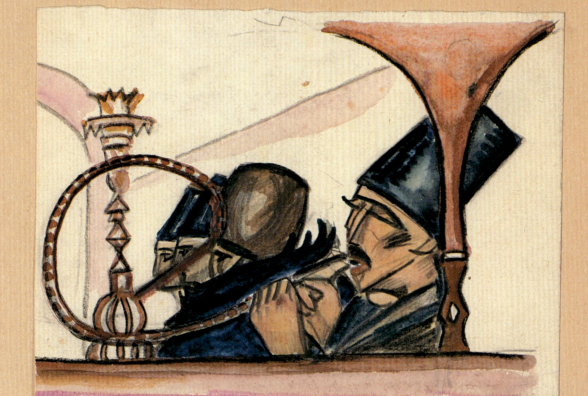

Продавецъ ковровъ

Персидская пустыни Переш
Глотая лишь пыль да рисъ
Съ цвѣтными коврами да съ пѣсками
На базаръ приѣхалю въ Тифлисъ.

Ай, верблюдъ совсѣмъ не лисица!
Не бѣжитъ, какъ быстрохвостая,
Ай, коверъ хорошій, персидскій,
Отъ сорока рублей до ста!

Коверъ узоромъ унизанъ...
Будто вылизанъ — такъ блеститъ,
Въ караван-сараяхъ Тавриза
Хозяинъ по немъ груститъ..

А вотъ ковры дороже —
Текинскіе ковры,
У нихъ рисунки строже —
Вотъ разверну, смотри!
Коснись, они нѣжны
И отливаетъ ворсъ,
Какъ бархатный твой голосъ,
Какъ глазъ твоей жены..
Прости, душа татарскій,
Что въ твой запрелъ я дворъ —
Дешевый, ферагскій
Я продаю коверъ!

Ай, новые, за грошъ я
Отдамъ и пусть слонъ,
Ковры, ковры хорошіе!
Персидскіе продаю.

Парижъ
1921.
декабрь

Г. Евангуловъ

Въ лохмотьяхъ ... лучи
Кричатъ на чуждомъ мнѣ царизмѣ
И въ ... дыму машинъ
Толпятся люди ... пёстрой.
Ты, ..., не мати
... больны изъ вагона!

На шапкахъ зурначей — ...
Мелькаетъ ... цвѣтъ малины,
По первымъ ... свистокъ,
И ... поѣздъ длинный.
Ахъ, спрячь свой маленькій платокъ!
Къ чему рыданье безъ причины!

... любовь. Разлуки часъ
Повѣрь, всегда приходитъ кстати.
Къ разгадкѣ не ищи ключа
Вѣдь намъ давно пора разстаться,
И обо мнѣ ты не скучай
Въ пыли ... полу-станцій.

(подпись)

мартъ 1920

Я и сам не верю — ненадо мне злата
Жажду малаго много — людей вновь вдосталь.
Человек после века — некурса заплата —
с весиами будет мало облов до ста

Борис Григор
921,
Раги

Пусть в жизни каждый свои
свои... имея семена —
но если имеют под итог фарисеям
или больше некурса эта...

147

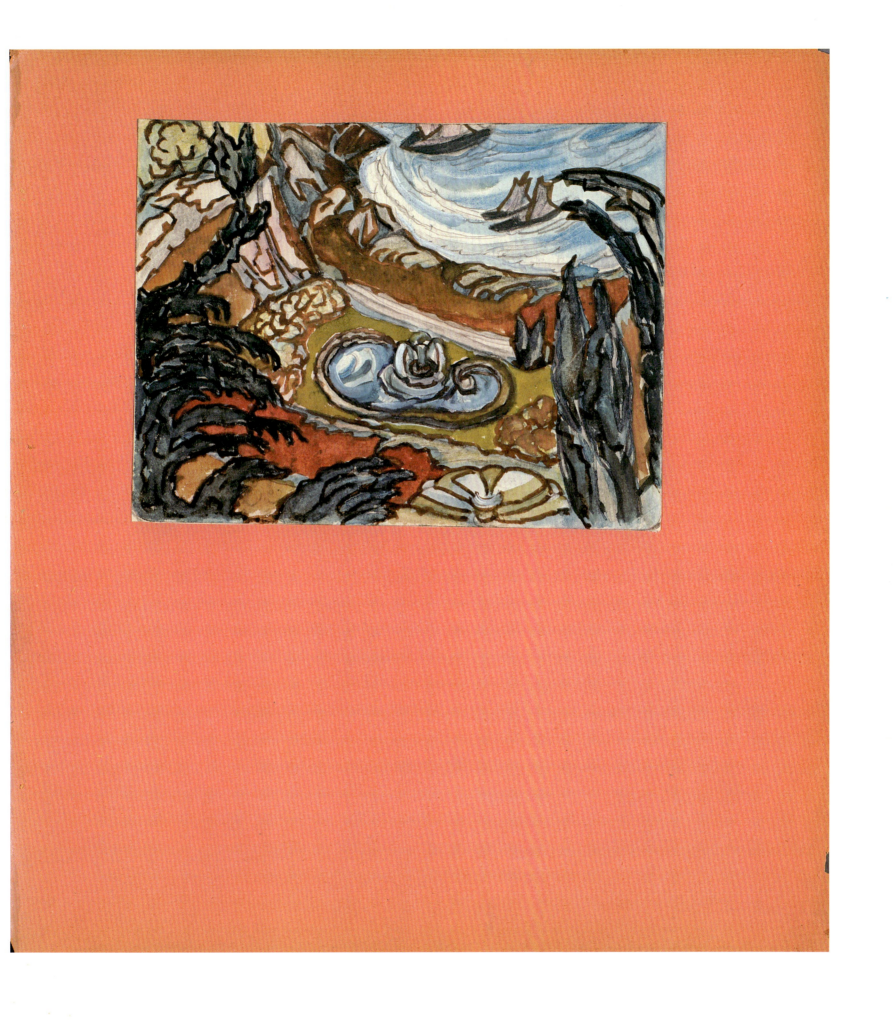

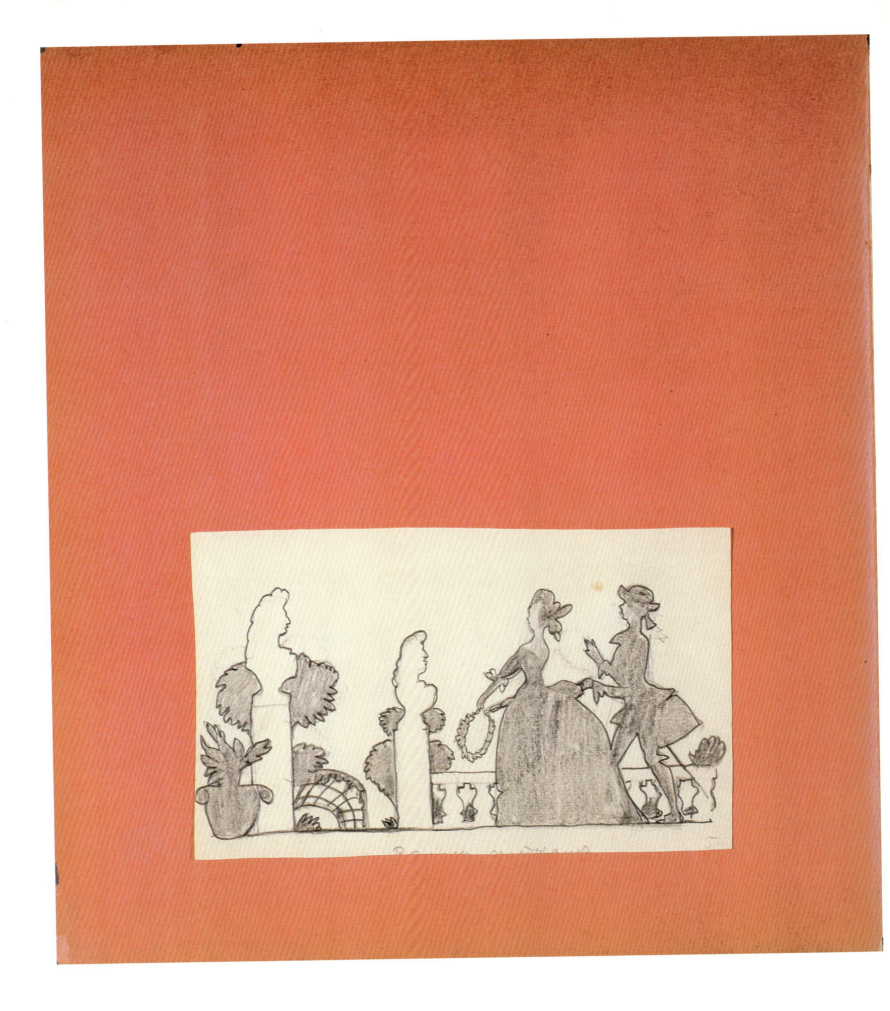

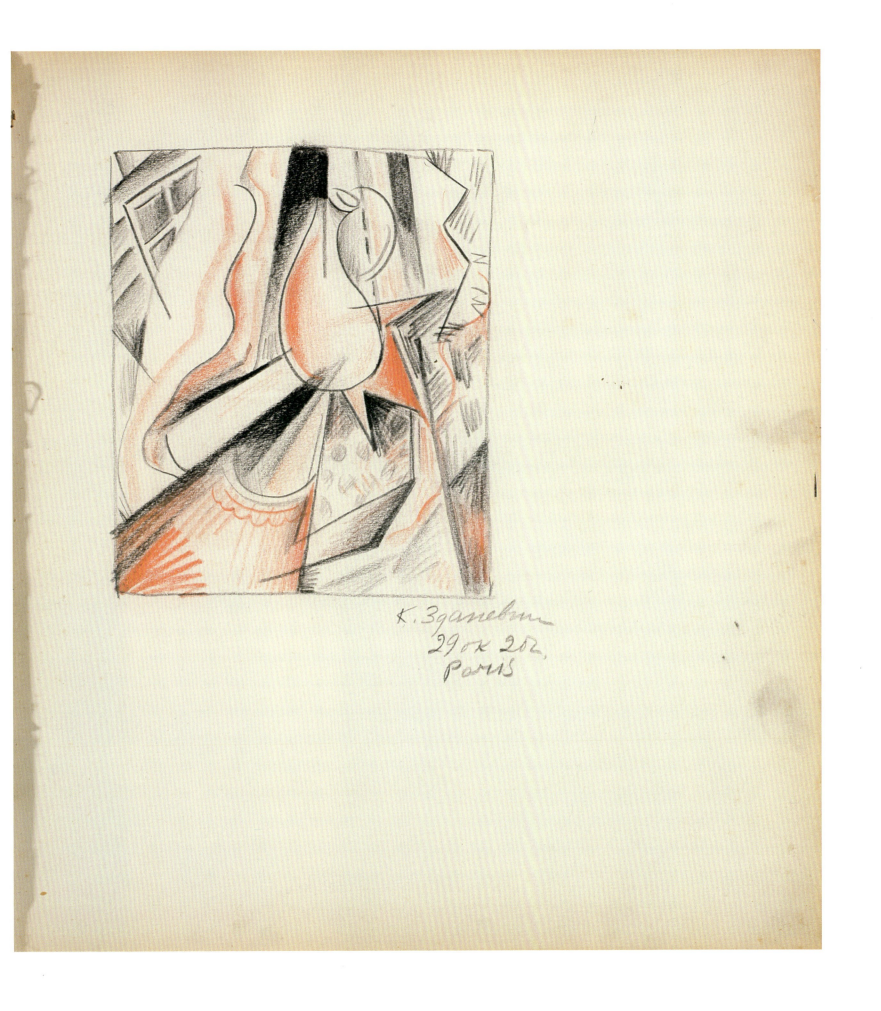

К. Зданевич
29 ок 20 г,
Paris

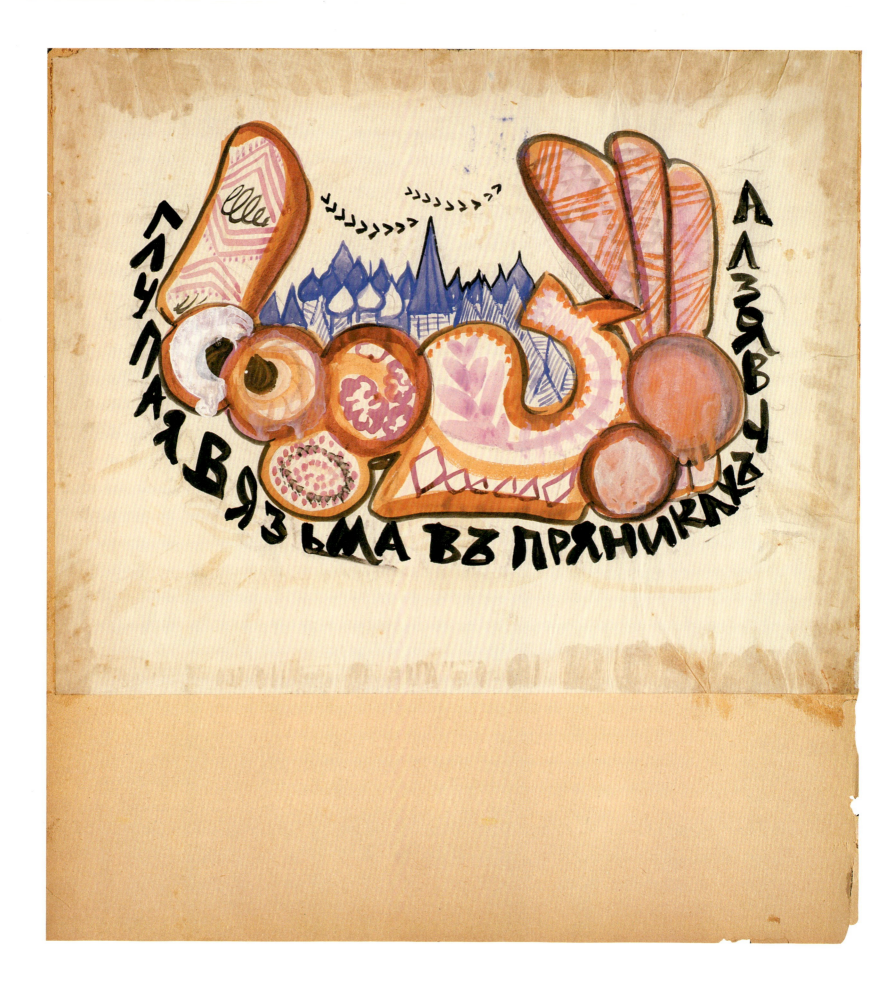

155

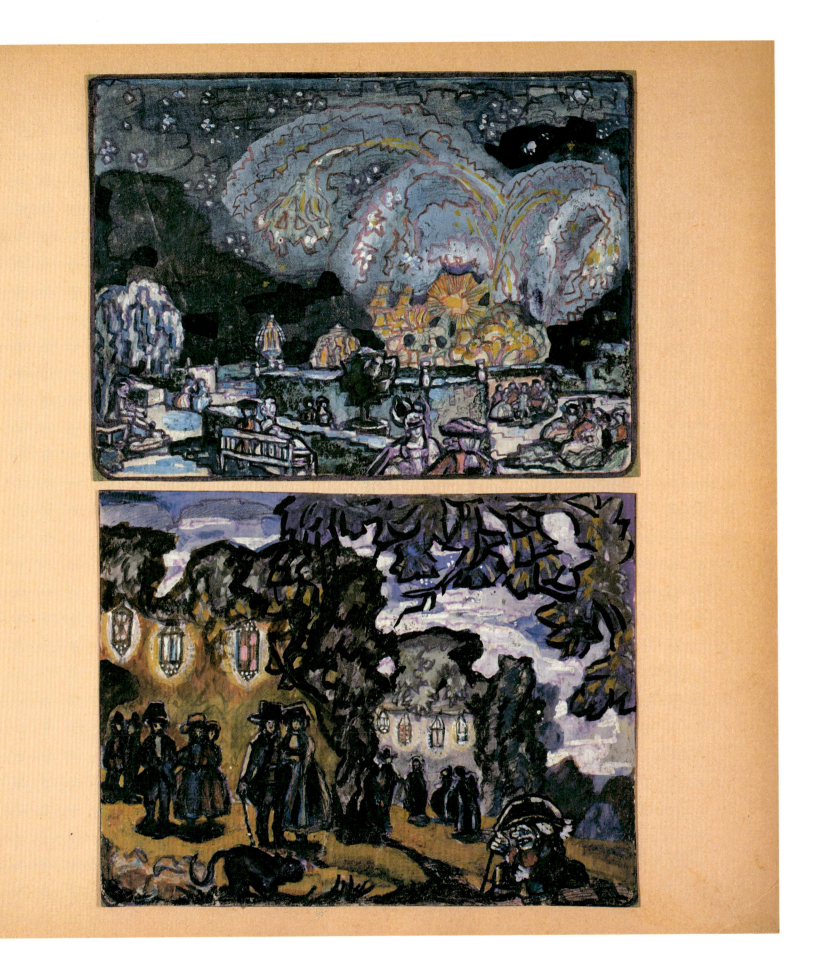

156a 156b

Въ Москвѣ на Красной площади
Толпа черна, черна,
Гудитъ отъ тяжкой поступи
Кремлевская стѣна.

На рву у мѣста Лобнаго,
У церкви Покрова
Возносятъ неподобныя —
Нерусскія слова.

Ни свѣты не засвѣчены,
На образъ не звонятъ,
Вѣетъ грудь красными мечами
И плещетъ красный платъ.

Но грянетъ ночи ...
Молчатъ ... подходятъ ... ждутъ.
На шепчутъ сипло ноютъ
Про казни, про кровь, про судъ ...

Максимиланъ Волошинъ

ноябрь 1918.
К. мѣстер.

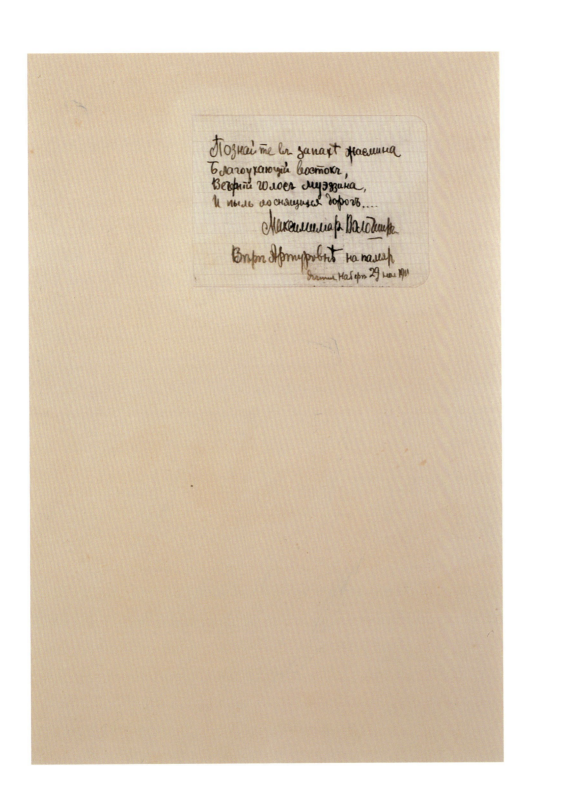

Познайте вы запахъ жасмина
Благоухающiй востокъ,
Вечернiй голосъ муэззина,
И пыль лоснящихся дорогъ....

Максимилiанъ Волошинъ

Вере Артуровнѣ на память

Усинэ Набергъ 29 мая 1911

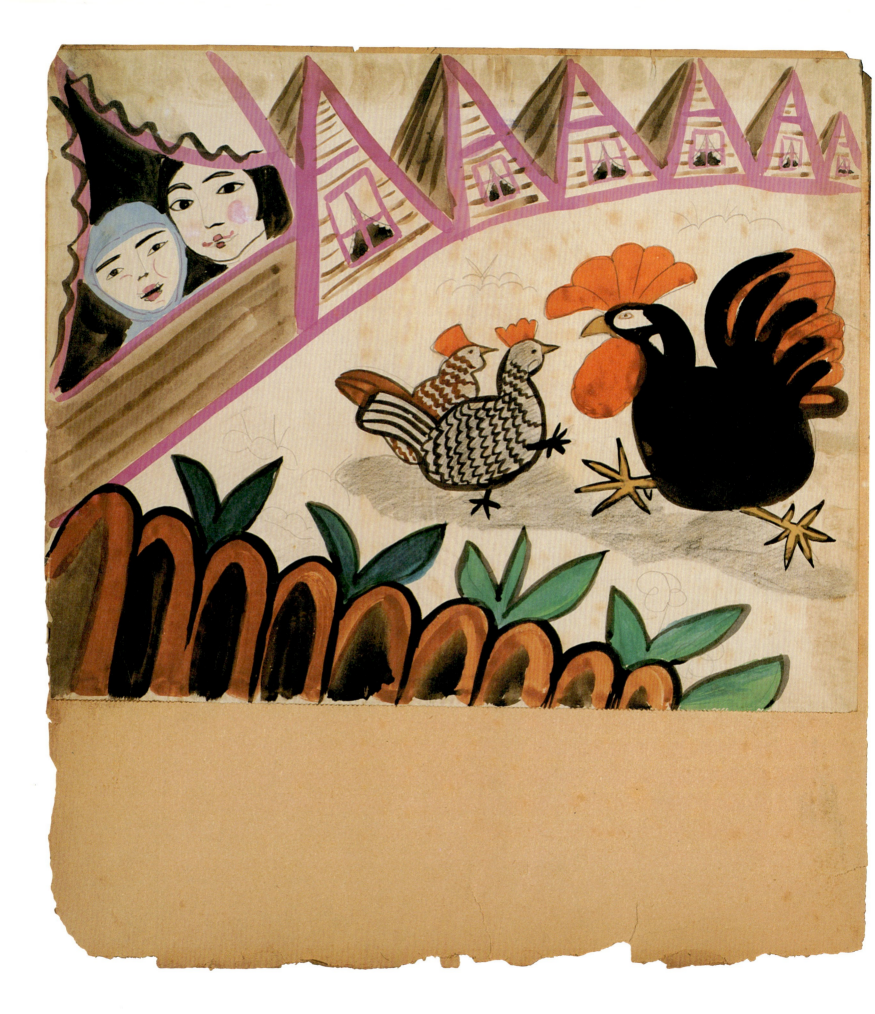

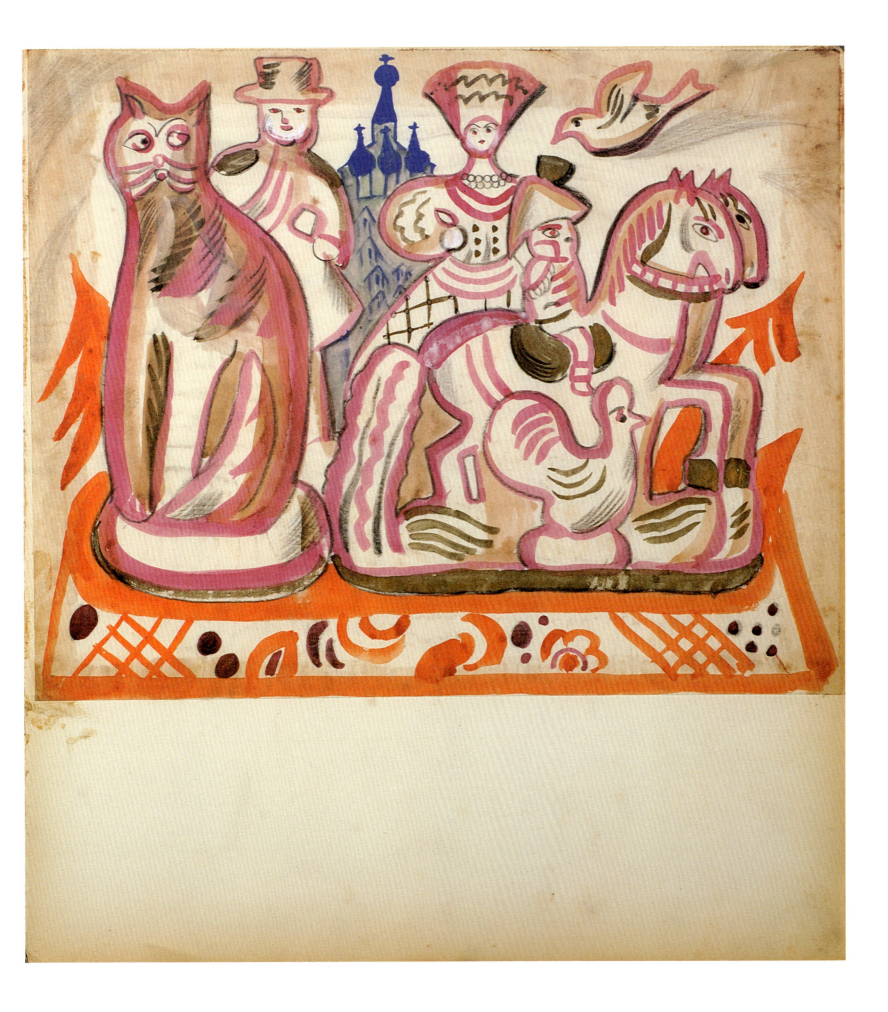

Сидёшкиа краскотратьь

MAWA

Запасная дама

161a 161b

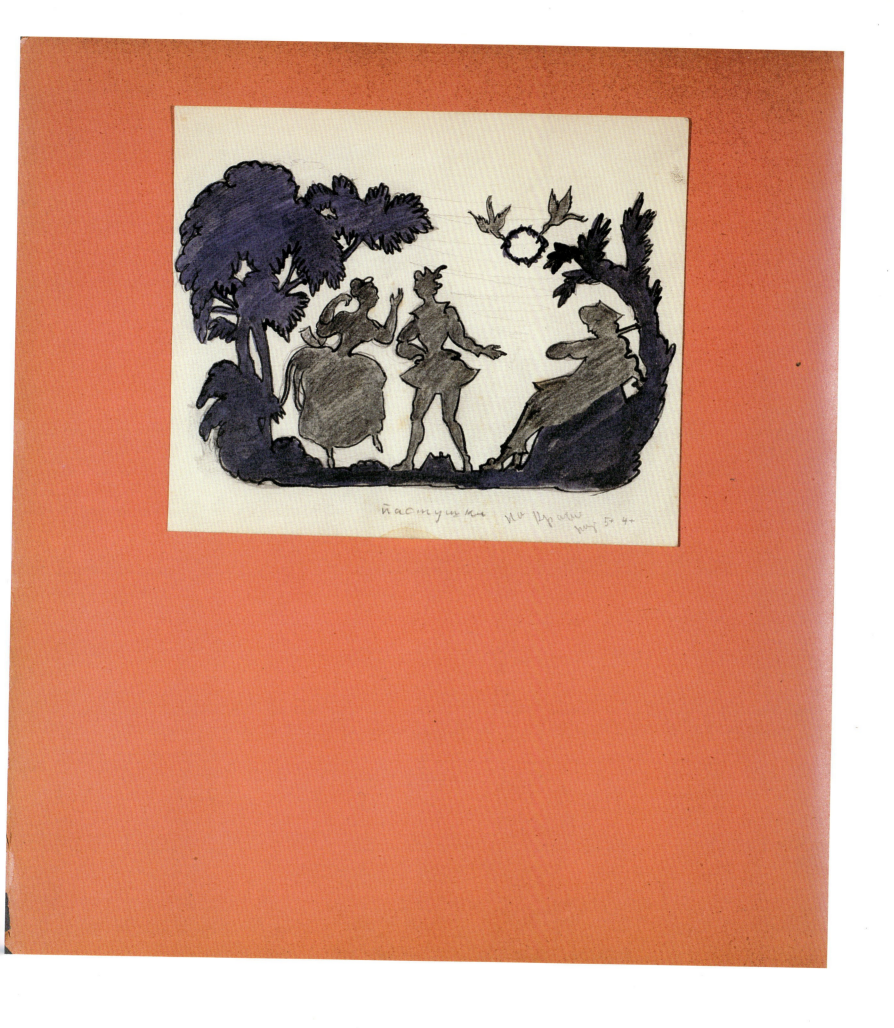

пастушки по Крыму
рис. 5. 4.

Сердейкинымъ

Немного чашекъ на столѣ
Въ корзинкѣ маленькой печенье,
За окнами большой Парижъ
Тамъ лодъ трамвайное гуденье
Застыла Сена въ черной мглѣ.

Брега не Вавилонскихъ рѣкъ
А вонъ нѣмецкихъ и французскихъ
Мы выиграли въ этотъ разъ,
Но думаемъ о сказкахъ вятскихъ
О томъ, что не забыть вовѣкъ.

Сначала былъ и милъ и любъ
Намъ электрический подарокъ
Но съ каждымъ часомъ ближе все
Оплывшей свѣчки намъ огарокъ
И поцѣлуй морозныхъ губъ.

Снѣговъ лохматыхъ терема
И чудеса и простовраки.
Беззвѣздной ночи паговоръ
Какъ сладко вспоминать о мракѣ
Въ тебѣ, пресвѣтлая тюрьма!

М. Струве
13 дек. 21
Парижъ

163

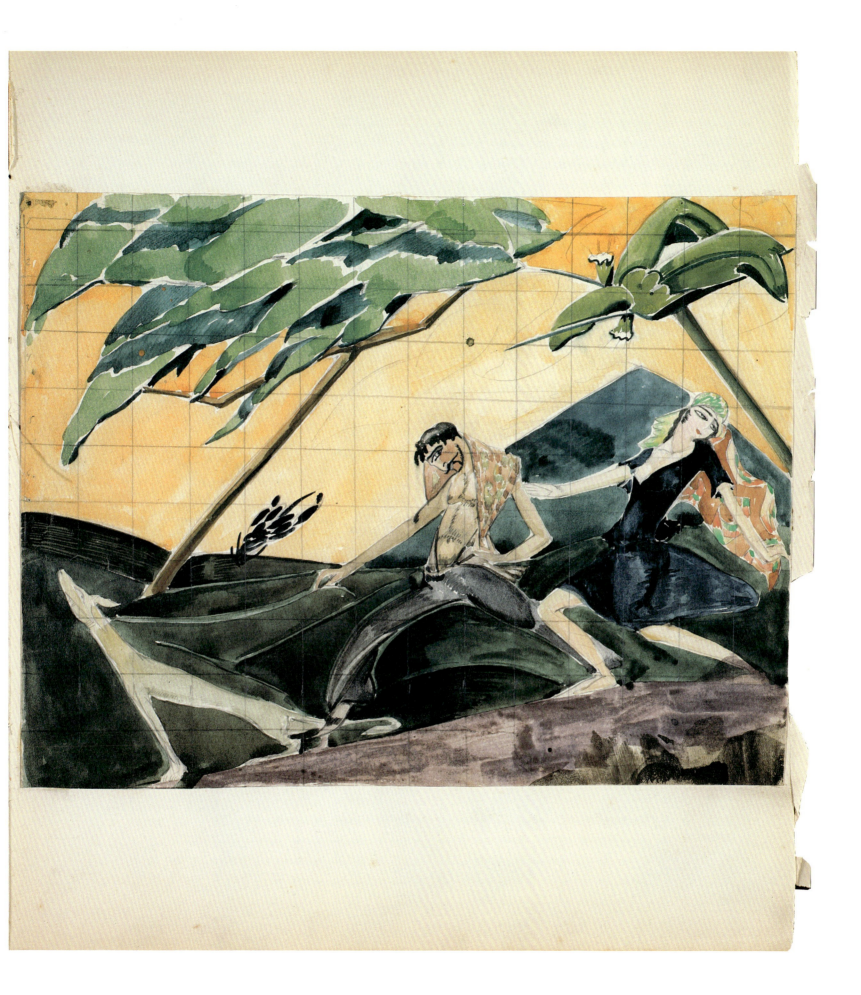

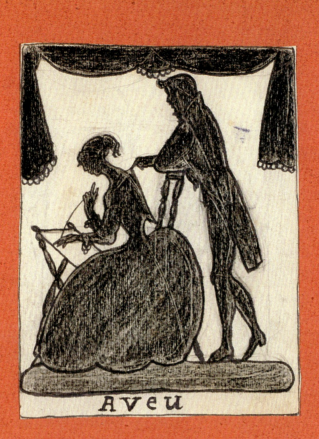

Aveu

167

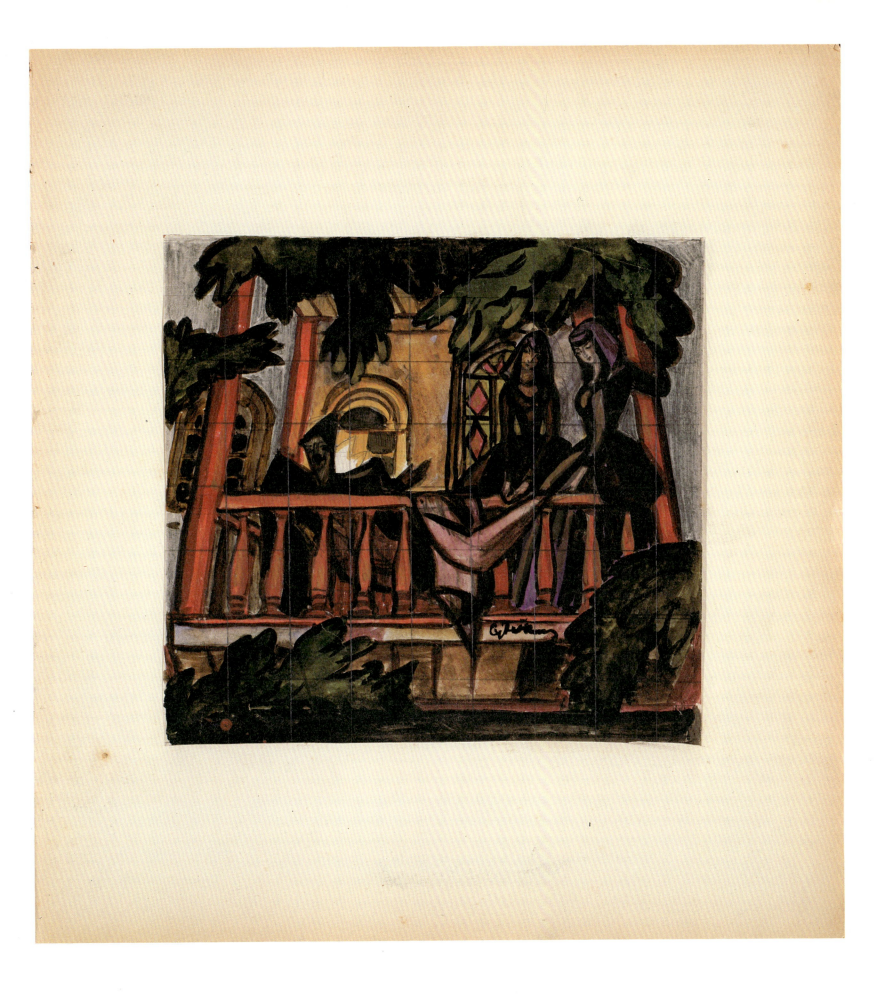

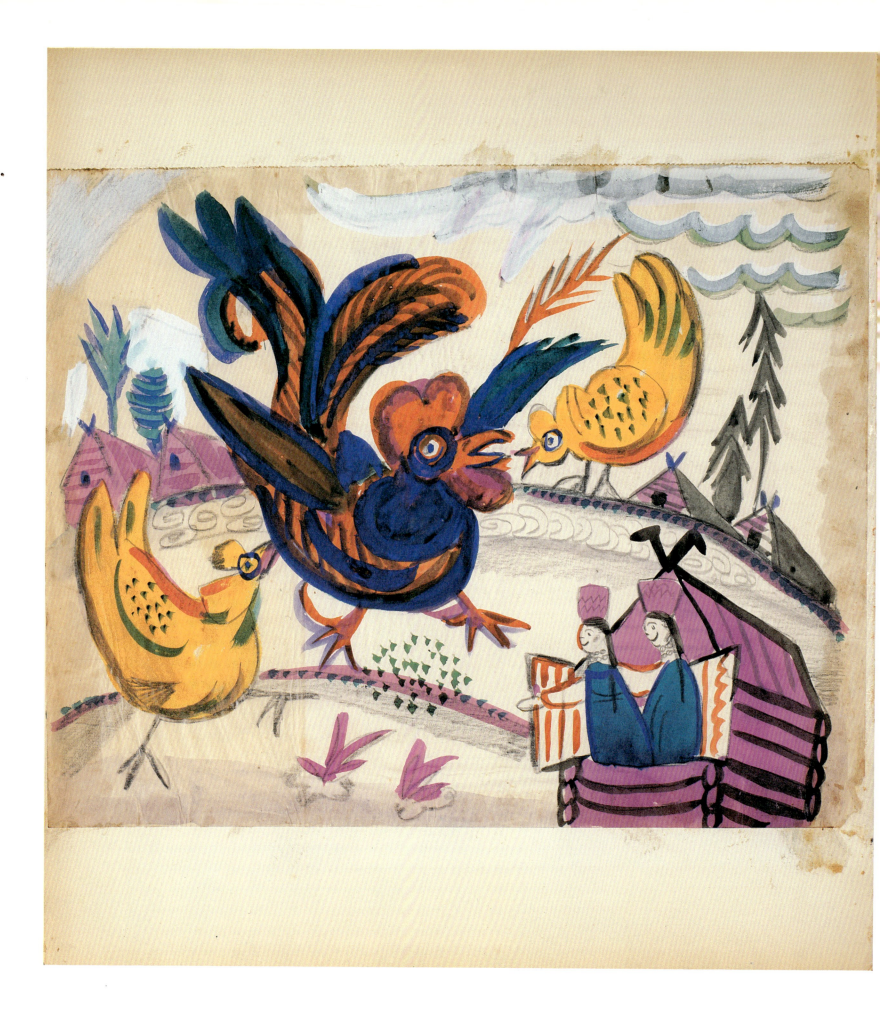

170

Сергѣй Судейкинъ.

Въ странѣ яркоцвѣтной Картинiи
Ждутъ молитвы - озари и согрѣй!
Кружевчатыя четкiя линiи -
Сердце-солнце Судейкинъ Сергѣй.

Мнѣ это имя - прибойное море,
Мнѣ это имя - Полетъ и Расцвѣтъ.
Вспоминаю, какъ въ Крымскомъ Мисхорѣ
Вмѣстѣ съ весной цвѣлъ Судажинъ-поэтъ.

Краски и пѣсни - вокругъ кипарисы -
Гдѣ-то свирѣлятъ въ горахъ пастухи -
Зовно рвутъ наклониться ирисы -
Прочитать огневые стихи.

А потомъ, - когда въ переплетномъ волжскомъ,
Въ мастерской живописнаго дня,
Этюдно напишется тайна томленiя -
Вѣра вернется, усталость гоня.

Въ краскахъ вечернихъ, рукой претворенныхъ,
До лика святого Мадонны, -
Звѣзды увидятъ, какъ двое влюбленныхъ
Въ судейкинскомъ паркѣ стоятъ у колонны.

Имя Твое - солнцесталь, озарившая
Дорогу пластическихъ плясокъ
Живопись намъ торжество подарившая
Карнавалъ колоритныхъ колясокъ.

Les boubentzi
de Yalta

Petite polka

à m-me V. et mr S
Soudéikine

S. W.

Alouchta
21 oct. 1917

173a 173b

173b

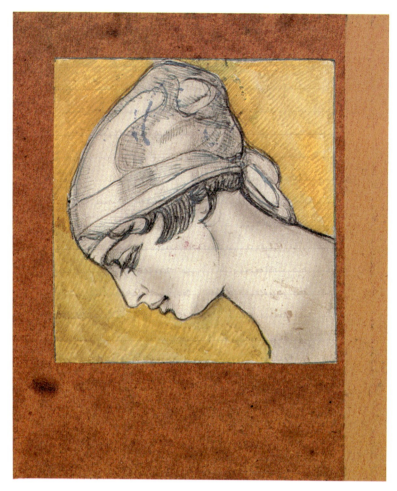

S1

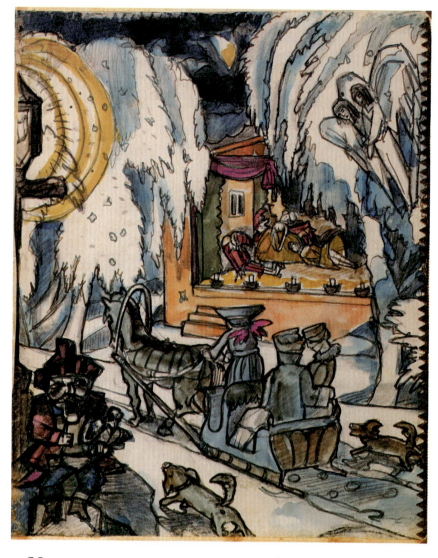

S2

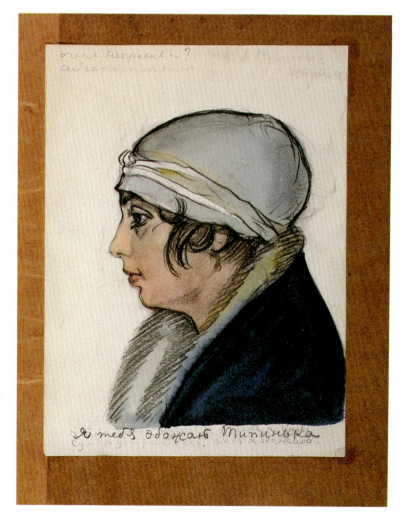

S3

THE SALON ALBUM OF

VERA SUDEIKIN-STRAVINSKY:

TRANSLATION AND

ANNOTATION

1a Konstantin Balmont (1920)

To Vera Arturovna Sudeikina

 Jag älskar dig.[1]

Love remains love
But there is a love that is in love.
It comes as a caprice,
And then, close by, it suddenly bursts out laughing
And stops abruptly in secret tears
And pours forth like a resonant light.
Prepare your heart only for this.

It is alone, always alive;
Therein lies your rebirth.
Once again it is like the May morn,
Like a spring where the ardent liquid
Crossing its own flow,
Courses, babbles, composing a melody.
I love you. I love it.

10 August 1920 K. Balmont
Paris

Ink on white page.

Balmont had been living as an émigré in Paris only two months when he wrote this poem in Vera's Album. The Sudeikins knew him and his poetry from various contexts, not least from his many publications in St. Petersburg and Moscow in the 1900s and 1910s, and he was also an important figure in the cultural development of Igor Stravinsky.[2] They met him, no doubt, during the Balmont Evening organized at the Stray Dog cabaret in St. Petersburg on 8 November 1913, and in fact a contemporary cartoon of that event included Sergei Sudeikin (as well as Evgenii Anichkov, Sergei Gorodetsky, Nikolai Kulbin, Petr Potemkin, and Fedor Sologub) in the welcoming group.[3] The exact circumstances of the Paris meeting between Balmont and Vera in August 1920 are not known, although they obviously had many friends in common and frequented the same salons and restaurants. It is of interest to note that Vera possessed a photograph of Lev Bruni's portrait of Osip Mandelstam, given to her by Nina Bruni-Balmont, Balmont's daughter and the wife of Bruni (see entry 51a).

Balmont, Konstantin Dmitrievich. Poet, dramatist, and critic. Born 1867 in Gumnishchi, Vladimir Province; died 1942 in Noissy-le-Grand, near Paris.

1885 published first verses. 1886 enrolled in the law school of Moscow University; quickly earned a reputation as a political radical. 1892 traveled to Scandinavia, the first of many trips abroad. Translated authors such as Ibsen and Shelley. 1894 published his first collection of poems under the title *Pod severnym nebom* (Beneath a northern sky); made the acquaintance of Valerii Briusov. 1896–97 traveled in Europe, delivering a lecture on modern Russian poetry at Oxford University. 1898–1901 lived in St. Petersburg and frequented the Symbolist circles. 1900 published his collection *Goriashchie zdaniia* (Buildings ablaze). 1903 published his most famous collection, *Budem kak solnste* (Let us be like the sun), which earned him a primary place among the Symbolist poets. 1902–5 traveled extensively in Europe and America, including Mexico, where he was deeply impressed by Mayan culture. 1905–7 wrote in sympathy with the revolutionary movements in Russia and was forced to flee abroad; formulated his conception of Russia as an organic part of the Slavic brotherhood of nations. 1906 onward lived predominantly in France but continued to travel while still publishing in Russia; became especially interested in oceanic culture during his trip through the Pacific in 1912. 1913 granted a political amnesty, which allowed him to return to Russia. 1915 made a lecture tour through Russia, visiting Tiflis and Kutaisi. 1917 while supporting the February Revolution, regarded the Bolsheviks of October as a destructive, neutralizing force. 1920 emigrated to Paris (June); as an émigré continued to publish poetry and criticism. 1937–42 suffered from progressive mental illness.

NOTES

1. The source of this epigraph has not been traced. For information on Balmont's epigraphs see V. Markov, "Some Remarks on Bal'mont's Epigraphs," in J. Connolly and S. Ketchian, eds., *Studies in Honor of Vsevolod Setchkarev* (Columbus, Ohio: Slavica, 1987), pp. 212–21.
2. For example, Stravinsky composed three pieces to Balmont texts in the summer of 1911: two songs and the cantata *Zvezdoliki* (Star-visages).
3. For a reproduction of the cartoon by Mark Shafran see A. Parnis and R. Timenchik, "Programmy 'Brodiachei sobaki,'" in *Pamiatniki kultury. Novye otkrytiia. Ezhegodnik 1983* (Leningrad: Nauka, 1985), p. 188.

FURTHER READING

Althaus-Schonbücher, S. *K. D. Balmont. Parallelen zu A. Fet. Symbolismus und Impressionismus.* Bern: Lang, 1975.
Balmont, Konstantin. *Polnoe sobranie stikhov 1907–1914.* Moscow: Skorpion, 1914.
Nikolaev, P., et al., eds. *Russkie pisateli, 1800–1917. Biograficheskii slovar.* Vol. 1, pp. 148–53. Moscow: Sovetskaia entsiklopediia, 1989.
Orlov, V., ed. *K. D. Balmont. Stikhotvoreniia.* Leningrad: Sovetskii pisatel, 1969.
Schneider, H. *Der frühe Balmont. Untersuchungen zu seiner Metaphorik.* Munich: Kubon and Sagner, 1970.
Terras, V., ed. *Handbook of Russian Literature,* pp. 37–38. New Haven: Yale University Press, 1985.

1b Sergei Sudeikin, untitled (1921)

Watercolor, ink, and pencil on paper laid on green paper glued onto white page. Mounted: 13.5 × 12.3 cm; unmounted: 12.8 × 11.6 cm. Inscribed "1921. He has put a philosophy lesson into practice" on the right in pencil. The reverse of the green paper carries a pencil drawing.

The date of Sudeikin's double portrait—1921—is significant, because it was on 19 February 1921 that Vera met Stravinsky in Paris—"the wittiest, most amusing man I had ever met."[1] The female figure

in classical garb seems to represent Vera Sudeikina. The bearded
man appears in a number of Sudeikin's allegorical scenes and can
sometimes be identified with Harlequin and, by extension, Sudeikin
himself (who sometimes sported a beard—see his group portrait
called *My Life*, 1916–19, in the Valerian Dudakov collection, Mos-
cow, reproduced on p. xiv);[2] on the other hand, the "philosopher"
may be Sudeikin's onetime lover, the poet Mikhail Kuzmin, who
"shaved off his beard in 1909."[3] The "lesson in philosophy" may well
refer to the new development in Vera's relationship with Sudeikin
after the appearance of Stravinsky, thereby connecting with the tri-
angle love theme of the commedia dell'arte that they all appreciated
and interpreted. See entries 37b, 39b, 45c, and 128. The theme of
Vera holding a scroll and adopting the role of the inspired or inspir-
ing spectator appealed to Sudeikin.

Sudeikin, Sergei Yurievich.[4] Artist. Born 19 March 1882 in Smo-
lensk; died 12 August 1946 in Nyack, New York.

Ca. 1894 enrolled in the Lazarev Institute of Oriental Languages
in Moscow. 1897–1909 attended the Moscow Institute of Painting,
Sculpture, and Architecture, where he studied principally under
Konstantin Korovin and Valentin Serov. Established close contact
with Savva Mamontov and the Abramtsevo group and then with the
World of Art group. 1904 participated in the "Crimson Rose" exhibi-
tion, Saratov. 1904 made the acquaintance of Vsevolod Meierkhold
and Konstantin Stanislavsky. 1905 served as co-editor of the journal
Iskusstvo (Art); contributed to the "Union of Russian Artists" exhibi-
tion in St. Petersburg. 1906 on the invitation of Sergei Diaghilev
traveled to Paris in connection with the Russian section of the Salon
d'Automne. 1907 participated in the "Blue Rose" exhibition, Mos-
cow; married Olga Glebova. 1908 moved away from Symbolism to a
more Primitivist style; began an intimate relationship with Mikhail
Kuzmin. 1909 settled in St. Petersburg, where he enrolled at the
Academy of Arts. 1911 designed murals for the Stray Dog cabaret.
1912 was hired by Diaghilev as scene painter for *L'Après-midi d'un
faune*, *Daphnis et Chloé*, *Thamar*, and *Le Sacre du printemps*. 1913
(spring) eloped with Vera to Paris (allegedly). Designed sets and
costumes for Diaghilev's production of *La Tragédie de Salomé* in
Paris, one of many stage presentations that Sudeikin designed in
Russia, Europe, and the U.S. 1915 designed Alexander Tairov's pro-
duction of *Le Mariage de Figaro* for the Chamber Theater, Moscow.
1916 (March) separated from Glebova and moved with Vera to Pet-
rograd. Designed murals for the Comedians' Halt cabaret in Petro-
grad; mobilized. 1917 departed from Moscow for the Crimea with
Vera. Took up residence in Alupka and then in Yalta, and contrib-
uted (December) to the "First Exhibition of Paintings and Sculpture
by the Association of United Artists" in Yalta; moved to Miskhor.
1918 (24 February) married Vera and participated (October) in the
exhibition "Art in the Crimea" in Yalta. 1919 (April) left the Cri-
mea via Novorossiisk for Constantinople, arriving instead at Batum
whence he and Vera journeyed to Tiflis. Rented an apartment on
Griboedov Street. 1919 worked in Tiflis and Baku, predominantly as

a muralist and designer, and participated (May) in the "Little Circle"
exhibition in Tiflis; arrived in Baku (December). 1920 (20 May) ar-
rived with Sorin and other friends in Paris. 1921 was a member of
Valentin Parnakh's Chamber of Poets. Contributed to the exhibition
"L'Art Russe" in Paris. 1922 (May) quarreled with Vera and left Paris
(August) to settle in New York. 1923 participated in the "Exhibition
of Russian Painting and Sculpture" at the Brooklyn Museum, New
York. Decorated the interior of the Caucasus and Cellar of Fallen
Angels nightclubs in New York. 1924 held a one-man exhibition at
the New Gallery, New York. During the 1920s worked for Nikita
Baliev's Chauve-Souris cabaret. Designed several productions for
the Metropolitan Opera. 1920s–30s worked for several ballet com-
panies. Painted many portraits, decorative panels, and murals (e.g.,
for Severance Hall, Cleveland, in 1936). 1934 designed the Holly-
wood movie *We Live Again*. 1941 (22 January) accompanied by
Sorin, saw Vera for the first time since Paris at a performance of
George Balanchine's *Balustrade* in New York; the following day they
met for the last time.

For more information on Sudeikin in Tiflis and Baku, see the
introduction.

NOTES

1. For a description of Vera's fateful encounter with Stravinsky see V. Stravinsky
 and R. McCaffrey, eds., *Igor and Vera Stravinsky: A Photograph Album, 1921 to
 1971* (London: Thames and Hudson, 1982), p. 240.
2. For a reproduction and commentary, see A. Konechnyi, V. Morderer, A. Par-
 nis, and R. Timenchik, "Artisticheskoe kabare 'Prival komediantov,'" in
 Pamiatniki kultury. Novye otkrytiia. Ezhegodnik 1988 (Moscow: Nauka, 1989),
 p. 135. The painting is mistitled and misdated in *100 Years of Russian Art,
 1889–1989, from Private Collections in the USSR* (exhibition catalog, Barbican
 Gallery, London; and Museum of Modern Art, Oxford, 1989), p. 110.
3. According to G. Ivanov, *Peterburgskie zimy* (New York: Chekhov, 1952),
 p. 131.
4. This biography is based on Sudeikin's own handwritten autobiography,
 which Vera kept among her papers (now in the Varia). Also see Vera's biogra-
 phy in entry 16.

FURTHER READING

Babenchikov, M. "Teatr Sudeikina." *Dekorativnoe iskusstvo*, no. 12 (Moscow,
 1975): 39–40.
Burliuk, D. *Russkie khudozhniki v Amerike*. New York: Burliuk, 1928.
Dzutsova, I. "Sudeikin v Tbilisi." *Literaturnaia Gruziia*, no. 1 (Tbilisi, 1978):
 176–85.
———, and N. Elizbarashvili. "S. Yu. Sudeikin v Gruzii." *Muzei*, no. 1 (Moscow:
 Sovetskii khudozhnik, 1980): 23–26.
———. "Zabytye freski." *Dekorativnoe iskusstvo*, no. 12 (Moscow, 1975).
Gorodetsky, S. "Tragediia khudozhnika." *Kavkazskoe slovo*, Tiflis, 18 July 1918.
Kiselev, M. "K 100-letiiu so dnia rozhdeniia khudozhnika." *Iskusstvo*, no. 2
 (Moscow, 1982): 49–55.
Kogan, D. *Sergei Sudeikin*. Moscow: Iskusstvo, 1974.
Levenson, A. "Neklassicheskaia krasota karuseli." *Dekorativnoe iskusstvo*, no. 9
 (Moscow, 1980): 31–34.
Lvov, Ya. "U khudozhnika Sudeikina (beseda)." *Kavkazskoe slovo*, Tiflis, 11 May
 1919.
Makovsky, S. "S. Yu. Sudeikin." *Apollon*, no. 8 (St. Petersburg, 1911): 5–16.

Palmer, E. "A Study of the Art of Sergei Soudeikine." *Musical Courier*, New York, 7 November 1931, pp. 3–8.

Rudnitsky, K. "Teatr Sergeia Sudeikina." *Dekorativnoe iskusstvo*, no. 12 (Moscow, 1975): 39–40.

Sayler, O. "Sergei Sudeykin, Court Painter." In *Morris Gest Presents Nikita Balieff*, 1928–29 season program, Chauve-Souris Theater, New York, pp. 29–31.

Sudeikin, S. "Georgian Artists" (in Georgian). *Sakartvelo*, no. 115 (Tiflis, 1919): 2–3. Russian translation of section on Gudiashvili in L. Gagua, ed., *Lado Gudiashvili. Kniga vospominanii. Stati. Iz perepiski. Sovremenniki o khudozhnike*, p. 218. Moscow: Sovetskii khudozhnik, 1987.

Tolstoi, A. "Pered kartinami Sudeikina." *Zhar-ptitsa*, no. 1 (Berlin, 1922): 23–28.

Zorin, Yu. "Balet 'Paganini.'" *Novyi zhurnal*, no. 125 (New York, 1976): 160–73.

———. "Neznakomyi Sudeikin." *Novoe Russkoe Slovo*, New York, 21 December 1975, p. 5; 28 December, pp. 5–8; and 4 January 1976, p. 5.

———. "Vnov obretaemyi profil." *Novoe Russkoe Slovo*, 15 August 1976, pp. 7–8.

2a Sergei Sudeikin, untitled (ca. 1920)

Watercolor and pencil on ruled paper, laid on paper glued onto white page. 16.6 × 16.2 cm. Inscribed on the work in French: "This is how they go, go, go, / This is the way marionettes go, / This is the way they go, go, go, / A little twirl . . . / And off they go." The reverse of the second paper carries a pencil drawing.

There seems to be no direct connection between Sudeikin's picture and the Kamensky poem adjacent (2b).

The exact occasion and date of this double marionette portrait of Vera and Sergei Sudeikin, accompanied by a traditional French nursery rhyme, are not known, although perhaps, as in entry 1b, there are private references to the Sudeikins' amatory inconstancies in Paris in 1920–21. Similar renderings of real people in the guise of puppets appear in a number of Sudeikin's paintings and drawings concerned either directly or indirectly with the commedia dell'arte and the Punch and Judy tradition (see, e.g., the painting called *Petrouchka* of 1915 in the Vladimir Andreev collection, Moscow).[1] In January 1913 Sudeikin even designed a marionette production of Kuzmin's nativity play *Christmas Mystery* (with puppets by Olga Glebova) for the Stray Dog.

Glebova, Kuzmin, and the Sudeikins were keen supporters of the marionette theater and in the late 1900s and 1910s contributed directly to its revival as an advanced medium of artistic expression. For example, Sudeikin established a puppet theater for the Society of Free Aesthetics in Moscow in 1907 with repertoire by Andrei Bely and designs by himself. Many representatives of the Symbolist movement—Alexander Blok, Fedor Sologub, Konstantin Somov—were interested in the traditions of the puppet theater and adapted them to their literary or pictorial creations. In this respect, they appreciated the efforts of Yuliia Slonimskaia (Sazonova) and her husband Pavel Sazonov in establishing an "adult" puppet theater in 1916 in Petrograd and welcomed their marionette activities in the Comedians' Halt. Slonimskaia even published an article in *Apollon* in which she clarified her objectives:

The marionette provides a theatrical formula without a carnal expression. Just as algebraic signs substitute certain desired quantities, so the conditional flesh of the marionette substitutes real human flesh. . . . The infinite variety of the puppet repertoire has preserved one basic characteristic: indifference to the prose of everyday life and to the manifestation of the eternal qualities of the human soul.[2]

The year 1916 was important in the history of the Russian puppet theater, for in that year the great puppeteer Nina Simonovich-Efimova made her debut at an evening of the Moscow Association of Artists. Simonovich-Efimova had started her career as a painter and then turned to the miniature theater as a medium of movement, because, as she put it, "[The puppets'] charm lies in movement, the meaning of their existence lies in play. . . . The theater of Petrouchka is the theater of action."[3] It was this "art of play" that attracted many modern Russian artists, not least Alexandra Exter, Nikolai Kalmakov, El Lissitzky, Liubov Popova, Sudeikin, and Elizaveta Yakunina. The Sudeikins collected dolls and other toys, and Vera records that Sudeikin once gave her "doughnuts and a ballerina doll for the New Year" (Diaries, 31 December 1918). Their interest in dolls and marionettes was stimulated by their several meetings in the Crimea in 1917 and 1918 with Sazonov, with whom Sudeikin discussed establishing a puppet theater. Vera was not so keen, recording slyly that Slonimskaia herself "looks like a badly carved puppet" (Diaries, 25 October 1918).

For Sudeikin's biography, see entry 1b.

NOTES

1. Reproduced in D. Kogan, *Sergei Sudeikin* (Moscow: Iskusstvo, 1974), p. 96. For further commentary on Sudeikin and the commedia dell'arte, see entry 125b.

2. Yu. Slonimskaia, "Marionetka," *Apollon*, no. 3 (Petrograd, March 1916): 30. Much of the March 1916 issue of *Apollon* was devoted to the Slonimskaia-Sazonov enterprise. Alexandre Benois also supported the project and published a positive article entitled "Marionetochnyi teatr" in the 20 February 1916 issue of *Rech*. After her emigration Slonimskaia renewed her puppet theater at the Théâtre du Vieux Colombier, Paris, on 24 December 1924, and Glebova, Natalia Goncharova, Mikhail Larionov, Nikolai Milioti, and other Russian artists designed marionettes for her. See "Teatr marionetok," in *Teatr, iskusstvo, ekran* (Paris, January 1925): 12–13; and L. Yakovleva-Shaporina, "Kukolnyi teatr v Peterburge," ibid. (February–March 1925): 22–23.

3. N. Simonovich-Efimova, *Zapiski petrushechnika* (Moscow and Leningrad: Gosizdat, 1925), pp. 25, 42.

2b Vasilii Kamensky (ca. 1919)

To the Potion "Vera"[1]

To Verochka Sudeikina I offer
An angelic juic-
e—a curaçao of
Melted emerald:
Meaning—
Don't forget.

 Vasia

Ink on pink paper, glued onto white page. 11.9 × 8.3 cm.

There seems to be no direct connection between entry 2b, which carries neither date nor location, and the Sudeikin picture adjacent (2a). The Russian word for "potion" (*zelie*) that Kamensky uses in this poem's heading has several connotations, including "poison," and "pest" or "nuisance." It can be assumed that Kamensky wrote and dedicated the poem when he was living in Menshevik Tiflis in May 1919 onward, after having been arrested and imprisoned in Yalta and escaping to the Caucasus.[1] Kamensky was no stranger to Tiflis; he had stayed there several times before. In 1914, for example, he had joined David Burliuk and Vladimir Maiakovsky in their Futurist tour of the Georgian capital, establishing contact with the local Futurist Kara-Darvish[2] and planning Futurist "affiliations" in Batum, Tiflis, and Baku, with Tiflis, which he mapped in one of his ferroconcrete poems, as the stronghold.[3] He was there again in 1916, preparing his collection of poems called *Devushki bosikom* (Barefoot girls) and then at the beginning of 1917, when, with Alexei Kruchenykh and Kirill Zdanevich, he prepared the miscellany *1918*. With such a rich bohemian past and as co-editor (with D. Burliuk and Maiakovsky) of the *Gazeta futuristov* (Newspaper of the Futurists), which he had just produced in Moscow in March of 1918, Kamensky was an experienced member of the avant-garde when he took refuge in Tiflis in 1919. That year he rented a house together with Evreinov (see entry 85b) and the painter Vladimir Boberman[4] and moved closely with the poets Sergei Gorodetsky and Riurik Ivnev, "delivering earnest lectures, reciting poetry, and, in general, behaving very virtuously."[5] In Tiflis in March 1919, Kamensky made a joint appearance with D. Burliuk and Maiakovsky, who according to the poster, "will deliver a scholarly lecture on art and literature: Vasilii Kamensky, pilot and aviator of the Imperial All-Russian Air Club, will lecture on 'Airplanes and the Poetry of the Futurists' . . . ; David Burliuk on 'Cubism and Futurism (in Painting)' . . . ; Vladimir Maiakovsky on 'The Achievements of Futurism' . . . ; and V. Maiakovsky, V. Kamensky, and D. Burliuk will read their poetry."[6]

The Sudeikins were acquainted with Kamensky from at least the early 1910s, thanks especially to their collective contributions to the Stray Dog cabaret. In 1915, for example, Sudeikin and Alexander Radakov painted a series of screens "consonant with his poetry" at the Evening of the Five (D. Burliuk and Igor Severianin also took

part).[7] It appears, from his other poem in the Album (entry 171), that Kamensky also knew the Sudeikins from Miskhor in 1917–18. Kamensky may have made this dedication to Vera in connection with the Kamensky Evening that she attended at the Fantastic Tavern on 7 May 1919, which Vera described so vividly in her Diaries (7 May 1919). Alternatively, the entry may be linked to another Kamensky Evening, at the Tiflis Conservatory in November 1919, organized to mark the first decade of his literary activity. With Evreinov as master of ceremonies and Alexander Cherepnin as musical accompanist (see entry 65a), several friends—including Grigorii Robakidze and Vera—declaimed Kamensky's poetry, and Sudeikin even designed a special poster. From Vera's Varia for Tiflis, it would seem that a scene from *Stenka Razin*, "Ai, My Persia," was also performed there, with designs by Kirill Zdanevich. The poets Vasilii Katanian and Boris Korneev then devoted a special number of their journal *Iskusstvo* (Art) to the event, printed on a piece of red calico.[8] Alternatively, Kamensky may have written this entry in connection with the Kamensky Evening organized at the Khimerioni Café, also in 1919, for which Sudeikin painted twelve decorative screens (marking the number of Kamensky's published books).[9]

Kamensky, Vasilii Vasilievich. Poet, painter, theorist, memoirist. Born 1884 on a steamship near Perm; died 1861 in Moscow.

1907 arrived in St. Petersburg, where he trained as a pilot. 1909 met David Burliuk, who exerted a profound influence on his literary development, orienting him toward the new, radical poetry. 1910 contributed to the first Russian Futurist miscellany, *Sadok sudei* (A trap for judges). 1911 published his story *Zemlianka* (Dugout). 1913 influenced by Velimir Khlebnikov and Kruchenykh, experimented with *zaum* (transrational language) in his poetry. 1914 published his ferroconcrete poems. 1915 published his poetical drama *Stenka Razin*. 1918 published his first collection of memoirs, *Ego—Moia biografiia velikogo futurista* (Him—My biography of a great Futurist). Contributed to *Fantasticheskii kabachok*, no. 1. 1927 published his autobiography, *I eto est. Avtobiografiia. Poemy i stikhi* (That's how it is. An autobiography. Poems and verses), in Tiflis.

NOTES

1. Kamensky, *I eto est. Avtobiographiia. Poemy i stikhi* (Tiflis: Zakkniga, 1927), p. 7.
2. Kamensky, *Ego—moia biografiia velikogo futurista* (Moscow: Kitovras, 1918), pp. 186, 210. Also see L. Magarotto, M. Marzaduri, and G. Pagani Cesa, *L'avanguardia a Tiflis* (Venice: Seminario di Iranistica, Uralo-Altaistica e Caucasologia dell'Università degli Studi di Venezia, 1982), p. 217. Kara-Darvish is the pseudonym of the Armenian Futurist poet Akop Minaevich Gendzhian (1872–1930).
3. Kamensky included his ferroconcrete map of Tiflis or Transcaucasian Futurism in the miscellany *1918*. See the introduction, n. 43.
4. Vladimir (Voldemar) Boberman (1897–1985), brother-in-law of Gregorio Sciltian (see G. Sciltian, *Mia avventura* [Milan: Rizzoli, 1963]), shortly moved on to Berlin, where he gained a reputation as a stage designer for Jascha Juschny's Blue Bird cabaret. He later moved to Paris, where he worked as a textile and carpet designer. See the collection of stencils by M. Raynal,

V. Boberman. Tapis. Vingt quatre compositions en couleurs (Paris: Editions des Quatre Chemins, 1929).

5. According to the writer Lev Shamurian. See S. Gints, *Vasilii Katanian* (Perm: Permskoe knizhnoe izdatelstvo, 1974), p. 162.

6. A copy of this poster is in the collection of Nina and Nikita D. Lobanov-Rostovsky, London.

7. See D. Kogan, *Sergei Sudeikin* (Moscow: Iskusstvo, 1974), p. 90; and A. Parnis and R. Timenchik, "Programmy 'Brodiachei sobaki,'" in *Pamiatniki kultury. Novye otkrytiia. Ezhegodnik 1983* (Leningrad: Nauka, 1985), p. 240.

8. See *Iskusstvo* (Tiflis, 22–24 November 1919), where Sudeikin's poster is reproduced. See also Magarotto, Marzaduri, and Cesa, *L'avanguardia a Tiflis*, p. 260.

9. See L. Gagua, ed., *Lado Gudiashvili. Kniga vospominanii. Stati. Iz perepiski. Sovremenniki o khudozhnike* (Moscow: Sovetskii khudozhnik, 1987), p. 41. Sudeikin also made an illustration for Kamensky's lyrical story *Zemlianka*, now in the Perm State Picture Gallery.

FURTHER READING

Bocharov, S., et al., eds. *Vasilii Kamensky.* Moscow: Kniga, 1990.
Gints, S. *Vasilii Katanian.* Perm: Permskoe knizhnoe izdatelstvo, 1974.
Kamensky, V. V. *Ego—Moia biografiia Velikogo Futurista.* Moscow: Kitovras, 1918.
———. *I eto est. Avtobiografiia. Poemy i stikhi.* Tiflis: Zakkniga, 1927.
———. *Izbrannoe.* Moscow: Sovetskii pisatel, 1948.
———. *Izbrannoe.* Perm: Knizhnoe izdatelstvo, 1945. (Compiled by Savvatii Gints)
———. *Izbrannye stikhi.* Moscow: Gospolitizdat, 1934.
———. *Poemy.* Moscow: Gospolitizdat, 1934.
———. *Sbornik pies.* Moscow: Moskovskii teatralnoe izdatelstvo, 1925.
———. *Stikhi.* Perm: Knizhnoe izdatelstvo, 1967. (Compiled by Savvatii Gints)
———. *Stikhotvoreniia i poemy.* Moscow-Leningrad: Sovetskii pisatel, 1966. (Compiled by Nikolai Stepanov)
———. *Zhizn s Maiakovskim.* Moscow: Khudozhestvennaia literatura, 1940.
Nikolaev, P., et al., eds. *Russkie pisateli, 1800–1917. Biograficheskii slovar.* Vol. 2, pp. 455–58. Moscow: Sovetskaia entsiklopediia, 1992.
Terras, V., ed. *Handbook of Russian Literature*, p. 214. New Haven: Yale University Press, 1985.

5a Sergei Sudeikin, self-portrait (ca. 1920)

Watercolor and pencil on rice paper page. Signed "Sergei Sudeikin" in pencil at the base, in Sudeikin's hand.

This self-portrait accompanies the poems by Gorodetsky and Altman (entries 5b, 5c) and so, presumably, was also created in Baku in late February 1920, before the Sudeikins returned to Tiflis. For Sudeikin's biography, see entry 1b.

5b Sergei Gorodetsky (1920)

Sudeikin

Viewing with a half-derisive smile
The raging hell of empty reality,
You open the doors of a golden paradise
And lead us into a garden unseen by any mortal.

There maidens burning with tender languor
Seek palpitating delights in sultry spinneys.
There a second lover lures Schumann
To a fantasy of madness, to songs unhindered.[1]

There at dawn the Muses bury Apollo,
And Cupid gives hookah to a Persian.
There Sulamith[2] has opened her couch to Solomon,

A bejacketed maid of beauty coaxes a merchant,
And amidst the mysterious and enchanting figures
Stands Sudeikin as yet by no one understood.

27 February 1920 Sergei Gorodetsky
Baku

Ink on rice paper page.

First published in *Bratstvo*, no. 1 (Tiflis, 1920): 31, this poem accompanies the Sudeikin self-portrait (entry 5a). Gorodetsky is represented in the Album by numerous entries, both verbal and visual. He once wrote, "I have hunted three hares: science, painting, and poetry. I have not yet caught up with any of them, but on the other hand none of them has escaped me."[3] The exact occasion for this poetical dedication to Sudeikin is not known, although both parties had arrived in Baku from Tiflis (see the introduction). In any case, Gorodetsky had long been fond of Sudeikin's pictorial themes; and occasionally his own paintings, with their bright reds and oranges, are reminiscent of Sudeikin's color schemes. In this poem Gorodetsky seems to be describing several of Sudeikin's paintings, with their constant references to languorous maidens, Robert Schumann,[4] the Orient, and Merchant Russia.

Gorodetsky, Sergei Mitrofanovich. Poet, prose writer, and painter. Born 1884 in St. Petersburg; died 1967 in Obninsk.

1902 enrolled in the department of history and philology at St. Petersburg University. Early 1900s much under the influence of Alexander Blok and the Symbolists; Blok, Valerii Briusov, and Viacheslav Ivanov were enthusiastic supporters of his talent.[5] 1907 published his first collection of verse, *Yar* (Spring corn), which enjoyed immediate success; Igor Stravinsky put two of Gorodetsky's songs to music. Late 1900s–10s became increasingly interested in Old Russian culture, primitive art, and children's painting and literature, demonstrated by collections such as *Rus* (Russia, 1910). 1908 married Anna (Nimfa) Bel-Kon-Liubomirskaia (Kozelskaia)[6] and began to publish stories and short novels. 1911 onward played an active

life in the cultural events of the Stray Dog and other cabarets. 1911 co-founder of the Guild of Poets. 1912 co-signed the Acmeist manifesto. 1914 interpreted the First World War as a fulcrum whereby the common folk and the intelligentsia would unite to produce a new Russia. 1916 (spring) left for the Middle East and the Caucasus. 1917 (February) was in Persia, then arrived (October) in Tiflis and began to publish articles in the Tiflis newspaper *Kavkazskoe slovo* (Caucasian word).[7] 1918 edited the journal *Ars*, published his poem *Shofer Vlado* (Vlado the driver); assisted by Sergei Rafalovich, established the Tiflis Guild of Poets. 1919 contributed to the Tiflis journal *Orion*; published his book of poems *Angel Armenii* (Angel of Armenia). 1920 (February) moved to Baku and (spring) visited Petersburg. 1920–21 edited the Russian-Azerbaijani journal *Iskusstvo* (Art) in Baku; designed propaganda posters for the Baku OknaROSTA (Baku Windows of the Russian Telegraph Agency). 1921 (fall) returned to Moscow. 1925 founded the Moscow Guild of Poets and published the collection *Styk* (Encounter), which also included verse by Tatiana Vechorka and Alexander Chachikov.

NOTES

1. Sudeikin maintained that Schumann was insane (Diaries, May–June 1918).
2. A reference to the biblical bride Sulamith.
3. S. Gorodetsky, unpublished autobiography. Quoted in P. Nikolaev et al., eds., *Russkie pisateli, 1800–1917. Biograficheskii slovar* (Moscow: Sovetskaia entsiklopediia, 1989), vol. 1, p. 639. Also see his autobiography in *Russkaia literatura*, no. 3 (Moscow, 1970): 186–90.
4. For commentary on Schumann and *Carnaval*, see entries 19, 25b, and 93.
5. See entries 71, 112–13.
6. See entry 7b.
7. Some of his articles from *Kavkazskoe slovo* are reprinted in V. Enisherlov, ed., *S. M. Gorodetsky. Zhizn neukrotimaia. Stati. Ocherki. Vospominaniia* (Moscow: Sovremenniki, 1984).

FURTHER READING

Elizbarashvili, N. "S. M. Gorodetsky—khudozhestvennyi kritik." *Literaturnaia Gruziia*, no. 9 (Tbilisi, 1978): 125–32.

Enisherlov, V., ed. *S. M. Gorodetsky. Izbrannye sochineniia*. Moscow: Sovetskii pisatel, 1987.

———, ed. *S. M. Gorodetsky. Zhizn neukrotimaia. Stati. Ocherki. Vospominaniia.* Moscow: Sovremenniki, 1984. (This book includes some of the articles that Gorodetsky had published in *Kavkazskoe slovo*)

Gorodetsky, S. "Iskusstvo i literatura v Zakavkazie." *Kniga i revoliutsiia*, no. 2 (Moscow, 1920): 12–13.

Mashinsky, S., ed. *Sergei Gorodetsky. Stikhotvoreniia i poemy*. Leningrad: Sovetskii pisatel, 1974.

Nikolaev, P., et al., eds. *Russkie pisateli, 1800–1917. Biograficheskii slovar*, pp. 639–41. 2 vols. Moscow: Sovetskaia entsiklopediia, 1989 and 1992.

Piast, V. "Bratia Gorodetskie." In V. Piast, *Vstrechi*, pp. 63–84. Moscow: Federatsiia, 1929.

Terras, V., ed. *Handbook of Russian Literature*, p. 182. New Haven: Yale University Press, 1985.

5c Moisei Altman (1920)

Children's Toys

No, here is no brush, no canvas,
Here are someone's fiery wounds.
You have hewn out a window
To other worlds, crazy and drunken.
April burns with its Easter day
Before the brown curtains. . . .
Are children's toys really
Given to the children of the earth by demons?

At what price, in what wine
Do we now pound out our days,
When on this tiny canvas
We erect such a bloody totem?

O, ineffable, who are you,
You who have surrendered to the embraces of eternity
Such a tender curse
And such dead flowers?

M. Altman

Ink on rice paper page.

This poem accompanies the Sudeikin self-portrait (entry 5a). The title of the poem alludes to the Sudeikins' love of toys, which they collected and researched, and which often served as a source of inspiration for Sergei's paintings (see entry 2b). Vera even stated that there was something "toylike" about her husband (Diaries, 13 November 1917). The reference to April and Easter in the poem would indicate a date of April 1920, although the location remains unclear. A "diligent student"[1] of the poet and philosopher Viacheslav Ivanov, Altman was in Baku in 1920; but according to entry 127a the Sudeikins had already returned from Baku to Tiflis by 7 April 1920, before going on to Batum. In early May they embarked on a ship bound for Marseilles (see entry 139 and the introduction).

Altman, Moisei Semenovich. Poet, critic, and translator. Born 1896 in Ulla, near Vitebsk; died 1986 in Leningrad.

1906–14 attended gymnasium in Baku. 1914–17 studied medicine at Kiev University. 1917–19 supported the Bolsheviks in the Ukraine. 1919 moved back to Baku. 1920 published collection of poems called *Khrustalnyi kladez* (Crystal trove). 1920 visited Persia. 1920–23 studied history and philology at Azerbaijan State University, where he attended classes (1920–21) given by Viacheslav Ivanov; he knew Georgii Kharazov there and was interested in his psychoanalytical researches. He also met Alexei Kruchenykh and Velimir Khlebnikov in Baku. 1925 enrolled at the Institute for the Comparative Study of Literatures and Languages of the West and East in Leningrad. 1930s taught at various institutions in Leningrad and published a number of books on ancient Greek classical culture. 1942–44 in prison camp (rehabilitated in 1955).

NOTE

1. L. Ivanova, *Vospominaniia. Kniga ob ottse* (Moscow: Kultura, 1992), p. 105.

FURTHER READING

Nothing substantial has been published on Moisei Altman, although the following sources should be noted:

Altman, M. S. "Avtobiografiia." *Minuvshee*, no. 10 (Paris, 1990): 205–39.
————. *Dostoevsky po vekham imen.* Saratov: Saratov University, 1975.
————. *Grecheskaia mifologiia.* Moscow and Leningrad: Sotsekgiz, 1937.
————. "Iz besed s poetom Viacheslavom Ivanovichem Ivanovym (Baku, 1921)." In *Trudy po russkoi i slavianskoi filologii*, no. 11 (Tartu, 1968): 302–12.
————. *Iz istorii materialnogo proizvodstva antichnogo mira.* Moscow: Gos. sots. econ. izd., 1935.
————. "Iz togo, chto vspominalos." *Literaturnaia gazeta*, no. 46 (Moscow, 1985): 5. (Publication prepared by Alexander Parnis)
————. *Khrustalnyi kladez. Sbornik stikhov.* Baku: Shneiderov, 1920.
————. *Perezhitki rodovogo stroia v sobstvennykh imenakh Gomera.* Moscow: OGIZ, 1936; French ed., *Survivances du régime de clan dans les nous propres cher Homère.* Moscow: Editions d'état, 1936.
————. *Sbornik ocherkov.* Tula: Prioksoe knizhnoe izdatelstvo, 1966.
————. *Slepoi Famir.* Leningrad: Academy of Sciences, 1930.
————. *U Lva Tolstogo.* Tula: Priokskoe knizhnoe izdatelstvo, 1980.
————. *The Undying Swan: Selected Poems in Russian.* Ed. Ilia Mamantov. Dallas, Tex.: Southern Methodist University, 1976.
————, ed. *Ivan Gavrilovich Prizhov. Ocherki, stati, pisma.* Moscow: Academia, 1934.
————, trans. *Voina myshei i liagushek.* Moscow and Leningrad: Academy, 1936.

7a Savelii Sorin, self-portrait (ca. 1920)

Pencil on rice paper page.

Sorin was a constant companion of the Sudeikins in St. Petersburg, Yalta, Miskhor, and then Tiflis (see entry 65c) and Baku. They sometimes shared the same residences, participated in the same exhibitions, and had many mutual acquaintances and pupils; and, not surprisingly, Sorin made at least one portrait of Vera. Consequently, in her Diaries Vera referred to Sorin many times and in many different situations, although ultimately she felt that he was "simply a very decent individual" if not an artist of the highest level; in fact, she found his drawings "pathetic" (Diaries, 12 March 1918 and 12 May 1919). In April 1920 Sorin moved back to Tiflis, and in May of that year he accompanied the Sudeikins and Prince and Princess Melikov on a steamer from Batum to Marseilles (see entry 139).

This self-portrait accompanies the Liubomirskaia poem (7b).

Sorin, Savelii (Savii, also Zavel) Abramovich (Izrailevich). Painter. Born 1878 in Polotsk; died 1953 in New York.

1894 entered the Odessa Art School, where he studied under Kiriak Kostandi. 1899–1907 studied at the St. Petersburg Academy of Arts under Ilia Repin, Vasilii Savinov, and Ivan Tvorozhnikov; began to specialize in portraiture. 1908 received an Academy fellowship and traveled in France and Italy; painted a portrait of Eleonora Duze while there. After graduating from the Academy of Arts was sent to Holland, France, and Italy. 1913 contributed to the "World of Art" exhibition in St. Petersburg. 1916–19 member of the Comedians' Halt. 1917 in Yalta; lived in the same house as the Sudeikins. Participated in the "First Exhibition of Paintings and Sculptures by the Association of United Artists" in Yalta. 1918 participated in the "Art in the Crimea" exhibition in Yalta. 1919 participated in the "Little Circle" exhibition in Tiflis. With Sudeikin designed the interior of the Boat of the Argonauts café in Tiflis. 1921 participated in the exhibition "L'Art Russe" in Paris. 1922 and 1923 contributed to the "Salon d'Automne," Paris; one-man exhibition in London. 1923 emigrated to the U.S.; participated in the "Exhibition of Russian Painting and Sculpture" at the Brooklyn Museum, New York. 1920s–30s continued to work mostly as a portrait painter of aristocrats, artists, actors, and dancers such as Alexandre Benois, Michel Fokine, and Anna Pavlova. One-man exhibition in Pittsburgh. Formed a close friendship with Alexandre Benois in Paris.

FURTHER READING

Bowlt, J. "Savelii Sorin v Krymu i Zakavkazie v 1917–19 godakh." In M. Parkhomovsky, ed., *Evrei v kulture Russkogo zarubezhia*, vol. 2, pp. 493–506. Jerusalem: Parkhomovsky, 1993.
Evreinov, N. "S. A. Sorin." In N. Evreinov, *Original o portretistakh*, pp. 47–51. Moscow: Gosudarstvennoe izdatelstvo, 1922.
Exhibition of Paintings by Sorine. Exhibition catalog, Wildenstein. New York, 1934.
Gorodetsky, S. "Sorin." *Bratstvo*, no. 1 (Tiflis, 1920): 31.
Makovsky, S. "Portrety S. Sorina." *Zhar-ptitsa*, no. 8 (Berlin, 1922): 2–6.
Opalov, L. "V studii Saveliia Sorina." *Russkaia zhizn*, New York, 6 November 1943, p. 4.
Proizvedeniia zhivopisi i grafiki, peredannye A.S. Sorinoi v dar muzeiam SSSR. Exhibition catalog, Tretiakov Gallery. Moscow, 1973.
Salmon, A. *S. Sorine: Portraits.* Berlin: Ganymede, 1929.
Sarabianov, A., ed. *1978. Khudozhestvennyi kalendar. Sto pamiatnykh dat*, pp. 124–26. Moscow: Sovetskii khudozhnik, 1977.
Schang, F., et al., eds. *Russian Artists in America*, p. 215. New York: Martianoff, 1932.
Severiukhin, D., and Leikind, O., eds. *Khudozhniki russkoi emigratsii*, pp. 426–28. St. Petersburg: Chernyshev, 1994.

7b Nimfa Bel-Kon Liubomirskaia (1920)

To S. A. Sorin

Singer of an ancient beauty,
Traveler of sad souls!
Your portraits, like flowers,
Grow in funerary valleys.

The true aristocrat has parted,
And the hands of women have grown coarse
But your keen eye—more tenderly than a reed pipe—
Has painted the world.

Dreams are dreamt when one ascends to you,
Dadiani[1] looks so mournful.

And, full of vicious depth,
The tigle's eye wounds the eager's.[2]

Scion of ancient tribes,
Prince Obolensky crumples his glove,[3]
And you take the viewer prisoner,
Beckoning back to the past as to an enigma.

But lest we think too much,
You call us to a landscape blue,
To some radiant path
To some becalmed park, to a sylvan drowsiness.

You are not at all like Nestor,[4]
But you still paint a chronicle;
And long will people sense the quiver
That you breathe into your portraits.

March 1920 Nimfa Bel-Kon Liubomirskaia
Baku

Ink on rice paper page.

As the wife of Sergei Gorodetsky and a poet of varying degrees of inspiration, Liubomirskaia was appreciated more for her literary salon in St. Petersburg than for her artistic output. Georgii Ivanov recalled that "in the ambience of literary ladies, Gorodetsky's wife, 'Nimfa,' shining in her rather ponderous beauty, pours out tea with her chubby little fingers."[5]

This poem accompanies the Sorin self-portrait (7a). Gorodetsky also published a poem called "Sorin" at the same time.[6]

Liubomirskaia (Kozelskaia), Nimfa Bel-Kon (Anna Alexandrovna [sometimes Alexeevna]). Poetess and prose writer. Born 1889; died 1945.

1908 married Sergei Gorodetsky. 1910s lived in St. Petersburg. 1918–19 lived in Tiflis. Member of the Tiflis Guild of Poets; contributed to the journals *Ars* and *Orion*. 1920 lived in Baku.

NOTES

1. A reference to Princess Elizaveta (Eliso/Elisor) Iosifovna Dadiani (1893–1943), whom Sorin painted in 1919 in Tiflis. The portrait was reproduced in *Zhar-ptitsa*, no. 1 (Berlin, 1921): 13. The portrait is now in the State Museum of the Arts of Georgia, Tbilisi, and is reproduced in *Proizvedeniia zhivopisi i grafiki, peredannye A. S. Sorinoi v dar muzeiam SSSR*, an unpaginated exhibition catalog from the Tretiakov Gallery (Moscow, 1973). Fainberg is probably referring to the same portrait in entry 121a.

2. Stanza 3, line 4 ("Tigrinyi vzor orlovyi ranit") carries a deliberate play on the words *tiger* and *eagle*; i.e., in normal Russian the line would read "Tigrovyi vzor orlinyi ranit."

3. The reference to "Prince Obolensky" is presumably to one of Sorin's aristocratic portraits. Sorin and the Sudeikins were in close touch with Prince Vladimir Andreevich Obolensky (1869–1938) in the Crimea in 1917 and 1918, and Vera's Diaries contain several references to him, e.g., "Sorin took me to the Obolenskys to show me his finished portrait of the Prince, but it did not move me—something too bourgeois in it, despite the handsome face" (Diaries, 7 April 1918). Sorin contributed a portrait of Prince S. P. Obolensky to the "Little Circle" exhibition in Tiflis in 1919 (no. 68 in the Catalog). He also

contributed a portrait of Princess L. P. Obolenskaia (1917) to the "Art in the Crimea" show in Yalta in 1918 (no. 180 in the catalog, where it is described as the property of Prince A. A. Obolensky). This portrait has been reproduced in *Novoye Russkoye Slovo*, New York, 20 August 1980, p. 3. For information on the Obolenskys in the Crimea see V. Obolensky, *Moia zhizn. Moi sovremenniki* (Paris: YMCA, 1988), pp. 574–751.

4. A reference to the monk and hagiologist Nestor (ca. 1080), who chronicled the lives of the martyred princes Boris and Gleb and St. Theodosius.

5. G. Ivanov, *Peterburgskie zimy* (New York: Chekhov, 1952), p. 89.

6. S. Gorodetsky, "Sorin," *Bratstvo*, no. 1 (Tiflis, 1920): 31.

FURTHER READING

Nothing substantial has been published either by or about Nimfa Liubomirskaia. Her poem "V sadu Allakha" was published in *Ars*, no. 1 (Tiflis, 1918): 27. Entries 18 and 71b, here, contain her portrait.

11 Nikolai Minsky (1920)

Concerning My Verses

Heralds, step into the world, know
That sufferings and deceptions are now ended
And that Izoldas do not have to lie about life
And that Tristans need not grieve.

It is you, O many breasted, O you
In love with weary dawns,
It is you, Astarte, that young Romeos
And Juliets, too, openly will serve.

Scorning the laws of the jealous soul
The body will submit only to its own,
And, in hiding, Othello will be glad,
As he hears Desdemona's cries of passion . . .

15 July 1920 N. Minsky
Paris

Ink on rice paper page.

The exact occasion for this entry is not known, although presumably Minsky, an old St. Petersburg acquaintance, was a frequent visitor to the Sudeikins' after they arrived in Paris in May 1920. Although of an older generation than the Sudeikins, Minsky, one of Russia's first major Jewish writers and an accomplished playwright, appealed to their Symbolist sensibility with his advocacy of the subjective experience and the supremacy of art.

Minsky, Nikolai Maximovich. Pseudonym of Nikolai Maximovich Vilenkin. Poet, essayist, dramatist, and translator. Born 1855 in Gluboko, Vilna Province; died 1937 in Paris.

1860s attended Minsk Gymnasium. 1875–79 studied at the law school of Moscow University. 1876 began to contribute essays and poems to journals, including *Vestnik Evropy* (Herald of Europe). 1880–82 lived in Paris. 1882 settled in St. Petersburg. 1883 his collection *Stikhotvoreniia* (Poems) was confiscated by the censor. 1884

published an article in which he professed individualism and self-idolatry as principal components of his worldview, which he then developed into his theory of Meonism. 1880s wrote poetry under the influence of Nikolai Nekrasov and Semeon Nadson. 1890s under the influence of Dmitrii Merezhkovsky became close to the St. Petersburg Symbolists and developed his philosophy of Monism, a combination of Nietzschean and Hindu religion. 1905 co-founder of the Religious-Philosophical Gatherings in St. Petersburg. 1909–13 lived in political exile in Paris; published a trilogy of dramas there. 1913 returned to Russia under political amnesty but departed again for Western Europe the following year. 1921 moved from Paris to London. 1922 lectured at the Haus der Künste, Berlin. 1923 returned to Paris.

FURTHER READING

Milton, E. "Vospominaniia o poete Minskom." *Novyi zhurnal*, no. 91 (New York, 1968): 141–61.

Minsky, N. M. *Polnoe sobranie stikhotvorenii.* 4 vols. St. Petersburg: Pirozhkov, 1907.

Rosenthal, B. "Vilenkin, Nikolai Maksimovich." In J. Wieczynski, ed., *Modern Encyclopedia of Russian and Soviet History* (Gulf Breeze, Fla.: Academic International Press, 1986), vol. 42, pp. 99–103.

Surkov, A., ed. *Kratkaia literaturnaia entsiklopediia.* Vol. 4, pp. 846–47. Moscow: Sovetskaia entsiklopediia, 1967.

Terras, V., ed. *Handbook of Russian Literature*, p. 283. New Haven: Yale University Press, 1985.

13a Sergei Rafalovich (1919)

A Prayer

Forgive us, Mother of God,
It will not be he who has lost the way,
Who is dusty and befouled,
And in some monstrous garb
Who will raise the burden
With his painful, calloused soul.

Forgive us, clean and sleek,
Real sweet, nice guys,
Refined and bored,
Who can't divine the water's movements
And who don't expect signs from heaven
In smoke and frenzied fire.

If we embrace, we'll not hurt ourselves.
Let problems come—we'll just pray,
We'll pay for all our sadness
And we'll hide from all our sins.
Our souls are thin-skinned.
Forgive us, Mother of God.

Have mercy upon us, but not upon him
Whose sin is coarse and patent,
Who is thirsty and chilled,

And who could be no other.
You know, Mother of God,
He has nothing to be forgiven for.

24 July 1919 Sergei Rafalovich
Tiflis

Ink on white page.

When Rafalovich arrived in Tiflis from Petrograd in 1917, he plunged immediately into cultural life, editing, publishing, lecturing, and in general serving as the literary factotum for the group of Russian writers and artists living in exile there. He followed the latest trends with great attention, as he demonstrated in his reviews;[1] and although his own style was that of a latter-day Symbolist and Decadent, he recognized the talent of the more extreme writers such as Alexei Kruchenykh and Igor Terentiev.[2] For their part, the latter tolerated him, even inviting him to take part in an avant-garde presentation in Borzhom Park, Tiflis, in August 1919.[3] On the other hand, the Futurists were not especially appreciative of Rafalovich's poetry, referring to him—along with Voltaire, Rousseau, and others—as "people of the eighteenth century."[4] He knew the Sudeikins from their St. Petersburg days, when, as early as 1911, Sudeikin had contributed illustrations to his collection of poems entitled *Speculum Animae*; and Sudeikin's 1916 painting *Babie leto* (Indian summer) (Tretiakov Gallery, Moscow) may well have been the visual inspiration for Rafalovich's comedy of the same name, published in Tiflis in 1919. Rafalovich was one of Sudeikin's most constant friends, and the two men pursued the same long itinerary from St. Petersburg and Moscow through Alushta, Tiflis, and then Paris, where, in 1921, they both attended the first meetings of the Chamber of Poets (see entries 90a–91a). Savelii Sorin painted a portrait of Rafalovich's wife, Melita Cholokashvili, in 1927.

Rafalovich included "Molitva" (A prayer) in his collection of poems called *Tsvetiki alye* (Tiflis: Kavkazskii posrednik, 1919), pp. 28–29, in which it carries a dedication to his daughter, Olga.

Rafalovich, Sergei Lvovich. Poet and playwright. Born 1873 in St. Petersburg; died 1944 in Paris.

1901 published his first collection of poetry, *Vesennie kliuchi. Stikhotvoreniia* (Vernal keys. Verse). 1900s–10s published numerous poems and plays. 1911 published *Speculum Animae*, with illustrations by Nikolai Feofilaktov, Sergei Sudeikin, et al. 1917–22 lived in Tiflis; 1918 helped Sergei Gorodetsky establish the Tiflis Guild of Poets. 1919 with Yurii Degen, Boris Korneev, and Igor Terentiev founded the Academy of Arts in Tiflis; contributed to several periodicals in Tiflis, including *Kuranty*, *Orion*, and *Ponedelnik*, and ran the Caucasian Mediator publishing house. 1920–22 directed Gorodetsky's so-called Tiflis Department of the All-Russian Union of Writers and Poets. 1922 moved to Berlin. 1923 lectured at the Haus der Künste and other institutions in Berlin. 1924 moved to Paris. Married Princess Melita Cholokashvili, famous for her literary salon in Tiflis, and continued to publish poetry and also novels.

NOTES

1. See, for example, his "Molodaia poeziia," *Kuranty*, nos. 3–4 (Tiflis, 1919): 15–18.

2. See, for example, his "Kruchenykh i Dvenadtsat," in S. L. Rafalovich, D. Burliuk, S. Tretiakov, and T. Tolstaia, *Buka russkoi literatury* (Moscow, 1923).

3. See poster advertising "The Great Corkscrews of Futurism. Kruchenykh Ilia Zdanevich Terentiev," a presentation scheduled to take place in August (day and year not indicated) in Borzhom Park, with contributions also by Nikolai Evreinov, Sergei Gorodetsky, Vasilii Kamensky, Sandro Korona, Sergei Sudeikin, and Sergei Trafalovich (sic). A copy of this poster, from the collection of the late Hélène Zdanevitch, is reproduced in the exhibition catalog *41°. Ilia i Kirill Zdanevich* (San Francisco: Modernism, 1991), p. 43.

4. A. Kruchenykh, I. Terentiev, and I. Zdanevich, *Traktat o sploshnom neprilichii* (Tiflis: 41°, 1919), p. 5.

FURTHER READING

Rafalovich was very productive, although a full bibliography of his poems, plays, novels, and reviews has yet to be published. The titles here represent the major part of his literary output in Russia and Georgia. Little, however, has been published about Rafalovich. For some information, see M. Marzaduri, ed. *Igor Terentiev. Sobranie sochinenii* (Bologna: S. Francesco, 1988), pp. 510, 518.

Babie leto. Komediia. Tiflis: Kavkazskii posrednik, 1919. (Cover by K. Zdanevich)

Buka russkoi literatury. With D. Burliuk, S. Tretiakov, and T. Tolstaia. Moscow, 1923. (Constructivist lithographs by Ivan Kliun and Gustav Klutsis.) Reprinted in 1925, with an additional contribution by Boris Pasternak, under the title *Zhiv Kruchenykh!*

Chetvertaia kniga stikhov. St. Petersburg: Shipovnik, 1913.

Goriashchii krug. Tiflis: Kavkazskii posrednik, 1919.

Khram. Melpomeny. St. Petersburg: Teatr i iskusstvo, 1902.

Marfa i Mariia. Piesa v 4 d. St. Petersburg: Dvigatel, 1914.

Mark Antonii. Poema. Tiflis: Kavkazskii posrednik, 1919. (Cover by K. Zdanevich)

Na vesakh spravedlivosti. St. Petersburg: Shipovnik, 1909.

Namestnik. Rasskaz. St. Petersburg: Goriazin, 1914.

Novaia mama i drugie rasskazy i stikhi. Moscow: Sytin, 1907.

Otvergnutyi Don-Zhuan. Dramaticheskaia trilogiia v stikhakh. St. Petersburg: Shipovnik, 1907.

Piesa. Reka idet. St. Petersburg: Merkushev, 1906.

Protivorechiia. Rasskazy. St. Petersburg: Goldberg, 1903.

Raiskie yasli. Chudo. 2 poemy. Tiflis: Kavkazskii posrednik, 1919.

Semi tserkvam. Tiflis: Kavkazskii posrednik, 1919. (Cover by K. Zdanevich)

Simon Volkhv. Tiflis: Kavkazskii posrednik, 1919.

Slova medvianye. Tiflis: Kavkazskii posrednik, 1919.

Sorvannye yabloki i drugie rasskazy i stikhi dlia malenkikh detei. Moscow: Sytin, 1908.

Speculum animae. Stikhotvoreniia. St. Petersburg: Shipovnik, 1911.

Stikhi Rossii. Paris, 1916.

Stikhotvoreniia. St. Petersburg: Shipovnik, 1914.

Stikhotvoreniia. St. Petersburg: Shipovnik, 1916.

Svetlye pesni. St. Petersburg: Sodruzhestvo, 1905.

Teatr. 5 pies. St. Petersburg: Shipovnik, 1914.

Triolety. St. Petersburg: Shipovnik, 1916.

Tsvetiki alye. Tiflis: Kavkazskii posrednik, 1919.

Vesennie kliuchi. Stikhotvoreniia. St. Petersburg: Volf, 1901.

Zerkalo dushi. St. Petersburg: Sodruzhestvo, 1914.

Zhenskie pisma. St. Petersburg: Sodruzhestvo, 1906.

Zolotaia skorb. Poema. Tiflis: Soiuz russkikh pisatelei v Gruzii, 1922.

13b Sergei Rafalovich, untitled (1919)

Mass is no longer served in the churches;
The bells will no longer ring.
Winter has passed, and spring, too;
The earth flowers and the sultry heat is triumphant.

The girls' choir has fallen silent long ago,
And yesterday wanders through the halls.
The clear chimes of the tower
Conduct a discourse with the past.

In our souls, agitated and restless,
We will find responses to it
And will maintain with careful labor
A different discourse, carefree, careless.

When the autumn wind will again lay bare
The neighboring hills
And twittering maidens will gather again
And silently we will disperse,

The church will radiate with lights
To the bronze sound of the bells;
And from every corner our actuality
Will begin to rustle like a fable.

All paths twist and turn within the gloom,
But the foreign land is gracious to us.
Bless, Saint Nina, those
Taking shelter in your house.

24 July 1919 Sergei Rafalovich
Institute of St. Nina, Tiflis

Ink on white page.

Rafalovich is describing the premises of the Institute of St. Nina, a prestigious woman's college and convent in Tiflis and (during the summer months) Kodzhory. St. Nina had been something of a patron saint of Tiflis since Alexander I had presented the Sion Cathedral with the ancient cross of St. Nina in 1801,[1] and a number of educational and philanthropical organizations in Tiflis and Baku bore her name. In July and August of 1919 Rafalovich and his family were living at the Institute of St. Nina, part of which was a guest house—where Vera also stayed in August of that year (as her Diary entry of 27 August 1919 attests). Rafalovich's poem suggests that by 1919 the school and the chapel of the Institute either were no longer functioning owing to the summer recess or were simply in a state of disrepair and general neglect. For Rafalovich's biography, see entry 13a.

15 Mikhail Kuzmin, untitled (1916)

The same dream, alive yet bygone,
Stands by and won't depart.
The window is closed tight by the shutter;
Beyond the shutter is the cool night.
The coals crackle, the stove bench is warm,
Far away a drowsy dog barks . . .
Today I got up very early
And the peaceful day passed peacefully.
The meek day is so religiously long,
Everywhere there is a gentle brilliance, and the snow, and
 the wide expanse . . .
One can read only the prologue here,
Or the Psalter of David . . .
And the heat of the stove in the tiny white room
And the ring of the night from far away
And by the flickering icon lamp
There is a hand so white!
Calming and cherishing,
Love flowers simply, splendidly,
While the snowstorm howls furiously in the field
Planting bindweeds by the window.
Driven by the downy blizzard
Live, love, do not die!
For us has come the fiery-icy
Frost-hot Russian paradise!
Ah! That there would be snow and my lover's glance,
And the tender colors of the icons,
The dream my soul has had for so long.

Copied for Serezhenka Sudeikin M. Kuzmin
1916

Ink on two sides of paper attached by paper hinges to the Album between pp. 14 and 15. 16.1 × 12.2 cm.

Kuzmin was one of Vera's favorite poets.[1] This untitled piece was first published in *Lukomorie*, no. 45 (Petrograd, 7 November 1915): 1, and then in M. Kuzmin, *Vozhatyi* (St. Petersburg: Prometei, 1918), pp. 51–52, where it is dated "1915. August." The poem was also published in *Orion*, no. 6 (Tiflis, 1919): 3. It is one of three manuscript poems by Kuzmin in Vera's Album and related papers, the other two being "Chuzhaia poema" (Another's poem), given as entry 17a here, and "Gospod, ya znaiu, ya nedostoin" (Lord, I know, I am unworthy).[2] The fact that Vera preserved and quoted from them throughout her long peregrinations indicates the closeness of Kuzmin to both Vera and Sergei. Furthermore, Vera transcribed other poems by Kuzmin, both in the Album (see entry 31b) and in her Diaries.

There are many examples of Kuzmin's cultural and sentimental proximity to the Sudeikins, not least Sudeikin's several portraits of the writer[3] and his illustrations for several of Kuzmin's texts, including *Kuranty liubvi* (Chimes of love), of 1910, and *Venetsianskie be-*

zumtsy (Venetian madcaps), of 1915. Sudeikin also decorated various related productions, for example, Vsevolod Meierkhold's production of Calderon's *Adoration of the Cross* at Viacheslav Ivanov's Tower in St. Petersburg in 1910 (in which Kuzmin acted), the production of *Venetian Madcaps* at the Nosovs' House in Moscow in 1914,[4] and the puppet production of Kuzmin's *Christmas Mystery* at the Stray Dog in 1913.[5] The Sudeikins and Kuzmin were keen supporters of the Stray Dog and Comedians' Halt, and if Sudeikin was one of the Stray Dog's muralists, Kuzmin was the author of its "Hymn."[6]

In this untitled poem with its references to the prayer book, the stove, and the icon lamp, Kuzmin seems to be depicting the two-room apartment that he rented in Viacheslav Ivanov's St. Petersburg apartment by the Tauride Garden (cf. entry 25a). Georgii Ivanov, one of Kuzmin's admirers, has left the following description of that ambience:

> The rooms are small. Foldaway furniture. Snapshots of Botticelli on the walls: tender, melancholy child-angels against the background of a soft, paradise-on-earth landscape. A lot of books. If you look at the backs, you find a very varied selection. Lives of the saints and the notes of Casanova, Rilke and Rabelais, Leskov and Wilde. Unfolded on the table is an Aristophanes in the original. A blue "bishop's" icon lamp hangs in front of the darkened icons in the corner. There is the mingled smell of perfume, tobacco, and a snuffed wick. Overheated. Very bright from the winter sun.[7]

Kuzmin's copying of the poem for "Serezhenka Sudeikin" is not fortuitous, for it indicates the more-than-amicable relationship that they enjoyed, as does the eager sentiment of the poem itself. Sudeikin's and Kuzmin's affair began in 1908, when the latter was living in the same apartment as Sudeikin and his first wife, Olga Glebova, whom he had married just the year before. Needless to say, Sudeikin's newfound love was too much for Glebova: "One day, by chance, Olga came upon the poet's diary and could not resist the temptation to read it. From that moment on there could no longer be any doubt about the spirit of the sentiments that joined the two men. Totally upset, Olga asked her husband for an explanation and demanded that Kuzmin leave their home."[8] But in spite of this contretemps, Kuzmin, Sudeikin, and Glebova continued to maintain a productive, professional relationship, collaborating on many ventures—plays, musical evenings, poetry declamations—especially at the St. Petersburg cabarets. For example, Sudeikin portrayed Glebova in the main role of Yurii Beliaev's vaudeville *The Muddle-Headed Woman; or, the Year 1840* of 1910, which Kuzmin praised very highly in his review.[9] Glebova also played in Kuzmin's pantomime *Venetian Madcaps*, with decorations by Sudeikin, at Evfimiia and Vasilii Nosov's Moscow mansion in 1914,[10] and she was much appreciated for her excellent recitations of Kuzmin's poetry at the Stray Dog and the Comedians' Halt. Some of Sudeikin's vignettes in the Album (e.g., entry 128) contain references to Glebova, and Vera even included three photographs of her posing in Sudeikin's costumes (en-

tries 100a–c); as late as 1922 Kuzmin dedicated his poem "Paraboly" (Parabolas) to Glebova. For her part, Vera never lost an opportunity to recite Kuzmin's poetry to guests at her various residences, whether in Miskhor, Tiflis, Paris, or New York.

Kuzmin, Mikhail Alexeevich. Poet and composer. Born 1872 in Yaroslavl; died 1936 in Leningrad.

Ca. 1900 studied music under Nikolai Rimsky-Korsakov; attended St. Petersburg University; and traveled in Egypt, Italy, and northern Russia. 1905 began to publish. 1900s at first much influenced by the Symbolists, contributing to journals such as *Vesy* (Scales); resided in Viacheslav Ivanov's tower apartment in St. Petersburg. 1908 had an intimate relationship with Sergei Sudeikin. 1910s had a number of literary protégés, including Yurii Degen, Georgii Ivanov, and Yurii Yurkun; played an active role in the events of the Stray Dog and Comedians' Halt cabarets. 1912 co-signed the Acmeist manifesto. 1916 composed the music for the production of Ilia Zdanevich's *Yanko krul albanskai* (Yanko, King of Albania) at Stefania Essen's house in Petrograd. 1919 contributed to Yurii Degen's *Neva. Almanakh stikhov* (Neva. Almanac of verses), published by Feniks in Tiflis.

NOTES

1. This was in response to a questionnaire that Vera, Sergei Sudeikin, Rimma and Leonid Brailovsky, and others compiled in Miskhor the evening of Saturday, 14 December 1918. In response to the question "Who's your favorite poet?" Vera answered, "Kuzmin and Blok. Riurik Ivnev" (see entry 97a); Rimma Brailovsky answered, "Beginning in December, Voloshin"; and Sudeikin answered, "Voloshin. Blok's 'The Twelve.' Anatole France's 'La Révolte des Anges.'" In response to the questions "Where would you like to live?" and "Who's your favorite woman in literature?" Vera answered, "In a villa in Moscow near the Sukharev Market" and "Ninon de Lenclos." She hastily jotted down these questions and answers in pencil on the back of her Diary entries for 14 and 15 December 1918.
2. Lord, I know, I am unworthy.
 In my heart I believe, and my belief is strong,
 One day I shall be a warrior for the Lord,
 But for the moment my hand is so weak.

 I see your dawn breaking;
 Your breath freshens me, your slave,
 But the soft light caresses your day so sweetly
 That the heart tarries to fly ahead.

 I am moved by the plowed field,
 By the brook on the road in the shadow of the birch trees,
 By the open tollgate, like some marvelous wayfarer,
 And by the smell of the rye that the wind has brought.

 Poor and powerless I still cry,
 As when a child is slapped on the cheeks
 Or when, beseeching a crust of bread,
 One hears the answer dry: "I shall not give."

 I am still agitated by the sigh of mutiny
 —Lord, save me from those sighs!—
 When I hear the tender call
 Of Mozart or of Debussy.

I can still forget my grief
And my eye catches fire with hope,
When I smell the sea
And dream of you, Bosphorus!

But I worry still, am still tormented, grow dumb,
—Lord, guard over my happiness—
I still do not venture to be light
Where footsteps should be winged.

I still believe in the spring flood,
I love the levkas and the red copper,
I still find it tedious to be just—
I want to burn with magnanimity!

The single sheet of ruled paper (25.6 × 20.5 cm) written on both sides in black ink and signed "M. Kuzmin" is in the Varia. "Levkas" is one of the basic ingredients used in the making of traditional icons; "red copper" refers to the base metal often used in icon frames. The poem was first published in octets, not quatrains, in Kuzmin's *Vozhatyi* (St. Petersburg: Prometei, 1918), pp. 14–15, where it is dated 1916.
3. See, for example, the pencil portrait by Sudeikin (ca. 1915) in the Sudeikin archive in RGALI, call nos. f. 947, op. 1, ed. khr. 300 (1), l. 426.
4. Kuzmin also composed the music for this production of the pantomime, in which, incidentally, Olga Glebova also performed.
5. For more information on Kuzmin, Sudeikin, and other artists in the context of the theater see M. Green, "Mikhail Kuzmin and the Theater," *Russian Literature Triquarterly*, no. 7 (Ann Arbor, 1974): 243–66.
6. Kuzmin's "Hymn" is published in B. Livshits, *Polutoraglazyi strelets* (Leningrad: Izdatelstvo pisatelei, 1933), pp. 259–60, and in the English translation by J. Bowlt, *The One and a Half–Eyed Archer* (Newtonville, Mass.: Oriental Research Partners, 1977), pp. 215–16.
7. G. Ivanov, *Peterburgskie zimy* (New York: Chekhov, 1952), p. 129.
8. Quoted from E. Moch-Bickert, *Kolumbina desiatykh godev* (Paris and St. Petersburg: Grzhebin, 1993), p. 44.
9. M. Kuzmin, "Khronika," *Apollon*, no. 4 (St. Petersburg, 1910): 78. For a reproduction of Sudeikin's portrait see D. Kogan, *Sergei Sudeikin* (Moscow: Iskusstvo, 1974), p. 51.
10. For information on this presentation see Yu. Podkopaeva and A. Sveshnikova, eds., *Konstantin Andreevich Somov* (Moscow: Iskusstvo, 1979), p. 538. Three of Sudeikin's costume designs for the *Venetian Madcaps* are reproduced in *Apollon*, nos. 8–10 (Petrograd, 1917): between pp. 16 and 17, 20 and 21, 24 and 25.

FURTHER READING

Kuniaev, S., ed. *M. Kuzmin. Stikhotvoreniia i poemy.* Moscow: Molodaia gvardiia, 1992.

Kuzmin, M. A. *Kuranty liubvi.* Moscow: Skorpion, 1910. (Illustrations by Nikolai Feofilaktov and Sergei Sudeikin)

———. *M. Kuzmin. Proza. V 11-ti tomakh.* With an intro by V. Markov. Berkeley: Berkeley Slavic Specialities, 1984–90.

———. *Osennie ozera.* Moscow: Skorpion, 1912. (Cover by Sergei Sudeikin)

———. *Sobranie sochinenii.* 9 vols. Petrograd: Semenov, 1914–18.

Lavrov, A., and R. Timenchik, eds. *M. Kuzmin. Izbrannye proizvedeniia.* Leningrad: Khudozhestvennaia literatura, 1990.

Malmstad, J., and V. Markov, eds. *Mikhail Kuzmin. Sobranie stikhov.* 3 vols. Munich: Fink, 1977.

Malmstad, J., ed. *Studies in the Life and Work of Mixail Kuzmin.* Vienna: Wiener Slavistischer Almanach, 1989.

Morev, G., ed. *Mikhail Kuzmin i russkaia kultura XX veka.* Leningrad: Akhmatova Museum, 1990.

Nikolaev, P., et al., eds. *Russkie pisateli, 1800–1917. Biograficheskii slovar.* Vol. 3, pp. 204–7. Moscow: Bolshaia russkaia entsiklopediia, 1994.

Surkov, A., ed. *Kratkaia literaturnaia entsiklopediia.* Vol. 3, p. 875. Moscow: Sovetskaia entsiklopediia, 1966.

Terras, V., ed. *Handbook of Russian Literature*, pp. 239–40. New Haven: Yale University Press, 1985.

16 Vera Sudeikina, untitled (ca. 1920)

Watercolor on paper glued onto white page. 21 × 16.3 cm. Signed in watercolor at the bottom left corner with the monogram "V.S." in Latin letters.

Although undated, this piece would appear to be one of the many embroidery designs that Vera and her friends and such colleagues as Rimma Brailovskaia, Olga Glebova, Pavel Kuznetsov, and Konstantin Somov made and exhibited during the 1910s and 1920s. Vera liked embroidering and sewing and often referred to these pastimes in her Diaries. The pastoral motif is typical of the vocabulary preferred by the World of Art and Apollo circles in St. Petersburg; and amid the classical imagery of his "Tristia 3" Osip Mandelstam celebrated Vera "who embroidered oh, so long."[1]

Sudeikina, Vera Arturovna. Actress, painter, and designer. Born 25 December 1888 at the family home at 5, Pecochnaia Street, St. Petersburg, to Henriette de Bosset (a Swede, *née* Malmgren) and Artur de Bosset (a Frenchman); died 17 September 1982 in New York.[2]

1898 onward grew up on the family estate at Gorki in Novogorod Province; was educated by governesses in music, German, and French. 1900 moved with her family to Kudinovo, north of Moscow, where Artur de Bosset owned the Kudinovo Electric Charcoals Factory, which manufactured coals for arc lighting and welding. 1901–5 attended Mariia Pussel's Women's Gymnasium in Moscow, where she demonstrated a particular interest in the theater and a talent for music, taking lessons from Rudolf Erlikh, Alexander Krein, and David Shor. Ca. 1910–12 attended Berlin University, studying philosophy and science and attending the anatomy lectures of Rudolf Virchow; after her first year she switched to art history, attending Heinrich Wölfflin's lectures.[3] 1910 married a certain Mr. Luryi. 1912 (November) saw the Ballets Russes in Berlin; returned to Moscow, where she married Robert Shilling, a Balt. 1913 (spring) eloped with Sudeikin to Paris (allegedly). 1913–14 attended classes at Lidia Nelidova's Ballet School in Moscow; met Sergei Diaghilev and Michel Fokine. 1914 returned to Moscow, cohabiting with Sudeikin; began her movie career under the direction of Yakov Protozanov, starring in such hits as *Arena of Revenge*, *Drama on the 'Phone*, and *If a Woman Wants, She Will Outwit the Devil*. 1915 starred as Helen in Protozanov's movie of *War and Peace*; hired by Alexander Tairov as an actress for his Chamber Theater, where she performed in a Spanish dance supplement to *Le Mariage de Figaro*. 1916 (15 March) moved with Sudeikin to Petrograd, where they took an apartment in the same building as the Comedians' Halt, before moving to another apartment on the Ekaterinskii Canal. 1917 (February) with Sudeikin went to Moscow and obtained a legal separation from Shilling; returned to Petrograd and then (April) returned to Moscow. 1917 (summer) departed from Moscow for the Crimea with Sudeikin. 1917 took up residence in Alupka and then in Yalta; moved to Miskhor. 1918 (January) mother arrived from Moscow; married Sudeikin (24 February) in Miskhor; contributed twenty silhouettes based on Sudeikin's motifs to the "Art in the Crimea" exhibition (October) in Yalta. 1919 (April) left the Crimea, via Novorossiisk, for Constantinople, arriving instead at Batum, whence she and Sudeikin journeyed to Tiflis; rented an apartment on Griboedov Street. 1919 (December) arrived in Baku. 1920 (20 May) arrived with Savelii Sorin and other friends in Paris. Ca. 1920 Artur de Bosset moved to Santiago, where he lived until his death in 1937. 1921 (19 February) Sergei Diaghilev invited Vera to dine with Igor Stravinsky; (November) danced the Queen in *The Sleeping Princess* (*Sleeping Beauty*) for the Ballets Russes at the Alhambra Theater, London. 1922 (May) quarreled with Sudeikin; Sudeikin left (19 August) for the U.S.; 1920s onward Vera designed costumes and accessories for Diaghilev's Ballets Russes and other enterprises. 1925 (December) mother returned to Moscow after a short visit. 1939 (September) Stravinsky departed for the U.S. 1940 (January) Vera departed for the U.S.; marriage with Sudeikin dissolved officially (5 March). 1941 Vera saw Sorin and Sudeikin (22 January), for the first time since Paris, at a performance of George Balanchine's *Balustrade* in New York; the following day they met for the last time.[4]

NOTES

1. See entry 51a and V. Stravinsky and R. Craft, *Stravinsky in Pictures and Documents* (New York: Simon and Schuster, 1978), p. 239.

2. For more information on Vera's family and early life see Stravinsky and Craft, *Stravinsky in Pictures and Documents*, pp. 233–40. Little is known of the family relatives, although a certain Alexander F. Bosse (= Bosset?) was active in St. Petersburg theatrical circles in the 1870s and wrote a book called *Chastnye teatry i frantsuzskie artisty v Peterburge* (Private theaters and French actors in St. Petersburg) (St. Petersburg: Khan, 1878). There was also a Garald Ernestovich Bosse (1812–94), who achieved some recognition as an architect in St. Petersburg. For information on him see *Pamiatniki kultury. Novye otkrytiia. Ezhegodnik 1988* (Moscow: Nauka, 1989), pp. 432–46. One of Vera's younger brothers, the cellist Evgenii Malmgren, employed the young Igor Stravinsky as piano accompanist around 1900.

3. There is a discrepancy in the dates of Vera's enrollment at the University of Berlin. In her Diaries (14 September 1918) she mentions being in Berlin in 1907; and according to V. Stravinsky and R. McCaffrey, eds., *Igor and Vera Stravinsky: A Photograph Album, 1921 to 1971* (London: Thames and Hudson, 1982), p. 40, she entered the University of Berlin in 1908; but according to E. Berman et al., *Fantastic Cities and Other Paintings: Paintings by Vera Stravinsky* (Boston: Godine, 1979), p. 69, she studied there from 1910 to 1912.

4. Also see the Sergei Sudeikin biography in entry 1b.

FURTHER READING

Berman, E., et al. *Fantastic Cities and Other Paintings: Paintings by Vera Stravinsky.* Boston: Godine, 1979.

Craft, R., ed. *Dearest Babushkin: The Correspondence of Vera and Igor Stravinsky,*

1921–1954, with Excerpts from Vera Stravinsky's Diaries, 1922–1971. London: Thames and Hudson, 1985.

Stravinsky, V., and R. Craft. *Stravinsky in Pictures and Documents.* New York: Simon and Schuster, 1978.

Stravinsky, V., and R. McCaffrey, eds. *Igor and Vera Stravinsky: A Photograph Album, 1921 to 1971.* London: Thames and Hudson, 1982.

17a Mikhail Kuzmin (1916)

To dear S.Yu.S. and V.A.B.

M. Kuzmin, for Easter, 1916

Another's Poem

1

In the autumnal dream this word resounded:
"The moon has arisen, yet Donna Anna is not here!"
Distant and mysterious greeting—
Do you now promise me an end or a beginning?
I waited long, I waited so many years,
To glimpse you as a fleeting shadow,
As a pale light amid branches above the water,
As an echo to a tree stump gone astray—
Once again I am devoted to love and to a strange excitement.

2

I thought that Donna Anna
Would meet me amid the trembling mist,
Tearstained, beautiful, and desired,
Of whom Don Juan no longer dreams.
The brazen deceit has been broken by the heavens,
The piercing and sulphuric smoke has dissipated,
And peace has forever been bestowed upon the
 Commendatore . . .
One movement of your gazellian eyes—
And I am at your feet, fickle and yet true.

3

These dreams came true—but as a phantasm!
The Russian autumn, almost winter,
The white sky above. . . . You appeared
On high (the houses are still standing).
Oh, Donna Anna, you are so pale,
And not only I am pale from this meeting.
I remember the strange fringe along
Your dress. . . . How barren is our reason!
Yet the voice sang so vivid and so triumphant in the heart.

4

Oh, heart, perhaps it would be better not to dream!
Spain and Mozart—*Figaro!*
The crazy day of the splendid wedding,
The different lights burning so brightly.
That day Destiny laughingly entrusted

Me with Harlequin's conic feather.
And dealt the Tarot in a new way.
Some mysterious force
Guided me, loved me, taught me.

5

Indeed, I myself created Negroes and Spaniards
And poured forth for you the magic of the astral spheres.
The luxury of the grape-beclustered tapestries
Grows blue for your fiery and rapid dances.
They are mine . . . mine! In vain does the cavalier
Shake your hand, but your gaze is strange.
From the languor of our manners I realize that
I am Figaro, and you—you are Donna Anna.
No, Don Juan is not here, and Susanna will not come!

6

Hurry, hurry! How pink is the cold!
How clearly the cupolas of the Kremlin burn!
He who has loved as I have, he who has been young,
Can still remember Hunters' Row.[1]
Some kind of Russian, warm, and somnolent poison
Links me to an Old Believer's soul.[2]
Here is the corridor, the icon lamp. . . . Someone is asleep,
Kissing . . . moaning . . . the heat curls gray. . . .
Behind the curtain there she is—my Venus.

7

So fugitive . . . the next morn you ran away
(Lord, oh, Lord, can you not have pity on her?)
And pressed your face so dolefully
To the Italian ironwork and looked into the distance.
A single tear, like some grave sadness,
Rolled heavy and leaden from your eyelids. . . .
Whether or not the dawn was in the sky
You did not know, and you did not turn . . .
Fixing your eyes and soul upon the Cathedral of the
 Assumption.

8

The black cape gripped your shoulders tightly
And motionless you raised your glance
To the holy candles of the Cathedral of the Annunciation
As if you could not stir.
And a golden, hammered mist
Took you, so felicitous, and placed you in a frame.
The heavy needle of your eyelashes
Lay down in touching astonishment.
And three grew mesmerized in the flickering languor.

9

And still besprinkled by the golden dust
(Oh, winter sun, play on, play on!)
You came to me: the fable became reality.

And the Russian paradise flung open the gates.
Blessed is this dear land of snow
And the roses on the pot-bellied teapot!
Breathe into me and sweetly die!
Let every atom of your body grow numb!
It was you that led me to the Russian paradise.

10

Do you remember that moment? We had both grown silent.
Your eyes, big and dark, were laughing:
"No, my friend, you must forget your grief!"
And you nudged me tenderly.
A tender column of smoke soared above us,
Bearing aloft two hearts, two hearts like icon lamps.
And their light is so warm, so deep,
And the days beneath them so slow and sweet—
And I fathomed the allusion of the charming enigma.

11

Oh, Donna Anna, oh, my Venus,
How can I record your strange visage?
What is its law, its measure?
It is aflame, it is mysterious, and great.
Can the call of the swan be painted?
I stand before you, my arms folded
Like those of devout and beggar pilgrims.
I do not sing, and yet I hear your sounds
That carry all—hell, paradise, snow, passion, and torment

April, Easter, 1916 M. Kuzmin

Ink on eleven sides of four double pages attached by a ribbon to Album leaf.
Each double page is 21.3 × 31 cm.

Kuzmin wrote "Another's Poem" as an Easter present for the Sudeikins in 1916 (the dedication is to Sergei Yurievich Sudeikin and Vera Arturovna Bosset), and it contains many private references to their romance. This version omits stanza 11, which appears in the published text (so that the present stanza 11 becomes 12 in the published version):

But still you are a foreigner in my land,
And you cannot be of Russian kin,
I feel that even when you depart for your
Homeland, you will not forget her.
Into the land of days to come and unbegun
You bear a culture divine
Through time. Sweeter and freer
Do I see the man of the future.

Although neither this piece nor the other Kuzmin manuscripts in Vera's legacy (see entry 15) relates directly to the Tiflis-Baku journey, it is clear that Vera held Kuzmin's poems very dear, preserving two of them in her Album. She recalled, for example, that in Yalta while Sudeikin worked she would read to him "poems by Viacheslav

Ivanov, Kuzmin, and Mandelstam; and 'Another's Poem' composed especially for us." She also read the poem to her many visitors in the Crimea, such as Vladimir Pol and Anna Yan-Ruban; and Sudeikin even wanted to paint the sections of the poem. As John Malmstad has explained in his annotations to Kuzmin's poetry, "Another's Poem" contains a number of direct and indirect references to Vera's activities and interests in 1915–16, not least her brief acting career in Alexander Tairov's Chamber Theater. Sudeikin was then designing a production of Beaumarchais's *Le Mariage de Figaro* (with incidental music by Mozart) and persuaded Tairov to include a separate Spanish dance for the beautiful Vera—hence Kuzmin's reference to "Spain and Mozart—*Figaro!*" Malmstad writes:

> The references to Donna Anna, who, of course, does not appear in Mozart's *Le Nozze de Figaro* but in *Don Giovanni*, are also explainable. Sudeijkin . . . referred to himself throughout the courtship as Figaro, but felt the name Susanna did not suit Vera Arturovna's special beauty. So he began to call her Donna Anna but refused to allow her to address him as Don Juan, as he felt the Don unsympathetic. The romance began in September and continued throughout the autumn and winter. Their favorite place for rendezvous was the Kremlin, especially its great cathedrals, and this too is reflected clearly in the poem (the Uspenskij and Blagovescenskij cathedrals are mentioned by name), as is even the black "šubka" [or, rather, "plat"—cape or shawl] she wore at the time.[3]

Clearly influenced by his mentor's art, Yurii Degen seems to have had Kuzmin's poem in mind when he wrote "Another's Muse" (entry 27).

For Kuzmin's biography, see entry 15.

NOTES

1. Hunters' Row (Okhotnyi riad)—in Soviet times, Marx Prospect, and now again called Hunters' Row—was a market district in downtown Moscow.
2. The Old Believers were members of the Russian Church who disagreed with ecclesiastical reforms instituted by the Patriarch Nikon in the mid–seventeenth century. The general policy of the Old Believers, who were from all classes, was to maintain, despite forceful opposition, the rich, Byzantine traditions of the Church, something that affected considerably the outward appearance of their dress, icons, and so on.
3. J. Malmstad and V. Markov, eds., *Mikhail Kuzmin. Sobranie stikhov* (Munich: Fink, 1977–78), vol. 2, p. 657; also quoted in V. Stravinsky and R. Craft, *Stravinsky in Pictures and Documents* (New York: Simon and Schuster, 1978), p. 238. The Uspenskij and Blagovescenskij cathedrals are the Assumption and Annunciation Cathedrals, respectively. (Osip Mandelstam also referred to the Cathedral of the Assumption and Vera's *shubka*, or fur coat, in his poem "In the Polyphony of the Maidens' Choir"; see entry 111a.) Malmstad verified this interpretation of the Kuzmin poem in a personal conversation with Vera on 7 May 1970. The problem with this explanation, however, is that it calls into question the date of Vera's encounter with Sudeikin: traditionally, the beginning of their relationship is placed in early 1913, when the couple is supposed to have eloped to Paris (see, e.g., V. Stravinsky and R. McCaffrey, eds., *Igor and Vera Stravinsky: A Photograph Album, 1921 to 1971* [London: Thames and Hudson, 1982], p. 42).

17b Sergei Sudeikin, portrait of Vera Sudeikina (1918)

Ink, pencil, and gold on ruled paper laid on board and glued onto white page. Inscribed "1918" in pencil at lower right on the board. Mounted, 15.9 × 13.5 cm; unmounted, 13.7 × 11.9 cm.

The model is clearly Vera Sudeikina. Sudeikin and other artists often portrayed her in this fashion, that is, in profile, wearing a kerchief (cf. entries 46 and S1). Vera had a collection of "Moscow kerchiefs," and several times in her Diaries she mentions posing for Sudeikin, wearing a kerchief (e.g., her entry for 6 August 1918). This portrait is reproduced in V. Stravinsky and R. McCaffrey, eds., *Igor and Vera Stravinsky: A Photograph Album, 1921 to 1971* (London: Thames and Hudson, 1982), p. 44, where the location is given as Yalta.

For Sudeikin's biography, see entry 1b.

18 Sergei Sudeikin, portrait of Nimfa and Sergei Gorodetsky (1920)

Watercolor, ink, and pencil on white page. Inscribed "Drawn in Baku 1920" at the lower right in black ink over blue ink.

The man in the drawing—with his big nose and pipe—is clearly Sergei Gorodetsky (see entry 5b and cf. Gorodetsky's self-portrait in entry 113; also see entry 107a). Contemporaries commented on Gorodetsky's "lanky" figure and his "no less lanky nose"; see V. Piast, *Vstrechi* (Moscow: Federatsiia, 1929), p. 69. Presumably, the femme fatale is his wife, the poetess Nimfa Bel-Kon Liubormiskaia (see entry 7a), who appears in a different guise in another of Gorodetsky's pictures later in the Album (entry 71b).

For Sudeikin's biography, see entry 1b.

19 Sergei Gorodetsky (23 May 1919)

To V. A. and S. Yu. Sudeikin

Most tender Kuzmin, Mandelstam the tree trunk[1]
Have blessed your morose coziness.
And I, entering your cellar,[2] like a quiet temple,
Will raise the loud voice of the bell!
Ring with your heart, sound with your eyes,
The Venus Vera,* maiden of three canvases,[3]
And you, Sergei, perspicacious yet somnolent,
Are in the magic suite by the very rainbow.
You were angels in the white world,
Schumann saw you in the brilliance of the carnival[4]
Moscow pealed its red ringing above you,[5]
You darted through the lyre of four poets,[6]
And here you are: I know no brighter *intérieur*—
The gilt of antique cups,
The brush scratching and the strawberries glowing,

Three radiant faces gazing from the walls,
And delighting in this is an Invisible Someone
From the unfathomable celestial space.

* Another version: Anna[7]

Tiflis Sergei Gorodetsky

Ink on rice paper page.

According to Vera's Diaries, the Sudeikins renewed their acquaintance with Gorodetsky in Tiflis on 2 May 1919, and they continued to meet regularly at the same cafés, cabarets, and exhibitions. Although they had all known one another from the St. Petersburg and Moscow years, Vera seems not to have had complete trust in Gorodetsky, since "he's capable of anything," as she stated in her Diaries (19 May 1919); and it was perhaps with reason that she suspected his ideological and cultural promiscuity. Still, Gorodetsky was much attracted by Sudeikin's painting, and his own pictorial style, with its bright colors and ingenuous subjects, betrays Sudeikin's influence.

For Gorodetsky's biography, see entry 5b.

NOTES

1. A play on the surname of Osip Mandelstam: *shtam/Stamm* (German) = trunk; Mandelstam = "almond tree trunk." Both Kuzmin and Mandelstam dedicated poems to the Sudeikins (see entries 17a and 51a).

2. Presumably a reference to the Sudeikin's apartment on Griboedov Street in Tiflis. In her Diaries (6 May 1919) Vera described their modest abode, mentioning that it had "lots of defects."

3. Contemporaries often referred to the passionate Vera Arturovna as Venera Amurovna (literally, "Venus, daughter of Cupid"). According to her notes in the Varia, Sudeikin even painted a portrait of her called *Venera Amurovna* in 1917, which may be the same work as the *Venus* that she mentions several times in her Diaries (see entry 37b). With all due respect to Vera, however, she was not the only Venus that Sudeikin portrayed; for we recognize Olga Glebova's features in the work called *Russian Venus*, reproduced in *Vesy*, no. 9 (Moscow, 1908): 51. Also see entry 37b.

4. Sudeikin painted a large painting called *Carnaval* (together with many studies on the same theme), which, according to Gorodetsky, was a "colorful illustration to Schumann's compositions." "Rabotniki iskusstva na yuge (interviu, vziatoe redaktsiei u S. M. Gorodetskogo)," in *Zhizn iskusstva* (Moscow, 1920). Quoted in D. Kogan, *Sergei Sudeikin* (Moscow: Iskusstvo, 1974), p. 137. In her Diaries for 1918 and 1919, Vera mentions this magnum opus many times, asserting that it was the hit of the "Art in the Crimea" exhibition in Yalta in October–November 1918 and at the "Little Circle" exhibition in Tiflis in May 1919. Sudeikin's picture was actually twelve colored drawings that were called *Figures of the Carnaval* (no. 212 in the Yalta catalog; one of these pieces is now in the State Museum of the Arts of Georgia, Tbilisi). Sudeikin also contributed a painting called *Russian Winter Carnival* to the "Exhibition of Russian Painting and Sculpture" at the Brooklyn Museum, New York, in 1923 (present whereabouts unknown; reproduced in the catalog). It is of interest to note that according to V. Stravinsky and R. Craft, *Stravinsky in Pictures and Documents* (New York: Simon and Schuster, 1978), p. 236, Vera's first encounter with the Ballets Russes was a performance of *Carnaval* in Berlin (orchestrated by Alexander Glazunov) in November 1912 and that the first production at the theater that Sudeikin was planning in Yalta prior to his departure for Tiflis was *Carnaval*. He mentioned in an interview with Yakov Lvov that "our proximity to the pianist Vladimir Drozdov, who used to play me Schumann's *Car-*

naval, the landscape of the Crimea, my love of Schumann, that herald of the new art and of the mystery that is so close to our contemporary refinedness—all this prompted me to paint my typically morose *Carnaval* with its figures frozen in ecstasy" (see Ya. Lvov, "U khudozhnika Sudeikina [beseda]," *Kavkazskoe slovo*, 11 May 1919, Tiflis). Schumann's piano solos *Carnaval: Scènes mignonnes sur quatre notes* of 1833–35 (Op. 9) and *Kreisleriana* of 1838 (Op. 16) were among the Sudeikins' favorite pieces of music, and they made continual reference to them in their conversations and works of art (the motif recurs in the Album). Undoubtedly the amorous subtext of *Carnaval*—the "four notes" are A, Es (= E♭), C, and H (= B), which spell Asch, the name of the town where Clara Wieck, Schumann's beloved, lived—must have appealed to the sentimental Sudeikins, and they extended some of the *scènes mignonnes* into their own writing and painting (e.g., no. 2, *Pierrot*; no. 3, *Arlequin*; no. 15, *Pantalon and Columbine*; and no. 18, *Aveu*). Schumann's musical rendering of the character Johann Kreisler from E.T.A. Hoffmann's stories coincided with the veritable cult of Hoffmann that the writers and artists of Russia's Silver Age maintained—reflected in Sudeikin's own tribute to Kreisler in entry 121c.

For further commentary on Sudeikin, Schumann, Schumann's *Carnaval: Scènes mignonnes*, and the carnival in general, see entries 5b, 25b, 93, and 171.

5. "Red ringing" is a translation of the Russian words *krasnyi zvon*, which were used to describe the mellow ringing of the Moscow church bells. There is perhaps an allusion here to the cathedrals in the Kremlin that Vera and Sergei Sudeikin frequented in the early days of their romance and that Mikhail Kuzmin mentioned in the poem that he dedicated to them (See entry 17a).

6. Which four poets Gorodetsky has in mind is not clear. Perhaps Yurii Degen, Kuzmin, Mandelstam, and himself.

7. In the early days of their romance, Sudeikin often addressed Vera as "Donna Anna." See entry 17a.

21–22a Sergei Gorodetsky (1919)

Corbeille des Arts

To Sergei Sudeikin

Unbridled life, all the luxury of the meadow,
Scattered images and feelings—
The laughing artist has tied them tightly
With the rawhide straps of his art.

And wearied by the imperious thirst for creativity,
So as to guard the mansion of his treasures,
In the wilderness of day and the voluptuousness of the night
He has created two mysterious monsters.

And above the star like a purple rose
A Lyre has ascended and a Mask appeared,
Corbeille des Arts—a tale of shifting arts—
On the yellow scrolls of azure antiquity.

Entwined in laurels, Theater and Music
Appeared before the world. The temples have been opened
 wide.
And marvelous flowers cherish the lyre
Nurturing the sound of epithalamiums in its strings.

Kindled by a prophetic art,
Your, my, our heart has opened up.

It sparkles like a rose and splashes boundlessly
Like Dionysus with his bottomless cup.

11 June 1919 Sergei Gorodetsky
Tiflis

Ink on red page.

The title of this poem translates as "basket of arts." The basket of flowers, often enhanced with bows and garlands, was a common motif in Sudeikin's paintings and designs. For Gorodetsky's biography, see entry 5b.

22b Sergei Sudeikin, portrait of Sergei Rafalovich (ca. 1919)

Pencil on paper glued onto white page. 15.9 × 22.6 cm. Inscribed "To Rafalovich [from] Sudeikin" in pencil at top left.

This amicable caricature of the poet, dramatist, and critic Sergei Rafalovich reveals Sudeikin's talent for satire and parody—a talent that led to more than one embarrassing moment. For commentary on Sudeikin and Rafalovich in Tiflis, see entry 13a. For Sudeikin's biography, see entry 1b. For Rafalovich's biography, see entry 13a.

23a–24a Sergei Rafalovich (1917–19)

Autumn

Calm and sunny are the days
On the border between autumn and summer.
But it has become just a little cooler in the shade,
And the tardy night grows fresher before the dawn

In heavy clusters hangs the juicy vine.
An amber brilliance pours along the mountain slopes,
And the orchard burdened with gold
Burns crimson like a still bonfire at the hour before sunset.

All-knowing is the soft silence,
And the tender conciliation has no reproach.
Nature is like a woman after childbirth
Now oblivious of a tension once beloved.

How incomprehensible at this silent hour
Of obedient and deft efflorescence
Is the perturbation that grows inexorably
Alarming us without design.

Indeed, throughout this dear and native land
So familiar, so meek,
There has passed—a red bandage on his brow—
The double of Christ, benumbed and corrupt.

For this moment of doubt, O, Lord, forgive.
The fire blinds and the thunders deafen.

But even in tempests this earth, so meek, so familiar,
Will not fail to flower.

 Sergei Rafalovich
June 1919 September 1917
Tiflis Alushta

Ink on white page.

This poem carries two dates and two locations in the same ink and is accompanied by Sudeikin's illustration (entry 23b). The concluding reference to the "double of Christ, benumbed and corrupt," is presumably a reference to the forces of the Bolshevik revolution, which many regarded as the Antichrist. The associative symbology calls to mind Alexander Blok's treatment of the Christ figure at the end of his poem "The Twelve" (1918). Rafalovich wrote several poems on the subject of autumn and published a comedy called *Babie leto* (Indian summer) in Tiflis in 1919. Sudeikin had illustrated sections of Rafalovich's Decadent collection called *Speculum Animae* (Mocow: Shipovnik, 1911).

For Rafalovich's biography, see entry 13a.

23b Sergei Sudeikin, untitled (ca. 1919)

Watercolor and pencil on white page.

Although the work is unsigned, it can be assumed that this drawing of flowers and acorns, accompanying Sergei Rafolovich's poem "Autumn," is by Sudeikin. For Sudeikin's biography, see entry 1b.

24b Sergei Rafalovich, untitled (1919)

Black, heavy, still
The gloom has pressed down to the damp earth,
Only the yellow streetlights
In the darkness burn obstinately,
Each at its post,
And, as if into a pit, they throw light
Into the nocturnal emptiness.
The stars cannot be seen, there is no moon;
In the black abyss are two walls,
Their two sides coming ever closer and
Receding into the distance at an angle.
And like a hard tongue
The damp stones lay cool.

July 1919 Sergei Rafalovich
Tiflis

Ink on white page.

The opening lines of this untitled poem bring to mind Alexander Blok's "Dances of Death" (1912), especially the section beginning "Noch, ulitsa, fonar, apteka" (Night, street, streetlight, pharmacy).

For Rafalovich's biography, see entry 13a.

25a Yurii Degen (ca. 1919)

From "The Thaw" (dedicated to M. Kuzmin)

 V Strophe of Chapter I

 V

I still remember the unfinished affair:
A nervous, awkward teenager,
And on the table the calm circle cast from the lamp
The hearth, the armchair—a festival for northerners,
And the enticing deceit of parties.
The fragrant tea with the enchanting mix of
Amatory conversation. Your figure,
No longer quite so quick and even,
Was dearer to me than accepted shapeliness.
The flight of hours offered by happiness
Was, you must agree, too rapid, as if
We had only just begun our affair.
And suddenly into our calm and dreamy world
There erupted the deafening battles of the street.

 Yurii Degen

Ink on rice paper page.

Along with Georgii Ivanov and Yurii Yurkun, the "degenerate" Degen[1] was one of Mikhail Kuzmin's protégés in St. Petersburg before the Revolution and, with him, headed the homosexual literary salon known as the Marseilles Sailors. Degen's sentiment was returned by Kuzmin, and their liaison resulted in creative undertakings such as Kuzmin's musical accompaniments to some of Degen's poems[2]—as well as in emotional problems when Degen decided to marry Kseniia (see entry 63a). The ambience that Degen is describing here is probably one of Kuzmin's St. Petersburg apartments (cf. entries 15 and 27). The poem is undated but is presumed to have been written in Tiflis in 1919, where Degen remained an enthusiastic apologist of Kuzmin's poetry.[3] In fact, it is reasonable to assume that in establishing the Fantastic Tavern there in 1917, Degen was paying homage to his mentor, who had composed the hymn for the Stray Dog. Paolo Yashvili even wrote that "into the Fantastic Tavern / Kuzmin desires again to move."[4]

By 1918–19, however, Degen had developed literary interests that went beyond his apprenticeship to Kuzmin, and he broke with the Acmeism of Sergei Gorodetsky's Tiflis Guild of Poets to establish his own group, Hauberk. He became interested in Futurism, published articles on Alexander Chachikov, Ilia Zdanevich, Igor Terentiev, and others,[5] and under Alexei Kruchenykh's influence even experi-

mented with *zaum*.[6] In turn, Kruchenykh encouraged this new orientation, publishing an article on Degen in 1919,[7] even though in his later memoirs of the period he asserted that the Futurist antics in Tiflis had vanquished "The Blokists and the Yurodegeneratovs, / The Kuzmin boys and the Yurkuns."[8] Riurik Ivnev (see entry 97a) described Degen's Baku period in his memoirs, *U podnozhiia Mtatsmindy. Memuary* (Moscow: Sovetskii izdatel, 1975).

This poem was published in its entirety as Yurii Degen, *Ottepel* (Tiflis: Feniks, 1920).

Degen, Yurii (Georgii) Evgenievich. Poet. Born 1896 in Warsaw; died 1923 in Baku.

1910s lived mainly in Tiflis with frequent visits to St. Petersburg. Deeply influenced by Mikhail Kuzmin and the Acmeists, close to Georgii Adamovich and Georgii Ivanov within the Guild of Poets, and frequent visitor to the Stray Dog and Comedians' Halt cabarets. 1915 onward was closely associated with the Blue Horns group of writers in Kutaisi and Tiflis. 1916 entered the law school of Petrograd University. 1917 hosted the Petrograd literary salon known as the Marseilles Sailors, which included Adamovich, G. Ivanov, Ivnev, Kuzmin, Mikhail Struve, and Yurkun. Degen's portrait shown at Kirill Zdanevich's one-man exhibition in Tiflis. Moved to Tiflis where, with Sandro (Alexander) Korona, Degen founded the Fantastic Tavern cabaret in Tiflis. 1918 with Tatiana Vechorka founded the Studio of Artistic Prose; contributed to *Fantasticheskii kabachok*, no. 1. 1919 with Boris Korneev, Sergei Rafalovich, and Igor Terentiev founded the Academy of Arts. After breaking with Sergei Gorodetsky's Guild of Poets, founded the group *Kolchuga* (Hauberk); participated (October) in the Evening of Poetry and Music at the Tiflis Conservatory. 1918–19 worked for several Tiflis periodicals, including *Feniks*, *Kuranty*, and *Orion*. 1918–22 published several collections of poetry; married Kseniia Degen. 1919 (spring) visited Baku and returned to Tiflis in the summer. 1920 moved to Baku. 1923 with the poet Alexander Poroshin was shot by the Bolsheviks.

NOTES

1. Nikolai Evreinov referred to Degen as "the degenerate." See M. Marzaduri, ed., *Igor Terentiev. Sobranie sochinenii* (Bologna: S. Francesco, 1988), p. 549.

2. The back cover of Degen's *Poema o sontse* (sic) (Petrograd, 1918) states that sheet music, with words by Degen, is being prepared for publication by the Marseilles Sailors, including *Ne legko trekhpalubnoe sudno* (A triple-deck vessel is not easy), with music by Kuzmin, part of which is dedicated to Degen's wife, Kseniia (see entry 63a).

3. Degen published some of Kuzmin's poetry in the miscellany that he edited in 1919, *Neva. Almanakh stikhov*, published by Feniks, in Tiflis. He also published two articles on Kuzmin: "Mikhail Kuzmin," *Kavkazskoe slovo*, no. 20 (Tiflis, 1918); and "Po povodu nastoiashchei otsenki M. Kuzmina," *Kuranty*, nos. 3–4 (Tiflis, 1919): 19–20. See entry 31b.

4. P. Yashvili, "Brodiachikh i khudykh sobak" (undated), published in L. Magarotto, M. Marzaduri, and G. Pagani Cesa, *L'avanguardia a Tiflis* (Venice: Seminario di Iranistica, Uralo-Altaistica e Caucasologia dell'Università degli Studi di Venezia, 1982), p. 321.

5. See T. Nikolskaia, "Yurii Degen," *Russian Literature*, no. 23 (Amsterdam, 1988): 111.

6. Degen used *zaum*, or transrational language, in his "Poema protsessii," published in *Fantasticheskii kabachok*, no. 1 (Tiflis, 1918). See Marzaduri, *Igor Terentiev*, p. 536. He also collaborated with the *zaumnik* Igor Terentiev on *Kolumb ili otkrytie Ameriki* (1919) and published an article on Kruchenykh's *zaum*, "A. Kruchenykh—Malakholiia v kapote," in *Ars*, nos. 2–3 (Tiflis, 1918): 138.

7. A. Kruchenykh, "Poeziia Yuriia Degena," *Tiflisskii listok*, no. 267 (Tiflis, 1919): 4.

8. A. Kruchenykh, *Igor pomnish* (ca. 1934), published in Marzaduri, *Igor Terentiev*, pp. 467–69. This quotation is on p. 467.

FURTHER READING

Degen, Yu. "Kirill Zdanevich." *Feniks*, nos. 2–3 (Tiflis, 1919): 1–6.
———. "Kirill Zdanevich." *Respublika*, no. 99 (Tiflis, 1917): 4.
———. "Rozovye verbliuzhata." *Ars*, no. 1 (Tiflis, 1918): 17–25; and nos. 2–3 (Tiflis, 1918): 13–26.
———. "Vl. Gudiashvili." *Tiflisskii listok*, no. 1 (Tiflis, 1919): 3–4. Reprinted in L. Gagua, ed., *Lado Gudiashvili. Kniga vospominanii. Stati. Iz perepiski. Sovremenniki o khudozhnike*, p. 220. Moscow: Sovetskii khudozhnik, 1987.
———. *Etikh glaz. Stikhi.* Tiflis: Feniks PTRG (sic), 1919.
———. *I-yi i II-oi Manifesty Respubliki Sontsa* (sic). Petrograd, 1918.
———. *Krylatoe ditia. Povest.* Petrograd: Marselskie matrosy, 1919. (Advertised in *Poema o sontse* as "in preparation," although no published copy has been located)
———. *Leto. 1-aia knizhka stikhov.* Petrograd: Marselskie matrosy, 1919.
———. *O zolotoi Lenor (stikhi).* Tiflis, 1926.
———. *Ottepel.* Tiflis: Feniks, 1919.
———. *Poema o sontse* (sic). Petrograd, 1918. (Cover and two drawings by Igor Terentiev)
———. *Smert i burzhui. Piesa.* Tiflis: Feniks, 1919. (Cover by Kirill Zdanevich)
———. *Volshebnyi ulov. 14 stikhotvorenii.* Vetrov: Degur, 1922.
———, and Igor Terentiev. *Kolumb ili otkrytie Ameriki.* 1919. (Advertised in *Poema o sontse* as "in preparation," although no published copy has been located)
Gorodetsky, S. "Degen, Terentiev i Kruchenykh." *Kavkazskoe slovo*, no. 110 (Tiflis, 1918): 3.
Kharazov, G. "Yu. Degen. Poema o sontse." *Igla*, no. 12 (Tiflis, 1918): 8.
Kruchenykh, A. "Poeziia Yuriia Degena." *Tiflisskii listok*, no. 267 (Tiflis, 1919): 4.
Magarotto, L., M. Marzaduri, and G. Pagani Cesa. *L'avanguardia a Tiflis*, pp. 105–6. Venice: Seminario di Iranistica, Uralo-Altaistica e Caucasologia dell'Università degli Studi di Venezia, 1982.
Marzaduri, M., ed. *Igor Terentiev. Sobranie sochinenii*, pp. 535–36. Bologna: S. Francesco, 1988.
Nikolaev, P., et al., eds. *Russkie pisateli, 1800–1917. Biograficheskii slovar.* Vol. 2, pp. 92–93. Moscow: Sovetskaia entsiklopediia, 1992.
Nikolskaia, T. "Yurii Degen." *Russian Literature*, no. 23 (Amsterdam, 1988): 101–12.
Vechorka, T. "Yu. Degen. Etikh glaz." *Kuranty*, no. 1 (Tiflis, 1918): 24.

25b Yurii Degen (ca. 1919)

Carnival

　　To S. Yu. Sudeikin

Enough! Decencies aside!
Life is sacred by love alone.
Is it not the same whose nudity
Intoxicates—male or maidenly?
What is our life? A momentary delirium,
A charming ephemerality. . . .
Empty arrogance or the ascetic's vow—
To us they are inconstant!
May each of our days be merry,
Full of excitement! . . .
Why, blind Pierrot, have you hung
Your powdered nose?
Ah! You won't forget the lips
And sly laughter behind the mask. . . .
On foot or in a carriage
You will distinguish the cunning maid from a hundred more!
Harlequin is so absurdly self-important
And proud of his love.
He does not notice the terrifying phiz
Of the coming, ghastly times.
But we are masks, not poets,
Spending time on bagatelles.
We'll tell you now: he who believes
In stupid tokens is a fool.
Yes! Nobles so refined
We take this day with honor.
When life is so charming
Why should we know about tomorrow?

Masks, wake up! Or it will be too late. . . .
The merry dream is ending.
Like a piston the heart will strain,
And death will awaken you all to life.

　　　　　　　　　　　　　　　　Yurii Degen

Ink on rice paper page.

Degen knew Sudeikin from his St. Petersburg days, especially from their proximity to Mikhail Kuzmin and their mutual activities in the Comedians' Halt. Degen has left his vivid impressions of one of the cabaret evenings in August 1917 to which all three had contributed:

> You are now in the Comedians' Halt. You are struck by the tables—elongated, round, big, little, covered with colorful Galician tablecloths, by the beautifully dressed men and women sitting in antique armchairs. . . . On the right of the stage is the Sudeikin room. Painted in the style of an epoch that not so long ago had conquered the hearts of Russian artists and poets—the epoch of idyllic shepherds and shepherdesses, of charming miniatures, amazing luxury, old-fashioned gallantry, and elegant marquis and marquises. . . . You're just in time for the beginning. A Lourié minuet. The composer's at the piano, and Glebova-Sudeikina is dancing. . . . Now that the lights are back on, let's take a look at those sitting over there . . . Georgii Ivanov . . . Adamovich . . . Vladimir Maiakovsky . . . Meierkhold . . . Yurii Yurkun. . . . Finally, they roll out the piano [again], and on comes Mikhail Kuzmin. His little songs, full of that buoyancy, nonchalance, and cunning with which all his works are so replete, draw an involuntary smile from the audience.[1]

That Degen and Sudeikin had more than an artistic relationship seems clear from the allusions in "Carnival" ("Is it not the same whose nudity / Intoxicates—male or maidenly?"), although Vera's descriptions of Sudeikin in her Diaries do not refer to such an affair. Perhaps Degen is recalling a romantic moment in St. Petersburg, even though it would seem that he entered the poem in Tiflis in 1919. In any case, Degen and the Sudeikins were in constant contact in Tiflis and then Baku, for this "indefatigable fabricator"[2] was a major force in the cultural life of both cities, especially through his supervision of the Hauberk group and the Fantastic Tavern. As frequent master of ceremonies there (with Sandro [Alexander] Korona),

> Degen, rocking back and forth,
> And intolerably inspired,
> Sliding past on sharp rhymes,
> Bears us away to the kingdom of rhythm.
> And, scorning the empty and trivial world,
> Suddenly flings a screeching plate.[3]

The carnival and Schumann were constant motifs in Sudeikin's work and appear in the Album on a number of occasions.[4] One of Degen's overt references here is probably to Sudeikin's important picture *Carnaval*, which he painted in 1918 and 1919 and that had such a success at the "Little Circle" exhibition in Tiflis. In any case, Degen was especially attracted to Schumann's music and, by association, to E.T.A. Hoffmann's tales; and one of his projects had been to publish the latter's complete works in Russian translation.[5]

For Yurii Degen's biography, see entry 25a.

NOTES

1. Yu. Degen, "V Privale komediantov" (1917). Quoted in *Pamiatniki kultury. Novye otkrytiia. Ezhegodnik 1988* (Moscow: Nauka, 1989), p. 141.
2. V. Katanian, "Iz vospominanii." Quoted in L. Magarotto, M. Marzaduri, and G. Pagani Cesa, *L'avanguardia a Tiflis* (Venice: Seminario di Iranistica, Uralo-Altaistica e Caucasologia dell'Università degli Studi di Venezia, 1982), p. 264.
3. From A. Poroshin, "Fantasticheskii kabachok" (1918), in ibid., p. 318. The full poem, with annotations, appears on pp. 318–20.
4. For commentary on Schumann and *Carnaval*, see entries 5b, 19, 93.
5. For further commentary, see entries 92, 93. Also see entries 5a, 19, 109a, and 171.

27 Yurii Degen (ca. 1919)

Another's Muse

　　To Vera Avgustovna Sudeikina

I drew love on antique cups
But sad were my thoughts: even so, those women
In embroidered crinolines and with a beauty spot
On their velvet cheek are distant to me.

But I did not say: my love is a burden.
Submissive I have trodden my earthly path.
And the Muse, wondering at my constancy,
Entered my house and became my wife.

　　　　　　　　　　　　　Yurii Degen

Ink on rice paper page.

As an apprentice of Mikhail Kuzmin, Degen seems to be making a direct literary reference to his mentor's "Another's Poem" of 1916 (see entry 17a). The poem is undated but is presumed to have been written in Tiflis in 1919. It is not clear why Degen changed the dedication in the published version of his poem, although "antique cups" and "embroidered crinolines" were a distinctive part of Vera's own physical and cultural universe. If the "Avgustovna" of the epigraph is not just a slip of Degen's pen, then the poet is imparting an added gesture of admiration to his dedication, for instead of the actual "Vera Arturovna" (i.e., "Vera, daughter of Arthur") he is writing "Vera, daughter of August" or "Vera, the August." Mandelstam makes a similar play on words in entry 51a.

This poem was first published under the title "Vasha muza," but with a dedication to Sergei Sudeikin, in the miscellany *Neva. Almanakh stikhov* (Tiflis: Feniks, 1919), p. 5. The miscellany also contains poems by Riurik Ivnev, Boris Korneev, Mikhail Kuzmin, Nikolai Semeiko, and Mikhail Struve.

For Yurii Degen's biography, see entry 25a.

29 Lado Gudiashvili, untitled (1919)

Pencil on board glued onto white page. 29.6 × 20.8 cm. Signed and dated "L. Gudiashvili 1919" in pencil (in Georgian) at the lower left. The reverse of the board carries a German reproduction of furniture.

Gudiashvili was a prime mover of Georgian Modernism in 1915–19, especially through his close working relationship with the Blue Horns poets. He developed an initial sketch by Yakov Nikoladze into an impressive decoration for the Fantastic Tavern in 1917 and, with David Kakabadze, Sudeikin, and others, produced the interior design of the Khimerioni cabaret in 1919. Indeed, the scene pictured in this untitled sketch may be of the Khimerioni (see the introduction). As a result of Gudiashvili's prominence in the Tiflis bohemia, and convinced of his rupture "with all those pseudoacademic canons,"[1] Degen devoted an entire issue of *Feniks* to the artist's oeuvre.[2]

The central figure in this drawing seems to be that of Vera Sudeikina, even though it bears a striking resemblance to the audacious Georgian girl in Gudiashvili's 1919 painting *Festival* (reproduced in entry 103b). Vera was very struck by Gudiashvili's work at the "Exhibition of Georgian Painting" that she saw in Tiflis, recording in her Diaries (1 May 1919) that the "monologic Gudiashvili . . . is surely the strongest artist here." The figure of Pierrot on the left could be Titsian Tabidze. The elegant young men on the right have not been identified, although it has been suggested that they represent Titsian Tabidze and Gudiashvili;[3] the resemblance of the second one to Boris Pasternak is surely coincidental. The presence of Pierrot, who has "hung his powdered nose," on the left may be a faint echo of Sudeikin's painting *Carnaval* or even of Degen's poem "Carnival" (see entry 25b).

During this early period, Gudiashvili made many drawings incorporating the motifs of Georgian maidens and animals, and his evocations of feminine beauty bring to mind the ample odalisques of Léon Bakst, although as the critic Maurice Raynal remarked in 1925, "Despite their suppleness, Lado's individuals retain a kind of respect for the hieratic poses that—deriving from Byzantine originals—still characterize Georgian art."[4] The meticulous headdresses with Art Nouveau patterns worn by Gudiashvili's women also remind us of Aubrey Beardsley and, more topically, of Erté. Even so, Gudiashvili was praised in Paris for his exotic, oriental subjects; and in fact he never managed to adjust to Western styles, for all his debt to André Derain and Amedeo Modigliani. As the historian Georgii Lukomsky wrote in 1921, "Gudiashvili does not need Paris. He does not need Europe. Back, as soon as possible, to Georgia, to sing the praises of his native land."[5] Gudiashvili did indeed return to Tbilisi in 1926 and soon favored a full, monumental style that might have earned him the title of the "Georgian Rubens" had the quality of his work not declined substantially.

Gudiashvili, Lado (Vladimir) Davidovich. Artist. Born 1896 in Tiflis (Tbilisi); died 1980 in Tbilisi.

1910–14 attended the School for the Encouragement of the Fine Arts in Tiflis. 1914 began to teach at a local high school. 1915 first one-man exhibition in Tiflis; from this time until the end of 1919 he played a leading part in the activities of the Tiflis artistic and literary world and associated closely with the Blue Horns group. 1916 member of the Society of Georgian Artists. 1917 with Ilia Zdanevich participated in Taq'aishvilis' third archaeological expedition to the south of Georgia; member of Alexei Kruchenykh's Syndicate of Futurists. 1919 participated in the "Little Circle" exhibition in Tiflis; with Kakabadze, Sudeikin, and Kirill Zdanevich worked on mural designs for the Khimerioni cabaret and contributed to the miscellany *Melnikovoi. Fantasticheskii kabachok*; with Sigizmund Valishevsky and Kirill Zdanevich illustrated Vasilii Katanian's *Ubiistvo na romanicheskoi pochve*; left Tiflis via Batum for Turkey and Italy (November), arriving in Paris on 1 January 1920. 1920–25 lived in Paris; visited the Académie Ranson; influenced by Bakst and the general

trend toward Art Deco. 1921 member of the Chamber of Poets in Paris. 1923 painted frescoes for the Caucasian Restaurant in Paris; participated in the "Exhibition of Russian Painting and Sculpture" at the Brooklyn Museum, New York. 1925 worked for Nikita Baliev's Chauve-Souris, designing revues such as *Not Far from Tiflis*. 1926 returned to Tbilisi; gave one-man exhibition there. 1930s attempted to combine his Parisian experience with methods of medieval Georgian art. 1930s and 1940s painted portraits, illustrated books, designed many productions for the Paliashvili Theater of Opera and Ballet in Tbilisi. 1950s continued to design spectacles and to paint themes related to ancient Georgia.

NOTES

1. Yu. Degen, "Vl. Gudiashvili" (1919). Reprinted in L. Gagua, ed., *Lado Gudiashvili. Kniga vospominanii. Stati. Iz perepiski. Sovremenniki o khudozhnike* (Moscow: Sovetskii khudozhnik, 1987), p. 220.
2. *Feniks*, no. 2 (Tiflis, 1918).
3. Letter from the Georgian art historian Irina Dzutsova to John E. Bowlt, dated 10 November 1990.
4. M. Raynal, *Lado Goudiachvili* (Paris: Au Sans Pareil, 1925), p. 15.
5. G. Lukomsky in *Le Figaro*, Paris, 25 February 1921. Quoted in L. Zlatkevich, *Lado Gudiashvili* (Tbilisi: Ganatleba, 1971), p. 29.

FURTHER READING

Degen, Yu. "Vl. Gudiashvili." *Tiflisskii listok*, no. 1 (Tiflis, 1919): 3–4. (Reprinted in L. Gagua, ed., *Lado Gudiashvili. Kniga vospominanii. Stati. Iz perepiski. Sovremenniki o khudozhnike*, p. 220. Moscow: Sovetskii khudozhnik, 1987.)
Feniks, no. 2 (Tiflis, 1918). (An entire issue devoted to Gudiashvili)
Gagua, L., ed. *Lado Gudiashvili. Kniga vospominanii. Stati. Iz perepiski. Sovremenniki o khudozhnike*. Moscow: Sovetskii khudozhnik, 1987.
Gudiashvili, L. "V Parizhe." *Literaturnaia Gruziia*, no. 9 (Tbilisi, 1979): 137–52; and no. 10 (Tbilisi, 1979): 136–50.
Kagan, M. *Lado Gudiashvili*. Leningrad: Aurora, 1983.
Kobaladze, T. *Lado Gudiashvili. Tainstvo krasoty*. Tbilisi: Merani, 1988.
Lado Gudiašvili. Exhibition catalog, Complesso Monumentale di San Michele a Ripa. Rome, 1991.
Mikhailov, A. *Lado Gudiashvili*. Moscow: Sovetskii khudozhnik, 1968.
Narakidze, V. *Gudiashvili*. Tbilisi: Khelovneba, 1976.
Raynal, M. *Lado Goudiachvili*. Paris: Au Sans Pareil, 1925.
Sudeikin, S. "Georgian Artists" (in Georgian). *Sakartvelo*, no. 115 (Tiflis, 1919): 2–3. (Russian translation of section on Gudiashvili in L. Gagua, ed., *Lado Gudiashvili. Kniga vospominanii. Stati. Iz perepiski. Sovremenniki o khudozhnike*, p. 218. Moscow: Sovetskii khudozhnik, 1987.)
Zlatkevich, L. *Lado Gudiashvili*. Tbilisi: Ganatleba, 1971.

31a Sergei Sudeikin, *August in Pskov* (ca. 1919)

Watercolor and pencil on paper glued onto red page. 25.7 × 33 cm.

Sudeikin's watercolor accompanies Mikhail Kuzmin's poem of the same name (entry 31b), illustrating the central images of the lake, the windmills, the lady with the umbrella, and so on. A version of the left side of the composition is in entry S2, and Sudeikin often repeated these images in different contexts. For example, the diago-

nal composition with the galloping carriage, huddled coachman, and running dogs appears in the painting *Russian Winter Carnival* (whose present whereabouts are unknown; it is reproduced in the exhibition catalog) that he contributed to the "Exhibition of Russian Painting and Sculpture" at the Brooklyn Museum, New York, in 1923.

For Sudeikin's biography, see entry 1b.

31b Mikhail Kuzmin (ca. 1919)

August in Pskov

Merrymakers and crybabies
The bridge rattles with the hooves of goats
And the hilltops on the other side of the river
Are full of roses looking like lollipops.
Over the motley, speckled lakes
The rowers are twisting in and out. Like white, grey, and black
 pepper
Boats are peppered about.
A mill by the cliff waves its
One arm millingly.
And an amber gruel
Drips from the cloud lead-colored.
To sound from the narrow bell tower
Like a bumblebee at evening.
The busy squirrel grinds away
Grub, grub, grub.
Wind up the screw of the sail—
It'll work somehow!
On the balcony the lieutenant's wife
Has unfurled a yellow umbrella.

Ink on red page.

A similar combination of a poem about Old Russia—by Sergei Gorodetsky/Kuzmin accompanied by an illustration by Sudeikin—is to be found in entries 35a and b. Kuzmin (or Vera, who transcribed the poem) seems to have omitted punctuation (periods and commas) deliberately in order to emphasize the conglomeration and constant flow of rich images and activities in the merry month of August. However, Gorodetsky regarded these devices as part of a Futurist pastiche written by someone "occupying an intermittent position between Kustodiev and Larionov."[1]

This poem was first published (with slight variations) in *Birzhevye vedomosti*, Petrograd, 25 August 1917 (evening ed.), and then in M. Kuzmin, *Vozhatyi* (St. Petersburg: Prometei, 1918), p. 58, where it is entitled *Pskovskoi avgust* and dedicated to the artist Yurii Annenkov. It is also published in Yu. Degen, ed., *Neva. Almanakh stikhov* (Tiflis: Feniks, 1919), pp. 11–12. The handwriting in the Album here is Vera's.

For Kuzmin's biography and commentary, see entries 15 and 17a.

NOTE

1. Gorodetsky in *Ponedelnik*, no. 1 (Tiflis, 20 December 1919). Quoted in J. Malmstad and V. Markov, eds., *Mikhail Kuzmin. Sobranie stikhov* (Munich: Fink, 1977), vol. 3, p. 653.

32a Veniamin Belkin, portrait of Sergei Sudeikin (ca. 1918)

Colored crayons on paper glued onto red page. 19.2 × 14.9 cm. Signed in crayon with the monogram "VB" at the lower left.

The caricature is of Sergei Sudeikin and accompanies Degen's poem *P.S.* (entry 32b). Belkin and Sudeikin had become friends in 1911 when, with Boris Grigoriev and Nikolai Kulbin, they worked on the interior decorations for the Stray Dog in St. Petersburg.[1] They both exhibited with the second World of Art society (founded in 1910)[2] and moved closely with the Apollo circle.[3] But in the 1910s and 1920s Belkin was known especially for his literary and political caricatures, working for the St. Petersburg magazines *Satirikon* (Satyricon) and *Novyi Satirikon* (New satyricon). Belkin was drawn especially to the mid–nineteenth century and has depicted Sudeikin here—with his necktie and high collar—as a gentleman of the 1830s or 1840s, reminiscent of the fictional Kozma Prutkov (see entries 108a and b).[4] Although the work is undated, it is known that Belkin and his wife, Vera Alexandrovna, visited the Crimea between at least December 1917 and December 1918 (see entry 45b), and it can be presumed that he made this caricature while visiting with the Sudeikins then. In her Diaries (7 December 1918) Vera compared his face to that of a "Russian cupid–cum–floor polisher."

Belkin, Veniamin Pavlovich. Artist , designer, and poet. Born 1884 in Verkhoturie; died 1951 in Leningrad.

1904–5 studied at the Bolshakov Art School in Moscow. 1906 onward contributed to the "Exhibition of Paintings by Young Artists" in Moscow; thereafter exhibited regularly at the "World of Art" and other societies. 1907–9 studied in Paris. 1909 onward lived in St. Petersburg; contributed caricatures and illustrations to such magazines as *Satirikon* and *Apollon*. 1911 member of the Art Bureau of the Stray Dog; helped to decorate its interior. 1910s frequent visitor to the Stray Dog and Comedians' Halt; close to Alexei Tolstoi, some of whose books he illustrated. 1917–18 visited the Crimea. 1919–21 worked intermittently for the State Porcelain Factory, Petersburg. 1921–46 taught painting at the Academy of Arts; illustrated many books by Russian and non-Russian authors. 1924–27 taught at the Architectural Institute and Higher Art–Industrial Institute in Leningrad.

NOTES

1. For details of the interior decoration see the introduction. Also see *Russkoe slovo*, St. Petersburg, 15 January 1913; K. Rudnitsky, "Teatr Sergeia Sudeikina," *Dekorativnoe iskusstvo*, no. 12 (Moscow, 1975): 40; and D. Kogan, *Sergei Sudeikin* (Moscow: Iskusstvo, 1974), p. 183. From time to time Belkin also

participated in the presentations at the Stray Dog—for example, as a discussant for Kulbin's lecture on 19 February 1913 (see *Pamiatniki kultury. Novye otkrytiia. Ezhegodnik 1983* [Leningrad: Nauka, 1985], p. 208).

2. See, e.g., Belkin's review of the 1922 World of Art exhibition, "Peterburgskie pisma. Vystavka 'Mir iskusstva,'" *Novaia russkaia kniga*, no. 7 (Berlin, 1922): 23–25.

3. Belkin occasionally contributed illustrations and vignettes to the magazine *Apollon*. See, e.g., his drawings for Nikolai Vrangel's article "Liubovnaia mechta sovremennykh russkikh khudozhnikov," *Apollon*, no. 3 (St. Petersburg, 1909), pp. 30–41.

4. Belkin illustrated a separate edition of Prutkov's tales: V. Belkin, *Prutkov—Basni* (Brandenburg: Vizik, 1923).

FURTHER READING

Nothing substantial has been published on Belkin. For some information, see the following:

Brambatti, A., et al. *Grafica Art Nouveau nelle riviste russe*, p. 28. Florence: Cantini, 1989.

Fleishman, L., R. Khiuz, and O. Raevskaia-Khiuz. *Russkii Berlin, 1921–1923*, pp. 262–92. Paris: YMCA, 1983.

Molok, Yu. "Kameiia na oblozhke." *Opyty*, no. 1 (Paris, 1994): 115–47.

Voltsenburg, O., et al., eds. *Khudozhniki narodov SSSR. Biobibliograficheskii slovar v shesti tomakh*. Vol. 1, pp. 337–38. Moscow: Iskusstvo, 1970.

32b Yurii Degen (ca. 1918)

Vl. Belkin's Caricature

P.S.

Looking at this caricature
We can understand Sudeikin's nature.
Yes! Not one of the epigrams
Of satirical and malicious brand
Will lower you, divine Sudeikin,
In the opinion of the ladies.
Everywhere you are handsome, just like the devil
A man of the first quality!

Yurii Degen

Ink on red page.

This poem accompanies the Belkin caricature of Sudeikin (entry 32a). For Yurii Degen's biography, see entry 25a.

33 Alexander Chachikov (1919)

Chanson Triste

Having forgotten the pattern of your sandals
And the slits of your orange lips,
I am ready to compose the words
Of melancholy masses on a thousand tablets.

Today I went out onto the Morskaia[1]
Sad and pale as always,
And above St. Isaac's,[2] rejoicing,
There burns an inessential star.

And I remembered my native Iran,
My many brazen forays. . . .
Like an eternal pilgrim
I shall create a dreamy ritual. . . .

Who wished to part us
Casting thousands of versts[3] between us?!
In place of the saffron rays
Came the wrinkled autumn time.

I shall not go to walk alone:
Tirelessly blow the winds. . . .
But why are the maîtres d'
Staring like kings of the deserts? . . .

On the Moika[4] the taxi sleeps.
There the spirit of Kavelin[5] wanders. . . .
Stingily the somber mist
Has covered the solemn granite. . . .

And I, like everyone, am a Petersburgian!
Why do I need a suntan on my face?!
Capital city—I am accustomed to your coldness
And am ready to live here without end!

3 July 1919
Tiflis

Ink on rice page.

Chachikov published comparatively little of his own poetry during his Tiflis period, devoting most of his creative energies to translations from oriental languages such as Persian (e.g., the poem *Inta*) and Assyrian.[6] Alexei Kruchenykh was an advocate of Chachikov; he made a study of his poetical integrations of East and West and even intended to co-author a collection with him.[7] As late as 1936 David Burliuk described Chachikov's poetry as a "triumphant moment in a colorful carnival."[8]

Chachikov, Alexander Mikhailovich. Poet, story writer, translator, and critic. Born 1893 in Gori, Georgia; died 1941.

Born into an aristocratic Georgian family; serving as a ship's boy, journeyed around the world. Early 1910s studied at the Oranienbaum Military School. 1914–16 began to publish poetry in *Golos*

Kavkaza. 1914–18 mobilized. 1918–19 lived in Tiflis, where he was in close touch with Yurii Degen, Sergei Gorodetsky, Kruchenykh, and Ilia Zdanevich; member of the Hauberk group. 1919 contributed to the miscellany *Melnikovoi. Fantasticheskii kabachok*; published several collections of poetry and articles at this time; moved to Batum; published in the Batum newspaper *Nash krai*; briefly head of the literary section of the Batum People's Commissariat for Enlightenment. Ca. 1922 moved to Moscow. 1925 member of the Moscow Guild of Poets; contributed to Gorodetsky's miscellany *Styk* (Encounter). 1930s published many collections of poems and songs, often with a strong political emphasis.

NOTES

1. One of the main thoroughfares in St. Petersburg, not far from the Field of Mars.
2. St. Isaac's Cathedral, Auguste Montferrand's neoclassical church (1819–59) on St. Isaac's Square.
3. One verst is the equivalent of thirty-five hundred feet.
4. The Moika is one of the principal canals in St. Petersburg. The Comedians' Halt was situated at 1, the Moika, on the corner of the Field of Mars and the Moika. For a photograph of the intersection, see *Pamiatniki kultury. Novye otkrytiia. Ezhegodnik 1988* (Moscow: Nauka, 1989), p. 97.
5. Konstantin Dmitrievich Kavelin (1818–85), St. Petersburg historian and jurist.
6. According to an announcement on the cover of *Inta*, Kruchenykh had prepared a study of *Inta* and Chachikov's own poetry, *Issledovanie ob Inte Chachikova i poeziia Alexandra Chachikova*, but it appears not to have been published. Also see his "Nastuplenie na Mossul. Assiriiskaia poema," *Melnikovoi. Fantasticheskii kabachok* (Tiflis, 1919), pp. 147–57.
7. See T. Nikolskaia, "Alexander Chachikov," *Russian Literature*, no. 24 (Amsterdam, 1988): 229.
8. Ibid., p. 230.

FURTHER READING

Chachikov's publications after 1934 are concerned mainly with the celebration of Stalin, the Soviet Constitution, and heroes of Soviet culture. The main card catalog of the Russian National Library, Moscow, lists most of these later titles. Nothing substantial has been published on Chachikov. For some information and a bibliography, see T. Nikolskaia, "Alexander Chachikov," *Russian Literature*, no. 24 (Amsterdam, 1988): 227–34.

Chachikov. A. M. *1000 strok. Stikhi 1918–1926*. Moscow: Federatsiia, 1931.
———. *Chai-Khane. Stikhi*. Moscow: Moskovskii tsekh poetov, 1927.
———. *Dalekie sestry. Rasskazy*. Moscow: Federatsiia, 1931. (Cover by Boris Titov)
———. *Dauda. Rasskaz iz indusskoi zhizni*. Moscow and Leningrad: 1-ia Obraztsovaia tipografiia v Moskve, 1928. Reprint, 1931.
———. *Inta. Persidskaia poema*. Tiflis: Iran, 1919.
———. *Korichnevyi bunt. Rasskazy*. Moscow: TsK MOPR SSSR, 1930.
———. *Krepkii grom*. Moscow, 1919. (Preface by Alexei Kruchenykh)
———. *Poemy Rustaveli*. Tbilisi: Zaria Vostoka, 1938.
———. *Ya sizhu zdes u moria*. Moscow, 1913.
———. *Zelenyi grebeshok. Rasskaz*. Moscow and Leningrad: 1-ia Obraztsovaia tipografiia v Moskve, 1928.
———, ed. *Lenin v poezii narodov Vostoka. Stikhi*. Moscow: Z.I., 1934.
———, ed. *Sem respublik. Stikhi narodov natsionalnostei SSSR*. Moscow: Moskovskoe tovarishchestvo pisatelei, 1933.
———, and Leo Miriani. *Kommuna 1871 goda. Piesa v 1 deistvii*. Moscow: Artilleriiskoe upravlenie, 1925.

35a Anonymous, untitled (ca. 1920)

Clink, clank, clouds,
Pods are on the hill,
Apples are in the orchard,
Partridges, too.
On the scoops
The hens are running
Like a black river.
Tartar maidens
Each with a stick
Beats a board.
They went to Moscow
And bought a cow,
A cow the size of a cat
And milked it with a spoon.
Doll, hey, doll,
How come you weren't at home?
Were you afraid of Jack the Stick?
Jack's children
Are sitting on a pole,
And wish to fly
To Ivan on the bridge.
Ivan and Roman have
A long-legged foal
He who's really literate—
He reads, he plays,
He even sings songs.
A muzhik lives on the edge of town
Who's neither poor nor rich,
But he has a lot of kids:
One is Vanka, another is Panka,
And a third is Vasia. A great guy, and
From the simple people is this little muzhik.
He's the brother of Poleshshik
And glad to have a coat.
The cockerel, the cockerel
With his golden comb
Was sitting on his perch
Weaving bast shoes.
For himself and his wife
And for the little children
Each a pair of bast shoes:
To Sergei a pair,
And to Masha,
And to Mikhail.
On go the bast shoes over their socks,
And off they went along the road.

Ink on white page.

This poem accompanies the Sudeikin illustration of entry 35b. The poem is unsigned, and the handwriting is Vera's. The author of the poem is not known, although it has been suggested that the work is a rendering or imitation of a folk song, and the circumstances in which the poem was written and illustrated by Sudeikin's accompanying sketch are not known. A similar combination of a poem describing rural Russia and an illustration by Sudeikin is to be found in entries 31a and b. The Russian here reminds us of the songs of the wandering minstrels and buffoons (the *skomorokhi*), preserving the particular enunciation and dialect of northern Russia.

35b Vera Sudeikina, untitled (ca. 1920)

Pencil on white page.

This drawing accompanies the anonymous poem of entry 35a. For Sudeikina's biography, see entry 16.

37a Ivan Bilibin, untitled (1918)

My friend, forgive me, but when you arise
The night star will be high
And you will see me no more,
A wanderer, I shall be far away.
Let clouds of thunder be my lot,
Let the sultry sun scorch me.
My friend, thank you! The wine and roses
Will long preserve my memory.

3 June 1918 I.B.
Miskhor

Ink on paper, glued onto white page. 10.5 × 16 cm.

Entries 37a and 37c are rare examples of Bilibin's poetical talent.[1] Known primarily as a graphic artist, stage designer, and art historian, Bilibin was a colleague of Sergei Sudeikin within the World of Art and other exhibition groups in the 1900s–20s, and to some extent both men shared the same cultural and intellectual interests. Bilibin was also a good friend of Igor Stravinsky, who shared his interest in ancient Russian art and folklore.[2] Like the Sudeikins, Bilibin was a fanciful designer and illustrator, a connoisseur of Old Russia, and also an avid collector of antiques. For example, embroideries from his private collection were included in the prestigious "Exhibition of Icon Painting and Artistic Antiquities" in St. Petersburg in 1911–12, and he published a pioneering article on the popular art of northern Russia in the *World of Art* journal.[3] Like Sudeikin, too, Bilibin brought a new insight into theatrical design thanks to his broad knowledge of the fashions and styles of sixteenth- and seventeenth-century Russia, and his costumes and sets for the *Golden Cockerel*, produced at Sergei Zimin's Theater in Moscow in 1909, were a great success.

Bilibin was a regular visitor to the Sudeikins' during their sojourn in Alushta-Yalta-Miskhor, since his country residence at Baty-Liman (Batiliman), also in the Crimea, was not far away. He left Petrograd in September 1917 and lived at Baty-Liman until October 1919, when he moved to Yalta and then to Rostov-on-Don and Novorossiisk.[4] In February 1920 he left Novorossiisk for Alexandria in Egypt. Baroness Liudmila Vrangel, a neighbor of Bilibin in those years, has left the following description of that stretch of the beautiful Crimean coast:

> The silver cliffs rose high above the chaos of stones in the chasm below, above the distant bays and dachas peeping into the limitless blue of the sea. There everything is wild, the land is barren, and this heroic beauty, this dominance of worlds over man, always attracted people with a pantheistic bent. It was with much affection that Bibilin often painted this stone chaos with its sparse but majestic green conifers and its lucid, azure sky.[5]

Before the Revolution Baty-Liman was an artists' and writers' retreat, consisting of dachas purchased on a shareholder basis, and Bilibin was very fond of the colony—which had many illustrious visitors, including Maxim Gorky, Pavel Miliukov, and Maximilian Voloshin.

During his Crimean years, Bilibin played an active role in local cultural affairs—in spite of his heavy drinking and tumultuous love life (in 1917 his young wife, Renée O-Konnel [O'Connel], left him, although he soon adopted another protégée, Liudmila Chirikova). With Savelii Sorin, Sergei Sudeikin, Vladimir Yanovsky, and others he participated in the "First Exhibition of Paintings and Sculpture by the Association of United Artists" in Yalta in December 1917 and the "Art in the Crimea" show in October–November of the following year. He wrote to Chirikova on 21 October 1918:

> The exhibition will open next Sunday. It will be very majestic. The whole of the Yalta and local beau monde will bedazzle the vernissage. You won't be able to protect yourself against all the princes and counts. Just like the old times! . . . Brailovsky has promised to give me the two Hoffmann volumes. . . . Sudeikin and Sorin give their full approval of my portrait of Novella Evgenievna.[6]

In spite of this optimism, however, Bilibin and Sudeikin were by then not the best of friends, especially because of the former's weakness for alcohol. Bilibin visited the Sudeikins several times in Miskhor in May and June 1918, but as Vera wrote in a long description entitled "Bilibin's Visit" in her Diaries for 4–20 May 1918, he was not the most serene of guests:

> During dinner, Bilibin charmed everyone, especially the ladies, who donated two bottles of wine to him. . . . The next morning Bilibin came, and we talked about drawings, various painters, and the World of Art. Incidentally, Bilibin doesn't like Cézanne—which rather shocked us. . . . The next morning Serezha wanted to devote all his energy to work and refused to go with Bilibin and the ladies to obtain wine. . . . We brought home ten bottles; Bilibin finished off one immediately and brought the rest for dinner, and a drinking party ensued. He was very unhappy at not having any drinking companions. . . . At first he was witty, sang folk songs, read out his Ovid translations, recited some of his political satirical poems, but after the third bottle he began to stutter and sing national anthems. . . . Serezha hates drunks and in the end began to hate Bilibin. The next morning Serezha opened the door to find Bilibin on the terrace opposite, shouting, "I have the honor to introduce the president of the World of Art, Mr. Ivan Bilibin." . . . Serezha continued to draw and Bilibin to provoke him, saying, "Come on, I'm also a professor. Stop drawing, and let's have a drink. What kind of graphic artist do you think you are, anyway?" "Ivan," was Serezha's terse reply, "Go flirt with the ladies and leave me alone." . . . Bilibin then came up to the table where Serezha was working and started to ask him stupid questions, and since he did not answer grabbed him by the hair. Serezha couldn't take any more, sprang to his feet, shook Bilibin, and pulled his beard. Bilibin turned pale and trembled, wondering what to do next. But friends took him away, telling him to forget the whole thing.

Bilibin, Ivan Yakovlevich. Artist. Born 1876 in St. Petersburg; died 1942 in Leningrad.

1890–96 attended gymnasium in St. Petersburg. 1895–98 took lessons at the School of the Society for the Encouragement of the Arts. 1896 enrolled at St. Petersburg University to study law. 1898 traveled to Munich, then to Switzerland and Italy. 1898–1900 attended Princess Mariia Tenisheva's art school in St. Petersburg, taking courses under Ilia Repin. 1899 onward close to the World of Art artists, contributing to the journal and exhibitions; contributed many illustrations to editions of Russian fairy tales. 1900–4 studied at the Higher Art Institute of the Academy of Arts. 1904 produced designs for Nikolai Rimsky-Korsakov's *Snegurochka* produced in 1905 at the Prague National Theater; published an article on the popular art of northern Russia in the *World of Art* magazine. 1905 contributed to the satirical journals such as *Zhupel* (Bugbear). 1907–11 worked on designs for Sergei Diaghilev's production of *Boris Godunov* in Paris; traveled to England; began to teach at the School of the Society for the Encouragement of the Arts; began work on designs for Rimsky-Korsakov's *Sadko* at the People's House, St. Petersburg. 1915 decorated ceilings for the Kazan Station, Moscow. 1917–20 lived in the Crimea. 1918 contributed to the "Art in the Crimea" exhibition in Yalta; member of the Commission for the Preservation of Artistic Treasures of the Crimea. 1920–25 lived in Egypt and then moved to Paris. 1920–30s continued to work as a stage and book designer. 1921 participated in the exhibition "L'Art Russe" in Paris. 1936 returned to Leningrad.

NOTES

1. For another example of Bilibin's poetry, also dated 1918, see S. Golynets, ed., *Ivan Yakovlevich Bilibin. Stati. Pisma. Vospominaniia o khudozhnike* (Leningrad: Khudozhnik RSFSR, 1970), pp. 179–80. Vera mentions in her Diaries (23 December 1917) that Bilibin had also translated Ovid into Russian and that he liked to recite his versions.

2. Both Bilibin and Stravinsky admired the efforts of Princess Mariia Tenisheva to revive public interest in the old Russian arts and crafts, and both visited her estate and workshop at Talashkino, near Smolensk. Stravinsky and Nicholas Roerich, also a colleague of Bilibin, composed the scenario for *Le Sacre du printemps* at Talashkino in the summer of 1911.

3. I. Bilibin, "Narodnoe tvorchestvo russkogo Severa," *Mir iskusstva*, no. 11 (St. Petersburg, 1904): 303–18.

4. For a detailed chronology of Bilibin's life in the Crimea see Golynets, *Ivan Yakovlevich Bilibin*, pp. 17–28.

5. L. Vrangel, *Vospominaniia i starodavnie vremena* (Washington, D.C.: Kamkin, 1964), p. 73.

6. Part of a letter from Bilibin to Liudmila Chirikova dated 21 October 1918, published in Golynets, *Ivan Yakovlevich Bilibin*, p. 109–12.

FURTHER READING

Golynets, G., and S. Golynets. *Ivan Yakovlevich Bilibin*. Moscow: Izobrazitelnoe iskusstvo, 1972.

Golynets, S. *Ivan Bilibin*. Leningrad: Aurora, 1981.

———. "Tvorchestvo I. Ya. Bilibina v gody pervoi russkoi revoliutsii." In *Voprosy otechestvennogo i zarubezhnogo iskusstva*, ed. N. Kalitina, pp. 109–23. Leningrad: Leningrad University, 1975.

———, ed. *Ivan Yakovlevich Bilibin. Stati. Pisma. Vospominaniia o khudozhnike.* Leningrad: Khudozhnik RSFSR, 1970.

Semenov, O. *Ivan Bilibin*. Leningrad: Detskaia literatura, 1986.

37b Sergei Sudeikin, untitled (ca. 1918)

Watercolor and pencil on paper laid on green paper, glued onto white page. Mounted: 17.6 × 14.6 cm; unmounted: 17.3 × 14.4 cm.

The central figure would appear to be Vera Sudeikina. The motif of the young beauty attended by an old servant and confidante appears in several of Sudeikin's renderings (cf. entry 134). Sudeikin often portrayed Vera holding a mirror, as, for example in the metaphorical double portrait in the panneau called *Lovers and a Girl Looking in a Mirror* that he made for the Comedians' Halt in connection with the production of the Schnitzler-Dohnanyi pantomime *The Scarf of Columbine* (1916). The languorous Vera and her mirror are also present in the group portrait called *My Life* (see the introduction, p. xiv), and Sudeikin combined the mirror with the theme of passion in his picture entitled *Magic Mirror* (1917), which, according to Vera's notes in the Varia, depicted "landscapes, and the faces of Venus and Cupid" (i.e., a play on the name Vera Arturovna; see entry 19). According to her notes in the Varia, Sudeikin even painted a portrait of her called *Venera Amurovna* in 1917 (see entry 19).

For Sudeikin's biography, see entry 1b.

37c Ivan Bilibin (1918)

To a Rose

Shining like a diamond, a drop trembled
On a beautiful rose;
In the languorous somnolence of noon
The splendid rose inclined.
Rose! Do you not realize that on your petal
Is reflected
A world in the little drop?
Tall cliffs are reflected,
The azure of the blue sea, the depth of
The fathomless sky,
The splendid leaves of the trees and the merciless
Brilliance of Apollo.

15 May 1918 I. Bilibin
Miskhor

Ink on paper glued onto white page. 10.5 × 16 cm.

Bilibin's choice of a rose as his poetical metaphor is not accidental. According to the Crimean historian Anna Galichenko, there was a veritable cult of roses in Miskhor and Alupka, and the Nikitskii Botanical Garden in Yalta is still famous for its rosarium (conversation between Anna Galichenko and John E. Bowlt, 11 May 1991).

Vladimir Pol put part of this poem to music under the title "An Eastern Romance" (see entry 37d).

For Bilibin's biography and further commentary, see entry 35a.

37d Vladimir Pol (1918)

An Eastern Romance
Words by Bilibin, music by Pol. Sudeikin album.

Languorously, Miskhorly.
 Shining like a diamond, a drop trembled on a beautiful rose; in the languorous somnolence of noon the splendid rose inclined . . .

Vl. Pol 1918

Ink on musical staff paper glued onto white page. 10.4 × 20.1 cm.

Pol had long family ties with the Crimea (Miskhor), where he wrote his "Eastern Romance." Because of his father's tuberculosis, the family lived for several years in Ekaterinoslavl; and in 1904 Pol himself, after graduating from Kiev University and also suffering from lung disease, moved to Yalta, where he became director of the Crimean section of the Imperial Musical Society. Pol's compositional taste was late romantic, and he often set poems by Anna Akhmatova, Sergei Gorodetsky, Fedor Tiutchev, and others to music. Sharing his generation's general predilection for the Orient, Pol composed a cycle of Japanese songs that he gave at a concert at the Brailovskys'

dacha in Miskhor on 7 July 1918. He was a Mason and also cultivated an interest in Indian music, philosophy, and culture, and was remarkably well read in occultism. Much influenced by Elena Blavatskaia (Mme Blavatsky), Georgii Giurdzhiev (Georges Gurdjieff), Nikolai Lossky, Alexander Scriabin, and Petr Uspensky, Pol believed that "man must gain power over the metabolism of substances, over every respiration of the living cell."[1] Pol found fellow enthusiasts of theosophy, vegetarianism, and Zen in the Stray Dog cabaret in St. Petersburg, such as Nikolai Kulbin and Sergei Volkonsky. Probably he first met Sudeikin there, for he also played an active part in its cultural program: for example, some of his music (and, incidentally, Igor Stravinsky's) was performed there on 13 March 1913.[2]

Pol wrote his "Eastern Romance" while he and his wife, the singer Anna Yan-Ruban, were living in the Crimea. Early in 1917 they had settled in Gaspra, near Simeiz, on the Black Sea coast, renting a house on the estate of Countess S. P. Panina, a relative of Anna Yan-Ruban. Like Baty-Liman (see entry 35a), Gaspra (also see entry 39a) and Miskhor were resort areas where many St. Petersburg and Moscow intellectuals gathered both before and after the Revolution. Among the visitors there in 1917–18 were the Brailovskys, Gleb Deriuzhinsky (Pallada's husband; see entry 77b), Konstantin Korovin, Sergei Makovsky, Nikolai Milioti, Yuliia Sazonova (Slonimskaia), Vladimir Nabokov, and of course the Sudeikins.[3] Because of the performance instructions "Languorously, Miskhorly," it can be assumed that Pol composed this song in Miskhor after he had seen the Bilibin poem (entry 37c). Vera recalls in her Diaries that Pol visited them several times in Miskhor and mentions that Sudeikin found him to be "entirely dedicated to art" (entry for 7 July 1918).

These are the opening lines of Bilibin's poem "To a Rose" (37c). It is not known whether Pol finished putting Bilibin's poem to music or even wrote more than these ten measures.

Pol (Pohl), Vladimir Ivanovich. Composer, pianist, and artist. Born 1874 in Paris; died after 1962 in Paris.

1870s father was a physician; family returned from Paris to Moscow, then moved to the Crimea and then to Kiev. 1904 graduated from Kiev University, where he had studied the natural sciences. 1900s studied pianoforte at the Kiev Conservatory under Vladimir Pukhalsky and attended the Kiev Art Institute; also took lessons from Sergei Taneev in Moscow. Ca. 1905 director of the Crimean section of the Imperial Musical Society. Late 1900s–10s lived predominantly in Moscow, making frequent trips to St. Petersburg. 1913 composed the music for the production of *Le Malade Imaginaire* at the Moscow Arts Theater (designed by Alexandre Benois). 1914 composed the music for the production of *Sakuntala* at the Chamber Theater, Moscow (designed by Pavel Kuznetsov). 1910s moved closely with leading artists, poets, and philosophers, such as Benois, Sergei Bulgakov, Viacheslav Ivanov, and Evgenii Trubetskoi; often gave piano recitals of music by Chopin, Liszt, Schumann, and Scriabin, sometimes appearing with his wife, the singer Anna Yan-Ruban. 1917–20 lived in the Crimea. 1918 (October–November)

participated in the "Art in the Crimea" exhibition in Yalta. 1920 onward lived in Paris. Mid-1920s with Nikolai Cherepnin, Thomas Von Hartmann, and others organized the Russian Musical Society. 1931–56 founded and taught at the Russian Conservatory in Paris, whose honorary president was Sergei Rachmaninoff. 1937–62 directed the Belyayev publishing firm in Paris.

NOTES

1. Quoted in S. Makovsky, *Na parnase serebriannogo veka* (Munich: Tsentralnoe obedinenie politicheskikh emigrantov iz SSSR, 1962), p. 349.
2. For details see *Pamiatniki kultury. Novye otkrytiia. Ezhegodnik 1983* (Leningrad: Nauka, 1985), p. 209. Stravinsky was in London at the time of the recital.
3. For the names of other celebrities who were in the Crimea at this time see Makovsky, *Na parnase serebriannogo veka*, pp. 355–56.

FURTHER READING

Nothing substantial has been published on Pol. For some information, see S. Makovsky, *Na parnase serebriannogo veka* (Munich: Tsentralnoe obedinenie politicheskikh emigrantov iz SSSR, 1962), pp. 348–62; and A. Ho and D. Feofanov, *Biographical Dictionary of Russian and Soviet Composers* (New York: Greenwood, 1989), p. 409.

38 Vera Sudeikina, untitled (ca. 1920)

Watercolor on paper glued onto white page. 25.8 × 33.2 cm.

Although the picture is not signed, it is reasonable to assume that the artist is Vera. She used analogous combinations of bright colors and loose forms to render simple, lyrical scenes. This seems to be a rough version of Sergei Sudeikin's composition in entry 79b.

For Vera Sudeikina's biography, see entry 16.

39a Vladimir Pol, untitled (1918)

Dear Sergei Yurievich,

I'm always trying to recall the first verse in Matthew 7:

"Judge not, that ye be not judged. For with what judgment ye judge, ye shall be judged: and with what measure ye mete, it shall be measured to you again."

1918 V. Pol
Gaspra

Red and black ink on musical staff paper glued onto white page. 28.8 × 23.3 cm.

Pol was a deeply religious man, and during his sojourn in Miskhor he often discussed Christianity, the Bible, and ecclesiastical questions with the philosopher and priest Sergei Bulgakov.

For Pol's biography and further commentary, see entry 37d.

39b Sergei Sudeikin, untitled (ca. 1920)

Watercolor and pencil on paper laid on paper, laid on green paper, glued onto white page. Mounted: 20.2 × 14.1 cm; unmounted: 19.8 × 13.9 cm.

Columbine would seem to represent Vera here. The bearded man behind her (Sudeikin?) reappears in various guises in Sudeikin's allegories of the period (see entries 1b, 45c, 128). The third figure might represent Olga Glebova or Mikhail Kuzmin (see entry 15). For commentary on the persistence of the motif of the commedia dell'arte in the work of Sudeikin and his colleagues, see entries 37b, 45c, and especially 125b. For Sudeikin's biography, see entry 1b.

40 Jean Jaquier, untitled (1919; in French)

To Madame Soudeikine

I waited in vain for you to come and sit on the
Stone seat beside the pool.
And slowly I watched the great white swans
In the shadow of the blades
The thick blades are full of the song of a male in love.
Others have despised me because I waited for you thus,
Sitting sadly beside the pool.

The breeze was full of love and spring playing
Joyfully in the grass.
I cursed you for your foolishness, which left me
All alone there, looking toward the horizon.
Little by little evening draws in, demoralizing the soul,
And your treachery, rather than any rational thought,
Leaves me with a heavy heart.
Beside the pool I awaited my marquise.

16 March 1919
Miskhor

Ink on ruled paper glued onto white page. 21.4 × 17.5 cm.

M. and Mme Jaquier were French neighbors of the Sudeikins in Miskhor, and Vera mentions them several times in her Diaries. Unfortunately, Vera does not provide the first names of M. and Mme Jaquier, and the first part of the signature here, as in the other Jaquier dedication (54a), is almost illegible, although there is some resemblance to the name Jean. Jaquier was rumored to have been the lover of Alexandra Khotiaintseva (see entry 77a), and in conversations with friends, Vera referred to Jaquier as a "gigolo who lives with an older woman," and according to the Crimean historian Anna Galichenko, "the philosopher" Jaquier left Miskhor for Paris with Mariia Mukhina (see entry 77a). (Conversation between John E. Bowlt and Anna Galichenko, 13 May 1991).

41a Petr Volkonsky, portrait of Vera Sudeikina (ca. 1918)

Pencil on paper glued onto white page. 11.2 × 10.9 cm. Inscribed in pencil at lower right with an illegible monogram.

Prince Petr Grigorievich Volkonsky (1897–1925) was an artist and friend of the World of Art artists, especially Konstantin Somov, and was married to Irina, Sergei Rachmaninoff's eldest daughter. He died in New York. Little else is known about this artist and poet (see entry 41b). Vera mentions a Dmitrii, but not a Petr, Volkonsky in her Diaries (29 June 1918).

Volkonsky, Prince Petr Grigorievich (Pierre Wolkonsky). Artist and poet. Born 1897 (sometimes given as 1901) in St. Petersburg; died 1925 in Corbeville, France.
His mother, Mariia Vladimirovna, was also an artist. Early 1910s emigrated to Western Europe; studied under Franz Stuck in Munich and under Ernst-Joseph Laurent in Paris. 1918 in the Crimea. Early 1920s painted many scenes of Capri and Venice; exhibited several times, including at the Salon d'Automne and the Salon des Indépendants in Paris. 1923 one-man show in London. 1924 married Irina Rachmaninova, Sergei Rachmaninov's eldest daughter. 1925 took lessons in Paris from Konstantin Somov.

FURTHER READING

Nothing substantial has been published on Volkonsky. For a few details, see D. Severiukhin and O. Leikind, *Khudozhniki russkoi emigratsii* (St. Petersburg: Chernyshev, 1994), pp. 135–36.

41b Petr Volkonsky

For the Album (1918)

Their kitchen is a marvelous picture,
A living tale of bylina monsters.
Dear antiquities look down
From the walls so deftly painted.

Rectilinear, round-faced,
He passes his brush across the wall.
Patterns wind like a creeping plant,
And figures arise as if in a dream.

And his stately spouse
Greets you cordially
And, like a friend, generously bestows upon you
The radiant light of her blue eyes.

The hospitable warmth there
Has so warmed everything and everyone
That even the lady of the kitchen could care less
That her stove is cold.

A fortuitous guest, long homeless!
I was so happy that I was able

To visit their cozy hearth
And corner of inspiration.

August 1918 P.V.
Miskhor

Ink on graph paper glued onto white page. 24.6 × 10.1 cm.

According to Vera's Diaries for 25 August and 23 September 1918, the Sudeikins were occupying the first floor of the Brailovskys' dacha, where they had painted the walls of the kitchen, the corridor, and other spaces to which this poem refers.

For Petr Volkonsky's biography, see entry 41a.

41c Sergei Sudeikin, untitled (ca. 1918)

Pencil on paper glued onto white page. 11.3 × 15 cm.

The woman seated resembles Vera Sudeikina; the man smoking the pipe, Sudeikin. For Sudeikin's biography, see entry 1b.

41d Sergei Sudeikin, untitled (ca. 1918)

Pencil on paper glued onto white page. 11.3 × 14.8 cm.

For Sudeikin's biography, see entry 1b.

42 Adam Albrekht, untitled (1920)

I have come upon a new world,
A world of marvel and beauty.
I have learnt much new
And have seen wisdom;
The days have become more lucid!

I lived in a vicious circle
Of barracks and slaves in bondage.
Thirsting for the ignorance of pain,
Nailed to the cross
I saw but gloom and darkness.

The veil of gloom was sleeping.
By chance before me,
My soul exulted
And wisdom arose before it
Shining in its beauty!

I saw the world differently.
To inspire a particle of knowledge
With the sound of a hundred lyres
Within me rages a feast,
The dawn of self-consciousness.

I have come upon a new world—
The world of the life of beauty.

I have learnt much new;
I have seen God.
The days have become more lucid!

8 March 1920 Adam Albrekht
Baku

Ink on white page.

The identity of Adam Albrekht has not been established.

43a Lidiia Koreneva, untitled (1918)

Thank you for the cordiality, the supper, the edifying and instructive conversation, the *chizhik* [tip-cat, a children's game that Koreneva often played with Sudeikin], the verses, the sugar, etc., etc., and I ask you not to forget me.

27 August 1918 L. Koreneva

Ink on paper glued onto white page. 10.4 × 15.8 cm.

Koreneva was in Miskhor from July through at least September 1918. As a well-known actress at the Moscow Arts Theater she knew—or knew of—the Sudeikins in Moscow and St. Petersburg. In her Diaries Vera mentions several visits by or to Koreneva, although, according to Vera's descriptions there (20 August 1918), Koreneva was a lost and lonely creature in the Crimea, a "walking psycho." Also see entries 43b, and 43c.

Koreneva, Lidiia Mikhailovna. Actress. Born 1885; died 1982 Moscow.

1904 enrolled in the acting school of the Moscow Arts Theater (MKhAT); on graduation became a member of the MKhAT company. 1909 played Verochka in the MKhAT production of Turgenev's *A Month in the Country*; thereafter played many roles in plays by Chekhov, Ibsen, and Molière. 1937 became People's Artist of the RSFSR.

FURTHER READING

Nothing substantial has been published on Koreneva. For some information see P. Markov, ed., *Teatralnaia enstiklopediia* (Moscow: Sovetskaia entsiklopediia, 1964), vol. 3, p. 198. Two major sources on the history of the Moscow Arts Theater also include references to her: C. A. Chevrel, *Le Théâtre Artistique de Moscou (1898–1917)* (Paris: CNRS, 1979); and V. Vilenkin, ed., *Vl. I. Nemirovich-Danchenko. Izbrannye pisma*, 2 vols. (Moscow: Iskusstvo, 1979).

43b Sergei Sudeikin, untitled (1918)

Watercolor and pencil on folded paper glued onto white page. Signed "S. Sudeikin" in watercolor beneath the leaf and cross. Unfolded: 22 × 33.4 cm; folded: 22 × 16.7 cm.

This sketch accompanies the Koreneva dedication (43c) on the same piece of paper. For Sudeikin's biography, see entry 1b.

43c Lidiia Koreneva, untitled (1918)

Surrender to the impossible dream,
Whatever is destined to happen—will.
The unfailing law of the heart
Is that Joy and Suffering are the same.

16 August 1918 Actress of the Moscow Arts Theater
Miskhor L. M. Koreneva

Ink on paper glued onto white page.

This dedication accompanies the Sudeikin sketch on the same piece of paper (43b). Koreneva is quoting part of Alexander Blok's lyrical tragedy called *The Rose and the Cross* (1913). The play, set in Languedoc in the thirteenth century, is dominated by the leitmotif sung by the minstrel Gaëtan: "Joy, oh, Joy, that is Suffering! / Pain of unspeakable wounds!" The mysterious paradox—that joy and suffering are one—is also the message in the Gaëtan quatrain that Koreneva is repeating from act 4.

Koreneva had been slated to play in the Moscow Arts Theater (MKhAT) version of *The Rose and the Cross* in 1915. But, although Konstantin Stanislavsky was very interested in the play—rehearsals proceeded, and designs (by Mstislav Dobujinsky) were made—the play was not produced there, in part because of Blok's own dissatisfaction.

For Koreneva's biography, see entry 43a.

44 Veniamin Belkin, "Swifter than a Steed I Hasten to Bring You My Best Wishes, My Friend, Do Not Forget Me" (ca. 1919)

Watercolor and pencil on paper laid on red paper glued onto white page. Mounted: 23.3 × 18.4 cm; unmounted: 18.7 × 13.5 cm. Inscribed with the monogram "VB" in pencil at lower left.

The signpost on the right carries the two names, "Sudeik[in]" and "Belk[in]," as if to indicate a parting of the ways for the two friends. Belkin returned from the south to Petersburg in December 1920.

For Belkin's biography and further commentary, see entry 32a.

45a Miron Yakobson (1918)

From "Grazioso"

Words by Igor Severianin

Not fast Slower
You see, it is vulgar to say in words, How gentle is my love
 for you
Not fast (like a waltz) Slower

1918 Miron Yakobson
Miskhor

Ink on musical staff paper glued onto white page. 10.5 × 25.3 cm.

The words are from the beginning of Severianin's poem "Grazioso." Igor Severianin (pseudonym of Igor Vasilievich Lotyrev, 1887–1942) was leader of the Ego-Futurists group in St. Petersburg (with Graal Arelsky, Georgii Ivanov, and Konstantin Olimpov), although the "real" Futurists had little time for him, as Alexei Kruchenykh made clear in his lecture on Severianin at the Fantastic Tavern in March 1918.[1] However, Severianin was a leading light in the St. Petersburg bohemia and a habitué of the Stray Dog and Comedians' Halt. It was in that demimonde that he made the acquaintance of the Sudeikins and also of Olga Glebova. Sudeikin had even designed the cover of Severianin's *Poesa o Belgii* (Poem about Belgium), which was set to music by Nikolai Tsybulsky and performed at the Stray Dog in November 1914.[2]

Yakobson was a frequent visitor to the Sudeikins' in Miskhor in 1918 and, with Alexander Drozdov and Vladimir Pol, was an important force in local musical life. Yakobson was much taken by the Sudeikins' piano in Miskhor and, according to Vera, played "wonderfully . . . artistically." Vera also recalled in her Diaries (9 June 1918) that he had "made a tidy ten thousand" from the concerts he had organized in Sevastopol. Opinions varied regarding Yakobson's musical gifts: Drozdov considered him to be "very talented," whereas Savelii Sorin, as Vera wrote in her Diaries, found his "little talent lower than average, but he narrates Jewish anecdotes very well." In any case, in the 1910s and 1920s Yakobson composed and published a number of songs based on Russian Symbolist and Futurist poetry, including *Grezy* (Daydreams), after Andrei Bely, in 1912 and *Victoria Regig*, after Severianin in 1926. One of the guest books at the Chekhov Museum in Yalta contains a musical excerpt from Yakobson's "Romance dedicated to Olga Leopoldovna Knipper," dated 1918.[3]

Yakobson, Miron Isaakovich (Izidorovich) (Myron Jacobson). Composer and pianist. Born ca. 1880 in Odessa; died 1934 in the U.S.

Composed romances. Ca. 1907 studied in Berlin. 1914–15 was accompanist for Leonid Sobinov on his Russian tours. 1917 accompanied Fedor Chaliapin at a concert in Sebastopol. 1917–19 lived in the Crimea. Ca. 1920 emigrated. 1925 moved to the U.S. and became a professor at the Cornish School in Seattle. 1926–27 published many songs, often based on Russian poetry. 1930s organized the Northwest Opera Intime; gave two-piano recitals with his wife, Herte Poncy Jacobson.

NOTES

1. *Melnikovoi. Fantasticheskii kabachok* (Tiflis, 1919), p. 180.
2. See *Pamiatniki kultury. Novye otkrytiia. Ezhegodnik 1983* (Leningrad: Nauka, 1985), p. 236. For more information on Severianin see V. Koshelev, ed., *Igor Severianin. Stikhotvoreniia* (Moscow: Sovetskaia Rossiia, 1988).
3. *Kniga pochetnykh posetitelei Muzeia A. P. Chekhova*, Chekhov Museum, Yalta, call no. 4128, p. 10.

FURTHER READING

Nothing substantial has been published on Yakobson. For a few details see K. Kirilenko, ed., *Leonid Vitalievich Sobinov* (Moscow: Iskusstvo, 1970), vol. 1, pp. 755–57; and Yu. Kotliarov and V. Garmash, eds., *Letopis zhizni i tvorchestva F. I. Shaliapina* (Leningrad: Muzyka, 1989), pp. 138, 152, 155.

45b Veniamin Belkin, untitled (1918)

If such a woman as you were not an exception, then people would grieve.

Not the 1st of April, 1918 Vl. Belkin
Crimea

Ink on paper glued onto white page. 10.5 × 15.8 cm.

For Belkin's biography and commentary, see entries 32a and 44.

45c Sergei Sudeikin, untitled (ca. 1920)

Watercolor and pencil on paper laid on green paper glued onto white page. 10.5 × 10 cm.

Sudeikin's Harlequin knight or Punch is another version of the motif of the bearded man that may or may not be a self-portrait. Sudeikin used the motif of the dwarf in his work for the Comedians' Halt. See D. Kogan, *Sergei Sudeikin* (Moscow: Iskusstvo, 1974), pp. 116–17; and cf. entries 1a, 39b, 128. For Sudeikin's biography, see entry 1b.

45d Miron Yakobson (1918)

The Fruits of Meditation

 16th Aphorism

Very slowly and mystically
No one can fathom the unfathomable
Very slowly and mystically
From Kuzma Prutkov

1918 Put to music by
N. Miskhor Miron Yakobson

Ink on musical staff paper glued onto white page. 10.4 × 24.4 cm. The reverse carries three measures of another melody, also in Yakobson's hand.

Yakobson has taken one of the most famous *aforizmy* of the fictitious author Kozma (Kosma, Kuzma) Prutkov. Invented by Alexei Tolstoi and Alexei and Vladimir Zhemchuzhnikov in the 1860s, Kozma Petrovich Prutkov, with his thoughts and aphorisms, typified a particular kind of bureaucrat—complacent, egocentric, and fatuous. His parodies, fables, comedies, and aphorisms were published in several St. Petersburg journals in the 1850s and 1860s, and some of them—such as the one used by Yakobson here—have be-

come everyday expressions. Prutkov enjoyed a certain vogue among the artists and writers of the Silver Age, especially for his clumsy wit and erotic play. In January 1913, for example, the Stray Dog hosted an evening dedicated to Prutkov's fiftieth anniversary (see *Pamiatniki kultury. Novye otkrytiia. Ezhegodnik 1983* [Leningrad: Nauka, 1985], p. 199). It is also known that an early Stravinsky cantata (now lost) based on extracts from Prutkov was performed in Nikolai Rimsky-Korsakov's home on one of his last birthdays and that in July 1914 Stravinsky made sketches (now in the Paul Sacher Foundation in Basel) for another Prutkov composition, which he abandoned after Alexandre Benois had convinced him that Prutkov was not in good taste. Sudeikin was fond of Prutkov's ironies and even designed one of his vaudevilles—*Fantasy*—for the Comedians' Halt in 1917. Other items in the Album also use Prutkov as a subject (see entries 108a and 108b). According to Vera, Yakobson based several of his musical romances on Prutkov's words, including them in his concerts (Diaries, 9 June 1918).

For Yakobson's biography and commentary, see entry 45a.

46 Sigizmund Valishevsky, portrait of Vera Sudeikina (ca. 1919)

Pencil on white page. Inscribed "Drawn by Sigizmund Valishevsky in Tiflis" in pencil at lower right.

In his student years, Valishevsky was drawn to the work of Rubens, Velasquez, Goya, Manet, and Cézanne, but his encounters with the Russian and Georgian avant-gardes in the mid-1910s countered this initial affection for Western Europe. Valishevsky was a master of the quick, informal portrait,[1] and he contributed a number of them to Tiflis exhibitions.[2] His book illustrations (see entry 87) and poetry contain the same spontaneous quality.[3] In 1917–19 he was a prime mover of the Tiflis bohemia centered on the Fantastic Tavern and the Khimerioni, and in the Varia for Tiflis Vera mentions a "dramatization of Valishevsky's paintings," with music by Sandro (Alexander) Korona, and other contributions by Yakov Lvov and Sudeikin. Valishevsky made several portraits of Savelii Sorin and Sudeikin, and perhaps also the portrait of Vera, while working with Sudeikin on the murals for the Khimerioni (see the introduction and entry 107a). This may well be the drawing that Vera mentions buying from Valishevsky in Tiflis (Diaries, 20 May 1919). Sudeikin also portrayed his wife in this pose (see entries 17b and S1).

Valishevsky, Sigizmund (Ziga) Vladimirovich (Waliszewski, Zygmunt). Artist and poet. Born 1897 in St. Petersburg; died 1936 in Kraców.
1903 family moved to Batum. Ca. 1910 studied art at Nikolai Sklifasovsky's drawing school in Tiflis. 1913 onward participated in exhibitions in Tiflis and elsewhere; interested in the work of Niko Pirosmanashvili. 1914 visited the Stray Dog in Petrograd. 1915 his sister Valeriia (also an artist) married Kirill Zdanevich; mid-1910s close to Lado Gudiashvili, Alexander Bazhbeuk-Melikov, Vasilii Ka-

tanian, and the Zdanevich brothers. 1917 member of Alexei Kruche-nykh's Syndicate of Futurists; contributed to the interior decoration of the Fantastic Tavern in Tiflis; with Nikolai Cherniavsky, Alexei Kruchenykh, and the Zdanevich brothers contributed to the miscellany *Zhlam*. 1919 contributed illustrations to the miscellany *Melnikovoi. Fantasticheskii kabachok*; participated in the "Little Circle" exhibition in Tiflis; worked on the interior decoration of the Khimerioni cabaret in Tiflis; designed the drop curtain for the Theater of Opera and Ballet in Tiflis; with Lado Gudiashvili and Kirill Zdanevich, illustrated Vasilii Katanian's *Ubiistvo na romanicheskoi pochve*. 1920 one-man exhibition in Tiflis. 1921–24 lived in Poland; taught at the Academy of Arts in Kracόw. 1925–31 lived in Paris; legs amputated because of circulatory disease. 1931 moved back to Poland.

NOTES

1. Cf. his portrait of Georges Gurdjieff, reproduced in *Kirill Zdanevich and Cubo-Futurism: Tiflis, 1918–1920* (exhibition catalog, Rachel Adler Gallery, New York, 1987), no. 73. Valishevsky himself was the subject of several portraits, e.g., by Gudiashvili and K. Zdanevich in 1917.
2. For example, he showed three portraits ("Mrs. A., Mrs. P., and Mrs. B.") at the "Little Circle" exhibition in Tiflis in May 1919.
3. Kruchenykh included one of Valishevsky's poems, "Kushai, khudogi, goviadinu Rubensa," in *Uchites khudogi* (Tiflis, 1917), p. 1; reproduced in E. Kovtun, *Russkaia futuristicheskaia kniga* (Moscow: Kniga, 1989), p. 218; and *41°. Ilia i Kirill Zdanevich* (exhibition catalog, Modernism Gallery, San Francisco, 1991), p. 37.

FURTHER READING

Dzutsova, I. "Gruziia." *Iskusstvo*, no. 12 (Moscow, 1974): 80.

Kakhreidze, A. "Talantlivyi khudozhnik." *Zaria Vostoka*, no. 167 (Tiflis, 17 August 1957).

Shmerling, R. "Gody tvorchestva khudozhnika S. Valishevskogo v Gruzii." In *Trudy Instituta istorii gruzinskogo iskusstva AN SSSR*. Tbilisi: Academy of Sciences, 1964.

Vystavka rabot polskogo khudozhnika Sigizmunda Valishevskogo. Exhibition catalog, Georgian Society for Cultural Contact with Foreign Countries. Tiflis, 1955.

In addition, some bibliographical references are provided in A. Rysziewicza, ed., *Polska Bibliografia Sztuki 1801–1944* (Warsaw: Wydawnictwo Polskiej Akademii nauk, 1976), vol. 1, pp. 295–96.

47a Georgii Kharazov (1919)

Fugue

Franklin abducted thunder from the sky.
In France the crown was melted down.
With his crutch Sir Pitt angrily threatened
Napoleon's insurgent eagles.

Arrogantly the Sonarkom[1] led the mutiny.
But the glorious madmen were beyond the law:
May evil be bridled by good,
The sword of Wilhelm by the olive branch of Wilson.

The reckoning of rights is seven times confused:
With the rubicund juice of centuries squeezed
The great Spirit matures and grows.

Where two quarrel, a third rejoices:
The smile of wise bitterness flowers
To the yells of marketplace interjections.

G. A. Kharazov

Ink on white page.

The occasion for this curious poem by Russia's first Freudian is not known, although it may have been the Fantastic Tavern in the late spring of 1919, which Kharazov and the Sudeikins frequented. It was there that he delivered his lecture "The Theory of Freud and *Zaum* Poetry" (5 April 1918), which seems to have impressed both Alexei Kruchenykh and Igor Terentiev and may have encouraged their literary investigations into anal eroticism (see entry 99). Perhaps the Sudeikins even attended Kharazov's lectures on psychoanalysis and on Pushkin's story "The Captain's Daughter" and Andrei Bely's novel *Petersburg*, which he gave at the Academy of Verse, also in 1919. It is interesting to note that Kharazov also interpreted Vera's dreams according to the principles of Freud (Diaries, 6 May 1919).

Clearly, Kharazov was a colorful figure who had many protagonists (the Sudeikins) and antagonists (including Grigorii Robakidze, who once punched him)[2] and even inspired poetry:

Grinning at a sentence just spoken,
Disclosing the secret sin of the muse,
A lover of Freudian ecstasies,
The very wise Dr. G. Kharazov
Made the entire Guild embarrassed.[3]

Moisei Altman remembered Kharazov both as the "devil" and as an "original and audacious scholar. He furnished his book with the epigraph 'Moi, je ne suis pas Marxiste.' The epigraph was provocative, but the signature of Marx himself beneath the epigraph disarmed [the reader]."[4]

Kharazov (Kharazian), Georgii Artemievich. Mathematician, economist, and psychiatrist. Born 1877; died ca. 1931.

1900s lived in Zürich, Heidelberg, and Berlin; taught at the University of Geneva; was a liberal Marxist and a specialist in psychoanalysis. 1917–19 frequented the Fantastic Tavern in Tiflis, lecturing on Freud. 1919 published on article on Freud and Tatiana's dream in *Evgenii Onegin* in *Ars*; founded the Academy of Verse, to which Igor Terentiev also belonged. 1921 moved to Baku; friendly with Moisei Altman. 1920s taught economics at the Azerbaijan Polytechnic Institute.

NOTES

1. Sonarkom (Sovnarkom) is an abbreviation for "Sovet narodnykh komissarov" (Soviet of People's Commissars), the first Soviet governmental body that Lenin headed immediately after the October Revolution.

2. According to Gregorio Sciltian in *Mia avventura* (Milan: Rizzoli, 1963), p. 132. On Robakidze, see entry 51b.

3. From Nina Vasilieva, "Fantasticheskii kabachok" (1918), in L. Magarotto, M. Marzaduri, and G. Pagani Cesa, *L'avanguardia a Tiflis* (Venice: Seminario di Iranistica, Uralo-Altaistica e Caucasologia dell'Università degli Studi di Venezia, 1982), p. 311. The full poem, with annotations, is published in ibid., pp. 310–16.

4. M. Altman, "Avtobiografiia," *Minuvshee*, no. 10 (Paris, 1990): 230. The book in question is G. Kharazov, *Vvedenie v teoreticheskuiu politicheskuiu ekonomiiu. Lektsii, chitannye na Ekonomicheskom fakultete A.P.I. v 1923–24 ak. godu* (Baku: Azerbaijan Polytechnic Institute, 1924).

FURTHER READING

Kharazov, G. A. *Arithmetische Untersuchhungen über Irreduktibilität.* Heidelberg: Hörning, 1902.
——— *Karl Marx über die menschliche und kapitalistische Wirtschaft.* Berlin: Bondy, 1909.
———. *Ne voskresnu. Poema pamiati P. A. Krapotkina.* Tiflis, 1921.
———. "Son Tatiany. Opyt tolkovaniia po Freidu." *Ars*, no. 1 (Tiflis, 1919): 9–20.
———. *Das System des Marxismus.* Berlin: Bondy, 1910.
———. "Yu. Degen. Poema o sontse [*sic*]." *Igla*, no. 12 (Tiflis, 1918): 8.
Magarotto, L., M. Marzaduri, and G. Pagani Cesa. *L'avanguardia a Tiflis*, p. 72. Venice: Seminario di Iranistica, Uralo-Altaistica e Caucasologia dell'Università degli Studi di Venezia, 1982.
Pasternak, B. "O Lili Kharazovoi." *Literaturnoe obozrenie*, no. 2 (Moscow, 1990): 17–18. (Text prepared by Elena Pasternak).
Sciltian, G. *Mia avventura*, p. 132. Milan: Rizzoli, 1963.

47b Sergei Sudeikin, untitled (ca. 1919)

Watercolor and pencil on paper laid on green paper glued onto white page. 10.5 × 10.6 cm.

The meaning of the sphinx emerging from the crucible, carrying a face on her midriff and surrounded by the attributes of knowledge and prediction, remains recondite, although it is bizarre enough to illustrate Kharazov's poetry on the same page.

For Sudeikin's biography, see entry 1b.

47c Sergei Sudeikin, untitled (ca. 1919)

Watercolor on ruled paper glued onto white page. 10.2 × 11.9 cm. The reverse carries writing, apparently in Sudeikin's hand.

For Sudeikin's biography, see entry 1b.

47d Georgii Kharazov (1919)

Mother of the Russian Miracle

Russian huts in the wretched steppe.
In the morning sleighs straggle along; what kind of
Star is that of tinsel? Wretched toys,
An angry smirk, and a rusty thorn in the flesh?

It's the wrong time for the angels to sing *chastushki*.[1]
How can a divine rose spring up
From a compost of thorns,
In the fumes of the cowhouse or on the floor of the transport car?

Oh, Lord, cease such stupid questions.
Bow closer to the couch of thorns
To cure the terrible delirium of the soul.

Who, awake, felt tedium in the wonderful drama,
Will, in the sleepless dream, realize and believe
That "faith moves mountains sacrificially."

19 June 1919 G. A. Kharazov

Ink on white page.

For Kharazov's biography and commentary, see entry 47a.

NOTE

1. *Chastushka*: a two- or four-line rhymed poem on a topical theme, often humorous.

48–49b Boris Kochno (1921–22)

To Dear Sergei Yurievich

 "Mavra,"
 London, 1921

I shall never betray the memory
Of this happy day today
And those last
Hours, when I sat down[1]
Before the canvas. In the window opposite
Your forbidden image watched.

But how can one forget those nights
When the brilliance of your eyes appeared
In the light smoke of dreams
And when your name for long

Resounded in a troubled semisleep.
But you did not respond to me.

Now the tiresome ban
Is lifted!
My darling!
There is no
End, my dear, to these felicities!
It all resembles a new dream.
When in a double union, a third
Is tender Cupid!

18 February 1922 Boris Kochno

Ink on white page.

This dedication accompanies the Sudeikin pastorale (49a). The reference at the head of the poem to "'Mavra,' London 1921," is to Igor Stravinsky's ballet of the same name and, in turn, the transvestite character Mavra in Pushkin's tale "The Little House in Kolomna" (the young girl Parasha has her lover—the hussar Vasilii—disguise himself as the cook Mavra, whom her mother has asked her to employ. After some amusing incidents, including the scene in which the "cook" is found shaving, the couple is united). Igor Stravinsky took Pushkin's text for his comic opera Mavra (at first called La petite maison de Kolomna and then La Cuisinière), for which Kochno wrote the libretto. The two dates and places here (London 1921 and [Paris] 1922) would perhaps indicate that Kochno is remembering a love unreturned and now gained between him and Sudeikin. In any case, Kochno and Sudeikin had been in close touch in Paris since at least February 1921, when Sudeikin was painting Kochno's portrait and advising him—incorrectly—how to gain access to Diaghilev.[2] Sudeikin and Kochno were again in London in October–November 1921 while Kochno and Diaghilev were formulating Mavra and Vera was performing the Queen in Diaghilev's production of The Sleeping Princess at the Alhambra Theater, London, in November 1921. Mavra was produced by Sergei Diaghilev at the Hotel Continental, Paris, on 29 May 1922 and then at the Théâtre de l'Opéra, Paris, on 3 June 1922 with choreography by Bronislava Nijinska and designs by Léopold Survage.

Mavra was something of a fateful denouement in the lives of Kochno, the Sudeikins, and also Lev Bakst. Between the conception of the opera and its realization (spring 1921–summer 1922), Diaghilev transferred his affections from Kochno to Anton Dolin, and Vera's attachment to Sergei weakened as she and Stravinsky deepened theirs:

Stravinsky, too, had reason to be cheerful, for he was with the woman he loved. But Stravinsky did not stay long in London. After he had gone, his love letters were some consolation to Vera for the frantic tirades of Sudeikin, who also bombarded Diaghilev with demands to send him back his wife. ("How ill is she? Is she having every possible care? Should I come?"). In mid-January [1922] Vera asked Diaghilev to release her.[3]

Lev Bakst was also grieved by the advancement of Mavra, for at first Diaghilev had given him the design commission, but Diaghilev was quick to express his dissatisfaction with the result and, on Mikhail Larionov's recommendation, transferred the commission to Survage. Survage recalled:

"Come along," [Larionov] said, "Diaghilev wants to see you." We set out for the Hotel Meurice [probably the Continental], and found Diaghilev on the sixth floor in a servant's bedroom furnished only with a bed, a table and a chair. Diaghilev sat on the bed, I on the chair, and Larionov remained standing. Diaghilev explained that he wanted me to make designs for Stravinsky's opera Mavra; but he wanted them by the next morning. I thanked Larionov and made two sketches during the night, of which Diaghilev chose one.[4]

One result of this episode was that Bakst then initiated a court proceeding against Diaghilev for reimbursement. The entire incident forced a breach between Diaghilev and Bakst, and consequently the two men ended their long artistic relationship once and for all. In 1921–22 Bakst was also in close contact with Vera and painted her portrait at least twice, once as the Queen in The Sleeping Princess (November 1921).[5]

From Vera's memoirs and letters, it appears that she was both a friend and a confidante of the poet and balletomane Boris Kochno, whom she had known in Russia in 1917–18: "I liked his young romantic appearance, his enthusiasm for the same things: we recited Russian poems to each other, and he copied a whole book of Anna Akhmatova's poems for me."[6]

In the spring of 1921, Kochno, often referred to euphemistically as "Diaghilev's secretary," was in a state of sentimental confusion because of Diaghilev's newfound love for Dolin, but found consolation in Vera's company (as did Diaghilev) and, as is clear from the end of this poem, in Sudeikin's also. The "omniscient" Kochno also realized that Vera's attraction to Stravinsky was a decisive moment in her life and that Stravinsky's momentary interest in the dancer Lidia Sokolova was about to surrender to Vera's more pressing demands— a supposition that he expressed in a poem to Vera dated October 1921.[7] Vera's papers contain several other dedications from Kochno, including one as late as 1924 written in Monte Carlo.[8] She and Kochno continued to collaborate on various projects throughout the 1920s and 1930s, such as Diaghilev's production of Les Biches in 1923.

Kochno, Boris Mikhailovich. Pseudonym: Sobeka. Poet and librettist. Born 1904 in Moscow; died 1990 in Paris.

Of Ukrainian extraction, grew up in Moscow and St. Petersburg. 1920 arrived with his mother in Paris via Constantinople. 1921 Sergei Diaghilev engaged him as his private secretary; wrote the libretto for Igor Stravinsky's Mavra. 1920s worked with Nijinska and Leonide Massine. 1925 onward played a major role in the artistic development of the Ballets Russes, writing the books for many ballets such as Zéphire et Flore (1925), La Pastorale (1926), and Ode and La

Chatte (1927). 1932–37 co-director of the Ballets Russes de Monte Carlo, writing scenarios for ballets such as *Cotillon* and *Jeux d'Enfants*. 1933 with George Balanchine established the group called Ballets. 1945–49 onward artistic director of Roland Petit's Ballets de Champs-Elysées.

NOTES

1. The Russian verb is *sadilas*—i.e., the ending is feminine, an inflection that reinforces the allusion to a homosexual relationship between Kochno and Sudeikin.
2. R. Buckle, *Diaghilev* (London: Weidenfeld and Nicolson, 1979), p. 376.
3. Ibid., p. 394.
4. Quoted in ibid., p. 402.
5. Reproduced in V. Stravinsky and R. McCaffrey, eds., *Igor and Vera Stravinsky: A Photograph Album, 1921 to 1971* (London: Thames and Hudson, 1982), p. 54. Vera's papers contain several notes from Bakst that have been translated.
6. R. Craft, ed., *Dearest Babushkin: The Correspondence of Vera and Igor Stravinsky, 1921–1954, with Excerpts from Vera Stravinsky's Diaries, 1922–1971* (London: Thames and Hudson, 1985), p. 13.
7. Published in ibid., p. 16. Also see Stravinsky's letters of November 1921 that Kochno was supposed to have passed to Vera, auctioned as lots 399–405 at *Collection Boris Kochno* (auction catalog, Sotheby's, Monaco, 11–12 October 1991).
8. See entry S4. The Monte Carlo inscription, written on fancy notepaper, is merely a message of good wishes. Both messages are in one of Vera's Paris albums for 30 September 1920 onward. See entry 135.

FURTHER READING

The Boris Kochno Collection: Designs for Diaghilev. Exhibition catalog, New York Public Library. New York, 1971.

Buckle, R. *Diaghilev*. London: Weidenfeld and Nicolson, 1979.

Collection Boris Kochno. Auction catalog, Sotheby's. Monaco, 11–12 October 1991.

Grigorovich, Yu., ed. *Balet. Entsiklopediia*, p. 272. Moscow: Sovetskaia entsiklopediia, 1981.

Hommage à Diaghilew. Collections Boris Kochno et Serge Lifar. Exhibition catalog, Musée Galliera. Paris, 1972.

Kochno, B. *Le Ballet*. Paris, 1954.

———. *Diaghilev and the Ballets Russes*. London: Harper and Row, 1970.

49a Sergei Sudeikin, untitled (ca. 1921)

Watercolor on paper glued onto white page. 14.2 × 14.2 cm (at widest diameter).

This pastorale accompanies the Kochno poem (entries 48–49b). For Sudeikin's biography, see entry 1b.

50 Group photograph (1919)

Original photograph glued onto Album leaf. 7.5 × 11.4 cm.

The photograph is of a group of enthusiasts connected with the Fantastic Tavern and Khimerioni cabarets, which the Sudeikins frequented in Tiflis in 1919. From left to right (standing) are the writers Titsian Yustinovich Tabidze (1895–1937) and Paolo Yashvili (Pavel Dzhibraelovich Yashvili; 1895–1937) (Tabidze and Yashvili were primary members of the Blue Horns group); seated are Alexander (Sandro) Ivanovich Kancheli, Nina Tabidze (Titsian's wife), and Grigorii Robakidze (see entries 51b, 103a).

51a Osip Mandelstam

To Vera Avgustovna and Sergei Yurievich S. (1917)

The stream of golden honey poured from the bottle
So heavily and long that the lady of the house had time to say:
"Here in sad Tauride[1] whither fate has carried us
We are not bored at all"—and she glanced over her shoulder.

Services to Bacchus everywhere! As if there were only
Watchmen and dogs in the world! As you go along, you notice
 no one;
The peaceful days roll by like heavy barrels;
Far away are voices in a hut: you cannot understand, you
 cannot answer. . . .

Whereafter we went out into the huge, brown garden.
The dark blinds were pulled down on the windows like
 eyelashes.
Past the white columns we went to look at the vine.
Where the drowsy mountains are showered in aerial glass.

I said: "A vine lives like an ancient battle,
Where curly-headed riders do battle in curly order!
In stony Tauride is the science of Hellas, and here we have
The noble, rusty beds of golden acres!"

But in the white room stillness stands like a distaff;
It smells of vinegar, paint, and fresh wine from the cellar. . . .
You remember, in that Greek house, the wife beloved by all
No, not Elena—the other one—who embroidered oh, so long!

Golden Fleece, where are you, Golden Fleece?
The whole journey the heavy waves of the sea crashed,
And, leaving the vessel, exhausted by the seas,
Odysseus returned, filled with space and time.

11 August 1917 Osip Mandelstam
Alushta

Ink on paper laid on board loosely inserted between pp. 50–51 of the Album. Mounted: 23.6 × 19.7 cm; unmounted: 22.1 × 17.7 cm.

This poem is no. 3 in Mandelstam's cycle of poems called *Tristia*. The "Avgustovna" (rather than Arturovna) of the epigraph at the head of the poem is a sign of Mandelstam's esteem of Vera, not a slip of memory (see entry 27). The poem was first published in the miscellany *Odessa-Povolzhiu* (Odessa: UkrGiz, 1921), p. 6. It has been reprinted many times, including in G. Struve and B. Filippov, eds., *Osip Mandelshtam. Sobranie sochinenii v trekh tomakh* (Washington, D.C.: Inter-Language Literary Associates, 1967), vol. 1, pp. 63–64 (commentary pp. 435–36); and is reproduced and translated in V. Stravinsky and R. McCaffrey, eds., *Igor and Vera Stravinsky: A Photograph Album, 1921 to 1971* (London: Thames and Hudson, 1982), p. 44. A partial translation appears in V. Stravinsky and R. Craft, *Stravinsky in Pictures and Documents* (New York: Simon and Schuster, 1978), p. 239.

Mandelstam, the "most risible creature in the world" according to Georgii Ivanov,[2] wrote the piece while he was living in Alushta, near Yalta, in 1917 and was a frequent visitor to the Sudeikins'. Vera described their old St. Petersburg acquaintance in her Diaries for February through the summer of 1917:

Suddenly Osip Mandelstam appeared. . . . We took him out to the vineyards—"We have nothing else to show you." And we had nothing to serve him except tea with honey. No bread. But the talk was lively, not about politics at all, but about art, literature, painting. A witty, cheerful, charming conversationalist. We were delighted by his visit. . . . "Come again. We're so glad to see you." . . . He did come, and brought us his poem. . . . We wanted to see him again, his animated expression, to hear his conversational enthusiasm. He wore a raincoat; I don't think he even had a suit; and he looked hungry, but we could not offer him anything—there was literally nothing; we ourselves were half-starving. I remember that there was a meat patty left over from dinner and hidden in the dresser "just in case." He stood in front of the dresser, looked over the sketches pinned to the wall, and I thought, "We must give him that meat patty; he probably senses its existence," but I didn't—it was intended for Seryozha [Sudeikin] before he went to bed.[3]

In fact, three days earlier, on 11 August, Mandelstam had already written another poem for Vera (see entry 111a). Vera herself explained some of the subtext of *Tristia*, no. 3: "Mme Sudeikina is the 'hostess' and the 'other' (i.e., Penelope). . . Mrs. Stravinsky reveals . . . that the 'cordial' was honey, and that the subjects of the embroidery, which she still possesses, were Columbine and Pierrot."[4] Vera also possessed a photograph of Lev Bruni's portrait of Mandelstam that Bruni's wife, Nina Konstantinovna (Balmont's daughter; see entry 1a), gave her in Petrograd in 1916.[5]

Mandelstam (Mandelshtam), Osip Emilievich. Poet and translator. Born 1891 in Warsaw; 1938 died in a labor camp.

1907 graduated form the Tenishev Institute in St. Petersburg. 1907–8 traveled in France. 1909 met Viacheslav Ivanov. 1909–10 traveled in Germany. 1910 published his poems in *Apollon*. 1911 was baptized a Methodist; enrolled in St. Petersburg University and joined Nikolai Gumiliev's Guild of Poets, supporting the Acmeist movement. 1913 published his collection *Kamen* (Stone). 1918–21 traveled in the Crimea and Georgia. 1920 (fall) in Batum; Ilia Zdanevich organized an evening in his honor there. 1921 (July–December) visited Georgia again. 1922 moved to Moscow. Mid-1920s wrote autobiographical pieces such as *Shum vremeni* (Noise of time) and *Egipetskaia marka* (Egyptian seal). 1934 arrested.

NOTES

1. Tauride (Tavrida) was the name given to the Crimean peninsula after it was annexed by Russia in 1783. The tavry were an ancient tribe inhabiting the southern part of the Crimea. Benedikt Livshits wrote of this region in his memoirs: "There, beyond the line of the horizon—the black-fleeced, louse-ridden belt of the Tauride Aphrodite (did she really exist?)—swarmed countless flocks of sheep. Well, not really. This was the cloak of Nessus dropped by Hercules (contrary to legend) in the Hylaean steppe." See B. Livshits, *Polutoraglazyi strelets* (Leningrad: Izdatelstvo pisatelei, 1933), p. 44. It is toward Tauride and Hylaea that the Argonauts sailed in their quest for the Golden Fleece.

2. G. Ivanov, *Peterburgskie zimy* (New York: Chekhov, 1952), p. 115.

3. Quoted in V. Stravinsky and R. McCaffrey, eds., *Igor and Vera Stravinsky: A Photograph Album, 1921 to 1971* (London: Thames and Hudson, 1982), p. 44.

4. V. Stravinsky and R. Craft, *Stravinsky in Pictures and Documents* (New York: Simon and Schuster, 1978), p. 239.

5. Reproduced in R. Craft, ed., *Dearest Babushkin: The Correspondence of Vera and Igor Stravinsky, 1921–1954, with Excerpts from Vera Stravinsky's Diaries, 1922–1971* (London: Thames and Hudson, 1985), p. 8.

FURTHER READING

Brown, C. *Mandelstam*. London: Cambridge University Press, 1973.

Complete Poetry of Osip Emilievich Mandelstam. With an intro. by S. Monas. Albany: State University of New York Press, 1973.

Harris, J. G., ed. *Osip Mandelstam: The Complete Critical Prose and Letters*. Ann Arbor: Ardis, 1979.

Harris, J. *Osip Mandelstam*. Boston: Twayne, 1988.

Karpovich, M. "Moe znakomstvo s Mandelshtamom." *Daugava*, no. 2 (Riga, 1988): 109–12.

Khardzhiev, N., ed. *Stikhotvoreniia*. Moscow, 1973.

Kourbourlis, D., ed. *A Concordance to the Poems of Osip Mandelstam*. Ithaca: Cornell University Press, 1974.

Kushner, A., ed. *Zhizn i tvorchestvo O. E. Mandelstama*. Voronezh: VGV, 1990.

Nikolaev, P., et al., eds. *Russkie pisateli, 1800–1917. Biograficheskii slovar*. Vol. 3, pp. 505–10. Moscow: Bolshaia russkaia entsiklopediia, 1995.

Osip Mandelshtam. Stikhotvoreniia, perevody, ocherki, stati. With an intro. by G. Margvelashvili. Tbilisi: Merani, 1990.

Sarnov, B. *Zalozhnik vechnosti. Sluchai Mandelshtama*. Moscow: Knozhnaia palata, 1990.

Struve, G., and B. Filippov, eds. *Osip Mandelshtam. Sobranie sochinenii v trekh tomakh*. 3 vols. plus supplemental vol. Washington, D.C.: Inter-Language Literary Associates, 1967.

Terras, V., ed. *Handbook of Russian Literature*, pp. 271–73. New Haven: Yale University Press, 1985.

51b Grigorii Robakidze (1919)

An Etching

"Negroes in white wigs"
From a décor by Sergei Sudeikin

Drowsy dream in the ashes of languors.
Streams of heavy, red braids.
White knees growing crimson
On the bosom of crumpled roses.
A whore of moonlit fervor
Is sapphire bright in rays:
Astarte basks in the sun
Amid the negroes in white wigs.
The bloody hops of sultry pomegranates
Call all women to debauchery.
The heavy nocturnal hum of amatory designs
Can be heard, can be heard.
Salomé[1] the tigress burns
In the garden by the wild bush
Beckoning to love, in amber overcome:
She kisses the dead lips,
The desired poison of the convolutions of the torso:
At this secret hour the whole earth debauches.
And the delirium of extinct races soars
In a cloak of albatross wings.
Suddenly the passionate whisper dies:
Ringing, sounding, is heard the flight,
Ever nearer comes the deathly clatter
Of the Horse of the Apocalypse.
And there will be the meeting of two passions:
Of the fire of hooves and the sting of flesh.
The Pale Horse will neigh still paler.
The wife will yearn until no more.
And the torture will be voluptuous
Of the mad and crazed whore.
But there the hooves will forever dream
Of a naked body.

Summer 1919 Grigorii Robakidze
Tiflis

Ink on rice paper page.

This poem was first published in *Novyi den*, no. 10 (Tbilisi, 30 June 1919). The "Dionysian" Robakidze[2] contributed much to Georgian Modernism in the late 1910s and brought to the Tiflis bohemia a heady mixture of Nietzsche, French Decadent poetry, and Russian mysticism that he preached with a "sober oratory that struck us like a wild tiger."[3] According to Gregorio Sciltian, Robakidze and Georgii Kharazov (entry 47d) represented the two main philosophical trends in Tiflis at that time:

And one might ironize their substance and value if they had not borne within them the germ of terrible events.

Robakidze, an elegant man who used to wear a trilby on his clean-shaven cranium and a monocle later moved to Germany as a theorist of racism and an intimate friend—almost the inspiration—of Hitler.[4]

Robakidze was a primary supporter of the activities at the Fantastic Tavern and the Khimerioni nightspots and was especially taken by their "phantasmagoric" designs.[5] Nina Vasilieva remembered how

The passionate pathos of Robakidze
Rocked our souls more than once
When he disturbed the ancient chaos
Or showed us the right
To combine ecstasy with calm.[6]

It is possible that his poem celebrates Sudeikin's mural for Khimerioni, although there is no record of "negroes in white wigs" as part of the decorative system there. Alternatively, Robakidze, the "local cavalier,"[7] is describing one or more of Sudeikin's evocations of orgy and revelry à la Bakst, which certainly appealed to his gothic imagination and which had many pictorial derivations—from Aubrey Beardsley to Nikolai Kalmakov. Like Sudeikin, although without his ironic buoyancy, Robakidze explored the themes of sex and death in his poems, plays, and even literary analyses,[8] and his necrological, demonic imagery also brings to mind the poetry of his Armenian friend Kara-Dervish (Akop Gendzian), whose *Dance on the Mountains (A Nocturnal Round)* of 1922 was dedicated to him.[9] In spite of his debt to French, German, and Russian literature, Robakidze did not forget his commitment to the Georgian Parnassus, as he emphasized in 1917: "Georgia is a piece of the Orient! And we should not forget our cradle. Western Europe is dear to us, but we cannot surrender the Orient for Europe. . . . We must follow Rustaveli and unite the surly oriental thought with the force of the Italian Renaissance in one synthesis!"[10]

After arriving in Berlin in 1931, Robakidze reestablished contact with Sudeikin, declaring that he had "matured as a writer. I have written three novels, fifteen novellas, five dramas . . . many essays and poems. . . . About you I know only two facts: your success and your divorce."[11]

Robakidze, Grigorii (Grigol) Titovich. Poet, novelist, and playwright. Born 1884 in Sviri, Georgia; died 1962 in Berlin.

Ca. 1900 attended the Ecclesiastical Institute in Kutaisi. Ca. 1905 studied in Germany; interested in Nietzsche, Spengler, and mysticism; visited Paris. Ca. 1910 taught at the University of Heidelberg. 1911 lectured on Nietzsche in Tiflis. 1915 close to the Blue Horns group. 1916 contributed to the Blue Horns journal. 1917–19 frequented the Fantastic Tavern in Tiflis, contributing to its miscellanies. 1918 (October) participated in the Evening of Poetry and Music at the Tiflis Conservatory. 1919 contributed to the journal

Orion. 1920 left Tiflis for Baku, returning to Tiflis shortly thereafter. 1927 traveled in Europe. 1931 left Georgia with a theater company touring Europe. 1932 defected and settled in Berlin. 1930s supported Hitler and the Nazi doctrine of racism.

NOTES

1. A reference, presumably, to Princess Salomeia Nikolaevna Andronnikova (Andronikova; 1889–1982) who was famous for her literary salon in St. Petersburg and then, after emigrating, in Tiflis, Paris, and London. She was also the focus of much poetical and amatory attention: Osip Mandelstam, allegedly in love with her, dedicated his poem "Salominka" (Straw; a play on the words *straw* and *Salomeia*) to her; Anna Akhmatova also dedicated her poem "Ten" (Shadow) to her. Andronnikova and the Sudeikins summered at Borzhom (a resort area near Tiflis) together in 1919. Vera and Salomeia (married name: Galperin or Halperin) maintained their friendship in Paris, London, and New York right up until they embarked on their final journeys in 1982. For information on Andronnikova, see G. Sharadze, "Muza dvadtsatogo veka," *Literaturnaia Gruziia*, no. 3 (Tbilisi, 1983): 168–78; L. Vasilieva, "Salomeia, ili salominka, ne sognutaia vekom," *Ogonek*, no. 3 (Moscow, 1988): 22–26; and entry 81.
2. Robakidze wrote "My emblem is the medallion of Dionysus" in his poem *Avtomedalioni* (1922). Quoted in L. Magarotto, M. Marzaduri, and G. Pagani Cesa, *L'avanguardia a Tiflis* (Venice: Seminario di Iranistica, Uralo-Altaistica e Caucasologia dell'Università degli Studi di Venezia, 1982), p. 65.
3. T. Tabidze, "Dadaizm da Cisperi q'anc'ebi" (in Georgian), *Meocnebe niamorebi*, no. 10 (Tiflis, 1923). Translated from the Italian translation from the Georgian in Magarotto, Marzaduri, and Pagani Cesa, *L'avanguardia a Tiflis*, p. 73.
4. G. Sciltian, *Mia avventura* (Milan: Rizzoli, 1963), p. 132.
5. G. Robakidze. Quoted in *Iliazd: Maître d'oeuvre du livre moderne* (exhibition catalog, Galerie d'art de l'Université de Québec, Montreal, 1984), p. 13.
6. From Nina Vasilieva, "Fantasticheskii kabachok" (1918), in Magarotto, Marzaduri, and Pagani Cesa, *L'avanguardia a Tiflis*, p. 310. The full poem with annotations is published in ibid., pp. 310–16.
7. Diaries, 1 May 1919.
8. See his analyses of the Russian writers Andrei Bely, Petr Chaadaev, Mikhail Lermontov, and Vasilii Rozanov in his book *Portrety. Vypusk 1* (Tiflis: Kavkazskii posrednik, 1919).
9. Osip Mandelstam translated Kara-Dervish's poem from the Georgian into Russian, and this version is published in Magarotto, Marzaduri, and Pagani Cesa, *L'avanguardia a Tiflis*, pp. 221–22 (see entry 2b).
10. Robakidze, "Leila" (in Georgian), in *Leila*, no. 1 (Tiflis, 1917). Translated from the Italian translation from the Georgian in Magarotto, Marzaduri, and Pagani Cesa, *L'avanguardia a Tiflis*, p. 64. He expressed similar thoughts in his article on Georgian Modernism in *Ars*, no. 1 (Tiflis, 1918): 46–52.
11. Letter from Robakidze in Berlin to Sudeikin, dated 12 September 1931, in the Sudeikin archive in RGALI, Moscow, call no. f. 947, op. 1, ed. khr. 236, l. 1.

FURTHER READING

For a partial listing of Robakidze's works in Georgian, see L. Magarotto, M. Marzaduri, and G. Pagani Cesa, *L'avanguardia a Tiflis* (Venice: Seminario di Iranistica, Uralo-Altaistica e Caucasologia dell'Università degli Studi di Venezia, 1982), pp. 96–97.

Magarotto, L., M. Marzaduri, and G. Pagani Cesa. *L'avanguardia a Tiflis*, pp. 63–66. Venice: Seminario di Iranistica, Uralo-Altaistica e Caucasologia dell'Università degli Studi di Venezia, 1982.

Reifild, D. "Grigol Robakidze." *Literaturnaia Gruziia*, no. 12 (Tiflis, 1990): 206–8.
Robakidze, G. "Andrei Bely." *Ars*, nos. 2–3 (Tiflis, 1918): 49–61.
———. "Gruzinskii modernizm." *Ars*, no. 1 (Tiflis, 1918): 46–52.
———. "Maiia." *Orion*, no. 3 (Tiflis, 1919): 45–48.
———. *Malshtrem*. Tiflis, ca. 1923.
———. "Pan." *Orion*, no. 1 (Tiflis, 1919): 24–25.
———. *Portrety. Vypusk 1*. Tiflis: Kavkazskii posrednik, 1919.

53a Georgii Kharazov (1917)

Tiflis

Screeching, the streetcar rushes me to the gardens.
And Tiflis seems like a galloping merry-go-round.
Watching over it, the unshaking David[1]
Composes a sermon on the mount by the ravine.

The carpet of centuries has been embroidered in vivid silks.
The coming of the tribes has sounded as they streamed into
 their new abode.
The abusive horn has been topped by the assiduous pipe.
The sacred trunk is entwined with ivy and lightning.

At the market there is the friendly hum of vying dialects;
And in the narrow street a rendezvous by car,
Where among the lace of railings stands a melancholy minaret.

The smithy of poets is next to the guardhouse.
The prophetic portrait of an old man barefoot
And the northern lights hang above the colored ottoman.

7 July 1917[2]

Ink on blue page.

For Kharazov's biography and commentary, see entry 47a.

NOTES

1. A reference to the Mountain of St. David (2,700 feet), also called Mt. Ishiturtuk or Mta-Tsminda, which overlooks Tbilisi (Tiflis) from the west.
2. It is presumed that Kharazov wrote these poems in Tiflis, where he was living in 1917. However, such a location—in conjunction with the date of 7 July 1917 for this and the subsequent entries 53b and 53c—is enigmatic, inasmuch as the Sudeikins arrived in Tiflis only in 1919. Perhaps Kharazov happened to meet the Sudeikins in Alushta or Yalta in 1917 (although in her Diaries Vera makes no mention of such an encounter); or perhaps in presenting Vera with these poems in Tiflis, Kharazov decided to inscribe the date of conception rather than that of dedication.

53b Georgii Kharazov (1917)

The Good Shepherd

The peoples cling to comforts and tranquility.
The savage bound the slave and nurtured him.
Like the pain of creativity, greed leaped
Forward with your smile, oh, cunning Capital.

You scattered caustic salt over the sweet world.
In the fever of growth the miser quivered.
He sought the secret of gold from the stars
And built a steel path to the ancient capital.

A thunderous current struggles in the empty glass.
A top released beyond the thundercloud rumbles.
There is hope in the forced victims.

But the Pharisee cries: "Kick him down!"
On the third day you will resurrect
The triumph of dogged calculations from the dead.

Ink on blue page.

7 July 1917

For Kharazov's biography and commentary, see entry 47a.

53c Georgii Kharazov (1917)

What Do You Mean, Mama, by Continually . . .

Yes, the Gospels are a real book, and vaudeville is great. . . .
Let the Alexander Library go up in flames.[1]
Like a smarmy tick bite into a flat corner
Of your teacher's little undried mouth.[2]

Gutenberg, did you realize
As you printed the first book
That setting type is a type of mania?
Buffoons!
Jubilee edition—twenty-fifth—
Of S. Ya. Nadson.[3]

In return for tips from the savings bank
The pedantic Salieri[4] struts around in his ancient furs.

Indefatigable barrel organ,
How many more years do you have to squeak it out?

With his beak a clever siskin drags off
The verses in established order.

7 July 1917 G. A. Kharazov

Ink on blue page.

For Kharazov's biography and commentary, see entry 47a.

NOTES

1. A reference both to the Alexander Public Library located on Golovinskii Prospect in Tiflis and to the burning of the library of Alexandria by Julius Caesar.
2. The fantastic nature of Kharazov's imagery, with its non sequiturs and dislocations (not altogether successful), brings to mind both nursery rhymes and fairy stories, and also the semantic "shifts" of the Cubo-Futurists (e.g., in David Burliuk's poetry). For example, the iconoclastic gesture in the first stanza here echoes the sentiments of the 1912 manifesto *A Slap in the Face of Public Taste*: "The past is crowded. The Academy and Pushkin are more incomprehensible than hieroglyphics" (quoted from V. Markov, *Russian Futurism* [Berkeley and Los Angeles: University of California Press, 1968], p. 46).
3. A reference to the poet Semeon Yakovlevich Nadson (1862–87), who enjoyed great popularity in the late nineteenth and early twentieth centuries for his sentimental poetry. It is not clear which edition Kharazov has in mind here—perhaps the collection *Proza. Dnevniki. Pisma*, published twenty-five years after Nadson's death in St. Petersburg.
4. A reference to Mozart's jealous rival, the composer Antonio Salieri (1750–1825), immortalized in Alexander Pushkin's play *Mozart and Salieri*. It is not clear whether, under this guise, Kharazov is also referring simultaneously to a contemporary Tiflis composer.

54a Olia Maidel, Jean Jaquier, N. Ulianinskaia, and
 Princess Mariia Vladimirovna Bariatinskaia (1919)

Olia Maidel[1]
Jean Jaquier[2]
N. Ulianinskaia[3]
Princess Mariia Vladimirovna Bariatinskaia[4]
14 April 1919 Last Steamship

I shall always remember our stay together, and remember my life with you![5]

Ink on board glued onto blue page. 29.5 × 24.2 cm.

The Yanovsky watercolor accompanies these signatures on the same board (entry 54b). Obviously, this entry refers to an episode or experience shared by all four of the individuals in Yalta on 14 April 1919. Probably it coincides with the Sudeikins' hurried departure from Yalta about this time, but in the absence of Vera's Diaries for April 1919 (if there were any), this is hard to verify. With the Red Army already outside Yalta, many Russians, especially the noble families who were living in the Crimea, were trying to escape by sea to Constantinople and beyond.[6] The day before this entry, on 13 April 1919, the Dowager Empress departed on the British destroyer Marlborough,[7] and the Sudeikins left a few days later—but on a more modest craft, a mere thirty-footer, loaded with oil drums. According to Vera's Diaries, a heavy storm arose, and, after many queasy hours, the couple was put ashore at Batum, at the wrong end of the Black Sea, whence they journeyed to Tiflis.[8]

In April 1919 the port of Yalta was the scene of much turmoil, anguish, and tragedy, as thousands of refugees tried to flee the Soviet advance. Baroness Liudmila Vrangel captured the moment in her memoirs:

We were leaving the Crimea, the last refuge of the past receding into a historic distance.

There is a crowd of people and children, luggage, bags, and teakettles on the deck of the Italian steamship and on the pier. The human anthill has been knocked over, is fussing about, running around, finally ending up on the deck of a steamship. Nothing unites this crowd of refugees, above whom screeches the winch dragging unknown bales and goods from the pier into the ship's hold.

The tearstained faces of those who have remained behind on the pier, and from the side of the deck you can make out the blue heights of the Yalta, the white dachas so familiar, and the distant noise of the crews on the quay.

We say farewell, maybe forever.[9]

NOTES

1. Presumably the daughter of Baroness Olga Afanasievna Maidel, who lived in Miskhor and Yalta in 1918–19. Vera mentions both Olga and Olia many times in her Diaries (e.g., 21 January and 17 March 1918). According to the Varia, they emigrated to Italy.
2. See entry 40.
3. The identity of Ulianinskaia has not been established.
4. Princess Mariia Bariatinskaia had a town house called Uch-Cham, in Yalta, and a country house called Serbliar, in Alupka, where Sergei Makovsky lived in 1918. She was president of the Yalta affiliation of the Russian Red Cross and directed a tuberculosis sanatorium. According to Makovsky's memoirs, the "dear Princess Bariatinskaia" was shot by the Soviets in the Crimea (*Na parnase serebriannogo veka* [Munich: Tsentralnoe obedinenie politicheskikh emigrantov iz SSSR, 1962], pp. 359–60), although he may have been referring to the mother or a sister. The Bariatinsky family also owned large properties in and around Tiflis, and the main public park there had been donated by them in the 1860s. In 1918–19 the Bariatinskys were living at the Villa des Roses in Yalta and played an active role in local cultural life. Princess Mariia Bariatinskaia, for example, contributed a number of Old Masters from her collection to the antiquity section of Makovsky's "Art in the Crimea" exhibition in Yalta in October–November 1918 (see entry 37c).
5. The sentiment is written in the same handwriting as that of Princess Bariatinskaia. It follows all four signatures and, therefore, seems to refer to the same episode.
6. Makovsky provides an impressive list of such families. See *Na parnase serebriannogo veka*, p. 356.
7. Diaries, 17 June 1918; and V. Stravinsky and R. McCaffrey, eds., *Igor and Vera Stravinsky: A Photograph Album, 1921 to 1971* (London: Thames and Hudson, 1982), p. 45.
8. Ibid.
9. L. Vrangel, *Vospominaniia i starodavnie vremena* (Washington, D.C.: Kamkin, 1964), p. 98.

54b Vladimir Yanovsky, untitled (ca. 1919)

Watercolor and pencil on paper laid on board glued on blue page. Mounted: 29.5 × 24.2 cm; unmounted: 16.1 × 16.6 cm. The four signatures accompany this watercolor on the same board (entry 54a).

It is has not been possible to establish the precise subject of this landscape, although it is tempting to assume that the cozy corner is where the Sudeikins were living in Miskhor in 1918, perhaps the "little house" to which they moved on 11 February or the Skvortsov dacha, part of which they rented in October (Diaries, 11 February and 28 October 1918). Yanovsky visited with the Sudeikins on several occasions (Diaries, 19 June and 27 August 1918) and Vera mentions one of his watercolors "that certainly doesn't appeal to Brailovsky" (Diaries, 2 September 1918). As is clear from this watercolor, Yanovsky was not an experimental artist, but according to one critic he managed to express "the poetry of the awakening day and the sensation of the freshness and eternal youth of nature."[1]

Yanovsky, Vladimir Konstantinovich. Artist. Born 1876 in Ortalan; died 1966 in Bakhchisarai.

1896–99 studied at the School of the Society for the Encouragement of the Arts in St. Petersburg. 1900 returned to the Crimea, taking up residence in Yalta; active as both a professional photographer and a painter. 1917 (December) contributed fourteen works to the "First Exhibition of Paintings and Sculpture by the Association of United Artists" in Yalta. 1918 (October–November) contributed three landscapes to the "Art in the Crimea" exhibition. 1925 took up residence in Bakhchisarai. 1927 contributed to the "Exhibition of Contemporary Art" in Simferopol. 1935 contributed to the "Art of the Soviet Crimea" in Moscow. 1940 contributed to the "Art Exhibition Dedicated to Twenty Years since the Liberation of the Crimea from the White Guards" in Simferopol.

NOTE

1. R. Bashchenko, *Krymskii peizazh* (Kiev: Mistetstvo, 1990), p. 12. Illustrations nos. 53–55 in this book are also of watercolors by Yanovsky.

FURTHER READING

Nothing substantial has been published on Yanovsky. Some information can be found in R. Bashchenko, *Krymskii peizazh* (Kiev: Mistetstvo, 1990), p. 12; and M. Bazhan, ed., *Slovnik khudonikiv Ukraini* (Kiev: Golovna redaktsiia ukrainskoi radianskoi entsiklopedi, 1973).

55a Ya. Lvov

The first Sudeikin encounter in Tiflis

8 July 1919 Ya. Lvov

Ink on rice paper page.

The exact occasion for this dedication is not known, although as a colleague of Sergei Gorodetsky in the latter's journal, *Ars*, Lvov was

in contact with many writers and artists in Tiflis in 1918–19, including the Sudeikins. For example, Titsian Tabidze recalled that Lvov introduced him to the Sudeikins, who then lived on Griboedov St. in a "semibasement room full of paintings under Lvov's apartment."[1] He did not enjoy universal respect and was considered to be a hack writer by the Futurists there. In one of his letters to Ilia Zdanevich, Igor Terentiev even compared Ilia Ehrenburg, whom he detested, to a "louse like Yakov Lvov."[2] Nevertheless, the Sudeikins rather liked him, and he was one of their primary contacts during the first weeks of their life in Tiflis. From Vera's Diaries (1 May 1919) it is clear that they knew Lvov well before this "first encounter" dated 8 July.

Lvov, Yakov Lvovich. Pseudonym of Yakov Lvovich Rozenshtein. Playwright and critic. Born ca. 1882 in Tiflis; died after 1934 in Italy.

1910s active as a journalist in Moscow; editor of the journal *Rampa i zhizn* (Footlights and life). 1911 published *Grimasy goroda* (Grimaces of the city). 1918 theater critic for the journal *Ars* and editor of *Kavkazskaia rampa* in Tiflis;[3] with Nikolai Mikhailovsky and Alexander Petrakovsky opened a studio of scenic art there. 1919 organized a costume ball at the Artistic Society of Tiflis.[4] 1921 edited a journal called *Na zare* in Milan (one issue only); ca. 1921 onward lived in Italy; 1934 organized the Kiki Palmer Theater Company.

NOTES

1. T. Tabidze, "Eto—moia doroga," *Literaturnaia Gruziia*, nos. 10–11 (Tbilisi, 1967): 49.
2. Letter from Terentiev to I. Zdanevich, dated 8 August 1922. Published in M. Marzaduri, ed., *Igor Terentiev. Sobranie sochinenii* (Bologna: S. Francesco, 1988), p. 396.
3. The journal *Kavkazskaia rampa* (Caucasian footlights), edited by Lvov and Alexander Petrakovsky, was advertised as "forthcoming" in *Ars*, no. 1 (Tiflis, 1918): 73. *Ars*, nos. 2–3 (Tiflis, 1918): 141 also carried an advertisement for another periodical entitled *Moi zhurnal* for which Yurii Degen, Sergei Gorodetsky, Sandro Korona, Lvov, and Iosif Sharleman were listed as contributors.
4. It is tempting to assume that this was the same "student ball" at the Artistic Society at which Ilia Zdanevich and Sigizmund Valishevsky organized a "Kiosk of Mug Painters" and "painted the faces of the public" (see the I. Zdanevich archive in the Department of Manuscripts, Russian Museum, St. Petersburg, call. no. f. 177, ed. khr. 26, l. 31).

FURTHER READING

Nothing substantial has been published on Lvov. He is the author of the following works:

Lvov, Ya. *Grimasy goroda. Chetyre tragicheskie karikatury*. Moscow: Sovremennye problemy, 1911.
———. "Tylovaia Melpomena." *Ars*, no. 1 (Tiflis, 1918): 63–65.
———. "U khudozhnika Sudeikina (beseda)." *Kavkazskoe slovo*, Tiflis, 11 May 1919.

55b Liuliu Markozov

Dear Sergei Yurievich and Vera Arturovna, I hope you make it to Constantinople and have a tremendous success there.[1]

9 July 1919 Liuliu Markozov
Tiflis

Ink on rice paper page.

Liuliu Markozov is presumably the same person as the mysterious poet Iosif Markozov, whose physical existence has often been questioned. According to Igor Terentiev, Markozov was the fourth founding member of the 41° group in Tiflis in 1919.[2] It is clear from Vera's Album and Diaries that Markozov did exist and was much more than just a Futurist mystification. Vera records, for example, that "Markozov [came] with a letter from Borzhom" to their home and shared his opinion of Nikolai Evreinov and Vasilii Kamensky with them (Diaries, July 1919).[3] According to the dedication on a self-portrait that Terentiev gave him, he was still in Tiflis in 1920.[4]

NOTES

1. The Sudeikins had arrived in Tiflis in April 1919 "by mistake," since they left Yalta hoping to reach Constantinople. They did not leave Tiflis until December 1919—but for Baku, not for Constantinople. See the introduction.
2. Terentiev lists the directors of the 41° group and their "cities of residence" on the back page of his *Traktat o sploshnom neprilichii* (Tiflis: 41°, 1919): I. Zdanevich (Pisa), A. Kruchenykh (Lodz), Iosif Markozov (Madrid), and Terentiev (Peking).
3. See entry 85a.
4. Reproduced in M. Marzaduri, ed., *Igor Terentiev. Sobranie sochinenii* (Bologna: S. Francesco, 1988), between pp. 80 and 81.

55c Mariia Davydova

My dear, sweet overcast little sun, many thanks for the Carmen.[1] You will always be with me.

 Mariia Davydova

Ink on rice paper page.

Presumably this is the mezzo-soprano Mariia Samoilova Davydova (1888–after 1963), formerly of the Theater of Musical Drama in St. Petersburg, who was about to emigrate to France. In her Varia from the Tiflis period, Vera refers to a production of Pushkin's *Stone Guest* there (with music by Nikolai Cherepnin and sets by Sudeikin) in which Davydova sang.

NOTE

1. The reference to "Carmen" is not clear, although in her Diaries (20 May 1919) Vera mentions attending a performance of *Carmen* at the Tiflis Opera Theater.

57 Titsian Tabidze (1919)

Self-Portrait

An astonishing profile, blue eyes—
The radiant Infanta hides in the mirror
From kisses tiring quickly.
Her hair spreads like green waves
And those amazing chiseled fingers
Are like astonishing horses swift of foot.
And it is a strange music that the waves
Bring me today.
I put on the robe of my luxurious poems,
I am dressed in my gown like a gentleman,
And I dream like a weary dandy,
As I leaf through the *Divagations* of Mallarmé.
It does not matter that reality be black and terrible,
But, oh, life, your bridle is in my hands,
And I can even change hell into paradise.

13 June 1919
Tiflis

The original version of this poem, in Georgian, was written in 1916. It is published in A. Sulakauli, ed., *Gruzinskaia poeziia* (Tbilisi: Nakaduli, 1982), vol. 12, p. 482. Titsian Tabidze was a co-founder and leading force of the Blue Horns group of Georgian poets that started in Kutaisi in 1915 and then moved to Tiflis. As the reference to Stephan Mallarmé's collection of verse entitled *Divagations* (Paris: Fasquelle, 1897) in entry 57 suggests, Tabidze and his friends were much influenced by Russian and French Symbolism, and they pursued the themes of reverie, cosmic harmony, the Eternal Feminine, and also Decadence (cf. Grigorii Robakidze in entry 51b). Tabidze was close to the Sudeikins in Tiflis in 1919, and obviously Vera was very struck by his lyrical imagery and his manner of recitation. The Tabidze House-Museum in Tiflis contains several souvenirs of the poet's friendship with the Sudeikins, including the photograph of one of Sudeikin's portraits of Vera, with her signed dedication "The Muse to the Muse."

Tabidze, Titsian Yustinovich. Poet. Born 1895 in Shuamt, Georgia; died 1937 in a labor camp.
1912 onward published poetry in Kutaisi and Tiflis periodicals. 1913 graduated from Kutaisi Gymnasium, where Vladimir Maiakovsky was also a student. Mid-1910s especially interested in Russian and French Symbolism. 1915 co-organizer of the Blue Horns group of poets in Kutaisi, whose journal, *Barricades*, he edited; especially close to Paolo Yashvili. 1917 graduated from the department of philology at Moscow University. 1917–21 played a major role in Tiflis cultural life, contributing to such cabarets as the Fantastic Tavern and Khimerioni and moving closely with such artists and writers as Lado Gudiashvili, David Kakabadze, Nikollo Mitsiishvili, and Yashvili. 1918 contributed to *Fantasticheskii kabachok*, no. 1. 1921

accepted Soviet Georgia and imparted an increasingly political value to his poetry. 1926 with Grigorii Kikodze, Nikolai Cherniavsky, and Kirill Zdanevich published a monograph on Niko Pirosmanashvili.

FURTHER READING

Asatiani, G. *Titsian Tabidze*. Leningrad: Sovetskii pisatel, 1958.
Surkov, A., ed. *Kratkaia literaturnaia entsiklopediia*. Vol. 7, pp. 324–25. Moscow: Sovetskaia entsiklopediia, 1972.
Tabidze, T. "Eto—moia doroga." *Literaturnaia Gruziia*, nos. 10–11 (Tbilisi, 1967): 45–56.
————. *Izbrannoe*. Moscow: Khudozhestvennaia literatura, 1957. (Russian translation from the Georgian)
————. *Stikhi*. Tbilisi: Literatura da khelovnela, 1967. (Russian translation from the Georgian)
————. *Stikhotvoreniia i poemy*. With an intro. by S. Chikovani. Moscow: Sovetskii pisatel, 1964. (Russian translation from the Georgian)
Tsurikova, G. *Titsian Tabidze*. Leningrad, 1971.

59a Yakov Nikoladze, untitled (ca. 1919)

At long last, in this Class 7, I found what I wanted to explain and teach my beautiful girl pupils—love and sensitivity to all that is beautiful, and out of two aesthetes in love with art, slaves of art, to create what I now see.[1] That is happiness.

Ya. Nikoladze

Ink on rice paper page.

This statement accompanies the Nikoladze self-portrait (entry 59b).

Much influenced by Rodin, under whom he studied in Paris, Nikoladze gained a strong reputation for his sensual evocations, such as *Salomé Kissing the Head of John the Baptist* (1906), before applying his talent to more political commissions such as *Heroes of the Paris Commune* (1922) and *Lenin* (1925). In the 1910s Nikoladze was an energetic member of the Tiflis café culture and was especially close to the Blue Horns poets (he made a clay portrait of Valeriian Gaprindashvili in 1915)[2] and to Lado Gudiashvili, who studied sculpture under him. Nikoladze provided one of the basic designs—interpreted by Gudiashvili—for the "left side of the vault" inside the Fantastic Tavern.[3] Obviously, Nikoladze encountered the Sudeikins many times in the Fantastic Tavern and the Khimerioni, although their first meeting seems to have been at the "Exhibition of Georgian Painting" in May 1919 when Vera was introduced to a certain sculptor (Diaries, 1 May 1919). Judging from entries 59a and 67a, it also appears that Nikoladze, Sudeikin, and Savelii Sorin were colleagues within the same art studio—Class 7—giving lessons to "beautiful girl pupils" such as Kseniia Degen, Tatiana Vechorka, and perhaps also Vera. According to Vera, Nikoladze helped arrange sales of Sudeikin's pictures in Tiflis (Diaries, 18 May 1919).

Nikoladze, Yakov Ivanovich. Sculptor. Born 1876 in Kutaisi; died 1951 in Tiflis.

1889–92 attended the Craft Institute in Batum. 1892–95 studied at the Stroganov Institute in Moscow. 1895 studied in Odessa. 1896 returned to Kutaisi. 1899–1902 studied in Paris. 1902–3 back in Georgia; worked as a decorative sculptor, fulfilling commissions for the central pavilion of the Transcaucasian Agricultural Exhibition in Tiflis. 1904–10 lived in Paris again, where he studied under Rodin for a year (1906–7). 1910 returned to Georgia. 1917–19 frequented the Fantastic Tavern; helped to design its interior. 1919 participated in the "First Exhibition of Georgian Artists" organized by the Society of Georgian Artists in Tiflis; frequented the Khimerioni and similar cabarets. 1922–51 professor at the Academy of Arts, Tbilisi; fulfilled commissions for monumental sculpture in Tiflis, Kutaisi, and other cities. 1938 appointed Deputy of the Supreme Soviet of the Georgian SSR. Many of his works are preserved in the Nikoladze House-Museum, Tbilisi.

NOTES

1. The "two aesthetes" are presumably Vera and Sergei Sudeikin.
2. For a reproduction of the portrait, see I. Urushadze, *Yakov Ivanovich Nikoladze* (Moscow and Leningrad: Iskusstvo, 1940), p. 32.
3. T. Kobaladze, *Lado Gudiashvili. Tainstvo krasoty* (Tbilisi: Merani, 1988), p. 13. Also see entry 29 and the introduction.

FURTHER READING

Beridze, B., and N. Ezerskaia. *Iskusstvo Sovetskoi Gruzii*, pp. 352–53, 369, 373. Moscow: Sovetskii khudozhnik, 1975.
Nikoladze, Ya. *God u Rodena*. Tbilisi: Zaria Vostoka, 1946.
Sysoev, P., ed. *225 let Akademii khudozhestv SSSR. Katalog vystavki*. Vol. 2, pp. 340–41. Moscow: Izobrazitelnoe iskusstvo, 1983.
Urushadze, I. *Yakov Ivanovich Nikoladze*. Moscow and Leningrad: Iskusstvo, 1940.
———. *Yakov Nikoladze*. Moscow: Sovetskii khudozhnik, 1968.

59b Yakov Nikoladze, self-portrait (ca. 1919)

Ink and watercolor on rice paper page.

The Nikoladze self-portrait accompanies the statement in entry 59a. For Nikoladze's biography, see entry 59a.

60 Karl Leitis

I shall always remember you.
I am a little guy who loves art.

12 March 1920 Karl Karlovich Leitis
Baku

Pencil on rice paper page.

Biographical information on Karl Karlovich Leitis has not been forthcoming, although it has been suggested that he worked under Sergei Gorodetsky as a poster copyist for the propaganda windows of Baku OknaROSTA (Baku Windows of the Russian Telegraph Agency). The spelling mistakes in the Russian here indicate that Leitis was a foreigner or perhaps, as he himself writes, a "little guy" with limited education. The date of the entry is the same as Gorodetsky's poem entitled "Night of Departure" (entries 117a–d) and would seem, therefore, to be a farewell message to the Sudeikins as they made their way back to Tiflis.

61a Nikolai Sokolov

One must believe in the Russian people—everything else will follow.

14 July 1919 Nikolai Sokolov
Tiflis

Ink on rice paper page.

It is presumed that the author is the lawyer Nikolai Dmitrievich Sokolov (1870–1928). He and his wife, Nina Alexandrovna, were the Sudeikins' neighbors in Miskhor and then in Tiflis in 1918–19 (Diaries, 30 January and 2 February 1918, and 1 May 1919). According to Vera (Diaries, 2 May 1919), Sokolov left Tiflis for Baku. It is presumed that Sokolov is the lawyer Sokolov who was involved in the arrest and trial of the Bolshevik Duma deputies in 1914–15 (see H. Shukman, ed., *The Blackwell Encyclopedia of the Russian Revolution* [Oxford: Blackwell, 1988], p. 74) and who also worked for the Kerensky Government in 1917 (Carl Bechhofer refers to him—see entry 127a). Vera writes in the Diaries (4–20 May 1918) and in the Varia that Nikolai Sokolov used the pseudonym "Grif." "Grif," however, was one of the pseudonyms of the literary critic and sometime poet Sergei Alexeevich Sokolov (1878–1936), who at one time edited a journal of the same name; so perhaps Vera confused the two identities.

61b Nikolai Cherniavsky

Real talent can be recognized not only in a person's creativity but also in casual, intimate conversation.
I appreciate Sergei Sudeikin in just such a conversation.

10 July 1919 N. Cherniavsky
Tiflis

We will return to Russia in 1920.

N. Cherniavsky

Ink on rice paper page

Cherniavsky was a prime mover of the Tiflis avant-garde and one of its most radical poets. Along with Alexei Kruchenykh, Igor Terentiev, and Ilia Zdanevich he founded the 41° group in 1919, he wrote *zaum* poetry, owned a number of Kirill Zdanevich's paintings, and published an article on the latter's stage designs.[1] Naturally, he was a frequent visitor to the Fantastic Tavern and was among the sup-

porters of Kruchenykh's and I. Zdanevich's self-styled Futurist University, which gave lectures there in February 1918. Kruchenykh included lithographs of Cherniavsky's *zaum* poems (rendered by K. Zdanevich) in his collection called *Ozhirenie roz* (Obesity of roses), published the same year. Of particular interest is Cherniavsky's graphic poetry, which he called "orchestral poetry" by analogy, presumably, with K. Zdanevich's "orchestral painting," some of which he published in the collection *Melnikovoi. Fantasticheskii kabachok*.[2] Konstantin Paustovsky, who met Cherniavsky in 1922, recalled that his "dedication to all artistic trends of the extreme left was limitless."[3] The exact occasion for this dedication to Sudeikin is not known, although the Fantastic Tavern may well have been the place of their encounter.

Cherniavsky, Nikolai (Kolau) Andreevich. Poet, translator, and folklorist. Born 1892; died 1942 (dates also given sometimes as 1892–1947 and 1883–1945).

1915 published poetry in the almanacs *V god voiny* and *Sbornik studencheskogo literaturnogo kruzhka pri Kazanskom universitete*. 1917 especially close to K. Zdanevich; member of Kruchenykh's Syndicate of Futurists; with Kruchenykh, Sigizmund Valishevsky, and the Zdanevich brothers contributed to the miscellany called *Zhlam*. 1918 member of Yurii Degen's Hauberk group; contributed to *Fantasticheskii kabachok*, no. 1. 1919 co-founder of the 41° group; with Kruchenykh, Igor Terentiev, and Ilia Zdanevich edited the single issue of its journal; contributed to the miscellany *Melnikovoi. Fantasticheskii kabachok*. 1924 co-founder of the H_2SO_4 group. 1926 published his collection of poetry called *Pisma. Stikhi*; with Grigorii Kikodze, Tsitsian Tabidze, and Kirill Zdanevich published a monograph on Niko Pirosmanashvili.

NOTES

1. According to Régis Gayraud. See his article "Iz arkhiva Ilii Zdanevicha," *Minuvshee*, no. 5 (Paris, 1988): 136.
2. See *Melnikovoi. Fantasticheskii kabachok* (Tiflis, 1919), pp. 158–63.
3. K. Paustovsky, "Brosok na yug," in *Sobranie sochinenii*, vol. 5 (Moscow: Khudozhestvennaia literatura, 1968). Quoted in L. Magarotto, M. Marzaduri, and G. Pagani Cesa, *L'avanguardia a Tiflis* (Venice: Seminario di Iranistica, Uralo-Altaistica e Caucasologia dell'Università degli Studi di Venezia, 1982), p. 122.

FURTHER READING

Nothing substantial has been published by or on Cherniavsky. In addition to the two works listed here, see G. Janecek, *The Look of Russian Literature* (Princeton: Princeton University Press, 1984), pp. 184–87; and M. Marzaduri, ed., *Igor Terentiev. Sobranie sochinenii* (Bologna: S. Francesco, 1988), p. 517. Part of Cherniavsky's archive is in RGALI, Moscow (call no. f. 2825).

Cherniavsky, N. A. *Pisma. Stikhi*. Tiflis: Zaria Vostoka, 1927. (Cover by Kirill Zdanevich)

Melnikovoi. Fantasticheskii kabachok, pp. 158–63. Tiflis, 1919.

63a Kseniia Degen (1919)

To Yurii Degen

I do not believe that I am loved,
I do not hear the tender voice of love.
For the heart, the prose of life
Of a tiny mouse is so intolerable.
Is not the well of the heart washed by blood?
Ever more softly I tread the path.
I do not believe that I am loved
I do not hear the tender voice of love.

21 July 1919 Kseniia Degen
Tiflis

Ink on rice paper page.

This poem accompanies the two Sudeikin portraits (63b and 63c). In view of Degen's manifest homosexuality (see entry 25a), one can understand the reasons for Kseniia's feelings of unrequited love. Still, he was not entirely indifferent to her affection, dedicating section IX of his poem *Ne legko trekhpalubnoe sudno* (A triple-deck vessel is not easy), with music by Mikhail Kuzmin, to her (see entry 25a).

Biographical details on Kseniia Degen have not been forthcoming, although it is known that she died in Tiflis in the 1960s. She was the wife of Yurii Degen (see entry 25a), a poet herself, and also an artist, since it is known that she was a student of Savelii Sorin, Sudeikin, and Yakov Nikoladze in Class 7 (see entries 59a, 67a, 83a, and 121a). According to Vera, Kseniia was living with Yurii Degen in Petrograd in the late 1910s and knew Olga Glebova and Arthur Lourié there (Diaries, 7 May 1919).

63b Sergei Sudeikin, portrait of Yurii Degen (1919)

Ink, charcoal, and pencil on rice paper page.

This portrait of Yurii Degen is one of two Sudeikin drawings that accompany the Kseniia Degen poem (63a). Sudeikin knew Yurii Degen from many contexts, but one reason for this sympathy would have been Degen's own interest in the visual arts, for he dabbled in painting, helped with the interior decoration for the Fantastic Tavern, and maintained a particular interest in children's art. Stylistically, the work has something in common with the portrait of Yurii Dolgushin in entry 67b. Contemporaries remarked on Yurii Degen's somber physiognomy—"Yurii Degen is not glad / That he is a degenerate," wrote Nikolai Evreinov and Alexei Kruchenykh (M. Marzaduri, ed., *Igor Terentiev. Sobranie sochinenii* [Bologna: S. Francesco, 1988], p. 549).

For Sudeikin's biography, see entry 1b.

63c Sergei Sudeikin, portrait of Kseniia Degen (1919).

Ink and pencil on rice paper page.

This portrait of Kseniia Degen is one of two Sudeikin drawings that accompany the Kseniia Degen poem (63a). See commentary in entry 63b.

64 Anonymous (ca. 1920)

On Soviet Square

Blow, oh, wind, more lightly, lightly
Rain, oh, rain, more softly, softly
Lenin shows [his prick] to heaven
On Soviet Square.

Pencil on rice paper page.

Neither the identity of the writer nor the location or date of this entry has been established. The original poem was not of reproducible quality and therefore does not appear in the facsimile section of this volume; the text, in Cyrillic characters, is as follows:

На советской площади

Легче, легче ветер дуй,
тише, тише дождь иди.
Кажет небу Ленин . . .
на советской площади.

65a Alexander Cherepnin

Honestly, I shall never marry.
Alexander Cherepnin

16 July 1919 Fitlifka
Grotesque Primitive no. 1

Ink on rice paper page.

The Cherepnin family traveled from Petrograd southward in 1917, arriving in Tiflis in 1918. There Alexander Cherepnin and Foma Gartman (Thomas Von Hartmann; also known as Thomas de Hartmann) helped Nikolai Cherepnin run the Theater of Opera (see entries 84, 92), supervising productions with designs by Nikolai Evreinov, Iosif Sharleman, Sudeikin, and Alexander Zaltsman (Diaries, 2 May 1919). Alexander Cherepnin also played a major role in local musical and literary life, giving recitals (Diaries, 22 May 1919) and often accompanying poetry readings at the Tiflis Conservatory and the Fantastic Tavern. He was also active as a reporter and reviewer for the local press, publishing articles on many cultural events—from Sandro Korona's concerts to the "Exhibition of the Armenian Artists," from the Matignon-Zaltsman Evening of Rhythmical Gymnastics, Plastics, and Dance to the "Exhibition of Geor-

gian Painters" in 1919. In Paris he maintained his interest in the new literature, and his friendship with the Sudeikins, by contributing to the meetings of the Chamber of Poets (see entries 90a–91a).

In spite of the sentiment expressed here, he married a Chinese pianist, Lee Hsien, and had two sons, Ivan and Sergei, both of whom are also musicians. "Fitlifka" is a neologism—perhaps a play on words by analogy with "Tifliska" (girl from Tiflis).

Cherepnin, Alexander Nikolaevich. Composer and pianist. Born 1899 in St. Petersburg; died 1977 in Paris.

Son of the musician Nikolai Cherepnin and the painter Mariia Albertovna Cherepnina (daughter of Albert Benois). 1917–18 studied at the Petrograd Conservatory. 1918–21 lived in Tiflis; studied at the Tiflis Conservatory; became musical director of E. T. Zhikhareva's Chamber Theater there; contributed regularly to Tiflis newspapers and journals such as *Tiflisskaia gazeta* (Tiflis newspaper), *Kavkazskoe slovo* (Transcaucasian word), and *Raduga* (Rainbow). 1918 member of Sergei Gorodetsky's Guild of Poets and of Yurii Degen's Hauberk; participated (October) in the Evening of Poetry and Music at the Tiflis Conservatory. 1921 the Cherepnin family left for France; enrolled in the Paris Conservatory, studying under Philipp and Vidal; attended the meetings of the Chamber of Poets. 1922 onward appeared regularly on tour. 1923 his ballet *Ajanta's Frescoes*, written for Anna Pavlova, premiered at Covent Garden. 1920s closely associated with the musicians Martinů, Mihalovici, and Conrad Beck. 1926 U.S. tour. 1934–37 lived in the Far East, editing a collection of modern Chinese and Japanese pieces. 1950 settled in Chicago. 1958 became a U.S. citizen. 1964 moved to New York. 1967 concert tour in the Soviet Union.

FURTHER READING

For biographical notes and a list of A. Cherepnin's written works, see G. Bernandt and I. Yampolsky, *Kto pisal o muzyke* (Moscow: Sovetskii kompozitor, 1979), vol. 3, pp. 193–94; and A. Ho and D. Feofanov, *Biographical Dictionary of Russian and Soviet Composers* (New York: Greenwood, 1989), pp. 88–89.

65b Yakov Kamsky (1919)

At the Sudeikins

I sit and look without knowing what to say.
The lady of the house is nice. Sudeikin is a little stern.
What are you painting?
How do I know? . . .
"As a gift to Colchis[1] I wish to decorate
My florid pranks
With the tartness of the Caucasus . . ."

14 September 1919 Ya. Kamsky
Tiflis

Ink on rice paper page.

According to the Varia, Yakov Kamsky was a journalist, but further details on his identity have not been forthcoming.

NOTE

1. Colchis, or Kolchis (Kolkhida), was the Greek name for a city-state in Western Georgia. For general information, see O. Lordkipandze, *Gorod-khram Kolkhidy* (Moscow: Nauka, 1978).

65c Ivan Radin, untitled (1920)

May many a grain of art ascend
Into the coming tome of time.
There will be only one Sudeikin
And unrepeated will be Sorin.

7 March 1920 Iv. Radin

Pencil on rice paper page.

The identity of Ivan Radin has not been established. In view of his reference to Sorin and Sudeikin, it can be supposed that he was one of their friends in Baku.

67a Yurii Dolgushin, untitled (1919)

Relentlessly we play with a submissive dream,
But will we wait to remember last spring
When the white summer lightnings flash
As we wander on the outskirts of the city?

Destiny casts lots odd and even,
But it's not for us to understand the fatal die
That, on the fortieth day, compels us
To bring tearstained candles to the altar.

Again memories pass away.
In the spring we will find that we have guarded more.
How happy we are that we can forget
The holy pilgrims of cherished words.

21 July 1919 Yurii Dolgushin
Tiflis
Seventh Class[1]

Ink on rice paper page.

Published in the handwritten journal *Skarabei* (Tiflis, April 1921), this poem accompanies the Sudeikin portrait (67b). Dolgushin, with his "ginger beard,"[2] was a leading figure in the Fantastic Tavern and probably made the Sudeikins' acquaintance there. In his poetical description of the cabaret, Alexander Poroshin wrote:

And then there's Dolgushin, our poet
(Please don't confuse him with Semeiko),
Throwing a charming rhyme enchantress

In the wake of the usual rhymes.
The muse of academic discomfitures
Has long forgotten him.[3]

Dolgushin seems to have been especially close to Degen and, for example, made the linocut of Evgenii Baratynsky for Degen's article in *Feniks*.[4]

Dolgushin, Yurii Alexandrovich. Poet and novelist. Born 1896 in Kvirily, near Kutaisi; died 1989 in Moscow.

1917–21 lived in Tiflis; member of Yurii Degen's Hauberk after breaking with Sergei Gorodetsky; close to Yurii Degen, Georgii Evangulov, Sergei Rafalovich, Tatiana Vechorka, et al.; co-editor of the journals *Feniks*, *Kuranty*, and *Skarabei*. 1918 contributed to *Fantasticheskii kabachok*, no. 1. 1919 (October) participated in the Evening of Poetry and Music at the Tiflis Conservatory. 1921 onward lived in Moscow, where he worked as a reporter for various newspapers, such as *Trud* and *Izvestiia*. 1930s onward wrote many stories. Ca. 1950 member of the Union of Writers of the USSR.

NOTES

1. "Seventh Class" refers to Class 7, the art class that Savelii Sorin, Sudeikin, and perhaps Yakov Nikoladze conducted in Tiflis and that Dolgushin seems to have attended (see entries 59a, 63a, 83a, and 121a).
2. From Nina Vasilieva, "Fantasticheskii kabachok" (1918), in L. Magarotto, M. Marzaduri, and G. Pagani Cesa, *L'avanguardia a Tiflis* (Venice: Seminario di Iranistica, Uralo-Altaistica e Caucasologia dell'Università degli Studi di Venezia, 1982), p. 311. The full poem with annotations is published in ibid., pp. 310–16. Presumably Dolgushin sported the beard before or after the portrait in entry 67b.
3. From Alexander Poroshin, "Fantasticheskii kabachok" (1918), in ibid., p. 318. The full poem with annotations is published in ibid., pp. 318–20. Semeiko is a reference to the Ukrainian Futurist poet Nikolai Kornilovich Semeiko (1896–1947).
4. Yu. Degen, "E. A. Boratynsky" (*sic*), *Feniks*, no. 1 (Tiflis, 1918): 4–6.

FURTHER READING

Dolgushin, Yu. *Pokorenie metalla*. Moscow and Leningrad: Detgiz, 1953.
———. "Doroga bogotyrei." In *Nauchno-fantasticheskie povesti*. Moscow: Trudovye rezervy, 1949.
Sudein, N. "Bakinskii tsekh khudozhnikov." *Kuranty*, nos. 3–4 (Tiflis, 1919), 27.

67b Sergei Sudeikin, untitled (1919)

Ink and pencil on rice paper page.

This portrait is accompanied by the Dolgushin poem (67a). Stylistically, the work has much in common with Sudeikin's portraits of Yurii and Kseniia Degen in entries 63a and b. For Dolgushin's biography, see entry 67a.

71a Sergei Gorodetsky, untitled (1920)

Memory beckons wearily
To distant days, when Father[1]
Wrote *Cor Ardens*—heart of hearts
For his loved ones in edification;
When as the Son and God of the Sun[2]
I was a hook-nosed and frivolous guy;
And Kuzmin the Spirit with his tender smile
Soared in the same skies.[3]
In those days, with irrepressible melancholy,
And dressed in a white shirt,
I met a nymph, a maid of maids,
In a revolutionary publishing house.[4]
And surrendered my life to her. And
Life flashed by.
But in a moment of calm
Everything came back to life again.
Ah, it would be good
To begin again,
Serezha,[5] that life of youth!

9 March 1920 S. Gorodetsky
Baku

Ink on blue page.

This poem accompanies the Gorodetsky illustration on the same page (71b). Gorodetsky is recalling here his Symbolist and Acmeist apprenticeship in St. Petersburg and Moscow in the 1900s. For Gorodetsky's biography, see entry 5b.

NOTES

1. The reference is to the Symbolist poet and philosopher Viacheslav Ivanov (see entries 71b and 112–13), whom Gorodetsky considered his principal mentor during the formative years of 1907–10. "I am more Viacheslav . . . than Viacheslav," he once wrote (P. Nikolaev et al., eds., *Russkie pisateli, 1800–1917. Biograficheskii slovar* [Moscow: Sovetskaia entsiklopediia, 1989], vol. 1, p. 640). See entries 112–13. *Cor Ardens* (Moscow: Skorpion, 1911) was one of Ivanov's major collections of poetry. See Ivanov's diary entries for 1906 in O. Deschartes and D. Ivanov, eds., *Viacheslav Ivanov. Sobranie sochinenii* (Brussels: Foyer Oriental Chrétien, 1974), vol. 2, pp. 752–63.
2. Gorodetsky may be alluding to another of his early idols, Konstantin Balmont (see entries 1a and 112–13), one of whose major collections of verse (1903) was called *Budem kak solntse* (Let us be like the sun).
3. The reference is to Mikhail Kuzmin (see entries 15, 71b, and 112–13) and to his magnum opus, *Wings* (1907).
4. The "nymph" is Gorodetsky's wife, Nimfa Bel-Kon Liubomirskaia (see entry 7a), whom he married in 1908 and to whom he dedicated one of his books of poetry. In August 1907, Gorodetsky was arrested in St. Petersburg for his involvement in the revolutionary movement, and on the basis of his experiences he published his collection of *Tiuremnye stikhi* (Prison verses). It is not known which "revolutionary publishing house" Gorodetsky has in mind here.
5. As a diminutive of the name Sergei, the reference could be both to Sergei Gorodetsky and to Sergei Sudeikin.

71b Sergei Gorodetsky, group portrait (1920)

Watercolor and pencil on blue page. Signed "S. Gorodetsky" at lower right; inscribed "Baku 920–4-III" at lower left.

This watercolor accompanies the Gorodetsky poem (71a) and is a multiple portrait illustrating Gorodetsky's poem. From left to right, hovering in the heavens, are Viacheslav Ivanov (holding the flaming heart symbolizing his *Cor Ardens*), Mikhail Kuzmin as an angel (symbolizing his *Wings*), and the neophyte Gorodetsky heeding the wise words of Ivanov. Gorodetsky returned to the same pictorial subjects in his large group portrait later in the Album (entry 112–13). The street scene shows the same "hook-nosed and frivolous" Gorodetsky pursuing his "nymph" (cf. entry 18).

The poet and painter Gorodetsky was known for his portraits of writers, and, as Georgii Ivanov recalled, "Two rows of poets were distributed over the canary walls of his living room."[1] Although he had no professional training in the visual arts, Gorodetsky managed to convey the salient features of his subjects in bright colors and primitive outlines, often imbuing them with a sarcastic tone. Gorodetsky's particular kind of naive painting reflected his passion for the "lubok, Russian spirit"[2] and deep interest in children's art:

If you have made Gorodetsky's acquaintance, have started to visit him and are also a poet, then he'll draw you as a matter of course. Rather brightly colored, but giving quite a resemblance, and "nice." And always on bast.

Gorodetsky always draws on bast—that's his invention. And it's cheap. And there's something "folksy" about it and close to his heart. And although the common folk certainly do not use bast for painting, Gorodetsky really thinks that in putting Max Voloshin onto a piece of bast (in his suit and with a chrysanthemum in his buttonhole) he is much closer to the "native simple element" than if he were to depict the same on canvas.[3]

Gorodetsky pursued his interest in children's art in Tiflis by organizing two "exceptionally successful" exhibitions in the *Caucasian Word* and *Ars* editorial offices in 1918[4] and by editing a magazine devoted to the subject.[5]

For Gorodetsky's biography, see entry 5b.

NOTES

1. G. Ivanov, *Peterburgskie zimy* (New York: Chekhov, 1952), p. 89.
2. Ibid., p. 90.
3. Ibid., p. 89. For other examples of Gorodetsky's drawings, see R. Duganov, *Risunki russkikh pisatelei XVII-nachala XX veka* (Moscow: Sovetskaia Rossiia, 1988), pp. 215–19.
4. See "Khronika," *Ars*, no. 1 (Tiflis, 1918): 70.
5. See *Raiskii orlenok. Zhurnal detskikh risunkov, stikhov i razskazov*, no. 1 (Tiflis, March 1918; no longer published).

72a Sergei Sudeikin, two profiles of Vera Sudeikina (ca. 1919)

Pencil on paper glued onto blue page. 13 × 23.8 cm.

Vera Sudeikina seems to have been the model for these two renderings of headgear. As manifested in other contemporary photographs and portraits, she often wore this kind of kerchief (cf. entries 17b, 46). For Sudeikin's biography, see entry 1b.

72b Sergei Sudeikin, untitled (ca. 1919)

Watercolor, ink, and pencil on paper glued onto blue page. 14.8 × 18.9 cm. The reverse carries part of another watercolor.

The confrontation of the St. Petersburg dandy and the Persian maiden reminds us of many similar encounters between the Russian intelligentsia and Transcaucasia and the Middle East, not least in the work of the nineteenth-century writers Mikhail Lermontov and Alexander Pushkin. More topically, we are reminded here of the "orientalism" of Mikhail Kuzmin, whose "Arabian Fairy Tale"—*The Mirror of the Maidens*—had played at the Comedians' Halt on 25 October 1916, with designs by Nikolai Remizov.

For Sudeikin's biography, see entry 1b.

75 Boris Grigoriev, untitled (1920)

Charcoal on white page. Signed and dated "Boris Grigoriew 20" in Latin letters at lower left.

Grigoriev had known the Sudeikins since their St. Petersburg days, and he and Sergei had been especially close when they (and Alexandre Jacovleff) worked on the interior walls of the Comedians' Halt in 1916, for which Grigoriev designed a "Paris bistro . . . with wonderful Paris frescoes."[1] Grigoriev and Sudeikin had also attended the Academy of Arts in St. Petersburg together, and one of their common patrons was the publisher and collector Alexander Burtsev, who reproduced some of their paintings and drawings in his *Moi zhurnal dlia nemonigkh* (My journal for the few).[2] Indeed, Grigoriev's works of 1912–13 were even described as "coarse imitations of Sudeikin."[3]

In form and content this full-page sketch relates directly to Grigoriev's parallel cycles of drawings for his four albums, *Raseia/Rasseja*, *Intimité*, *Boui Bouis*, and *Faces of Russia*. The two girls in this drawing are particularly close to the Paris and Marseilles bordello scenes in *Boui Bouis*, and it can be assumed that, as with the other Grigoriev pieces in the Album (see especially entries 110, 116a, 116b, 122a, 143a, 147), they were created in the summer or fall of 1920, just after he and the Sudeikins had arrived in Paris.

Like Jacovleff and Vasilii Shukhaev, Grigoriev was a member of the second generation of World of Art artists, and he maintained the best traditions of Léon Bakst, Alexandre Benois, Mstislav Dobujinsky, and Konstantin Somov. Above all, Grigoriev regarded line as the most expressive visual element, and even in his paintings line was the dominant component. In the intensity of its emotional value, Grigoriev's line sometimes brings to mind later German Expressionists such as Otto Dix and George Grosz. As Grigoriev once stated, "Line encloses all the weight of form within its angles and dispenses with all the immaterial. . . . Line is the creator's swiftest and most intimate medium of expression."[4] In his piquant *intimités* of bordello scenes, Grigoriev also maintained the strong erotic tradition of the World of Art, although for him erotic titillation was to be found in heterosexuality, not in homosexuality. When we examine the erotic works of Grigoriev, we see immediately that their anatomical and perspectival proportions are more precise than that of Bakst, Benois, Somov, and Sudeikin. Moreover, in the incisive contours of his drawings, Grigoriev seems to evoke the very life force of Russia: "Portraits of souls, cosmic stylizations. Beneath the impression of a chance characteristic feature of a face, he sees the eternal, permanent physiognomy of the chance model; it is not an episodic visage but, so to say, its astral essence."[5] So impressive was Grigoriev's artistic skill that the critic Nikolai Punin, one of the first champions of Grigoriev's art, compared the artist to a coachman who knows every quirk of his horses, their strengths and weaknesses.[6] But not everyone liked Grigoriev's often harsh realism—as the writer Georgii Grebenshchikov made clear in a letter to Grigoriev in 1935: "Your art does not delight in the sense of mastery, IT DOESN'T MAKE ME JOYFUL. Imagine—I like you, but I'm afraid of your art. It emphasizes the negative features of life, the body, and even nature too much."[7]

Grigoriev, Boris Dmitrievich. Artist and poet. Born 1886 in Rybinsk; died 1939 in Cagnes-sur-mer.

1901 the Grigoriev family moved to Moscow. 1903–7 Grigoriev studied at the Stroganov Central Industrial Art Institute in Moscow under Dmitrii Shcherbinovsky. 1907–13 attended the Higher Art Institute at the Academy of Arts in St. Petersburg, taking courses under Dmitrii Kardovsky and Alexander Kiselev. 1909 onward contributed to many exhibitions including the "Impressionists," the "World of Art" and the Munich "Secession." 1912–13 contributed caricatures to the journal *Satirikon* and then, in 1914, to *Novyi satirikon* (New satyricon). 1912–14 lived in Paris; studied at the Académie de la Grande Chaumière; made many drawings and paintings of Paris life that were published in 1918 in the collection *Intimité*. 1915 visited Alupka. 1916 with Sudeikin and Alexandre Jacovleff decorated the interior of the Petrograd cabaret the Comedians' Halt. 1917–18 worked on a cycle of pictures that became the basis of the book *Raseia* (Russia), published in Russia in 1918 (and in Germany in 1922). 1918 taught at the Stroganov Institute, Moscow. 1919 emigrated to Berlin. 1920 arrived in Paris. 1921 designed *Snegurochka* for the Bolshoi Theater, Moscow (not produced); participated in the "L' Art Russe" exhibition in Paris; one-man show at the Galerie Povolozky, Paris (December 1921–January 1922). Early 1920s was

close to Jacovleff and Shukhaev. 1921–26 visited the U.S. several times. 1923 participated in the "Exhibition of Russian Painting and Sculpture" at the Brooklyn Museum, New York. 1927 built a house at Cagnes-sur-mer, the Villa "Borisella." 1928 professor at the Academy of Fine Art, Santiago, Chile; one-man show at the Museo de Bellas Artes there. 1930 returned to France. 1935 became dean of the New York School of Applied Arts. 1936 visited Chile. 1938 returned to Cagnes-sur-mer.

NOTES

1. G. Ivanov, *Peterburgskie zimy* (New York: Chekhov, 1952), p. 72. For information on Grigoriev's involvement in the Comedians' Halt, see V. Perts and Yu. Piriushko, "Klub khudozhnikov, artistov i poetov," *Dekorativnoe iskusstvo*, no. 11 (Moscow, 1983): 29–34; and *Pamiatniki kultury. Novye otkrytiia. Ezhegodnik 1988* (Moscow: Nauka, 1989).

2. See, e.g., *Moi zhurnal dlia nemnogikh* (St. Petersburg, 1913), vols. 8–10.

3. Essem, "Tovarishchestvo nezavisimykh," *Russkaia khudozhestvennaia letopis*, no. 3 (St. Petersburg, March 1913).

4. B. Grigoriev, "Liniia," in P. Shchegdev et al., *Boris Grigoriev. Raseia* (Petrograd: Yasnyi, 1918).

5. G. Shaikevich, "Mir Borisa Grigorieva," in ibid.

6. N. Punin, "Tri khudozhnika," *Apollon*, nos. 8–9 (Petrograd, 1915): 1.

7. Letter from Georgii Grebenshchikov to Boris Grigoriev, dated 7 June 1935 in the collection of Cyrille Grigorieff, Cagnes-sur-mer, France.

FURTHER READING

Boris Grigoriev. Exhibition catalog, Château-Musée de Cagnes-sur-mer. Cagnes-sur-mer, 1978–79.

Boris Grigoriev. Exhibition catalog, Pskov State Combined Historical, Architectural, and Art Museum. Pskov, 1991.

Dmitriev, V., and V. Voinov. *Boris Grigoriev. Intimité.* Petrograd and Berlin: Yasnyi, 1918.

Dudakov, V. "Boris Grigoriev." *Russkaia mysl*, Paris, 25 May 1990, p. 11.

Farère, C., et al. *Boris Grigoriev. Boui Bouis.* Berlin: Razum, 1924.

Galeeva, T. "Risunki Borisa Grigorieva." *Sovetskaia grafika*, no. 10 (Moscow, 1986): 251–62.

Grigoriev, B. *Der Moskowitische Eros. Eine Sammlung russischer dichterischer Erotik der Gegenwart.* Munich: Allgemeine Verlagsanstalt, 1924.

———. *Russische Erotik: Zwölf Zeichnungen.* Munich, n.d.

Kamensky, A. "Boris Grigoryev's 'Russia.'" *Moscow News Weekly*, nos. 8–9 (Moscow, 1990): 23.

Radlov, N. "Boris Grigoriev." In N. Radlov, *Ot Repina do Grigorieva*, pp. 49–58. St. Petersburg: Brokgauz and Efron, 1923.

Réau, L., et al. *Boris Grigoriev. Faces of Russia.* Berlin and London: Sinaburg, 1924. (French and German editions also available)

Shchegolev, P., et al. *Boris Grigoriev. Raseia.* Russian eds., Petrograd: Yasnyi, 1918; Potsdam: Müller, n.d.; and Petrograd and Berlin: Efron, n.d.; German eds., Potsdam: Müller, n.d.; and Berlin: Efron, n.d.

Stommels, S.-A. *Boris Dmitrievich Grigoriev.* Nijmegen: Quick Print, 1993.

Voltsenburg, O., et al., eds. *Khudozhniki narodov SSSR. Biobibliograficheskii slovar v shesti tomakh.* Vol. 3, pp. 174–75. Moscow: Iskusstvo, 1976.

77a Daria Konstantinovna Kalnina (?) Davidovskaia, A. Khotiaintseva, and M. Mukhina

A fool in any event

Daria Konstantinovna Kalnina Davidovskaia
A. Khotiaintseva
M. Mukhina

> Ink on paper glued onto green page, part of which has been cut out. 31.5 × 23.9 cm. The same board carries entry 77b, and the reverse carries entry 78.

The statement is written above the name of Daria Kalnina (?) Davidovskaia and in the same hand, and the other two signatures follow as if in agreement. The artist Alexandra Alexandrovna Khotiaintseva (1865–1942)[1] also owned a boarding house and "cuisine populaire" in Miskhor (Diaries, 12 January 1918), where at various times the Sudeikins, Vera's mother (Diaries, 1 January 1918), the Sokolovs and Vera Tishchenko (30 January 1918), the Riabushinskys (13 June 1918), Viktor Pinegin (26 September 1918), Savelii Sorin (24 December 1918), and many other visitors stayed. The house, now demolished, was next to Mariia Chekhova's dacha, the Seagull. Alexandra Khotiaintseva contributed eight paintings and twelve embroideries to the "Art in the Crimea" exhibition in Yalta in October–November 1918. In her Diaries Vera refers to Khotiaintseva, her pictures, and her dolls several times (e.g., 8 February 1918). The identity of Kalnina (?) Davidovskaia has not been established, and she is not mentioned in Vera's Diaries, but it can be assumed by association that she was also a neighbor of the Sudeikins in Miskhor in 1918. Mariia Ignatievna Mukhina, sister of the famous sculptress, Vera, was also a neighbor of the Sudeikins and, with Jean Jaquier, emigrated to Paris (see entry 40). For a photograph of Mariia and Vera Mukhina in the early 1910s, see P. Suzdalev, *Vera Ignatievna Mukhina* (Moscow: Iskusstvo, 1981), p. 2.

NOTE

1. Khotiaintseva was a professional artist who had trained at the Moscow Institute of Painting, Sculpture, and Architecture and the Academy of Arts under Ilia Repin before going to Paris. After that, she established her own private studio in Moscow. Supporting a gentle Art Nouveau style, she produced muted watercolors and some embroideries. She made the acquaintance of Anton Chekhov in Yalta, and her memoirs of their meetings were published later as "Vstrechi s Chekhovym," in I. Anisimov et al., eds., *Literaturnoe nasledstvo. Chekhov* (Moscow: Academy of Sciences, 1960), pp. 605–12. Khotiaintseva participated in the "Art in the Crimea" exhibition in Yalta in 1918 and at this time had a sentimental involvement with Jean Jaquier. For reproductions of her works, some of which are in the Chekhov Museum, Yalta, see I. Varentsova and G. Shcheboleva, *A. P. Chekhov. Dokumenty i fotografii* (Moscow: Sovetskaia Rossiia, 1984), pp. 117–19.

77b Pallada (Pallada Deriuzhinskaia), untitled (1918)

Here is the real image of
a northerner,
I now see the light through you in front of
me.
And your painting seems
of porcelain.
And the Mother of God truly
holy.
And your shepherd sleeps with you in
such close friendship
As you do with your beautiful wife!
You really have to be ungrateful
and nasty
To get even with me like this after
our friendship.

9 August Pallada
Miskhor

Ink on paper glued onto green page, part of which has been cut out. 31.5 × 23.9 cm. The same board carries entry 77a, and the reverse carries entry 78.

Pallada's numerous surnames indicate the mercurial intensity of her love life, even though, according to Sergei Sudeikin, she "lacked depravity while possessing cynicism" (Diaries, 7 March 1919). One of the brilliant St. Petersburg socialites of the 1910s, Pallada "turned her residence into a model 'ladies' club,'"[1] and her *jours fixes* attracted all manner of writers, artists, and musicians, who often paid homage to her charms in their portraits, poems, and memoirs.[2] She was a constant visitor to the Stray Dog, "after six A.M. . . . taking the first tram home,"[3] "adored boys and girls,"[4] and played the role of the femme fatale, making no attempt to conceal her liberal behavior and often shocking her more demure neighbors. In spite of their common acquaintances and interests, it seems that Vera met Pallada for the first time only toward the end of 1917 (Diaries, 15 November 1917).

Pallada visited the Sudeikins in Miskhor in May–August 1918 several times, before relocating there from Yalta in September of that year (Diaries, 6 September 1918). Vera records that during these visits Sudeikin worked on the cover design for one of Pallada's books of poetry (Diaries, May–June 1918). The intermittent wife of the sculptor Gleb Deriuzhinsky (Derujinsky; 1888–1975),[5] Pallada, accompanied by a protégée, arrived on Vera's doorstep "all dressed up in veils, chains, ribbons, and roses" (Diaries, May–June 1918). Joined by Deriuzhinsky, for whom she still felt a "physical need," Pallada kept the Miskhor community up late with her passionate lovemaking, relating the events to Vera the next morning. Although Pallada's two poems in this Album indicate that Sudeikin, too, may have succumbed to her charms at some distant point, he had little time for her in Miskhor: "I [Vera] felt sorry for her, but it really was

impossible to be seen with her. . . . Once again Sergei expressed his opinion of her—very just and sincere, but merciless, at which she began to cry. . . . After Sergei's conversation, she can no longer visit us. It'll be interesting to see how she'll behave now."[6] Sudeikin even asserted that sexually Pallada "didn't turn him on" (Diaries, 9 December 1918). But Vera rather liked Pallada, and her Diaries contain many sympathetic references to their meetings in Yalta and Miskhor, sometimes in a literary context (e.g., Diaries, 14 June 1918) but more often in the context of Pallada's complicated love life, especially of her disastrous affair with Prince Felix Yusupov (Diaries, 18 December 1917 and 14 June 1918).

Deriuzhinskaia, Pallada Olimpievna (Olimpovna), *née* Gross. Also known as Pallada Berg, Pallada Bogdanova-Belskaia, Pallada Peddi-Kabetskaia, and Pallada Starynkevich. Daughter of the engineer and inventor Olimpii Starynkevich. Known generally as Pallada. Writer. Born 1885 in St. Petersburg; died 1968 in Leningrad.

1911 graduated from Nikolai Evreinov's dramatic studio in St. Petersburg. 1910s primary supporter of the Stray Dog and Comedians' Halt cabarets; conducted literary salons; close to Mikhail Kuzmin, Igor Severianin, Sergei Sudeikin, et al. 1915 published collection of poems called *Amulety* (Amulets). 1918 lived in Crimea. Ca. 1920 returned to St. Petersburg.

NOTES

1. B. Livshits, *Polutoraglazyi strelets* (Leningrad: Izdatelstvo pisatelei, 1933), p. 270.
2. Sudeikin drew her portrait on more than one occasion. For a reproduction of one of them see *Pamiatniki kultury. Novye otkrytiia. Ezhegodnik 1983* (Leningrad: Nauka, 1985), p. 180. Also see entry 128. Anna Belokopytova, an artist and habituée of the St. Petersburg cabarets, showed her portrait of Pallada at the "First Exhibition of Paintings and Sculpture by the Association of United Artists" in Yalta in December 1917. Ilia Zdanevich wrote the text of one of his lectures at her apartment.
3. Pallada, "Brodiachaia sobaka" (unpublished memoirs). Quoted in *Pamiatniki kultury. Novye otkrytiia. Ezhegodnik 1983*, p. 253.
4. E. Moch-Bickert, *La Dame aux Oiseaux. Olga Soudéikine* (undated manuscript ca. 1980, private collection, Paris), p. 106.
5. Later, in New York, Deriuzhinsky wrote his memoirs, although he avoided reference to Pallada's amorous escapades. See G. Deriuzhinsky, "V Krymu," in *Novyi zhurnal*, no. 179 (New York, 1990): 259–64.
6. In the Varia.

FURTHER READING

Nikolaev, P., et al., eds. *Russkie pisateli, 1800–1917. Biograficheskii slovar.* Vol. 1, p. 299. Moscow: Sovetskaia entsiklopediia, 1989.

Pallada. *Amulety*. Petrograd, 1915.

Pamiatniki kultury. Novye otkrytiia. Ezhegodnik 1983, p. 253. Leningrad: Nauka, 1985.

78 Sergei Yablonovsky (1919)

Harmony of Souls

He was so sorry to part again;
Hateful train and foreign distance. . . .
They kissed. . . . A word of farewell. . . .
All around is so alien, there is sadness in his soul.

A single salvation—back to work as soon as possible!
The weeks will pass, and again
He will return and cast his troubles aside,
Carefree again and again in love.

She's so pleased: a slice of freedom.
The phantom of freedom. . . . She feels as light
As a child in the field on a May morn
Or like a fish in the river. He's far away.

The weeks will pass, and he will return,
Carefree again and again in love.
But like a soft light in her soul there still flow
Her recent repose and her dream of happiness. . . .

20 March 1919 Sergei Yablonovsky

Ink on the reverse of entries 77a and b.

Sergei Yablonovsky was a Moscow art and literary critic and some-
time poet of lighter talent who seems to have been especially im-
pressed by the work of Anton Chekhov: "I both loved him and feared
him infinitely, so delicate and yet so severe, so modest and yet so
strict."[1] On the other hand, Yablonovsky did not enjoy a strong rap-
port with the avant-garde and was especially vehement in his attacks
against the Jack of Diamonds group, which included Robert Falk,
Petr Konchalovsky, and Aristarkh Lentulov.[2] According to the latter,
for example, Yablonovsky's diatribes against the new art became so
offensive that at the "Exhibition of Painting" in Moscow in 1915,
Lentulov squeezed out some ocher paint onto a piece of cardboard
and hung it up, with the caption "Sergei Yablonovsky's Brain."[3]

The date would indicate that this entry was written in Miskhor or
Yalta not long before the Sudeikins departed for Tiflis. The following
year Yablonovsky departed from Novorossiisk for Constantinople
on the same ship as Ivan Bilibin and his family, who were astonished
by his phenomenal literary memory: "He [Yablonovsky] could quote
by memory whole pages of prose from the Russian classics. Ivan
Yakovlevich [Bilibin] once thought up a special game—making him
quote any stanza by a Russian poet where such-and-such a word
appeared. Indeed, for the most banal word, such as *boots* or *yogurt*,
Yablonovsky produced an immediate response."[4]

Yablonovsky, Sergei Viktorovich. Pseudonym of Sergei Viktoro-
vich Potresov. Poet, playwright, and translator. Born 1870 in Khar-
kov; died 1954 in France.

Ca. 1900 graduated from Moscow University. 1901 onward con-
tributed regularly to such newspapers and magazines as *Russkoe
slovo* (Russian word) and *Rampa i zhizn* (Footlights and life); was
especially interested in developments at the Moscow Arts Theater,
hosting the Literary Tuesdays there. 1909 published his book *O
teatre* (On theater). 1910s active as a poet and critic in Moscow;
member of the Literary-Artistic Circle there. 1918–19 lived in the
Crimea. 1920 sailed from Novorossiisk for Constantinople; taught
Russian language and literature at the Russian Gymnasium in Tel-El-
Kebire. 1920s onward lived in France, where he taught Russian lan-
guage and literature at various secondary schools; worked for émigré
periodicals such as *Illiustrirovannaia Rossiia* (Illustrated Russia) and
Na chuzhoi storone (On the other side). 1933 edited a journal called
Voskhod in Paris.

NOTES

1. From Yablonovsky's entry in one of the Chekhov Museum guest books, *Kniga
pochetnykh posetitelei Muzeia A. P. Chekhova* (Chekhov Museum, Yalta, call
no. 4128), p. 4. The entry is dated 22 September 1918.
2. See, e.g., Yablonovsky's reviews of the Jack of Diamonds exhibitions: "Ot-
zovites!" *Russkoe slovo*, Moscow, 13 January 1913; and "Shampanskoe v
platku," ibid., 25 October 1913.
3. A. Lentulov, "Avtobiografiia," in *Sovetskie khudozhniki* (Moscow: Iskusstvo,
1937), vol. 1, p. 162.
4. V. Chirikovo-Ulianisheva, "Po sledam proshlogo," in S. Golynets, ed., *Ivan
Yakovlevich Bilibin. Stati. Pisma. Vospominaniia o khudozhnike* (Leningrad:
Khudozhnik RSFSR, 1970), p. 183.

FURTHER READING

Nothing substantial has been published on Yablonovsky. In addition to the two
works by Yablonovsky listed here, some information may be found in P.
Markov, ed., *Teatralnaia entsiklopediia* (Moscow: Sovetskaia entsiklopediia,
1967), vol. 5, p. 1075; and Yu. Abyzov, *Russkoe pechatnoe slovo v Latvii* (Stan-
ford: Stanford Slavic Studies, 1991), vol. 4, p. 399.

Yablonovsky, S. *O teatre*. Moscow: Sytin, 1909.
———. *Stikhotvoreniia S. V. Potresova*. St. Petersburg: Pogozhev, 1896.
———. *Stikhi*. St. Petersburg: Pogozhev, 1895.

79a Anonymous, untitled (ca. 1920)

The sun luminesced brightly
On the city snowdrift.
An Italian was meeting
A young queen.

"I love you, my beauty,"
The Italian says.
Blushing, the queen
Says to the Italian:

"I would like to be Barbara,
An Italian wife;
I would play a guitar
In the morn, the eve, and at dawn."

. . . Ah, you city folk,
You're all so good-looking!

Your blue eyes
Have brought tedium to people. . . .

Ink on white page.

The handwriting is Vera's, and this poem accompanies Vera's
watercolor (entry 79b).

79b Vera Sudeikina, untitled (ca. 1920)

Watercolor on paper glued onto white page. 25.6 × 33.1 cm.

This watercolor accompanies the poem in entry 79a. In color and
style the watercolor is similar to entries 158 and 170. Entry 38, by
Vera, contains a rough sketch of the same composition. For Vera
Sudeikina's biography, see entry 16.

80 Kirill Zdanevich, portrait of Ilia Zdanevich (ca. 1919)

Pencil on paper glued onto white page. 21 × 28.7 cm.

With his brother, Ilia (Iliazd), portrayed here, Iraklii Gamrekeli,
Lado Gudiashvili, David Kakabadze, Sudeikin, Sigizmund Valishev-
sky, and others, Kirill Zdanevich played an active part in the Tiflis
bohemia during 1917–20 and a primary role as the importer of
Moscow Cubo-Futurism. His close association with Natalia Goncha-
rova and Mikhail Larionov in Moscow in 1912–13 had led to his own
investigations into Rayism and the formulation of his style called
"orchestral painting," which also drew upon his direct experiences
of Orphism and Simultanism in Paris. Although the moderate Sergei
Gorodetsky dismissed this as "experimental Bolshevism,"[1] more rad-
ical writers, such as Yurii Degen, Ilia Zdanevich, and Alexei Kruche-
nykh, were quick to recognize his talent, predicting a brilliant career
for their friend. In their introduction to his one-man exhibition in
October 1917, Kruchenykh and Iliazd even asserted that he had sur-
passed Larionov: "In combining styles, an artist liberates art from the
power of temporal tasks; and in destroying the casual character of all
styles, he provides the work with an extraordinary fullness. That is
how Kirill Zdanevich discovered his orchestral painting."[2]

In combining "Impressionism, Cubism, and the line of Matisse"[3]
with his knowledge of Cubism and Futurism (one is tempted to say
Vorticism, recalling his dynamic action scenes from the trenches of
the First World War), K. Zdanevich soon came to occupy the "ex-
treme left."[4] Moving closely with Kruchenykh, Nikolai Cherniavsky,
Vasilii Kamensky, the Sudeikins, Igor Terentiev, Valishevsky, Ta-
tiana Vechorka, Paolo Yashvili, et al., Zdanevich contributed much
to the cosmopolitan mix of radical individuals and ideas that made
Tiflis such a cultural hotbed just after the Revolution. In 1919–20 he
and his colleagues contributed designs to a number of avant-garde
productions at the Fantastic Tavern and helped paint the interiors of
the Khimerioni and Peacock's Tail cafés and also, according to one
source, the Boat of the Argonauts—an "Americanized bar"[5]—where

local artists and writers used to meet, especially those associated
with Sergei Gorodetsky's Guild of Poets. K. Zdanevich illustrated the
poems of his friends, painted the faces of their audience,[6] followed
Georges Gurdjieff's eurhythmical experiments, and, like his brother,
remained a loyal supporter of traditional Georgian art.

This portrait accompanies the Ilia Zdanevich poem on the oppo-
site page (entry 81) and presumably can also be dated 6 July 1919.
That this drawing is a portrait by Kirill Zdanevich of his brother,
Iliazd, was confirmed by Marzio Marzaduri in a letter to me dated
30 October 1989. I would like to thank the late Marzio Marzaduri
for this and many other important pieces of information regarding
the Tiflis avant-garde that he kindly shared with me.

Zdanevich, Kirill Mikhailovich. Artist. Brother of Ilia (Iliazd) (see
entry 81). Born 1892 in Tiflis (Tbilisi); died 1969 in Tbilisi.

1911–12 studied art at Nikolai Sklifasovsky's drawing school in
Tiflis. 1912–13 studied at the Academy of Arts, St. Petersburg. 1912
met the Georgian primitive painter Niko Pirosmanashvili; close to
Goncharova and Larionov; contributed to the "Donkey's Tail" exhi-
bition, Moscow. 1913 signed the manifesto *Rayonists and Futurists*
and contributed to the "Target" exhibition in Moscow (together with
Gontharova, Larionov, Kazimir Malevich, and other members of the
avant-garde); with his brother organized a one-man exhibition of
Pirosmanashvili in Tiflis. 1913–14 studied in Paris, where he soon
gained a reputation as an accomplished Cubist painter; made the
acquaintance of Alexander Archipenko and Serge Charchoune there.
1914 participated in the "No. 4" exhibition in Moscow; mobilized
(serving at the front intermittently until 1917). 1915 married Va-
leriia Valishevskaia, Sigizmund Valishevsky's sister. 1917 one-man
exhibition in Tiflis; with Nikolai Cherniavsky, Kruchenykh, Vali-
shevsky, and his brother, Ilia, contributed to the miscellany called
Zhlam. 1917–19 member of the Syndicate of Futurists in Tiflis; with
Ilia Zdanevich, Kruchenykh, and Terentiev associated with the 41°
group in Tiflis. 1919 with Gudiashvili and Kakabadze helped with
the interior design of the Khimeironi cabaret; with Gudiashvili and
Valishevsky, illustrated Vasilii Katanian's *Ubiistvo na romanicheskoi
pochve*; with Terentiev attended Gurdjieff's Institute for the Harmo-
nious Development of Man; contributed to the miscellany *Melni-
kovoi. Fantasticheskii kabachok*; contributed to the journals *Feniks*,
Kuranty, and *Orion*. 1920 visited Baku, Batum, and, from there, Italy,
Paris, and Berlin; returned to Tiflis (November) via Constantinople.
1921–22 with Terentiev visited Constantinople. 1920s onward con-
tinued to paint, design theater productions, and publish books and
articles. 1926 with Grigorii Kikodze, Cherniavsky, and Tsitsian Ta-
bidze published a monograph on Pirosmanashvili. 1930s moved to
Moscow. 1949 sent to a labor camp. 1953–63 lived in Tbilisi and
Moscow. 1966–67 spent several months with Ilia in Paris.

NOTES

1. Quoted by F. Le Gris-Bergmann, "Kirill Zdanevich: A Georgian Futurist
Painter," in *Kirill Zdanevich and Cubo-Futurism: Tiflis, 1918–1920* (exhibition
catalog, Rachel Adler Gallery, New York, 1987).

2. A. Kruchenykh and E. Eganbiuri (I. Zdanevich), intro. to *Vystavka kartin Kirilla-Zdanevicha* (exhibition catalog, Tiflis Society of Fine Arts, Tiflis, 1917), p. 2.

3. Yu. Degen, "Kirill Zdanevich," *Feniks*, nos. 2–3 (Tiflis, 1919): 1–6.

4. G. Sciltian, *Mia avventura* (Milan: Rizzoli, 1963), p. 131.

5. Letter from Irina Dzutsova to Nikita D. Lobanov-Rostovsky, dated 30 January 1984.

6. E.g., according to the poster for the second evening of events organized by the Syndicate of Futurists in Tiflis on 11 February 1918, K. Zdanevich, Vladimir Gudien, and Alexander Bazhbeuk-Melikov "painted the guests and painted for the guests" (*Kirill Zdanevich. Ilia Zdanevich* [exhibition catalog, State Museum of Arts of the Georgian SSSR, Tbilisi, 1990], p. 40).

FURTHER READING

A comprehensive list of books by Yurii Degen, Alexei Kruchenykh, Igor Terentiev, Tatiana Vechorka, et al., illustrated by K. Zdanevich, may be found in *Kirill Zdanevich and Cubo-Futurism: Tiflis, 1918–1920* (exhibition catalog, Rachel Adler Gallery, New York, 1987), nos. 63–90, and in the unpaginated section there entitled "Books Illustrated by Kirill Zdanevich." To this list should be added A. Kruchenykh, *Milliork* (Tiflis: 41°, 1919) (layout); A. Kruchenykh, ed., *Neizdannyi Khlebnikov* (Moscow: Gruppa druzei Khlebnikova, 1929 and 1930), vols. 12–14 and 16 (covers); and *Poligrafiia s 57 reproduktsiiamiu* (Tiflis: 41°, 1919). Also see entries under Ilia Zdanevich in the bibliography.

Degen, Yu. "Kirill Zdanevich." *Feniks*, nos. 2–3 (Tiflis, 1919): 1–6.

———. "Kirill Zdanevich." *Respublika*, no. 99 (Tiflis, 1917), p. 4.

Dessins Cubistes de Kyrill Zdanévitch. Exhibition catalog, Galerie Darial. Paris, 1973.

Kaushansky, V. "Freski podporuchnika Zdanevicha." *Krasnaia zvezda*, Moscow, 28 April 1990, p. 4.

Kirill Zdanevich and Cubo-Futurism: Tiflis, 1918–1920. Exhibition catalog, Rachel Adler Gallery. New York, 1987.

Kirill Zdanevich Ilia Zdanevich. Exhibition catalog, State Museum of Arts of the Georgian SSSR. Tbilisi, 1990.

Kruchenykh, A. "Tvorchestvo Kirilla Zdanevicha." *Tiflisskii listok*, no. 43 (Tiflis, 1919): 4.

Voltsenburg, O., et al., eds. *Khudozhniki narodov SSSR. Biobibliograficheskii slovar v shesti tomakh*. Vol. 4, pp. 274–75. Moscow: Iskusstvo, 1984.

Zdanevich, K. "A. Kruchenykh kak khudozhnik." *Kuranty*, nos. 3–4 (Tiflis, 1919): 12–14.

———. *Niko Pirosmani* (in Georgian). Tbilisi, 1963. Russian translation, Tbilisi: Sabchota Sakartvelo, 1965. French translation, Paris: Gallimard, 1970.

81 Ilia Zdanevich

the galosh
of the lawyer who had begun to kick ended
with a bird's expedition on a mountain after
the screwing up of an apparently[1] dead woman . . .
and the apparently dead woman, enlivened
with comma signs by watersheds,
 like a howler unexpectedly turned into a resurrection and
 became
 ZDANEVICH
 apparently a man
and apparently evil.

6 July 1919 Ilia Zdanevich
22 Viliaminovskii St.

Ink on rice paper page.

This poem accompanies the Kirill Zdanevich portrait on the opposite page (entry 80).

Ilia Zdanevich (Iliazd) and his brother, Kirill (see entries 80 and 153), played a vital role in the Russian-Georgian-French avant-garde, especially as the apologists and disseminators of new pictorial and calligraphic ideas. Although Iliazd was proud of his Georgian roots and was an earnest supporter of both ancient and modern Georgian culture, he was a man of broad views and flexible mind, recognizing at once the achievements of Moscow and Milan Futurism, Paris Cubism, and Tiflis Primitivism.[2] It is not surprising, then, that together with his friend, the painter Mikhail Le-Dantiu, he should have founded the Everythingist movement in 1913, moved constantly between Tiflis, Moscow, and St. Petersburg, published numerous experimental books of poetry and prose, rejected the Venus di Milo,[3] and been the instigator of the most radical aesthetic systems and groups—from "face painting" in 1912–13[4] to 41°. In fact, his contribution to the theoretical, practical, and publicist activities of the 41° group is among his most famous exploits: in October 1916 he and Le-Dantiu established the group First Rose, which also included Vera Ermolaeva, Nikolai Lapshin, and Olga Leshkova (Mikhail Le-Dantiu's wife), issuing their homemade journal called *Beskrovnoe ubiistvo* (Bloodless murder).[5] In May 1917 Iliazd relocated to Tiflis, where he was joined by Kara-Darvish, Alexei Kruchenykh, and then Igor Terentiev, a consolidation that resulted in the establishment of the 41° group. As Iliazd explained in Paris in November 1921, 41° was a:

society for . . . the exploration of the world's poetical ideas—Peking, Samarkand, Tiflis, Constantinople, Rome, Madrid, New York.

There are sections in Paris, London, Berlin, Moscow, Tokyo, Los Angeles, Teheran, Calcutta. . . .

41° is the most powerful organization at the leading edge of the avant-garde in the field of poetical industry. . . . At the mo-

ment 41° embraces more than sixty linguistic systems, each year absorbing new territories and attracting new capitals.[6]

Between November 1917 and August 1919 41° centered its activities on the Fantastic Tavern, organizing around "fifty conferences and a hundred productions of *dras*,"[7] and in July 1919 publishing its manifesto in the one and only issue of its review: "The 41° company resembles leftist Futurism and affirms that *zaum* language is the essential form for the incarnation of art. The aim of 41° is to use all the great discoveries of its collaborators and to place the world on a new axis."[8]

Iliazd was still living in Tiflis when he made this entry into the Album just after the Sudeikins had arrived. Viliaminovskii Street was at the south end of the fashionable Golovinskii Prospect, and no. 22 is where Salomeia Andronnikova had her apartment. The Zdanevich home was nearby at 13, Kirpichnyi Lane, while the Sudeikins were renting on Griboedov Street. The passage is an example of his *zaum*, or transrational system of prose and poetry, which he was developing in Tiflis at this time and according to which "the world is now beyond the frontiers of reason and reasoning; the world of instinct, the world of intuition—this is what sounds tell us of. Each sound has its own texture, character, and nature."[9]

In his linguistic analyses and applications, Iliazd was especially close to Kruchenykh and Terentiev at this time (see entry 99) and contributed much to the elaboration of their brand of Futurism. In pursuing their avant-garde researches, these "three idiots"[10] mixed linguistic registers, drew heavily on slang and "bad" words, and delved liberally into anal and necrological imagery. The results were often disturbing, if not shocking.

In Tiflis Iliazd was not only an energetic organizer but also a productive writer and linguistic investigator, since in 1919–20 he published some of his most remarkable experiments in poetry, dramaturgy, and book design, including four of his so-called *dras* (dramas).[11] Vera was witness to many of Iliazd's antics in Tiflis in 1919, although she clearly did not like his propensity for intoxication and scandals (Diaries, 7 May 1919). Still, she recognized his creative talent, and his several dedications in the Album (e.g., entry 119) indicate that the affection was mutual. In Paris in 1923, assisted by André Lanskoy and Constantin Terechkovitch, he even offered her a "poème-portière."[12]

Zdanevich, Ilia Mikhailovich. Pseudonyms: Eli Eganbiuri and Iliazd. Poet, playwright, and artist. Brother of Kirill Zdanevich, the avant-garde painter (see entry 80).

Born 1894 in Tiflis (Tbilisi); died 1975 in Paris. Before 1911 studied painting and sculpture in Tiflis. 1911 traveled to Batum and then to St. Petersburg where he entered law school at the university; met Viktor Bart, Le-Dantiu, Mikhail Larionov, and other members of the Russian avant-garde. 1912 with his brother Kirill and Le-Dantiu "discovered" the primitive artist Niko Pirosmanashvili; lectured on Futurism at the Troitsky Theater, St. Petersburg; went to Moscow and then back to St. Petersburg. 1913 published a monograph on

Natalia Goncharova and Mikhail Larionov under the pseudonym Eli Eganbiuri; advocated the new movement of Everythingness; co-signed, with Larionov, the manifesto "Why We Paint Ourselves"; involved in many Futurist happenings. 1914 continued his studies in St. Petersburg; gave lectures at the Stray Dog cabaret; met Marinetti in Moscow; joined the Centrifuge group, which also included Boris Pasternak. 1914–18 Caucasus correspondent for the St. Petersburg newspaper *Rech* (Discourse) and for the *Manchester Guardian*. 1916 was in Kutaisi and Petrograd; with Vera Ermolaeva, Mikhail Le-Dantiu, Nikolai Lapshin, and Olga Leshkova, published the journal *Beskrovnoe ubiistvo* (Bloodless murder) in Petrograd; with Kirill organized a one-man show of Pirosmanashvili in Tiflis. 1917 received his diploma in law; left Petrograd for Tiflis; traveled to Turkey; with Lado Gudiashvili participated in Taq'aishvilis' third archaeological expedition to the south of Georgia; back in Tiflis established the 41° group with Alexei Kruchenykh and Igor Terentiev; co-signed several 41° manifestos; member of Kruchenykh's Syndicate of Futurists; with Kruchenykh, Nikolai Cherniavsky, Sigizmund Valishevsky, and his brother Ilia contributed to the miscellany called *Zhlam*. 1917–19 primary supporter of the Fantastic Tavern in Tiflis. 1918 participated in the Evening of Poetry and Music at the Tiflis Conservatory; contributed to *Fantasticheskii kabachok*, no. 1. 1919 began to use the pseudonym Iliazd; with Nikolai Cherniavsky, Kruchenykh, and Igor Terentiev edited the single issue of the 41° journal; left Tiflis for Batum. 1920 in Batum organized an evening in honor of Osip Mandelstam; left for Constantinople. 1921 (November) arrived in Paris; member of the Chamber of Poets; secretary of the Union of Russian Poets. 1922 lectured at the Haus der Künste, Berlin. 1920s–70s continued to be active as an avant-garde writer and illustrator, mixing with the international community in Paris.

NOTES

1. The repeated Russian word for "apparently" in this poem is *yakoby*, which was part of the title of one of Iliazd's books of the same period, *Zga Yakoby* (Tiflis: 41°, 1920).

2. With his brother and Le-Dantiu, for example, he was an enthusiastic propagator of the painting of the signboard painter and naive artist Niko Pirosmanashvili (1862–1918), whose work, incidentally, Vera found especially interesting (Diaries, 1 May 1919). Having "discovered" him in 1912, Iliazd proceeded to write articles on this Georgian primitive and organize exhibitions of his work, and he even ensured that four of Pirosmanashvili's canvases were included in Larionov's "Target" show in Moscow in 1913.

3. I. Zdanevich delivered his lecture "An American Shoe Is More Beautiful than the Venus di Milo" at the Polytechnic Museum, Moscow, on 13 March 1913, at the debate entitled "The East, Nationality, and the West." Zdanevich then gave another lecture entitled "Adoration of the Shoe" at the Stray Dog cabaret in St. Petersburg on 17 April 1914, the text of which he wrote in Pallada's apartment (see entry 77c).

4. See the manifesto "Pochemu my raskrashivaemsia" (Why we paint ourselves), signed by Larionov and Zdanevich in the Christmas issue of *Argus* (Moscow, 1913). For a translation, see J. Bowlt, ed., *The Russian Avant-Garde: Theory and Criticism, 1902–1934*, 2d ed. (London: Thames and Hudson, 1988), pp. 79–83.

5. For information see N. Gurianova, "Beskrovnoe ubiistvo," *Iskusstvo*, no. 10 (Moscow, 1989): 54–56.

6. Lecture by Iliazd in Paris, dated 27 November 1921. Quoted in *Iliazd* (exhibition catalog, Centre Georges Pompidou, Paris, 1978), p. 94.

7. See *Melnikovoi. Fantasticheskii kabachok* (Tiflis, 1919), pp. 179–83.

8. Translated from the French translation in *Iliazd: Maître d'oeuvre du livre moderne* (exhibition catalog, Galerie d'art de l'Université de Québec, Montreal, 1984), p. 13. The reference to a "new axis" is to one of the derivations of the name "41°"—"the latitude of Tiflis, city of Zdanevich's birth and predilection"—apart from representing the "temperature of delirium" and "one degree above the alcohol level in vodka" (ibid., pp. 10–11).

9. Iliazd, *Notes inédites*. Quoted in *Iliazd: Maître d'oeuvre du livre moderne*, p. 36.

10. Terentiev published his portrait called *The Three Fools* (Kruchenykh, Terentiev, and I. Zdanevich) in *Melnikovoi. Fantasticheskii kabachok*, p. 178.

11. *Yanko, krul Albanskoi* (Tiflis: Syndicate, 1918), dedicated to Sofia Melnikova and printed by Iliazd himself. Iliazd wrote the piece in 1916 (see Kuzmin's biography in entry 15). Vera owned a copy of this booklet. The others were *Asel na prokat*, published in *Melnikovoi. Fantasticheskii kabachok*, pp. 39–68, and illustrated by Goncharova; *Ostraf Paskhi* (Tiflis: Union of Cities of the Republic of Georgia, 1919), with a cover by K. Zdanevich; and *Zga Yakoby, aslaabichia* (Tiflis: 41°, 1920), with a cover by I. Zdanevich. Iliazd published his last *dra* in this series in Paris, his homage to Le-Dantiu entitled *Ledentiu faram* (Paris: 41°, 1923), with a cover by Naum Granovsky. Vera owned a copy of this booklet (pages uncut), with a dedication from Iliazd. She also owned a copy of Iliazd's *Yanko krul albanskai*, with a dedication from the author to Sergei Sudeikin dated 10 January 1922, Paris.

12. At the Galerie La Licorne, Paris, on 29 April 1923. See *Iliazd*, p. 55.

FURTHER READING

For a comprehensive bibliography of I. Zdanevich's writings, see *Iliazd* (exhibition catalog, Centre Georges Pompidou, Paris, 1978), pp. 107–17; and *Iliazd: Maître d'oeuvre du livre moderne* (exhibition catalog, Galerie d'art de l'Université de Québec, Montreal, 1984), pp. 22–32. Also see L. Magarotto and G. Scarcia, eds., *Georgica II. Materiali sulla Georgia Occidentale* (Bologna: Il Cavaliere Azzurro, 1988).

Eganbiuri, Eli [I. Zdanevich]. *Natalia Goncharova i Mikhail Larionov*. Moscow: Miunster, 1913.

Gayraud, R. "Un recueil inédit attribué à Il'ja Zdanevic." *Cahiers du monde russe et soviètique* 25, no. 4 (Paris, 1984): 403–27.

I libri di Iliazd. Exhibition catalog, Biblioteca Nazionale Centrale. Florence, 1991.

Iliazd and the Illustrated Book. Exhibition catalog, Museum of Modern Art. New York, 1987.

Iliazd, H. *Iliazd*. Paris: Union, 1987.

Iliazd. Exhibition catalog, Centre Georges Pompidou. Paris, 1978.

Iliazd: Maître d'oeuvre du livre moderne. Exhibition catalog, Galerie d'art de l'Université de Québec. Montreal, 1984.

Kirill Zdanevich Ilia Zdanevich. Exhibition catalog, State Museum of Arts of the Georgian SSR. Tbilisi, 1990.

Magarotto, L. "L'esotismo di Il'ja Zdanevic." In L. Magarotto and G. Scarcia, eds., *Georgica II. Materiali sulla Georgia Occidentale*, pp. 9–31. Bologna: Il Cavaliere Azzurro, 1988.

Marzaduri, M., D. Rizzi, and M. Evzlin, eds. *Russkii literaturnyi avangard. Materialy i issledovaniia*. Trento: Università di Trento, 1990.

Zdanevich, I. "Niko Pirosmanashvili." *Vostok*, no. 4 (Tiflis, 29 June 1914).

———. "Niko Pirosmanashvili." *Zakavskazskaia rech*, no. 34 (Tiflis, 10 February, 1913).

83a Tatiana Vechorka (ca. 1919)

To S. A. Sorin

In a snow of Whatman paper screens
The fur and pearl have been outlined,
The sanguine of the matte lips is just a touch,
And the crystal of the arrant eyes beckons.
Calmly, the scalpel of the noble brush
Was divining the truth with incorporeal strength
When the artist opened up the nerve
Of the soul respectfully yet boldly.

Tatiana Vechorka

Pencil on paper glued onto pink page. 13.6 × 12 cm.

Along with Salomeia Andronnikova, the actress Sofia Melnikova, Nina Vasilieva, and of course Vera, Vechorka was one of the leading ladies of the Tiflis intelligentsia, writing feverishly and declaiming poetry.[1] She was a major force in the cultural activities of the Fantastic Tavern, delivering a lecture on Alexei Kruchenykh there in December 1918,[2] and a primary contributor to its miscellany.[3] The poet Alexander Poroshin recorded his impressions on her in poetical form:

Vechorka captivates us with melancholy,
And warmed by an impotent tenderness
Or a topsy-turvy sonnet
Will strike you unexpectedly.
Or to the delight of her friends
She might read a naive ballad.[4]

As Poroshin indicates, Vechorka was a poet of many moods and could move easily from nineteenth-century romanticism to *zaum*.[5] Similarly, only a curious stylistic dyslexia could have enabled Vechorka to appreciate the more traditional painting of Savelii Sorin (see entry 7a) and Sudeikin on the one hand and the extreme trends of the 41° group on the other; and her poetry here (entries 83a and 83b) is strangely tame in contrast to her belligerent support of Futurism and proximity to Khlebnikov and Kruchenykh, whom she praised in lectures and articles.[6]

Evidently, Tatiana Vechorka made this and the following entry while attending Class 7 in Tiflis, where both Sorin and Sudeikin (and Yakov Nikoladze) were teaching in the summer of 1919 (see entries 59a, 63a, 67a, and 121a)

Vechorka (also Vecherka), Tatiana Vladimirovna. Pseudonym of Tatiana Vladimirovna Tolstaia. Poetess, novelist, and translator. Born 1892 in Baku; died 1965 in Moscow.

Early 1900s educated in St. Petersburg. 1918 onward in Tiflis; member of Sergei Gorodetsky's Guild of Poets and Yurii Degen's Hauberk; participated in the "Evening of Poetry and Music" at the Tiflis Conservatory; influenced by Velimir Khlebnikov; associated with the 41° group; contributed to *Fantasticheskii kabachok*, no. 1.

1919 contributed to the miscellany *Melnikovoi. Fantasticheskii kaba-chok*; organized the Alpha-Lyre group. 1920 left for Baku. Ca. 1923 left for Moscow, where she became a journalist and novelist. 1925 contributed to Sergei Gorodetsky's *Styk* (Encounter) in Moscow.

NOTES

1. She recited two of her poems at the Evening of Poetry and Music held on 23 October 1918 at the Tiflis Conservatory. See her article "Vecher poezii i muzyki," *Kuranty*, no. 1 (Tiflis, 1918): 22.

2. Kruchenykh talked about Vechorka's poetry in his lecture there on 22 June 1918, "On Women's Poetry and Much Else"; he also dedicated his *zaum* book *Tsvetistye tortsy* (Tiflis: 41°, 1920) to her.

3. She published her cycle of poems called *Soblazn afish* there. See *Melnikovoi. Fantasticheskii kabachok* (Tiflis, 1919), pp. 17–26.

4. From A. Poroshin, "Fantasticheskii kabachok" (1918), in L. Magarotto, M. Marzaduri, and G. Pagani Cesa, *L'avanguardia a Tiflis* (Venice: Seminario di Iranistica, Uralo-Altaistica e Caucasologia dell'Università degli Studi di Venezia, 1982), p. 318. The full poem, with annotations, is published in ibid., pp. 318–20.

5. In later life, Vechorka published several works on Lermontov. See, e.g., her editorship of *M. Yu. Lermontov. Stikhotvoreniia. Pesn o kuptse Kalashnikove* (Moscow: Gosliizdat, 1936); and her biography *Detstvo Lermontova* (Moscow: Detgiz, 1957), also translated into Czech as *Jaro básnika. Détstv M. J. Lermontova* (Prague: Lidova demokracie, 1959). While in Tiflis Vechorka experimented with *zaum* systems and even prepared *zaum* poetry for publication (e.g., *Kniga zaumi*, which was not published).

6. See the book of poetry *My i ostalnoe* (Baku, ca. 1920), which she co-authored with Khlebnikov and Kruchenykh. She paid homage to Khlebnikov in her article "Vospominaniia o Khlebnikove," in A. Kruchenykh, *Zapisnaia knizhka Velimira Khlebnikova* (Moscow: Vserossiiskii soiuz poetov, 1925), pp. 21–30.

FURTHER READING

Nothing substantial has been published on Vechorka. For some information, in addition to the works by Vechorka listed here, see B. Piradov, "Nad Tbilisi zveneli ee stikhi," *Vechernii Tbilisi*, no. 183 (Tbilisi, 1977); and L. Magarotto, M. Marzaduri, and G. Pagani Cesa, *L'avanguardia a Tiflis* (Venice: Seminario di Iranistica, Uralo-Altaistica e Caucasologia dell'Università degli Studi di Venezia, 1982), p. 314.

Vechorka, T. *A. A. Bestuzhev*. Moscow: Vsesoiuznoe obshchestvo politkatorzhan, 1933.
———. *Bespomoshchnaia nezhnost*. Tiflis, 1918. (Unpublished manuscript).
———. *Bestuzhev-Marlinsky*. Moscow: Vsesoiuznoe obshchestvo politkatorzhan, 1932.
———. "Dnevnikovye zapisi." *Vek Pasternaka*. Literary supplement to *Literaturnaia gazeta*. Moscow, 19 February 1990.
———. *Literaturnaia gazeta*. Moscow, 19 February 1990.
———. *Magnolii (stikhi)*. Tiflis: Kolchuga, 1918.
———. *Soblazn afish (poemy i stikhi)*. Tiflis: 41°, 1918.
———. *Soblazn afish. Tri knigi stikhov*. Baku, 1920.
———. *Tret dushi. Stikhi*. Moscow: Moskovski tsekh poetov, 1927.
———. "Yu. Degen. Etikh glaz." *Kuranty*, no. 1 (Tiflis, 1918): 24.
———, D. Burliuk, S. Tretiakov, and S. Rafalovich, *Buka russkoi literatury*. Moscow, 1923. Reprinted in 1925, with an additional contribution by Boris Pasternak, under the title *Zhiv Kruchenykh!*
———, A. Kruchenykh, and V. Khlebnikov. *Mir i ostalnoe*. Baku, n.d.

83b Tatiana Vechorka (ca. 1919)

To S. Sudeikin

A poet in a top hat and cape
Is going to his dreamy neighbor,
But in the shadow of the neat and tidy summer house
He sings his madrigal in vain.
Eros fears to cast a wound
Into the unlaced bodice
Where, above the starch of tarlatan,
Dots of rouge have been scattered
And the mascara pencil has clearly been at work on the
 eyebrows.
Wandering with catalog in hand,
We apprehend life in museum corners,
And flowers in glass hothouses
And entangled stars
Float sweetly in our eyes.

 Tat. Vechorka

Pencil on paper glued onto pink page. 13.6 × 12 cm.

For Vechorka's biography and commentary, see entry 83a.

83c Sergei Sudeikin, untitled (ca. 1920)

Watercolor and pencil on board glued onto pink page. Mounted: 8.9 × 14.8 cm; unmounted: 8.1 × 14 cm.

For Sudeikin's biography, see entry 1b.

84 Vera Sudeikina, untitled (ca. 1920)

Watercolor and pencil on paper glued onto white page. 25.7 × 33.1 cm.

The palette used and the type and size of paper are reminiscent of other entries, such as 79b, 92, 158, and 170. It is possible that the theatrical scene was inspired by the Sudeikins' friend Nikolai Evreinov, the actor, producer, and sometime painter whose portraits appear on the next page in the Album (entries 85a and b) and who was involved in theaters and cabarets in Tiflis and Baku. For example, in Tiflis Evreinov produced his play *Merry Death* (see entry 85a) and helped with the designs for several spectacles at the Theater of Opera there (see entry 65a). Alternatively, the interior here may depict the Theater of Miniatures in Tiflis, where, for example, Sofia Melnikova acted. Entry 92, also by Vera, seems to relate to the same theatrical ambience.

For Vera Sudeikina's biography, see entry 16.

85a Sergei Sudeikin, untitled (1919)

Watercolor and ink on white page. Inscribed "N. N. Evreinov and V. V. Kamensky 1919 Tiflis" at lower left.

The attribution to Sudeikin has been established through comparative stylistic and calligraphic analysis. The scene portrays Nikolai Evreinov (center) and Vasilii Kamensky (see entries 2b and 85b), who, with Vladimir Boberman, shared the same apartment in Tiflis in the summer and fall of 1919 (see entry 2b), although this picture excludes certain attributes of their residence. According to a memoir by Vasilii Katanian,

> In a large, light room, beneath a spreading ficus stood a piano, which Nikolai Nikolaevich [Evreinov] was wont to play, composing his "musical grimaces." . . . Posters of Kamensky's appearances for the last three years hung on the walls of the big room, brocade jackets hung from nails all over the place, and over here you could see the iron bed with its gypsy quilt, with which Vasia used to cover himself.

However, as Katanian also noted, tea—and less often bread rolls and cookies—were also a part of their ambience.[1] Iosif Markozov (see entry 55b) shared his opinion of Evreinov and Kamensky when he visited the Sudeikins in July 1919: "Kamensky—generous nature, full of life, sincere . . . Evreinov—unbalanced, on the qui vive, inspired" (Diaries, July 1919). Anna Kashina, who married Evreinov in 1921, even remembered that "Vasia played the accordion, Evreinov the comb, and each of them was a virtuoso."[2]

Evreinov and Kamensky had been friends from the early 1910s (Kamensky dedicated poems to Evreinov and even drew a portrait of him in 1914),[3] and in fact the first monograph on Evreinov as playwright and theater personality had just been written by Kamensky, *Kniga o Evreinove* (Petrograd: Sovremennoe iskusstvo, 1917).[4]

For Sudeikin's biography, see entry 1b. For Evreinov's biography, see entry 85b. For Kamensky's biography, see entry 2b.

NOTES

1. V. Katanian, "Iz vospominanii." Published in L. Magarotto, M. Marzaduri, and G. Pagani Cesa, *L'avanguardia a Tiflis* (Venice: Seminario di Iranistica, Uralo-Altaistica e Caucasologia dell'Università degli Studi di Venezia, 1982), pp. 259–60. For information on Katanian see entries 87 and 89.
2. Quoted in S. Bocharov et al., eds., *Vasilii Kamensky* (Moscow: Kniga, 1990), caption to illustrations 226 and 27.
3. See, e.g., "Kolybaika," in A. Belenson, ed., *Strelets* (Petrograd, 1915), pp. 77–78; and "Vo Imia okeanskoe N. N. Evreinova," in V. Kamensky, *Zvuchal vesneianki* (Moscow: Dortman, 1918), pp. 45–46. Kamensky's portrait of Evreinov is reproduced in E. Proffer, *Evreinov: A Pictorial Biography* (Ann Arbor: Ardis, 1981), p. 19. This collection also contains photographs of Evreinov, Kamensky, and their friends in Sukhumi in 1923. For a photograph of Evreinov and Kamensky together in 1922, see Bocharov et al., *Vasilii Kamensky*, illustration 29.
4. Also see N. Evreinov, "O Vasile [sic] Kamenskom," *Moi zhurnal—Vasiliia Kamenskogo*, no. 1 (Moscow, 1922): 9.

85b Photograph of Nikolai Evreinov (ca. 1920)

Photograph glued onto white page. 11 × 6.9 cm. This photograph, printed on orange paper, is from a journal or program of the time and is photomechanically signed "N. N. Evreinov" at the lower left. The caption below reads, "N. N. Evreinov. In Connection with His Appearances in Tiflis and Baku."

With many important accomplishments and distinctions to his name, Evreinov was one of the most famous members of the cultural community in Tiflis and Baku in 1917–20. Actor, playwright, poet, and painter, Evreinov had scored his first major successes in St. Petersburg as director of the cabaret known as the Crooked Mirror in 1910 onward (founded in 1908 by the critic Alexander Kugel and his wife Zinaida Kholmskaia); and during his tenure, he commissioned or produced about one hundred plays there. These included Nikolai Urvantsov's operetta *The Fugitive*, for which Evreinov composed the music and Sudeikin designed the sets and costumes—one of their first collaborations. In all his theatrical endeavors, Evreinov attempted to provide a scenic experience radically different from that offered by the traditional theater, for he wished "to create a very special kind of theater, mobile, simple, 'sharp,' one that can provide space for individuality and that is quite free of routine."[1]

Evreinov was a favorite model for artists of the 1910s–20s, and he even considered himself to be a Futurist painter.[2] Yurii Annenkov, Alexander Arnshtam, Boris Grigoriev, Nikolai Kulbin, Savelii Sorin, and Sudeikin (to name just a few painters) turned their attention to him, and Evreinov even wrote a book about his experiences as a sitter.[3] Artists were attracted to Evreinov because of his dynamic and often eccentric personality: "How young Evreinov was then, how passionate and inexhaustibly witty! A pupil of Rimsky-Korsakov, how marvelously he improvised at the piano! How incredibly he used to tap his forehead, the crown of his head, the back of his neck, his cheekbones—with teaspoons, making folk melodies and opera arias!"[4] In 1918–20 Evreinov was very active as an actor and director in the south, touring Tiflis, Baku, Sukhumi, and other centers before returning to Petersburg to co-direct Storming of the Winter Palace. For example, his production of his harlequinade *Merry Death* at the Aloizi Theater, Sukhumi, in March 1919 scored a great success, thanks also to Alexander Shervashidze's "original, stylish, fine costumes, very interesting decors, and general restraint of tone."[5] Even so, meeting him in Yalta in August 1918, Vera found him "weary, not lively like he used to be" (Diaries, 22 August 1918).

Evreinov, Nikolai Nikolaevich. Playwright, artist, and musician. Born 1879 in Moscow; died 1953 in Paris.

1901 graduated from St. Petersburg University; also studied music at the St. Petersburg Conservatory. 1907–8 and 1911–12 with Nikolai Drizen produced plays at the Antique Theater. 1908–9 worked closely with Vera Komissarzhevskaia at her theater. 1909 onward published major treatises on the history and aesthetics of theater, such as *Teatr kak takovoi* (Theater as such). 1910–17 directed the Crooked Mirror cabaret in St. Petersburg. 1911 ran a private dramatic studio; among his students was Pallada Gross. 1913–14 trav-

eled extensively in Western Europe and Egypt. 1914–16 lived in Finland. 1917–20 traveled in the Caucasus, staying for a brief period in Sukhumi and Tiflis. 1919 member of Sergei Gorodetsky's Guild of Poets. 1920 returned to Petrograd; co-directed the mass action *Storming of the Winter Palace.* 1921 his play *The Chief Thing* premiered in Petrograd. 1922–23 traveled in Berlin and Paris, then to the Caucasus again. 1925 emigrated to Paris; worked for various companies, including Maria Kousnezoff's Opéra Privé de Paris. 1926 visited the U.S.

NOTES

1. A. Yufit et al., eds., *Sovetskii teatr. Dokumenty i materialy* (Leningrad: Iskusstvo, 1968), vol. 1, p. 400.
2. See, e.g., the reproduction of Evreinov's painting *Dancing Spanish Lady* in *Stolitsa i usadba,* no. 11 (Petrograd, 1914), between pp. 14 and 15. Evreinov refers to this here as the "first Futurist picture in the world."
3. Evreinov, *Original o portretistakh* (Moscow: Svetozar, 1922).
4. Yu. Annenkov, *Dnevnik moikh vstrech* (New York: Inter-Language Literary Associates, 1966), vol. 2, p. 117.
5. Kin, "Spektakl N. N. Evreinova," in *Nashe slovo* (Sukhumi, 1919). Copy supplied by Rusudama Shervashize, Sukhumi. See entry 125b.

FURTHER READING

Carnicke, S. *The Theatrical Instinct: Nikolai Evreinov and the Russian Theatre of the Twentieth Century.* New York: Lang, 1989.
Evreinov, N. N. *Istoriia russkogo teatra.* New York: Chekhov, 1955.
———. *Original o portretistakh.* Moscow: Svetozar, 1922.
———. *Pamiatnik mimoletnomu.* Paris: Navarra, 1953.
———. *Predstavlenie liubvi.* In Nikolai Kulbin's miscellany *Studiia impressionistov.* St. Petersburg: Sovremennoe iskusstvo, 1910.
———. *Teatr dlia sebia.* 3 vols. Petrograd: Sovremennoe iskusstvo, 1915–16.
———. *Teatr kak takovoi.* St. Petersburg: Sovremennoe iskusstvo, 1912.
———, S. Sudeikin, et al. *Kulbin.* St. Petersburg: Society of Intimate Theater, 1912.
Golub, S. *Evreinov: The Theatre of Paradox and Transformation.* Ann Arbor: UMI, 1985.
Kamensky, V. *Kniga o Evreinove.* Petrograd: Sovremennoe iskusstvo, 1917.
Kashina-Evreinova, A. *N. N. Evreinov v mirovom teatre XX veka.* Paris: Les Editeurs Réunis, 1964.
"Nicolas Evreinov, l'Apôtre Russe de la Théatralité." Entire issue, *Revue des Etudes Slaves* 53 (Paris, 1981). (Part 1 is devoted to Evreinov)
Proffer, E. *Evreinov: A Pictorial Biography.* Ann Arbor: Ardis, 1981.

86 Sergei Sudeikin, untitled (ca. 1919)

Watercolor and pencil on green paper on board glued onto white page. Mounted: 15.9 × 15.9 cm; unmounted: 15.4 × 15.5 cm.

Sudeikin sometimes used Spanish motifs in his work, and perhaps this particular rendering expressed his nostalgia for the "Spanish Week" that the Comedians' Halt organized in February 1917. Sudeikin, in fact, had designed sets and costumes for a "Spanish" ballet produced by Leonid Leontiev especially for that celebration; for information, see *Pamiatniki kultury. Novye otkrytiia. Ezhegodnik 1988* (Moscow: Nauka, 1989), p. 134–35.

For Sudeikin's biography, see entry 1b.

87 Vasilii Katanian, untitled (1919)

A brilliant cavalier dances, gliding with his lady—
A beslobbered tailcoat, a terribly white bodice.
Through the acrid smoke of English cigarettes
You strive toward me almost like Sulamith.[1]
Your longing gaze shines with sweetness,
The soul lives and every nerve suffers!
No! Aside with love, the heart, and Baudelaire,
And you, young maid, so profligate!

15 September 1919 Vasilii Katanian
Tiflis

Ink on rice paper page.

"Young, pleasant, the son of one of the best Tiflis physicians,"[2] Katanian was a teenager when he entered the bohemian world of the Fantastic Tavern and Khimerioni cabarets. He was still a "Symbolist," avidly reading Baudelaire, Rimbaud, and Verlaine, and in this respect sympathized with the literary searches of the Blue Horns group. But despite his tender years, Katanian was "somber like Charon"[3] and an astute observer of the society of "tailcoats, bodices, and English cigarettes" that he poeticized and parodied so ably. Later, he became one of the Soviet Union's leading Maiakovsky scholars.

This passage is from his poem entitled *Ubiistvo na romanicheskoi pochve* (Murder on romanic [romantic] grounds), which was published by Feniks as a separate booklet in 1919 in Tiflis, with a cover by Kirill Zdanevich and illustrations by Lado Gudiashvili and Sigizmund Valishevsky (including a linocut by Katanian himself).[4] In the separate edition the page opposite this passage carries an illustration by Sigizmund Valishevsky called *A Brilliant Cavalier Dances with His Lady.* In addition, Katanian's poem appeared in *Melnikovoi. Fantasticheskii kabachok* (Tiflis, 1919), pp. 79–92, with this particular section printed on page 88, but without the Valishevsky illustration. The "young maid, so profligate" is, no doubt, a reference to Vera Sudeikina.

Katanian, Vasilii Abgarovich. Poet and critic. Born 1902 in Moscow; died 1980 in Moscow.

1910s attended the Polytechnic Institute in Tiflis. 1917–19 frequent visitor to the Fantastic Tavern, contributing to both its miscellanies. 1918 member of Yurii Degen's Hauberk group; participated in the Evening of Poetry and Music at the Tiflis Conservatory. 1920 with Boris Korneev co-editor of *Iskusstvo* (Art). 1923 (December) arrived in Moscow. 1926 published a book about censorship and Tolstoi; contributed to *Novyi lef* (New left); early 1930s began to edit the collected works of Vladimir Maiakovsky; married Lilia Brik. 1954 wrote the play called *They Knew Maiakovsky.* 1963 wrote the screenplay for movie version of *Anna Karenina.*

NOTES

1. A reference to the biblical bride Sulamith.
2. G. Sciltian, *Mia avventura* (Milan: Rizzoli, 1963), p. 133.

3. From Nina Vasilieva, "Fantasticheskii kabachok" (1918), in L. Magarotto, M. Marzaduri, and G. Pagani Cesa, *L'avanguardia a Tiflis* (Venice: Seminario di Iranistica, Uralo-Altaistica e Caucasologia dell'Università degli Studi di Venezia, 1982), p. 311. The full poem, with annotations, is published in ibid., pp. 310–16.
4. According to Ilia Zdanevich, however, *Ubiistvo na romanicheskoi pochve* was published by 41° and then "appropriated" by the Feniks publishing house. See I. Zdanevich archive in the Department of Manuscripts, Russian Museum, St. Petersburg, call no. f. 177, ed. khr. 41, l. 1 (reverse).

FURTHER READING

Nothing substantial on Katanian has been published. In addition to the Katanian works listed here, some information may be found in A. Surkov, ed., *Kratkaia literaturnaia entsiklopediia* (Moscow: Sovetskaia entsiklopediia, 1966), vol. 3, p. 443.

Katanian, V. "Korni stikhov." In *Almanakh s Maiakovskim*. Moscow: Gosizdat, 1934.
———. *Maiakovsky. Literaturnaia khronika*. Moscow: Gosudarstvennoe izdatel-stvo khudozhestvennoi literatury, 1945.
———. *Ubiistvo na romanicheskoi pochve*. Tiflis: Feniks, 1919. (Cover by Kirill Zdanevich; illustrations by Lado Gudiashvili and Sigizmund Valishevsky)
———. "Vospominaniia." In L. Magarotto, M. Marzaduri, and G. Pagani Cesa, *L'avanguardia a Tiflis*, pp. 259–66. Venice: Seminario di Iranistica, Uralo-Al-taistica e Caucasologia dell'Università degli Studi di Venezia, 1982.
———, and Valerian Kara-Murza. *Sinim vecherom*. Tiflis: Uchenicheskii klub, 1918.

89 Vasilii Katanian (1919)

To Vera Arturovna Sudeikina

And the strong tea, and the red wine,
And the vernal garden, and the black visage of death.
I know that I am destined to be put to the test
And to discover happiness in a lilac envelope.
To me it is all the same whence the wind blows—
From an Armenian hill or from the northern Neva,
But why does the Maidens' Field of maidenly Moscow[1]
Now so excite my heart?

17/30 September 1919[2] Vasilii Katanian
Tiflis

Ink on blue page.

For Katanian's biography and commentary, see entry 87.

NOTES

1. A reference to Maidens' Field (Devichie pole), a green area to the south of Kropotkinskaia Street on the way to the Novodevichii Monastery (literally, New Maiden's Monastery). Katanian may also be alluding to the location of Sergei Sudeikin's family house in Moscow (Diaries, 12 January 1917).
2. The double date refers to the old and new calendars (see the preface). Sergei Rafalovich also wrote a poem for the Album on the same day and with the same double date (see entry 102).

90a–91a Georgii Evangulov (1921)

Childhood
Extracts

To Vera Arturovna and Sergei Yurevich Sudeikin

I remember the muffled howl of the wind
In the jaws of bared ravines
An efflux of swaying fir trees
And the call of distant shepherds.

And the echo of the wild mountains I would heed,
When unexpectedly in the angry night,
Willed by the echo, a cry of suffering
Sounds like a bolt of laughter.

And after the storms—the mountain cemetery,
The roots looking like hands
Uptorn from pain and torments,
Outstretched into the air.

The earth tears off its shroud,
Desire alone fires us,
And, like blood, every brook
Gurgles in my arteries.

The heat of the earth is in my palms
The skin is transparent upon my fingers,
And how many bodies have grown faint
With my anxious caresses. . . .

How many times in the gloom of the night
I went alone to the tavern
And summoned the clarinetists of passage
And listened to a fragrant song. . . .

Beneath the furious whistle of the storm
Throwing on cloak and hood
I watched the lamb shashlik
Sputtering noisily on the metallic roads.

And beyond the tavern where at night
A false shot rang out in the mountains,
And puffing their cheeks like sails,
The clarinetists played their pipes.

I went, and the wind clapped and ripped
The tavern so that it bowed to the ground.
Onto my Karabak horse
I leapt, and at a gallop
Knew not whither I raced.

And the cliffs rang out loud and clear,
And in the dark night my horse
Jumped all obstacles and neighed,

And beneath his shoes trembled
And bent the booming highway.

1921 Georgii Evangulov
Paris, Passy

Ink on blue page.

The intense visual imagery and sharp contrasts in Evangulov's po-
etry (see his other entry, 138b) remind us that he was much attracted
to the cinema—as well as to riotous living. Alexander Poroshin de-
scribed him in the Fantastic Tavern:

A friend of joyful *kintos,*
A connoisseur of taverns and good times,
Georgii Evangulov will read how he had his coat cleaned
And with his lady cousin used to go
Off to the Piccadilly Theater.[1]

Still, Evangulov wrote his poems for the Album not in Tiflis but in
Paris, shortly after his emigration and when he was a member of the
Chamber of Poets along with Serge Charchoune, Alexander Che-
repnin, Lado Gudiashvili, David Kakabadze, Vladimir Parnakh, Ser-
gei Rafalovich, Sudeikin, Samuil Vermel, and Iliazd (their first meet-
ing was at the Café Caméléon).[2] Evangulov and his colleagues later
founded the group Cherez (Through).[3]

The watercolors by Mikhail Gerasimov (entries 90b and 91b) that
accompany this poem seem to have little if anything to do with its
contents, providing a general "ethnographic" background rather
than a discreet commentary (a similar disharmony is to be found in
entries 138a and b).

Evangulov, Georgii Sergeevich. Pseudonym: Krasnyi. Poet. Born
ca. 1890; died 1967 in Hamburg.

1917–19 played a major role in Tiflis cultural life; frequented the
Fantastic Tavern and contributed to its first miscellany. 1918 mem-
ber of Sergei Gorodetsky's Guild of Poets and Yurii Degen's Hauberk
in Tiflis; participated in the Evening of Poetry and Music at the Tiflis
Conservatory; published poetry in the journal *Fenix* (Phoenix). 1920
emigrated to Paris. 1921 member of the Chamber of Poets and the
Gatarapakh group in Paris. 1923 lectured at the Haus der Künste,
Berlin; published comparatively little as an émigré.

NOTES

1. From A. Poroshin, "Fantasticheskii kabachok" (1918), in L. Magarotto,
 M. Marzaduri, and G. Pagani Cesa, *L'avanguardia a Tiflis* (Venice: Seminario
 di Iranistica, Uralo-Altaistica e Caucasologia dell'Università degli Studi di
 Venezia, 1982), p. 319. The full poem, with annotations, is published in ibid.,
 pp. 318–20. The Georgian word *kinto* means something like a "dashing young
 fellow" or "daredevil out to enjoy wine, women, and song." The reference to
 the Piccadilly Theater is presumably to the Piccadilly Cabaret in Moscow.
2. See "Raznye izvestiia. Palata poetov," in *Poslednie novosti*, no. 399 (Paris, 5
 August 1921): 3.
3. See L. Fleishman, R. Khiuz, and O. Raevskaia-Khiuz, *Russkii Berlin, 1921–
 1923* (Paris: YMCA, 1983), p. 312.

FURTHER READING

Nothing substantial has been published on Evangulov. For some information, in
addition to the Evangulov works listed here, see Lolo, "Epigramma," *Segod-
nia,* no. 290 (Riga, 1926); L. Magarotto, M. Marzaduri, and G. Pagani Cesa,
L'avanguardia a Tiflis (Venice: Seminario di Iranistica, Uralo-Altaistica e Cau-
casologia dell'Università degli Studi di Venezia, 1982), pp. 315, 320; and Yu.
Abyzov, *Russkoe pechatnoe slovo v Latvii* (Stanford: Stanford University Press,
1990), vol. 2, p. 66.

Evangulov, G. *Baron v zaplatannykh shtanakh.* Tiflis, 1918.
———. *Belyi dukhan.* Paris: Palata poetov, 1921. (Cover by Lado Gudiashvili)
———. *Neobyknovennye prikliucheniia Pavla Pavlovicha Pupkova v SSSR i v emi-
gratsii.* Paris, 1946.
———. *Noev kovcheg.* Vladikavkaz, 1920.
———. "Russkaia poeziia v Tiflise (1917–1920," *Tvorchestvo,* no. 1 (Vladi-
kavkaz, 1920): 19–20.
———. *Vtoroe serdtse.* Tiflis, 1920.
———. *Zolotoi pepel.* Paris: Palata poetov, 1922.

90b Mikhail Gerasimov, untitled (1920)

Watercolor and pencil on paper glued onto blue page. 20.5 × 18.6 cm. Signed
"M. Gerasimov" at lower left and inscribed "To dear Sergei Sudeikin from
M. Gerasimov, Baku, 1920" at lower left.

This watercolor accompanies the Evangulov poem (entries 90a–
91a). The local merchants wearing their fezzes and the sailor's head
and cap looming out of the darkness of the bazaar suggest the racial
interaction and commotion that this Caspian port witnessed during
the months of the Russian emigration. The Album also contains a
third Baku scene by Gerasimov (see entry 138a).

Gerasimov, Mikhail Nikolaevich. Artist. Born ca. 1883 in Penza;
died 1958 in Baku.

1910 graduated from the Penza Art Institute. 1911 moved to
Baku, where he taught drawing in a local grammar school and com-
mercial institute. 1915–17 taught in Evgenii Samorodov's studio.
1921 one-man exhibition in the Baku Circus, which included his
portraits of circus stars. 1920s contributed to exhibitions regularly
in Baku, Kharkov, and other cities. 1920s–40s professor at the Art
School in Baku. Early 1920s produced agit-designs for outdoor Rev-
olutionary festivals. 1930 contributed to the Baku exhibition of the
Association of Artists of Revolutionary Russia. 1930s turned from
topical scenes to more historical subjects.

FURTHER READING

Nothing substantial has been published on Gerasimov. For some information see
N. Ezerskaia et al., *Iskusstvo sovetskogo Azerbaizhana* (Moscow: Sovetskii khu-
dozhnik, 1970), pp. 49, 189.

91b Mikhail Gerasimov, untitled (1920)

Watercolor and pencil on paper glued onto blue page. 18.5 × 25.2 cm. Signed "M. Gerasimov" at lower right. A pencil inscription at the base of the picture beginning "In memory" and ending with "to dear Sergei Sudeikin" has been partially erased.

This watercolor accompanies the Evangulov poem (entries 90a–91a). For Gerasimov's biography, see entry 90b.

92 Vera Sudeikina, untitled (ca. 1919)

Watercolor and pencil on paper glued onto blue page. 25.8 × 33.1 cm.

The scene of the violinist and the dancing dolls brings to mind Johann Kreisler (entries 115b, 121c), the wild and eccentric Kapellmeister created by E.T.A. Hoffmann, or, in the case of the dolls, of Léo Delibes's *Coppélia*. Schumann's rendering of the Hoffmann story into the *Kreisleriana* might have played in one of the Tiflis theaters where Nikolai Evreinov was working. According to Gregorio Sciltian, for example, Offenbach's *Tales of Hoffmann* was playing at the Theater of Opera in Tiflis in 1919.[1] This also connects to the several references in the Album to Schumann (see entries 5b, 19, 25b, 93), Johann Kreisler (entries 115c, 121c), and E.T.A. Hoffmann, who, according to Dora Kogan, was "one of Sudeikin's favorite writers"[2] and who, in any case, prompted a veritable cult with Yurii Degen, Mikhail Kuzmin, and other members of the Marseilles Sailors (see entry 25a). In her Diaries Vera mentions Hoffmann several times both as reading entertainment and as artistic inspiration for them (e.g., Diaries, 14 November 1917, and 23 February and 16 July 1918). Sudeikin, incidentally, had designed a production of the *Tales of Hoffmann* in 1915 for Sergei Zimin's opera company in Moscow, which, unfortunately, had not been realized.

The style, palette used, and the type and size of paper appear in several other pieces in the Album by Vera (e.g., entries 79b, 84, 155, 158, 159, and 170).

For Vera Sudeikina's biography, see entry 16.

NOTES

1. G. Sciltian, *Mia avventura* (Milan: Rizzoli, 1963), p. 133. Also see entries 65a and 84.
2. D. Kogan, *Sergei Sudeikin* (Moscow: Iskusstvo, 1974), p. 116. It is of interest to note that Boris Pronin, director of the Comedians' Halt, expressed the wish to produce a pantomime based on Hoffmann that was to include "Erasmus, Dr. Dappertutto, . . . Kreisler himself, all this together with a black cat and a fireplace" (letter from Pronin to Vladimir Podgornyi dated 21 September 1915). Quoted in ibid., p. 190.

93 Suren Zakharian, untitled (1920)

Confused in soul, I gaze upon the canvases
And powerful sounds ascend in a wave,
And I hear: hiding behind the dark foliage
Is Schumann's incorporeal spirit.[1]

And over there, behold, Moscow celebrates
Big and free, her revelry at Shrovetide.
The air is splashed with the needles of sharp cones,
They tickle me, I feel the frost.

A splendid carnival of vivid canvases,
A vivid delight of styles and centuries
Explode mundanity into a holiday of inflorescence.

There flies a sunlit avalanche of colors,
And the exciting colors whirl and race
In a crazy dance like an explosion of rockets.

7 March 1920 S. Zakharian
Baku

To my dear neighbors
V. A. and S. Yu. Sudeikin

Ink on rice paper page.

Information on the poet Suren Zakharian has not been forthcoming, although it is known that he was the Sudeikins' neighbor in Baku in 1920 (cf. entry 136).

NOTE

1. For commentary on Sudeikin's interest in Schumann and the carnival (*Carnaval*), see entries 5b, 19, 25b, 31a, 92, and 171.

95a Untitled, name undeciphered (1917)

Maybe the secret cannot be narrated by the word,
But can our hearts really lie
That henceforth our lives are bound
Without an engagement ring. . . .
Maybe our days have long been wasted,
Like Harlequin and his silver,
But we are destined for each other—
You a Columbine and I Pierrot!
Both you and I are worn out with embraces;
Only disaster now grows in our soul.
But we have long been used
To concealing our eyes beneath the mask.
Who will divine our pain
Beneath the white powder and rouge,
When we are playing this mute role
Amid the drunken tables?
Maybe the secret cannot be narrated by the word
But can our hearts really lie

That henceforth our lives are bound
Without an engagement ring. . . .

Dedicated to Vera Arturovna and Signature undeciphered
Sergei Yurievich
(Copied 15 October 1917)

Ink on paper glued onto white page. 16.6 × 12.5 cm.

95b Undeciphered (1917)

In the Café

The sounds of the night café,
The hum of the noisy voices and the shadows outside
 the window,
Your thin, painted hands
And the refined breach of your red lips entice me.
I love to sit with you at a cozy table;
To pour the green wine into our goblets;
To watch phantoms come and go and fall away
In the mirror dull and patterned.
After all, I am not your date, and you are not a prostitute;
Traces of recent servants are upon your cheeks.
But our passion is not a dirty joke
In exchange for the gold coin's ring and a bouquet of roses.
Does it matter that around us revel the muttering drunks?
I shall whisper you a new triolet. . . .
We have wine still left in our glasses
And the tremor in our hands conceals a dream.

 Undeciphered signature
(Copied 31 October 1917 in spite of everything)[1]

Ink on paper glued onto white page. 16.5 × 12.4 cm.

The signature of the author or copyist of entries 95a and 95b is illegible and has not been deciphered, but the dates indicate that both these poems were written or copied in Yalta in October 1917. Unfortunately, Vera's Diaries for that month are missing.

NOTE

1. The Bolshevik Revolution took place on 25 October 1917 according to the old calendar (= 7 November according to the new calendar).

95c Sergei Sudeikin, untitled (ca. 1920)

Pencil on paper glued onto white page. 21.3 × 14.1 cm.

This is an enlarged copy of part of the group scene in entry 114. For Sudeikin's biography, see entry 1b.

96a Anonymous (1919)

Ai, Ai, Ai, Rain, Rain, Rain

Inscribed "Kodzhory 19" at lower right in pencil. Pencil on blue paper glued onto white page. 17.6 × 22.4 cm.

The identity of the composer has not been established, although the location, Kodzhory, and the barely legible date (which appears to be 1919) prove that he or she was in touch with the Sudeikins in Tiflis—which, in turn, might indicate Alexander Cherepnin (see entry 65a). Kodzhory, which figures in at least one painting by Sudeikin,[1] was a dacha district about twelve miles from Tiflis. The Sudeikins seem to have spent the summer of 1919 at Kodzhory (Diaries, 27 August 1919), and the Zdanevich family had their dacha there. The words appear to be part of a nursery rhyme or children's song.

NOTE

1. The State Museum of Arts in Tbilisi houses a "simple and spontaneous" painting by Sudeikin called *Hour of Sunset. Kodzhory*, dated 1919. See I. Dzutsova and N. Elizbarashvili, "S. Yu. Sudeikin v Gruzii," *Muzei*, no. 1 (Moscow: Sovetskii khudozhnik, 1980): 26.

96b Leonid Brailovsky, untitled (ca. 1918)

Watercolor on paper glued onto white page. 13.2 × 11.2 cm.

Brailovsky and his wife, Rimma Nikitichna (also called Nikolaevna) Brailovskaia (1877–1959),[1] were close friends of the Sudeikins in the Crimea, in spite of various emotional ups and downs. In fact, the Brailovskys' house in Miskhor provided the Sudeikins with their first residence after their move from Yalta in December 1917, and Vera wrote warmly of the reception that they were given: "Wouldn't let us go, dined us, gave us tea" (Diaries, 9 December 1917). After living in a "little house" from early February through 22 June 1918, the Sudeikins moved back to the Brailovskys' dacha (Diaries, 22 June 1918). Consequently, they saw each other often in Miskhor, Gaspra, and Yalta, entertained mutual acquaintances such as Pallada (see entry 77b) and Miron Yakobson (entry 45d), and contributed to the same cultural events, such as the "First Exhibition of Paintings and Sculpture by the Association of United Artists" in Yalta in December 1917 and Sergei Makovsky's "Art in the Crimea" exhibition in Yalta in October–November 1918.[2] Vera owned several of Brailovsky's paintings, and both she and Rimma Nikolaevna shared a great passion for embroidery and patchwork. Beginning with 9 December 1917, when Vera met the Brailovskys for the first time, her Diaries contain numerous references to them, especially during 1917–18; and the exercise book for 1 January–15 February 1919 even bears the address "Miskhor. Brailovsky's Dacha."

The attribution of this unsigned watercolor to Leonid Brailovsky is made on the basis of stylistic analogy (cf. entry 108a). The subject, a rocking toy, can easily be accommodated within the Brailovskys' iconographic vocabulary, given their intense interest in peasant toys

and dolls.[3] However, the subject matter, color scheme, and rough-ness of contour also bring to mind Sergei Sudeikin, and an attribu-tion to him should not be ruled out.

Brailovsky, Leonid Mikhailovich. Artist and architect. Born 1867 in Kharkov; died 1937 in Rome.

1886 enrolled in the Academy of Arts, St. Petersburg, and received several prizes during his study there, including the Small Gold Medal in 1894. 1891 onward exhibited regularly in St. Petersburg and Moscow, including at the "Society of Watercolorists." 1895–98 studied in Paris and Rome. 1898 became a professor at the Moscow Institute of Painting, Sculpture, and Architecture. 1900s taught at the Stroganov Art Institute, Moscow. 1890s onward became known for his watercolor renderings of classical ruins and medieval Russian architecture. 1900s–10s was much affected by the Neo-Russian style and designed buildings and books that demonstrated this. 1909–10 contributed (with his wife, Rimma) to Vladimir Izdebsky's "Interna-tional Exhibition of Paintings, Sculpture, Engraving, and Drawings" in Odessa, St. Petersburg, and other cities. 1910–11 contributed (with Rimma) to Vladimir Izdebsky's "Salon 2" in Odessa. 1910s designed several spectacles for major theaters, such as *The Merchant of Venice* and Molière's *Le Médecin malgré lui* for the Malyi Theater, Moscow, and Mozart's *Don Juan* for the Bolshoi Theater, Moscow. 1912 designed the tombstone for Anton Chekhov's grave at the No-vodevichii Cemetery in Moscow. 1916–17 contributed to the "Con-temporary Painting" exhibition in Moscow. 1917 left Moscow for the Crimea; participated in the "First Exhibition of Paintings and Sculpture by the Association of United Artists" in Yalta. 1918 partic-ipated in the "Art in the Crimea" exhibition in Yalta. 1921 member of the Union of Russian Art Workers in Belgrade; participated in the exhibition "L'Art Russe" in Paris. 1924 took up residence in Rome. 1920s–30s with Rimma, contributed to many exhibitions, including the "Salon d' Automne" in Paris.

NOTES

1. For information on Rimma Brailovskaia, see O. Voltsenburg et al., eds., *Khu-dozhniki narodov SSSR. Biobibliograficheskii slovar v shesti tomakh* (Moscow: Iskusstvo, 1972), vol. 2, p. 59.

2. According to the Varia and the Diaries for 1 October 1918, the Brailovskys, Savelii Sorin, and Sudeikin were shareholders in Makovsky's corporation, which sponsored "Art in the Crimea."

3. See, e.g., Brailovsky's design for the poster "Dolls to Benefit the War Orphans" (1914), reproduced in M. Anikst and E. Chernevich, *Russian Graphic Design, 1880–1917* (New York: Abbeville, 1990), p. 152.

FURTHER READING

In addition to the following titles, some of Brailovsky's designs for Crimean projects are reproduced in S. Barkov et al., eds., *Ezhegodnik Obshchestva arkhitektorov-khudozhnikov* (St. Petersburg, 1908), pp. 22–23.

"Beseda s Brailovskim." *Teatr*, no. 1146 (Moscow, 1912): 4–5.

Novitsky, A. "L. M. Brailovsky i ego proizvedeniia." *Stroitel*, no. 5 (St. Peters-burg, 1905): 321–25.

Voltsenburg, O., et al., eds. *Khudozhniki narodov SSSR. Biobibliograficheskii slo-var v shesti tomakh.* Vol. 2, p. 60. Moscow: Iskusstvo, 1972.

97a Riurik Ivnev (1918–19)

St. Petersburg

Oh, my dead city, how sad I am,
My Peter, my Peter, I feel as if I am abroad.
Through the Kremlin here I see: above the Neva
Floats a mist but slightly pink and blue.

I hear the creak of the fir trees. Fir tree bows
To fir tree. O time, O movement,
As if in a dream I hear the granite noise
And the tranquil currents of the wise waves.

My Peter, my Peter, restore, restore,
Restore my house, restore my legacy,
The agonizing days of my love,
The agonizing childhood of my love.

1918, Moscow

14 September 1919, Tiflis

Ink on pink page.

Much influenced by Mikhail Kuzmin, Ivnev ultimately belonged more to a latter-day Decadence than to the hearty Futurism of the Burliuks and Vladimir Maiakovsky. True, Ivnev was close to Futurist groups such as the Mezonine of Poetry and Tsentrifuga and pub-lished in a number of avant-garde miscellanies such as *Yav* (Awake) (Moscow, 1919). But his worldview remained "Symbolist," nurtured by erotic fantasy, religious ecstasy, and urban necrosis, themes re-flected in the very titles of his works (e.g., *Samosozhzhenie* [Self-immolation], *Neizbezhnoe* [The inevitable], and *Neschastnyi angel* [Unhappy angel]). One critic even described Ivnev as "a regular St. Petersburg boy, helpless and melancholy, unhappy in a feminine manner . . . and disorderly, telling us about St. Petersburg . . . and about himself, a bundle of nerves, weary and sick."[1] Ivnev's uncon-ventional private life, his histrionic posing, and his often melodra-matic poetry provoked the most varied reactions—from Alexander Blok's curt dismissal[2] to Mikhail Kuzmin's high commendation.[3] For some he was the "scapegoat" of his generation;[4] for others he was merely a "pseudo-Futurist."[5]

The attribution of entries 97a and 97b to Riurik Ivnev has been confirmed by Alexander Parnis. Ivnev was a colleague of Sergei Gorodetsky and Vasilii Kamensky in Tiflis in 1919 (see entry 2b) and, with Boris Korneev, Kuzmin, Nikolai Semeiko, and Mikhail Struve, he contributed to Yurii Degen's *Neva. Almanakh stikhov* (Tif-lis: Feniks, 1919). Vera knew the "aesthetisizing" Ivnev and liked his work (Diaries, 9 November 1917).[6] According to Vera's Varia, Ivnev was a friend of Iosif Markozov and Savelii Sorin.

Ivnev, Riurik. Pseudonym of Mikhail Alexandrovich Kovalev. Poet. Born 1891 in Tiflis; died 1981 in Moscow.

1900–8 attended the Tiflis Cadet Corps; began to write poetry. 1908–12 attended law school at St. Petersburg University. 1909 on-

ward published poems in various journals. 1914 graduated from the law school of Moscow University; much influenced by the poetry of Semeon Nadson and the Russian Symbolists. 1913 met Alexander Blok and Maiakovsky; published first collection of verse under the title *U piati uglov* (At the five corners). 1915–17 worked at the Office of State Inspection in Petrograd; close to the Futurists of the Mezzanine of Poetry and Tsentrifuga; frequented the Stray Dog; close to Georgii Adamovich, Georgii Ivanov, and Kuzmin. 1915 made the acquaintance of Sergei Esenin, which later brought him close to the Imaginists. 1916 published the collection *Zoloto smerti* (Gold of death). 1917 member of Yurii Degen's literary salon known as the Marseilles Sailors. 1918 living in Moscow. 1919 with Esenin, Vasilii Kamensky, et al. contributed to the miscellany *Yav* (Awake); living in Tiflis. Ca. 1920 in Baku; close to Yurii Degen. 1920s onward continued to write and publish poetry, prose pieces, and memoirs.

NOTES

1. A. Dobryi in *Novyi zhurnal dlia vsekh* (1915). Quoted in P. Nikolaev et al., eds., *Russkie pisateli, 1800–1917. Biograficheskii slovar* (Moscow: Sovetskaia entsiklopediia, 1992), vol. 2, p. 395.
2. Kornei Chukovsky referred to Ivnev as one of those poets who "pretend to be Futurists while in fact they are merely Modernist eclectics" (1914). Ibid.
3. In 1911 Blok advised Ivnev not to publish "at any cost." Ibid.
4. Ibid.
5. Kuzmin referred to Ivnev as "one of the most talented of the young poets." Ibid.
6. In 1918 Vera even wrote that Ivnev—and Alexander Blok and Mikhail Kuzmin—were her favorite poets (see entry 15).

FURTHER READING

For an extensive bibliography of additional publications by Ivnev, see P. Nikolaev et al., eds., *Russkie pisateli, 1800–1917. Biograficheskii slovar* (Moscow: Sovetskaia entsiklopediia, 1992), vol. 2, pp. 394–95.

Bogomolov, N., ed. *G. Ivanov: Stikhotvoreniia, Tretii Rim. Roman, Peterburgskie zimy. Memuary, Kitaiskie teni. Literaturnye protrety*. Moscow: Kniga, 1989.

Ivnev, R. *Chetyre vystrela v Esenina, Kusikova, Mariengofa, Shershenevicha*. Moscow: Imazhinisty, 1921.
———. *Izbrannoe*. With an intro. by N. Leontiev. Moscow: Pravda, 1988.
———. *Moia strana. Stikhi*. Tbilisi: Zaria Vostoka, 1943.
———. *Plamia pyshet. Stikhi*. Moscow: Mezonin poezii, 1913.
Riurik Ivnev. Izbrannoe. Stikhotvoreniia i poemy 1907–1981. With an intro. by N. Leontiev. Moscow: Sovetskii pisatel, 1981.
Riurik Ivnev. Izbrannye stikhi. With an intro. by K. Zelinsky. Moscow: Khudozhestvennaia literatura, 1965.
Riurik Ivnev. Izbrannye stikhotvoreniia. With an intro. by V. Pertsov. Moscow: Khudozhestvennaia literatura, 1974.
Ivnev, R. *Samosozhzhenie. Stikhi 1912–16*. Petrograd: Felan, 1917.
———. *Samosozhzhenie. Stikhi 1913–16*. Moscow: Sakhonov, 1916.
———. *Solntse v grobe. Stikhi*. Moscow, 1921.
———. *Stikhi*. Tbilisi: Zaria Vostoka, 1947.
———. *U podnozhiia Mtatsmindy. Memuary*. Moscow: Sovetskii izdatel, 1973.
McVay, G. "Black and Gold: The Poetry of Ryurik Ivnev." *Oxford Slavonic Papers* 4 (Oxford, 1971): 83–104.
Obraz, Vremenem sozhzhennyi. With an intro. by N. Leontiev. Moscow: Sovremennik, 1991.

97b Riurik Ivnev (1919)

V.A.S.

Looking at you and remembering Russia
Beneath the cupola of shining ["beaming" crossed out] Moscow
I unite into a single love
The waves of the Rhine and the waves of the Neva.

And from the eyes of love I read:
The steppe. The rustle of the wind and the grass,
A wonderful head inclined.
And the Third Rome is like a holiday in May.

28 September
Tiflis

Ink on paper glued onto pink page. 9.9 × 12.4 cm.

During the Silver Age Moscow was often referred to as the Third Rome, the eschatological argument being that, after Rome and Constantinople, it was Moscow that would become the center of religious and cultural rebirth. This idea was certainly not new; it had been first been expressed by a monk from Pskov in the early sixteenth century. In a letter dated 1511 to Tsar Vasilii III, Philotheus of the Eleazar Monastery wrote: "Two Romes have fallen [Rome and Constantinople], a third [Moscow] stands, a fourth there shall not be" (quoted in W. Brumfield, *Gold in Azure* [Boston: Godine, 1983], p. 78). For information on the concept of Moscow as the Third Rome, see D. Strémoukhoff, "Moscow, the Third Rome: Sources of the Doctrine," in M. Cherniavsky, ed., *The Structure of Russian History* (New York: Random House, 1970), pp. 108–25. Georgii Ivanov, one of Ivnev's close friends, wrote a novel called *Tretii Rim* (Third Rome). See N. Bogomolov, ed., *G. Ivanov: Stikhotvoreniia, Tretii Rim. Roman, Peterburgskie zimy. Memuary, Kitaiskie teni. Literaturnye protrety* (Moscow: Kniga, 1989), pp. 179–242.

The poem's heading refers to Vera Arturovna Sudeikina. For Ivnev's biography and commentary, see entry 97a.

98 Sergei Sudeikin, untitled (ca. 1920)

Watercolor and pencil on paper glued onto pink page. 15.2 × 19.5 cm.

The scene of the masked Harlequin and Columbine dancing in a copse is another expression of the theme of the commedia dell'arte in Sudeikin's work. For commentary on the persistence of this imagery, see entry 125b. For Sudeikin's biography, see entry 1b.

99 Igor Terentiev, untitled (ca. 1919)

My poetry
Flower daughter of a bitch
Romulus and Remus
Sucked the tin
Of a uniform badge
 Sozdakruterdigon
 Slovoizverzhogva
 Nebada
 Nepaba
 I feet
 Feeteet

 Ready!

Terentiev

Sssss	Court	(!)		
Piss	to her		(Siu) and Co.	(scribe)
Court	kin			
Sudei				(scholar)
Sudeiki				(porcelain dishes)
Sudeikin				

Pencil on white page.

This poem appeared, with slight variations (e.g., "Nepaba / Ne-bada" instead of "Nebada / Nepaba"), in *Melnikovoi. Fantasticheskii kabachok* (Tiflis, 1919), pp. 130–32; and that version has been reprinted in M. Marzaduri, ed., *Igor Terentiev. Sobranie sochinenii* (Bologna: S. Francesco, 1988), p. 134.

Although Terentiev was often called a "salon Futurist"[1] in Tiflis, he possessed an audacious and original mind that rivaled that of Alexei Kruchenykh, his friend and mentor. With Nikolai Cherniavsky, Alexei Kruchenykh and Ilia Zdanevich, Terentiev represented the most radical poetical trends in Tiflis in 1917–19, and there were many occasions—lectures, poetry declamations, conferences, and publications—in which they endeavored to propagate their extreme forms of verbal and visual Futurism. The "three archbishops, three popes, three old gossips"[2] (i.e., Kruchenykh, Terentiev, and I. Zdanevich) founded their Futurist University in November 1917, rejected Yurii Degen's Syndicate of Futurists, and began to propagate their *zaum* with particular zeal in the summer and fall of 1919. Terentiev was one of the first serious researchers of Zdanevich's dramaturgy, publishing his study of one of the *dras* in *Rekord nezhnosti*.[3] Terentiev's linguistic play with roots, suffixes, and prefixes has much in common with I. Zdanevich's (cf. entry 81), and the latter even designed the layout of Terentiev's most famous book, *17 erundovykh erund.*

This remarkable example of Igor Terentiev's *zaum*, or transrational language, and graphic ability indicates that in Tiflis the Sudeikins mixed with highly experimental poets and artists as well as with the tamer bohemia that they had known in St. Petersburg and Moscow (such as Sergei Gorodetsky and Savelii Sorin). The bald head on the far right of the drawing is that of Terentiev himself, and the tiny portrait at the base of the page is of Sudeikin. Both portraits demonstrate Terentiev's graphic expertise, especially as a caricaturist and illustrator.[4] Degen even traced a parallel between this pictorial acuity and Aubrey Beardsley's elegance of line, since "although neither is an inventor, they . . . perfect and refine what they have assimilated."[5] The poetical structure of the piece illustrates Terentiev's application of semantic shift that relied heavily on chance association and the stream of the unconscious.

Unfortunately, it is impossible to render Terentiev's poem into idiomatic English, because of the complex experimentation with Russian roots, prefixes, and suffixes. This is especially true of Terentiev's meditation on "Sudeikin" on the left side of the page, where he divides the name into individual components—*sud* ("judge"), *ssu* (a child's word for "piss"), *ei* ("to her"), Siu and Co. (a French confectionery and perfume empire in Moscow), *diak* ("scribe"), *posuda* ("plates and dishes"). The cluster of neologisms in lines 6–11 is also rich in its reverberations, containing the Russian words or roots denoting "create," "yes," "steep," "word," "ejection," "born," "feet," and so on. Not surprisingly, both Terentiev and Kruchenykh, following the Freudian exploration of Georgii Kharazov (see entry 47a), were liberal in their application of scatological and sexual references and formulated an entire theory of anal eroticism.[6] The piece in question, for example, is a rich internet of salacious associations—from the connotations of "daughter of a bitch" (*sukina doch*) (echoed in the wordplay of *sud kin*) and "sucked" to the word "tin" (*lud*), from which the slang verb *ludit* (to screw) is derived, the sense of which returns in the word "badge" (*bliakha*), which associated with *bliad* (*blia*), "whore." Knowing of Sudeikin's intricate love life, therefore, Terentiev has provided an entertaining—and realistic—portrait of his friend.

Terentiev, Igor Gerasimovich. Writer and artist. Born 1892 in Ekaterinoslav (now Dnepropetrovsk); died 1937 in a labor camp.

1910s lived in Kharkov. 1914 graduated from Moscow University. 1916 arrived in Tiflis. 1917–19 frequent visitor to the Fantastic Tavern and contributor to its miscellanies; member of 41°; wrote and published many books and articles, contributing to such journals as *Feniks* and *Kuranty*. 1918 (April) participated in the "Exhibition of Paintings by Moscow Futurists" in Tiflis; participated (October) in the Evening of Poetry and Music at the Tiflis Conservatory; joined Degen's Hauberk group. 1919 with Nikolai Cherniavsky, Alexei Kruchenykh, and Ilia Zdanevich edited the single issue of the journal *41°*; with Yurii Degen, Boris Korneev, and Sergei Rafalovich founded the Academy of Arts; with Kirill Zdanevich attended Georges Gurdjieff's Institute for the Harmonious Development of Man; associated with Georgii Kharazov's Academy of Verse. 1922 met Kirill Zdanevich in Constantinople; returned to Tiflis and then left for Moscow. 1923 published in the journal *Lef*; moved to Petersburg; with Kirill Zdanevich contributed to the journal *Krysodav* (Rat-crush). 1927 produced Nikolai Gogol's *Inspector General*, designed

by Pavel Filonov's students in Leningrad. 1928–29 lived in Moscow; projected an "anti-artistic theater." 1929 moved to Kharkov. 1929–30 contributed several designs to the series of booklets called *Neizdannyi Khlebnikov* (Unpublished Khlebnikov). Late 1920s arrested. 1931 arrested again and released.

NOTES

1. According to Tatiana Nikolskaia. See her essay on Terentiev in Tiflis in L. Magarotto, M. Marzaduri, and G. Pagani Cesa, *L'avanguardia a Tiflis* (Venice: Seminario di Iranistica, Uralo-Altaistica e Caucasologia dell'Università degli Studi di Venezia, 1982), p. 191.

2. Terentiev, *Traktat o sloshnom neprilichii* (Tiflis: 41°, 1919), p. 3.

3. Terentiev also published the study in the miscellany *Melnikovoi. Fantasticheskii kabachok* (Tiflis, 1919), pp. 129–46.

4. For other calligraphic and *zaum* designs and self-portraits by Terentiev, see M. Marzaduri, ed., *Igor Terentiev. Sobranie sochinenii* (Bologna: S. Francesco, 1988), between pp. 80 and 83, p. 373, and between pp. 414 and 417.

5. Degen, "I. Terentiev," *Kuranty*, no. 1 (Tiflis, 1919): 18. The article is reprinted in Marzaduri, *Igor Terentiev. Sobranie sochinenii*, p. 432.

6. For some commentary, see Magarotto, Marzaduri, and Pagani Cesa, *L'avanguardia a Tiflis*, pp. 198–200.

FURTHER READING

Degen, Yu. "I. Terentiev." *Kuranty*, no. 2 (Tiflis, 1919): 18.

Magarotto, L., M. Marzaduri, and G. Pagani Cesa. *L'avanguardia a Tiflis*, pp. 189–209, 270–72. Venice: Seminario di Iranistica, Uralo-Altaistica e Caucasologia dell'Università degli Studi di Venezia, 1982.

Marzaduri, M., ed. *Igor Terentiev. Sobranie sochinenii*. Bologna: S. Francesco, 1988. (Contains Terentiev's collected works)

Terentiev, I. *17 erundovykh orudii*. Tiflis: 41°, 1919. (Cover by K. Zdanevich)

———. *A. Kruchenykh grandiozar*. Tiflis: 41°, 1919. (Cover by K. Zdanevich)

———. *Fakt*. Tiflis: Union of Cities of the Republic of Georgia, 1919.

———. *Kheruvimy svistiat*. Tiflis: 41°, 1919.

———. "Lef Zakavkaziia." *Lef*, no. 2 (Moscow, 1923): 177.

———. "Otkrytoe pismo." *Lef*, no. 3 (Moscow, 1923): 5.

———. *Rekord nezhnosti. Zhitie Ilii Zdanevicha*. Tiflis: 41°, 1919. (Illustrations by K. Zdanevich)

———. *Traktat o sploshnom neprilichii*. Tiflis: 41°, 1919. (With A. Kruchenykh and I. Terentiev)

100a Photograph of Olga Glebova modeling a costume designed by Sergei Sudeikin (1916)

Photograph from a journal of the time, glued onto white page. 14.8 × 10 cm.

This photo was reproduced in *Illiustrirovannaia Rossiia*, no. 9 (Paris, 1929): 9.

Glebova was Sudeikin's first wife, whom he married in 1907 after meeting her during the rehearsals for *Soeur Béatrice*. Andrei Bely remembered their visits to the Society of Free Aesthetics in Moscow:

> His standing on ceremony and ardent aridity commanded respect; a fragile, young, charming blonde, his wife, chirping intelligently like a little bird, reminded one—with the splash of her blue and orange silks amid a cloud of pale tassels—of a

Senegalese butterfly; of course her husband dressed her; I looked at her toilettes—Sudeikin canvases![1]

Their union was brief, thanks in part to Sudeikin's many love affairs, particularly his involvement with Mikhail Kuzmin in 1908 (see entry 15)—and also to Glebova's own sentimental attachments, for in the 1910s she is rumored to have been one of Alexander Blok's mistresses and, in the early 1920s, to have shared more than an apartment with Anna Akhmatova, who at one time was also in love with Sudeikin.[2] In spite of their unstable matrimony, Glebova and Sudeikin maintained a close cultural liaison during the 1910s, and he seems to have continued to have "dressed and undressed his doll," especially in costumes in the style of the 1830s, as can be seen in the three photographs shown here (entries 100a–c).[3] For example, Glebova played in Alexander Tairov's 1910 production of Yurii Beliaev's vaudeville *The Muddle-Headed Woman; or, the Year 1840*, which Sudeikin designed,[4] and also in Kuzmin's pantomime *Venetian Madcaps* with decorations by Sudeikin in 1914; she also made the marionettes for Kuzmin's *Christmas Mystery* designed by Sudeikin in 1913. Even after Sudeikin left her for Vera, they still appeared in public together, even in his teaching studio:

> Sudeikin once brought two ladies with him and, standing with them in the doorway, showed them his studio as if it were his zoo, and showed off our talents. Both ladies were pretty, each in her own way. Aleshka [one of Sudeikin's pupils] whispered that they were Olenka and Veronka, Sudeikin's wives—one the ex-wife, the other the present wife: an imposing, gray-eyed beauty eyed us through her lorgnette with serene curiosity.[5]

But in spite of her open mind, Glebova never forgot her great love for Sudeikin: "In the depths of her soul Olga continued to love the man who meant something to her. To her very death—and with bitterness—she continued to think of him."[6] Certainly, Olga found some consolation in her love affair with Arthur Lourié, which began in 1913; but even so, Glebova was distressed and angered when, already an émigré in Paris, she learned after the fact that Sudeikin had married Vera "officially" in Miskhor in 1918 (Diaries, 24 February 1918), since they had never been divorced. "Always unlucky in love," as Vera described her,[7] she even threatened Sudeikin with a lawsuit for bigamy but withdrew her proceedings on the advice of their mutual friend Savelii Sorin. At the same time, and in spite of his wayward behavior, Sudeikin also seems to have retained an affection for Glebova, as he indicated in his 1915 portrait of her and his group portrait called *My Life* of 1916–19 (reproduced on p. xiv),[8] and neither he nor Vera held any grudge against her new husband, Arthur Lourié.[9] Some of Sudeikin's vignettes in the Album (e.g., entry 128) also contain references to Glebova. The three photographs here show Glebova wearing costumes designed by Sergei Sudeikin in 1916.

Glebova was a woman of many talents, writing and declaiming poetry, translating French Symbolist poetry, making embroideries

and puppets, acting, and modeling. At the Comedians' Halt she used to dance "charming little polkas"[10] and perform "dance stylizations on the theme of Russian folk art and eighteenth-century French art, thereby interpreting the same themes that also attracted her husband."[11] Glebova also made flowers, bred birds, and painted panneaux, and during the Revolutionary period she created several ceramic statuettes for the State Porcelain Factory in Petersburg, twelve of which she showed at the "Exhibition of Paintings by Petrograd Artists of All Directions" in 1923. Among these figurines were groups on the theme of the commedia dell'arte, reflecting an intellectual interest in the history of the Italian comedy as well as, no doubt, her own romantic adventures and triangular predicaments (Glebova, Sudeikin, Kuzmin; Glebova, Sudeikin, Vera; Glebova, Vsevolod Kniazev, Kuzmin; etc.).[12] In this endeavor she was perhaps also influenced by Sudeikin's own pictorial motifs, since she owned a number of his miniature designs for porcelain done in 1908.[13] As a leading light in the St. Petersburg demimonde, especially in the Stray Dog and Comedians' Halt, Glebova inspired artists (e.g., Yurii Annenkov drew her portrait, and Moisei Nappelbaum photographed her) and received dedications from many poets, including Akhmatova, Blok, Georgii Ivanov, Igor Severianin, and Fedor Sologub (she was a close friend of Sologub and his wife, Anastasiia Chebotarevskaia).

The exact occasion for Vera's inclusion of these three photographs of Glebova modeling Sudeikin's clothes in her Album is not known, although, inevitably, she must have often compared Glebova's physical grace and deportment with her own. Vera's archive also contains a single page (p. 12) from an unidentified journal published during the First World War carrying these three photographs under the caption "The Actress O. A. Glebova-Sudeikina at an 'Evening of Fashion.' Costumes Designed by S. Yu. Sudeikin." In fact, Sudeikin designed dresses for Vera, and a surviving photograph of 1916 shows her modeling one of his elegant costumes, which in pattern and pose looks very much like the Glebova here.[14] The two women met frequently before and after leaving St. Petersburg, but although Vera feared for Olga's fate in the chaos of Revolutionary Petrograd (Diaries, 7 May 1919) she also had serious misgivings when Savelii Sorin suggested that Olga set up house in Miskhor (Diaries, 10 June 1918). Moreover, Vera does not seem to have appreciated Glebova's artistic acumen, describing her as "a fluffy blond, rosy, slender, naturally flirtatious. She was unable to remember enough poetry to be able to recite any, and she could dance nothing but polkas, but she had charm."[15]

Glebova, Olga Afanasievna. Actress, poet, puppeteer, and artist. Born 1885 in St. Petersburg; died 1945 in Paris.

1902–5 studied at the Theater Institute of the Alexandrinsky Theater, St. Petersburg. 1905–6 worked in the Alexandrinsky Theater company. 1906 worked for Vera Komissarzhevskaia's Theater, St. Petersburg, performing in Vsevolod Meierkhold's productions of *Hedda Gabler* and *Soeur Béatrice*, designed by Sergei Sudeikin;

eloped with Sudeikin. 1907 married Sudeikin. 1909 played the main role in Beliaev's *The Muddle-Headed Woman; or, the Year 1840* at the Malyi Theater, Moscow; participated in Meierkhold's production of *Columbine's Scarf* at the House of the Intermedia. 1914 played in Kuzmin's *Venetian Madcaps*. 1910s regular visitor to the St. Petersburg cabarets; close to Akhmatova, Blok, Kniazev, and Lourié; acted at the Liteinyi Theater, the Stray Dog, and the Comedians' Halt; exhibited at Nadezhda Dobychina's Art Bureau. 1916 (March) separated from Sudeikin. 1918 played in Annenkov's production of Debussy's *Golliwog's Cakewalk* at the Comedians' Halt; worked for the State Porcelain Factory, Petersburg. 1923 contributed to the "Exhibition of Paintings by Petrograd Artists of All Directions, 1919–1923" in Petrograd. 1924 emigrated to Paris via Berlin. 1932 contributed to the exhibition "Artists of the RSFSR over the Last XV Years" in Leningrad.

NOTES

1. A. Bely, *Mezhdu dvukh revoliutsii* (Leningrad: Izdatelstvo pisatelei v Leningrad, 1934), pp. 235–36.

2. Akhmatova dedicated at least two poems to Glebova, "Golos pamiati" (1913) and "O.A.G.S." (1921). See Yu. Annenkov, *Dnevnik moikh vstrech* (New York: Chekhov, 1955), vol. 1, pp. 125–27. Annenkov's portrait of Glebova is reproduced there on p. 26.

3. E. Moch-Bickert, *Kolumbina desiatykh godov* (Paris and St. Petersburg: Grzhebin, 1993), p. 42.

4. It is not entirely clear where Tairov produced his version of *The Muddle-Headed Woman; or, the Year 1840* (see P. Markov, ed., *A. Ya. Tairov. Zapiski rezhissera. Stati, besedy, rechi, pisma* [Moscow: VTO, 1970], p. 508), although it would seem to have been at the Theater of the Literary-Artistic Society (often called the Little Theater) in St. Petersburg (see M. Kuzmin in "Khronika," *Apollon*, no. 4 [St. Petersburg, 1910]: 78). Sudeikin painted a portrait of Glebova in the title role. For a reproduction, see *Apollon*, no. 5 (St. Petersburg, 1910): between pp. 8 and 9; and D. Kogan, *Sergei Sudeikin* (Moscow: Iskusstvo, 1974), p. 51.

5. O. Morozova, "Odna sudba," *Novyi mir*, no. 9 (Moscow, 1964): 117.

6. Moch-Bickert: *Kolumbina desiatykh godov*, p. 51.

7. Statement by Vera. Quoted in R. Craft, *Dearest Babushkin: The Correspondence of Vera and Igor Stravinsky, 1921–1954, with Excerpts from Vera Stravinsky's Diaries, 1922–1971* (London: Thames and Hudson, 1985), p. 5.

8. For a reproduction of Sudeikin's ink portrait of Sudeikina, dated 24 March 1915, see K. Chukovsky, *Chukokkala* (Moscow; Iskusstvo, 1979), p. 138. For a color reproduction of his group portrait, see *100 Years of Russian Art, 1889–1989, from Private Collections in the USSR* (exhibition catalog, Barbican Gallery, London; and Museum of Modern Art, Oxford, 1989), p. 110, where it is mistitled and misdated.

9. Sudeikin and Lourié often collaborated on the same artistic and theatrical projects in the 1910s, such as the pantomime *The Devil in Love* (1916), for which Kuzmin wrote the libretto, Lourié composed the music, and Sudeikin apparently painted the designs. Lourié, incidentally, later served as Igor Stravinsky's musical assistant, particularly between 1924 and 1930.

10. G. Ivanov, *Peterburgskie zimy* (New York: Chekhov, 1952), p. 73.

11. D. Kogan, *Sergei Sudeikin* (Moscow: Iskusstvo, 1974), p. 185.

12. For reproductions of Glebova's figurines and silk dolls, see *Khudozhestvennyi trud*, no. 1 (Moscow and Petrograd, 1923): 13–14; and no. 4 (Moscow and Petrograd, 1923): 18.

13. See the list of Sudeikin's works accompanying S. Makovsky's article "S. Yu. Sudeikin," in *Apollon*, no. 8 (St. Petersburg, 1911): 5–16.

14. Reproduced in Craft, *Dearest Babushkin*, p. 8.

15. V. Stravinsky and R. Craft, *Stravinsky in Pictures and Documents* (New York: Simon and Schuster, 1978), p. 289. As a matter of fact, in the 1910s Glebova was much appreciated for her excellent recitations of Kuzmin's poetry at the Stray Dog and the Comedians' Halt.

FURTHER READING

L'Avant-Garde au Féminin, p. 58. Exhibition catalog, Artcurial. Paris, 1983.

Kogan, D. *Sergei Sudeikin*. Moscow: Iskusstvo, 1974.

Kravtsova, I. "Olga Glebova-Sudeikina." *Russkaia mysl*, Paris, 15 November 1991, p. 14.

Lourié, A. "Olga Afanasievna Glebova-Sudeikina." *Vozdushnye puti*, no. 5 (New York, 1967): 139–45.

Moch-Bickert, E. *Kolombina desiatykh godov*. Paris and St. Petersburg: Grzhebin, 1993.

———. *La Dame aux Oiseaux. Olga Soudéikine*. Undated typescript, ca. 1980. Private collection, Paris.

100b Photograph of Olga Glebova modeling a costume designed by Sergei Sudeikin (1916)

Photograph from a journal or newspaper of the time, glued onto white page. 15.1 × 10 cm.

This photo is reproduced in *Illiustrirovannaia Rossiia*, no. 9 (Paris, 1929): 9. For Glebova's biography and commentary, see entry 100a.

100c Photograph of Olga Glebova modeling a costume designed by Sergei Sudeikin (1916)

Photograph from a journal or newspaper of the time glued onto white page. 13 × 6.6 cm.

This photo is reproduced in *Illiustrirovannaia Rossiia*, no. 9 (Paris, 1929): 9. For Glebova's biography and commentary, see entry 100a.

101 Georgii Kharazov, untitled (1919)

Screwing up my left eye,
I reach for my chin
In search of faith, and I castigate
My motley beard and think of you:

Leaning my cheek on my hand,
In the pattern of displaced wrists
Finding unknown peace
From exhausting tempests.

17 September 1919　　　　　　　　　　G. A. Kharazov

Ink on white page.

For Kharazov's biography and commentary, see entries 47a and 53a–c.

102 Sergei Rafalovich (1919)

To Vera Sudeikina

Unknown beings
Come to us from blue distances,
So as to speak earthly words
With us on the earthly plains,

So as to be reembodied in our humdrum life
And to love and think beside us
Every day, every hour
In our trivial and difficult cares.

But you, born of this earth, have trodden
The slow and usual path
Over the earth so burdened down
To meet the blue abyss;

And embraced in a bright flame,
All of a sudden you have entered a fable
As the vision of a winged dream,
With the wreath of immortality around your brow.

17/30 September 1919　　　　　　　　Sergei Rafalovich
Tiflis

Ink on white page.

Vasilii Katanian also wrote a poem for the Album on the same day, with the same double date (see entry 89).

For Rafalovich's biography and commentary, see entry 13a.

103a Lado Gudiashvili, group portrait (1919)

Photograph from a journal or book, glued onto white page. 8.4 × 11.8 cm.

Gudiashvili has portrayed members of the Blue Horns, with whom Gudiashvili was closely associated from their foundation in Kutaisi in 1916. From left to right are Grigorii Robakidze, Titsian Tabidze, Paolo Yashvili, Gudiashvili, and an unidentified man.[1] The poet Iraklii Abashidze recalled that "Gudiashvili's closest friends were above all poets."[2] The picture may relate to the Blue Horns meeting that Vera describes in her Diaries on 3 May 1919:

At seven P.M. Kamensky[3] comes by for us together with his sister Sonia (actually, his cousin), and by eight o'clock we're already sitting in the red plush reception room of the Blue Horns publishing house, while the tables are being set in the room adjacent and the various purchases brought in. Nobody's around except Paolo Tabidze,[4] who's embarrassed not knowing how or with what to occupy us. Like waiting your turn in the doctor's surgery: silence, plush armchairs, two or three magazines on the table, a newspaper, something like an Aivazovsky on the wall,[5] and a few business cards in a bowl. . . . At last at eleven P.M. Yashvili flings open the doors and invites us in, full

of apologies for the delay. . . . The table is laden with turkeys, fruit, wine, all kinds of hors d'oeuvre (even caviar), while the chef fusses over everything. Serezha is installed in the place of honor between Nina Mikhailovna Madchavariani[6] and the Georgian Princess X, while I am seated between the old Armenian poet Ovanes Tumanian[7] and the poet Robakidze, the master of ceremonies. I'm not far from Salomeia Andronnikova and Rafalovich, while opposite me are Lvov, Kamensky—in all, about thirty people.[8]

For Gudiashvili's biography, see entry 29.

NOTES

1. Gudiashvili designed both their first almanac, published in Kutaisi on 28 February 1916, and their journal, called (in Georgian) *Dreaming Gazelles* and published in Kutaisi and then Tbilisi in 1919–24. For more information on the Blue Horns, see the introduction. In a letter to John E. Bowlt dated 10 November 1990, the Georgian art historian Irina Dzutsova suggests that the "young men might well be seated in the Khimerioni." On Grigorii Robakidze, see entry 51b; on Titsian Tabidze, see entry 57; and on Paolo Yashvili, see entry 50.

2. L. Gagua, ed., *Lado Gudiashvili. Kniga vospominanii. Stati. Iz perepiski. Sovremenniki o khudozhnike* (Moscow: Sovetskii khudozhnik, 1987), p. 279.

3. On Vasilii Kamensky, see entry 2b.

4. Vera is confusing Titsian Tabidze and Paolo Yashvili.

5. Ivan Konstantinovich Aivazovsky (1817–1900), Armenia's and Russia's foremost maritime painter.

6. The identity of Nina Madchavariani has not been established.

7. Ovanes Tadevosovich Tumanian (1869–1923), epic poet.

8. On Salomeia Andronnikova, see entry 51b, n. 1; on Sergei Rafalovich, see entry 13a; and on Yakov Lvov, see entry 55a.

103b Lado Gudiashvili, *Holiday* (1919)

Photograph from a journal or book, glued onto white page. 20 × 15.5 cm.

This reproduction is of Gudiashvili's oil on canvas called variously *Holiday*, *To Kristina*, and *On the Outskirts of Town*. The painting, now in the State Museum of the Arts of Georgia, Tbilisi, and measuring 104 × 7 cm, was first shown at the "Exhibition of Georgian Artists" in Tiflis in May 1919. It is reproduced in color in M. Kagan, *Gudiashvili* (Leningrad: Aurora, 1983), p. 189. Behind the provocative young lady can be seen a tavern (*dukhan*) and the entrance to a park. In composition, *Holiday* is rather similar to the drawing in entry 29.

For Gudiashvili's biography, see entry 29.

105 Sergei Sudeikin, portrait of Vera Sudeikina (ca. 1920)

Watercolor on paper glued onto pink page. 20.8 × 9.1 cm.

For Sudeikin's biography, see entry 1b.

106 Sergei Gorodetsky (1919)

Coffee

A naked girl picked you
In the thickets of fragrant Java.
Like a lizard, the curly-bearded ray
Wildly burned her skin more red.

Tormented by her midday work
She ran to the moonlit marsh,
To a house plaited of vernal twigs,
To her lover, naked like her.

And there, like children, they shouted from joy
That work was over and that the night was young
And the pearly moonlight showed
Their faces shining from caresses long.

At the wharf in the morn a Dutchman
With a belted whip watched the packing
Of the bonded crates and with blood so meek
Deftly painted his taut lash.

Then, the ship cut through the mutinous foam
Of the mighty billows of the ocean,
While, in the captain's cabin deluxe,
Merchants calculated the weight and price.

Before the wharf wrapped in fog,
The proud grain languished, withering.
And there in Java the joys and pains
Of the red-black maiden came and went.

That is why, when black coffee
With its golden sheen boils in the jug,
A sea of turbulent desires arises in the mind
And suddenly the soul yearns for a catastrophe.

Blow up Europe! Wipe away the evil shamelessness
Of buying and selling from the native's freedom.
Magnolia flowers do not need whips
The ocean's sun needs no custodian.

Take revenge for the fury of belted lashes!
May the harbors recede into a bloody mist
So that such naked lovers could
Exult in freedom in the marshes of Java!

13 December 1919 Sergei Gorodetsky
Baku

Ink on pink page.

Gorodetsky's evocation of the Far East maintains a strong oriental tradition in Russian Modernist poetry, practiced by his colleagues and acquaintances, such as Konstantin Balmont and Nikolai Gumiliev. However, in contrast to their exotic poems, Gorodetsky's "Coffee" is a committed statement carrying a clear political message

about the oppressed natives of the imperial colonies, and it marks a sharp deviation away from his Symbolist and "environmental" poetry (e.g., his descriptions of fellow writers in his circle) toward a more ideological and didactic imagery. In fact, "Coffee" had an immediate resonance in international leftist circles, being translated into French by Henri Barbusse. Gorodetsky's new literary trend coincided with his work for the Baku OknaROSTA (Baku Windows of the Russian Telegraph Agency) in 1920–21.[1] The journalist Carl Bechhofer (see entry 127a) described Gorodetsky in Baku in 1920:

> I spent most of my evenings with an old friend of mine who had turned up in Baku. He was Sergey Gorodetsky. . . . I had last met him in Petrograd in 1915, after which he had been, I gathered, a Red Cross commissioner in Armenia. Here the Russian Revolution had found him, and for two years he had been living in Tiflis, Baku, and Persia. I found him now an ardent pro-Bolshevist, anxiously waiting for the Bolsheviks to take Baku in order that he might be able to return through their lines to Moscow and Petrograd. I confess that I have never taken Gorodetsky's political opinions seriously, and his present pro-Bolshevism seemed only to balance a curiously bad poem celebrating the Tsar that he wrote in 1915 or 1916. . . . Here in Baku with his wife, who also writes poems, he was leading a curiously cosmopolitan life. He would be reading poems one day to an Armenian audience; the next day he would be in a Jewish circle; later in the evening he would be among Russians; and so on.[2]

According to his memoirs, Gorodetsky first declaimed the poem "in a tavern in December 1919"[3]—perhaps the Merry Harlequin (see entry 125b). It was first published in *Ponedelnik*, Baku, 5 January 1920; and reprinted in S. Mashinsky, ed., *Sergei Gorodetsky. Stikhotvoreniia i poemy* (Leningrad: Sovetskii pisatel, 1974), pp. 343–44 (commentary, p. 586), where it is dated 13 December 1919.

For Gorodetsky's biography, see entry 5b.

NOTES

1. For a reproduction of one of Gorodetsky's posters made in Soviet Baku, see *Avanguardia Russa* (exhibition catalog, Palazzo Reale, Milan, 1989), p. 142. For a reproduction of one of the abstract collages from his book *Zavertil* (Baku, 1920), see A. Sarabianov and N. Gurianova, *Neizvestnyi russkii avangard* (Moscow: Sovetskii khudozhnik, 1992), p. 62.
2. C. Bechhofer, *In Denikin's Russia and in the Caucasus, 1919–1920* (London: Collins, 1921), p. 311.
3. Quoted in S. Mashinsky, ed., *Sergei Gorodetsky. Stikhotvoreniia i poemy* (Leningrad: Sovetskii pisatel, 1974), p. 586.

107a Sigizmund Valishevsky, *Marusia the Horsewoman* (1919)

Watercolor and pencil on paper glued onto pink page. 34 × 21.7 cm. Inscribed "Sketch for a poster. The horsewoman Marusia. Ziga [Sigizmund] Ilia (?) Ustabnek (?)" in pencil at the base.

Valishevsky was known for his humorous portraits and caricatures. For example, he portrayed Ilia Zdanevich delivering a lecture to an audience of donkeys in 1915[1] and, perhaps inspired by Alexei Kruchenykh and I. Zdanevich, drew an entire series of pictures of Gorodetsky's nose, publishing them in a volume called *Puteshestvie Sergeia Gorodetskogo v Batum* (Sergei Gorodetsky's journey to Batum) (Tiflis, 1919).[2]

The attribution of entry 107a to Valishevsky is based on stylistic comparison, on the signature that seems to begin with "Ziga" (= Zigizmund, or Sigizmund), and on the evidence supplied by Yurii Degen's poem to the right of the drawing (entry 107b). It is not known for which occasion the drawing was made or whether the poster was actually produced, although it is probable that it was for the Esikovsky Brothers' Circus, located off the west end of Golovinskii Prospect, where in October 1916 Vasilii Kamensky also declaimed his "Poetry of the Circus . . . on horseback."[3] At that time it was Vano and Tamara Khundadze who were the famous trick riders at the Esikovsky Circus, and the identities of Marusia and Ilia (?) Ustabnek (?) have not been established; although Kamensky includes a similar, miniature horsewoman falling off her horse in his reference to the circus "where I am" in his "ferroconcrete map" of Tiflis. Alexei Kruchenykh, too, dedicated one of his Tiflis poems to a certain "Sardinian wearing the papakha of a horseman."[4] Presumably, Valishevsky had in mind a particular time, place, and person in Tiflis, although his iconographic reference to Georges Seurat's painting *The Circus* (1891; Musée d'Orsay, Paris) is also very clear. Valishevsky showed two poster designs at the "Little Circle" exhibition in Tiflis in May 1919.

This drawing accompanies the Degen poem (107b). For Valishevsky's biography, see entry 46.

NOTES

1. The pencil portrait, called *At a Lecture by I. Zdanevich* and dated "Winter 1915," is in the collection of the Russian Museum, St. Petersburg. The "donkeys" are identified as Lev Bakst, Alexandre Benois, Ivan Bilibin, Mikhail Larionov, Sergei Makovsky, Filippo Tommaso Marinetti, Boris Pronin, and others. The location would seem to be the Stray Dog cabaret in Petrograd, although the date is perplexing, since Marinetti was in St. Petersburg and Moscow in January–February 1914. A version of the drawing, dated 1919, is reproduced in *Iliazd* (exhibition catalog, Centre Georges Pompidou, Paris, 1978), p. 17; and, dated 1918, in *I libri di Iliazd* (exhibition catalog, Biblioteca Nazionale Centrale, Florence, 1991), p. 124.
2. According to an advertisement on the back cover of Ilia Zdanevich's book *Ostraf Paskhi* (Tiflis: Union of Cities of the Republic of Georgia, 1919), his 41° publishing house produced a booklet entitled *Nos Alexeia Kruchenykh* (Alexei Kruchenykh's nose). Zdanevich had delivered this work as a lecture at the Fantastic Tavern on 23 June 1918 under the title "Kruchenykh and the Soul of His Nose."
3. See Kamensky's poem "Ya—v tsirke" (1916), and its English translation in V. Markov and M. Sparks, eds., *Modern Russian Poetry* (Indianapolis: Bobbs-Merrill, 1967), p. 356–59. Kamensky mentions several of the circus performers by name here, including the "bareback riders Verina and Victoria Harini," but makes no reference to a Marusia.
4. A. Kruchenykh, "Samoubiitsa-tsirk," in *Fantasticheskii kabachok*, no. 1 (Tiflis: Hauberk, 1918), pp. 9–10.

107b Yurii Degen (1919)

A Drawing

In the zigzags of lines is the circus fire.
Rush forward, staccato steed of tournaments,
Whip out, red-haired trainer, with your two whips.

Oh! Each spectator will delight in the circus
When the strawberry backside of the daring rider
Ascends yet higher to the cupola.

To the owners of the Album.
A postscript.

And you, the reason for so many inspirations,
Will you recall Yurii Degen?
Will you remember the "psychometric" red tape
Of the impassioned Zigmunt?[1]

July 1919
Tiflis

Ink on pink page. This poem accompanies the Valishevsky drawing (entry 107a)

The attribution of this poem to Yurii Degen is based on the evidence within the poem itself ("Will you recall Yurii Degen?") and on the handwriting. For Degen's biography, see entry 25a.

NOTE

1. Degen invests the name "Zigmunt" with a double reference—to the artist of the drawing, Sigizmund Valishevsky, and to Sigmund Freud and the science of psychometrics (the measurement of mental abilities and processes such as speed and precision). Freud enjoyed a particular vogue in Tifllis at this time thanks especially to the efforts of Kruchenykh and Georgii Kharazov (see entry 47a).

108a Leonid Brailovsky, *The Poet Kosma Petrovich Prutkov Out for a Walk* (ca. 1919)

Watercolor on paper glued onto pink page. 19 × 16.6 cm. This watercolor accompanies Yurii Degen's poem (108b).

For Brailovsky's biography, see entry 96b. For commentary on Kozma Prutkov, see entry 45d.

108b Yurii Degen (ca. 1919)

The Poet Kosma Petrovich Prutkov Out for a Walk

Out for a walk, Kosma Petrovich
In top hat and checkered trousers,
Saw a lady looking just like a sweetloaf.
He forgot his wife and uttered, "Ah!"

But severe in word, her husband
Managed to cut short this amatory fervor,
And the poet got the point: our earthly destiny
Lies not in the new but in the old.

Hence the moral:
Only one's wife is almost available.

Executed by Yurii Degen on commission from S. Yu.

Ink on pink page. This poem accompanies the Brailovsky watercolor (108a).

That this poem was "commissioned" by Sergei Sudeikin is not surprising, given the latter's enthusiasm for Prutkov's erotic verse—a passion shared by many artists and writers of the Silver Age.
For Degen's biography, see entry 25a. For commentary, see entry 45d.

109a A. Fainberg (ca. 1919)

To Sudeikin
For the Delirium of Madness—and the Delirium of the Madman

The noisy carnival goes on to the whisper of the night.
The vernal mists are full and crimson. . . .
Pierrot, bowed, was quietly sobbing.
Like a shadow, death was counting.

The wheezy laughter of the dead rang out. . . .
In a dead file the shadows floated past. . . .
Mute birds followed the path
From the lands of the Fathers to the Kingdom of Dreams.

Whirlwinds will disperse the sorrow of the times . . .
And so the feast of Life will be over.
Erecting the sepulchral throne to all,
Only Death will inhabit the gloom.

I saddled my stirruped horse
And made the headlong race;
Flying up the snowy Kazbek[1]
To You I extolled the Nameless One,
You—born of a titanic fury
From the bowels of the hungry earth. . . .
We have woven the aforesaid path
With the cheer of wise and drunken Bacchus.
In a dream of fiery mysteries
We have put on life like a burning mantle. . . .
Madman, savage, and saint
Arise to the call of Dionysus.

A. Fainberg

Red ink on ruled paper glued onto white page and covering entry 109c. 35 × 16.2 cm.

The identity of A. Fainberg has not been established. His name appears in the context of the Baku Guild of Poets, but since he dedicated poems to both Sudeikin and Savelii Sorin in the Album, he may have been one of their students in Class 7 in Tiflis (see entries 59a, 63a, 67a, and 83a). In any case, he was an admirer of Sudeikin's art—the references to the carnival (*Carnaval*) (see entries 5a, 19, 25b, 93) and Pierrot indicate that the poet may be describing one or more of Sudeikin's paintings. Based on Fainberg's other poems in the Album (entries 121a and b), this poem appears to have been written in Tiflis in July 1919. Entry 121b is also dedicated to Sudeikin.

NOTE

1. The snow-capped Kazbek is the highest mountain in the Caucasus chain.

109b Boris Grigoriev, untitled (ca. 1920)

Of his course of study
Of his torment—
A soldier grew weary,
Weary [crossed out]
A soldier grew weary.

A soldier grew weary—
And sat down in the bush over there—
And had a dream.

And had a dream—
Brazen Mashka.
Offers [crossed out] Pours some tea.

Offers [crossed out] Pours some tea
And she herself offers:
Let's go and have a fuck. . . .

 B.G.

Pencil on white page under entry 109a. Because of its placement here the original poem could not be photographed and therefore does not appear in the facsimile section of this volume. This poem accompanies Sudeikin's portrait of Grigoriev (109c).

Grigoriev was much attracted by the erotic and the pornographic and used these themes frequently in his art and writings. His letters of the 1910s and 1920s to such friends as Vasilii Kamensky, for example, contain explicit descriptions of his sexual exploits. His album of drawings, *Intimité* (Petrograd, 1918), also reveals his fascination with forbidden themes. Presumably, Grigoriev made this entry in 1920–21 after the Sudeikins had arrived in Paris—the date of other Grigoriev items in the Album (e.g., entries 75 and 143b).

For Grigoriev's biography, see entry 75.

109c Sergei Sudeikin, portrait of Boris Grigoriev (ca. 1920)

Ink and pencil on paper glued onto white page. 11.2 × 9.9 cm. This drawing accompanies the Grigoriev poem (109b).

For Sudeikin's biography, see entry 1b.

110 Boris Grigoriev, untitled (ca. 1920)

Pencil on white page.

The identity of the sitter has not been established. For Grigoriev's biography, see entry 75.

111a Osip Mandelstam, untitled (1917)

In the polyphony of the maidens' choir
Each tender church sings in its own voice,
And in the stony arches of the Cathedral of the Assumption[1]
My eyebrows, high, appear to be an arch!

And from the vault fortified by archangels
I observed the city from a marvelous height.
In the walls of the Acropolis[2] I was consumed by
A sadness for Russian names and Russian beauty.

Is it not a miracle that we dream of a garden
Where doves soar in the hot blueness,
That a nun sings the Orthodox staves:
Heavenly Assumption, Florence in Moscow![3]

And the five domed Moscow churches
With their Italian and Russian soul
Remind me of the appearance of Aurora[4]
But with a Russian name and in a fur coat!

8 August 1917 O. Mandelstam
Alushta, Professors' Corner[5]

Ink over pencil on two ruled pieces of paper glued onto white page. First piece: 17 × 14.7 cm; second piece: 9.8 × 14.5 cm.

This poem was first published in *Almanakh Muz* (1916). Reprinted many times thereafter, including in G. Struve and B. Fillipov, eds., *Osip Mandelshtam. Sobranie socheinenii v trekh tomakh* (Washington, D.C.: Inter-Language Literary Associates, 1967), vol. 1, pp. 57–58 (commentary, pp. 429–30).

For Mandelstam's biography, see entry 51a.

NOTES

1. The Cathedral of the Assumption is one of the churches in the Moscow Kremlin. The year before, Mikhail Kuzmin had also associated Vera with the cathedrals of the Kremlin in "Another's Poem" (see entries 17a and 19). Even though the Kremlin has come to symbolize the "Russianness" of Russia, much

of the complex was built by Italian architects—for example, the Cathedral of the Dormition by the Bolognese Aristotile Fioravanti, and the Hall of Facets by Marco and Pietro-Antonio Solari.

2. Presumably, Mandelstam traveled in Greece during one of his European trips in 1907–8 or 1909–10. Strangely enough, according to G. Struve and B. Filipov, eds., *Osip Mandelstam. Sobranie socheinenii v trekh tomakh* (Washington, D.C.: Inter-Language Literary Associates, 1967), vol. 1, p. xxxv, Mandelstam was forced to interrupt his studies at the University of Heidelberg in 1910 because he failed the examination in Greek literature.

3. Apart from the debt of parts of the Kremlin to Italian designers, Mandelstam may also be alluding to the general popularity of Florentine culture in early twentieth-century Moscow and St. Petersburg, especially among such poets as Alexander Blok and Viacheslav Ivanov (see entries 112–13).

4. Aurora, goddess of the dawn. Mandelstam is also alluding to St. Petersburg, city of the aurora borealis, as well as to Vera through the verbal association with Arturovna and the physical attribute of her fur coat (*shubka*). See entry 17a.

5. Three days later Mandelstam dedicated another poem to Vera, which he also wrote at the Professors' Corner, a boarding house in Alushta whose tenants were predominantly academics (see entry 51a).

111b Nikollo Mitsishvili (1923)

Farewell

Translation by O. Mandelstam

When I collapse to die under a fence in some pit
And my soul will have nowhere to escape from the cast-iron
 cold
I, courteously and quietly, will depart.
Imperceptibly I shall merge with the shadows
And the dogs will take pity on me, kissing me beneath the
 dilapidated fence.

There will be no procession. Violets will not decorate me,
And girls will not scatter flowers over my fresh grave.
No decent jades will be found for my catafalque.
Sorrowful in step, the hearse will somehow carry me.

And who will allow my scars, and boils, and scabs into the place
Where the rank of saints is sternly restricted?
Who honestly will open the patriarchal paradise of saved souls
 to me?
Friends, give forgiveness to one who has sinned so much.

Vanquished is my every thread. I am pursued by sins.
And my blood perishes from an admixture of pus.
And good is the name of our fathers. The square name of tillers
Has become bogged down in lust, knowing peace no more.

Is it for me to carry the ancestral yoke of broad-shouldered
 peasants?
I have turned the good blood of my fathers into vinegar and
 poison.
I myself am burned up like kindling wood in a tardy heat.
In earthly dreams the black nightmare is of no cheer.

My unsung thoughts burn out in the sunset's disarray.
In vain do I then wish to finish my monstrous dreams.
I have no one, no friend, no faithful brother,
Not even a rude lout to give me a resounding punch.

And now—dead, barefoot, growing numb in a withered body—
I must hang tortured by the rains and the merciless wind,
Blackening in some drying room at the crossroads of the worlds
And cursing the gods with hoarse and rabid bark.

Summer, 1923 Nikollo Mitsishvili
Paris

Ink on white page.

Mitsishvili and Mandelstam were friends and translators of each other's work, and both contributed to the Tiflis journal *Figaro* in 1921–22. As a member of the Blue Horns in Tiflis, Mitsishvili did much to propagate the work of Mandelstam, and even helped to free him from prison in Batum in the fall of 1920. As soon as Mandelstam and his wife, Nadezhda Yakovlevna, arrived in Tiflis in July 1921, he began to work feverishly on poems, lectures, and translations, including many renderings from Georgian into Russian, and he must have worked on this Mitsishvili poem at that time, which Mitsishvili then presented to Vera in Paris in the summer of 1923. One result was his translations of Mitsishvili's *Proshchanie* (Farewell) for *Figaro* and then for the *Poets of Georgia* anthology. While in Tiflis, Mandelstam also translated from the Armenian, including poems by the Futurist Kara-Darvish (Akop Gendzhian).[1] In Tiflis Mandelstam lived "poorly, proudly, and with poetical unconcern,"[2] but after leaving Tiflis at the end of 1921, he published sympathetic impressions of the new Georgian movements.[3]

This poem was first published in *Figaro*, no. 1 (Tiflis, 1921), where it is dedicated to Nina Mdivani, sister of the sculptress Rusudam Mdivani, who emigrated to Paris in 1921. It appears with commentary in *Osip Mandelshtam. Stikhotvoreniia, perevody, ocherki, stati*, with an intro. by G. Margvelashvili (Tbilisi: Merani, 1990), p. 278.

Mitsishvili, Nikollo (Nikoloz) (Nikolai Iosifovich). Pseudonym of Nikollo Sirbiladze. Poet and translator. Born 1897 in Kutaisi Province; died 1937 in a labor camp.

Ca. 1912 graduated from Kutaisi City Institute; began to publish. 1917 onward member of the Blue Horns group in Tbilisi; edited *Soldier's Voice*, the newspaper of the Kutaisi Soviet of workers and peasants. 1919 contributed to the journal *Orion*. 1921–22 editor of the Tbilisi Russian-language journal *Figaro*. 1922 edited the miscellany *Poety Gruzii* (Poets of Georgia) in Tiflis; traveled to Constantinople and Paris. 1925 returned to Georgia. 1920s–30s active as a writer, editor, and translator; editor-in-chief of the Zaria Vostoka (Dawn of the East) publishing house; leading member of the Union of Soviet Writers of Georgia.

NOTES

1. Among Mandelstam's translations was Kara-Darvish's *Night on the Mountains*, dedicated to Grigorii Robakidze. See L. Magarotto, M. Marzaduri, and G. Pagani Cesa, *L'avanguardia a Tiflis* (Venice: Seminario di Iranistica, Uralo-Altaistica e Caucasologia dell'Università degli Studi di Venezia, 1982), pp. 215–16; and entry 51b.

2. M. Bulgakov in S. Ermolinsky, "O Mikhaile Bulgakove," *Teatr*, no. 9 (Moscow, 1965). Quoted by Alexander Parnis in his article "Zametki o prebyvanii Mandelshtama v Gruzii v 1921 godu," in Magarotto, Marzaduri, and Pagani Cesa, *L'avanguardia a Tiflis*, p. 212.

3. See "Koe-chto o gruzinskom iskustve," *Sovetskii yug*, Rostov-on-Don, 19 January 1922. For further information on Mandelstam and the Tiflis connection, see Magarotto, Marzaduri, and Pagani Cesa, *L'avanguardia a Tiflis*, pp. 229–30; and P. Nerler, "Mne Tiflis gorbatyi snitsia" in *Osip Mandelshtam. Stikhotvoreniia, perevody, ocherki, stati*, with an intro. by G. Margvelashvili (Tbilisi: Merani, 1990), pp. 376–86.

FURTHER READING

For some information, in addition to the titles listed, see A. Surkov, ed., *Kratkaia literaturnaia entsiklopediia* (Moscow: Sovetskaia entsiklopediia, 1967), vol. 4, p. 892.

Mitsishvili, N. *Perezhitoe*. In Georgian. Tbilisi: Zaria Vostoka 1929. Russian ed., Moscow, 1930.

———. *Perezhitoe. Stikhotvoreniia. Novelly. Vospominaniia*. Tbilisi: Literatura da khelovneba, 1963.

———. *Poety Gruzii v perevodakh B. L. Pasternaka i P. S. Tikhonova*. Tiflis: Zakavkazskoe gosudarstvennoe izdafelstvo, 1935.

———. "Strakhi." *Orion*, no. 5 (Tiflis, 1919): 52–53.

———, ed. *Poety Gruzii*. Moscow: NKP, 1922.

112–13 Sergei Gorodetsky, group portrait (1920)

Watercolor and pencil on white page. Signed and dated "Sergei Gorodetsky Baku 6 III 920" at lower right. The base of the scene carries four stanzas, also by Gorodetsky, written in ink:

Valerii Briusov in ecstasy
Reads his venercreations,
And venomous Sologub
Pours a snake from his narrow lips.

Snuggled up in his shawl, Remizov
Looks tenderly at what's in the potty.
And revealing his vehement temper,
Viacheslav has fastened his eyes upon Cupid [crossed out] Eros.

Pressing his divine lips,
Blok pines for his unknown ladies.
And the enchanted Kuzmin
Falls into an angelic spleen.

Drooping his mustache à la Nietzsche,
Bugaev is quite on the qui vive,
Balmont, bristling up and looking daggers,
Wants to outshout Valera.

On this Olympus the neophyte
Sits entirely relaxed.

This centerfold of the Album is a mosaic of literary references and allusions that had particular meaning to Gorodetsky. Presumably, the scene is meant to be the interior of Viacheslav Ivanov's St. Petersburg apartment, near the Tauride Palace, where he moved in 1905. This apartment—the so-called Tower—became a primary intellectual center where poets, philosophers, artists, and musicians congregated every Wednesday to discuss life and art. Beginning in 1906 one of the keenest visitors to Ivanov's Wednesdays was Gorodetsky.[1] Around the table are grouped Symbolist and Acmeist writers who exerted a formative influence on the young Gorodetsky (the "neophyte" relaxing with his feet on the table). From left to right they are Valerii Yakovlevich Briusov (1873–1924), famous for his erotic poetry, especially "Oh, close your pale legs!" (symbolized by the pink nude in the goblet in front of him); the sardonic Fedor Kuzmich Sologub (pseudonym of Fedor Kuzmich Teternikov; 1863–1927, "a stone rather than a human being"[2]), whose most famous novel, *Melkii bes* (The petty demon), is also extended into the goblet in front of him; the "Chinaman" Alexei Mikhailovich Remizov (1877–1957), who often wore a checkered shawl, is here pictured with the chamber pot, upon which his hero Kostia Klochkov sits at the end of his novel *Chasy* (Hours); Viacheslav Ivanovich Ivanov (1866–1949), "with his golden mane,"[3] the author of *Cor Ardens* (see entries 71a and b), who is looking across the heart in his glass at Eros, one of his frequent poetical and philosophical subjects; Alexander Alexandrovich Blok (1880–1921), author of the play *Roza i krest* (The rose and the cross) (see entry 43c), whose angelic curls and waxen forehead gave a false impression of purity and erectitude and whose obsession with the "unknown lady" (*neznakomka*) was refracted in much of his poetry and playwriting;[4] Mikhail Alexandrovich Kuzmin (1878–1936), whose homosexual idylls placed in St. Petersburg and Italy are reflected in his magnum opus called *Krylia* (Wings) (Diaries, 22 July 1918); Andrei Bely (pseudonym of Boris Nikolaevich Bugaev; 1880–1934), whose early poetry and philosophical tracts were heavily influenced by Nietzsche; Konstantin Dmitrievich Balmont (1867–1942), whose poetical bravura was matched by his arrogant superiority complex; and Gorodetsky himself, listening to the voices of this Olympus, including that of Eros.

The Florentine, heraldic background of the Tower, furnished with antique Italian furniture,[5] was in keeping with many of the Florentine references in the poetry of the authors represented (see entry 111a), including that of Gorodetsky, who had "fallen in love with Italy."[6]

Gorodetsky painted this group while he was in Baku in 1920, a few months before Ivanov himself arrived there. Although suffering from "malaria and an eye ailment,"[7] Ivanov was hired to teach classics at the new University of Baku in November 1920, availing himself of the many kindnesses of Alexandra Chebotarevskaia (Sologub's sister-in-law), and he stayed there for almost four years. For his part, Gorodetsky was working for the local People's Commissariat for Enlightenment as editor of the journal *Iskusstvo* (Art)[8] and, together with Alexei Kruchenykh, "frightening and astonishing,"[9]

was designing posters for the local OknaROSTA (Windows of the Russian Telegraph Agency).[10]

This work is reproduced in color in V. Stravinsky and R. Craft, *Stravinsky in Pictures and Documents* (New York: Simon and Schuster, 1978), plate 10. For Gorodetsky's biography, see entry 5b.

NOTES

1. See O. Deschartes and D. Ivanov, eds., *Viacheslav Ivanov. Sobranie sochinenii* (Brussels: Foyer Oriental Chrétien, 1971), vol. 1, p. 98.
2. G. Ivanov, *Peterburgskie zimy* (New York: Chekhov, 1952), p. 177.
3. Ibid., p. 78.
4. The rose in the glass in front of Blok may also be a distant reference to his 1910 poem *V restorane* (In the restaurant), in which he speaks of ordering a "black rose in a glass of golden champagne" for his heroine—Olga Glebova (see entry 100a).
5. See Ivanov, *Peterburgskie zimy*, p. 131.
6. Ibid., p. 89.
7. L. Fleishman, R. Khiuz, and O. Raevskaia-Khiuz, *Russkii Berlin, 1921–1923* (Paris: YMCA, 1983), p. 272.
8. As editor of the Russian-Azerbaijani journal *Iskusstvo* in Baku, Gorodetsky published Kruchenykh's and Velimir Khlebnikov's "Declaration of *Zaum* Language" in the first issue for 1920–21.
9. According to Tatiana Vechorka. Quoted in D. Kogan, *Sergei Sudeikin* (Moscow: Iskusstvo, 1974). p. 124.
10. See entry 106. For reproductions of other portraits by Gorodetsky of Blok, Remizov, and himself, see R. Duganov, *Risunki russkikh pisatelei* (Moscow: Sovetskaia Rossiia, 1988), pp. 216–17.

114 Sergei Sudeikin, untitled (ca. 1919)

Ink, pencil, and colored crayons on paper glued onto white page. 16.4 × 22.2 cm.

The two figures on the far right of this piece also appear as a separate drawing in entry 95c. It is reasonable to assume that each figure in the group is the portrait of a real individual—for example, perhaps the dancing couple represent Vera and Sergei Sudeikin. To some extent the composition is reminiscent of Sudeikin's *Panneau on the Theme of the Venice Theater* of 1915 (Z. Kotliareva collection, St. Petersburg; reproduced in D. Kogan, *Sergei Sudeikin* [Moscow: Iskusstvo, 1974], p. 99).

For Sudeikin's biography, see entry 1b.

115a Alexander Debua (1920)

To S. Yu. Sudeikin

The masks fly in a tempestuous dance.
All have merged—Pierrot, his cap—
And next to him a tall skeleton
Looks just like an enigma in a fairy tale.

Awakened by the rays of the morning,
Apollo arises lazily.

Again echoes the sound of his lyre
Again he is captured by the Muses.

And again the mighty hand has
Brought to life the Song of Songs
More beautiful, more fine, more splendid
Than the age-old routine.

But to tell all there is no strength . . .
Here—a surge of voluptuousness,
There—an exultant appeal,
And close by—the song of the grave.

Yes, you are truly an artist!
No storm will put out your fire,
Or sweep it away as the wild horse
Tramples down the grass on the highway! . . .

7 March 1920 Alexander Debua
Baku

Ink on paper glued onto white page. 35.6 × 21.4 cm.

Debua, Alexander. Poet. 1920–24 lived in Baku. Member of the Baku Guild of Poets.

FURTHER READING

Nothing substantial has been published on Debua, and his name is omitted from the standard reference works on Soviet literature. Debua met the Sudeikins when they arrived in Baku in the winter of 1919. Judging from the description here, he was an enthusiast of Sudeikin's painting, but the exact occasion of this entry is not known. Debua seems to have stayed in Baku long after the Sudeikins left in 1920 and to have welcomed the Soviet occupation. By 1923–24 he was already writing highly political, pro-Communist poetry and dramaturgy.

Debua, A. *Agitator Chernogo predmestia. Piesa v dvukh kartinakh.* Baku: Azpoligrafitrest, 1923.
———. *Pod gul zavodov. Stikhi.* Baku: Bakinskii rabochii, 1924.

115b Mikhail Struve (1920)

A Despondent Hexameter

Thrice the poet climbed, sadly counting the stairs.
Wearied by sweet hope, he thrice stood at the door.
Thrice he knocked at the artist's door 'til it hurt his hand.
Thrice the answer was an evil emptiness.

29 October 1920 M. Struve
Paris, at a café near you

Ink on white page, in Vera's handwriting.

Struve—"a poet, married to Shop, a rich Jewess" (Diaries, 5 August 1918)—had known the Sudeikins from at least the mid-1910s, when they had all frequented the Stray Dog and Comedians' Halt,

and he met up with them again in Miskhor, Tiflis, Baku (see entries 131a and 131b), and then Paris. One of Vera's other Paris albums (30 September 1920 onward), which contains various entries by, among other people, Adolf Bolm, Natalia Krandievskaia, Georgii Lukomsky, Mikhail Struve, and Alexei Tolstoi—and lots of wine labels (see entry 135)—also contains another poem by Struve called *Chetverostishiia pozdravitelnye* (Congratulatory quatrains) and dated 17 September 1921 (Vera's name day):

1

In the rustle of the silk are birds and snakes,
And coming forth are noble shoulders.
I cannot explain
Why I am deprived of sight and speech. . . .

2

Just the briefest meter has been jotted down—
Four lines—may Nature help!
More beautiful than all the queens on earth is Vera
The beautiful, the daughter of King Arthur.

3

Long did the artist search, long did his heart endure,
Like a bright butterfly he flew in ineffable gardens,
But on finding his queen, the same, Single Rose,
He lives with a new breath and sings with clear conviction.

Struve, Mikhail Alexandrovich. Poet. Born 1890 in St. Petersburg; died 1948 in Paris.

Ca. 1915 graduated from Petrograd University. 1916 close to Georgii Adamovich and Georgii Ivanov within the Guild of Poets in Petrograd; published book of verse called *Staia* (Flock); contributed to the issues of the Petersburg *Almanakh muz* (Almanac of the Muses). 1910s frequented the Stray Dog and Comedians' Halt cabarets; contributed to various miscellanies such as *Vtoroi sbornik Tsentrifugi* (Second centrifuge collection) and *Ocharovannyi strannik* (Enchanted traveler). 1917 member of Yurii Degen's literary salon known as the Marseilles Sailors. 1919 in Tiflis contributed to Yurii Degen's *Neva. Almanakh stikhov* (Neva. Almanac of verses). 1920 lived in Baku before emigrating to Paris. 1921 with Serge Charchoune, Georgii Evangulov, et al. member of the Chamber of Poets and Gatarapakh group in Paris, frequenting the Café Caméléon. 1922 contributed to the Berlin journal *Spolokhi* (Northern lights). 1920s–30s published regularly in the émigré press, including *Illiustrirovannaia Rossiia* (Illustrated Russia) and *Poslednie novosti* (Latest news); during the Second World War was a member of the French Resistance; after the War was an enthusiast of the Soviet regime.

FURTHER READING

Nothing substantial has been published on Struve. For some information, in addition to the single work listed here, see M. Otradin, ed., *Peterburg v russkoi poezii* (Leningrad: Izdatelstvo Leningradskogo universiteta, 1988), pp. 306, 364.

Struve, M. *Staia*. Petrograd: Giperborei, 1916.

115c Sergei Sudeikin, *Johann Kreissler* (ca. 1918)

Pencil on paper glued onto white page. 13.8 × 11.4 cm.

This is one of the many early nineteenth-century "Hoffmann-esque" scenes in the Album that treat of the artist or musician inspired by the Muse. Both Sudeikin and Vera drew many such pencil or ink silhouettes, paying tribute to the revival of this early nineteenth-century Russian tradition, which was also shared by Alexandre Benois, Mstislav Dobujinsky, Elizaveta Kruglikova, Egor Narbut, and other associates of the World of Art group. Vera and Sudeikin drew a series of "figures on posters," including Johann Kreisler, for a concert by Vladimir Drozdov on 23 June 1918 in Alupka (Diaries, 23 June 1918). For commentary on the motif of Johann Kreisler (whose name Sudeikin has misspelled here), see entries 92 and 121c.

For Sudeikin's biography, see entry 1b.

115d Sergei Sudeikin, untitled (ca. 1918)

Pencil on paper glued onto white page. 13.5 × 10.7 cm.

Both Sergei and Vera often made silhouettes while living in the Crimea in 1917–19, and it is obvious that they shared the same iconographic sources, perhaps even working on the same compositions. Vera mentions silhouettes several times in her Diaries (e.g., 23 September and 21 and 25 October 1918). The Album contains several other silhouettes by Sudeikin (see entries 118, 132, 150, 162, and 173a). Vera showed twenty of them at the "Art in the Crimea" exhibition in Yalta in 1918.

For Sudeikin's biography and other commentary, see entries 1b and 115c.

116a Boris Grigoriev, untitled (ca. 1920)

Charcoal and brown crayon on paper glued onto white page. 11.4 × 8.9 cm.

For Grigoriev's biography, see entry 75.

116b Boris Grigoriev, untitled (ca. 1920)

Charcoal and brown crayon on paper glued onto white page. 11.4 × 8.9 cm.

For Grigoriev's biography, see entry 75.

117a Sergei Gorodetsky, *Day of Arrival* (1920)

Watercolor and pencil on paper glued onto white page. 16.5 × 14.2 cm. Signed and dated "S.G. 920"[1] at lower right.

This watercolor accompanies the poem in entry 117b. The date of 12 March 1920 appears at the bottom of the page, below the poem "Day of Arrival," but it obviously refers to Gorodetsky's completion of the entire pictorial and poetical composition and to the Sudeikins' departure from Baku.

For Gorodetsky's biography, see entry 5b. For commentary, see entry 117d.

117b Sergei Gorodetsky (1920)

Day of Arrival

When wife and husband arrived
From Tiflis to Baku
They raised their eyebrows to the ceiling
Scared stiff by their mansion.

With all due respect
Shushanik meets them.
Covered in a cold sweat,
Zudeikin[1] drooped in anguish.

Wheezing, the three-legged chair
Dropped a curtsy in their honor.
And Vera wonders in alarm
Where she'll play patience?[2]

12 March 1920 S.G.
Baku

Ink on white page.

This poem accompanies the Gorodetsky watercolor above (117a). For Gorodetsky's biography, see entry 5b. For commentary, see entry 117d.

NOTE

1. A play on words. Gorodetsky combines the Russian word *zud* ("itch" or "urge") with Sudeikin's name
2. One of Vera's pastimes was playing patience (Diaries, 24 January 1918). See entry 134.

117c Sergei Gorodetsky (1920)

Night of Departure

The bundles of money have been checked.
But some still have to be counted.
How much is—Oh, how tired I am—
Twenty-five plus twenty-five?

The bank notes cling just as if Nassib-bek
Had smeared them with honey.
Not even an entire populus, let alone just you,
Would ever be able to count them up.

You lay them out again—and again mix them up!
So count them up again!
Ah, Serezha's having a real hard time
With his thousand earnings!

 S.G.

Ink on white page.

This poem accompanies the Gorodetsky watercolor below (117d). For Gorodetsky's biography, see entry 5b. For commentary, see entry 117d.

117d Sergei Gorodetsky, *Night of Departure* (1920)

Watercolor and pencil on paper glued onto white page. 22.4 × 17.7 cm. Signed and dated "S.G. 920" at lower right. This watercolor accompanies the Gorodetsky poem (117c). Sergei is counting up the money, while Vera lies in bed, her head on an abacus.

When they arrived in Baku in December 1919, the Sudeikins rented an apartment, where, as *Day of Arrival* tells us, their landlady was a certain Shushanik. During their sojourn in Baku, that "most American of cities,"[1] the Sudeikins met up with many old friends from St. Petersburg and Tiflis, including Yurii Degen, Gorodetsky, Viacheslav Ivanov, Alexei Kruchenykh, Mikhail Struve, and Tatiana Vechorka. According to Gorodetsky's inscription (and to entry 60), 12 March 1920 was the date of the Sudeikins' departure back to Tiflis (and thence for Batum, Marseilles, and Paris). The graphic, unpretentious style of Gorodetsky's two renderings here reminds us that he was working as a poster artist for the Baku OknaROSTA (Baku Windows of the Russian Telegraph Agency) at the time.

For more information on Gorodetsky as an artist, see entry 71b; and on the cultural ambience of Baku in 1920, see the introduction. For Gorodetsky's biography, see entry 5b.

NOTE

1. A. Kruchenykh, *Kozel-Amerikanets* (Baku, 1920). Quoted in M. Marzaduri, *Dada Russo* (Bologna: Caviliere azzuro, 1984), p. 137.

118 Sergei Sudeikin, untitled (ca. 1918)

Ink and pencil on paper glued onto white page. 14.9 × 21.5 cm.

For Sudeikin's biography, see entry 1b. For commentary, see entry 115d (also cf. entries 132, 150, 162, and 173a).

119 Ilia Zdanevich, untitled (ca. 1919)

Pencil on white page. Inscribed "Napoleon Bonap" in pencil at lower right center.

This page of drawings and doodles contains five portraits. It is partly reproduced in V. Stravinsky and R. Craft, *Stravinsky in Pictures and Documents* (New York: Simon and Schuster, 1978), p. 240, where it is dated 1920. The drawing subtitled "Napoleon Bonaparte" is of Sergei Sudeikin, the double portrait is of Sergei and Vera Sudeikin, and the profile is of Vera; the top portrait appears also to be of Vera. Why Zdanevich has associated Sudeikin with Napoleon is not clear, although Sudeikin was known for his affirmative and often dictatorial manner, sometimes "adopting a Napoleon pose" (Diaries, 22 December 1917) with his "Napoleonic hands,"[1] and Rimma Brailovskaia once referred to him as Napoleon (Diaries, 17 February 1918). Since Vera and Sergei Sudeikin still seem very much together in this multiple portrait, it can be assumed that Zdanevich made the drawings while they were all in Tiflis in 1919, or perhaps in the summer of 1920 in Batum. Certainly, by the time he saw them again in Paris in 1921, Vera and Sergei were no longer the peaceful lovers depicted here.

For I. Zdanevich's biography, see entry 81.

NOTE

1. G. Ivanov, "Brodiachaia sobaka," in V. Kreid, ed., *Vospominaniia o serebrianom veke* (Moscow: Respublika, 1993), p. 442.

121a A. Fainberg (ca. 1919)

To Sorin

A portrait of the Georgian princess Dadiani.
The unearthly visage of a chapel Madonna.
The transparent dream of linear thoughts.
The heavenly path of divine meanderings.

The rustle of velvet eyebrows barely moving,
The slipping ray of beseeching radiances.
More speechless, the earthly poet has fallen prostrate,
Captured by the mystery of Dadiani's innocent eyes.

A. Fainberg

Red ink on paper glued onto white page. 35 × 16.3 cm (same sheet as 121b).

It is presumed that Fainberg wrote these two poems to Savelii Sorin and Sergei Sudeikin (entries 121a and 121b) at the same time as other similar "double dedications" were being written by Ivan Radin and Tatiana Vechorka (see entries 65c and 83a)—in Tiflis in 1919 or Baku in 1920. From this it can also be concluded that Fainberg was perhaps a pupil of both artists as well as a poet, attending their Class 7 in Tiflis (also see entries 59a, 63a, 67a, and 83a). Another poem by Fainberg in the Album (entry 109a) is also dedicated to Sudeikin.

Sorin painted Princess Elizaveta Dadiani, to whom Nimfa Bel-Kon refers, in 1919 in Tiflis (see entry 7b). According to the literary historian Alexander Parnis, Sorin and Sudeikin had an exhibition in Baku in 1920, which may have included the Dadiani portrait to which the first line of this poem refers (conversation between Alexander Parnis and John E. Bowlt, 1 June 1991, Moscow).

For commentary on Fainberg, see entry 109a. For Sorin's biography, see entry 7a.

121b A Fainberg (ca. 1919)

To Sudeikin

An instant split my soul
When I was seeking the avid fetters. . . .
Lapses of thought guard over
The icy schism of the madman.

Beyond the world of the frontier, in the delirium of the ages,
Erecting the altar of Christ,
The madman sobbed by the Cross
Reopening all the earthly wounds.

The end of the earthly path has come. . . .
The poppy of bloody moons has grown crimson.
The cesspool of the earth will sting everyone.
The universal Sodom ends.

A. Fainberg

Red ink on ruled paper glued onto white page. 35 × 16.3 cm (on the same sheet as 121a).

For commentary on Fainberg, see entries 109a and 121a. For Sudeikin's biography, see entry 1b.

121c Sergei Sudeikin, *Johann Kreissler's Flucht* (The flight of Johann Kreisler) (ca. 1918)

Watercolor and pencil on paper glued onto white page. 20.7 × 16 cm. Signed at lower right with the monogram "SS" in Latin letters.

This sketch is connected to the posters that Sudeikin and Vera designed for the Vladimir Drozdov concert in Alupka on 23 June 1918:

> Drozdov played wonderfully. . . . Serezha sat next to me. When Drozdov played Schumann, we so enjoyed *Carnaval*, every note of which we know so well. Looking at the figures that we had drawn on the posters (*Aveu* and *Johann Kreisler*), Serezha told me: "Vera, if you want, I can paint the whole of *Carnaval*, all twenty sections, in a fantastic nocturnal landscape." What a subject! (Diaries, 23 June 1918)

Like his *Aveu* (entry 167), *Johann Kreissler's Flucht* was taken from Schumann's *Carnaval*, one of the Sudeikins' favorite pieces of music. For commentary on the motif of Johann Kreisler (whose name Sudeikin has misspelled here), see entry 92; on the carnival (*Carnaval*) motif, see entries 5b, 19, 25b, 93, and 171. For Sudeikin's biography, see entry 1b.

122a Boris Grigoriev, self-portrait (ca. 1919)

Pencil on white page. This self-portrait accompanies the Grigoriev poem (entry 122b).

Presumably, Grigoriev drew this self-portrait after he had just arrived in Paris in 1920, when he made his other entries in the Album, and by which point he had already achieved his strong reputation as a master draftsman and portraitist. Grigoriev made a number of similar pencil and charcoal self-portraits, including one dated 1914 in the Isaak Brodsky Museum in St. Petersburg. For a reproduction, see N. Barsheva, *Muzei-kvartira I. I. Brodskogo* (Moscow: Izobrazitelnoe iskusstvo, 1985), plate 110.

For Grigoriev's biography, see entry 75.

122b Boris Grigoriev (1919)

The Soviet Provinces

The acacia by the house.
Not a house, but a crimson chintz
Wherein like cliffs
Lie my four volumes.

The window is wide open
Whiter and finer than a girl's skirt,
Wide open just like the lips
Of an untried maiden.

The girls know more than you think they do,
They plait their braids in a ribbon,
Amused, with their turned-up noses,
And as silent as icon cases.

Like magpies from the hillock
They dart along the ditch.
Clearly, they know the times
Of the sweet and ardent reality.

The duffer carries his portfolio
Early in the morn.
A young lady from half a mile away
Hastens over the hot dust
All dressed up in a foam of lace.

Boom the curses of her mother:
"Do it for a hundred silver rubles."
In a narrow side street
A horse has died of starvation.

The holes in the windows,
The stores and the tavern are boarded up.
Comfortably installed above the W.C.
A red falcon has paid his respects!

The gates are bolted,
The day will be difficult.
The idleness of youth
Has gone fishing.

The telegraphist and the priest,
No longer recognizing their own people,
Have ended up in the same mess [crossed out]
Have become a good deal prettier
Dragging the coffin of the fatherland.

 B.G.

Pencil on white page. This poem accompanies the Grigoriev self-portrait (122a).

This poem is also an extension of Grigoriev's cycle of pictures called *Raseia* (Russia), published in 1918 (see entry 75). In these pictures of peasants, animals, and village huts, Grigoriev presents

the brutal reality of the rural way of life just before and after the Revolution. Certainly, neither in this poem nor in *Raseia* does Grigoriev idealize rural Russia; he evokes its backwardness and surliness rather than its bucolic charms. Grigoriev's peasants do not delight in their agricultural pursuits and the simple round of the seasons. The country maidens are knowing and vengeful rather than sweet and ardent, and Grigoriev reminds us that the Russian countryside was a place not of peace and harmony but of cruelty, inequality, and duplicity. In his essay for *Raseia* Alexei Tolstoi wrote:

Grigoriev has many admirers and no fewer enemies. Some consider him a "Bolshevik" in painting, some are offended by his *Raseia*, others endeavor to fathom the essence of the Slavic physiognomy that they know so well but that is still enigmatic and as silent as a stone, while still others turn away in anger: "It's a lie! That kind of Russia does not exist and never did."[1]

For Grigoriev's biography, see entry 75.

NOTE

1. A. Tolstoi, "Rossiia Grigorieva," in P. Shchegolev, et al., *Boris Grigoriev. Raseia* (Petrograd: Yasnyi, 1918); and the Russian ed. (Petrograd and Berlin: Efron, 1922). On Tolstoi, see entry 135.

123 Sergei Sudeikin and Igor Stravinsky, *The Firebird* (1921)

Watercolor and pencil on paper glued onto white page. 29 × 27 cm. Inscribed "Firebird. To Vera Arturovna Sudeikina. Igor Stravinsky. Paris 1921 March" in pencil at lower right. The reverse carries part of a pencil drawing.

Sudeikin's fanciful depiction of a firebird with a tail of thistles accompanies the opening notes—in Stravinsky's hand—from Stravinsky's ballet *The Firebird*, first produced by Sergei Diaghilev in Paris in 1910, with designs by Lev Bakst and Alexander Golovin. It is is reproduced in V. Stravinsky and R. Craft, *Stravinsky in Pictures and Documents* (New York: Simon and Schuster, 1978), plate 11. Presumably, the image should be looked at with the musical measure at the top of the page. Stravinsky met Vera on 19 February 1921 when, invited by Sergei Diaghilev, they all dined at an Italian restaurant in Paris. Heeding Diaghilev's request that she "be nice to him," Vera charmed the composer, finding him to be the "wittiest, most amusing man I had ever met."[1] The elaborate nature of this particular dedication symbolizes the emotional collusion of Vera, Sudeikin, and Stravinsky and Vera's imminent transition from the one to the other. From Vera's and Stravinsky's correspondence for 1921, their liaison appears to have begun in July of that year, although neither mentioned it to their current companions (Sergei Sudeikin and Ekaterina Stravinskaia, respectively) until later in the year.[2] Stravinsky's musical and textual entry beginning "To this charming, this lovely, this dear lady" and dated "Paris, 1921" (see entry S5) makes it explicit that Vera and Stravinsky were no longer just platonic friends. Until at least November 1921 Sudeikin seems to have been unaware

of—or to have ignored—Vera's infidelity. His recognition of the fait accompli and his own extramarital interests served as the primary reason for their rift and for his departure for New York on 19 August 1922.

Although it is generally acknowledged that the Sudeikins and Stravinsky had not met before Paris, their paths had crossed a number of times in the 1910s. For example, as early as 1 February 1913 Sudeikin made special decorations for the Stray Dog cabaret in connection with an "Evening of New Music" that included music by Stravinsky. Recalling this event, Nikolai Evreinov mentioned that "the musical Sudeikin's decorative panneaux were a real success—executed in colorful consonances like the compositions of Ravel, Debussy, and Stravinsky."[3] Later in 1913, if the chronology is correct, Vera and Sudeikin might have attended Diaghilev's preparations for Stravinsky's *Le Sacre du printemps* in Paris (produced in May), if the two were indeed in Paris at that time.[4] It is of interest to note that members of the Stravinsky family were also represented at the "Art in the Crimea" exhibition that Sergei Makovsky organized in Yalta in October–November 1918 and to which both Vera and Sergei Sudeikin contributed: Elena Nikolaevna Stravinskaia (*née* Novoselova, wife of Yurii Stravinsky; 1879–1948) showed eight pieces (including views of Petrograd and a silk embroidery), while her husband, Yurii Fedorovich Stravinsky (Igor's brother, an architect; 1878–1941) contributed to the historical section a miniature portrait by Mikhail Terebenev from his own collection.

For Sudeikin's biography, see entry 1b.

Stravinsky, Igor Fedorovich. Composer. Born 1882 in Oranienbaum; died 1971 in New York.

Born into a musical family. 1900 was making an independent study of composition. 1900–5 attended law school at St. Petersburg University. 1902 began to study under Nikolai Rimsky-Korsakov; deeply influenced by him and by Mussorgsky and Debussy. 1908 wrote *Fantastic Scherzo* and orchestral piece called *Fireworks*. Early 1910s lived in France, Switzerland, and Russia. 1910 first ballet, *The Firebird*, performed by Sergei Diaghilev's Ballets Russes in Paris. 1911 *Petrouchka* performed in Paris. 1913 *Le Sacre du printemps* performed. 1914 moved to Switzerland. 1920 moved to France. 1922 comic opera *Mavra* produced in London. 1924–25 with his Piano Concerto and Piano Sonata adopted a new classical style. 1934 became a French citizen. 1939 moved to the U.S. 1940s–50s especially interested in the tonal system of Arnold Schoenberg. 1945 became a U.S. citizen. 1962 concert tour in the Soviet Union.

NOTES

1. V. Stravinsky and R. Craft, *Stravinsky in Pictures and Documents* (New York: Simon and Schuster, 1978), p. 240.

2. See R. Craft, ed., *Dearest Babushkin: The Correspondence of Vera and Igor Stravinsky, 1921–1954, with Excerpts from Vera Stravinsky's Diaries, 1922–1971* (London: Thames and Hudson, 1985), pp. 13–16.

3. N. Evreinov, *Tvorcheskii put Sudeikina* (1926). Quoted in *Pamiatniki kultury. Novye otkrytiia. Ezhegodnik 1983* (Leningrad: Nauka, 1985), p. 206.

4. Sudeikin was in Paris in the spring of 1913, working on his designs for Dia-

ghilev's production of *La Tragédie de Salomé* (produced at the Théâtre des Champs-Elysées on 12 June; *Le Sacre du printemps* premiered there on 29 May). It is rumored that Vera eloped with him to Paris early in 1913 (Stravinsky and McCaffrey, *Igor and Vera Stravinsky: A Photograph Album, 1921 to 1971*, p. 42), although this report is not confirmed by documents, and circumstantial evidence suggests that the two did not fall in love until at least 1914.

FURTHER READING

See the various works both by and about Stravinsky listed in the bibliography.

125a Sergei Gorodetsky, *Merry Harlequin* (1919–20)

Watercolor and pencil on white page.

This watercolor accompanies the Gorodetsky poem (125b). For Gorodetsky's biography, see entry 5b.

125b Sergei Gorodetsky (1919–20)

Hymn of the Merry Harlequin Nightclub in Baku

I was born in Italy,
Where the grapes grow ripe.
I appeared beneath the sun
About five hundred years ago.

People then were not morose;
They had faith in the youthful spring.
And they all dressed up in costumes
Just like I'm wearing now.

For a good five hundred years I've been warming people's
 hearts,
And fighting with stupid tedium.
That's why I don't grow old,
And why I'm not gloomy or angry.

People, let me give you some advice:
Be merry just like me.
Eat what you have on the plate in front of you,
Forget how to moan and groan.

Let the empty steamships
Take the gloomy spleen to London.
Peoples, be merry
Like the Merry Harlequin.

I have wandered much throughout the world,
Now rich, now penniless.
And believe me—a poet—
Life, I kid you not, is great.

One day you get bitten, the next a pat on the back,
A kiss and then a punch on the brow.
Sometimes life helps you out, sometimes it plays a mean trick,
But even so, it's better than the coffin.

I went to see Volodia Lenin[1]
To chase his melancholy away,
And then the windy weather
Brought me into Baku.

Everything smells of kerosene here[2]
People, animals, and homes,
Even the sturgeon in the sea
And the jail outside of town.

The peoples are overcast by oil
And I'm the only one who laughs
Because by nature
I'm a Merry Harlequin.

But I've exchanged laughter for toil and trouble
And have bought a piece of land
In the neutral zone
So no one will shoot at me.[3]

So here I am, drilling
Among other rakes like me.
I praise the land of oil
And await a fountain to the skies.

But every night without fail
I descend into the cellar
Where a fat Momus used to sleep
In peaceful sadness.

My aim, I must confess,
Is to pierce the bronze brow of melancholy,
To teach you how to smile,
And maybe how to laugh.

All peoples are dear to me,
Except for those who like spleen,
Because by nature
I am a Merry Harlequin.

Sergei Gorodetsky

Sung in the Merry Harlequin in
December 1919 and January 1920

Ink on white page. This poem accompanies the Gorodetsky watercolor (125a).

The nightclub, or little theater, called the Merry Harlequin was located in Baku. Organized by Nikolai Evreinov, Gorodetsky, and Sergei Sudeikin at the end of 1919, the Merry Harlequin maintained the traditions of the Moscow, St. Petersburg, and Tiflis cabarets such as the Bat, the Stray Dog, and the Fantastic Tavern. Even the idea of this "hymn" for the Merry Harlequin followed a ritual established by the Bat and the Stray Dog; and whereas Mikhail Kuzmin had been responsible for the Dog's hymn,[4] Gorodetsky (with Nikolai Tsybulsky) had composed one of the Dog's other favorite songs, "A Spring Farewell." During its brief life, the Merry Harlequin served as a ren-

dezvous for the local intelligentsia in Baku (see entry 106), which, of course, included many of those artists, writers, and musicians who had been habitués of the pre-Revolutionary nightspots—including Moisei Altman, Evreinov, Alexei Kruchenykh, Savelii Sorin, Mikhail Struve, and the Sudeikins. Although the Merry Harlequin seemed to have functioned for only a few months, its traditions were renewed in December 1920, when part of the Bat company that had not followed Nikita Baliev to Paris organized the Satire-Agit Theater. In 1923 this was renamed the Baku Workers' Theater. The name Merry Harlequin may echo Evreinov's harlequinade *Merry Death*, first performed in 1909 at Fedor Komissarzhevsky's Merry Theater for Elderly Children, St. Petersburg, with designs by Mstislav Dobujinsky and Nikolai Kalmakov. The play was revived many times, including a production by Konstantin Tverskoi at the Comedians' Halt on 13 December 1918, with designs by Sergei Sudeikin and "dancing on the table with flaming candelabras" by Olga Glebova.[5] The play was repeated at the Aloizi Theater, Sukhumi, on 30 March 1919, with music by Evreinov, choreography by Natalia Butkovskaia, and designs by Alexander Shervashidze; at the Théâtre du Vieux Columbier, Paris, under the direction of Jacques Copeau, in March 1922; and again at the Teatro dell'Arte, Rome, under Luigi Pirandello, in 1925. The plot of the play must have appealed to Gorodetsky, Kuzmin, Sudeikin, and other St. Petersburg Modernists captivated by the theme of the Italian comedy:

> Knowing that the aged Harlequin must die at midnight, Pierrot puts the clock back two hours so as to prolong Harlequin's life. But when Pierrot's suspicion that Harlequin is deceiving him with Columbine becomes a certainty (for Harlequin, wishing to dine for his last time, requests three places at table, together with Death and Columbine, who is singing a love song), Pierrot corrects the time. Satisfied with his vendetta, Pierrot feigns indifference as he watches the love scene between Harlequin and Columbine—until Death arrives.

The Merry Harlequin, like *Merry Death*, extended a persistent motif in the artistic practice of the St. Petersburg and Moscow bohemia of the 1910s,[6] and the Album contains many references to it in terms both of private metaphor (e.g., entry 39b) and of dramatic interpretation (e.g., entry 98). The triangle relationship of Columbine, Harlequin, and Pierrot illustrated or allegorized many of the sentimental involvements of the contributors to this Album (Yurii Degen, Olga Glebova, Boris Kochno, Mikhail Kuzmin, Pallada, Sudeikin, and, of course, Vera), and also served as a deep source of inspiration to primary verbal and pictorial creations of the 1910s. Vsevolod Meierkhold, for example, interpreted the theme in his production of Alexander Blok's *Balaganchik* (Fairground booth) at Vera Komissarzhevskaia's Theater in St. Petersburg in 1906 (designed by Nikolai Sapunov, Sudeikin's rival), as did Konstantin Miklashevsky in his production of Kuzmin's nativity play *Christmas Mystery* at the Stray Dog in 1913 (designed by Sudeikin, with puppets by Glebova). Many of the World of Art artists, especially Alexandre Benois and Konstantin Somov, and the Symbolist poets, including Andrei Bely,

Blok, Elena Guro, and Viacheslav Ivanov, paid homage to the theme, and, of course, Igor Stravinsky immortalized it in his *Petrouchka*, produced by Sergei Diaghilev in Paris in 1911. This wealth of interpretations caused the critic Alexander Mgebrov to observe in 1910–11 that people were talking about the commedia dell'arte at every moment and in every place.[7]

For Gorodetsky's biography, see entry 5b.

NOTES

1. After leaving Tiflis and before transferring to Baku, Gorodetsky seems to have visited Moscow, coinciding with the First Congress of the Communist International (Comintern) in March 1919, and presumably he met Lenin there. It was during these months that Gorodetsky changed his political views considerably, expressing an increasing sympathy for the Bolsheviks (see entry 106). Georgii Ivanov recalled meeting Gorodetsky in Petersburg in the spring of 1920:

 > Sent ahead by the Communist Larisa Reisner, he arrived with a brand new Party ticket. . . .
 > This time it was not Koltsov but Lenin who was on the stage . . . and Gorodetsky was wearing not a Russian blouse but a "revolutionary" jacket. . . .
 > After Reisner [spoke], Gorodetsky shook his curls and looking round the auditorium with his dear, kind, gray eyes, started to recite poetry about the Third International. (G. Ivanov, *Peterburgskie zimy* [New York: Chekhov, 1952], p. 97)

2. Baku was the capital of the Russian (Soviet) oil industry.

3. Between 1917 and April 1920, Baku was occupied by many opposing forces—Azerbaijan, Soviet Bolsheviks, the Centro-Caspian dictatorship, and the British military legation. See the introduction.

4. Nikita Baliev, conferencier of the Bat, composed its hymn. For details, see N. Efros, *Teatr "Letuchaia mysh" N. F. Balieva* (Petrograd: Solntse Rossii, 1918). Mikhail Kuzmin composed the "Hymn" for the Stray Dog, the text of which, carrying references to Veniamin Belkin, Sergei Sudeikin, and other personages, is published in B. Livshits, *Polutoraglazyi strelets* (Leningrad: Izdatelstvo pisatelei, 1933), pp. 259–60.

5. Letter from S. S. Obnevsky to M. K. Yarotskaia, dated 29 December 1958. Quoted in *Pamiatniki kultury. Novye otkrytiia. Ezhegodnik 1988* (Moscow: Nauka, 1989), p. 147.

6. For contemporary commentary on the subject, see K. Miklashevsky, *Teatr italiankikh komediantov* (St. Petersburg: Butkovskaia, 1914). For an informative discussion of the commedia dell'arte and Russian Modernism, see Carla Solivetti, *Konstantin Miklasevskij. La Commedia dell'Arte* (Venice: Marsilio, 1981); and J. Douglas Clayton, *Pierrot in Petrograd* (Montreal and Kingston: McGill-Queen's University Press, 1994).

7. A. Mgebrov, *Zhizn v teatre* (Leningrad: Academia, 1932), vol. 2, p. 175.

127a Carl Eric Bechhofer (1920)

Spring
(after Chavchavadze) To S. Y. Sudeikin, Esq.

The swallow's song is heard again;
The forest dons its leafy dress;
The rosebush in the garden pours
Tears for very happiness.

The hills are blossoming all around,
And flowers bloom upon the fen.
Home of my fathers and my own,
Wilt thou too blossom soon again?

7 April 1920 C. E. Bechhofer
Tiflis

Ink on white page.

This is a loose paraphrase of the poem by the Georgian romantic poet Alexander Garsevanovich Chavchavadze (1786–1846), a "Caucasian Wordsworth" whose lyrical nature poems must have appealed to Carl Eric Bechhofer, then far from his homeland. Evidently the poem was one of Bechhofer's favorites, for he also quoted it—in a slightly different version—in his memoirs.[1] Bechhofer was a British freelance journalist who spoke Russian and Georgian. In 1919–20 he was in Tiflis and Baku, where he observed the vagaries of the Civil War, which he then described in his memoirs, *In Denikin's Russia and in the Caucasus, 1919–1920*. But Bechhofer was much more than an observer of political events, for both before and after the Revolution he took an eager interest in Russian cultural life, even translating and publishing a collection of five Russian plays, including Nikolai Evreinov's *The Beautiful Despot*.[2] In December 1914, Bechhofer visited the Stray Dog in Petrograd, where he may have met Sudeikin, whose wall decorations left such a strong impression on him that he published a description of them in one of his "Letters from Russia": "There are also simply ornaments here: Pierrot with Pierrette and Harlequin; and the sad fate of the Poet; and Don Quixote with his hag; and a bourgeois with a gramophone; and themes from fantastic novels of all times."[3] Bechhofer renewed his acquaintance with this cabaret culture when he visited Tiflis again in the spring of 1920, encountering the Sudeikins on their way back from Baku to Batum. He had fond memories of his brief sojourn in that "centre of the world's culture":

> With the gradual ruin of life in Russia during the last five years, Tiflis, which had been almost outside the danger zone, had become a centre for what was left of Russian society. One found the strangest people there. Poets and painters from Petrograd and Moscow, philosophers, theosophists, dancers, singers, actors and actresses. Paul Yashvili, the leader of the younger Georgian poets, was once moved, after a hearty meal, to climb on a chair in the Café International, in the chief boulevard of Tiflis, and declare, in a loud voice, that "Not Paris, but Tiflis, is the

centre of the world's culture." You would find him in the underground cabaret, the "Chimerion," a huge hall decorated by the Modernist painter from Petrograd, Sergei Sudeikin. The cabaret belonged, I believe, to the Tiflis Poets' Guild, of whom Yashvili was the chief; and Sudeikin had worked their portraits into various parts of his mural decoration. The cabaret was not bad; indeed, for this part of the world, very good. . . . The show would finish at about four in the morning. . . . During the day you went to numbers of new cafés. . . . One afternoon I sat at a table with Yashvili, two or three other Georgian poets (among them, Robakidze), painters and sculptors; Sudeikin, Sorin (another well-known Russian painter), a certain Sokolov, who had taken a prominent part in Kerensky's Government in 1917; and a curious individual named Georgiy Ivanovich Gourjiev.[4]

Bechhofer was also a keen observer of cultural life in Baku in 1920, where, for example, he often heard his friend Sergei Gorodetsky declaim poetry (see entry 106).

Bechhofer, Carl Eric (Carl Eric Bechhöfer Roberts). Journalist, poet, and translator. Born 1894; died 1949 in London.

1911 onward traveled a great deal in the Near and Far East, including India and Japan, and in North Africa. 1910s contributed articles to various British publications, such as *Nineteenth Century and After*, *Morning Post*, *Land and Water*, and the *Times Literary Supplement*. 1914 visited Russia; was in St. Petersburg, where he visited the Stray Dog cabaret; married a Russian woman. 1915 contributed to London magazine *New Age*; visited Batum. 1919–20 covered the Civil War in the Caucasus; visited Tiflis and other towns; in close touch with the White Army. 1920 visited Tiflis again before going on to Baku and then back to Tiflis and Batum; returned to England. 1921 published his account of the Civil War. 1920s–30s continued to write and lecture on Russia and the Caucasus.

NOTES

1. C. Bechhofer, *In Denikin's Russia and in the Caucasus, 1919–1920* (New York: Arno Press, 1971), p. 62.

2. C. Bechhofer, *Five Russian Plays* (London: Kegan Paul, Trench, Trubner, 1916). The collection includes plays by Anton Chekhov, Nikolai Evreinov, Dmitrii Fonvizin, and Lesia Ukrainka.

3. C. Bechhöfer, "Letters from Russia," *New Age*, London, 28 January 1915, p. 344. Russian translation in *Pamiatniki kultury. Novye otkrytiia. Ezhegodnik 1983* (Leningrad: Nauka, 1985), p. 173.

4. C. Bechhofer, *In Denikin's Russia and in the Caucasus, 1919–1920*, pp. 63–65. Paul Yashvili = the poet Paolo Yashvili, leader of the Blue Horns group (see entries 50, 103a); on Robakidze, see entry 51b; for information on the "certain Sokolov," see entry 61a; Gourjiev = Georges Gurdjieff, or Georgii Ivanovich Giurdzhiev (1887–1949), who at this time in Tiflis was directing the Institute for the Harmonious Development of Man, with which Igor Terentiev, Alexander Zaltsman, and the Zdanevich brothers were also associated (see ibid., pp. 67–68; and A. Butkovsky-Hewitt, *With Gurdjieff in St. Petersburg and Paris* [London: Routledge and Kegan Paul, 1978], p. 102).

FURTHER READING

Of the many books that Bechhofer wrote, the following titles relate to his experiences and interpretations of Russia:

Bechhofer, C. *In Denikin's Russia and in the Caucasus 1919–1920*. London: Collins, 1921. Reprint. New York: Arno Press, 1971.

———. *The Mysterious Madame: Helena Petrovna Blavatsky*. New York: Brewer and Warren, 1931.

———. *Russia at the Crossroads*. London: Kegan Paul, Trench, Trubner, 1916.

———. *Through Starving Russia; Being the Record of a Journey to Moscow and the Volga Provinces in August and September 1921*. London: Methuen, 1921.

———. *A Wanderer's Log; Being Some Memories of Travel in India, the Far East, Russia, the Mediterranean and Elsewhere*. London: Mills and Boon, 1922.

———, trans. *Five Russian Plays*. London: Kegan Paul, Trench, Trubner, 1916.

———, ed. *A Russian Anthology in English*. London: Kegan Paul, Trench, Trubner, 1917.

Blok, A. *The Twelve*. Trans. C. Bechhofer. London: Chatto and Windus, 1920. (Illustrated by Mikhail Larionov)

127b Sergei Sudeikin, untitled (ca. 1920)

Ink and pencil on paper glued onto white page. 12.4 × 8.3 cm. The reverse carries part of another drawing.

For Sudeikin's biography, see entry 1b.

127c Pallada (Pallada Deriuzhinskaia) (1918).

To Vera and Sergei Sudeikin

We have long been acquaintances,
But only now have become closely acquainted.
To the shortsighted everything seems dark
So in no way can he count his losses.
At first you turned your happy step
Absentmindedly toward me.

But even in my sleep profound and dead
The rays of your serene eyes burned me.
By chance you discovered my eyelids
And your heart beat faster full of sympathy.

But suddenly life gave me hope
And perhaps even the right to happiness.
And beauty, like marble, shone more brightly.

And like the music of pearls your voice
Suddenly became so much more tender
And the symbol of life was aroused by them!

How can I sing the joys of reveries before you?
How can I thank you for the quickness of your glance?
Before you my streams of frozen tears
Are an antidote that kills the poison.

If you wish—suddenly, submissively,
I can ascend instantly to the clouds like a bird.

Indeed, the golden chariot of torments
Reiterates with you my [my] dreams.
Happiness is indeed a miracle.

Like an icon,
Sergei, you accepted Vera to your glory
Alluringly a crown shines upon you.
Resurrected after lethargy, I am resolved,
In this greater glory I do believe.

I now want to soar quite differently
My dear beloved ones,
To be sure, your path
Must lead you to success!

Pa

Ink on eight sides of four pieces of paper glued onto white page. Each piece measures 10.5 × 16.6 cm.

This entry was probably made on one of Pallada's frequent visits to Vera and Sergei Sudeikin in Miskhor in the summer of 1918. According to Vera (Diaries, May–June 1918), Pallada dedicated a poem to them "badly written, but with a warmth and tenderness that moved us."

For Pallada's biography and commentary, see 77b.

128 Sergei Sudeikin, untitled (ca. 1920)

Watercolor and pencil on green paper glued onto white page. Mounted: 15.6 × 12.9 cm; unmounted: 14.8 × 12.1 cm.

The bearded dwarf appears in various guises in Sudeikin's drawings in the Album (cf. entries 1b, 39b, and 45c) and seems to represent the artist. Although part of the subtext of this private allegory remains recondite, it is reasonable to assume that the dwarf (Sudeikin) is holding the hand of his new discovery (Vera), after clearing his life (broom) of Olga Glebova (right background). The identity of the gentleman on the far left has not been identified, although it has been suggested that he may be Robert Shilling, whom Vera had married in 1912 and from whom, supposedly, she eloped with Sudeikin the following year. Alternatively, the gentleman may be the officer and poet Vsevolod Kniazev, object of both Mikhail Kuzmin's and Sudeikin's affections, who, infatuated by Glebova, committed suicide in 1913 after learning that she was having an affair with Alexander Blok.

For commentary on Kniazev, Kuzmin, and Glebova, see J. Malmstad, "Kuzmin's 'The Trout Breaking through the Ice,'" in G. Gibian and H. Tjalsma, *Russian Modernism* (Ithaca: Cornell University Press, 1976), especially p. 139. For Sudeikin's biography, see entry 1b.

131a Mikhail Struve (1920)

S. Yu. Sudeikin

I don't know where to hide from the cloying moon,
I wander like a madman beneath the mask of Pierrot,
And a unique bird sings me songs
From a unique country, otherly and magic.

A poet racing in the enormous carnival,
I have come to love the inflections and the colors of life.
But the mask has been torn off, and the baneful downfall
Reveals an all-insipid and evil emptiness.

Crazy world, whirl on. Masks, do not tire.
Love cannot live without mannered guises,
And I alone am singer and lord
Of the last terrible dreams of a never-ending fairy tale.

February 1920 M. Struve
Baku

Ink on paper glued onto red page. 26.2 × 19.5 cm.

This poem accompanies the Sudeikin portrait (131b). For Struve's biography, see entry 115b. For commentary, see entries 115b and 163.

131b Sergei Sudeikin, portrait of Mikhail Struve (ca. 1920)

Tempera on red paper.

The left side of this portrait coincides immediately with the piece of paper bearing Mikhail Struve's poem (131a) dedicated to Sergei Sudeikin. For Sudeikin's biography, see 1b.

131c Sergei Sudeikin, untitled (ca. 1920)

Watercolor and pencil on paper laid on paper glued onto red page. Mounted: 11 × 14 cm; unmounted: 10.3 × 13.1 cm.

Sudeikin's "lady at her toilette" reminds us of a similarly salacious tailpiece that Konstantin Somov, one of Sudeikin's early mentors, included among his illustrations to *Le Livre de la Marquise* (St. Petersburg: Golike and Vilborg, 1918), p. 192 (and other editions). For Sudeikin's biography, see entry 1b.

132 Sergei Sudeikin, untitled (ca. 1918)

Pencil on paper glued onto red page. 14.8 × 16 cm. Inscribed "Gold Gold" in pencil at lower center.

From the indication to use gold paint, it would appear that this romantic courtship scene was a study for a painting on the same subject, or for a theatrical set design. Sudeikin made many silhouettes of this kind, some of which are in the Album (see entries 115c, 115d, 118, 150, 162, and 173a). For Sudeikin's biography, see entry 1b.

133 Sergei Sudeikin, untitled (ca. 1920)

Watercolor and pencil on paper glued onto pink page. 10.9 × 13.4 cm. Inscribed "70g" [= 1870] on the right in watercolor.

For Sudeikin's biography, see entry 1b.

134 Sergei Sudeikin, untitled (ca. 1920)

Watercolor and pencil on paper glued onto pink page. 8 × 11.5 cm.

The young lady having her fortune told by the gypsy resembles Vera. Sudeikin often interpreted the theme of a young lady attended by an old confidante (cf. entry 37b). Vera herself dabbled in fortune telling, and playing patience was one of her pastimes (see entry 117b). Her recourse to cards during her first meeting with Igor Stravinsky has often been related. Sudeikin contributed a work called *Fortune Telling* to Sergei Makovsky's "Art in the Crimea" exhibition in Yalta in October–November 1918. See V. Stravinsky and R. Craft, *Stravinsky in Pictures and Documents* (New York: Simon and Schuster, 1978), p. 240. In the catalog to the exhibition (*Iskusstvo v Krymu. Khudozhestvennaia vystavka* [Yalta: Lupandina, 1918]), the work (no. 215) is also described as being in the possession of V. A. Sudeikina. According to her Diaries (20 May 1919), Vera sold the piece to Veisbrut, a Tiflis banker.

For Sudeikin's biography, see entry 1b.

135 Sergei Sudeikin, portrait of Alexei Tolstoi (ca. 1920)

Charcoal on rice paper page.

Sudeikin and Alexei Tolstoi had been acquainted since at least the early 1910s, when they frequented the Stray Dog and then the Comedians' Halt in St. Petersburg–Petrograd. In fact, Tolstoi had donated the famous "pigskin album," in which visitors to the Stray Dog entered their poems and pictures just as they did in Vera's Album later.[1] Tolstoi was especially fond of Sudeikin's art and published an important article on him in the Berlin journal *Zhar-ptitsa*.

The Sudeikins renewed their acquaintance with Tolstoi and his then wife Natalia Krandievskaia[2] in Paris in 1920 when he was lead-

ing an active life among the émigré community, publishing, lecturing, and polemicizing in the same cafés and clubs. One of Vera's Paris albums (30 September 1920 onward; see entries S4 and S5) actually starts with a poetical entry by Natalia Krandievskaia, followed by a sentimental statement by Alexei Tolstoi:

Verses in an album is a sweet custom!
One still alive in our despondent age.
But, alas, my paths have long been closed
Toward a sentimental melody.
Can I compare cheeks to roses
Or a maiden to a nymph?
Neither a fulsome verse nor some nice nonsense
Can wound skeptical hearts.
And who will now keep a lock
In a dusty box?
We are now severe and miserly with verses
And study beautiful girls with magnifying glasses.
However, habits are sometimes strong,
And involuntarily I am attracted by them.
Faded pages beckon me
To hide a name in some acrostic!

Tolstoi, signing himself "Count Alexei N. Tolstoi" and quoting from a certain *Love Is a Golden Book*, continues on the following page: "The month of May. People born in this month possess only what is beautiful and light—and such a cruel fury in all their feelings that their husbands can only shed bitter tears, cursing the day that they ventured to marry these fickle and naughty mischief-makers."

For Sudeikin's biography, see entry 1b.

Tolstoi, Alexei Nikolaevich. Writer. Born 1882 in Nikolaevsk; died 1945 in Moscow.

1901 graduated from the Samara Practical School and entered the St. Petersburg Technological Institute. 1907 left the Institute after deciding to devote himself to a literary career; influenced by the Symbolists; published his collection of verse called *Lirika* (Lyrics). 1908 published his first story in the journal *Niva* (Field); thereafter wrote and published numerous stories, poems, and plays; moved away from Symbolism toward a more realist style. 1914–16 as war correspondent for the newspaper *Russkie vedomosti* (Russian news) traveled to the front and to England and France. 1918 emigrated to France and Germany. 1923 returned to the Soviet Union; published his novel *Aelita*, which was released as a movie the following year. 1920s–30s concentrated on large novels such as *Khozhdenie po mukam* (Road to cavalry) and *Petr Pervyi* (Peter the Great). 1939 member of the Academy of Sciences. 1941 received the Stalin prize for *Petr Pervyi*.

NOTES

1. Unfortunately, this important cultural record has been lost. For information on its contents, see *Pamiatniki kultury. Novye otkrytiia. Ezhegodnik 1983* (Leningrad: Nauka, 1985), p. 173.
2. See her memoirs in Z. Nikitina and L. Tolstaia, eds., *Vospominaniia ob A. N. Tolstom* (Moscow: Sovetskii pisatel, 1982), pp. 95–119.

FURTHER READING

Nikitina, Z., and L. Tolstaia, eds. *Vospominaniia ob A. N. Tolstom.* Moscow: Sovetskii pisatel, 1982.
Surkov, A., ed. *Kratkaia literaturnaia entsiklopediia.* Vol. 7, pp. 542–47. Moscow: Sovetskaia entsiklopediia, 1972.
Terras, V., ed. *Handbook of Russian Literature*, pp. 475–76. New Haven: Yale University Press, 1985.
Tolstoi, A. "Pered kartinami Sudeikina." in *Zhar-ptitsa*, no. 1 (Berlin, 1922): 23–28.
————. *Polnoe sobranie sochinenii.* 15 vols. Moscow: Nedra, 1929–30.
————. *Polnoe sobranie sochinenii.* 10 vols. With an intro. by V. Shcherbina. Moscow: Sovetskii pisatel, 1958–61.

136 Suren Zakharian (1920)

To My Glorious Neighbors Sergei Sudeikin and His Wife
I Compose These Whistling Verses

It'll soon be seven o'clock. Look,
The gray twilight has descended like a canopy.
The light is dim. The sun is setting.
The garden is calm. The lilac is asleep.

A gang of country urchins
Is rounding up the herd from the steppes.
The serenades of the silver-toned
Nightingales can be heard.

The obstinate chirrup of the dragonflies has abated,
And the chatter of the crickets.
It's as if the village has been struck
By the terrible, passionate power of dreams.

The silver firmament shines. . . .
Gathering up their coats,
The fireflies perform a wedding—
A fairy-tale wedding, a dream wedding.

Suren

Red and black ink on ocher page.

Each word in the poem begins with the letter *S*, colored in red ink—hence the reference to "whistling verses." This overt alliteration is the kind of instrumentation that the Symbolists, especially Konstantin Balmont, explored at the beginning of the twentieth century.

For commentary, see entry 93.

138a Mikhail Gerasimov, untitled (1920)

Watercolor and pencil on paper glued onto ocher page. 15.2 × 21.3 cm.

This scene of Middle Eastern pipe smokers is a third component in Gerasimov's interpretations of Baku street life of 1920 (see entries 90b and 91b) and accompanies the Evangulov poem (entry 138b). For Gerasimov's biography and commentary, see entries 90b and 91b.

138b Georgii Evangulov (1921)

The Carpet Seller

Traversing the deserts of Persia
Swallowing only dust and rice,
With colored carpets and with songs
I come to the bazaar in Tiflis.

Ah, the camel is not at all like the vixen!
He does not run like her, quick-tailed.
Hey! Here's a good Persian carpet
From forty to one hundred rubles!

The carpet is studded with patterns
It shines as if it's been licked.
Its owner mourns for it
In the Tabriz caravansaries.

Here are some carpets more costly—
Techin carpets
With more restrained patterns—
Look, I'll unfurl them!

Touch them. How soft they are.
The pile plays its color
Like your velvet voice
Or like the eyes of your wife!

Tartar soul, forgive me
For wandering into your courtyard—
I am selling a cheap
Fergana carpet!

Hey! I'll give you new ones
For a farthing and sing my song:
Carpets, great carpets,
I sell Persian carpets.

December 1921 G. Evangulov
Paris

Ink on ocher page.

The poem accompanies the Gerasimov watercolor (138a) and was first published in G. Evangulov, *Belyi dukhan* (Paris: Palata poetov, 1921), pp. 16–17.

For Evangulov's biography and commentary, see entries 90a–91a.

139 Alexandra Melikova, untitled (1920)

Dark-complexioned men in rags
Shout to me in their foreign slang,
And in the lamp-black smoke of machines
People crowd together on the platform.
As you depart, don't wave
Your white handkerchief from the carriage window!

The color of raspberry suddenly flashes
On the drums of the *kinto* musicians.
But the whistle blows through your nerves
And the long train rocks, aroused.
Ah, hide your little handkerchief!
Why these sobs without reason?

Love has passed. It's time to part.
Believe me, it always comes at the right moment.
The key to the solution is not here.
Surely, we should have parted long ago.
And don't yearn for me
In the dust of deserted wayside stations.

1920 Zamtary
Tiflis

Ink on ocher page.

The poem is signed "Zamtary" (a Georgian word meaning "winter"), the pseudonym of the Georgian Princess Alexandra Melikova, also known as the duchess of Leuchtenberg (Diaries, 7 May 1919). This has been confirmed thanks to a signature reading "Sasha Melikova (Zamtary)" in one of Vera's Paris albums (30 September 1920 onward). The same page in this album contains another signature by Asheliia Melikova following the statement "Last year Tiflis, this year Paris, and what will it be next year?" Presumably, Melikova made this entry in April or May 1920, when the Sudeikins were in Tiflis again on their way back from Baku to Batum and France, although, according to Vera (Diaries, 30 July 1919), they were already acquainted then. Melikova also bought two or three of Sudeikin's studies from the "Little Circle" exhibition in May 1919.[1] Melikova and her husband, Prince Alexander Melikov (the former Georgian-British liaison officer at Tiflis), sailed with the Colonel and Mrs. Haskell (American commissioner in Transcaucasia), Savelii Sorin, and the Sudeikins on the same French steamer, the *Souirah*, from Batum to Marseilles in early May 1920, arriving in Paris on the twentieth of that month.[2]

Melikova continued to write and declaim poetry as an émigré and, with Sergei Charchoune, Georgii Evangulov, Valentin Parnakh, et al., was a member of the Chamber of Poets in Paris.[3] But Melikova never achieved fame as a writer—perhaps because, as Degen observed, "She has a considerable reservoir of words and an undeniable sense of rhythm, which for the moment she hardly knows how to use."[4]

Melikova (Melikian), Alexandra Nikolaevna, Princess; duchess of Leuchtenberg; also Leikhtenbergskaia. Pseudonym: Zamtary (Zamtari; Dzamtari). Born 1895; died in Paris, date unknown.

1919 in Tiflis. 1920 arrived in Paris. 1921 frequented the Café Caméléon, taking part in its literary and artistic meetings. 1922 lived in Berlin.

NOTES

1. According to Vera's inscription in the exhibition catalog, *Malyi krug* (Tiflis, 1919).
2. See C. Bechhofer, *In Denikin's Russia and in the Caucasus, 1919–1920* (London: Collins, 1921), p. 322.
3. For relevant information, see M. Marzaduri, "41°—iz Tiflisa v Parizh," in M. Marzaduri, D. Rizzi, and M. Evzlin, eds., *Russkii literaturnyi avangard. Materialy i issledovaniia* (Trento: Università di Trento, 1990), pp. 121–27.
4. Yurii Degen, "Al. Blok: *12*, *Kuranty*, 1919; A. Chachikov: *Inta. Persidskaia poema*, Tiflis: Iran, 1919; A. Zamtari: *Oblaka. Stikhi*, Tiflis, 1919," a review article in *Kuranty*, nos. 3–4 (Tiflis, 1919): 29.

FURTHER READING

Degen, Yu. "Al. Blok: *12*, *Kuranty*, 1919; A. Chachikov: *Inta. Persidskaia poema*, Tiflis: Iran, 1919; A. Zamtari: *Oblaka. Stikhi*, Tiflis, 1919." Review article in *Kuranty*, nos. 3–4 (Tiflis, 1919): 29.
Melikova, A. *Fire in the Dark: A Picture of the Russian Revolution.* A play in 3 acts, trans. from the Russian by the author. Tiflis, 1919 (typewritten copies).
———. *Oblaka. Stikhi.* Tiflis, 1919.
———. *Stikhotvoreniia.* Berlin, 1922.

140 Sergei Sudeikin, untitled (ca. 1918)

Pencil on paper glued onto ocher page. 16.1 × 21.3 cm.

For Sudeikin's biography, see entry 1b.

143a Boris Grigoriev, untitled (1921)

Pencil on rice paper page. Illegibly inscribed in pencil at lower right.

This unfinished double portrait (perhaps of Vera and Sergei Sudeikin) accompanies the two Grigoriev poems (143b and c) on the same page, although it does not seem to relate to them. The two words to the right have not been deciphered.

143b Boris Grigoriev, untitled (1921)

I myself am not great—and I don't need gold.
There's a lot of petty greed—and there are plenty of people.
Man wears his own century—and needs no patches.
There are few new clothes that you need for the first hundred
 springs.

1921 Boris Grigoriev
Paris

Pencil on rice paper page.

This poem accompanies the Grigoriev portrait and poem (143a and c). For Grigoriev's biography, see entry 75. For commentary, see entries 75, 109b, and 122b.

143c Boris Grigoriev, untitled (ca. 1921)

Let every sonnet in the world
Its . . . seeds
But if my thoughts suit the pharisees
Then I don't need them any more. . . .

Pencil on rice paper page.

This elliptical enigma, unsigned but clearly by Grigoriev, seems to have been written at the same time as the other Grigoriev poem and portraits on this page (143a and b). For Grigoriev's biography, see entry 75. For commentary, see entries 75, 109b, and 122b.

145 Sergei Sudeikin, untitled (ca. 1920)

Watercolor and ink on paper glued onto pink page. 16.1 × 21.8 cm. Figure "7" appears in lower left corner. The reverse carries part of another watercolor.

The precise attribution of this landscape cannot be established, although the color scheme and oval format are close to Sergei Sudeikin's style. The background here is also reminiscent of entry 155. On the other hand, the abstracted mountains, night sky, and billowing clouds bring to mind the "cosmic" paintings that Vera was creating in the 1950s onward, and her involvement here should not be excluded.

For Sudeikin's biography, see entry 1b.

147 Boris Grigoriev, portrait of Sergei Sudeikin (ca. 1921)

Pencil on rice paper page.

For Grigoriev's biography and commentary, see entry 75.

149 Sergei Sudeikin, untitled (ca. 1920)

Watercolor and pencil on paper glued onto red page. 16.2 × 21.9 cm.

Sudeikin painted and drew a number of such landscapes and sea-scapes containing his beloved fountain and sailboat motifs in the late 1910s, such as *Sea Idyll* (I. D. Afanasiev collection, St. Petersburg).[1] As Dora Kogan emphasized in her monograph on Sudeikin, these kinds of panoramas integrate a "concrete, sensual world" and a "fantastic world, a mirage," whereas his deliberate, rhythmical distribution of images produces the impression of an "ornamental and decorative carpet."[2]

For Sudeikin's biography, see entry 1b.

NOTES

1. Reproduced in D. Kogan, *Sergei Sudeikin* (Moscow: Iskusstvo, 1974), p. 132.
2. Ibid.

150 Sergei Sudeikin, untitled (ca. 1918)

Pencil on paper glued onto red page. 12.7 × 21.8 cm. Inscribed "5" in pencil at lower right.

The paper has been cut at the base, leaving sections of two words now rendered illegible. Given the scene of homage to the two busts and the parts of letters visible, the second word would seem to be *predkam,* or "to ancestors." Sudeikin made many silhouettes of this kind, some of which are reproduced in the Album (see entries 115c, 118, 132, 162, and 173a.)

For Sudeikin's biography, see entry 1b. For commentary, see entry 115d.

153 Kirill Zdanevich, untitled (1920)

Pencil and colored crayon on white page. Signed and dated "K. Zdanevich, 29 Oct. 20, Paris" in pencil at lower right.

K. Zdanevich had just arrived in Paris from Berlin when he drew this still life. Obviously he was pleased to see so many Russian and Georgian friends (Sergei Charchoune, Goncharova, Larionov, Gudiashvili, Kakabadze, the Sudeikins) and to refresh his Paris memories of seven years before. Unable to secure permanent status abroad, K. Zdanevich spent only a few weeks in Paris before returning to Tiflis, meeting his brother, Ilia, in Constantinople on the way home. The two brothers met again in Paris forty-six years later (see entries 80 and 81).

In the late 1910s and early 1920s K. Zdanevich made numerous drawings of still lifes, using a vase or jug as the center of the composition. For similar drawings, see *Kirill Zdanevich and Cubo-Futurism: Tiflis, 1918–1920* (exhibition catalog, Rachel Adler Gallery, New York, 1987), nos. 1, 2, 37; and *Kirill Zdanevich. Ilia Zdanevich* (exhi-

bition catalog, State Museum of Arts of the Georgian SSR, Tbilisi, 1990), pp. 22, 41. For K. Zdanevich's biography, see entry 80.

155 Vera Sudeikina, *Stupid Viazma Has Gotten Bogged Down in Gingerbreads* (1917)

Watercolor and pencil on paper glued onto ocher page. 25.8 × 33.2 cm. Inscribed "Stupid Viazma has gotten bogged down in gingerbreads" in watercolor along the edge of the composition

The reference is to the city of Viazma, in Smolensk Province, which was famous for its cookies—and little else. The title is a version of one of the proverbs associated with Viazma: "We are illiterate people, we eat unwritten pastries and gingerbreads with anise. Stupid Viazma, and slow-witted Dorogobuzh."[1] In style, palette used, and type and size of paper, the piece is very similar to entries 158 and 159.

Reproduced in V. Stravinsky and R. Craft, *Stravinsky in Pictures and Documents* (New York: Simon and Schuster, 1978), plate 11.

For Sudeikina's biography, see entry 16.

NOTE

1. A. Burtsev, *Polnoe sobranie etnograficheskikh trudov* (St. Petersburg: Burtsev, 1911), vol. 9, p. 15. The word "unwritten" (*ne pisannye*) here denotes that the cakes have not been decorated with words or painted. Dorogobuzh is a city not far from Viazma. I would like to thank Bella Solovieva for her useful suggestions regarding entry 155.

156a Sergei Sudeikin, untitled (ca. 1919)

Tempera on paper glued onto ocher page. Mounted: 15.9 × 22 cm; unmounted: 15.7 × 21.7 cm.

The *fêtes galantes* were one of Sudeikin's favorite themes, which he inherited from the World of Art artists such as Alexandre Benois and Konstantin Somov. In contrast to that older generation, however, Sudeikin often presented his scenes of Versailles and the Sun King as grotesqueries wherein the dramatis personae, unrefined and deformed, are dwarfed by the theatrical firework displays and tinsel skies. No doubt, Sudeikin's special approach to the theme betrayed his passion for the parody and caricature of the cabaret (cf. entry 145).

For Sudeikin's biography, see entry 1b.

156b Sergei Sudeikin, untitled (ca. 1919)

Tempera on paper glued onto ocher page. 16.1 × 21.7 cm.

The Chinese lanterns, dwarf, and black cat were frequent attributes of Sudeikin's iconography (cf. entry 132).

For Sudeikin's biography, see entry 1b.

157a Maximilian Voloshin (1918)

In Memory of the Sudeikins—Amicably and Tenderly

In Moscow on Red Square
A black crowd grows blacker.
The Kremlin wall
Drones from the heavy tread.

On the ditch by the Place of Execution[1]
By the Cathedral of the Intercession of the Virgin[2]
They offer up unlikely,
Un-Russian words.

Neither are the candles lit
And the bells do not call to mass,
All breasts are marked in red
And the red kerchief billows.

Slushing through the mud . . .
They are silent . . . they approach . . . they wait.
Blind men sing in the church porches
Of executions, blood, and trials. . . .

November 1918 Maximilian Voloshin
N. Miskhor

Pen on board glued onto ocher page. 28.3 × 23 cm. The reverse of the board carries entry 157b.

This poem was first published under the title "Mart" (March) in *Slovu-svoboda!*, Moscow, 10 December 1917, where it carried a dedication to Voloshin's friend, the architect Vladimir Alexandrovich Ragozinsky, and was dated "20 November 1917." In this poem Voloshin was recalling scenes that he had witnessed on Red Square on 12 March 1917. For commentary, see Z. Davydov, ed., *Maximilian Voloshin. Poeziia. Risunki. Akvareli. Stati. Koktebelskie berega* (Simferopol: Tavriia, 1990), p. 240. The poem also appeared in M. Voloshin, *Demony glukhonemye* (Kharkov: Kamena, 1919); and in subsequent collections such as B. Filippov, G. Struve, and N. Struve, eds., *Maximilian Voloshin. Stikhotvoreniia i poemy v dvukh tomakh* (Paris: YMCA, 1982), vol. 1, p. 223.

Like Sergei Gorodetsky, Voloshin was a product of the Symbolist age and learned much from Konstantin Balmont, Andrei Bely, Alexander Blok, and Valerii Briusov, although he rarely attained their Parnassian heights. However, Voloshin should not be judged only by his poetical output, for his talents were wide-ranging. Influenced by Konstantin Bogaevsky (who, in turn, was influenced by Mantegna), Voloshin painted Crimean landscapes and seascapes, evoking the solitude and eternity of the natural wilderness. He was also a keen student of theosophy and anthroposophy, an advocate of open marriage (for a while), an apologist of the early avant-garde in the visual arts,[3] and at the same time an archaeologist and ethnographer, especially in the context of Crimean prehistory.

From this entry and from Vera's Diaries (26–28 November 1918) it appears that Voloshin was in Miskhor/Novyi Miskhor in November 1918 when the Sudeikins were living there. His home in Koktebel, to the east of Yalta, also on the Black Sea, had already gained a reputation as a literary and artistic center; for beginning in the 1900s, Voloshin and Koktebel received a steady stream of visitors, including Nikolai Gumiliev, Osip Mandelstam, and Alexei Tolstoi, and, no doubt, the Sudeikins. From all reports, Voloshin's house in Koktebel attracted visitors not only because of the beauty of its environment but also because of its very liberal lifestyle, aesthetic tolerance, and sensual indulgence.

According to one source,[4] Voloshin met Sudeikin in the fall of 1906 as a result of his interest in Vera Kommissarzhevskaia's theater in St. Petersburg and thereafter mentioned Sudeikin several times in his various articles and reviews. The time and place of Voloshin's first encounter with Vera is not known, although it can be presumed that they had met before the Revolution in St. Petersburg, perhaps in the context of the *Apollon* magazine (which published Voloshin's writings and reproductions of Sudeikin's paintings) or at one of the cabarets. In 1918 Sudeikin named Voloshin among his favorite poets, together with Alexander Blok and Anatole France,[5] and both he and Vera put him on their list of favorite people (Diaries, 21 February 1919). Like the other works in *Demony glukhonemye* (Deaf-mute demons)—a cycle of poems about war and insurrection—"In Moscow on Red Square" reflects Voloshin's ambivalence toward the political evolution. He wrote to Alexei Tolstoi at this time, "I once told you that I imagined Red Square immersed in blood. You can now see that I was not altogether wrong."[6] This "former Socialist Revolutionary [who] accepted October with disgust," as Sergei Makovsky recalled later,[7] had little time for either war or revolution: "They do not frighten me and do not disenchant me in the slightest; I have been expecting them for a long time and in forms even crueler then these."[8]

Voloshin, Maximilian Alexandrovich. Poet and artist. Born 1877 in Kiev; died 1932 in Koktebel.

1887–88 studied at Polivanov's Gymnasium in Moscow. 1890 onward wrote poetry. 1893 onward lived in Koktebel and Feodosiia. 1895 published first poems. 1897 entered law school at Moscow University. 1900 visited Europe and Central Asia. 1901–3 traveled in Europe; attended lectures at the Sorbonne. 1903 close to Symbolist poets such as Bely and Briusov; returned to Paris, where he lived until 1906. 1906 met Gorodetsky and Mikhail Kuzmin; began to contribute to *Zolotoe runo* (Golden fleece). 1909 joined the staff of

Apollon (Apollo); began to publish on the new Russian artists such as Konstantin Bogavesky and Martiros Sarian. Early 1910s onward began to give much time to landscape painting. 1914 traveled to Dornach to participate in the building of Goetheanum; moved to France. 1916 returned to Koktebel. 1917 participated in the "World of Art" exhibition in Moscow. 1918 participated in "Art in the Crimea" exhibition in Yalta. 1920s continued to live and work at Koktebel.

NOTES

1. Voloshin uses the phrase *lobnoe mesto* (literally, "forehead place"), which was the traditional place of public executions on Red Square.
2. The Cathedral of the Protection of the Virgin (Tserkov Pokrova) stands at the southern gate of the Kremlin.
3. For example, Voloshin hastened to defend the Jack of Diamonds group in 1911 and the Donkey's Tail in 1912. See "Bubnovyi valet," *Russkaia khudozhestvennaia letopis*, no. 1 (St. Petersburg, 1911): 9–15; and "Oslinyi khvost," ibid., no. 7 (St. Petersburg, 1912): 105–9.
4. See V. Manuilov et al., eds., *Maximilian Voloshin. Liki tvorchestva* (Leningrad: Nauka, 1988), p. 785.
5. See entry 15, n. 1.
6. Letter from Voloshin to A. Tolstoi (1919). Quoted in B. Filippov, G. Struve, and N. Struve, eds., *Maximilian Voloshin. Stikhotvoreniia i poemy v dvukh tomakh* (Paris: YMCA, 1982), vol. 1, pp. 496.
7. S. Makovsky, *Na parnase serebriannogo veka* (Munich: Tsentralnoe obedinenie politicheskikh emigrantov iz SSSR, 1962), p. 319.
8. M. Voloshin, *Avtobiografiia* (n.p., n.d.). Quoted in P. Nikolaev et al., eds., *Russkie pisateli, 1800–1917. Biograficheskii slovar* (Moscow: Sovetskaia entsiklopediia, 1989), vol. 1, p. 477.

FURTHER READING

Davydov, Z., ed. *Maximilian Voloshin. Poeziia. Risunki. Akvareli. Stati. Koktebelskie berega*. Simferopol: Tavriia, 1990.

Filippov, B., G. Struve, and N. Struve, eds. *Maximilian Voloshin. Stikhotvoreniia i poemy v dvukh tomakh*. Paris: YMCA, 1982–84.

Kupchenko, V., and Z. Davydov, eds. *Vospominaniia o Maximiliane Voloshine*, Moscow: Sovetskii pisatel, 1990.

Maksimilian Volochine. Exhibition catalog, Centre Culturel Jacques Brel. Thionville, 1990.

Manuilov, V., et al., eds. *Maximilian Voloshin. Liki tvorchestva*. Leningrad: Nauka, 1988.

Nikolaev, P., et al., eds. *Russkie pisateli, 1800–1917. Biograficheskii slovar*. Vol. 1, pp. 475–78. Moscow: Sovetskaia entsiklopediia, 1989.

Voloshin, M. *Peizazhi Maximiliana Voloshina*. Leningrad: Khudozhnik RSFSR, 1970.

———. *Stikhotvoreniia*. Leningrad: Sovetskii pisatel, 1977.

Wallrafen, C. *Maksimilian Volosin als Künstler und Kritiker*. Munich: Sagner, 1982.

157b Maximilian Voloshin, untitled (1918)

In the scent of jasmine
Know the fragrant East
The vesper voice of the muezzin
And the dust of the shining roads

To Vera Arturovna—a keepsake Maximilian Voloshin
29 November 1918
Yalta, the Quay

Ink on ruled paper laid on the reverse of entry 157a. 6.8 × 9.7 cm.

Voloshin wrote these lines for Vera when he met Sergei Sudeikin on a shopping expedition in Yalta on 29 November 1918 (Diaries, 29 November 1918).

For Voloshin's biography, see entry 157a.

158 Vera Sudeikina, untitled (ca. 1918)

Watercolor and pencil on paper glued onto ocher page. 25.9 × 33 cm.

This quaint farmyard with its energetic rooster, crimson huts, and awestruck spectators looks more like a stage set than an actual scene from rural Russia. It has much in common with entry 170, and both pieces may have been part of the same cycle. The coy couple, she in her kerchief, bears a distant resemblance to Vera and Sergei Sudeikin (also cf. entries 79b and 155).

For Vera Sudeikina's biography, see entry 16.

159 Vera Sudeikina, untitled (ca. 1918)

Watercolor and pencil on paper glued onto white page. 25.8 × 33 cm.

This piece is painted on the same kind of paper as entry 158. Both Vera and Sergei Sudeikin often used traditional Russian toys and porcelain figures in their pictorial evocations of Old Russia (cf. entries 79b and 155).

For Vera Sudeikina's biography, see entry 16.

161a Vera Sudeikina, *Sudeikin's Paint Wasters* (1918)

Pencil on graph paper glued onto red page. 17.7 × 22.6 cm. Inscribed "Sudeikin's paint wasters" in pencil at the top.

The attribution of this unsigned drawing to Vera has been established by stylistic analysis, although the possibility of another hand should not be excluded. The person smoking the pipe would seem to be Sudeikin himself, and the woman smoking the cigarette (with the inscription "Masha") is perhaps Vera's maid (Diaries, 3 January 1917), while the man seated on the far right with the inscription "Nikodim" is Sudeikin's student, who "wants desperately to be a painter, but is completely ignorant in art" (Diaries, 13 March and

4 April 1918). Because, according to Vera's Diaries, Nikodim (whose last name is unknown) took lessons from Sudeikin in Miskhor in April 1918, it can be presumed that this sketch was done there and then.

For Vera Sudeikina's biography, see entry 16.

161b Vera Sudeikina, *Woman in Reserve* (1918)

Pencil on paper glued onto red page. 13.4 × 13.8 cm. Inscribed "Woman in reserve" in pencil at the top. The reverse carries another drawing.

The identity of the sitter has not been established. One possibility is Rimma Brailovskaia (see entry 96b).

For Vera Sudeikina's biography, see entry 16. For commentary, see entry 161a.

162 Sergei Sudeikin, *The Swains* (ca. 1918)

Pencil and watercolor on paper glued onto red page. 16.7 × 20.5 cm. Inscribed "The swains. On red [illegible] 5+ 4+" in pencil at base.

From the notations, it would appear that this drawing was a preparatory sketch for a larger work or for another medium—perhaps a stage design or an embroidery. The theme recalls Mikhail Kuzmin's erotic pastorale called *Two Swains and a Nymph in a Hut*, which Nikolai Evreinov produced at the Comedians' Halt in Petrograd on 29 October 1916 with designs by Sudeikin.[1] Sudeikin also used the motif of "idyllic shepherds and shepherdesses" in his murals for the Comedians' Halt.[2] Moreover, Sudeikin's designs were used there in his absence for a production of Paul Le Coq's *Shepherd and Shepherdess* in January 1919 in which, incidentally, Olga Glebova performed some of her dances.[3] Sudeikin made many silhouettes of this kind, some of which are in the Album (see entries 115c, 115d, 118, 132, 150, and 173a).

For Sudeikin's biography, see entry 1b. For commentary, see entry 115d.

NOTES

1. For further information, see *Pamiatniki kultury. Novye otkrytiia. Ezhegodnik 1988* (Moscow: Nauka, 1989), pp. 128–29. In February 1919 the Tiflis journal *Feniks* (Phoenix) also organized an evening of songs and performances that included a rendering of Kuzmin's *Two Swains and a Nymph in a Hut*.
2. Yu. Degen, "V 'Privale komediantov'" (1917). Quoted in *Pamiatniki kultury. Novye otkrytiia. Ezhegodnik 1988*, p. 141.
3. For further information, see ibid., p. 148.

163 Mikhail Struve (1921)

To the Sudeikins

A few cups on the table
Cookies in the little basket.
Great Paris outside the windows.
Where, to the rattle of the trams,
The Seine has frozen in a black gloom.

This time we've gained
The banks not of the rivers of Babylon
But of German and French waters.
Yet we think of children's fairy tales
And of what is not forgot.

At first our electric gift
Was near and dear to us.
But with every hour the end
Of the guttered candle and the kiss
Of frosty lips becomes nearer to us.

Towers of tousled snows
And miracles and simple nonsense,
The incantation of the starless night,
How sweet it is to remember the darkness
In you, most radiant prison!

13 December 1921 M. Struve
Paris

Ink on white page.

Struve's use of paradoxes and counterpoints is typical of his poetry, both early and late. His ambiguous attitude toward civilized Paris after his departure from "barbaric" Russia and his nostalgia for her "darkness" is a sentiment expressed by many fellow émigrés in the 1920s–30s.

For Struve's biography, see entry 115b.

165 Lado Gudiashvili, untitled (ca 1919)

Watercolor and pencil glued onto white page. 23.9 × 31.8 cm.

The young girl in this romantic scene resembles Vera, the man Gudiashvili. With his curious drawings and Chagall-like painting" (Diaries, 1 May 1919), Gudiashvili seems to have been attracted to Vera as a pictorial subject (see entry 29), perhaps after their first meeting at the "Exhibition of Georgian Painting" in May 1919 (Diaries, 1 May 1919). The grid arrangement of this watercolor suggests that it was a study for one of the murals that Gudiashvili painted for the Khimerioni cabaret in April–May 1919 just after the Sudeikins had arrived and under Sudeikin's supervision (cf. entry 169) or for another cabaret, such as the Boat of the Argonauts. However, from the existing descriptions of the two frescoes that Gudiashvili

made for the Khimerioni, entitled *Stepko's Tavern* and *Fox Guard*,[1] this particular combination does not seem to have been used. Sudeikin was a keen admirer of Gudiashvili's art, dedicating one of his few critical publications to him in 1919: "Gudiashvili's technical potentials are lapidary—his language is lucid and his paintings . . . seem to perfect Pirosmanashvili's popular style. . . . His masterful command of the pencil makes us wish that his drawings be done on a larger scale . . . so that we could enjoy the total strength of his form."[2]

For Gudiashvili's biography, see entry 29.

NOTES

1. For information on the two frescoes, see L. Gagua, ed., *Lado Gudiashvili. Kniga vospominanii. Stati. Iz perepiski. Sovremenniki o khudozhnike* (Moscow: Sovetskii khudozhnik, 1987), pp. 36–40; and T. Kobaladze, *Lado Gudiashvili. Tainstvo krasoty* (Tbilisi: Merani, 1988), pp. 14–15. In 1919 Gudiashvili also painted a picture called *Stepko's Store* (State Museum of the Arts of Georgia, Tbilisi) based on the fresco *Stepko's Tavern*. For a color reproduction of this, see Gagua, *Lado Gudiashvili. Kniga vospominanii. Stati. Iz perepiski. Sovremenniki o khudozhnike*, p. 36.

2. S. Sudeikin, "Georgian Artists" (in Georgian), *Sakartvelo*, no. 115 (Tiflis, 1919): 2–3. A Russian translation of the section on Gudiashvili appears in Gagua, *Lado Gudiashvili. Kniga vospominanii. Stati. Iz perepiski. Sovremenniki o khudozhnike*, p. 218. The reference to Pirosmanashvili is to the Georgian primitive painter Niko Pirosmanashvili (1862–1918).

167 Sergei Sudeikin, *Aveu* (ca. 1918)

Pencil on paper glued onto white page. 14.5 × 11.4 cm.

Vera and Sudeikin produced a series of "figures on posters" based on *Carnaval*, including one called *Aveu*, in connection with the Vladimir Drozdov concert in Alupka on 23 June 1918 (see entry 115c). Vera wrote in her Diaries (19 January 1919): "I'm reworking *Aveu* from *Carnaval* for an embroidery."

For Sudeikin's biography, see entry 1b. For commentary, see entry 115d.

169 Sergei Sudeikin, untitled (ca. 1920)

Watercolor and pencil on paper glued onto white page. 20.4 × 22.4 cm. Signed "Sudeikin" in watercolor at lower right. The reverse carries a pencil drawing.

The scene depicts a Georgian *kinto* ("dashing young fellow," or "daredevil out to enjoy wine, women, and song") and two ladies on a balcony in old Tiflis. The grid arrangement of this watercolor suggests that it was a study for the mural that Sudeikin painted for the wall of the left staircase in the Khimerioni cabaret in April–May 1919 just after Vera and he had arrived (cf. entry 165). According to Lado Gudiashvili, one of the themes for this mural was "episodes from the life of old Tbilisi" (L. Gagua, ed., *Lado Gudiashvili. Kniga vospominanii. Stati. Iz perepiski. Sovremenniki o khudozhnike* [Moscow: Sovetskii khudozhnik, 1987], p. 37).

For commentary on Sudeikin's contribution and reproductions, see I. Dzutsova and N. Elizbarashvili, "S. Yu. Sudeikin v Gruzii," *Muzei*, no. 1 (Moscow: Sovetskii khudozhnik, 1980), especially pp. 24–26. For Sudeikin's biography, see entry 1b.

170 Vera Sudeikina, untitled (ca. 1917)

Watercolor and pencil on paper glued onto white page. 25.5 × 33 cm.

The rural subject matter (chickens, hens, peasant huts), peculiar spherical perspective, and bright colors of this piece have much in common with the "theatricized farmyard" in entry 158, of which this is perhaps a continuation (cf. entry 79b).

For Vera Sudeikina's biography, see entry 16.

171 Vasilii Kamensky (ca. 1919)

Sergei Sudeikin

In the brightly colored country of Picturia
Prayers await—illumine and bring warmth!
The precise lines are like lace.
The sun and heart is Sudeikin Sergei.

That name to me is the billowing sea
That name to me is Flight and the Dawn.
I remember the artist-poet flowering
Together with the spring in the Crimean Miskhor.

Colors and songs around the cypress
Somewhere in the mountains the shepherds pipe
Resonantly calling the irises to bow
And to read the ardent verses.

And later, when, in ephemeral agitation,
In the studio of the picturesque daylight,
The mystery of languor is sketched,
Vera returns, driving away the weariness.

In the evening colors by hand transformed
And in the holy visage of the Madonna, too,
The stars can see two lovers
Standing at a pillar in a Sudeikin park.

Your Name is Sun-Arise. It has illumined
The path of *danses plastiques*
Your painting is triumphant, bestowing upon us
A carnival of colored carriages.[1]

I feel I am drunk, and you are all intoxicated—
All of you whose eyes contemplate the dreams
Made by the master in his proud creativity,
In the reflection of these radiant words.

Pitch, beauty, beauting,[2] wedding songs—
Blossom! The hymn has sounded.

Now aware forever of my superpictoriality[3]
I praise my seesaw fate.

With love
Vasilii Kamensky

Pen on two sides of ruled paper glued onto white page. 27.5 × 21 cm.

The handwriting of the manuscript of the poem is not Kamen-sky's. However, the signature, "With love, Vasilii Kamensky," is his, although it is in a different-colored ink and seems to have been added at a different date. Kamensky may have made the dedication in connection with one of the Kamensky Evenings in Tiflis in 1919 (see entry 2b).

For Kamensky's biography, see entry 2b.

NOTES

1. Both "carnival" and "colored carriages" were frequent motifs in Sudeikin's painting, and there are several items in the Album that incorporate them. See especially entries 5b, 19, 25b, 31a, 93, and S2.
2. The Russian word is *krasotinnost*, a neologism combined from the words *kra-sota* (beauty) and *kartinnost*, an abstract noun derived from the word *kartina* (picture, or painting).
3. The Russian word is *sverkhkartinnost*, a neologism combined from the words *sverkh* (above, or super-) and *kartinnost*.

173a Sergei Sudeikin, untitled (ca. 1918)

Pencil on paper glued onto blue page. 13 × 19.2 cm.

Sudeikin drew many such pencil or ink silhouettes (cf. entries 115c, 115d, 118, 132, 150, and 162). For his biography, see entry 1b. For commentary, see entry 115c.

173b D.W., *Les boubentzi de Yalta* (1917)

Les boubentzi di Yalta.
Petite polka
 à m-me V. et mr S.
 Soudeikine

21 October 1917 D.W.
Alushta

Ink on three sides of paper glued onto blue page. Paper unfolded: 30.3 × 18.9 cm.

The "boubentzi" (*bubentsy* in Russian) are the little bells attached to Russian carriages and sleighs. According to information on a note supplied by Edwin Allen, "D.W." was the husband of Evgeniia Ma-nozon, a friend of Vera (letter from Edwin Allen to John E. Bowlt, dated 15 July 1990). Presumably, they were also living in Alushta in the summer and fall of 1917, before the Sudeikins moved to Yalta.

❀ ❀

The supplementary entries S1, S2, and S3 refer to the three water-colors in one of Sudeikin's exercise books at the back of the Album. The exercise book dated January–February 1917 on the outside cover contains only these three items. For Sudeikin's biography, see entry 1b.

The entries S4 and S5 are from another album (now in a private collection) that Vera kept in Paris from 30 September 1920 on-ward and that also contains entries by, among other people, Adolf Bolm, Natalia Krandievskaia, Georgii Lukomsky, Mikhail Struve, and Alexei Tolstoi—along with lots of wine labels.

S1 Sergei Sudeikin, portrait of Vera Sudeikina (1917)

Watercolor, pen, and ink on ruled paper glued onto inside cover of exercise book. 12 × 11.4 cm.

A close version of this portrait of Vera Sudeikina's head in profile, dated 1918, is in entry 17b. Her coy inclination attracted other art-ists, including Sigizmund Valishevsky (entry 46).

S2 Sergei Sudeikin, untitled (1917)

Watercolor and pencil on paper laid on ruled paper. Mounted: 21.2 × 17 cm; unmounted: 20.5 × 16.6 cm.

A version of this scene appears in entry 31a.

S3 Sergei Sudeikin, portrait of Vera Sudeikina (1917)

Watercolor and pencil on paper glued onto inside of back cover of exercise book. 16.2 × 12.3 cm. Inscribed "Very ugly? No, I'm terribly tired. Let's go right away" in pencil at the top, and "[illegible] I again / I adore you, Ti-pinka / Be able to arrange [illegible] adore you" at the base.

S4 Boris Kochno and Igor Stravinsky (1921)

Boris Kochno
On the day of Dear
Vera Arturovna
1921

Yes, yes. Yes!
And not yes-yes.
I. Stravinsky
To Vera
[After the music] "I don't remember any more"

Ink on paper. Ca. 20 × 14 cm.

Kochno wrote the preceding lines, one of several poetical dedications (see entries 48–49b), on 30 September 1921, Vera's name day (the *0* has been crossed out and replaced with *1*). The fact that Kochno's gesture precedes Stravinsky's eager succession of "da" (yes), playing consciously on the term "Dada," is significant: when Sergei Diaghilev introduced Stravinsky to Vera in Paris on 21 February 1921, the composer—thirty-nine, married, and the father of four children aged seven to fourteen—fell head over heels in love. One result of this new sentiment was his inscription of the initial theme of *The Firebird* in Vera's Album a few weeks later (see entry 123).

At the beginning of October 1921 Diaghilev invited Vera to play the mimed role of the Queen in his revival of *The Sleeping Princess* (a version of *Sleeping Beauty*), which was to begin a long engagement in London on 2 November. She was there for rehearsals on 27 October, when Kochno warned her that the composer could be fickle. In London for the premiere of the ballet, Stravinsky arranged for Kochno to act as a liaison between Vera and himself. The irony of the story is that while fielding Stravinsky's letters to Sudeikin's wife, Kochno was sending love letters and poems of his own to the bisexual Sudeikin (see entries 48–49b). Astonishingly, Stravinsky confided his feelings for Vera to the seventeen-year-old Kochno in more than forty extant letters.

Reproduced in V. Stravinsky and R. McCaffrey, eds., *Igor and Vera Stravinsky: A Photograph Album, 1921 to 1971* (London: Thames and Hudson, 1982), p. 51. The Stravinsky dedication that follows, S5, is directly related to this entry. For Kochno's biography, see entries 48–49b. For Stravinsky's biography, see entry 123.

Robert Craft has supplied much of the information given in this commentary.

S5 Igor Stravinsky (1921)

Pronounce "e" as "ie" *everywhere*

Car accident
I then drank cognac
Off went the *gardes de marine*
And Kuznetsova and I
Discussed opera on the sofa

To a lady,
This charming,
This lovely,
This dear
Vera Sudeikina

[Within the musical excerpt] She's a really great girl, but even if you leave her alone she still costs one ruble, and if you screw her, you'll have to pay two.

Ink on paper. Ca. 29 × 20 cm.

Stravinsky worked on his choral ballet *Svadebka*, or *Les Noces* (originally called *Les Noces Villageoises*), for several years; and in his correspondence with Stravinsky, Diaghilev even refers to *Les Noces* as early as November 1914, although he did not produce it until 13 June 1923 at the Théâtre de la Gaîté-Lyrique, Paris. With choreography by Bronislava Nijinska, designs by Natalia Goncharova, and the lead role filled by Felia Doubrovska, *Les Noces* was an immediate success.

The theme of *Les Noces* is a traditional Russian peasant wedding—the consecration of the bride, the consecration of the bridegroom, the leave-taking of the bride, and the wedding celebration—a theme that was especially meaningful to Stravinsky after his fateful meeting

with Vera in 1921. This is clear both from the overt narrative and from Stravinsky's more covert instruction at the head of the page, "Pronounce 'e' as 'ie' *everywhere*," wherein the assumed reference is the Russian word "iebla" (fuck). However, the connection between this bawdy dedication and the rather Dada "accident d'automobile" remains perplexing. The reference to Kuznetsova is to the opera singer Mariia Nikolaevna Kuznetsova (Marie Kousnezoff, 1880–

1966), a frequent performer at the Paris Opéra and in 1928 the founder of the Opéra Privé de Paris, for which many Russian musicians and designers worked.

Reproduced in V. Stravinsky and R. McCaffrey, eds., *Igor and Vera Stravinsky: A Photograph Album, 1921 to 1971* (London: Thames and Hudson, 1982), p. 52. The preceding Kochno and Stravinsky dedication, S4, is directly related to this entry.

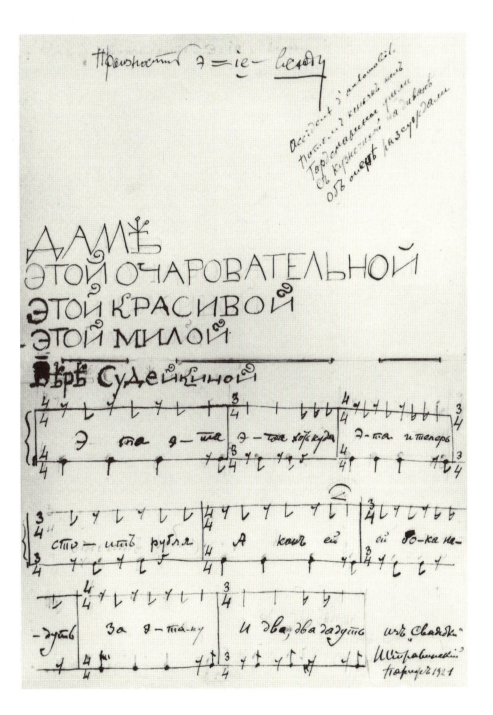

BIBLIOGRAPHY

Abashidze, I., et al., eds. *Letopis druzhby gruzinskago i russkogo narodov.* 2 vols. Tbilisi: Literatura da Khelovneva, 1967.

Afanasyan, S. *L'Arménie, L'Azerbaidjan et La Géorgie de l'indépendance à l'instauration du pouvoir soviétique (1917–1923).* Paris: L'Harmattan, 1981.

Alexeev, A., et al., eds. *Russkiaa khudozhestvennaia kultura kontsa XIX–nachala XX veka.* 4 vols. Moscow: Nauka, 1968–80.

Les Ballets Russes de Serge Diaghilev, 1909–1929. Exhibition catalog, Conseil de l'Europe. Strasbourg, 1969.

Bechhofer, C. *In Denikin's Russia and in the Caucasus, 1919–1920.* London: Collins, 1921. Reprint. New York: Arno Press, 1971.

Beridze, V., and N. Ezerskaia. *Iskusstvo Sovetskoi Gruzii.* Moscow: Sovetskii khudozhnik, 1975.

Beridze, V., et al. *David Kakabadze.* Moscow: Sovetskii khudozhnik, 1989.

Beyssac, M. *La Vie Culturelle de l'Emigration Russe en France. Chronique (1920–1930).* Paris, 1971.

Bogomolov, N. *Materialy k bibliografii russkikh literaturno-khudozhestvennykh almanakhov i sbornikov.* Moscow: Lanterna-Vita, 1994.

Bowlt, J. *The Russian Silver Age: Russian Art of the Early Twentieth Century and the "World of Art" Group.* Newtonville, Mass.: Oriental Research Partners, 1979.

———. *Scenic Innovation: Russian Stage Design, 1900–1930, from the Collection of Mr. and Mrs. Nikita D. Lobanov-Rostovsky.* Jackson: Mississippi Museum of Art, 1982.

———. *Sobranie Nikity i Niny Lobanovykh-Rostovskikh. Khudozhniki russkogo teatra. Katalog-rezone.* Moscow: Iskusstvo, 1994.

Buckle, R. *Diaghilev.* London: Weidenfeld and Nicolson, 1979.

Bulgakov, V. *Slovar russkikh zarubezhnykh pisatelei.* New York: Ross, 1993.

Butkovsky-Hewitt, A. *With Gurdjieff in St. Petersburg and Paris.* London: Routledge and Kegan Paul, 1978.

Butorina, E., et al., eds. *Vystavki sovetskogo izobrazitelnogo iskusstva. Spravochnik.* 4 vols. covering 1917–53; ongoing series. Moscow: Sovetskii khudozhnik, 1965–75.

Craft, R., ed. *Dearest Babushkin: The Correspondence of Vera and Igor Stravinsky, 1921–1954, with Excerpts from Vera Stravinsky's Diaries, 1922–1971.* London: Thames and Hudson, 1985.

———. *Stravinsky: Selected Correspondence.* Vol. 1. New York: Knopf, 1982.

———. *A Stravinsky Scrapbook.* London: Thames and Hudson, 1983.

De Hartmann, T., and O. de Hartmann. *Our Life with Mr. Gurdjieff.* San Francisco: Harper and Row, 1983.

Diachkov, L., ed. *I. F. Stravinsky. Stati i materialy.* Moscow: Sovetskii kompozitor, 1973.

Diaghilev: Les Ballets Russes. Exhibition catalog, Bibliothèque Nationale. Paris, 1979.

Douglas Clayton, J. *Pierrot in Petrograd.* Montreal and Kingston: McGill-Queen's University Press, 1994.

Dzutsova, I., and N. Elizbarashvili. "S. Yu. Sudeikin v Gruzii." In I. Antonova et al., eds., *Muzei,* no. 1 (Moscow: Sovetskii khudozhnik, 1980): 23–26.

Ezerskaia, N., et al., eds. *Iskusstvo sovetskogo Azerbaizhana.* Moscow: Sovetskii khudozhnik, 1970.

Flaker, A., ed. *Glossarium der russischen Avantgarde.* Graz: Droschl, 1989.

Fleishman, L., R. Khiuz, and O. Raevskaia-Khiuz. *Russkii Berlin, 1921–1923.* Paris: YMCA, 1983.

Foster, L. *Bibliografiia russkoi zarubezhnoi literatury, 1918–1968.* Boston: Hall, 1970.

Gagua, L., ed. *Lado Gudiashvili. Kniga vospominanii. Stati. Iz perepiski. Sovremenniki o khudozhnike.* Moscow: Sovetskii khudozhnik, 1987.

Gladkova, T., et al., eds. *L'Emigration Russe: Revues et Recueils, 1920–1980. Index Général des Articles.* Paris: Institut d'Etudes Slaves, 1988.

Godeladze, E. *Iskusstvo gruzinskogo naroda.* Moscow and Leningrad: Iskusstvo, 1937.

Golynets, S., ed. *Ivan Yakovlevich Bilibin. Stati. Pisma. Vospominaniia o khudozhnike.* Leningrad: Khudozhnik RSFSR, 1970.

Gray, C. *The Great Experiment: Russian Art, 1863–1922.* London: Thames and Hudson, 1962. Reprinted as *The Russian Experiment in Art, 1863–1922.* London: Thames and Hudson, 1970. Rev. ed. London: Thames and Hudson, 1986.

Gregor, J., and R. Fülöp-Miller. *Das Russische Theater.* Vienna: Amalthea, 1927. Translated into English as *The Russian Theatre.* London: Harrap, 1930. American ed. New York: Blom, 1968. Translated into Spanish as *El teatro ruso.* Barcelona: Gili, 1931.

Grigorovich, Yu., ed. *Balet. Entsiklopediia.* Moscow: Sovetskaia entsiklopediia, 1981.

Grishashvili, I. *Literaturnaia bogema starogo Tiflis.* Tiflis: Gruzgosizdat, 1928.

Guenther, J. von. *Ein Leben im Ostwind. Zwischen Petersburg und München.* Munich: Biederstein, 1969.

Ho, A., and D. Feofanov. *Biographical Dictionary of Russian and Soviet Composers.* New York: Greenwood, 1989.

Igor Stravinsky. La carrière européenne. Exhibition catalog, Musée d'art moderne de la ville de Paris and other institutions. Paris, 1980–82.

Iliazd. Exhibition catalog, Centre Georges Pompidou. Paris, 1978.

Iliazd: Maître d'oeuvre du livre moderne. Exhibition catalog, Galerie d'art de l'Université de Québec. Montreal, 1984.

Ivanov, G. *Peterburgskie zimy.* New York: Chekhov, 1952.

Ivanova, L. *Vospominaniia. Kniga ob otse.* Moscow: Kultura, 1992.

Janecek, G. *The Look of Russian Literature.* Princeton: Princeton University Press, 1984.

Johnston, R. H. *New Mecca, New Babylon: Paris and the Russian Exiles, 1920–1945.* Montreal: McGill-Queens University Press, 1988.

Kazemzadeh, F. *The Struggle for Transcaucasia (1917–1921).* New York: Philosophical Library, 1951.

Kennedy, J. *The "Mir iskusstva" Group and Russian Art, 1898–1912.* New York: Garland, 1977.

Kirill Zdanevich and Cubo-Futurism: Tiflis, 1918–1920. Exhibition catalog, Rachel Adler Gallery. New York, 1987.

Kobaladze, T. *Lado Gudiashvili. Tainstvo krasoty.* Tbilisi: Merani, 1988.

Kogan, D. *Sergei Sudeikin.* Moscow: Iskusstvo, 1974.

Konechnyi, A., V. Morderer, A. Parnis, and R. Timenchik. "Artisticheskoe kabare 'Prival komediantov.'" In *Pamiatniki kultury. Novye otkrytiia. Ezhegodnik 1988,* pp. 96–154. Moscow: Nauka, 1989.

Kovalevsky, P. *Zarubezhnaia Rossiia.* 2 vols. Paris: Librairie des Cinq Continents, 1971–73.

Kreid, V., ed. *Vospominaniia o serebrianom veke.* Moscow: Respublika, 1913.

Kuliev, N., ed. *Istoriia Azerbaidzhana.* Baku: ELM, 1970.

Lapshina, N. *Mir iskusstva.* Moscow: Iskusstvo, 1977.

Lehmann, J. *Prometheus and the Bolsheviks.* New York: Knopf, n.d.

Livshits, B. *Polutoraglazyi strelets.* Leningrad: Izdatelstvo pisatelei, 1933. New ed., ed. L. Nikolaeva, A. Parnis, et al., Leningrad: Sovetskii pisatel, 1989. Translated by J. Bowlt into English as *The One and a Half–Eyed Archer.* Newtonville, Mass.: Oriental Research Partners, 1977.

Long, D. Marshall. *A Modern History of Georgia.* London: Weidenfeld and Nicolson, 1962.

Lvov (Lwoff), L. *Russkie khudozhniki v Parizhe/L'Art Russe à Paris*. Paris: La Russie et le Monde Slave, 1931.

Magarotto, L., and G. Scarcia, eds. *Georgica II. Materiali sulla Georgia Occidentale*. Bologna: Il Cavaliere Azzurro, 1988.

Magarotto, L., M. Marzaduri, and G. Pagani Cesa. *L'avanguardia a Tiflis*. Venice: Seminario di Iranistica, Uralo-Altaistica e Caucasologia dell'Università degli Studi di Venezia, 1982.

Makovsky, S. *Na parnase serebriannogo veka*. Munich: Tsentralnoe obedinenie politicheskikh emigrantov iz SSSR, 1962.

Marzaduri, M. *Dada Russo*. Bologna: Caviliere azzurro, 1984.

———, ed. *Igor Terentiev. Sobranie sochinenii*. Bologna: S. Francesco, 1988.

Melnikovoi. Fantasticheskii kabachok. Tiflis, 1919. (The contents of this almanac, or miscellany, reflected the activities of writers and artists such as Lado Gudiashvili, Alexei Kruchenykh, Grigorii Robakadze, Igor Terentiev, and the Zdanevich brothers at the Fantastic Tavern cabaret in Tiflis for 1917–19. It was preceded by a first volume that was published in 1918 but not put on sale, which is referred to in the main text as *Fantasticheskii kabachok*, no. 1.

Mochulsky, S., et al., eds. *Teatralanaia entsiklopedia*. 5 vols. Moscow: Sovetskaia entsiklopediia, 1961–67.

Moskvin, G. Assorted guides to South Russia, the Caucasus, and the Black Sea, especially *Prakticheskii putevoditel po Kavkazu*. Odessa: Levinson, 1899; and *Putevoditel po Chernomorskomu Poberezhiu*. Petrograd: Redaktsiia Putevoditelei, 1915.

Nicolas Evreinoff, 1873–1953. Exhibition catalog, Bibliothèque Nationale. Paris, 1981.

Nikolaev, P., et al., eds. *Russkie pisateli, 1800–1917. Biograficheskii slovar*. 3 vols. Moscow: Sovetskaia entsiklopediia. Vol. 1, 1989. Vol. 2, 1992. Vol. 3, 1994.

Nikolskaia, T. "Fantasticheskii kabachok." *Literaturnaia Gruziia*, no. 11 (Tbilisi, 1980): 208–12.

———. "Russian Writers in Georgia in 1917–1921." In *The Ardis Anthology of Russian Futurism*, ed. C. Proffer, pp. 295–326. Ann Arbor: Ardis, 1980.

100 Years of Russian Art, 1889–1989, from Private Collections in the USSR. Exhibition catalog, Barbican Gallery, London; and Museum of Modern Art, Oxford, 1989.

Ossorguine-Bakounine, T. *L'émigration russe en Europe. Catalogue collectif des périodiques en langue russe 1855–1944*. Paris: Bibliothèque russe de l'Insitut d'études slaves, 1976.

Parnis, A., and R. Timenchik. "Programmy 'Brodiachei sobaki.'" In *Pamiatniki kultury. Novye otkrytiia. Ezhegodnik 1983*, pp. 160–257. Leningrad: Nauka, 1985.

Pasler, J., ed. *Confronting Stravinsky*. Berkeley and Los Angeles: University of California Press, 1986.

Piast, V. *Vstrechi*. Moscow: Federatsiia, 1929.

Protazanov, Ya. *O tvorcheskom puti rezhissera*. Moscow: Iskusstvo, 1957.

Raeff, M. *Russia Abroad: A Cultural History of the Russian Emigration, 1919–1938*. New York: Oxford University Press 1990.

Reisner, I. *Georgia*. Freiburg, 1989. French ed. *La Géorgie*. Turnhout, Belgium, 1990.

Rempel, L. *Zhivopis sovetskogo Zakavkazia*. Moscow-Leningrad: Ogiz-Izogiz, 1932.

Rudnitsky, K. *Russian and Soviet Theatre*. New York: Abrams, 1988.

Schouvaloff, A., and V. Borovsky. *Stravinsky on Stage*. London: Stainer and Bell, 1982.

Sciltian, G. *Mia avventura*. Milan: Rizzoli, 1963.

Severiukhin, D., and O. Leikind. *Khudozhniki russkoi emigratsii*. St. Petersburg: Chernyshev, 1994.

Shukman, H., ed. *The Blackwell Encyclopedia of the Russian Revolution*. Oxford: Blackwell, 1988.

Stravinsky, I. *An Autobiography*. New York: Norton, 1962.

———. *Dialogi. Vospominaniia. Razmyshleniia. Kommentarii*. Leningrad: Sovetskii kompozitor, 1971.

———, and R. Craft. *Conversations with Stravinsky*. Berkeley and Los Angeles: University of California Press, 1980.

———. *Dialogues*. Berkeley and Los Angeles: University of California Press, 1982.

———. *Expositions and Developments*. Berkeley and Los Angeles: University of California Press, 1981.

———. *Memories and Commentaries*. Berkeley and Los Angeles: University of California Press, 1981.

———. *Stravinsky in Pictures and Documents*. New York: Simon and Schuster, 1978.

———. *Themes and Conclusions*. Berkeley and Los Angeles: University of California Press, 1981.

Stravinsky, V., and R. McCaffrey, eds. *Igor and Vera Stravinsky: A Photograph Album, 1921 to 1971*. London: Thames and Hudson, 1982.

Stravinsky and the Dance. Exhibition catalog, New York Public Library. New York, 1962.

Stravinsky and the Theatre. Exhibition catalog, New York Public Library. New York, 1963.

Stravinsky-Diaghilev. Exhibition catalog, Cordier and Ekstrom Gallery. New York, 1973.

Strawinsky. Sein Nachlass. Sein Bild. Exhibition catalog, Kunstmuseum. Basel, 1984.

Suny, R. *The Making of the Georgian Nation*. Bloomington: University of Indiana Press, 1988.

Surkov, A., ed. *Kratkaia literaturnaia entsiklopediia*. 9 vols. Moscow: Sovetskaia entsiklopediia, 1962–78.

Terras, V., ed. *Handbook of Russian Literature*. New Haven: Yale University Press, 1985.

Varunets, V., ed. *I. Stravinsky. Publitsist i sobesednik*. Moscow: Sovetskii kompozitor, 1988.

Vershinina, I. *Rannie balety Stravinskogo*. Moscow: Nauka, 1967.

Voltsenburg, O., et al., eds. *Khudozhniki narodov SSSR. Biobibliograficheskii slovar v shesti tomakh*. 6 anticipated vols.; 2 vols. still forthcoming. Moscow: Iskusstvo, 1970–84.

Vrangel, L. *Vospomoninaniia i starodavnie vremena*. Washington, D.C.: Kamkin, 1964.

Yufit, A., et al., eds. *Sovetskii teatr. Dokumenty i materialy, 1917–1967*. 4 vols. Leningrad: Iskusstvo, 1968–84.

Zilbershtein, I., and V. Samkov. *Sergei Diaghilev. Literaturnoe nasledie. Perepiska. Vospominaniia sovremennikov*. Moscow: Izobrazitelnoe iskusstvo, 1982.

Znosko-Borovsky, E. *Russkii teatr nachala XX veka*. Prague: Plamia, 1925.

The following periodicals also contain important information about the Sudeikins' Petrograd-Moscow-Crimea-Tiflis-Baku-Paris cultural itinerary in 1917–20.

Almanac: Russian Artists in America, no. 1. New York: Martianoff, 1932. (No longer published)

Apollon. St. Petersburg, 1909–17 (= 1918).

Ars. Tiflis, 1918–19.

Bratstvo. Tiflis, 1920.

Chisla. Paris, 1930–34.

Feniks. Tiflis, 1918–19.

Figaro. Tiflis, 1920–21.

Illustrirovannaia Rossiia. Paris, 1924–39.

Iskusstvo. Baku, 1920–21.

Kuranty. Tiflis, 1918–19.

Mir i iskusstvo/Le Monde et l'Art. Paris, 1930–31.

Novyi zhurnal. New York, 1942 to date.

Orion. Tiflis, 1919.

Parus. Baku, 1919–20.

Perezvony. Riga, 1925–28.

Skarabei. Tiflis, 1921.

Teatr i zhizn/Theater und Leben. Berlin, 1921–22.

Theatr/Das Theater/Le Théâtre. Berlin, 1921–23.

Le Théâtre et la vie/Teatr i zhizn. Paris, 1929–32.

Zhar-ptitsa/Jar-ptitza. Berlin and Paris, 1921–26. (Contains summaries in French, German, and English)

INDEXES

GENERAL INDEX

Abashidze, I., 71
Abramtsevo, 4
Académie de la Grande Chaumière, 51
Academy of Arts (Kraców), 35
Academy of Arts (St. Petersburg), 4, 25, 51–52, 55, 66
Academy of Arts (Tiflis), 11, 21, 46, 68
Academy of Fine Art (Santiago), 52
Academy of Verse, 35–36, 68
Adamovich, G., 21–22, 67, 79
Afanasiev, I., 92
Aivazovsky, I., xix, 71–72
Akhmatova, A., xiv, 29, 37, 41, 69–70
Albrekht, A., 32
Alexander I, 12
Alexandrinsky Theater, 70
Alhambra Theater, xxv, 15, 37
Allen, E., 97
Aloizi Theater, 60, 85
Altman, M., 7–8, 35–36, 85
Altman, N., xii
Alupka, xxviii–xxix, 4, 15, 29, 43, 51, 79, 82, 96
Alupka Palace Museum, xxviii
Alushta, vii–viii, 11, 20, 28, 38–39, 41, 75–76, 97
Andreev, V., 5
Andronnikova, S., 40–41, 57–58, 72
Andzhaparidze, G., xxix
Anichkov, E., 3
Anikst, M., 66
Anisimov, I., 52
Annenkov, Yu., 24, 60–61, 70
Anona Restaurant, xxii
Antique Theater, 60
Antonova, I., 96
Apollon, xi, xix, xxviii, 5, 14, 25, 39, 52, 70, 93–94
Archipenko, A., 55
Architectural Institute, 25
Arelsky, G., 33
Argus, 57
Arnshtam, A., 60
Ars, xxi, xxviii, 8, 10, 21, 36, 41, 43–44, 50
Art Bureau, xxvii
"Art Exhibition Dedicated to Twenty Years since the Liberation of the Crimea from the White Guards," 43
"Art in the Crimea," xviii, xix, xxviii, 4, 9–10, 15, 18, 28, 30, 43, 52, 65–66, 79, 83, 88, 94
Artistic Society of Tiflis, 44
"Art of the Soviet Crimea," 43
"Artists of the RSFSR over the Last XV Years," 70
Art School (Baku), 63
Association of United Artists, xviii, 4, 9
Auslender, S., xiv

Azerbaijan Polytechnic Institute, 36
Azerbaijan State University, xxiv, 8

Bakst, L., xviii, xix, 23, 37–38, 40, 51, 73, 83
Baku, vii–ix, xii–xiii, xix, xxiii–xxv, xxvii–xxviii, 4, 6–10, 12, 15, 17, 21–22, 32, 36, 41, 44, 46, 49–50, 55, 58–60, 63–64, 67, 72–73, 75, 77–81, 84–86, 88, 90
Baku Art Studio, xxiv
Baku Worker's Theater. *See* Satire-Agit Theater
Balanchine, G., 4, 15, 38
Baliev, N., xiii, xxvii, 4, 24, 85
Ballets Russes, xv, xxiii, xxv, 15, 18, 37–38, 83
Balmont, K., vii–ix, xii–xiv, xxiii, xxvii, 3, 50, 72, 77, 89, 93
Baratynsky, E. *See* Boratynsky, E.
Barbican Gallery, 4, 70
Barbusse, H., 73
Bariatinskaia, M., 42–43
Barnov, V., xxiii
Barricades, 45
Barsheva, N., 82
Bart, V., 57
Bashchenko, R., 43
Bat (cabaret), xiii, xxvii, 84–85
Batum, vii, ix, xi, xix–xx, xxiii, xxviii, 4, 6, 8–9, 15, 23, 26, 34, 39, 42, 46, 55, 57, 73, 76, 80–81, 86, 90
Baudelaire, C., xiv, xxii, 61
Bazhbeuk-Melikov, A., 34, 56
Beardsley, A., 23, 40, 68
Beaumarchais, P., xv, 17
Bechhofer, C., xxv, xxix, 46, 73, 86, 91
Beck, C., 48
Belenson, A., 60
Belgian Ministry of Arts and Sciences, xix
Beliaev, Yu., 13, 69–70
Belkin, V., xiv, 25, 33–34, 85
Belkina, V., 25
Belokopytova, A., xviii, 53
Bely, A. (pseudonym of B. Bugaev), xxii, 5, 33, 35, 41, 69–70, 77, 85, 93
Benois, Albert, 48, 79, 92
Benois, Alexandre, viii, 5, 9, 30, 34, 51, 73, 85
Berlin University, xv, 15
Berman, E., 15
Beskrovnoe ubiistvo, 56–57
Bi-Ba-Bo (cabaret), xiii
Bilibin, I., vii, xii, xvii–xviii, xxviii, 27–30, 54, 73
Birzhevye vedomosti, 24
Blavatskaia, E., 30
Blok, A., 5, 7, 14, 20, 33, 66–67, 69–70, 76–78, 85, 87, 91, 93
Blue Bird (cabaret), 6
Blue Horns, xxi–xxii, xxv, xxviii, 21, 23, 38, 40, 45, 61, 71–72, 76, 86
"Blue Rose," 4

Boat of the Argonauts (café), xxi, xxiii, 9, 55, 95
Boberman, V., 6–7, 60
Bocharov, S., 60
Bogaevsky, K., 93–94
Bogomolov, N., 67
Boll, A., xiii, xxvii
Bolm, A., 38, 79
Bolshoi Theater, 51, 66
Bolshakov Art School, 25
Boratynsky (Baratynsky), E., 49
Borovikovsky, L., xix
Bosset, A., 15
Bosset, H., 15
Botticelli, S., 13
Bowlt, J., xxvii, xxviii, xxix, 14, 24, 29, 31, 57, 72, 81, 97
Brailovskaia, R., xvii, xix, 14–15, 29–30, 32, 65–66, 81, 95
Brailovsky, L., xvii–xviii, xix, 14, 28–30, 32, 43, 65–66, 74
Bratstvo, 7, 10
Brik, L., 61
Briullov, K., xix
Briusov, V., 7, 77, 93
Brooklyn Museum, xxiii, 4, 9, 18, 24, 52
Brumfield, W., 67
Bruni, L., 3, 39
Bruni-Balmont, N., 3, 39
Briusov, V., 3
Buchinskaia, N., xxvii
Buckle, R., 38
Bulgakov, M., 77
Bulgakov, S., 30
Bulgakov, V., 67
Burliuk, D., xx, xxix, 6, 12, 26, 42, 66
Burtsev, A., 51, 92
Butkovskaia, N., 85
Butkovsky-Hewitt, A., 86

Caesar, J., 42
Café Caméléon, 63, 79, 91
Café International, 86
Café Voltaire, xxi
Caucasus (club), 4
Cellar of Fallen Angels (cabaret), 4
Centre Georges Pompidou, 73
Cézanne, P., 28, 34
Chaadaev, P., 41
Chachikov, A., 8, 20, 26, 91
Chagall, M., xii, 95
Chaliapin, F., 33
Chamber of Poets, 4, 11, 24, 48, 57, 63, 79, 91
Chamber Theater, xv, 4, 15, 17, 30
Charchoune, S., 55, 63, 79, 91–92
Chauve-Souris (cabaret), xiii, xxvi–xxvii, 4, 24
Chavchavadze, A., 86
Chebotarevskaia, A., 70, 77
Chekhonin, S., xiii
Chekhov, A., 32–33, 52, 54, 66, 86
Chekhov Museum, Yalta, 33, 54
Chekhova, M., 52
Cherepnin, A., xxi, xxiii, xxix, 6, 48, 63, 65
Cherepnin, I., 48
Cherepnin, N., xxi, xxix, 30, 44, 48

Cherepnina, M., 48
Chernevich, E., 66
Cherniavsky, M., 67
Cherniavsky, N., xxi, xxix, 35, 45–47, 55, 57 68
Chikovani, S., xxiii
Chirikova, L., 28–29
Chirikovo-Ulianisheva, V., 54
Cholokashvili, M., 11
Chopin, F., 30
Chukovsky, K., 67, 70
Clayton, J., 85
Comedians' Halt (cabaret), xiii–xvi, xxi–xxii, xxviii, 4–5, 9, 13–15, 21–22, 25–26, 29, 33–34, 51–53, 61, 64, 69–71, 78–79, 85, 88, 95
Commission for the Preservation of Artistic Treasures of the Crimea, 28
Connolly, J., 3
Conservatory (Tiflis), xxi–xxii
Copeau, J., 85
"Contemporary Painting," 66
Cornish School, 33
Covent Garden, 48
Craft Institute, 46
Craft, R., x, xv, xvii–xviii, xxii, xxv–xxix, 15, 17, 18, 38–39, 70–71, 78, 81, 83, 88, 92
"Crimson Rose," 4
Crooked Mirror (cabaret), 60

Dadiani, E., 9–10, 81
Davidovskaia, D., 52
Davydov, Z., 93
Davydova, M., 44
Debua, A., 78
Debussy, C., 14, 70, 83
Degen, K., 20–21, 26, 45, 47–49
Degen, Yu., vii, ix, xi–xii, xxi–xxii, xxiv–xxv, xxviii–ix, 11, 14, 17, 19–25, 44, 47–49, 55–56, 58, 61, 63–64, 66–69, 73–74, 79–80, 85, 91, 95
Dejevsky, N., xxviii
Delaunay, S., xxvii
Delibes, L., 64
Della-Vos-Kardovskaia, O., xi, xxvii
Denikin, A., xxiv, xxix, 73, 86, 91
Derain, A., 23
Deriuzhinsky, G., 30, 53
Deschartes, O., 50, 78
Diaghilev, S., xiii–xv, xix, xxii–xxiii, xxv–xxvi, 4, 15, 28, 37–38, 83–85
Dix, O., 51
Dobrokovsky, M., xxiv
Dobryi, A., 67
Dobujinsky, M. xix, 33, 51, 79, 85
Dobychina, N., xi–xii, xxvii, 70
Dolin, A., 37
Dolgushin, Yu., 47, 49
"Donkey's Tail," 55
Dowager Empress, 42
Dreaming Gazelles, xxii, 72
Drizen, N., 60
Drozdov, A., 33, 79, 82
Drozdov, V., 18, 96
Dudakov, V., xiv, 4
Duganov, R., 50, 78
Duncan, I., 97
Duze, E., 9

D.W., viii, 97
Dzutsova, I., xxix, 24, 56, 65, 72

Ecclesiastical Institute, 40
Efros, N., 85
Eganbiuri, E., 56
Ehrenburg, I., 44
Eidelman, N., xxviii
Elin, A. (pseudonym of A. Kruchenykh), xxix
Elizbarashvili, N., xxix, 65
Enisherlov, V., 8
Erlikh, R., 15
Ermolaeva, V., 56–57
Ermolinsky, S., 77
Erté (pseudonym of R. Tirtoff), 23
Esenin, S., 67
Esikovsky Brothers Circus, 73
Essen, S., 14
Evangulov, G., xii, 49, 62–64, 79, 90–91
Evreinov, N., vii, xiv, xix, xxiii, 6, 12, 21, 44, 47–48, 53, 59–61, 64, 83–86, 95
Evzlin, M., 91
"Exhibition of the Armenian Artists," 48
"Exhibition of Contemporary Art," 43
"Exhibition of Georgian Artists," 72
"Exhibition of Georgian Painting (Painters)," xxi, xxix, 23, 45–46, 48, 95
"Exhibition of Icon Painting and Artistic Antiquities," 27
"Exhibition of Painting," 54
"Exhibition of Paintings and Drawings by Moscow Futurists," xxi, xxviii
"Exhibition of Paintings by Moscow Futurists," 68
"Exhibition of Paintings by Petrograd Artists of All Directions, 1919–1923," 70
"Exhibition of Paintings by Young Artists," 25
"Exhibition of Portrait Sketches of Tiflis Beauties," xxi
"Exhibition of Russian Painting and Sculpture," xxiii, 4, 9, 18, 24, 52
"Exposition Internationale Universelle," xix
"Exposition des oeuvres des artistes russes," xxiii
Exter, A., 5

Fainberg, A., xii, 10, 74–75, 81
Falk, R., 54
Fantastic Tavern (cabaret and publications), xiii, xxi–xxiii, xxviii–xxix, 6, 20–23, 26, 33–36, 38, 40–41, 45–49, 55, 57–59, 61–63, 68–69, 73–74, 84
Feniks, xxii, 14, 21, 23–24, 49, 55–56, 61–63, 68, 95
Feofilaktov, N., 11
Figaro, 76
Figaro, Le, 24
Filippov, B., 39, 75–76, 93–94
Filonov, P., 69
Fioravanti, A., 76
"First Exhibition of Georgian Artists." See "Exhibition of Georgian Painting"
"First Exhibition of Paintings and Sculpture by the Association of United Artists," xviii, 4, 9, 28, 43, 53, 65–66
Fledermaus, xiii
Fleishman, L., 63, 78
Florenskaia, R., xxiii
Florensky, P., xxiii
Fokine, M., 9, 15
Fonvizin, D., 86
Fort, P., xiv
41° (group and publication), xxi, xxiv, xxviii, xxix, 12, 35, 44, 46–47, 55–59, 62, 68–69, 73, 91
Foster, S., xxix

France, A., 14, 93
Franklin, B., 35
Fraternal Consolation (café), xxi
Freud, S., 35–36, 68, 74

Gagua, L., xxix, 7, 24, 72, 96
Galerie Bernheim Jeune, xix
Galerie d'art de l'Université de Québec, xxix, 58
Galerie La Licorne, 58
Galichenko, A., 29, 31
Gamrekeli, I., 55
Gaprindashvili, V., xxii, 45
Gayraud, R., xxx, 47
Gazeta futuristov, 6
Golos Kavkaza, 26
Gerasimov, M., xxiv, 63–64, 90
Gibian, G., 87
Gints, S., 7
Girshman, G., xi–xii, xxvii
Girshman, V., xxvii
Giurdzhiev, G., xxi, xxviii, 30, 35, 55, 68, 86
Glazunov, A., 18
Glebova, O., xiv–xvi, xxvii–xxviii, 4–5, 13–15, 18, 22, 31, 33, 47, 69–71, 78, 85, 87, 95
Godunov, B., 28
Gogol, N., 68
Golovin, A., 83
Golynets, S., xxviii, 29, 54
Goncharova, N., xx, xxviii, 5, 55, 57–58, 92
Gorky, M., 28
Gorodetsky, S., vii–viii, ix, xi–xiv, xix, xxi, xxiii–xxv, xxviii–xxix, 3, 6–8, 10–12, 18–21, 24–26, 29, 43–44, 46, 48–50, 55, 58–59, 61, 63, 66, 68, 72–73, 77–78, 80, 84–86, 93
Gourjiev, G. See Giurdzhiev, G.
Goya, F., 34
Granovsky, N., 58
Grebenshchikov, G., 51–52
Green Lampshade (cabaret), xiii
Green, M., 14
Greuze, J., xix
Grif, 46
Grigorieff, C., 52
Grigoriev, B., vii, ix, xii–xv, xix, 25, 51–52, 60, 75, 79, 82–83, 91
Grosz, G., 51
Gudiashvili, L., vii, ix, xiii, xxi–xxiii, xxv, xxix, 7, 23–24, 34–35, 45–46, 55, 57, 61, 63, 71–72, 92, 95–96
Gudiashvili, V., 24
Gudien, V., 56
Guild of Poets, xxi, xxviii, 8, 10–11, 20–21, 26, 39, 48, 55, 58, 61, 63, 75, 78–79, 86
Gumiliev, N., 39, 72, 93
Gurdjieff, G. See Giurdzhiev, G.
Gurianova, N., 58, 73
Guro, E., 85
Gutenberg, J., 42

Harini, Verina, 74
Harini, Victoria, 74
Hartmann, O. de, xxix
Hartmann, T. von, xxi, xxix, 30, 48
Haskell, Colonel, 90

Hauberk, xxi, xxviii, 21–22, 26, 47–49, 58, 61, 63, 68
Haus der Künste, 11, 57, 63
Higher Art-Industrial Institute, 25
Higher Art Institute of the Academy of Arts, 28, 51
Hitler, A., 40–41
Hoffman, E., xxviii, 19, 22, 28, 64
Hsien, L., 48
Hughes, R., 63, 78
H₂SO₄ (group and publication), xxiii, xxix, 47

Ibsen, H., 32
Illiustrirovannaia Rossiia, 54, 69, 71, 79
Imperial Musical Society, 29–30
Imperial Theater, xxii
Institute of Modern Russian Culture, xv, xviii
Imredí Restaurant, xxi–xxii
Institute for the Comparative Study of Literatures and Languages of the West
 and East, 8
Institute for the Harmonious Development of Man, xxi, 55, 68, 86
Institute of St. Nina (Baku), xxiv
Institute of St. Nina (Tiflis), 12
"International Exhibition of Paintings, Sculpture, Engraving, and Drawings," 66
Isaak Brodsky Museum, 82
Iskusstvo, xxiv, xxix, 4, 6–8, 61, 77–78
Ivanov, D., 50, 78
Ivanov, G., xxix, 4, 10, 13–14, 20–22, 33, 39, 50, 52, 67, 70, 78–79, 85
Ivanov, V., ix, xxiv, 7–8, 13–14, 17, 30, 39, 50, 76–77, 80, 85
Ivanova, L., 9
Ivnev, R., xxiv–xxv, 6, 14, 21, 23, 66–67
Izdebsky, V., 66
Izvestiia, 49

Jacobson, H., 33
Jacovleff, A., xvi, 51–52
Janecek, G., xxviii–xxix
Jaquier, J., 31, 42, 52
Juschny, J., 6

Kagan, M., 72
Kaiser Wilhelm, 35
Kakabadze, D., xxi–xxiii, 23, 45, 55, 63, 92
Kalmakov, N., 40, 85
Kamenskaia, S., 71
Kamensky, V., ix, xi–xii, xix, xxi, xxiii–xxiv, xxviii–xxix, 5–7, 12, 44, 55, 60, 66–
 67, 71–75, 96–97
Kamsky, Ya., 48–49
Kancheli, A., xxi, xxix, 38
Kandinsky, V., xxix
Kara-Darvish (pseudonym of A. Gendzhian), xxi, 6, 40–41, 56, 76–77
Kardovsky, D., xxvii, 51
Karsavina, T., xiv
Kashina, A., 60
Kashuro, M., xiv
Katanian, V., 6–7, 22–23, 34–35, 55, 60–62, 71
Kavelin, K., 26
Kavkazskaia rampa, 44
Kavkazskoe slovo, xxviii, 19, 21, 48, 50
Kazemzadeh, F., xxviii, xxix
Keilikhis, Ya., xxiv
Kelly, L., xxviii

Kerdimun, B., xxviii
Kerensky, A., xxv, 46, 86
Ketchian, S., 3
Kharazov, G., 8, 35–36, 40–42, 68, 71, 74
Khimerioni (cabaret), xxi–xxiii, xxviii, 6, 23, 34–35, 38, 40, 45–46, 55, 61, 72, 86,
 95–96
Khlebnikov, V., xxiv, xxix, 6, 8, 58–59, 69, 78
Kholmskaia, Z., 60
Khotiaintseva, A., 31, 52
Khudozhestvennyi trud, 70
Khundadze, T., 73
Khundadze, V., 73
Khutsishvili, G., xxviii
Kiev Art Institute, 30
Kiev Conservatory, 30
Kiev University, 29–30
Kiki Palmer Theater Company, 44
Kikodze, G., 45, 47, 55
Kirov, S., xx
Kiselev, A., 51
Kniazev, V., 70, 87
Knipper, O., 33
Kobaladze, T., xxix, 46, 96
Kochergin, N., xxiv
Kochno, B., vii, ix, xii, xxv, xxvii, xxix, 36–38, 85, 98
Kogan, D., xxvii–xxviii, 5, 7, 14, 18, 34, 64, 70, 78, 92
Koktebel, 93
Koltsov, S., 85
Komissarzhevskaia, V., 60, 70, 85, 93
Komissarzhevsky, F., 85
Konchalovsky, P., 54
Konechnyi, A., xxvii–xxviii, 4
Koreneva, L., 32–33
Korneev, B., xxii, 6, 11, 21, 23, 61, 66, 68
Kornilova, A., xxvii
Korona, S., xxi 12, 21–22, 34, 44, 48
Korovin, K., 4, 30
Koshelev, V., 33
Kostandi, K., 9
Kotliareva, Z., 78
Kousnezoff, M., 61
Kovtun, E., 35
Kozlova, Yu., xxvii
Krandievskaia, N., 38, 79, 88–89
Kreid, V., 81
Krein, A., 15
Kruchenykh, A., ix, xx–xxii, xxiv–xxv, xxviii–xxix, 6, 8, 11–12, 20–21, 23, 26, 33,
 35, 44, 46–47, 55–59, 68, 73–74, 77, 85
Kruglikova, E., 79
Krysodav, 68
Kugel, A., 60
Kulbin, N., xiv, xx, 3, 25, 30, 60
Kuleshova, V., xxviii
Kuranty, xxii, xxix, 11–12, 21, 49, 55, 59, 68–69, 91
Kustodiev Art Gallery, xxviii
Kustodiev, B., 24
Kutaisi City Institute, 76
Kuzmin, M., vii, ix, xi–xii, xiv–xv, xix, xxi, xxvii–xxviii, 4–5, 13–14, 16–25, 31, 47,
 49, 51, 53, 58, 64, 66–67, 69–71, 75, 77, 84–85, 87, 93, 95
Kuznetsov, P., 15, 30

Lancéray, E., xiv, xxiv
Lanskoy, A., 57
Lapshin, N., 56–57
Larionov, M., xxix, 5, 24, 37, 55, 57, 73, 92
"L'Art Russe," 4, 9, 28, 51, 66
Laurent, E., 31
Le Coq, P., 95
Le-Dantiu, M., xx, xxviii, 56–58
Lef, 68
Le Gris-Bergmann, F., 65
Leitis, K., 46
Lenin, V., 45, 48, 84–85
Leningrad. *See* St. Petersburg
Lentulov, A., 54
Leontiev, L., 61
Lermontov, M., xix, xxviii, 41, 51, 59
Leshkova, O., 56–57
Leskov, N., 13
Lissitzky, El, 5
Liszt, F., 30
Liteinyi Theater, 70
Literaturnaia Gruziia, 41, 49
"Little Circle," xxiii, 4, 9–10, 18, 22–23, 35, 73, 90
Liubimov, A., xxx
Liumbomirskaia, Nimfa Bel-Kon, 7, 9–10, 18, 50, 81
Livshits, B., xiv–xv, xxvii–xxix, 14, 39, 53, 85
Lobanov-Rostovsky, Nikita 7, 56
Lobanov-Rostovsky, Nina, 7
Lordkipandze, O., 49
Lossky, N., 30
Lourié, A., xiv, xx, xxiv, xxviii–xxix, 22, 47, 69, 70
Lukomorie, 13
Lukomsky, G., 23–24, 38, 79
Luryi, 15
Lvov, Ya., xvi, xxviii, 19, 34, 43–44, 72

Madchavariani, N., 72
Magarotto, L., xxviii–xxix, 6–7, 21–22, 36, 41, 47, 49, 59–60, 62–63, 69, 77
Maiakovsky, V., xx, 6, 22, 45, 61, 66–67
Maidel, Olga, 43
Maidel, Olia, 42–43
Makashvili, N., xxii
Makovsky, S., ix, xvii–xix, xxviii, 30, 43, 65–66, 70, 73, 83, 88, 93–94
Malevich, K., xi, xiv, 55
Mallarmé, S., xxii, 45
Malmgren, E., 15
Malmstad, J., 17, 25, 87
Malyi Theater, 66, 70
Mamontov, S., 4
Manchester Guardian, 57
Mandelstam, N., xxviii, 76
Mandelstam, O., vii–ix, xii, xix, xxviii, 3, 15, 17–19, 23, 38–39, 41, 57, 75–77, 93
Manet, E., 34
Manozon, E., 97
Mantegna, A., 93
Manuilov, V., 94, 97
Margvelashvili, G., 76–77
Marinetti, F., xiv–xv, 57, 73
Markov, P., 70

Markov, V., 3, 17, 25, 42, 74
Markozov, I. (also L.), 44, 60, 66
Marseilles, vii, ix, xi, xxv, 8–9, 51, 80, 90
Martinů, 48
Marx, K., 17, 35
Marzaduri, M., xxi, xxviii–xxix, 6–7, 21–22, 36, 41, 44, 47, 49, 55, 59–60, 62–63, 68–69, 77, 80, 91
Mashinsky, S., 73
Massine, L., 37
Matisse, H., 55
McCaffrey, R., xxvii, 4, 15, 17–18, 38–39, 43, 83–84
Mdivani, N., 76
Mdivani, R., 76
Meierkhold, V., xv, 4, 13, 22, 70, 85
Melikov, A., xxv, 9, 90
Melikova, A., xxv, 9, 90–91
Melnikova, S., xxi, xxiv, xxviii–xxix, 58–59
Meocnebe niamorebi, 41
Merezhkovsky, D., 11
Merry Harlequin (cabaret), xiii, xxiv, 73, 84–85
Merry Theater for Elderly Children, 85
Metropolitan Opera, xxvi, 4
Mgebrov, A., 85
Mihalovici, 48
Mikhailovsky, N., 44
Miklashevsky, K., 85
Milioti, N., 5, 30
Miliukov, P., 28
Milner-Gulland, R., xxviii
Minsky, N., xii, xxiii, 10–11
Miskhor, vii, xvi, 4, 6, 9, 14–15, 27–34, 43, 46, 52–54, 65, 69–70, 79, 93, 95–96
Mitsishvili, N., viii, xxii, 45, 76
Moch-Bickert, E., 14, 53, 70
Modernism Gallery, xxviii
Modigliani, A., 23
Moi zhurnal, 44
Molière, 32, 66
Moore, J., xxvii
Morderer, V., xxvii–xxviii, 4
Morozova, O., 70
Moscow, vii, ix–xviii, xx, xxiii–xxx, 3–9, 11, 16, 18–21, 24, 26–27, 30, 32, 37, 39, 44–46, 49–52, 54–62, 64, 66–69, 72–73, 75–77, 81–82, 84–86, 93, 95–96
Moscow Arts Theatre (MKhAT), xiv, 30, 32–33, 54
Moscow Association of Artists, 5
Moscow Institute of Painting, Sculpture, and Architecture, xxviii, 4, 52, 66
Moscow University, 10, 45, 54, 67–68, 93
Moskvin, G., xxviii–xxix
Mozart, W., xii, 14, 16–17, 42, 66
Mukhina, M., 31, 52
Mukhina, V., 52
Musée d'Orsay, 73
Museo de Bellas Artes, 52
Museum of Modern Art (Oxford), 4, 70
Mussorgsky, M., 83

Nabokov, V., 30
Na chuzhoi storone, 54
Nadson, S., 11, 42, 67
Napoleon, 35, 81
Nappelbaum, M., 70

Narbut, E. (also G.), 79
Nash krai, 26
Nashe slovo, 61
Na Zare, 44
Nechaev, V., xxix
Neigauz, G., xxi, xxix
Nekrasov, N., 11
Nelidova, L., 15
Nerler, P., 77
Nestor, 10
New Gallery, 4
New York School of Applied Arts, 52
Nietzsche, F., 40, 77
Nijinska, B., 37
Nikitina, Z., 89
Nikoladze House-Museum, 46
Nikoladze, Ya., xxi–xxii, 23, 45–47, 49, 58
Nikolaev, P., 8, 50, 67, 94
Nikolskaia, T., 21, 26, 69
Niva, 89
"No. 4," 55
Northwest Opera Intime, 33
Nosov, V., 13
Nosova, E., 13
Novaia russkaia kniga, 25
Novorrossiisk, vii, xi,xix, 4, 15, 28, 54
Novoye Russkoye Slovo, 10
Novyi den, 40
Novyi lef, 61
Novyi satirikon, 25, 51

Obnevsky, S., 85
Obolenskaia, L., 10
Obolensky, A., 10
Obolensky, S., 10
Obolensky, V., 10
Odessa Art School, 9
Offenbach, J., 64
OknaROSTA (Baku Windows of the Russian Telegraph Agency), xxiv, 8, 46, 73, 78, 80
O'Konnel, R., 28
Olimpov, K., 33
"One Hundred Years of French Painting," xix
Oranienbaum Military School, 26
Orion, 8, 10–11, 13, 21, 41, 55, 76
Ovid, 28–29

Pagani-Cesa, G., xxviii–xxix, 6–7, 21–22, 36, 41, 47, 49, 59–60, 62–63, 69, 77
Pallada, xiv, xviii, 30, 53, 57, 60, 65, 85, 87
Palmer, J., xxvi
Panina, S., 30
Paris, vii–viii, xi, xiii, xv, xix, xxiii, xxv, xxvi, 3–7, 9–11, 14, 23, 28, 30–31, 35, 37, 40–41, 45–46, 48, 51–53, 55–58, 60–61, 63, 66, 69–70, 75–76, 78–79, 83–86, 88–93, 95
Paris Conservatory, 48
Parnakh, V., 4, 63, 91
Parnis, A., xxvii–xxix, 3–4, 7, 66, 77, 81
Parus, xxiv xxix
Pasternak, B., 23, 57
Patriarch Nikon, 17

Paustovsky, K., 47
Pavlova, A., 9, 48
Peackock's Tail (café), xxi, xxiii, 55
Penza Art Institute, 63
People's House, 28
Perm State Picture Gallery, 7
Petit, R., 38
Perts, V., 52
Petrakovsky, A., xxi, 44
Petrograd. *See* St. Petersburg
Petrograd Conservatory, 48
Petrograd University, 21, 79
Petrov, N., xiv
Petrov-Vodkin, K., xix
Philipp, 48
Philotheus, 67
Piast, V., xiv, 18
Piccadilly (cabaret), 63
Piero della Francesca, xvi
Pinegin, V., 52
Pink Lantern (cabaret), xiii
Pirandello, L., 85
Pirosmanashvili, N., xx, xxix, 34, 45, 47, 55, 57, 96
Piriushko, Yu., 52
Pitt, W., 35
Podgornyi, V., xvi, xxviii, 64
Podkopaeva, Yu., 14
Pol, V., xiii–xiv, 17, 29, 30, 33
Polytechnic Institute, 61
Polytechnic Museum, 57
Ponedelnik, 11, 25, 73
Popova, L., 5
Poroshin, A., xxi, xxiv–xxv, xxix, 21–22, 49, 58–59, 63
Poslednie novosti, 63, 79
Potemkin, P., 3
Prague National Theater, 28
Proffer, E., 60
Pronin, B., xiv–xvi, xxviii, 64, 73
Pronina, V., xvi, xxi
Protozanov, Ya., 15
Pukhalsky, V., 30
Punin, N., 51–52
Pushkin, A., xxviii, 35–36, 42, 44, 51

Rabelais, F., 13
Rachel Adler Gallery, xxviii, 35, 55, 92
Rachmaninoff, I., 31
Rachmaninoff, S., 30–31
Radakov, A., xiv, 6
Radin, I., 49, 81
Radio City Music Hall, xxvi
Raevskaia-Hughes, O., 63, 78
Rafalovich, O., 11
Rafalovich, S., xix, xxiii, xxvii, 8, 11–12, 19–21, 49, 62–63, 68, 71–72
Ragozinsky, V., 93
Raiskii Orlenok. Zhurnal detskikh riusunkov, stikhov i razskazov, 50
Rampa i zhizn, 44, 54
Ravel, M., 83
Raynal, M., 6, 23–24
Rech, 57

Reeve, F., xxviii
Reeve, H., xxviii
Reisner, L., 85
Religious-Philosophical Gatherings, 11
Remizov, N., xiii, 51, 77–78
Repin, I., 9, 28, 52
Riabushinsky, S., 52
Rilke, R., 13
Rimbaud, A., xxii, 61
Rimsky-Korsakov, N., 14, 28, 34, 60, 83
Rizzi, D., 91
Robakidze, G., vii, xi xxii, xxiv–xxv, xxix, 6, 35–36, 38, 40–41, 45, 71–72, 77, 86
Rodchenko, A., xxix
Rodin, A., 45–46
Roerich, N., xix, 29
Rousseau, J.-J., 11
Rozanov, V., 41
Rubens, P., 23, 34
Rudnitsky, K., 25
Russian Conservatory, 30
Russian Museum, xxix, 57, 62, 73
Russian Musical Society, 30
Russian State Archive of Literature and Art (RGALI), xxvii–xxviii, xxx, 14
Russkaia khudozhestvennaia letopis, 52, 94
Russkie vedomosti, 89
Russkoe slovo, 25, 54

Sacher, P., 34
St. Petersburg, vii–xiii, xv–xvi, xviii–xxiv, xxvii, xxix, 3–6, 8–11, 13–15, 18, 20–22, 24–35, 37, 39, 41–42, 44, 47–48, 50–51, 53, 56–58, 60–62, 66, 68–70, 73, 75–80, 82–86, 88, 92–95
St. Petersburg Academy of Arts, 9
St. Petersburg Conservatory, 60
St. Petersburg Technological Institute, 89
St. Petersburg University, 7, 14, 28, 39, 60, 66, 83
Salieri, A., 42
Sallard, O., xxviii
"Salon," xix
"Salon d'Automne," 9, 66
Samoradov, E., xxiv, 63
Sapunov, N., xv, xxviii, 85
Sarabianov, A., 73
Sarian, M., 94
Satire-Agit Theater, 85
Satirikon, xix, 25, 51
Savinov, V., 9
Sayler, O., xiii
Sazonov, P., 5
Sazonova, Yu., 30
Schnitzler-Dohnanyi, A., xv, 29
Schoenberg, A., 83
School for the Encouragement of the Fine Arts (Tiflis), 23
Schumann, R., xii, 7–8, 18–19, 22, 30, 64, 82
Sciltian, G., xxi, xxix, 6, 36, 40–41, 56, 61, 64
Scriabin, A., 30
Segal, H., xxvii
Semeiko, N., xxiv, 23, 49, 66
Serov, V., xii, 4
Seurat, G., 73
Severance Hall, 4

Severianin, I., 6, 33, 53, 70
Shafran, M., 3
Shaikevich, G., 52
Shamurian, L., 7
Sharadze, G., 41
Sharleman, I., xxiv, 44, 48
Shcheboleva, G., 52
Shchegolev, P., 52, 83
Shcherbinovsky, D., 51
Sheldon, R., xxvii
Shervashidze, A., 60, 85
Shervashidze, R., 61
Shilling, R., xv, 15, 87
Shklovsky, V., xxvii
Shor, D., 15
Shukhaev, V., xiii, 51–52
Shukman, H., xxviii, 46
Shushanik, 80
Simonovich-Efimova, N., 5
Skarabei, 49
Sklifasovsky, N., 34, 55
Skripitsyn, S., xxi
Slonimskaia, Yu., 5
Snyders, F., xix
Sobinov, L., 33
Society for the Encouragement of the Arts, 28, 43
Society of Baku Artists, xxiv
Society of Free Aesthetics, xii, 5, 69
Society of Georgian Artists, xxiii, 23
Sokolov, N., 46, 52, 86
Sokolov, S., 46
Sokolova, L., 37
Sokolova, N., 46, 52
Solari, P., 76
Soldier's Voice, 76
Solivetti, C., 85
Solovieva, B., 92
Sologub, F., 3, 5, 70, 77
Somov, K., xxvii, 5, 14–15, 31, 51, 85, 88, 92
Sorbonne, 93
Sorin, S., xiv, xvii–xix, xxiii, xxv, xxvii, xxx, 4, 9, 10–11, 15, 28, 33–34, 45, 47, 49, 52, 58, 60, 66, 68–70, 75, 81, 85–86, 90
Sparks, M., 74
Spengler, O., 40
Spolokhi, 79
Stable of Pegasus (cabaret), xiii
Stalin, xxiii
Stanislavsky, K., 4, 33
Starye gody, xi
Starynkevich, O., 53
State Museum of Arts of the Georgian SSR, 10, 18, 56–57, 65, 72, 92, 96
State Porcelain Factory, 70
Stelletsky, D., xix
Stravinskaia, E., xix, 83
Stravinsky, I., vii, ix, xii, xviii–xix, xxv–xxix, xxx, 3–4, 7, 15, 18, 27, 29–30, 34, 37–39, 43, 70–71, 81, 83–85, 88, 98–99
Stravinsky, Yu., xix, 83
Stray Dog (cabaret), xiii–xv, xviii, xx–xxii, xxvii–xxviii, 3–6, 8, 13–14, 20–21, 25, 30, 33–34, 53, 57, 67, 70–71, 73, 78–79, 83–86, 88
Strémoukhoff, D., 67

Stroganov Institute, 46, 51, 66
Struve, G., 39, 75–76, 93–94
Struve, M., vii, xxiii, 21, 23, 38, 66, 78–80, 85, 88, 95
Struve, N., 93–94
Stuck, F., 31
Studio of Artistic Prose, 21
Studio of Poets, xxi
Styk, 26
Sudeikin (Sudeikin-Stravinsky), V., vii–xxx, 3–19, 22–25, 27–35, 37–49, 51–53, 55, 57–62, 64–72, 75–76, 78–97
Sudeikin, S., vii–xxx, 3–20, 22–25, 27–53, 55, 57–72, 74–75, 78–97
Sulakauli, A., 45
Suny, R., xxviii
Survage, L., 37
Suzdalev, P., 52
Sveshnikova, A., 14

Tabidze, N., xxiii, 38
Tabidze, P., 71
Tabidze, T., xxi–xxiii, xxv, xxix, 23, 38, 41, 44–45, 47, 55, 71–72
Tairov, A., xv, 4, 15, 17, 69–70
Talashkino, 29
Taneev, S., 30
Taq'aishvili, 23, 57
"Target," 55, 57
Tarkhov, N., xix
Tatlin, V., xi, xiv
Tbilisi. *See* Tiflis
Teatro dell'Arte, 85
Teffi, N., xiii
Teniers, D., xix
Tenishev Institute, 39
Tenisheva, M., 28–29
Terebenev, M., xix, 83
Terechkovitch, C., 57
Terentiev, I., xi, xix, xxi, xxviii–xxix, 11–12, 20–21, 35–36, 44, 46–47, 55–58, 68–69, 86
Theater of Miniatures, xxi, xxiii, xxviii, 59
Theater of Musical Drama, 44
Theater of Opera and Ballet (Tiflis), xxi-iii, 24, 35, 48, 59, 64
Théâtre de l'Opéra, 37
Théâtre des Champs-Elysées, 84
Théâtre du Vieux Colombier, 5, 85
Tiflis, vii–ix, xi–xiv, xvi, xix, xx–xxv, xxviii–xxix, 3–4, 6–15, 17–24, 26, 33–36, 38, 40–50, 54–69, 71–81, 84–86, 88, 90–92, 95–97
Tiflis Artistic Society, xxii
Tiflis Conservatory, 6, 21, 40, 48–49, 57–59, 61, 63, 68
Tiflis Department of the All-Russian Union of Writers and Poets, 11
Tiflis Opera Theater, 44
Tiflisskaia gazeta, 48
Tiflisskii listok, 21
Timenchik, R., xxvii–xxviii, 3–4, 7
Tishchenko, V., 52
Tiutchev, F., 29
Tjalsma, H., 87
Tolstaia, L., 89
Tolstaia, T., 12
Tolstoi, A., 25, 34, 38, 79, 83, 88–89, 93–94
Tolstoi, L., 61
Tretiakov Gallery, 10–11
Tretiakov, S., 12

Troitsky Theater, 57
Trubetskoi, E., 30
Trud, 49
Tsybulsky, N., 33, 84–85
Tumanian, O., 72
Tumanishvili, xxii
Turgenev, I., 32
Tverskoi, K., 85
Tvorozhnikov, I., 9

Ukrainka, L., 86
Ulianinskaia, N., 42–43
"Union of Russian Artists," 4
Union of Russian Art Workers, 66
Union of Russian Poets, 57
University of Baku, 77
University of Geneva, 36
University of Heidelberg, 40
Urushadze, I., 46
Urvantsov, N., 60
Uspensky, P., 30

Valishevsky, S., ix, xxi–xxiii, 23, 34–35, 44, 46, 55, 57, 61, 73–74, 97
Valishevskaia, V., 34, 55, 77
Van der Neer, A., xix
Van Rozen, R., xxx
Varentsova, I., 52
Vasiliev, N., xix
Vasilieva, L., 41
Vasilieva, N., xxi, 36, 40–41, 49, 58, 62
Vasilii III, 67
Vechorka, T., xxiv–xxv, 8, 21, 45, 49, 55, 58–59, 78, 80–81
Velasquez, D., 34
Verlaine, P., xxii, 61
Vermel, S., 63
Vestnik Evropy, 10
Vesy, 14, 18
Vidal, 48
Virchow, R., 15
Volkonsky, D., 31
Volkonsky, P., 31–32
Volkonsky, S., 30
Volkonskaia, M., 31
Volkonskaia, Z., xi
Voloshin, M., vii, ix, xii, xvii, xix, 14, 28, 50, 93–94, 97
Voltaire, F., 11
Voltsenburg, O., 66
Voskhod, 54
Vrangel, L., xxviii, 28–29, 42–43
Vrangel, N., 25

Wieck, C., 19
Wilde, O., 13
Wilson, W., 35
Wöfflin, H., 15
World of Art, 27–29
"World of Art," 9, 25, 94

Yablonovsky, S., 54
Yakobson, M., 33–34, 65
Yakovleva-Shaporina, L., 5

Yakulov, G., xx, xxviii
Yakunina, E., 5
Yalta, vii–ix, xi, xvi–xix, 4, 6, 9–10, 15, 18, 28–30, 33, 39, 41–44, 52–54, 60, 65–66, 79, 83, 88, 93–94, 97
Yanovsky, V., xviii, 28, 42–43
Yan-Ruban, A., 17, 30
Yarotskaia, M., 85
Yashvili, P., xxi–xxiii, xxix, 20–21, 38, 45, 55, 71–72, 86
Yufit, A., 61
Yurkun, Yu., 14, 20–22
Yusupov, F., 53

Zack, L., xviii
Zakharian, S., 64, 89

Zaltsman, A., xxii–xxiii, 48, 86
Zdanevich, I., xi, xix–xxiii, xxviii–xxx, 12, 14, 20, 23, 26, 35, 39, 44, 46–47, 53, 55–58, 62–63, 65, 68, 73, 81, 86, 92
Zdanevich, K., xi, xx, xxii–xxiv, xxviii–xxix, 6, 12, 21, 23, 34–35, 45–47, 55–58, 61, 65, 68, 86, 92
Zdanevitch, H., 12
Zhar-ptitsa, 10, 88
Zhemchuzhnikov, V., 34
Zhikhareva, E., 48
Zhizn iskusstva, 18
Zhupel, 28
Zimin, S., 27, 64
Zlatkevich, L., 24
Zolotoe runo, 93

The indexes that follow contain references to Album entry numbers. The list below shows the numerical sequence of the entries throughout the Album.

1a	37a	54b	85b	111b	138b
1b	37b	55a	86	112–13	139
2a	37c	55b	87	114	140
2b	37d	55c	89	115a	143a
5a	38	57	90a–91a	115b	143b
5b	39a	59a	90b	115c	143c
5c	39b	59b	91b	115d	145
7a	40	60	92	116a	147
7b	41a	61a	93	116b	149
11	41b	61b	95a	117a	150
13a	41c	63a	95b	117b	153
13b	41d	63b	95c	117c	155
15	42	63c	96a	117d	156a
16	43a	64 (translation only)	96b	118	156b
17a	43b	65a	97a	119	157a
17b	43c	65b	97b	121a	157b
18	44	65c	98	121b	158
19	45a	67a	99	121c	159
21	45b	67b	100a	122a	161a
22a	45c	71a	100b	122b	161b
22b	45d	71b	100c	123	162
23a	46	72a	101	125a	163
23b	47a	72b	102	125b	165
24a	47b	75	103a	127a	167
24b	47c	77a	103b	127b	169
25a	47d	77b	105	127c	170
25b	48	78	106	128	171
27	49a	79a	107a	131a	173a
29	49b	79b	107b	131b	173b
31a	50	80	108a	131c	S1
31b	51a	81	108b	132	S2
32a	51b	83a	109a	133	S3
32b	53a	83b	109b (translation only)	134	S4
33	53b	83c	109c	135	S5
35a	53c	84	110	136	
35b	54a	85a	111a	138a	

INDEX TO WRITTEN ENTRIES

Albrekht, Adam, 42
Altman, Moisei, 5c
anonymous or indecipherable written entries, 35a, 64, 79a, 95a, 95b

Balmont, Konstantin, 1a
Bariatinskaia, Mariia, 54a
Bechhofer, Carl, 127a
Belkin, Veniamin, 45b
Bilibin, Ivan, 37a, 37c

Chachikov, Alexander, 33
Cherniavsky, Nikolai, 61b

Davidovskaia, Daria, 77a
Davydova, Mariia, 55c
Debua, Alexander, 115a
dedications:
 —to Yurii Degen: by Kseniia Degen, 63a
 —to Mikhail Kuzmin: by Yurii Degen, 25a
 —to Savelii Sorin: by Nimfa Bel-Kon Liubomirskaia, 7b; by A. Fainberg, 121a; by Tatiana Vechorka, 83a
 —to Sergei Sudeikin: by Carl Bechhofer, 127a; by Alexander Debua, 115a; by Yurii Degen, 25b; by A. Fainberg, 108a, 121b; by Mikhail Gerasimov, 90b; by Sergei Gorodetsky, 21; by Vasilii Kamensky, 171; by Boris Kochno, 48–49; by Vladimir Pol, 39a; by Mikhail Struve, 131a; by Tatiana Vechorka, 83b
 —to Sergei Sudeikin and Vera Sudeikina: anonymous, 95a; by Georgii Evangulov, 90a–91a; by Sergei Gorodetsky, 19; by Mikhail Kuzmin, 17a; by Osip Mandelstam, 51a; by Pallada, 127c; by Mikhail Struve, 163; by Maximilian Voloshin, 157a; by D.W., 173b; by Suren Zakharian, 93, 137
 —To Vera Sudeikin: anonymous, 97b; by Konstantin Balmont, 1a; by Yurii Degen, 27; by Jean Jaquier, 40; by Vasilii Katanian, 89; by Boris Kochno and Igor Stravinsky, S4; by Sergei Rafalovich, 102; by Igor Stravinsky, 123, S5; by Maximilian Voloshin, 157b
Degen, Kseniia, 63a
Degen, Yurii, 25a, 25b, 27, 32b, 107b, 108b
Dolgushin, Yurii, 67a

Evangulov, Georgii, 90a–91a, 138b

Fainberg, A. 109a, 121a, 121b

Gorodetsky, Sergei, 5b, 19, 21–22a, 71a, 106, 112–13, 117b, 117c, 125b
Grigoriev, Boris, 109b, 122b, 143b, 143c

Ivnev, Riurik, 97a, 97b

Jaquier, Jean, 40, 54a

Kamensky, Vasilii, 2b, 171
Kamsky, Yakov, 65b

Katanian Vasilii, 87, 89
Kharazov, Georgii, 47a, 47d, 53a, 53b, 53c, 101
Khotiaintseva, Alexandra, 77a
Kochno, Boris, 48–49b, S4
Koreneva, Lidiia, 43a, 43c
Kuzmin, Mikhail, 15, 17a, 31b

Leitis, Karl, 60
Leuchtenberg, duchess of. See Zamtary
Liubomirskaia, Nimfa Bel-Kon, 7b
Lvov, Yakov, 55a

Maidel, Olga, 54a
Mandelstam, Osip, 51a, 111a, 111b
Markozov, Iosif, 55b
Melikova, Alexandra. See Zamtary
Minsky, Nikolai (pseudonym of Vilenkin, Nikolai Maximovich), 11
Mitsishvili, Nikollo (pseudonym of Nikollo Sirbiladze), 111b
Mukhina, Mariia, 77a

Nikoladze, Yakov, 59a

Pallada (Pallada Bogdanova-Belskaia; Pallada Deriuzhinskaia), 77b, 127c

Radin, Ivan, 65c
Rafalovich, Sergei, 13a, 13b, 23a–24a, 24b, 102
Robakidze, Grigorii, 51b

Severianin, Igor, 45a
Sokolov, Nikolai, 61a
Stravinsky, Igor, 123, S4, S5
Struve, Mikhail, 115b, 131a, 163

Tabidze, Titsian, 57
Terentiev, Igor, 99
Tolstaia, Tatiana. See Vechorka, Tatiana

Ulianinskaia, N., 54a

Vechorka, Tatiana (pseudonym of Tatiana Tolstaia), 83a, 83b
Vilenkin, Nikolai. See Minsky, Nikolai
Volkonsky, Petr, 41b
Voloshin, Maximilian, 157a, 157b

Yablonovsky, Sergei, 78

Zakharian, Suren, 93, 137
Zamtary (pseudonym of Princess Alexandra Melikova, duchess of Leuchtenberg), 139
Zdanevich, Ilia, 81

INDEX TO ILLUSTRATIVE ENTRIES

Belkin, Veniamin, 32a, 44
Brailovsky, Leonid, 96b, 108a

Gerasimov, Mikhail, 90b, 91b, 138a
Gorodetsky, Sergei, 71, 112–13, 117a, 117d, 125a

Grigoriev, Boris, 75, 110, 116a, 116b, 122a, 135, 143a, 147
Gudiashvili, Lado, 29, 165

Nikoladze, Yakov, 59b

photographs: of the Blue Horns (group portrait), 103a; of Nikolai Evreinov, 85b; of Olga Glebova, 100a–c; of Lado Gudiashvili's painting *Holiday*, 103b; of Titsian Tabidze, Paolo Yashvili, Alexander Kancheli, Nina Tabidze, and Grigorii Robakidze, 50

Sorin, Savelii, 7a
Stravinskaia, Vera. *See* Sudeikin, Vera
Sudeikin, Sergei, 1b, 2a, 5a, 17b, 18, 22b, 23a, 31a, 37b, 43b, 45c, 47b, 47c, 49b, 63a, 63b, 67b, 72a, 72b, 72c, 83c, 85a, 86, 95c, 98, 105, 109c, 114, 115c, 115d, 118, 121c, 123, 127b, 128, 131b, 131c, 132, 133, 134, 140, 145, 149, 150, 156a, 156b, 162, 167, 169, 173a, S1, S2, S3

Sudeikin, Vera, 16, 35b, 38, 79b, 84, 92, 155, 158, 159, 161a, 161b, 170

Terentiev, Igor, 99

Valishevsky, Sigizmund, 46, 107a
Volkonsky, Petr, 41a

Yanovsky, Vladimir, 54b

Zdanevich, Ilia, 119
Zdanevich, Kirill, 80, 153

INDEX TO MUSICAL ENTRIES

anonymous musical entry, 96a

Cherepnin, Alexander, 65a

D.W., 173b

Pol, Vladimir, 37d, 39a

Stravinsky, Igor, 123, S5

Yakobson, Miron, 45a, 45d

INDEX TO PORTRAITS

Balmont, Konstantin: by Sergei Gorodetsky, 113
Bely, Andrei (pseudonym of Boris Bugaev): by Sergei Gorodetsky, 113
Blok, Alexander: by Sergei Gorodetsky, 71b, 113
Bonaparte, Napoleon (as Sergei Sudeikin): by Ilia Zdanevich, 119
Brailovskaia, Rimma: by Vera Sudeikin, 161b
Briusov, Valerii: by Sergei Gorodetsky, 112

Degen, Kseniia: by Sergei Sudeikin, 63c
Degen, Yurii: by Sergei Sudeikin, 63b
Dolgushin, Yurii: by Sergei Sudeikin, 67b

Evreinov, Nikolai: by Sergei Sudeikin, 85a

Glebova, Olga: by Sergei Sudeikin, 128
Gorodetsky, Sergei: by self, 71b, 112–13; by Sergei Sudeikin, 18
Grigoriev, Boris: by self, 122a; by Sergei Sudeikin, 109c
Gudiashvili, Lado: by self, 165

Ivanov, Viacheslav: by Sergei Gorodetsky, 71b, 112

Kamensky, Vasilii: by Sergei Sudeikin, 85a
Kuzmin, Mikhail: by Sergei Gorodetsky, 71b, 113

Liubomirskaia, Nimfa Bel-Kon: by Sergei Sudeikin, 18

Nikodim (Sudeikin's student): by Vera Sudeikin, 161a

Nikoladze, Yakov: by self, 59b

Prutkov, Kozma: by Leonid Brailovsky, 108a

Rafalovich, Sergei: by Sergei Sudeikin, 22b
Remizov, Alexei: by Sergei Gorodetsky, 112

Sologub, Fedor (pseudonym of Fedor Teternikov): by Sergei Gorodetsky, 112
Sorin, Savelii: by self, 7a; by Vera Sudeikin, 161b
Stravinskaia, Vera. *See* Sudeikin, Vera
Struve, Mikhail: by Sergei Sudeikin, 131b
Sudeikin, Sergei, and Vera Sudeikin: by Sergei Sudeikin, 1b, 2a, 41c; by Ilia Zdanevich, 119
Sudeikin, Sergei: by Veniamin Belkin, 32a; by Boris Grigoriev, 147; by self, 2a, 5a; by Vera Sudeikin, 161a; by Igor Terentiev, 99; by Ilia Zdanevich, 119 (as Bonaparte and as self)
Sudeikin, Vera: by Lado Gudiashvili, 29 and 165; by Sergei Sudeikin, 17b, 37d, 41d, 72a, 72b, 105, 128, 134, S1, S3; by Sigizmund Valishevsky, 46; by Petr Volkonsky, 41a; by Ilia Zdanevich, 119

Terentiev, Igor: by self, 99
Tolstoi, Alexei: by Sergei Sudeikin, 135

Zdanevich, Ilia: by Kirill Zdanevich, 80

INDEX TO DATES

1916	April (Easter), Petrograd	Mikhail Kuzmin, 17a
1916	n.d., Petrograd	Mikhail Kuzmin, 15
1917	7 July, Tiflis	Georgii Kharazov, 53a–c
1917	8 August, Alushta	Osip Mandelstam, 111a
1917	11 August, Alushta	Osip Mandelstam, 51a
1917	September, Alushta	Sergei Rafalovich, 24a
1917	15 October, n.p.	unidentified, 95a
1917	21 October, Alushta	D.W., 173b
1917	31 October, n.p.	unidentified, 95b
1918	15 May, Miskhor	Ivan Bilibin, 37b
1918	3 June, Miskhor	Ivan Bilibin, 37a
1918	May–June (or both), Miskhor	Vladimir Pol, 37c
1918	9 August, Miskhor	Pallada, 77b

1918	16 August, Miskhor	Lidiia Koreneva, 43c
1918	27 August, Miskhor	Lidiia Koreneva, 43a
1918	August, Miskhor	Petr Volkonsky, 41b
1918	April (not the 1st), Crimea	Veniamin Belkin, 45b
1918	November, Novyi Miskhor	Maximilian Voloshin, 157a
1918	29 November, Yalta	Maximilian Voloshin, 157b
1918	n.d., Novyi Miskhor	Miron Yakobson, 45a and d
1918	n.d., Gaspra	Vladimir Pol, 39a
1919	16 March, Miskhor	anonymous, 40
1919	20 March, n.p.	Sergei Yablonovsky, 78
1919	14 April, Yalta	Olga Maidel, Jean Jaquier, N. Ulianinskaia, Mariia Bariatinskaia, 54
1919	23 May, Tiflis	Sergei Rafalovich, 19
1919	11 June, Tiflis	Sergei Gorodetsky, 21
1919	13 June, Tiflis	Titsian Tabidze, 57
1919	19 June, Tiflis	Georgii Kharazov, 47d
1919	June, Tiflis	Sergei Rafalovich, 23b
1919	3 July, Tiflis	Alexander Chachikov, 33
1919	6 July, Tiflis	Ilia Zdanevich, 81
1919	8 July, Tiflis	Yakov Lvov, 55a
1919	9 July, Tiflis	Iosif Markozov, 55b
1919	10 July, Tiflis	Nikolai Cherniavsky, 61b
1919	14 July, Tiflis	Nikolai Sokolov, 61a
1919	16 July, Tiflis	Alexander Cherepnin, 65a
1919	21 July, Tiflis	Kseniia Degen, 63b; Dolgushin, 67
1919	24 July, Tiflis	Sergei Rafalovich, 13a–b
1919	July, Tiflis	Sergei Rafalovich, 23b
1919	July, Tiflis	Sigizmund Valishevsky, 107a
1919	July, Tiflis	Yurii Degen, 107b
1919	summer, Tiflis	Grigorii Robakidze, 51b
1919	14 September, Tiflis	Yakov Kamsky, 65b
1919	15 September, Tiflis	Vasilii Katanian, 87
1919	17 September, Tiflis	Vasilli Katanian, 89
1919	17 September, Tiflis	Sergei Rafalovich, 102
1919	17 September, Tiflis	Georgii Kharazov, 101
1919	19 September, Tiflis	Riurik Ivnev, 97a
1919	28 September, Tiflis	Riurik Ivnev, 97b
1919	n.d., Tiflis	Lado Gudiashvili, 29
1919	n.d., Tiflis	Nikolai Evreinov and Vasilii Kamensky, 85a and b
1919	13 December, Baku	Sergei Gorodetsky, 106
1919	n.d., Kodzhory	unidentified, 96a
1919	20 December–January 1920, Baku	Sergei Gorodetsky, 125
1920	22 February, Baku	Sergei Gorodetsky, 5a
1920	22 February, Baku	Moisei Altman, 5a
1920	February, Baku	Mikhail Struve, 131c
1920	4 March, Baku	Sergei Gorodetsky, 71b
1920	6 March, Baku	Sergei Gorodetsky, 112–13
1920	7 March, Baku	Suren Zakharian, 93
1920	7 March, Baku	Alexander Debua, 115a
1920	8 March, Baku	Adam Albrekht, 42
1920	9 March, Baku	Sergei Gorodetsky, 71a
1920	12 March, Baku	Karl Leitis, 60
1920	12 March, Baku	Sergei Gorodetsky, 117a–d
1920	March, Baku	Nimfa Bel-Kon Liubomirskaia and Savelii Sorin, 7a
1920	n.d., Baku	Sergei Sudeikin, 18
1920	n.d., Baku	Mikhail Gerasimov, 90
1920	7 April, Tiflis	Carl Bechhofer, 127a
1920	n.d., Tiflis	Zamtary, 139
1920	15 July, Paris	Nikolai Minsky, 11
1920	10 August, Paris	Konstantin Balmont, 1a
1920	29 October, Paris	Kirill Zdanevich, 153
1920	7 November, n.p.	Ivan Radin, 65c
1920	29 November, Paris	Mikhail Struve, 115b
1920	n.d., Paris	Boris Grigoriev, 75
1921	March, Paris	Igor Stravinsky and Sergei Sudeikin, 123
1921	30 September, Paris	Boris Kochno and Igor Stravinsky, S4
1921	13 December, Paris	Mikhail Struve, 163
1921	December, Paris	Georgii Evangulov, 138b
1921	n.d., Paris	Georgii Evangulov, 91b
1921	n.d., Paris	Boris Grigoriev, 143a–c
1921	n.d., Paris	Igor Stravinsky, S5
1922	18 February, Paris	Boris Kochno, 49b
1923	summer, Paris	Nikollo Mitsishvili, 111b

John E. Bowlt is Professor of Slavic Studies at the University of Southern California, Los Angeles. He is the author of numerous books, including *The Russian Avant-Garde*. Among his recent publications is *Twentieth-Century Russian and East European Painting in the Thyssen-Bornemisza Collection*, which he coauthored with Nicoletta Misler.